THE GUARDIAN
YEAR, 2003

Edited by Luke Dodd

Introduction by
Helena Kennedy QC

Atlantic Books
London

First published in 2003 by Atlantic Books, on behalf of Guardian Newspapers Ltd.
Atlantic Books is an imprint of Grove Atlantic Ltd.

10 9 8 7 6 5 4 3 2 1

A CIP record for this book is available from the British Library.

ISBN 1 84354 043 6

Printed in Great Britain by Creative Print & Design Wales, Ebbw Vale
Design by Helen Ewing

Grove Atlantic Ltd
Ormond House
26–27 Boswell Street
London WC1N 3JZ

CONTENTS

TURF WARS

LOST IN ACTION

INTRODUCTION

Helena Kennedy QC

The year 2003 was the year of Blair's war, a war of choice which was dressed up as a war of necessity. While a week may seem like a long time in politics, 45 minutes is even longer when so much has turned upon the urgency communicated by that timeframe. The decision to go to war, arm in arm with the United States, has had tragic human and political consequences: as well as lives lost and a nation reduced to rubble, terrorism has been fostered and a region destabilized, a deep wound has been inflicted on the United Nations, international law trashed and domestic politics relegated to second-order issues for most of the year.

The justification for war against Iraq came to hinge upon the statement in a dossier produced in September 2002 that Saddam Hussein could deploy biological and chemical weapons inside an hour. According to the House of Commons Intelligence and Security Committee, that '45 minutes' claim was the jewel in the dossier crown, mentioned four times to galvanize a British public and members of Parliament who were wavering about going to war.

Doubts about that piece of information led to confrontations between Downing Street and the BBC and the outing of the BBC source, Dr David Kelly, an experienced weapons inspector who shared the views of members of the intelligence community that the claim was 'over-egged'. The suicide of Dr Kelly and the inquiry by Lord Hutton into his death could easily have drawn attention away from the reasons why a dossier was required in the first place.

In the run up to war, the prime minister sought to justify his commitment to President Bush and military intervention in Iraq in a variety of ways. First the justifications were based on the threat of weapons of mass destruction; then the emphasis changed to links with al-Qaida; then it was the oppression of the Iraqi people. Neo-conservatives in the Bush administration were less inhibited and outlined their new doctrine of pre-emptive strikes against any state perceived to be hostile. It was a public renunciation of the UN Charter, which limited the use of force to circumstances of self-defence or in response to an imminent threat. But like Tony Martin, our homegrown hero, who took a pump action shotgun to some local burglars, pre-emptive action has become an authoritarian preference.

It is important to remember that Saddam Hussein did continue to behave like a man with something to hide, whose compliance with UN resolutions remained reluctant and incomplete. The assumption was that he must have weapons somewhere. But a war that would claim innocent lives had to be justified by a stricter evidential test than the balance of probability. Unfortunately for the prime minister such evidence was thin on the ground.

At least the moral case for wishing an end to the Iraqi regime had the singular merit of being unanswerable and our prime minister likes the moral high ground. The human rights abuses of Saddam Hussein had been documented for years; they had been the basis of campaigns by Amnesty and Human Rights Watch, albeit without much response from Whitehall or Capitol Hill. However, the brutality of a regime provides no basis in law for intervention unless it would prevent a grave humanitarian crisis such as genocide or a massive and destabilizing refugee mobilization as we saw in Kosovo. The reasons are well established. Unless there is wide international consensus for such intervention, nations will cover their aggressive or avaricious motives with manufactured claims about preventing human rights abuses. Even if the international community could not be persuaded that Saddam Hussein presented an imminent threat, Tony Blair persuaded the British public on a flawed prospectus that he did.

Coupling himself so inextricably to President Bush was a tragic mistake for Tony Blair. We elect our leaders to avoid the follies the rest of us might entertain. For a man so committed to the Third Way he failed to see that on this occasion there really was a middle course. He could easily have resisted engagement in the Iraq war by expressing his warmth and commitment to the United States but declaring an overriding belief in the Rule of Law and the requirement of a second resolution from the UN Security Council. Now his claim is that history and God will judge him. No doubt they will.

The *Guardian* newspaper covered itself in laurels with Suzanne Goldenberg's powerful reporting from the heart of darkness in Iraq. It also created a public space in which well-informed debate about the war could take place. Hugo Young, as always, brought a genuine moral authority to the issues; David Aaronovitch challenged any knee-jerk opposition from the left; Jonathan Freedland confronted the allegation that to be anti-war was to be pro-Saddam. The paper provided opportunity to present real alternatives to war. As distinct from the United States, where the media buckled under the requirements of patriotism, the British press covered all bases and via the internet became a source of sustenance to many Americans.

The aftermath of the war was a solid reminder that there is more to war than winning. Planning for war also requires planning for the days that immediately follow. If we learned anything from the conflict in the Balkans it is that any vacuum left after hostilities is quickly filled with organized and disorganized crime unless the rule of law is quickly asserted. The murder of Prime Minister Djindjic in Belgrade was a stark echo of those truths.

In this bleak international landscape, hopes for the road map to peace in the Middle East have been dashed repeatedly and the conflicts in the Congo and Liberia remind us how selective the West is in its interventions. Of course, war is one of the reasons why people flee their homes and seek sanctuary in other countries but these links are rarely articulated in the rhetorical battles between the main political parties on war or asylum, each vying with the other for the tougher stance. Outside of the war – and a pre-occupation with Mrs Blair's style guru – asylum is the one issue that has dominated the tabloid press throughout the year, with refugees scapegoated for crime, terrorism and an influx of disease.

The government's latest response is to set up 'protection areas' so that Britain can deport most of the one-hundred thousand asylum seekers that arrive here each year. As Raekha Prasad points out in her piece 'Refugee Camps Don't Work': 'New ideas are needed to tackle the inequality and hopelessness that drive people to risk death by crossing borders, but meddling in the affairs of sovereign nations and creating no man's lands in some of the world's poorest regions is not the answer.'

The war has also eclipsed most domestic concerns. In a bid to recover the party faithful who were outraged by the invasion of Iraq a ban on foxhunting is again on offer – a bit of class warfare to compensate for the real thing. The Lord Chancellor and his fancy dress were shown the door and abolition of the ancient role was triumphantly announced until it was discovered that constitutional change could not be done so fast – whole rafts of legislation bearing his name would have to be removed from the statute books; the House of Lords needed a speaker; lots of judges had to be sworn in. By the following Monday the new thoroughly modern Secretary of State for Constitutional Affairs found himself on the Woolsack looking rather sheepish, dressed up as Dick Whittington.

There is no doubt that the prime minister feels a change in the wind: the unions have rediscovered their voice; there is more open criticism of policy amongst loyal Labour backbenchers and his own magic touch with the wider public seems to be losing its potency. If there was an election tomorrow, it is claimed that fewer people would vote than they do for *Big Brother*. In the midst of such disillusion the speculation that there might be regime change at Downing Street is unsurprising, but also unlikely. A man so determined to win history's approval would never want to leave on a low note.

The Guardian Year 2003 describes a perilous world, but it is also a world full of delights and absurdities, captured by the most wonderful writers. For every desperate wrong that has taken place there is story of great humanity to restore your faith. This book is a feast of comment and insight, which will help you make sense of some recent events, and convince you that some events made no sense at all.

In memory of Hugo Young

1938–2003

EDITOR'S NOTE

Luke Dodd

I came to the *Guardian* about four years ago to establish the Newsroom – an archive, education and exhibition space for Guardian Newspapers. In doing so I have become very familiar with the early nineteenth-century origins of the *Guardian* and the story of how the regional upstart evolved into a national (and increasingly international) mouthpiece for liberal values in the broadest sense. The business of news-gathering and publishing is notoriously resistant to reflection. We live in an age where there is almost no slippage between events and their coverage, where the sheer saturation and availability of news militate against the very serious business of reporting.

By any standards, the period covered by the present volume of *The Guardian Year* is extraordinary. In the last year, as the seismic aftershocks of the attacks of 11 September 2001 recede, a blatant neo-imperialism has emerged which seems to make a nonsense of the cooperative idealism that characterized the post second-world-war era, and the generally humanistic discourses that it fostered. It is no accident that during this same time the *Guardian* made the transition from regional broadsheet to national newspaper. Since it was founded in 1821, the *Guardian* has shown a remarkable ability to modulate its liberal, anti-establishment values to the vicissitudes of society at large (the phenomenal success of Guardian Unlimited is a particularly good example). This ability flows directly from the proprietor, the Scott Trust, the remit of which is deceptively simple: to ensure that the *Guardian* carries on as heretofore.

The profound implications of the Scott Trust proprietorship cannot be underestimated and its effects are particularly palpable during periods of extraordinary change such as those witnessed over the past year. It fosters a climate where priority is given to balance, reflectiveness and quality (whether that be in terms of research, reporting, writing, subediting, photojournalism or design); it provides a direct link with the *Guardian*'s pioneering charter and traditions; and it ensures that no single interest can hijack or influence editorial independence.

With obvious justification, the war in Iraq has dominated the news in 2003. In these uncertain times all we can be really sure about is that the world order is shifting its axis, significantly. It was in the pages of the *Guardian* more than any other newspaper that this process was endlessly and rigorously examined, commented on, contextualized and analysed. But the war coverage did not dilute the *Guardian*'s commitment to addressing other issues – the unprecedented levels of disease and hunger globally; the plight of refugees; race, gender and sex discrimination. At the same time the newspaper continues to provide compelling arts, sport, media and features coverage. Even at its most frivolous, *Guardian* journalism is informed by a fundamental desire to question.

Perhaps the *Guardian* provides one other important function – through an unwavering long-term commitment to the principle of human rights and justice for all, it reminds us that, however bad things become, the agenda is still set by the centre-left.

Editing is often a lofty term for putting on one's friends. I would like to thank the below for their help: Ed Pilkington, Georgina Henry, Lisa Darnell, Annalena McAfee, Sheila Fitzsimons, Gina Cross, Roger Browning, Matt Walton, Roger Tooth, David Marsh, Don McPhee, David Austin, Stuart Jeffries, Charlotte Ainsworth and all at Atlantic Books. I would particularly like to thank Helena Kennedy for her thoughtful introduction.

Luke Dodd, September 2003

ONGOING BATTLES, UNFINISHED WARS

30 September 2002

GARY YOUNGE

Churchill: The truth

Winston Churchill's finest hour may, yet again, be upon us. More than fifty years after he won the war and lost the election, Churchill is the man of the moment. On the night of 11 September his biography was on the bedside table of the then New York mayor, Rudolph Giuliani; now his bust sits on the Oval office desk of George W. Bush. In May his name topped a BBC poll of the 100 greatest Britons. And last week, the televised portrayal of his pre-war years, *The Gathering Storm*, won three Emmys.

There is a certain irony in the timing of this transatlantic adulation. As Tony Blair and Bush trot the globe, warning of the evils of chemical weapons, Churchill hardly stands out as a role model. As secretary of state for war and air in 1919, he wrote: 'I do not understand the squeamishness about the use of gas. I am strongly in favour of using poisonous gas against uncivilized tribes.' A few years later mustard gas was used against the Kurds. Nor did his distaste for the 'uncivilized' stop there. He branded Gandhi 'a half-naked fakir' who 'ought to be laid, bound hand and foot, at the gates of Delhi and then trampled on by an enormous elephant with the new viceroy seated on its back'.

True, despite these flaws, Churchill led his nation to victory in war. But then so did Stalin, and it is unlikely Russians would put him at the top of their 100 greatest. That Churchill remains so revered tells us more about Britain than it does about him.

We live in a multi-racial nation that champions a mono-racial history. It puts Sir Henry Havelock, who distinguished himself by leading the massacre of thousands of Indians, in Trafalgar Square, and it shamelessly displays its colonial booty.

So as black history month begins tomorrow, we should turn the tables. October is when black people relate the truth about our past so that we might better understand the present and, it is hoped, navigate a better future. It aims to redress the imbalance in whose stories are told and how. Thirty-one days may be insufficient, but the purpose is important: it gives us the chance to hear narratives that have been forgotten, hidden, distorted or mislaid. It is time to ask whether white people would not benefit from doing the same for the other eleven months of the year. White people are in desperate need of becoming better-acquainted with their own history.

The very notion of black and white history is, of course, both a theoretical nonsense and a practical necessity. There is no scientific or biological basis for race. It is a construct to explain the gruesome reality that racism built. So long as there is discrimination against races, we will also need to discriminate between them. Yet while blackness is relentlessly examined, whiteness is eternally presumed.

Black history is not a sub-genre of history. It is not an isolated part of the past with sole relevance to black people. Logic suggests that you cannot have black history without white history. There would be no Nelson Mandela, as we know him, without the architect of apartheid, Hendrik Verwoerd, nor would we have known of Rosa Parks had it not been for Mr Blake, the white driver who refused to let her sit at the front of the bus.

Nonetheless, given the imbalance of whose stories are told, the demand for a white history month might appear odd. The trouble is not that we do not hear enough about white history, but that what masquerades as history is more akin to mythology. White people, like black people, need access to a past that is accurate, honest and inclusive. We do not need more white history; we need it better told.

The object here is not individual guilt – there are therapists for that – but collective responsibility. Slavery, colonialism and empire – propelled by economic expansion and justified by white supremacy – inform much of what Britain is today. The wealth they created funded everything from industry to commerce and roads to railways in Britain. The poverty they engendered elsewhere contributed to everything from famine to war and disease to debt.

To deny this is just one more version of white flight – a dash from the inconveniences bequeathed by inequality. 'I am born with a past and to try to cut myself off from that past is to deform my present relationships,' writes Alasdair MacIntyre in his book, *After Virtue*. 'The possession of an historical identity and the possession of a social identity coincide.' This is not just true of race but of gender, nationality and religion as well. Arguably, one of the principal beneficiaries of historical honesty would be the Irish.

So it does not mean that white history is racist history. A white history month would include many a progressive voice. Anti-slavery campaigner William Wilberforce, anti-apartheid leader Trevor Huddleston, and Rhaune Laslett, who was instrumental in organizing the Notting Hill Carnival, would be on the syllabus, as would the story of the Lancashire cotton workers in 1862, who supported the blockade of the Southern states during the American Civil War to show their 'detestation' at the attempt 'to organize a nation having slavery as its basis'.

But in place of this reckoning we have a national psyche that is both selective in its memory and particular in its perspective. 'When it comes to empire there are several types of ignorance,' says Katharine Prior, the historical adviser of the new British Empire and Commonwealth Museum in Bristol. 'There are some who are not aware of the different dimensions of the history of colonialism and others who know only a version. It's a mix of received opinions and vast gaps.'

The problem with these 'gaps' is not only that they omit historical truths, but that they distort current realities. The ignorance goes all the way to the top. Only this could explain a home secretary who calls on immigrants to speak the local language at home and integrate here when the British tradition was to do exactly the opposite in the Empire. Or the Labour minister Jeff Rooker, who refers to asylum seekers as 'young, single men who have deserted their families for money', when he could just as easily be talking about the staff at the East India Company. The myopia reaches all over the world. Britain once ruled

Palestine, Zimbabwe, India, Pakistan, Sri Lanka, Sudan and Iraq – to name but a few – where conflicts now rage that are directly related to their colonial legacies. But to look at our foreign policy you wouldn't know it.

Black Britons know it because we experienced it first hand. It is those white Britons who have either forgotten or never knew, or prefer a version edited beyond both comprehension and credibility, who need to be taught. The first white history lesson would start with a quote from a prominent politician: 'This small island [is] dependent for our daily bread on our trade and imperial connections. Cut this away and at least a third of our population must vanish speedily from the face of the earth.' His name? Winston Churchill.

21 October 2002

PETER PRESTON

Tory peers and gay parents

The house is a redbrick three-up, three-down in south Manchester. A quiet and ordinary street full of ordinary and quiet people. Except that, upstairs, there's a baby stirring in his sleep. Charlie is my new grandson and the House of Lords is 200 miles away down the M6.

Which is maybe just as well. Charlie (at almost six months) hasn't heard about the Nasty party and the Nice party. He doesn't know that the Conservatives used to be nasty and are trying to be nice. He couldn't tell his Earl Howe from his Baroness O'Cathain (or, indeed, from a pot of sieved carrot). But one day he'll know that these distant pontificators – and their heirs and successors – are talking about him. One day he'll feel the heat.

That heat was on last week in ermine land as Earl Howe set out to gut the adoption bill MPs had passed his way. Adoption by unmarried or lesbian or gay partners? Not here, in the other place, m'lud.

'Eighty-three per cent of cohabitations break up within ten years,' observed the noble omniscience. 'The average length of a cohabiting relationship is two years.' And, in full statistical flow: 'I defy any social worker, however experienced, to identify unfailingly couples of the same sex who are likely to remain together in a stable and permanent relationship ... The average length of a so-called closed gay relationship is twenty-one months. "Closed" in this sense means that sexual fidelity has been maintained for the past month.'

Quite so, said the Baroness. 'An assessment of primary schoolchildren in Australia shows that scores in language skills and mathematics for the children of homosexual couples are twenty-nine per cent and thirty per cent lower respectively than for those with married parents.'

Absolutely, said the former Tory minister, Patrick Jenkin, now Lord Jenkin of Roding: 'I find it quite impossible to believe that a child who has two mothers or two fathers will not be regarded as a bit of a freak at school. It's well known that children who go from local authority homes already suffer stigma. Should we add to that by creating the stigma of having two parents of the same sex?'

He cited an 'interesting' letter from a South Woodford clinical psychologist who didn't want 'gay rights put before the legitimate best interests of children'.

And so on and so forth, bishop succeeding bishop, the pieties of family life spilling like Rice Krispies from a full packet, until their lordships passed the Howe amendments and picked another high-profile fight with the Commons (self-appointed cheerleader, the *Daily Mail*).

Lord Alli, when he spoke, confessed himself 'ashamed of the way in which this debate has been conducted'. 'Ashamed,' in context, seems mild. For these arguments are always subliminally conducted in terms of 'them' and 'us'. They are the deviants over there, those barely tolerated floaters on the peripheries of society. We are quite different. We are the bearers of the sacred cup, the upholders of marriage and all normality.

OK, I'm one of the happy, lucky 'we' party. But what has marriage to do with this? Two signatures on a piece of paper: two oaths that have lasted decades with the two people who gave them.

Tory peers have no concept of the new patterns of society. Down this ordinary street there is a kid adopted by a supposedly single lesbian – as the law allows – which gives her long-term, caring partner no rights.

And there's Charlie upstairs. I've written about my lesbian daughter a couple of times over the years, because she has taught me many things and hopes I can pass them on to a few others. Charlie isn't adopted. My daughter's partner gave birth to him; he has two mothers and a gay father. He is the child of a bonding that has endured for six years. In a world of unwanted children – 5,000 of them looking for an adoptive parent to rescue them from institutional care – he was wanted utterly and is tended now with devotion.

Who on earth can say what will last or won't last? We all live on the edge of oblivion. But it seems to me, very close to the edge, that what matters most – all of the time – is love and commitment in people. Of course Charlie may not have it easy. But he will be loved – and my daughter has sealed that with a legal commitment, with parental responsibility granted in court.

How can we talk about all this as though it were some facile, heedless process? There is nothing easy about lesbians or gay men choosing to have a child. On the contrary. And, beyond that, the business of adoption is more daunting still.

Do you remember Matt Engel's brilliant, angry articles for the *Guardian* a few years ago about the mountain of forms and interrogations he and his wife encountered when they wanted to adopt a baby from abroad? Don't think it's any easier back home. There is (saving South Woodford's blushes) no right, gay or otherwise, to adopt. There is only an entitlement to jump through hoops and hope authority will smile on you. Nothing undertaken lightly, importunately. Nothing of whim or fashion.

In logic and fact, of course, there are no statistics – no British statistics – for what happens to the adopted children of unmarried or same sex couples. Since there are no such adoptions, there are equally no progress charts. If you want to argue from abroad – from Sweden, Holland, Denmark – then that's both possible and positive.

But stick with people, not percentages. Stick with what people do, the way they are, the way they relate and care, not with the narrow guardians of

prescribed propriety. I'm sick of the nastiness of 'them' and 'us'. I'm sick of hand-me-down morality and brace-us-up legislation. I'm standing by Charlie's cot as he stirs.

9 November 2002

KATHARINE VINER

Men and monsters

When Peter Sutcliffe was charged with murder in 1981 I was so pleased that I sent a letter to the West Yorkshire police. 'Thank you!' I wrote. 'I have been worried sick! But now every woman in Yorkshire is relieved and proud of you.' I was ten years old at the time. For as long as I could remember, growing up in Yorkshire, I had been terrified that the Ripper might kill someone I knew. My relief at Sutcliffe's capture was as if he were the only murderer of women in the world, my letter to the West Yorkshire police an absurd irony when the extent of the force's ineptitude in the case was revealed.

And now there's another 'madman' on the loose, who has raped ten women and girls in the south-east. It is 'the biggest manhunt since the Ripper'. His victims have been as young as ten, his rapes are increasingly violent, and police believe he will kill. Because all strangers who attack women must have a nickname, he is the Trophy Rapist – he steals small items from the women he attacks.

There is also another man on the loose, a media personality about whom several women have complained of unpleasant sexual behaviour – including violence – to the newspapers, who, it is claimed, may have raped a woman so brutally that she had to spend four days in hospital afterwards, and who has been reported to the police by four women. He, however, if you believe what you read, is not a 'madman', but a 'highly sexed sleazeball', apparently because the women who made the allegations met him in bars rather than woodland. All you ever hear is jokes about him, rather than sympathy for his alleged victims.

So rape is a hot subject; it often is. But what has changed since the Yorkshire Ripper's day? Have the police, men, society got a better view of women, of sexual violence, of rape?

The hunt for the Yorkshire Ripper, who killed thirteen women and attacked seven others, is widely agreed to be one of the most useless in recent memory. Sutcliffe was brought in for questioning nine times, he was one of only 300 men who could have received a new £5 note found in the bag of one of the victims. His appearance matched the photofits. The investigation was also the most openly misogynistic, as spelt out by authors Nicole Ward Jouve (in her book *The Streetcleaner*) and Joan Smith (*Misogynies*).

The police divided women into 'good' and 'bad', depending on what they termed 'loose morals'. Only the 'good' women deserved our pity. As Detective Jim Hobson said: 'He [the Ripper] has made it clear that he hates prostitutes. Many people do ... But the Ripper is now killing innocent girls.' Sutcliffe often

targeted prostitutes because they were the women it is easiest to kill, as other men do today – at least sixty prostitutes have been murdered in the past ten years.

The way rape is dealt with by the police has certainly improved since 1981, when brutal interrogation of victims was the norm. Today there are rape suites, women chaperones, increased sensitivity – although a recent study by Jennifer Temkin of Sussex University shows that sometimes 'disgraceful' practices persist.

But it is in court where raped women face most problems. In 1977, when Sutcliffe was at large, 33 per cent of rape cases reported to the police resulted in a conviction. Today the rate is 7 per cent. This is partly due to increased reporting of the crime but it is also because the simple fact of having had more than one sexual partner means that women are unlikely to be believed in court. In a more sexualized society, where violent sex and pornography are increasingly acceptable, there is an assumption that 'she was asking for it'. Moreover, court procedure gets ever more brutal. The recent suicide of a seventeen-year-old girl who had been raped was blamed not on the rape itself but on her ordeal in court: she was made to hold up the underwear she was wearing during the assault.

Is it any wonder, then, that so few of the 'Sleazeball's' alleged victims reported him to the police? Many sexual attacks on women go unreported, still, and who can blame a woman, post-rape, for not wanting to go through intrusive medical examinations and the near-certain humiliation of the court?

So has rape become more acceptable since the Ripper's time? On the one hand, it is hard to imagine football crowds today chanting, 'there's only one Yorkshire Ripper', and 'eleven-nil' (there were eleven known victims at the time) as they did in the late 1970s. On the other, much of the jocular treatment awarded rapists and woman-beaters has not disappeared – it's just acquired a twenty-first-century gloss.

In an episode of *Fantasy Football*, the audience cheered at the story of Ulrika Jonsson being beaten up and kicked in the head by her boyfriend. Newspaper reports of the women who had sex with the 'Sleazeball' and complained of his brutality focus as much on their 'stupidity' for going out with him as his alleged aggression. Many columnists care mostly for the man's reputation, which is 'in tatters'.

And what of the good girl/bad girl split, which proved so crucial in West Yorkshire police's failure to catch the Yorkshire Ripper? It is as resonant as ever, if not articulated in the same way: the Trophy Ripper's victims are good, because some are children and none appears to be a prostitute; the 'Sleazeball's' alleged victims are bad, because they agreed to have a date with him in the first place. (In reality, victims who know their attacker may be more traumatized than those who have suffered stranger rape, because of the abuse of intimacy and trust.)

The curfew, too, is still in place. In the wake of the Trophy Rapist's attacks, women and children have been told to stay inside. This is exactly what happened in Leeds and Bradford in the late 1970s. In response, some women made spoof police posters telling men to stay at home at night until the Ripper was caught. Why is the idea so laughable? Why imprison all women for the crimes of some men?

It is clearly questionable whether we are any closer to dealing realistically with sexual violence against women. The Trophy Rapist has already been turned into a 'monster' – thus separating him from ordinary men – even though apparently ordinary men are the most common rapists.

Some psychoanalysts argue that we all know this on some level. Nicole Ward Jouve describes how it is possible 'very deeply not to wish to see something, while still seeing it'. Peter Sutcliffe's workplace nickname, years before his arrest, was 'the Ripper'. Was it stupidity or something more worrying: an unconscious collusion on the part of his friends – just like the detectives – which stopped them seeing an obvious truth?

A startlingly similar case came to light this week, when detectives named John Cannan, now in prison for abduction, murder and rape, as the chief suspect in the murder of Suzy Lamplugh. On the day of her disappearance in 1986, Lamplugh was due to meet a 'Mr Kipper'. John Cannan had recently been released from jail for another rape, where his nickname had been 'Kipper'.

There seems to be a certain kind of bungling that accompanies crimes against women. What might help stop it is an admission that there is a resilient strain of misogyny within this society, often unconscious, which at one end of the spectrum makes excuses for the murder of prostitutes and at the other blames women who make allegations of rape against men who date them.

Surprisingly, considering their workload, the West Yorkshire police found time to reply to my congratulatory letter in 1981. Tightly typed with single spacing, they thanked me for my 'kind remarks'. Three years later, that same police force sent a 'best wishes' card to Sutcliffe himself, for Christmas, in Broadmoor.

14 February 2003

JOSEPH HARKER

Back to Africa

'Kunta Kinte. My name is ... Kunta Kinte.' Ask any black person with memories of the late seventies and they will immediately recall the scene of the slave from Alex Haley's *Roots* series, who had just survived the crossing to America, hanging from a post being whipped by his new 'owner', and defiantly refusing to give up his African identity. But after several more lashes, with his back encrusted in blood, he could stand no more and submitted.

That was the reality for several million men and women who were forcibly removed from their west or central African villages, to become the property of plantation owners of the New World. Religion and language, as well as names, were beaten out of them.

From then on they were taught that Europeans were powerful, Africans were weak; that Europeans were civilized, Africans savage; that Europe mattered, Africa didn't.

Over the generations, much of this seeped into the consciousness, and a feeling of inferiority, even shame, began to dominate their view of their ancestral

home. Every negative stereotype about the 'dark continent' became a reason to turn their back on Africa. In the Caribbean, for example, many took on an identity based on their new-found home – a rootless identity, which seemed to proclaim that their history began with slave plantations. To this day, even in Britain, many will still assert: 'I am Caribbean, not African.'

In recent years, though, across the diaspora, there has been a rebirth of interest in Africa. Rastafarians adopted Ethiopia as their home more recently, and many children have been given African names. But these developments have limited significance – people may choose Zulu or Swahili names, for example, which have little connection with their direct history.

Now, though, things may be about to change. As detailed in a BBC documentary tonight, for the first time, black people across the globe have a chance to trace their lineage back to specific areas of Africa. By analysing DNA it is possible to trace the sequence of ancestors along the mother line – and (for men only) by Y-chromosomes, through the father line – and match them with samples taken across the continent. Although a costly and unpredictable procedure at present, it is only a matter of time before it becomes widely commercially available.

The programme links south Londoner Mark Anderson with the Kanuri people of Niger, and Beaula McCalla, of Jamaican parentage, with the Bubi people on the tiny island of Bioko off the coast of Cameroon. Both are completely overwhelmed at meeting their long-lost, directly blood-related cousins, describing their reunions as 'the most amazing day of my life'.

In a way, I know how they both felt. Fifteen years ago I traced the village in eastern Nigeria where the father I never knew was raised. It was one of the most powerful and fulfilling experiences in my life and, though I haven't returned, I feel that there is at least one place where I can sense I belong. Of course, I may, ultimately, be deluding myself, but while sometimes it seems I am at best tolerated in Britain, this warm, comforting feeling is one I have no intention of letting go.

The documentary also followed teacher Jacqueline Harriott, from Peterborough, who, despite her dark skin and typical west African features, believed she was at least 60 per cent white. 'My African descent ... is sort of hidden and suppressed and it's not evident,' she says. On hearing that she was in fact just 28 per cent European, she was consoled to learn that this was still three times more white than most others from her parental island of Jamaica. However, when tracing her European line back to the master who impregnated her female slave ancestor, and visiting his former plantation, she is shaken from her fantasy and for the first time feels a sense of pride in her African heritage.

Soon black people across the globe can share these experiences. For the first time, in thinking of Africa, they'll be able to discard the stories of war, famine and disease and focus instead on real people and real ways of life. Not some far-flung people with whom they have no connection apart from skin colour – but their own brothers, sisters and cousins, offering a whole new history and culture. Could this be the moment when a new sense of identity emerges?

The problem with the current racial label, 'black', is that no one has yet worked out what it means. Can you be black if your skin colour is a little bit

lighter? Are you a 'real' black if you don't like soul or reggae music? Must you live on 'the street' and take 'no shit from nobody'?

Once black people begin retracing their roots, will it not be a huge encouragement for those with internalized negative stereotypes to rediscover a thirst for knowledge? Is it a coincidence, for example, that Caribbean-parentage children on average perform so much worse in Britain's schools than their direct-from-Africa peers, or than Asians, who have never lost their historic identity?

Just as important, it could finally break down the barriers that have us identify ourselves as a colour rather than what we all really are – Africans. This, surely, is what Kunta Kinte would have wanted.

13 March 2003

ROSIE COWAN

Marian Price

A detective who questioned Marian Price after her arrest at Heathrow airport on 8 March 1973, recalled that just before 3 p.m., she calmly looked at her watch and smiled.

The IRA had phoned a warning to a newspaper an hour earlier, but only two of the four car bombs they had positioned, at New Scotland Yard and the British Forces Broadcasting Office in Westminster, were defused in time. The other two ripped through the Old Bailey and the Whitehall army recruitment centre. One man died of a heart attack, but with 200 injured, it was sheer chance there were not many, many more fatalities.

In another time, another place, Price might have fulfilled her childhood dream to become a nurse, finished the course she started in a Belfast hospital, and spent her working years tending those shot and blown up by her IRA colleagues.

But compulsory residence in the nurses' home was incompatible with night-time activities in the paramilitary group she joined at seventeen, and so she left to enrol at teacher training college instead. Two years later, she, her 22-year-old sister, Dolours, Gerry Kelly, now Sinn Fein's north Belfast representative and the party's policing spokesman, and eight others were bound for London, determined to hurl the IRA's bloody campaign on to the government's doorstep. Ten were caught; one got away.

A life sentence ended any chances of Price becoming a nurse or teacher. The sisters went on hunger strike in protest at being kept in an English jail and were force-fed for 200 days, mouths clamped open, tubes rammed down their throats.

They were not allowed out for the funeral when their mother, Chrissie, a staunch Republican, died of cancer in February 1975, a month before they were transferred to Armagh prison. Marian developed tuberculosis and anorexia, her body wasting to 5st 10lbs before she was freed in 1980.

At first glance, that fanatical teenage terrorist seems worlds away from this slim, well-spoken, pretty woman, a young-looking forty-nine, a married mother of two

teenage daughters. Sitting in a café in the centre of Belfast, surrounded by shoppers, there is nothing about her ordinary, neatly dressed appearance and assured manner that betrays her violent past. She may be softly spoken, so quiet you almost have to lean forward to hear her, but Price has lost none of her fervour.

'I don't expect sympathy,' she says quickly, knowing most will not offer it. 'I have no regrets. I joined young but I knew the risks involved. I had thought long and hard. It wasn't an emotional reaction to something that happened to my family or me. It was a question of fulfilling the beliefs I still hold.'

The Provisonals are now believed to be on the brink of unprecedented moves to stand down and decommission most of their arms. Price is convinced this will happen and sees this virtual disbandment as a scandalous capitulation to the British government. The Republican movement's fierce code of secrecy prevents her from disclosing any details about terrorist operations or her former comrades. But she is full of contempt for the man who allegedly commanded the IRA's Belfast brigade – Sinn Fein president Gerry Adams.

'Adams says he was never in the IRA. That is total hypocrisy,' she said, her voice spitting scorn. 'Nothing has changed to make what we did in the 1970s right then and wrong now. Sometimes I wonder, is he trying to work out his own conscience, is that what this so-called peace process is all about?'

Price believes decommissioning was the logical conclusion of the Provisionals' recent strategy, though she doesn't think this third act will happen in full glare of the cameras, as Ulster Unionist leader David Trimble would like.

'They'll explain it away to their grassroots as a tactical move, but they'll do it. They conceded the principle in their heads a long time ago.'

As a woman whose aunt was blinded in the 1930s, when the IRA munitions she was hiding exploded, she obviously views disarmament as treachery. But for Price, the ultimate betrayal was Sinn Fein entering Stormont, colluding in a partitionist government twenty-five years after the IRA succeeded in bringing it down.

But surely there's no excuse for terrorism in a democracy? Isn't all politics about compromise and winning popular support?

'No, democracy is an illusion, particularly in the Western world. Ultimately, the most powerful decide,' she said. 'I don't believe Stormont is a stepping stone to a united Ireland. If Sinn Fein wanted to administer British rule [in Northern Ireland] there were easier ways to do it than fight a 25-year war. They could have joined the SDLP.'

But post-11 September, post-Omagh, isn't any terrorist campaign simply counter-productive, never mind the terrible human cost?

She hits back, eyes blazing: 'Is Bush a good guy, just because his bombs are bigger and better than mine and he drops them from further away? Does that make him right and me wrong? I don't take moral lectures from the likes of George Bush.'

But maybe bombing was as wrong in the 1973 as it is in 2003?

'OK, I can respect that view as at least consistent, but I don't agree. Bombs are legitimate weapons of war and the IRA used them against an occupying force. The IRA campaign was never about killing civilians, that was not our intention, but accidents happen, that is an unfortunate consequence of war.'

Tell that to the families of almost 2,000 people murdered by the IRA in the past thirty years. Doesn't Price realize they would see her teenage ambition to be a nurse as horrifyingly ironic? Yes, she accepts that. Nonetheless, she is adamant there is no contradiction. She was prepared to kill for a cause but equally prepared, once someone was injured, to give them the medical care they were entitled to, no matter which side they were on.

While many Northern Irish Catholics found the Provisional IRA campaign as odious as their Protestant neighbours, it tapped deep into a tacit vein of support in the nationalist community. But with opinion polls showing well over 90 per cent of Catholics now back the Good Friday Agreement, how can there be any justification for more violence?

For Price, popularity is no measure of the legitimacy of a cause. 'The majority of Irish people have never supported the Republican cause,' she admits. 'Most are not willing to make the sacrifices it requires. But as long as there is a British presence in Ireland there will always be justification. Republicanism will never fade. My principles and ideals will never be crushed. I didn't make the choices I did for individuals within the Republican movement or Sinn Fein. The fact they've sold out does not belittle me,' she says.

Price now works for a prisoners' welfare organization, and belongs to the hardline Republican pressure group, the 32-County Sovereignty Committee. But she denies the widespread view that its members are merely political apologists for the Real IRA, the dissident terror group that bombed Omagh in August 1998, killing twenty-nine people.

She does not speak for the Sovereignty Committee, but claims there are diverse opinions within it on how to achieve Irish unity, not all necessarily espousing violence.

'We're not war-mongering maniacs who want to bathe in the blood of Englishmen. Armed struggle is only a tactic, not an end in itself.'

She is circumspect about groups like the Real IRA, riven by splits and informers in the past couple of years, and fellow renegades, the Continuity IRA, who have stepped up activity in the last few months and vowed to kill Catholic police officers as Sinn Fein edges closer to endorsing policing for the first time in Northern Ireland's history.

Her days as an activist are long past, she says, with something like regret. But she will not be found guilty of double standards. 'I cannot condemn another young person for following the same path I did.'

21 March 2003

RANDEEP RAMESH

Redrawing the colour line

A casual cultural tourist in Britain today would get the impression that an indelible mark has been left by the nation's Asian community. In music, both the naff strains of Gareth Gates's cover of 'Spirit in the Sky' and the hip thud of Dr Dre

have borrowed from *bhangra*. On television, *The Kumars at No. 42* refreshed a wilted genre, the late-night chatshow. Advertising spotted the trend early and multinationals like Peugeot and Virgin both used Bollywood to suggest a dreamy, cool exotica.

But a closer look reveals not what has, but what has not penetrated the mainstream. In fact there is a subtle, perhaps more unconscious than deliberate, sifting of cultural identities. In terms of history, the most significant addition that Asian migration has brought to society, Islam, is absent from the picture that British society paints of itself. This is troubling given the bombing of Iraq and the feelings of a religious community under siege from immigration officials and police.

It is ironic perhaps that some of the most compelling examples of Britain's post-war ease with its new multi-cultural self were subcontinental Muslims – Salman Rushdie, fellow author Hanif Kureishi and cricketer Nasser Hussain. Maybe they represented what empire-builders like Lord Macaulay yearned to create: 'A class of persons, Indian in blood and colour, but English in taste, in opinions, in morals and in intellect.'

Today, more visible are those non-white Britons whose religions, customs and ceremonies are lent a nutty flavour by the British media. After all, it is much easier to quip and accept yoga courses, obscure sexual practices and strangely hypnotic dances than Muslim demands for separate schools or requests for the teaching of Arabic in comprehensives.

The ability to assimilate and be fêted for retaining traditional values has seen Hindus, Buddhists and Sikhs increasingly accepted by most Britons as 'one of us'. This may be partly to do with class. A quick glance at the list of wealthy Asians highlights upwardly mobile British Hindu and Sikh entrepreneurs. While Indians get better grades than most other ethnic minorities and the white majority, they suffer high rates of unemployment. But British Pakistanis and Bangladeshis have it much worse. The rising tide of interest in Bollywood and Pashmina shawls has not lifted their boats.

The war on terror has ended up casting Muslims both as barbarians at the gates and as the enemy within. As a group they have been castigated by Liberals and Conservatives alike. Charles Moore, editor of the *Daily Telegraph*, had written before 11 September of Islam's 'hooded hordes', and after the terrorist attack said there was 'a sense that too many British Muslims are hostile to the society in which they live and place their deepest loyalties elsewhere'. Peter Hain, one of Labour's big thinkers, wondered why British Muslims were so 'isolationist'. Neither is an appealing invitation for Muslims to join British society. Worse still, the thinking suggests that Muslims' plight is of their own making.

No surprise that if voices at the centre of British life could utter such thoughts, then overt racists at the edge of it would use louder, harsher language. What has happened is that Pakistanis and Bangladeshis appear inessential to the modern south Asia, all baubles and Bollywood, imagined by the British public. A Hindu or a Sikh has had to deal with racism, for sure, but for the past two years it has been less intense than that being focused on Muslims. This may be because Hinduism is not seen as threat to the West or as a force that could clash with European civilization.

But like Islam, Hinduism has its fundamentalists. A number are members of the Indian government – one minister from the religious revivalist wing announced last month that discos in five-star state-owned hotels would be shut down to halt the influx of Western culture. The Hindu right spends heavily on religious schools, where hate and distrust are subjects on the curriculum, mimicking hardline Islamist groups in the Muslim world. Perhaps Hinduism is not perceived as structurally 'illiberal' – a charge often levelled at Muslims. Strange then to remember that Hindu priests sat atop a caste system that chained millions to a life of grinding poverty and despair in the subcontinent for centuries.

The British state has long understood and exploited these differences. Raj Britannica in the early twentieth century divided and ruled India with separate electorates for different communities. Today the modern-day state is keen to exploit talented Indian computer technicians and to stop Pakistanis and Bangladeshis from joining British spouses.

The changing vocabulary of the race debate means greater emphasis on religion, custom and language. The colour line, as African-American thinker W.E.B. Du Bois foretold, was the most important thing about the twentieth century. In the new millennium, ethnicity is smudging the boundary between black, brown and white. There is nothing wrong with a plurality of immigrant experience in Britain – but it is unjust to elevate one above another.

9 May 2003

POLLY TOYNBEE

Sexual dealing

Tear-jerkers' or 'weepies' are usually sentimental, manipulative films but *Lilya 4-Ever* has whole audiences in tears of shock. Yet this heart-breaking story of a young Russian girl trafficked to Sweden and sold into sex slavery is not particularly graphic or 'explicit'. Nor is it even very violent: the police I talked to from the Met's clubs and vice unit said it pulls its punches compared with the beaten-up women they see. Lukas Moodysson's film may not be anyone's idea of a fun night out, but it is a rare and brilliant movie that will change the way people see prostitution.

The UN estimates about 2 million women are trafficked globally. No one knows how many are trafficked into Britain's brothels and massage parlours – but then virtually no one is looking or counting: it's a low police priority. The Met reckons some 75 per cent of London's prostitutes are foreign. Are they trafficked? A few may be kidnapped, most are illegals who may or may not have known for what trade they were destined. Some were promised jobs as nannies or waitresses, others knew it was prostitution but had a rose-tinted offer of life as an up-market escort. Once here, many are slaves kept by violence, debt-bondage and threats against themselves or their families back home, forced into sex twenty or more times a day. (The same goes for many British prostitutes too: the line between voluntary 'sex-workers' and abused, intimidated or drug-

addicted slaves is vanishingly thin.) Traffickers frighten victims from going to the police by warning them the police are in their pay: they'll just be serially raped in a police station and sent back to their pimps. Worse still awaits them, they are told, if they fall into the hands of immigration.

A tiny, tentative Home Office pilot project opened a few weeks ago in London to try to help trafficked women escape. Will it work? The prognosis is not good. Eaves Housing, a charity that takes in all kinds of vulnerable women, has been given funding to take in trafficked women brought to them by the police or other agencies, as a safe haven. But the conditions are so tight hardly any women qualify. The women must be working in prostitution now – no use if they escaped a few weeks ago. Women must cooperate with the police – but many are terrified of giving evidence, as their traffickers know where their families live back home and will take revenge. Police say this requirement to give evidence will sink the project: once a trafficker knows someone is at Eaves, he will know she is a grass. That will deter women who fear reprisals back home. Yet worse, to qualify for Eaves, women must not claim asylum – when many have every reason to dread returning home to the same traffickers who sent them here.

Denise Marshall at Eaves has had eleven trafficked women sent to her in the few weeks since the pilot began: only two qualify according to this strict criteria. That has left her hard-pressed charity taking them all in, at great expense, though the Home Office will only pay for two. One of those not to qualify is an Albanian who dare not give evidence against the Albanians who trafficked her as they have threatened her family. One Romanian escaped earlier and before arriving at Eaves was badly advised to make a spurious asylum claim for religious persecution, so she doesn't qualify either, despite horrendous internal injuries. Not all women want to stay – some want to go straight home, but they need time to decide. If caught by immigration, many are told by traffickers to say they want to go home – straight into the arms of those who will ship them off again to another country.

Are these women victims to be protected – or illegals to be hounded out? The trouble is that they are both – but their need for rescue should always come first. The Home Office fears that offering them protection that includes the right to stay would be a 'pull factor' encouraging floods of false claims. Campaigners say that if traffickers find their victims all escape easily, the trade will become unprofitable.

What would save these women? The very thing the Home Office fears – a big campaign in all languages, telling women there is a safe place where they will not be deported. Freeing prostitutes needs to become a police priority: this crime is horrible, unending torture. The tiny Met squad of fourteen struggles to follow up the worst cases involving juveniles: they say another 200 officers might begin to make a dent on this slavery. Even then, convictions are hard to get. The new sexual offences bill will make trafficking a crime worth up to fourteen years in prison – but they worry that judges don't take pimping seriously.

The sex trade has boomed in the last few years. Once it was a few sleazy city red-light areas – now every local paper has pages of ads for suburban brothels, saunas and massage parlours. The trade has got worse, according to clubs and

vice police: 'The women have to do things now they didn't a few years ago. Before, no one would do anal; now they all have to. No one would do unprotected; now most do and men demand it, God knows why. Women all have to take pain now – caning, whipping – but that used to be just specialist.'

Why the growth? More money, say the police, more criminal gangs into sex where rewards are high and risks almost zero. But above all, more social acceptability. It all starts with City brokers and celebs making it cool, hip and postmodern to buy up-market lapdancers in Stringfellows or Spearmint Rhino – whose owners promise another 100 venues (though the club has been investigated for allegations of prostitution on its premises). But expensive West End clubs act as a social veneer for the abusive trade beneath, where most women are exploited victims of one kind or another. Dr Liz Kelly, director of the child and women's abuse study unit at London Metropolitan University, will have no truck with the idea that these 'sex-workers' are doing their own thing, that they are liberated women. Even if some protest they chose the way of life, most prostitutes, she says, talk of the terrible damage it did them, once they get out of it.

But the *Pretty Woman*, Cynthia Payne, cheery hearts-of-gold image is more comfortable. Odd how much fiction is obsessed with glorifying and mystifying this sordid business. It's not prudishness but decent feminism to say prostitution is a filthy trade that exploits the poor, the disturbed, the addicts and other helpless women. The many men who pay to near-rape women must often deliberately turn a blind eye to blatant cruelty and violence in the transaction. In Sweden in 2000, buying (but not selling) sex was made illegal. Prostitution there has gone underground and diminished sharply: it has become the dirty illegal trade it should be – not something to be advertised in respectable newspapers. Britain could at least ban advertising, as a small first step to express public disapproval of trading in women.

23 May 2003

NATASHA WALTER

Terror at Dol Dol

Hundreds of women have gathered in a garden in Dol Dol, a remote town in Kenya's windswept highlands. The garden is full of colour, because these are Masai women, most of whom wear scarlet and white necklaces like beaded ruffs, and wrapped skirts in sun-bright colours. One of their chiefs, a tall man wearing a faded baseball cap, is addressing the crowd: 'Do you want to go on with your action against the British army?' he asks in their language. A ripple of agreement passes through the women.

This action is based on the staggering claim that, over the last twenty years, British soldiers stationed in Kenya on training exercises have been carrying out rapes against local women, and that no soldier has ever been investigated or punished for those rapes. When I visited Kenya, hundreds of women had come

together to discuss the possibility of legal action with their chiefs and a British solicitor, Martyn Day.

As the meeting finishes, I find myself sitting under a tree, talking to one of the very few women here who speaks any English. Elizabeth Rikanna is wearing Western clothes today, but she grew up within a Masai family who lived in the traditional pastoralist way. Most of the Masai in this area still lead that life, drawing water from the streams, gathering firewood from the scrub, and herding their goats and their all-precious cows to seek pasture in one area and then another.

But Elizabeth is rare for her generation, because the chief of her community persuaded her father to send her to school – which he did reluctantly, moaning about having to sell his cows to pay the fees. Elizabeth did so well that by the time she was twenty-two and had finished high school, she planned to become a lawyer. That year, 1983, she was staying with her cousin, and one afternoon in the dry season, when the women often travel far to find water in the parched scrubland, she walked 3 kilometres to an old riverbed where a waterhole was still just about functioning. She was scooping the water into her jerrycans when she saw three British soldiers approaching along the riverbed. '*Jambo*,' they said to her, Swahili for hello.

'I thought they wanted some water, so I spoke to them,' Elizabeth says, and suddenly she seems to be reliving the moment. Her voice, which until now has been so clear and measured, drops and speeds up, and I have to lean close to hear her words. 'I ask myself always: why did I speak in English to them? That haunts me even today. If I had not said anything to them, would they have been so harmful to me? I keep asking myself questions I cannot answer. I said, "Can I help you with the water?" One of them picked up the can, as if he wanted to help me. He said, "How can you speak English?"'

'Suddenly I did not feel comfortable. They were looking at each other and I sensed something was not very good. Then one held my hand like this.' Elizabeth reaches out, and grabs my wrist. 'I shouted. I wanted his hand off me, but he pulled me to himself. Already the man behind me had some of his clothes off. The man who raped me first was the man behind me. The third man did not rape me. He held the guns. Two men raped me. They did things I had never thought of. I have still not forgiven. I have not yet come to forgiveness.'

After the attack, Elizabeth struggled back 3 kilometres without water in her torn clothes. 'I arrived back with empty cans. I told my cousin and she told her husband. But that was as far as a lady could go at that time. I felt pain. I felt shame. I felt my dignity go out of me.'

After a few weeks Elizabeth went to her parents' house. 'One month passed. Then two. When I realized I was expecting, I had to tell my parents. They were wild. My father had sold cows to pay my school fees. Now he thought I had lost my culture and my morals. They sent me away.' Elizabeth went back to her cousin's house and kept inside, too ashamed to show herself. 'But when the labour began it was so long that I had to be taken to hospital. They operated. It was not good. I had twins, but one died – the boy. I was left with the girl. I love her now, but imagine my pain that day. A caesarean, a dead child, and another child who was not even my colour.' Elizabeth stretches out her arms, partly to

show the deep black colour of her skin, and partly in a gesture of despair. 'It was such pain for me.'

Elizabeth had dreamed of becoming a lawyer, but with a child to look after she had to do something closer to home. 'I went to be a teacher. And I never married. In our society, marriage is so important. If I had married, it would have added value to me and to my family. But who would want to marry the mother of a half-white child? All my life, I have not been living the life that is really mine. Only now is it dawning on me that I do not suffer alone.'

Elizabeth Rikanna is certainly not alone. Over 200 Masai women in this area can tell stories of rapes that are supported by some independent evidence, sometimes police or medical records, more often the testimony of their chiefs. And hundreds more women from the Samburu tribe around Archers Post, another training area in northern Kenya, have also come forward with similar stories.

Martyn Day, a matter-of-fact solicitor, remembers when the women first approached him with their shocking claims. He was in Dol Dol handling another breakthrough case, the community's demand for reparation for the harm caused by unexploded bombs left on their land by the British army. 'About half a dozen women came up to me in September 2001,' Day remembers. 'They said, "Look, we have also been injured by the British army." To be honest, at that time, I was slightly dismissive of them – I had so much on my plate with the bomb cases and I thought it would just be a couple of cases and damn difficult to prove anything.'

Last summer, Day won a grand victory on the bomb cases, when the Ministry of Defence agreed to pay £4.5m in compensation to those injured and bereaved by the army's unexploded ordnance. 'Then the women came back to me,' Day says. 'This time we had a meeting and eighty-five women turned up. I said, "OK, I'm sure you've got real grievances, but it will be impossible to move on this without evidence." But when I came back last December, they had obtained documentary evidence, medical records and so on. I was really impressed.'

Because of the difficulty of trying to gather evidence for criminal prosecutions after such a long time lapse, Day thought the best hope for legal action was to bring a civil case for damages for the trauma suffered – but that would succeed only if there was evidence that the British army knew rapes were going on and had not taken steps to stop the soldiers' behaviour.

That evidence has now emerged, since at least eight separate instances of reports being made to the British army – all of which were ignored – have now come to light. I have seen the minutes of one meeting between local chiefs and British army officers that took place in October 1983, in which the chiefs complained of gang rapes that had been carried out by soldiers, and in which named officers pledged to take 'serious steps'. Chief Simon Kinyaga Nduru, the man I first saw addressing the women, remembers the meeting well. He tells me about it regretfully. 'We discussed it all at length,' he says. 'Their officers said that they would warn their soldiers. They said, "Yes, we will solve the matter, yes, we will sort it out." But it did not stop.'

Evidence has also emerged of individual allegations of rape being reported to the British army, including one incident just five years ago. Peter Kilesi is an eager young man with a bright manner who worked as a guard for a British army camp

and carries in his pocket a letter of recommendation from the commanding officer. On the morning of 22 February 1998, Peter Kilesi remembers how his fellow guard, Kabori Ole Saikol, came rushing into the camp, shaking, carrying a spear. 'He said, "A soldier has raped my wife." He could not speak English and he called to me to translate. I went to the major's office and told him what he was telling me, that a soldier had raped this man's wife, that she was badly hurt, bruised. Everyone was arguing, everyone was very much annoyed. The major said they would investigate further. Saikol wanted to kill the soldier he thought had done it. I had to stop him. They are foreign people. It is not good to injure them.'

Kabori Ole Saikol's wife, Tianta Ilkabori Saikong, also remembers the day clearly. She is now seventy-two and was sixty-seven at the time of the rape, a woman who might have felt herself free of the fear that stalked other women. But she still literally bears the scars of the assault. When the soldier came running towards her as she walked home from the market, he threw her to the rocky ground. Her front teeth were knocked out, her high forehead is scarred, and one of her fingers was broken and has set at an odd angle. 'Even today when I sleep,' she tells me through an interpreter, 'sometimes I feel as if I am running away from the British man.'

Yet despite all the complaints made to the army, the alleged rapes continued unabated. Just a few years ago, one of the most publicly outrageous of all the many attacks took place. I speak to Margaret Agwaa, one of those caught up in that gang rape. She is a young woman, who sits and plaits and plaits the fringes on her wrapped skirt as she speaks to me. Four years ago, she was going for wood and water at a nearby river. Because of the dangers, women had by now taken to moving around in groups. But that day, the six women who were out together were surrounded by more than a dozen soldiers from a camp of Gurkhas stationed on a nearby ranch. They tried to run away but they were outnumbered.

'I alone,' says Agwaa, speaking through an interpreter, 'was raped by three men. I screamed, but only young boys came who were scared of the soldiers.' She still suffers from the experience. 'Before the rape I lived in harmony with my husband. We planned our family – we were going to have four children. But after this, my husband is rough with me. He says, "You have had sex with all these men, you cannot refuse me."'

Her chief, Isaac Hassan Lenguyo, confirms the story to me and remembers that it was reported to the police. 'Yes, the police visited the Gurkhas' camp and set up a patrol along the river for a while. Our warriors, the young Masai men, said they would fight the soldiers, but we said, "No, don't fight, actions will be taken." But soon the police left the river and we heard of more rapes the following year.'

Now that there is a threat of legal action, the army has finally decided to act – twenty years after the first complaints were made. A team from the Royal Military Police arrived in Kenya last month to begin investigating some of the women's stories. The Ministry of Defence refuses to comment on any aspect of any case until those investigations are complete.

For each woman I spoke to, the experience has left a different legacy, of secret shame or public humiliation, of divorce or unwanted pregnancy, of broken bones or knocked-out teeth, of night-time fears or the curtailment of everyday

life. Those women who became pregnant as a result of the rapes have suffered a particular burden. Mixed-race children are hardly tolerated by the Masai, who are well known as the 'proud' tribe, proud of their traditions and their lineage. So the children of these rapes have had a terrible load to bear. Maxwell is the son of Elizabeth Naeku Mburia, who alleges that she was raped by two soldiers twenty-five years ago in Dol Dol town. He first realized what an outsider he was when he was just seven, and went to school. 'We had to sit at long desks and the other children wouldn't sit next to me,' he tells me. 'Even now everyone calls me *mzungu*, white man. The Masai men hate me very much. And when it came to be time for me to be married, none of the Masai ladies would have me. I had to go outside my tribe to find a wife.

'I live a hopeless life now. No one will give me work. I went to school, but I do not even have money to buy one goat.' When he talks of the British soldiers, his anger flares up. 'One day,' he says, 'some soldiers were passing in their truck and they threw me a packet of biscuits. I couldn't touch it.'

None of the women who spoke to me had recovered from the trauma of being raped, whether it took place twenty-five or five years ago, whether they were in their teens when it happened or in their sixties. One woman, Naituyu Lemolo, was raped twenty years ago by five soldiers when she was herding goats. 'Before I was raped, I was a very happy woman. I had all the freedom of walking alone on this land.' She gestures out of the door, to where the wild, bleached highlands stretch for miles into the hazy mountains. 'But now I have lost my freedom. If I had a *panga* [the knife used by Masai women] in my hand and the British soldiers in front of me now, I would take my revenge.'

6 June 2003

SUZANNE GOLDENBERG

Not much to be done with the US abortion ban, is there?

The ground was laid for an epic US supreme court battle over abortion yesterday when conservatives delivered their most significant blow in decades to a woman's right to choose.

Hours after Congress voted 282 to 139 to outlaw a method of abortion sometimes used in the late stages of pregnancy, pro-choice activists and the medical community were gearing up to challenge the ban in the courts.

'When the president signs it, we will immediately go to court to have it enjoined," said Vicki Saporta of the National Abortion Federation.

The bill passed on Wednesday nightcaps an eight-year struggle by the anti-abortion movement to ban this type of procedure, emotively called 'partial birth abortion'.

Doctors carrying out the procedure could be fined and jailed for up to two years. Although the bill makes an exception when the woman's life is in danger, it makes no other allowances for her health.

The import of the legislative victory was driven home by an almost immediate message of congratulations from President George W. Bush.

Mr Bush, long known for his strong sympathies with the anti-abortion movement and other causes of the Christian right, said the law would 'help build a culture of life in America'. He also urged Congress to forward him the final bill as fast as possible, so that he could sign it into law. The Senate approved a nearly identical bill in March.

The president's support appears crucial to the bill's fate. Earlier attempts to outlaw late terminations have been ruled unconstitutional. In 2000 the Supreme Court threw out a similar bill in Nebraska, which also made no exception when a woman's health was at risk.

The bill's opponents say it interferes unduly in medical matters, which should be restricted to a patient and her doctor. But they have had a struggle to defend the procedure, which, though relatively rare, is gruesome.

Few abortions are performed with the controversial method – 0.17 per cent of the 1.3 million terminations in 2000, according to the Alan Guttmacher Institute, which studies issues of reproductive health.

The method, which doctors call dilation and extraction, is a last resort used during the final stages of pregnancy when the foetus is fatally malformed. It is only generally used for hydrocephalic babies and involves collapsing their enlarged skulls.

While doctors and the pro-choice movement have been successful in blocking previous efforts to ban the procedure, time is now on the side of the conservatives.

Mr Bush's response to the bill stands in contrast to that of Bill Clinton, who vetoed two attempts to ban the procedure.

It is also unclear who will be serving on the Supreme Court when it reviews the measure. Two of the justices who opposed the Nebraska law – Sandra Day O'Connor and John Paul Stevens – are nearing retirement age, giving Mr Bush the opportunity to nominate far more conservative judges.

That appears to be the hope of right-wingers, who are waging a multi-fronted campaign to erode support for Roe versus Wade, the test case that established the right to abortion in 1973, before embarking on a climactic confrontation several years down the road.

'Roe versus Wade is ultimately vulnerable to correction by the court, and we do hope that that day will come,' said Douglas Johnson, legislative director of the National Right to Life Committee.

The patient doggedness of the anti-abortion movement, and opinion polls that suggest younger Americans are less likely to support abortion rights than their mothers, has the pro-choice movement worried.

'This is a broad, unconstitutional bill, which sacrifices women's health and future fertility on the altar of extreme right-wing ideology,' Kate Michelman, president of Naral Pro-Choice America, said.

25 June 2003

MARTIN KETTLE

When America talks about race, we need to listen

When the nine justices who make up the United States Supreme Court pro-
nounce on a case involving racial issues, it is not just Americans who listen, but
nations around the whole world.

That is because, even today, nearly forty years after the passing of the Equal
Rights Act, laws on race still send a resonant message to and about Americans.
'We are not far from an overtly discriminatory past,' Supreme Court Justice Ruth
Bader Ginsburg reminded her colleagues this week, 'and the effects of centuries
of law-sanctioned inequality remain painfully evident in our communities and
schools.' Americans may assume that the rest of the world should 'conform to
us as the benchmark of normal civilized values', as the *New York Times* colum-
nist Bill Keller teased his readers this week. But unless those values are upheld
by the highest public figures in the land, race will always be, as it was for so long,
the dark shadow across America's sun.

So when the Supreme Court speaks, it matters. And we distant nations listen
almost as hard as Americans do themselves. That was true nearly fifty years ago,
when the court banned segregation in education. It was true again twenty-five
years ago, when the court said that racial quotas were illegal. And it was true
again this week when the court gave its long-awaited judgment in two cases
brought against the positive discrimination admissions policies of the
University of Michigan. By the narrowest margin, the justices took a stand in
defence of the right of Michigan (and, by implication, of hundreds of other col-
leges) to take race into account in their admissions policies to uphold the prin-
ciple of diversity. But they could only do it, the judges ruled, by 'narrowly
tailored' methods based on individual circumstances. They must not use quotas
or – as Michigan did with undergraduate applicants – award automatic extra
admission credits to disadvantaged minorities.

This all adds up to a great defensive victory for affirmative action against its
challengers. Colleges across the United States have given a collective sigh of
relief, summed up in the view of Lee Bollinger, the former president of the
University of Michigan against whom the cases were brought, that the judg-
ments are 'as clear as constitutional law gets'. Colleges with affirmative action
programmes – as most of them have – have been given a thumbs-up to continue
with them. Colleges that had been forced to abandon them by lower level
appeals courts, as happened to the University of Texas during George Bush's gov-
ernorship in 1996, may now reinstate them.

The rulings send a powerful domestic political signal as well as a powerful one
for would-be students. A win for affirmative action is also a defeat for neo-
conservatism, especially for the militants who long for Bush to appoint an even
more rightward-leaning Supreme Court that can take the lead in annihilating
America's pro-diversity laws and pro-abortion laws. Nor would such activists

stop there. As the Chicago law professor Cass Sunstein pointed out in a *New Yorker* interview last month, the new right-wing activists are different from their Reagan-era predecessors: 'They're also against Franklin Roosevelt and the New Deal. They want to restore the status quo from about 1934. They want to cut back on what government is allowed to do, whether it's campaign finance legislation, or affirmative action, or the right to sue for environmental violations ... It's a radical agenda.'

Much of that, it now seems, is for another day. In its own submission to the court on the Michigan cases, the White House signalled that racial diversity within the student body could be a worthwhile goal. So, too, just as significantly, did dozens of major corporations and the American military, all of which submitted 'friend of the court' briefs in support of the university – a sign that was picked up by the 'swing' judge on the court, Justice Sandra Day O'Connor, who wrote the majority ruling in very much those terms. Bush was then quick to welcome the court's rulings in a statement that said diversity is 'one of America's greatest strengths'. The president's priority, for the next eighteen months, is to win his second term, not to provide his enemies with ready-made causes, such as racial equality, abortion rights or conservative judicial appointments, around which to rally coalitions against him. Bush's remark may have 'dismayed' those like the leading neo-conservative writer Bill Kristol, who see diversity as a sacred cow. But the signs are that the long-expected radical changes in the Supreme Court (from which Day O'Connor and the veteran Chief Justice William Rehnquist are keen to retire) may now not come until the Bush second term in 2005.

The Michigan cases may seem to belong to a different world. Yet there is a clear connection with Britain, not just with our own racial diversity goals, but also with the debate about the way in which top-up tuition fees will affect equality of access to our own colleges. Here, as the government's April white paper 'Widening Participation in Higher Education' pointed out, the 'attainment gap' between students from middle-class and working-class backgrounds has widened over the past forty years, even before top-up fees became an issue. Once they are introduced, even the intended Office for Fair Access will be hard put to prevent the gap widening further.

If it is to do so, the office will surely be tempted to move from the rather vague 'milestones, indicators and benchmarks' of which the white paper speaks, towards a more individual-centred set of yardsticks that colleges can use for assessing applicants and attaining the desired diversity – towards the American model, in fact.

Until the US Supreme Court struck it down this week, the University of Michigan used a points system to quantify the claims of its freshman applicants. Applicants could score up to 150 points, with a score of 100 or more entitling a student to an automatic place. On Tuesday, in a judgment written by Rehnquist, the court threw out Michigan's rule allowing twenty automatic points to anyone from an underrepresented racial minority group. But the points system had more to it than that. Applicants could also get points for such things as socio-economic disadvantage, attending a socio-economically disadvantaged high school, or being a resident of an under-represented county in Michigan.

If those considerations ring bells here too, then so they should. Criteria like these are very close to the things that the Office for Fair Access will have to be concerned with. As yet, there is little detailed talk in Britain about diversity strategies in college admissions. But this is the direction in which we are surely moving. Michigan may seem a distant place to most of us. But it is getting nearer all the time, and rightly so.

25 July 2003

ANA LOPES AND CALLUM MACRAE

The oldest profession

When they prosecuted Paula for running a brothel last year they had to resort to a 450-year-old law (the charge called it a 'bawdy house'). That says it all, really.

But if you ask Paula who she is really mad at, it isn't the legal ass that convicted her – it's the kind of people who read this newspaper. 'There's people who think they're open-minded – people who don't accept racism, don't accept sexism, don't think of themselves as homophobic. They like to think they can accept all walks of life, but they can't. They have an 'ism', a "prostitute-ism".'

Paula is right. Something strange happens to otherwise democratically-minded people when it comes to sex work. We too have seen this 'ism' close-up.

One would have thought it self-evident that the best way to confront exploitation in the sex industry is to empower the women and men who work in it. Change happens when the oppressed themselves say enough is enough. It was black people who confronted racism, gender inequality was fought first and foremost by women and dreadful working conditions by workers self-organizing through unions.

Yet when it comes to the sex industry, social reformers become moralists and certain strands of feminism lose the plot. Witness Julie Bindel, writing on these pages recently, who was enraged at the very idea of a sex workers' trade union.

The justification for this position is riddled with contradiction. It usually starts with a description of the misery of prostitutes who face daily victimization and violence, concludes that this abuse defines the industry and that allowing prostitutes a union would simply legitimize it. In other words, the greater the exploitation, the less justification there is for a union. What complete nonsense.

But there is something more sinister about this argument: why do these moralists want to portray all sex workers as degraded junkies with lives of unremitting misery? In fact, less than a third of prostitutes are street workers. Of these, not all are drug users, and it is insulting to assume they are. Of those who are, a chaotic lifestyle and drug use usually preceded their **sex** work and is not (as Bindel suggested) an inevitable consequence of it.

The problem is that in their hearts these concerned moralists regard all sex workers as, by definition, degraded people who are somehow no longer capable of social self-determination. They may think they want labour rights, the argu-

ment goes, but in fact they are so debased by their circumstances that they don't know what they want. They need to be rescued. This is dangerous and condescending nonsense.

The other plank in the anti-union case is even weaker. The moralists argue that sex work is not work at all, but abuse – and therefore workplace safeguards like unions are not relevant. On what conceivable grounds is it not work? It is certainly an important economic activity.

Prostitution generates in excess of £700m a year in Britain. The wider industry, including lap dancing and pornography, earns millions more and employs tens of thousands. For many women around the world sex work is not just work, it is the only available job and the best of the options on offer. Better than working shifts in a fish-processing factory, say. As one working woman put it: 'When I become Jazz [her working name] I like myself better. I get less hassle and less aggro in here [the massage parlour] than I get at home. I get treated with more respect here than I did when I worked in a bar. Here I am liked.'

Of course, that says much about our society and the contempt in which many workers, and many women, are held. It says a lot about the hardship in Jazz's family life, too. But it also says something about sex work. A lot of sex work is dreadfully exploitative. But not necessarily all of it. The people able to say what is acceptable and what must be challenged are those who work in that industry. It is not up to outsiders to say to Jazz: 'OK, you can join a union – but only if you leave sex work and get a job in a bar.'

Finally, in an attempt to silence sex workers altogether, liberal opponents of the union attempt to dismiss the sex worker activists in the GMB as 'not typical'. The same could be said of the Tolpuddle Martyrs, but their activism helped improve the lives of 'typical' workers.

In the few months since the sex industry branch was formed it has attracted 150 members, and has signed recognition agreements with several table-dancing clubs, where working conditions have improved – codes of conduct and grievance procedures have been introduced, and union reps have been elected. It's a start.

Concerned hand-wringing over the morality of prostitution will neither remove nor reform the industry. And telling sex workers that what they do is so degrading that they are not entitled to a union helps perpetuate the stigma, which encourages the violence from which so many sex workers suffer. Whether you like it or not, women such as Paula and Jazz don't want to be saved – they want the right to do their work in a decriminalized industry, they want labour, health and safety rights. They want dignity and respect.

CASUALTIES, CONSEQUENCES

Austin

18 September 2002

SIMON TISDALL

Saddam's concessions will never be enough

To the 'man in the street', on whose support Tony Blair and George Bush ultimately depend, it looks like a fair enough offer. For months the US has been huffing and puffing, mouthing and mithering, making waves over Iraq, demanding that it do what Washington wants. Now, finally, it has received a simple answer: yes. So what does the US do? Ask for more.

It is worth recalling how this pseudo-epiphany was reached. The build-up began in earnest with Bush's 'axis of evil' speech in January then came his doctrine of 'pre-emptive attack' (what security adviser Condoleezza Rice sweetly calls 'anticipatory defence'). Then a startled world learned that 'rogue states' holding weapons of mass destruction were more or less on the team with Osama and al-Qaida. That, it transpired, made them legitimate targets for America's 'war on terror' and 'regime change'.

Last week, Bush turned his screw yet more fiercely. If Iraq truly wished peace, he hectored, it must not only agree to full, certified disarmament under UN auspices (and on US terms). It must also swiftly honour all the numerous obligations laid upon it after the Gulf War.

But Iraq's weapons remained the principal focus. Some chemical and biological capability is still most likely at Saddam Hussein's disposal, according to the final reports of the UN inspectors in 1998. He may since have developed more. Scarier still, hawks squawk, Iraq may be only three years, or three months, or who knows, three weeks away from acquiring a nuclear weapon. An image was conjured of the Baghdad bazaar: 'Pop round next Tuesday, Mr Saddam. Your package will be waiting.'

Such angst with all this blethering did Bush and his cohorts inspire. Such discomfiture and war-feverish unease did they spread among European allies such as Blair and his party followers. What strains and stresses stole like shadows of the night over the deserts of the Middle East as Arab allies and foes alike contemplated a coming US onslaught. How greatly did they clamour and cringe, to the delight of the Cheneys and Rumsfelds, Wolfowitzs and Perles. One by one, slinking Saudis followed *chapeau*-chomping French into the American sheepfold.

And then, after all this hot and bother fuss, suddenly and out of the blue, even before General Tommy Franks, the wannabe 'Stormin' Norman', has unpacked his Qatar camp bed, Iraq simply says, 'OK.' To all these provocations, Baghdad puts a timely stopper.

Nor is there any doubting the popularity of Saddam's shift, enough to make the White House sick. Security Council members declare themselves encouraged. Russia looks forward to a political settlement and an end to threats of war. China discerns a positive sign. Backsliding Germany's Joschka Fischer rubs it in

with a told-you-so about the efficacy of the UN-centred, multilateral approach. Even in London, predictions fly, suggesting that war, if it comes, has now been put back a year, that Bush and Blair are split over how to proceed, and that Downing Street will be blamed by US hardliners for steering their president up a diplomatic blind alley. Some Muslim countries, meanwhile, demand a lifting of sanctions.

Worse still, the no-strings nature of Iraq's riposte has plain-spoken appeal. And to the 'man in the street', increasingly bowed, browbeaten and bamboozled by the government's line (as polls show) but now relieved and hopeful, it seems reasonable. After all, what more do these people want?

Quite a lot, actually, and the Bushmen's demands will increase rather than diminish as yesterday's momentary flummoxing fades. The gap between what America might wisely do, and what it really does, may yet grow schismatically chasmatic.

The US has a 'moral obligation', says sensible Liberal Democrat Menzies Campbell, to take the Iraqi offer seriously and explore it fully. Will it do so? The initially scornful and dismissive response can be expected to harden in the days ahead into a firm line insisting the threat has not diminished one whit, that Iraq will be judged by actions, not words, and that merely 'tactical' manoeuvres of this sort have been seen before.

Far from welcoming Iraq's *prima facie* compliance with weapons inspections resolutions, the coming US emphasis will be on the several other 'materially breached' UN decrees. And whatever Moscow says, the dogged pursuit of a new resolution authorizing a yet tougher line will continue apace.

Far from facilitating the inspections process, quickly agreeing a timetable and fixing an end point, as Iraq has previously asked, the stress now will be on any-where, anytime coercion, intrusion, paramilitary enforcement, and re-extraction of inspectors at the first glimmer of obstruction. The public message will be scepticism, that anything worth finding has already been hidden, that 'cheat and retreat' is Iraq's game, and that the military option may still be the only option.

To this end, despite yesterday's developments, the military build-up will con-tinue, the ships and tanks, planes and carriers so vital to America's sense of self-worth will edge towards Iraq, the tone-deaf Rumsfeld's Pentagon will bang on at what Syria calls the drums of war and deathly ominous B52s, like so many unChristian soldiers marching as to war, will once more silence the hedgerows of Gloucestershire. Expect US pretexts for escalation, fake and insincere negoti-ations, and false horizons.

For Saddam, with every concession, the bar will be raised ever higher. Almost whatever he says or does, the gun will remain at his head, the trigger ever cocked for the commencement of a battle that Bush et al will not be denied. Despite a broad international consensus against it, regime change and nothing less will remain the ultimate objective.

And why, the 'man in the street' might ask, do they appear so set on violence? Because Bush's misconceived, over-hyped global 'war on terror' has run out of targets and is far from won. Because Iraq is oil-rich (the second biggest reserves) and the Saudis grow unreliable. Because, purely in domestic policy terms,

especially post-Enron, this government is political roadkill. Because the administration's predominant, evangelical clique believes it is solo superpower America's historic mission (Bush says it is a 'calling') to spread its universal values and rescue a muddled world from itself. Because the Bush family has old scores to settle and new elections to win. Because Bush lacks the insight and imagination to act differently. Because in their 11 September pain and unforgotten anger, not nearly enough of America's 'men in the street', and in high places too, are prepared to say stop, pause and consider what it is they do.

19 February 2003

JONATHAN FREEDLAND

What would you suggest?

Here's the question every opponent of the coming war on Iraq fears most: well, what would you do? We're comfortable enough announcing what we would not do, rattling off all the flaws, contradictions and hypocrisies of the war camp. We've got those arguments down pat, and apparently they're winning the day: witness not only the million-plus who marched last weekend but the clear majority polled by the *Guardian* yesterday against a military attack.

But what do we say when our opponents ask not for our criticisms but our alternative course of action? I don't mean our solution to Iraq's arsenal of weapons of mass destruction. On that we can legitimately dispute the scale and urgency of the threat, citing other more pressing dangers. Nor do we have to find a response to the alleged links between Baghdad and al-Qaida: the evidence for those is so flimsy even Downing Street seems embarrassed by the claim.

No, we need an answer to the argument that has become Tony Blair's favourite in recent days: that war is needed to topple a cruel tyrant who has drowned his people in misery. In this view, the coming conflict is a war of liberation, which will cost some Iraqi lives at first, to be sure, but will save many more. It will be a moral war to remove an immoral regime. To oppose it is to keep Saddam in power.

This is a much harder case for the anti-war movement to swat aside. We have to take it seriously, if only because no slogan will sink the peace cause faster than 'anti-war equals pro-Saddam'. And the anti-war movement has made itself vulnerable to that charge. Tony Benn's patsy interview with the dictator was a terrible error, while aspects of Saturday's rally hardly helped. Few speakers paid more than lip service to Saddam's crimes; indeed, most seemed to regard George Bush as by far the more evil despot. Tariq Ali suggested regime change was needed in Britain more than it was in Iraq, while the official banners told their own story. 'Don't Attack Iraq,' they shouted, above a second line, 'Freedom for Palestine'. Why was that not 'Freedom for Iraqis'?

So the anti-war campaign has to make three sharp moves. First, we have to establish that we oppose the Ba'athist regime with all the fervour now claimed by the PM. (And it won't do to bring out the yellowing scrapbook, and brag

about all the anti-Saddam rallies we held in the 1980s: the issue is now.)

Second, we have to dispute Blair's description of the coming attack as a war of liberation. He may be claiming that now, as he seeks to win over a stubbornly sceptical public opinion, but it hardly squares with the rhetoric coming from the chief prosecutors of the war. Washington does not cast this conflict centrally in humanitarian, Kosovo-style terms, but as a way of snuffing out a threat to US security. Those who claim this as a war for the Iraqi people need to listen harder to the men who will be fighting it: Bush, Rumsfeld and the guys don't talk that way. People cannot pretend this is the war they want it to be, they have either to support or oppose this war as it actually is.

Third, the peace camp has to set out its own, alternative method of ridding Iraq of its oppressor. We have to have an answer to our critics' legitimate question: what would you do?

So far the offerings have been pretty meagre. Tariq Ali spoke of 'strengthening the people' on Saturday, but we will have to do better than that. We need to start coming up with detailed, fleshed-out ideas that might work.

One approach would be to use this moment of pressure – admittedly brought about by the threat of war – to demand Saddam not only give up his armoury but also open up his society. The UN could demand that Hans Blix's team be joined by a squad of 'human rights inspectors', keeping tabs on, say, the fate of political prisoners. That finds favour with Mary Kaldor, a leading light in the 1980s anti-nuclear movement, who has published a long list of ideas on the openDemocracy website. Her objective: to open a few cracks in the Iraqi frost that might lead to the home-grown, peaceful regime change that eventually came to eastern Europe. She imagines a UN resolution demanding, among other things, the right for opposition parties to open offices inside Iraq. If the same pressure that is currently being applied to Baghdad on arms were transferred to freedom and democracy, it could bring results.

Scilla Elworthy of the Oxford Research Group, which specializes in conflict resolution, returned from a visit to Baghdad last month with her own scheme to undermine Saddam through means other than force. She imagines an instant lifting of sanctions and permission for Saddam to sell oil – on condition that some or all of the revenue go into an account controlled by the UN. Those funds would only be released if and when the regime made democratic reforms: no change, no cash.

Backed by a military presence, 'muscular rights inspectors' could force Baghdad to open up. They could demand that Iraqis be allowed access to Western media, the internet and mobile phones (intriguingly, Saddam recently placed an order for a million mobiles). Most pressing of all, the UN could demand the return of Iraqi exiles. Numbering in the millions, these are the professionals with skills who either fled or were chased out of their country. Elworthy suggests an electronic tagging system to guarantee their safety: if the regime arrested or harassed them, the UN human rights monitors would be on hand to help. 'Returnees are the key,' says Elworthy. 'Within two or three years they would have organized and got rid of Saddam.'

Elworthy and Kaldor both imagine change coming to Iraq the way it reached communist Europe or fascist Spain and Portugal, through gradual exposure to

the outside world – and delivered by the people themselves. It would require persistent UN commitment and the constant pressure of a military threat hanging over the regime. But it would be a lot less bloody than an invasion.

You can pick holes in such thinking – many UN members are hardly democratic paragons themselves – you can point out what might not work. If Saddam is refusing to cooperate with arms inspectors, even as the world puts a gun to his head, why would he allow democracy stewards to crawl all over his country? Those are fair worries. But even so, these ideas have to be worth a try. If they fail, we could always turn to war as a last resort. But if they are brushed aside, not even attempted, then neither Blair nor Bush can say that 'all other means' were exhausted – a pre-requisite for a just war.

Whether the UN follows such a route or not, the peace camp should surely begin advocating it. If we do not, we allow our opponents to say we are coddlers of evil, allowing an oppressor to rule unchecked. This way, we can hold our heads high with a new slogan: pro-peace, aggressively anti-Saddam.

27 February 2003

LEADER

A brave revolt

History was made at Westminster last night. The revolt of 121 Labour MPs against Tony Blair's Iraq policy was the largest against a sitting government by its own supporters in decades, perhaps even centuries. In turn it fuelled one of the most substantial acts of parliamentary resistance against a war policy in British history. Of course, there are mitigating points to be made. It was a big revolt because Labour has a big majority, knowing the outcome was not in doubt, it came relatively cheap. But do not underestimate it either. MPs do not like to revolt and governments hate revolts against them. Last night's division lists contained many virgin rebels. But the votes were not capriciously cast. Anything but. The results of the voting were heard in sombre silence. That was because MPs knew what was at stake, both in terms of the Iraq policy and in terms of Mr Blair's authority. To describe last night's result as a shot across the bow is to understate its significance. These revolts were a direct hit – not enough to sink the government, but enough to disable it for a while. It is possible that these votes will embolden further action. It is a mistake to suppose that this is the end of the story.

Nevertheless, the overall outcome is a bleak one. By accepting the government's motion last night, which MPs did by 434–124 votes, and by rejecting the amendment moved by Chris Smith, which they did by 393–198, the House of Commons has backed the aggressive 'last chance' policy that is embodied in the draft Security Council resolution put forward this week by the United States and Britain. Last night may not be Westminster's final word on the Iraq crisis – Jack Straw appeared to promise another vote before the start of military action – but it was a fateful moment all the same. Though wounded, the Blair government

will treat the result as a green light to go along with America's intention to attack Iraq at a moment of its own choosing. MPs had a choice, and they made the wrong one. The die has been cast for a war-enabling policy. It is one that Britain may rue for many years to come.

Yesterday was good for democracy and politics. It was a reminder that MPs really do matter, not just for their votes, not just for their speeches, but also for their seriousness. Seasoned observers had rarely seen the house so divided across party lines. On the Labour side, left-wing backbenchers like Alice Mahon and Ann Clwyd, who often sit and vote together, came at the issues from different standpoints. On the Tory benches, Kenneth Clarke and Michael Portillo, last weekend's dream ticket to unseat Iain Duncan Smith, were ranged against one another. It all added to the tension of the debate and the power of the occasion. Ministers were scared, as Mr Straw's speech frequently showed. But the tone of the debate was rarely cheap and only briefly angry – mainly over Palestine. These were serious people, debating serious questions and doing it seriously. It was a reminder that we sneer at Parliament at our collective peril.

There were impressive speeches from all sides. But it was Mr Clarke who rose to the occasion best. 'I cannot rid myself of doubts that the course to war we are now embarked on was actually decided on many months ago, primarily in Washington,' Mr Clarke told the house. That was why middle Britain and so much moderate opinion was so anxious, he said. And, he might have added, it was the key reason why last night's votes were so fateful to our national interest. Mr Clarke spoke for Britain. The rebels voted for Britain too. But we have placed ourselves in George Bush's hands now.

6 March 2003

TIMOTHY GARTON ASH

Islam and us

Well, Happy New Year. Happy Islamic New Year, that is – for yesterday was the first day of 1424. This is according to the Islamic calendar that operates in lunar years dating back to the prophet's move from Mecca to Medina in 622, Christian time. As a New Year's gift, the West offers another crusade.

So far as I know, no one in the Bush administration has actually talked of a 'crusade' over Iraq, partly because President Bush burned his fingers by using the c-word after the 11 September terrorist attacks and partly because Saddam Hussein is anything but a serious Islamist. Indeed, Osama bin Laden, that leading authority on true and false Islamism, has called Saddam an apostate. But the rhetoric in Washington is that of a crusade – not for Christ but for democracy – and many Muslims around the world will view the Iraq war as yet another Western missionary imperialist incursion.

That includes many of the estimated 20 million Muslims who already live in Europe. British Muslims were strongly represented in the great peace march through London. And it includes millions more just across the Mediterranean,

who would love to come and live in Europe. People like the Algerians who recently greeted President Chirac with the unforgettable chant 'Visa! Visa! Visa!'

So in this lull before the second Desert Storm, it's worth reflecting on our attitude to Islam – starting with the fact that most of us are so pig ignorant we don't even know that the Islamic New Year started yesterday, what year in their calendar it is, or why. (Nor did I, until I looked it up.)

The politically correct position on the war against terrorism is 'this is not about Islam'. Two groups dissent: American fundamentalist Christians and European fundamentalist secularists. Born-again Christians of the American Midwest think that the reunification of all the biblical lands of Israel will hasten the Second Coming, in which Rapture they will be forever saved. European fundamentalist secularists think that all religion is blindness and stupidity, a kind of mental affliction, of which Islam is a particularly acute example.

The polite form of this attitude is to say, 'Islam must have its Reformation'. After all, Muslims are still living in the Middle Ages, aren't they? In 1424, to be precise. This, apart from being unbearably condescending ('Come on, you chaps, reform yourselves and maybe we'll let you into the house'), is also half-baked. The Reformation started as a revolt against the Pope in the name of a true reading of the holy books. Islam doesn't have a Pope, which is one reason it's so hard for it to have a Reformation. But anyway, would those who say, 'Islam must have its Reformation' really want Muslims to get back to a strict, literal interpretation of the Koran? No, what people who say this really mean is 'Islam must have its Enlightenment'. Or, better still, its post-Darwinian secularization. Muslims must, in short, evolve.

The one form of evangelism that is still acceptable on the European left is evangelical Darwinism. Its fundamental belief is that all other forms of belief are symptoms of intellectual backwardness. Thus Martin Amis wrote on this page a couple of days ago: 'we are obliged to accept the fact that Bush is more religious than Saddam: of the two presidents, he is, in this respect, the more psychologically primitive.' By this logic, Archbishop Rowan Williams is more psychologically primitive than Stalin and Chief Rabbi Jonathan Sacks is more psychologically primitive than Hitler.

Europe is the place where post-Darwinian secularization is most advanced. It's now the most secular continent on earth. And it's precisely the fact that Europeans, especially on the left, have such a secular imagination that makes it so difficult for us to understand and accept the religious Muslims who have come among us in growing numbers. You need a religious imagination to respond to the music of other religions. Jonathan Sacks expressed this well in his account of a meeting with radical Muslims, including a senior Iranian Ayatollah. 'We established within minutes a common language, because we take certain things very seriously: we take faith seriously, we take texts seriously. It's a particular language that believers share.'

Nineteenth-century European writers still knew this language and had this imagination. Take, for example, the wonderfully sympathetic account of the Islamic hero Saladin in Walter Scott's great novel of the Crusades, *The Talisman*. In a famous scene, Saladin appears in disguise as the Arab doctor El Hakim, to cure his adversary, Richard the Lionheart. He's greeted with 'disdainful coldness' by

the grand master of the Knights Templar, who 'sternly demanded of the Moslem, "Infidel, hast thou the courage to practice thine art upon the person of an anointed sovereign of the Christian host?" "The sun of Allah," answered the sage, "shines on the Nazarene as well as on the true believer, and His servant dare make no distinction between them when called on to exercise the art of healing."'

The leap of imaginative sympathy from Christianity or Judaism to Islam is much smaller than that from evangelical secularism to any of them. That's why America, which has preserved the religious imagination it imported from Europe, may actually be better placed to accept the Islamic other. That's not all. America has a rare combination of religious imagination and an inclusive, civic identity. Europe has a fateful combination of secular imagination and exclusive, ethnic identities.

A couple of months ago, taking a crash course of enculturation in the American Bible Belt, I sat in Homer's coffee house, in a suburb of Kansas City, talking to Chris Mull, a singer of rather excruciating 'Christian rock'. He said some interesting things about the local Muslims. Being religious themselves, he said, the local Christians were better able to understand Muslim religiosity. Since this was an area of so many competing religious sects, everyone accepted that religion had to be a matter of private choice and community life. In this sense, a place where most people are religious can come closer to the pluralist ideal in which, as Rabbi Sacks has memorably put it, 'Values are tapes we play on the Walkman of the mind – any tune we choose so long as it does not disturb others.' Finally, my Christian rocker said that local Muslims made more efforts to adapt to American ways because 'they're living the American dream'.

Pie in the sky, you may retort. Apple pie in the sky. But can you imagine anyone in Marseille or Hamburg or Oldham even thinking of saying of the local Muslims that 'they're living the European dream'? Contemporary Europeanness is secular, but it's not an inclusive, civic identity, as Americanness is. That's Europe's double problem. The Iraq war may be America's crusade, but it's Europe that is closer to the likely Muslim backlash and worse equipped to deal with it.

None of this is to deny that there are large dangers in Islam itself, especially in radically politicized Islam. The captured al-Qaida commander Khalid Sheikh Mohammed chillingly reminds us of this when he describes the 9/11 terrorist attacks as 'the holy raids on Washington and New York'. But the beginning of the Islamic New Year is a good moment for post-Christian Europe to look not at the mote in our Islamic neighbour's eye but at the beam in our own.

14 March 2003

MARTIN WOOLLACOTT

Make-or-break UN crisis

The white satellite dishes on the television trailers drawn up in line next to the elegant office building in midtown Manhattan look like giant ears striving to pick up every whisper.

The world is listening to what is going on at the United Nations in a way it has not done for many years. In striving to create a coalition of the willing for war in Iraq, and to get UN blessing for that war, America has created instead a coalition of the unwilling.

This is 'Hell, No, We Won't Go' rewritten as a diplomatic drama. On the patch of land in Turtle Bay, which the Rockefellers gave to the UN in 1947 to entice the new international organization to set up its headquarters in New York, a struggle is going on not only over Iraq but over the future of the world body. The question for the UN is whether Iraq will make it or break it.

The sense is of both a kind of elation and a deep anxiety. Elation because the UN is so much at the centre of things, because the daily manoeuvres over resolutions and the blasts from Washington have been exciting, and because it is not difficult to construct a theory according to which the UN will, over the long run, benefit from the crisis. Anxiety, because it is also possible to see a future in which the UN will be bypassed and demoted.

'If you were a fatalist,' says Jim Hoge, the editor of *Foreign Affairs*, 'you might argue that this was an institution whose time to die is slowly coming. I say if, but it is not just American wilfulness that makes it so difficult to place decisions to go to war within a legal or pseudo-legal framework.'

Mr Hoge himself does not take this view, hoping instead – 'if that's not too Pollyanna-ish' – for future good relations between the US and the UN, after lessons are learned from inevitable difficulties and perhaps disasters to come.

Among UN officials and delegates the mood is 'sombre to say the least', said one. 'Everyone is aware this is a crisis for the organization.'

Yet in the midst of it, he went on, people at the UN were discussing possible reforms, of the Security Council in particular, to which the crisis might in time give impetus. That well expresses the strange way in which confidence about the organization's future co-exists with fearfulness about the immediate prospects.

The physical ambience of the UN building, a somewhat worn 1950s antique, studded with art works and wall hangings, which are, with few exceptions, of almost comical mediocrity, has often seemed to suggest that nothing much was going on except that people of every race, nation and creed were being gradually dried out by American air conditioning. But Iraq has sent new energy down those well-polished corridors.

'Let's look at our assets,' says Richard Gardner, professor of law and international organizations at Columbia University, whose long career began in the Kennedy administration and who has been in intimate contact with the UN for more than forty years, most recently as a delegate to the Millennium General Assembly.

'Number one, we have Kofi Annan, who is the best secretary-general ever. Number two, up to this moment the US–UN relationship was developing very positively. We had paid most of our dues, Jesse Helms is gone – not a small thing – and there is growing moderation in the attitude of Congress to the United Nations. Number three – and I don't know how to put this except to recall the remark about Wagner's music being a lot better than it sounds – the foreign policy of this administration is better than it sounds.'

Professor Gardner said the rhetoric chosen to please, not just a domestic audience, but a particularly extreme constituency within that audience, was counterproductive. He singled out in particular President Bush's statement that 'when it comes to our security, we really don't need anybody's permission'.

The UN, he argues, cannot be either the main enforcer of international decisions involving coercion, nor the sole source of legitimacy for military action. But legitimacy was nevertheless vital and, he hoped, the value of the UN was understood by people in the administration. He concedes that 'there are certainly in Washington now a lot of neo-conservatives who never liked the UN'.

This is the group others fear will respond to America's recent bruising experience at the UN by vowing never again to let US policy be put on the table at the Security Council, and by sidelining the world body, including the work of the specialized agencies, in many other ways. They will be emboldened if the war in Iraq is quick and clean, and if the consequent occupation is less dogged by problems than is generally predicted.

But at this point, the UN optimists come into the fray. Even if it turns out to be that easy, they argue, the US will need the UN after the war far more than it has needed it to go to war.

'Iraq is the scene of an accident, but that doesn't mean cars will no longer be seen on the roads,' says Sir Jeremy Greenstock, the British permanent representative to the UN. On this reckoning, the 'accident' – the polarization at the UN over how to deal with Iraq – will be followed by 'ambulances', representing a common effort at damage limitation.

One of the ways in which traffic will resume, the optimists say, is through cooperation between the US, on the one hand, and its allies and the UN, on the other, in post-war Iraq.

The argument is that America will be in dire need of a retrospective legitimization for its action, especially if there is no second resolution, and in equal need of financial and other help from allies, and of the specialized expertise that only the UN agencies and non-governmental organizations working under the wing of the UN can provide. Others think that countries such as France and Germany will let the US and Britain 'stew in their own juices' in Iraq for a while.

But it is whether the American side will respond generously in this supposed reconciliation to come that is more open to doubt. Will the UN go into Iraq, in other words, as the servant of the US, or as its partner, able to impose conditions on its help and to participate in key decisions?

Michael Hirsh, the author of a forthcoming book, *At War With Ourselves*, on the neo-conservative capture of American foreign policy, is gloomy. He predicts that, as in Afghanistan, 'the administration will expect the UN to do all manner of things but will not acknowledge its help. Remember, this is an administration that came into office with a world view that did not include the UN, except as an ineffective expression of the kind of globalization they despise.'

What unites different views of the crisis at the UN is the agreement that it is right, if very uncomfortable, that the central issue of the relations of a uniquely powerful America with the rest of the world be tackled, and that the resolution of this issue is going to take time.

Time, in Iraq, as America struggles with post-war difficulties that are potentially overwhelming. Time, in Washington, as the claims of the neo-conservatives are tested by events. Time, in Turtle Bay, as the UN explores its leverage with America, a leverage, the optimists hope, that will be greater after the war than before it.

Ahead lies either a parting of the ways, after which the UN will be a much-diminished thing, or, perhaps, as Sir Jeremy speculates, the possibility that 'the world will shock itself into an understanding that the collective approach is more and more necessary. It might even produce a whole new approach to international politics.'

20 March 2003

PATRICK WINTOUR AND JON HENLEY

The French protest

The British and French governments yesterday exchanged insults ahead of tonight's first meeting between Tony Blair and Jacques Chirac since Britain accused the French president of scuppering any chance of a peaceful diplomatic settlement in Iraq.

The two men are due to discuss the Iraq crisis at a European Union heads of government dinner in Brussels that was initially called to discuss economic reform in Europe. There are fears that the clash over Britain's alliance with the US over Iraq could isolate Britain from Europe on other issues such as common defence, the euro and the new constitutional architecture for Europe.

Dominique de Villepin, the French foreign minister, yesterday telephoned his British counterpart, Jack Straw, to express 'shock and dismay' at the anti-French rhetoric being deployed by British ministers, MPs and officials at Westminster. Both Mr Blair and Mr Straw have blamed France for paralysing diplomacy at the UN by vowing to use their veto to block a second resolution whatever the circumstances.

The French insist Mr Chirac was willing to be flexible and is being misquoted deliberately by the British to suit Mr Blair's interests and to disguise his failure to win support of the majority of states on the Security Council.

As French newspapers and commentators reacted incredulously to the British allegations, Mr de Villepin asked the foreign secretary 'in the strongest possible terms' to refute any insinuation that Paris was to blame for the imminent war against Baghdad. 'We fully understand the internal pressure on the British government, but these comments are not worthy of a country which is a friend and a European partner,' Mr de Villepin told Mr Straw, according to his spokesman. 'Moreover, this presentation of the facts does not match reality, and does not fool anyone.'

Denis MacShane, minister for Europe, responded: 'It is not helpful for France to maintain a line of abuse. It is time to stop exchanging insults and to get on with the business of defeating Saddam Hussein and ensuring Europe speaks with

one voice in future on the great issues of terror and tyranny.' The Welsh secretary, Peter Hain, said: 'We need to encourage the French government and President Chirac in particular to seek a role of partnership with the United States, not a position of conflict or tension. And we are in a position to help him do that.'

Britain claimed France's rejection of the now-abandoned second UN resolution removed any motive for the swing six states on the UN Security Council to support a new resolution. The prime minister's spokesman said: 'Clearly, the prime minister's view is that had the international community stuck by 1441 and sent a strong message of unity to Saddam, that pressure could have borne dividends. We could have achieved the disarmament that we all want to see and achieved it peacefully.'

In response, France claims that Britain and the US were simply unable to persuade the swing six to back a resolution containing such a tight deadline for war. Mr Blair tried to scotch talk of a showdown tonight, telling MPs: 'At the end of this I think we need a period of reflection to see how we put that partnership [between Europe and the US] back together.'

He rejected suggestions he should pull out of talks on European defence, saying: 'The worst thing we could do in any debate about European defence is leave the chair empty and then those who might oppose our vision over European defence would be strengthened.'

Privately, a debate is already under way inside Downing Street on how to repair damaged relations with France and Germany.

Pro-Europeans are arguing that Mr Blair needs to make a clear pro-European move, but current public antipathy to France would make a shift on the euro or stronger closer European integration difficult to sell.

French newspapers yesterday complained that the British pro-war camp was guilty of 'shameful distortion' of France's position on the second UN resolution. 'Chirac, Blair's scapegoat' was the headline in an outraged *Libération*, which said Mr Blair was plainly 'criticizing his neighbour to silence his critics'.

'The American president, out of frustration, and the British prime minister, out of a pathetic need to justify himself, are fanning the latent Francophobia of their electorates,' the paper said in its editorial yesterday. 'By making Paris the scapegoat for their failures, they hope to dodge some embarrassing questions on the eve of a war they will wage alone against (almost) everyone, and having placed themselves beyond international law.'

Le Figaro said Britain would 'doubtless be weakened for a very long time' by the hole it had dug for itself over Iraq, while *Le Monde* said that Mr Blair had once again 'decided to dump on France the main bulk of the responsibility for his own diplomatic failure'.

In a stinging editorial, France's newspaper of record said Mr Blair's efforts to win a majority for a second resolution had failed and that contrary to the internationalist principles he has avowed 'since the start', the war would now begin without specific UN authorization.

14 April 2003

LARRY ELLIOTT

Don't leave it to lone rangers

Images of Iraqis looting and pillaging their own capital were not what America and Britain expected in the aftermath of the collapse of Saddam Hussein's regime. That should not detract from what was a mighty efficient operation. Whatever your view about the legitimacy of the war, the prosecution of it went pretty much to plan.

One of the lessons of the three-week battle is that when the most powerful nation on earth puts its mind to it, things happen. Fast. Success in Iraq was down to three things: political will, money and the unbending commitment of the United States.

It was hard not to reflect on this as the international community returned to business as usual with the meetings of the World Bank and the International Monetary Fund at the weekend. The best that can be said of the meetings was that they did not end in disaster, with the first tentative attempts at rapprochement between the US and Europe since the schism at the United Nations. Even so, it was hardly earth-shattering stuff, especially given the pile of problems that need to be tackled. There was little sense of strategy, decisive action was replaced by the search for compromise, and tough language by the usual bureaucratic fudge. It is not difficult to understand why there are some in the Bush administration who are losing patience with the messy compromises that oil the wheels of multilateralism and are extolling the merits of a go-it-alone policy.

In reality, things are less clear-cut. The US does not face an all or nothing choice between being unilateralist or multilateralist, and the notion that it will now retreat into sullen isolationism is absurd. As ever, the world's most powerful country will have to position itself somewhere between the two poles of unilateralism and multilateralism, and various parts of the administration have competing views on where that should be. The Pentagon is more unilateralist, the State Department and the US Treasury are keener on a multilateralist approach. While the war was being prosecuted, Donald Rumsfeld was free to follow his go-it-alone instincts; the State Department and the Treasury are now raising their voices in an attempt to rally the international community for the much longer job of post-war economic reconstruction and nation building. George Bush sits somewhere between the two, but it is clear that so far as the White House is concerned, the multilateral system, which has been in existence since the Second World War, is now on trial.

In the light of that, it was a relief that the Europeans and Americans avoided a slanging match over Iraq at the weekend. John Snow, the US Treasury secretary, wants the World Bank in Iraq as soon as possible and he is urging creditors to write off the impoverished country's debts so that the new regime can get off to a fresh start. Both ideas make sense and should have been supported unblinkingly. There was, however, a pointless wrangle over whether there was a need for

a UN Security Council resolution before a Bank team could be mobilized, while the response from Germany and Russia to debt relief was churlish. A smarter approach would have been for Europe to use support for a Bank mission to Iraq as a way of building bridges across the Atlantic and to urge Washington to extend its approach to debt forgiveness in Iraq to the many other countries where development is being hindered by repayments on loans extended to brutal dictators.

While it was a small achievement to prevent the World Bank and IMF becoming a new front in the diplomatic and political war between Europe and America, far more needs to be done if the multilateral system is to prove its worth. Iraq is the most pressing issue, the collapse of Saddam's regime posing questions that cannot be ducked while polite debate is conducted by the international community. As one G7 deputy put it last weekend, Iraq needs a currency acceptable to its people, and it needs a system of payment for the reconstruction work, which ought to get under way at once. These are the building blocks of economic policy, and they need to be sorted out today, not tomorrow or next week. Ultimately, America will implement a plan agreed with international partners or impose its own solution. As the occupying force in Iraq and given the risks of full-scale economic implosion, it has no choice but to act.

The second area ripe for concerted effort is the state of the global economy, where the emollient language in the G7 communiqué failed to disguise the fact that keeping the show on the road depends on growth in the US. The Europeans talk a good game, with Wim Duisenberg waxing lyrical on Saturday about how monetary policy is supportive of growth, and the stability and growth pact a perfect mix of flexibility and discipline, but the numbers tell a different story. The eurozone economy is on course for its third successive year of 1 per cent growth in 2003, with even the IMF – not exactly softies when it comes to economic policy advice – calling on the European Central Bank to cut rates, raise its inflation target and take a relaxed view if budget deficits rise above 3 per cent. As one participant in Washington put it, the tactics of the Europeans at the weekend were like a football team on the defensive: they tried to hoof the ball into the opposing team's half by berating the US for increasing the size of its deficit through tax cuts.

Curing America's twin deficit problem should be a priority not just for the Americans but the rest of the global community. The sensible way to do so would be for the US to shoulder less of the burden of global demand and for Europe and Japan to take up the slack. That means coordinated macroeconomic policies, not mutual recriminations. After growing faster than the eurozone in nine of the past ten years, the US is no more willing to take lectures from the Europeans on economic policy than it is on security policy.

In an ideal world, joint action on Iraq and growth would unlock progress in other areas, which were tangential to the weekend's minimalist agenda. The US and Europe would agree to settle their differences over the stalled round of trade talks in Geneva, America would not have been able to kick into the long grass plans for a bankruptcy system for debt-laden countries simply to satisfy Wall Street, there would be agreement that Gordon Brown's plan for doubling world aid needs to go through quickly if the world's poorest nations are to meet the development goals laid down by the United Nations, and the modest amount of

money would be found for the ten countries that have come up with credible policies for universal education. It says something when $80bn can be mobilized for war but not $400m to educate the poor.

This is not an ideal world. America has shown it has the power, the money and the will to act. Not all it seeks to do is good, nor bad. The rest of the world can engage and show Washington that multilateralism works. Or sit carping on the sidelines and watch as the Americans do things on their own.

12 June 2003

IAN TRAYNOR

The US aid card

The US is turning up the heat on the countries of the Balkans and eastern Europe to secure war crimes immunity deals for Americans and exemptions from the year-old international criminal court.

In an exercise in brute diplomacy, which is causing more acute friction with the European Union following the rows over Iraq, the US administration is threatening to cut off tens of millions of dollars in aid to the countries of the Balkans unless they reach bilateral agreements with the US on the ICC by the end of this month.

The American campaign, which is having mixed results, is creating bitterness and cynicism in the countries being intimidated, particularly in the successor states of former Yugoslavia, which perpetrated and suffered the worst war crimes seen in Europe since the Nazis. They are all under intense international pressure, not least from the Americans, to cooperate with the war crimes tribunal for former Yugoslavia in The Hague.

'Blatant hypocrisy,' said Human Rights Watch in New York on Tuesday of the US policy towards former Yugoslavia.

Threatened with the loss of $73m (£44m) in US aid, Bosnia signed the exemption deal last week just as Slovenia rejected American pressure and cut off negotiations. Of all the peoples of former Yugoslavia, the Bosnians suffered the most grievously in the wars of the 1990s, from the siege of Sarajevo to the slaughter of Srebrenica. They signed reluctantly, feeling they had no choice. Former Yugoslavia is particularly central to the US campaign to exempt Americans from the scope of the ICC because there are US troops in Bosnia and Kosovo.

Washington is vehemently opposed to the permanent international criminal court, arguing that US soldiers, officials and citizens will be targeted for political reasons, an argument dismissed by the court's supporters, who point out that safeguards have been built into the rules governing the court's operations.

Under President Bill Clinton, Washington signed the treaty establishing the court. But the US did not ratify the treaty and Mr Bush rescinded Mr Clinton's signature.

While the Slovenes have said no to the Americans, probably forfeiting $4m in US aid, Croatia, Serbia and Macedonia are now being pressed to join the thirty-

nine other countries worldwide with which Washington has sealed bilateral pacts granting Americans immunity from war crimes.

'While the United States rightly insists that the former Yugoslav republics must fully cooperate with the [Hague] tribunal, it is turning the screws on the very same states not to cooperate with the ICC,' said Human Rights Watch.

Croatia is sitting on the fence, refusing to accept what the prime minister, Ivica Racan, dubbed 'an ultimatum', but still hoping to reach a compromise with the US. The American ambassador in Zagreb published a letter in the Zagreb press last week warning that Croatia would lose $19m in US military aid if it did not capitulate by 1 July.

In Serbia, too, where the issue of war crimes is explosive, the US pressure is being attacked as a ruthless display of double standards.

The EU has sent letters to all the countries in the region advising them to resist the US demands and indicating that surrender will harm their ambitions of joining the EU.

Regional leaders are waiting to see what kind of offers or promises this month's EU summit in Greece makes to the region before deciding on their stance towards the ICC. One idea being floated is that the EU could make up the lost US aid money in return for Balkan refusal to toe the American line.

Although the eight east European countries joining the EU next year are expected to follow the Brussels policy and reject the US demands, the Poles in particular are also being pressed to reach an immunity deal with Washington.

Sources in Warsaw say that the US State Department has made several requests in recent weeks for a deal by 1 July. Poland is the biggest American ally in the region but has not yielded to the US requests.

29 July 2003

GEORGE MONBIOT

America is a religion

'The death of Uday and Qusay,' the commander of the ground forces in Iraq told reporters on Wednesday, 'is definitely going to be a turning point for the resistance.' Well, it was a turning point, but unfortunately not of the kind he envisaged. On the day he made his announcement, Iraqi insurgents killed one US soldier and wounded six others. On the following day, they killed another three; over the weekend they assassinated five and injured seven. Yesterday they slaughtered one more and wounded three. This has been the worst week for US soldiers in Iraq since George Bush declared that the war there was over.

Few people believe that the resistance in that country is being coordinated by Saddam Hussein and his noxious family, or that it will come to an end when those people are killed. But the few appear to include the military and civilian command of the United States armed forces. For the hundredth time since the US invaded Iraq, the predictions made by those with access to intelligence have proved less reliable than the predictions made by those without. And, for the

hundredth time, the inaccuracy of the official forecasts has been blamed on 'intelligence failures'.

The explanation is wearing a little thin. Are we really expected to believe that the members of the US security services are the only people who cannot see that many Iraqis wish to rid themselves of the US army as fervently as they wished to rid themselves of Saddam Hussein? What is lacking in the Pentagon and the White House is not intelligence (or not, at any rate, of the kind we are considering here), but receptivity. Theirs is not a failure of information, but a failure of ideology.

To understand why this failure persists, we must first grasp a reality that has seldom been discussed in print. The United States is no longer just a nation. It is now a religion. Its soldiers have entered Iraq to liberate its people not only from their dictator, their oil and their sovereignty, but also from their darkness. As George Bush told his troops on the day he announced victory: 'Wherever you go, you carry a message of hope – a message that is ancient and ever new. In the words of the prophet Isaiah, "To the captives, 'Come out,' and to those in darkness, 'Be free'".'So American soldiers are no longer merely terrestrial combatants; they have become missionaries. They are no longer simply killing enemies but casting out demons. The people who reconstructed the faces of Uday and Qusay Hussein carelessly forgot to restore the pair of little horns on each brow, but the understanding that these were opponents from a different realm was transmitted nonetheless. Like all those who send missionaries abroad, the high priests of America cannot conceive that the infidels might resist through their own free will, and if they refuse to convert, it is the work of the devil, in his current guise as the former dictator of Iraq.

As Clifford Longley shows in his fascinating book *Chosen People*, published last year, the founding fathers of the USA, though they sometimes professed otherwise, sensed that they were guided by a divine purpose. Thomas Jefferson argued that the Great Seal of the United States should depict the Israelites, 'led by a cloud by day and a pillar of fire by night'. George Washington claimed, in his inaugural address, that every step towards independence was 'distinguished by some token of providential agency'. Longley argues that the formation of the American identity was part of a process of 'supersession'. The Roman Catholic Church claimed that it had supplanted the Jews as the elect, as the Jews had been repudiated by God. The English Protestants accused the Catholics of breaking faith, and claimed that they had become the beloved of God. The American revolutionaries believed that the English, in turn, had broken their covenant: the Americans had now become the chosen people, with a divine duty to deliver the world to God's dominion. Six weeks ago, as if to show that this belief persists, George Bush recalled a remark of Woodrow Wilson's. 'America,' he quoted, 'has a spiritual energy in her which no other nation can contribute to the liberation of mankind.'

Gradually this notion of election has been conflated with another, still more dangerous idea. It is not just that the Americans are God's chosen people, America itself is now perceived as a divine project. In his farewell presidential address, Ronald Reagan spoke of his country as a 'shining city on a hill', a reference to the Sermon on the Mount. But what Jesus was describing was not a

temporal Jerusalem, but the kingdom of heaven. Not only, in Reagan's account, was God's kingdom to be found in the United States of America, but the kingdom of hell could also now be located on earth: the 'evil empire' of the Soviet Union, against which His holy warriors were pitched.

Since the attacks on New York, this notion of America the divine has been extended and refined. In December 2001, Rudolph Giuliani, the mayor of that city, delivered his last mayoral speech in St Paul's Chapel, close to the site of the shattered twin towers. 'All that matters,' he claimed, 'is that you embrace America and understand its ideals and what it's all about. Abraham Lincoln used to say that the test of your Americanism was ... how much you believed in America. Because we're like a religion really. A secular religion.' The chapel in which he spoke had been consecrated not just by God, but by the fact that George Washington had once prayed there. It was, he said, now 'sacred ground to people who feel what America is all about'. The United States of America no longer needs to call upon God, it is God, and those who go abroad to spread the light do so in the name of a celestial domain. The flag has become as sacred as the Bible, the name of the nation as holy as the name of God. The presidency is turning into a priesthood.

So those who question George Bush's foreign policy are no longer merely critics, but blasphemers, or 'anti-Americans'. Those foreign states that seek to change this policy are wasting their time: you can negotiate with politicians, you cannot negotiate with priests. The US has a divine mission, as Bush suggested in January, 'to defend ... the hopes of all mankind', and woe betide those who hope for something other than the American way of life.

The dangers of national divinity scarcely require explanation. Japan went to war in the 1930s convinced, like George Bush, that it possessed a heaven-sent mission to 'liberate' Asia and extend the realm of its divine imperium. It would, the fascist theoretician Kita Ikki predicted: 'light the darkness of the entire world'. Those who seek to drag heaven down to earth are destined only to engineer a hell.

6 March 2003

RICHARD DAWKINS

Letter: Who are the real appeasers?

The distorting mirror of Munich and appeasement is held up with irritating regularity ('Secret UN plan to take over Iraq', 5 March). George Bush is said to admire Churchill, but the comparison is vain. Bush's zig-zagging around the US on 11 September 2001 has been defended, somewhat lamely, against the obvious charges of cowardice and panic. Well, maybe. But can you imagine Churchill doing it?

Turn it round. Who is the petulant bully, the 'bloodthirsty guttersnipe' today? On 16 February, the *Observer* reported that the Pentagon had been ordered by Donald Rumsfeld to impose sanctions to punish Germany for leading international opposition to a war against Iraq. 'We are doing this for one reason only:

to harm the German economy.' Yesterday you quoted Colin Powell as warning that time is running out: 'Either the international community's will has meaning or does not have meaning.' One might have hoped that the will of the international community would mean whatever emerges from the deliberations of the UN. Apparently it means the unilateral will of the current US government. Most chilling of all, you report that Bush himself has warned Chirac 'he will neither forgive nor forget if France continues to oppose the resolution'.

Where should we look for our Chamberlain? Jack Straw warns that Washington would abandon the UN and Nato if Europe refuses to fall into line: 'What I say to France and Germany and all my other EU colleagues is take care, because just as America helps to define and influence our politics, so what we do in Europe helps to define and influence American politics ... And we will reap a whirlwind if we push the Americans into a unilateralist position in which they are the centre of this unipolar world.' If that is not appeasement, I'd like to know what you call it.

8 March 2003

STEPHEN FRANKLIN

Letter: A war would be legal

War with Iraq would be legal under two of the grounds cited by lawyers (Letters, 7 March): self-defence and as a collective response to a threat to the peace.

Iraq has been sponsoring terrorism all the time Saddam Hussein has been in power. Iraqi agents directed the attack on the Iranian embassy in London in 1980, it sponsored Abu Nidal as he ran a vicious terrorist gang from Baghdad, which paralysed and eventually killed the Israeli ambassador to London, and last month an Iraqi diplomat was expelled from the Philippines for involvement in a terrorist attack there.

Iraq has launched ballistic missile attacks on four of its neighbouring states and used chemical weapons against its own people. There is no question that Saddam considers the US and the UK to be enemies and is quite capable of supplying terrorists with biological weapons that present a real threat to us.

Resolution 1441 called for a full and complete disclosure of all facts relating to Iraq's chemical and biological weapons programmes within thirty days. It is clear that Iraq did not do so – in fact, the small amount of new evidence that it is producing now is proof that it failed to provide full and complete information by the deadline. This is a clear material breach of 1441. The resolution is passed under chapter seven of the UN charter, which authorizes military action for a breach, and the US, sponsors of the resolution, made it very clear that the serious consequence was military action.

The will of the UN is expressed by resolutions that are passed. A resolution that is not passed has no bearing on international law. A war that ends twelve years of breaches of mandatory (chapter seven) resolutions of the Security Council, and puts an end to a reign of terror for the people of Iraq and an end to the threat of terror, emanating from Iraq, to all nations is a just, prudent and humanitarian war.

AWE AND SHOCK

25 March 2003

JAMES MEEK

The battle for hearts and minds

Hopes of a joyful liberation of a grateful Iraq by US and British armies are evaporating fast in the Euphrates valley, as a sense of bitterness, germinated from blood spilled and humiliations endured, begins to grow in the hearts of invaded and invader alike.

Attempts by US marines to take bridges over the River Euphrates, which passes through Nassiriya, have become bogged down in casualties and troops taken prisoner. The marines, in turn, have responded harshly.

Out in the plain west of the city, marines shepherding a gigantic series of convoys north towards Baghdad have reacted to ragged sniping with an aggressive series of house searches and arrests.

A surgical assistant at the Saddam hospital in Nassiriya, interviewed at a marine check point outside the city, said that on Sunday, half an hour after two dead marines were brought into the hospital, US aircraft dropped what he described as three or four cluster bombs on civilian areas, killing ten and wounding 200.

Mustafa Mohammed Ali said he understood US forces going straight to Baghdad to get rid of Saddam Hussein, but was outraged that they had attacked his city and killed civilians. 'I don't want forces to come into the city. They have an objective, they go straight to the target,' he said. 'There's no room in the Saddam hospital because of the wounded. It's the only hospital in town. When I saw the dead Americans I cheered in my heart. They started bombing Nassiriya on Friday but they didn't bomb civilian areas until yesterday, when these American dead bodies were brought in. We know the difference between a missile and a cluster bomb. A missile shoots to one target whereas a cluster bomb spreads after they release it.'

Mr Ali said marines now controlled the centre of the city, but that fighting was continuing, with members of Saddam Hussein's Ba'ath party in the forefront.

Asked about the much-vaunted fedayeen militia, reported by some sources to be leading the battle, Mr Ali said: 'They are children.' Other travellers from Nassiriya said they were press-ganged youths who went into battle dressed in black with black scarves wound around their faces and who fight for fear of the execution committees waiting to shoot them if they try to run.

Watching from behind a barbed-wire barrier as hundreds of the marines' ammunition trucks, armoured amphibious vehicles, tankers, tanks and trucks lumbered past through clouds of dust as fine as talcum powder, Mr Ali asked why such a huge army was needed just to catch a single man. 'We don't want Saddam, but we don't want them [the Americans] to stay afterwards,' he said. 'Like they entered into Saudi Arabia, Kuwait and Qatar and didn't leave, they will do here. They are fighting Islam. They're entering under the pretext of tar-

geting Ba'ath, but they won't leave.'

Another Iraqi squatting next to him leaned over, pointed to the convoys and said: 'This is better than Saddam's government.'

The marine convoys, which have been passing northward now almost non-stop for two days, are using a partly-built concrete motorway bridge over the Euphrates, which US military engineers have made strong enough to take one tank at a time.

At this point the river is a narrow, slow-flowing blue current. Nassiriya is at the western end of the waterlands once occupied by 200,000 Marsh Arabs, the Ma'dan, whose culture, thousands of years old, was all but destroyed by Saddam Hussein with terrible loss of life.

A few yards from the bridge it is possible to sit by the riverbank and watch the green spring reeds, which defined the marshes, bending in the wind. One of the Ma'dan's high-prowed canoes drifts from side to side on its mooring rope. But it is not long before the sound of the wildfowl and the lapping water is drowned out by a pair of ash-grey Huey helicopters, chugging low past the palm trees beside the bridge, and the whine of the next tank to cross.

Staff Sergeant Larry Simmons, a Floridian from a marine reconnaissance unit in a foxhole overlooking the bridge, was not impressed by what he saw. 'You learn about the Euphrates in geography class, and you get here and you think, "This is the Euphrates? Looks like a muddy creek to me."'

The marines are aggrieved: aggrieved that the Iraqis aren't more grateful; aggrieved that the Iraqis are shooting at them; aggrieved that the US army's spearhead 3rd Infantry Division tore through Nassiriya earlier in the invasion without making it safe.

'They didn't clear the place, and then they left, and now the marines sure have to clear it,' he said. 'Just like the goddam army.'

And the Iraqis are aggrieved at the marines. A fifty-year-old businessman and farmer, Said Yahir, was driving up to the main body of the reconnaissance unit, stationed under the bridge. He wanted to know why the marines had come to his house and taken his son Nathen, his Kalashnikov rifle and his 3m dinars (about £500).

'What did I do?' he said. 'This is your freedom that you're talking about? This is my life savings.'

In 1991, in the wake of Iraq's defeat in the first Gulf War, Mr Yahir was one of those who joined the rebellion against Saddam Hussein. His house was shelled by the dictator's artillery. The US refused to intervene and the rebellion was crushed.

'Saddam would have fallen if they had supported us,' Mr Yahir said. 'I've been so humiliated.'

Under the bridge, Sergeant Michael Sprague was unrepentant. The money, the marines said, was probably destined for terrorist activities – buying a suicide bomber, for instance. 'The same people we determined were safe yesterday were found with weapons today,' he said.

Marine scouts shot two Iraqi men yesterday when they were seen carrying Kalashnikovs. Each man was found to be carrying three magazines, but they never fired at the marines before they were killed.

'They were pointing their weapons in an aggressive manner, and they were taken out,' said Sergeant Sprague. He added that Nathen had been captured the previous day, along with dozens of others, and like them, had been let go. Then they caught him again with a Kalashnikov in mint condition and 3m dinars. 'So the question I would like to be asked is, if this person already went through EPW [enemy prisoner-of-war] questioning and was found to be OK, why on earth would he come back? The problem with these people is that you can't believe anything they say.'

Could he understand the locals' distrust of the US after what happened in 1991?

'If it weren't for the liberal press, we might have taken Baghdad last time,' said the sergeant.

In the end the marines let father and son go on their way with gun and money, accepting that both were for personal use. But Sergeant Sprague was none too happy to see them go. The convoys have, after all, come under sporadic mortar attack. 'There's a mad mortarman out there,' he said.

A few miles from the bridge to the south lie the ruins of the ancient city of Ur, founded 8,000 years ago, the birth place of Abraham and a flourishing metropolis at a time when the inhabitants of north-west Europe were still walking round in animal skins.

Sergeant Sprague, from White Sulphur Springs in West Virginia, passed it on his way north, but he never knew it was there. 'I've been all the way through this desert from Basra to here and I ain't seen one shopping mall or fast food restaurant,' he said. 'These people got nothing. Even in a little town like ours of twenty-five hundred people you got a McDonald's at one end and a Hardee's at the other.'

A few hundred yards downstream, a group of Iraqis, some of them hiding out in the country from the fighting in Nassiriya, invited journalists to strong sweet tea in a farmhouse of whitewashed mud. They spread carpets and cushions on the floor and generously allowed the guests not to take their muddy boots off. Light shone through a triangular window.

Mohsen Ali, a devout Shia fingering amber beads as he spoke, said the Iraqi people would fight for Iraq, if not for President Saddam, although he supported the dictator. The country needed a strong leader, he said – even a brutal one.

'If in Iraq there's a leader who's fair, he'll be killed the next day,' he said. 'Iraqis have hot blood. If he's not tough, he dies the next day.'

31 March 2003

AUDREY GILLAN

Friendly fire

They will never forget the sound of the guns. A cross between a moan and a roar, a fierce rattling of heavy rounds of 30mm canon fire from two A-10 Thunderbolts flying low overhead. Aircraft that shouldn't have been in the

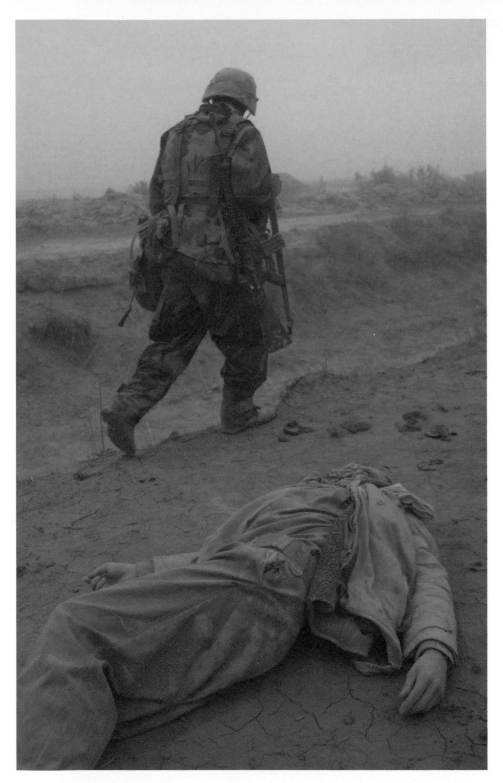

A US marine walks past the corpse of an Iraqi soldier killed during a failed ambush on US forces marching to Baghdad. (Paul O'Driscoll)

US soldiers begin to bury bodies in the Presidential Palace compound, Baghdad. (Sean Smith)

A child dressed in military uniform, Baghdad. (Sean Smith)

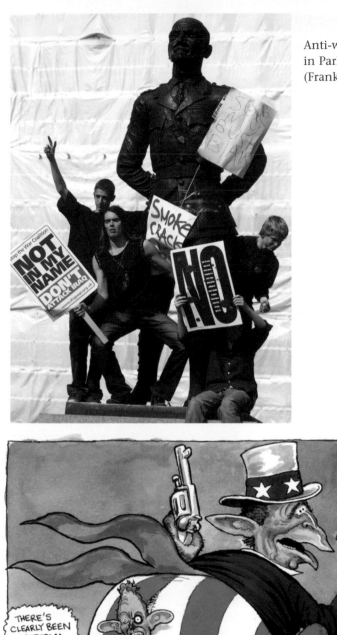

Anti-war demonstrators
in Parliament Square.
(Frank Baron)

Material breach. (Steve Bell)

Sympathy. (Steve Bell)

The US and the UN.
(Peter Till)

British-controlled area, 'cowboying' at just 500ft and looking for something to have a crack at.

Last Friday morning, two American pilots turned their guns on a convoy of five British vehicles from the Household Cavalry, killing one man just three days shy of his twenty-sixth birthday, injuring four others, and wiping out two armoured reconnaissance vehicles from the squadron's 2 Troop. Two Iraqi civilians, waving a large white flag, were also killed.

Coloured smoke signs were sent up to indicate that they were friendly troops but it didn't stop the attack. The planes came back a second time, seriously injuring those who had managed to scramble out of their vehicles with only superficial wounds. The gunner, Corporal Matty Hull, was the victim of a direct hit into his gun turret.

The men in the Scimitars were screaming over the radio, 'Stop the friendly fire, we are being engaged by friendly fire' and 'Pop smoke, pop smoke'. The forward air controller, who liaises with coalition air forces to bring in fire missions, was shouting, 'Check fire, check fire'. Frantic calls were made to 16 Air Assault Brigade headquarters to find out what was going on. But no one seemed to know.

The A-10s were about to take a third swing when they were told by the American air controller working with the Household Cavalry to stop firing. Instead of providing air cover while helicopters came in to evacuate the casualties, they flew away.

Lance Corporal of Horse Steven Gerrard said of the pilot who shot up Corporal Hull: 'He had absolutely no regard for human life. I believe he was a cowboy. There were four or five [planes] that I noticed earlier and this one had broken off and was on his own when he attacked us. He'd just gone out on a jolly.' He told Patrick Barkham of *The Times*: 'I'm curious about what's going to happen to the pilot. He's killed one of my friends and he's killed him on the second run.'

The attack took place within the Household Cavalry's battlefield control line, which means that everything in the air should be controlled by them and their embedded American air controller. The A-10s were well out of their area and the matter is now being investigated amid calls from some of the British troops that the pilots be prosecuted for manslaughter.

So far in this conflict, Britain has suffered more casualties from friendly fire, five, than from assaults by the Iraqis.

That morning's plan had been to use artillery, air and helicopter strikes against Iraqi positions to secure the area for future operations. D Squadron is an armoured reconnaissance unit and its job is to move in first and secure locations before other troops move in. The two Scimitars had been probing a road, checking for landmines, enemy locations and assault batteries.

At this point, 2 Troop was given orders to move forward. Squadron Leader Richard Taylor said: 'I remember saying, "Move quickly through the urban area, as we will be vulnerable from civilians, make best speed, good luck." I don't think I will be wishing anyone good luck again.'

Ears pricked up as shouting came over the radio. At first it seemed like someone had just lost their rag. Then the full horror dawned. One of the vehicles had

been hit, no two, and by 'friendly call signs'.

They stood still, stopping what they were doing. At first they thought it was one lad, then another. Whoever it was, it didn't ease the twist of knots that started knitting themselves in their stomachs. Later, they learned it was Matty Hull, who, aside from being a gunner, was also a military instructor and being considered for a posting to Sandhurst to train officers.

Amid the grief, their anger could not be contained. All of D Squadron's vehicles are clearly marked, with fluorescent panels on the roofs, flags and other markings. It was something the soldiers kept repeating.

'We spend all this money marking out our vehicles so this doesn't happen,' one said. 'If it was the heat of battle, shit happens. But it was clear daylight.'

Another said: 'As far as I am concerned, those two pilots should be done for manslaughter. There's no way on the planet that they couldn't see two vehicles, that they couldn't see the dayglo panel on the top.'

Trooper Joe Woodgate, aged nineteen, the driver of the Scimitar in which Corporal Hull was killed, walked away with holes in his bulletproof vest and a tear in either side of his shirtsleeve where shrapnel entered and exited, without touching his arm. All the rest of his colleagues had to be evacuated to the hospital ship Argus.

'We were given this mission to go along and clear one of the furthest routes, a road running along between the River Euphrates and this village. We knew it was going to be pretty hairy because we had been bombing the shit out of the Iraqis all day,' he said.

'I was moving along and for some reason, the wagon just stopped dead and these two massive sparks came flying into my cab. I turned round and the turret was just a well of fire behind me. There was fire everywhere. I tried to get out and my hatch was jammed. I was banging away at it for what seemed like a lifetime but it was probably only a few seconds. As soon as I saw the fire, I thought, "Get the fuck out of here." I managed to get out and rolled on the floor. I didn't realize that it was the Americans that had hit us.

'I remember seeing the front wagon which had been hit and I remember seeing the people getting out of that and running for cover. I thought there must be ground troops coming to get us. I went pegging it after them and jumped in a ditch. That was when the American plane came round to do a second swoop on us. That fucking gun, I don't want to ever hear that again. It's like a cross between a moan and a roar it's that fast.

'Chris Finney helped people get out of the wagon, he was amazing. I didn't know what was going on at that point. We were in this ditch and I still didn't realize it was Americans. I didn't realize that Matty was still in the turret. So we ran back over to the wagons. The engineers who had been in our convoy were there helping with the casualties and getting them into their Spartan while they were under fire.

'By all accounts, I found Finney and he had a shrapnel wound all up his arse. Gerry knew exactly what needed to be done. I remember seeing him stand up and wave his arms in the air, trying to get these planes to stop.

'When I got out, I thought Matty had got out as well but when I was pegging it off after Gerry, I thought, "Where's Matty?" and I looked behind me and the

fucking wagon was just a mess, man. It's weird because you are thinking, maybe if I had done things differently ... I don't know why Matty couldn't get out. People said they remember hearing him on the radio but I don't remember a thing. In hindsight, you always think there's something else you could have done.

'I went back there on Saturday when they went to recover the vehicles and Matty's body, but I wasn't allowed out of the vehicle until they held a service for him. Part of me thinks, I have already cheated death and I may be tempting fate by staying out here, but they have moved me to squadron headquarters because I don't have a vehicle to drive any more.'

The Scimitar was so badly ablaze it was still smoking the next morning. Fully loaded with ammunition, it had become an exploding tinderbox. Much of it, including its gun turret and its tracks, had melted.

The troops could do nothing but evacuate the casualties and leave the gunner's body behind. When daylight came, the squadron leader, a padre and a number of the troops returned to the scene to bring the body out. Chemical warfare suits had to be worn because of the threat from the depleted uranium used in the American weapons. A remembrance service yesterday was interrupted by the thuds of incoming Iraqi artillery and the padre saying, 'And the Lord said, oh, that was a bit close, get down.'

Afterwards, Squadron Leader Taylor said: 'Militarily, it was a very successful operation that was marred by the tragic events that led to friendly fire casualties. To Mrs Hull, I would like to say that the hearts of the squadron are with her and her family today. Her husband did not die in vain. He was an immaculately professional soldier. He was highly regarded and immensely popular within the regiment, he will always be remembered for his smiley face and professional manner.'

Trooper Joe Woodgate said of the incident: 'It was the most irresponsible thing in the world ... I can't stop thinking about how he died.'

8 April 2003

JAMES MEEK

'This is not the face of a peacekeeper'

The Cuban was the driver, the least painted-up of the Combined Anti-Armour Team Humvee that carried his name. Every other US marine in the car had coated his face in black and green warpaint in preparation for yesterday's entry into Baghdad. Eric the medic had painted his eyes black with stars like a clown, and blackened his lips so they spread across his chops from side to side.

Staff Sergeant Jeff Fowler had completely blackened the bottom of his face, up to halfway up his nose, the top half remaining its natural pink.

'This is not the face of a peacekeeper,' he said. 'I'm doin' the whole *Last of the Mohicans* kinda thing.'

They rolled into the military-industrial southern and eastern suburbs of Baghdad yesterday in their thousands, by pontoon bridge, by half-damaged

bridge, and in amphibious vehicles across the River Diyala. Some had used the black and green warpaint to reproduce skulls on their faces, and death did come to the banks of the Diyala – to Iraqis, not marines.

At mid-morning the third battalion of the 7th Marine regiment, one of three columns waiting to cross over into Baghdad city limits, was queued up on the highway leading up to a bridge over the river, fizzing with adrenalin and testosterone.

Like a video clip repeating itself over and over, the same columns of black oily smoke, which had risen over a string of towns in the marines' fast march from Kuwait, rose over the treeline ahead, and Cobra helicopter gunships thudded through the smoke.

The Cobras were 'prepping' the areas of Baghdad the marines were to enter: firing rockets and machine guns at targets deemed hostile. This had been going on all the previous night, and involved artillery and laser-guided bombs dropped from F18s and Harriers. Then the marines' first tank battalion would race forward, firing to the right and left as it broke through what resistance remained, followed by the infantry.

The tanks had already gone in, and the infantry were sitting, waiting, getting fired up, getting damped down, moving forward a hundred yards, eating. It would have been like a queue on a bank holiday motorway if it had not been for the sound of rockets and small arms fire up ahead.

Away from the city moved a strange procession of looters, hundreds of people, many barefoot or in cheap sandals, driving forklift trucks, pushing motorbikes or dragging generators looted from a nearby warehouse.

Fearful of suicide bombers, the US troops sternly warned off any Iraqi civilian vehicles that tried to approach. They ignored the looters, except occasionally to cheer them on.

'Yeah, lookin' good!' called one marine to a thin, exhausted man pushing an enormous load of several generators on a trolley that was not up to the task.

'Water, water,' called the man.

'Ain't got none, buddy.'

The waiting and the looting dragged on into the afternoon under the sullen, smoky sky that combined the aftermath of a sandstorm with the stinking smoke of burning oil and vehicles. The Cuban made a jam, peanut butter and cracker sandwich. Then, as the light began to fail, the column began to move.

In front of the bridge, and beyond it, the Iraqis had made a last-minute attempt to create a minefield: ripping open boxes of anti-tank mines, looking like plate-sized smoke detectors, and scattering them.

Marine engineers had fired specialized rockets through the minefields, which dragged snaking lines of explosive-filled hose behind them, designed to detonate or throw clear the mines.

Some had exploded, leaving neat discs gouged out of the road. Others lay on either side.

The Iraqis had tried to blow the bridge, and had punched two huge holes in it with explosives. But marine engineers had been able to lay a temporary metal roadway across the gap strong enough to take tanks and trucks.

This attack had initially been intended as a feint to draw Iraqis away from

other river crossings to the south and north into Baghdad. But the engineers were so successful that the 7th went forward and created a beachhead, heading towards the Rashid airport inside Baghdad.

'We knew this moment would come, and it has come very quickly,' said Colonel Michael Belcher, commander of Regimental Combat Team 7 (RCT 7), the combined-arms unit that includes the 7th regiment. 'We are at the gates at this point and ready to start to push forward.'

He contrasted the US army's strike into central Baghdad yesterday with the marines' approach, which was, he said, more like shouldering your way into a place.

On the Baghdad side of the river, a strange and sad ragbag of weapons and corpses lay ruined and dead among the pest and weed foliage of the industrial riverbank. A T-72 tank of the type used by the Republican Guard was a charred mess of metal. An old-fashioned Soviet surface to air missile had not escaped destruction by being hidden under a tree.

A huge rice supper for whatever collection of Iraqi unfortunates had been press-ganged into defending the bridge lay cold and congealed where it had been tipped from the metal tub in which it was being cooked. Rumpled blankets, snagged in sudden panic and flight, were scattered with hardening bread rolls. Nearby lay seven dead Iraqis, men in civilian clothes mixed in with those wearing military green.

'I wouldn't say it was a difficult battle,' said Major Davin Keith, responsible for calling in air strikes. 'We showed up last night, we ran Cobras into this grove of trees, we had jets come over a couple of times this morning.'

Captain Matthew Regner, an intelligence officer with RCT 7, described the Iraqis as a 'pot-pourri' of Republican Guardsmen, regular soldiers and fedayeen militia. One prisoner captured recently had whip marks on his chest, he said. After a recent battle in the town of Salman Pak, five out of nineteen Iraqi corpses had bullet wounds in the back of the head, suggesting, he said, that they had been executed *pour encourager les autres.*

Major Andy Milburn, a career US marine officer from Lymington in Hampshire, looked around the marines' beachhead on the Baghdad side of the river yesterday evening and reflected on the distance they had travelled and the strangely non-urban feel of this part of the capital.

'It's kind of anti-climactic, isn't it?' he said. 'I thought it'd be a little different. It's not the liberation of Paris. The guys who are holding out and fighting, I think, are fighting out of desperation. They know most of the locals help us.'

The looters and deserters thronging the road earlier yesterday seemed genuinely welcoming of the Americans, yet still their welcome was tinged with fear.

'Saddam is still alive,' said Mohamed, a driver. 'This person can use magic. They use such things in our country.'

Fearful not just of Saddam. 'Please signal for me,' said a portly Iraqi, standing on his dignity as the marines told him to turn his vehicle around. 'Maybe somebody shoot me.'

'Shoot you? You think somebody's gonna shoot you?' said an uncomprehending marine.

'Maybe,' said the man.

9 April 2003

SUZANNE GOLDENBERG

A picture of killing

Death's embrace gave the bodies intimacies they never knew in life. Strangers, bloodied and blackened, wrapped their arms around others, hugging them close.

A man's hand rose, disembodied, from the bottom of the heap of corpses to rest on the belly of a man near the top. A blue stone in his ring glinted as an Iraqi orderly opened the door of the morgue, admitting daylight and the sound of a man's sobs to the cold silence within.

Here were just some of the results of America's progress through Saddam Hussein's dominions yesterday, an advance that obliterated the symbols of his regime at the same time as it claimed to be liberating its people.

These were mere fragments in a larger picture of killing, flight and destruction inflicted on a sprawling city of 5 million – and it grew more unbearable by the minute.

In two adjoining stalls of the casualty ward of Kindi hospital, the main trauma centre of eastern Baghdad, a girl, long black plait held off her forehead by a red Alice band, was laid out beside her little brother. Their mother lay across the aisle, beige dress soaked in blood from hem to armpits. Another brother slumped on the floor, insensible to the fact that he was sitting in his mother's blood.

A neighbour who had followed the family to hospital said the girl had been called Noor Sabah and was twelve years old, though she looked smaller next to the doctors who surged into the examining cubicle. Her brother, Abdel Khader, who began the day neatly dressed in dark trousers and a check shirt, was four or five. When their two small corpses were loaded on to the same trolley to take them to the morgue, even the nurses were reduced to tears.

The elderly female orderlies, who had been constantly lugging blood-encrusted trolleys back and forth to the ambulances and battered cars that pulled up at the gates, wailed until they were hoarse, and thumped their pain out on the walls.

The doctors turned to watch the small bodies pass, the best they could offer by way of a ceremony, and abandoned the mother, Wael Sabah, on her trolley. 'She's fatal,' said one. The doctors could do no more than watch her die.

The Sabah family, in their home in the eastern Baladiyat district, had been as far as they could possibly be from the focus of American operations yesterday and still be in Baghdad. A neighbour, leaning heavily against a grubby, tiled wall, said their home had been hit by a rocket fired from a low-flying American aircraft. Nobody was certain of the details, and they would not change anything anyway for the head of the family, who wept in a doctor's arms outside. Only one thing was clear: nowhere was safe.

On the western banks of the Tigris, American forces began reasserting their

mastery over Baghdad before dawn yesterday, with several concussive explosions announcing their presence in President Saddam's preserves.

At dawn, truckloads of Iraqi fighters – a few regular soldiers among the militiamen – had dared a counterattack on the compound of President Saddam's palace, which had been seized by American forces on Monday and occupied overnight. The Americans clearly had been expecting them, or had their own plans to expand their base in central Baghdad from the palace and the Rashid Hotel, which commands sweeping views of the area. This time, with tanks and covered by low-flying aircraft, the US forces were determined to tear deeper into the heart of the city.

As thick black smoke swirled out of at least six separate pyres, and amid a barrage of mortar and artillery fire, the US forces moved northwards along the river embankment and a parallel road. They moved past the grounds of the palace to offices of the Republican Guard, the force under the command of President Saddam's second son and heir, Qusay, which had been pounded on an almost nightly basis for two weeks.

Nothing was safe in their path. At 7 a.m. a correspondent from al-Jazeera television was killed by two rockets fired on the local bureau of the Arab satellite network, cutting him down live on camera.

Certainly, the Iraqi militiamen and the remnants of the Republican Guard and the regular army would have encountered no mercy. Only a day before they had waved and made V-signs to passers-by from their small positions on the main road off the bridge. They were underarmed, and were pitifully exposed in their small sandbag posts, but they had seemed resolved to fight.

By 9 a.m. yesterday they must have fled or been killed as wave after wave of A-10 aircraft swooped overhead, pulverizing the entire western bank of the Tigris with heavy machine gun fire. At one point a few dozen Iraqi fighters dived for the river and swam upstream; others scurried into the reeds along the bank. And still it did not stop.

By 9.30 a.m. two Abrams tanks loomed into view on Jumhuriya (Republic) Bridge, one of the principal spans of central Baghdad, turrets spitting fire and devastation on the Iraqi positions, and on at least one car foolish enough to venture on to the bridge from the eastern shore.

By mid-morning the centre of the Iraqi capital was effectively split in two: the western bank of the Tigris, with its modern neighbourhoods and broad, tank-friendly roads, was under American control. On the eastern side of the river, shabbier now, but still the repository of Arab history as the site of medieval Baghdad, Iraqi soldiers and militiamen sealed off three bridges that cross the heart of the city with concrete blocks and lorries. Accepting US supremacy west of the Tigris, they tried to hang on to the eastern shore. But it seemed futile. By midday the tanks on the Jumhuriya Bridge were firing on both sides of the river. They targeted a telephone exchange on the eastern side and fired on a multistorey hotel at least a mile away, the Palestine, home to the contingent of foreign journalists.

A Reuters television cameraman was killed as he filmed them from his balcony on the fifteenth floor. Three other staff from the news agency were injured, one seriously, and a cameraman for a Spanish channel was killed.

As it had from the outset of this war, America had absolute control over the skies. Fighter planes prowled low overhead, attacking the eastern, southern and northern suburbs. In one surreal moment two rockets travelled the length of Sadoon Street, a main artery on the east side of the river, flying at about 20 metres.

The amount of firepower deployed, and its duration – with only intermittent pauses from dawn to dusk yesterday – was almost beyond belief. So too were the results as the Iraqi regime began to enter its death throes.

Even on the eastern banks of the river, the city came to a halt, with little evidence of the presence of the millions of Iraqis who normally live there, beyond the accumulating piles of rubbish in the largely deserted streets. Teashops and cigarette kiosks, the last preserves of commerce in a shocked and battered city, were shut.

The militiamen who had swarmed the area only a few days ago, toting their assault rifles and rocket-propelled grenades over their shoulders, melted away. The army trucks, which had sheltered beneath palm trees and highway overpasses, vanished, as did the heavy gun emplacements.

The only sign of motion came from the dreary trickle of civilians heading for safety. They had withstood the bombardments for more than a fortnight, and had been without electricity and phones for nearly a week, and they could take no more. They packed up whatever they could carry and made their way out of the city on foot.

Over at Kindi hospital, doctors had already passed their own point of exhaustion. By mid-afternoon all twelve operating theatres were in action, and still the wounded and dead kept coming in.

The doctors tried to maintain their clinical detachment, reeling off the kinds of injuries they were seeing – burnt faces, disembowelled torsos, fractured limbs and skulls, bodies coated with an all-over glaze of blood. They spoke about the technical difficulties of operating with fitful generators, and with their limited stocks of surgical and other supplies. They attempted to put a figure on the daily death toll – four or five, they said.

But there had been perhaps fifteen bodies packed together in just one of the refrigerated containers at the back of the hospital, and a constant ebb and flow of orderlies wheeling the dead to the morgue and families collecting them for the speedy burial dictated by Muslim custom. As with the flow of casualties, too fast and too many to accurately count, it became too much for the doctors. They were overwhelmed.

'This is severely traumatic,' said Osama Salah, the director of medical services. 'It is very difficult to a see a child lying in front of you and I have seen three children. I keep seeing the faces of my own children in these children. It could be my kid. It could be my cousin, and still the Americans continue, and they don't stop.'

10 April 2003

SUZANNE GOLDENBERG

The toppling of Saddam

It was a slow collapse. The statue of Saddam Hussein, huge and commanding, resisted the crowds tugging on the noose around its neck for two hours. Right arm held steady above their heads, pointing towards the horizon.

At last, metal legs buckled at the knee, forcing Saddam to bow before his people, and the statue snapped in two, revealing a hollow core. It was the end, or one sort of ending. Thirty years of brutality and lies were coming to a close – not decisively, not in full measure, not without deep fears for the future or resentment at this deliverance by a foreign army – but on a day of stunning changes.

Iraqis had begun drifting towards the statue on Firdouz Square, on the eastern bank of the Tigris, in the late afternoon, when the noisy grinding of gears announced the arrival of the American tanks.

This was the real heart of Baghdad – not the conglomeration of security buildings and palaces that were the preserve of the regime on the opposite shore and had been bombed for three weeks by the US military.

The crowds seemed to know what was expected of them. A man went up to one of the marines, whose tanks now controlled the circle and both sides of Sadoon Road, a main artery in east Baghdad, and asked for permission to destroy the statue.

But it was still too heady an idea. 'You, you shoot it,' the Iraqi pleaded. The marine replied, with no apparent irony for the days of killing that preceded their arrival in Baghdad: 'No, no, I cannot shoot. There are too many innocent people around.'

So it was left to the Iraqis themselves. A scrawny man tore down the brass plate on the plinth; others set off to find a rope to pull the statue down.

A marine threw the Stars and Stripes on top of Saddam's head, before thinking better of it. Within minutes an Iraqi flag was in its place. It was the old flag, without the inscription in Saddam's own handwriting of Allahu Akbar (God is most great) that had been added to the gaps between the stars after the last Gulf War.

The symbols of his legacy were becoming undone. But the process was halting and hesitant, with Iraqis waiting until the last possible moment to assert even the tiniest freedoms. At the Palestine Hotel, where foreign journalists have been stabled, the system functioned right until the very end.

At 9 a.m., as the marines were trundling into the southern suburbs of Baghdad, the minders from the Information Ministry, who spy on journalists, were lined up for duty at the table in the lobby, dictating where, and where not, it was possible to travel.

Outside, the streets were still and almost monochrome, coated with the thick dust of a persistent sandstorm. The crude sandbag posts for the Iraqi militiamen were empty.

For two miles there was no sign of the fighters who had tried to slow the American onslaught on Baghdad, until at last one man came into view beneath a highway overpass, slumped in the dirt, cradling a rocket launcher in his arms.

Further down the road, a desperate exodus was under way from the north-eastern neighbourhoods of Baghdad.

They were entirely male and of fighting age, and they were travelling on foot, carrying bedrolls and belongings. They would not stop to talk. A few more cars came into view – the white pick-up trucks with the red chevrons used by the Iraqi security forces. Yesterday, the drivers were all in civilian clothes, and they had rolled-up mattresses in the back.

The minder who accompanied us pointed to a branch office of Iraqi Airways, which was improbably open, and where employees were waiting for their pay. A hair salon next door was open as well. 'You see, everything is normal,' he said.

We crossed the river to the western bank of the Tigris, keeping a distance from the enclave around Saddam's Republican Palace, the staging ground for American troops.

Off to the side about ten fighters, many wearing red *keffiyehs*, sat on the grass with their guns and rocket launchers. They did not appear to be Iraqis, but from among the Arab recruits to Saddam's cause, who have been killed in such appalling numbers in the war against America. As we approached, an Iraqi handler barked an order, and the men ran into an abandoned house.

We drove on through Mansour, one of the richest residential areas of Baghdad, and were flagged down by yet another minder, who had been trying for hours to hail a taxi and report for duty at the Palestine Hotel.

'Did you listen to the statement from the information minister yesterday?' he said. 'He gave a very accurate picture. He said that the Americans had been in west Baghdad and that the Iraqis had driven them out.'

A few days ago, the US military disgorged four bunker-busting bombs on one of the side streets, targeting, the Pentagon said, one of the last hideaways of Saddam and his sons. On the main road, shop owners swept up shards of glass, and attempted to prise open metal shutters. The minders were distracted and a chemist motioned for us to come inside.

'This is the price of freedom, between you and me,' he said. 'This son of a bitch destroyed us. Ariel Sharon – all the dictators in the world – become angels beside him.'

It was not an entirely unexpected confession. The last days of the war had brought increasing moments of candour from Iraqis, trained over the years to suppress all critical thoughts of the regime. The self-repression was infectious. During eleven weeks in Iraq, I rarely referred to Saddam by name even in hotel rooms, which are bugged. He became Puff Daddy.

But as the end grew near, the lies became more intolerable. Acquaintances tugged me aside and blurted out that their cousins and brothers had been killed by Saddam for various offences. Drivers, who are vetted by the Information Ministry, reacted with excitement and smiles when the American army made its first foray into southern Baghdad at the weekend. And the minder, never viewed as especially solid by his colleagues at the Information Ministry, boarded the bus for the ritual tour of the city one morning, describing with great excitement the

report on the BBC that Saddam airport had fallen. 'Very optimistic news,' he said. Then he remembered.

It was the same yesterday. After unburdening himself of his hatred for Saddam, the chemist begged me not to reveal his name, or his shop's location. 'I wish the coalition forces would come here,' he said. 'I would guide them to all the Iraqi positions. But if the coalition forces stay longer in Iraq, I think it is going to be a disaster.'

They had arrived already. We deposited the minder at the hotel and headed back across the river for Saddam City, that dumping ground for the dispossessed and secretly disaffected Shias that had become notorious over the years. The tanks had been and gone, and a carnival of looting was under way. Teenagers, laughing recklessly, rolled away swivel chairs from government buildings. At an electrical supply depot, grown men piled whatever they could carry on to fork-lifts and wheeled them out to their homes. An Epson printer lay abandoned in the road.

'Have we got rid of that criminal Saddam?' asked one man, carting off a red space heater and an ancient adding machine. 'Until when?'

But it wasn't all celebration. As the looters streamed by, a bearded engineer erupted in anger. 'This is the freedom that America brings to us,' he said. 'They destroyed our country. They are thieves. They stole our oil and killed many people. Here are the results.'

A battered red Saab drove by with six tractor tyres on the roof and the boot, and two tied down on the bonnet. A teenager turned up with a rifle in each hand, freshly stolen from a shop, twitching convulsively at each trigger. 'Bush, Bush,' he screamed. '*Zain*.' (Very good.) Two more youths pushed a small Suzuki jeep along. There was no sign of police, or the militias from the ruling Ba'ath party, those in khaki uniform who had kept an iron grip for years on Saddam City.

Viewed with suspicion by the regime and dread by its better-off countrymen, Saddam City was in the grip of the very nightmare Iraqis had envisaged for the ending of this war: rioting and lawlessness. Smoke billowed from a government store on the edge of the neighbourhood. Beneath a highway overpass, young men tried to cart away the field guns abandoned by the Iraqi fighters when they fled.

Meanwhile, US marines had moved into the north of Baghdad, taking control of the last bridges across the Tigris. The circle of territory still under the nominal charge of Saddam was shrinking.

Back at the Palestine Hotel, it was not yet immediately apparent that the regime had entered its final day. True, the most senior officials from the Information Ministry had decamped, either in the dead of night or secretly in the morning. None had said goodbye. But a few journalists still hovered forlornly in the driveway, waiting for their minders. Shots were fired from the nearby Education Ministry at vehicles marked TV.

In the south of the city, a few bands of fighters were making their last stand. A trail of burned-out cars, one with a corpse at the steering wheel, led to sounds of gunfire from residential neighbourhoods. A few men stood outside their homes, waving whatever pieces of white cloth came to hand. A column of US

tanks was lumbering into view in the distance, but it was too early to think of anything but survival.

A statue of Saddam had been destroyed at the main turn-off, but it had been chopped in half at the waist by an American tank shell, not rebellious Iraqis. Here, and in other pockets of the city, the diehards of the regime were making their last stand. One US marine, asked yesterday what had sustained the ragtag and woefully underarmed groups of fighters for so long, said, 'Adrenaline.'

By nightfall yesterday, the rush was beginning to wear off. The crackle of gun-fire in the distance – met by the boom of American tank shells – tapered off. A few Iraqis, watching the chaotic and emotionally charged scenes at Firdouz Square, and the ritualized toppling of the statue of Saddam, grew silent, and edged away from the crowd.

'Can you believe it?' said one man, holding his four-year-old son close to his side. It was impossible to read the emotions flickering across his face. 'People are happy. I am not sure.'

He sighed, and nudged his chin in the direction of the American tanks. 'Shit, all of these problems because of Saddam. They are going to stay for ever, these Americans.'

14 April 2003

JONATHAN STEELE

A father's desperate search for his son

He knelt by the graveside with lines of anxiety etched on his forehead while a hospital orderly in a blue coat dug at the earth with his bare hands. Two other men joined in, moving the soil away in gentle scoops.

Dark blue trousers emerged, first one leg, then the other. A small hand, its fist slightly clenched, was slowly uncovered. The dead boy's face was hidden by a red cloth. The orderlies hesitated for an instant as if they needed extra strength before they started to remove it.

By now Aboudi Kazem was lying above the grave on one elbow, drawing fiercely at a cigarette. Was this going to be his moment of truth? Were they about to find the missing body of his son Ali, the sixteen-year-old he had not seen for seven months since he left home in Najaf to come to stay with his uncle in Baghdad?

As the cloth was unwound, the father's face tensed and then suddenly relaxed. The teenage boy whose eyelids the orderlies were carefully clearing of dust was not Ali.

Aboudi Kazem knew his son was dead, victim of a trigger-happy American marine at a Baghdad checkpoint.

He even knew Ali must be in this hospital since this is where he was brought before he died. But Aboudi Kazem desperately needed to find Ali to say goodbye and give him a decent burial. Yet when discovery was imminent he flinched at the horror of seeing his boy's face emerge from the grave.

He dragged himself to his feet and lit another cigarette while orderlies tossed earth back on to the 'wrong' boy. They moved towards another grave to dig again. The only clue was a label stuck in the ground – 'grey T-shirt, blue trousers, no name, 11 April'.

'The pain is in my heart,' said Aboudi Kazem before breaking into tears and walking on to the next exhumation.

Three metres away a crowd watched the sad scene through the hospital's white fence. An orderly with a Kalashnikov sent them away. Inside the hospital grounds the mood was angry. 'The Americans can stay here one week, and no more. If they stay longer, we will screw them. They only want our oil,' said one man.

This was the Central Teaching Hospital for Children, but the roughly fifty new graves laid out in its side garden contain more adults than children. A few new corpses were coming in, killed in shoot-outs as neighbourhoods defended themselves from looters, but the vast majority of the dead were victims of American fire.

'We are the only hospital in Baghdad that receives the wounded and the dead. We are the only working hospital left,' Ahmed Mohammed, its assistant director, explained.

Every day families arrive searching for their dead. Ali Kazem's case is one of many. His uncle Mohammed was with the boy when he died. He has no doubt his nephew's death was unnecessary.

'We had a white flag on the car to show the Americans we came in peace,' he said. 'We got out at the checkpoint and put up our hands. Ali died with his arms raised. A bullet hit him in the side just below his left shoulder.'

Mohammed took us to his home in the middle-class suburb of Mansour. Dressed in black robes, Ali's grandmother fished out a family picture with Ali in it. She pointed to a pink plastic bag containing his clothes. Nothing else was left of him, except memories and love. Ali had come to Baghdad to look for work, she said. He loved football and spent hours practising on the front lawn.

During the American bombing the family rarely left the compound of their home. When the bombing was over, they thought it was safe. Ali had gone out with his uncle to have a look around.

15 April 2003

LUKE HARDING

Pure Hollywood in the town of a thousand Saddams

It is not difficult to find a statue of Saddam Hussein in Tikrit, the town of a thousand Saddams. There is the equine statue of Saddam – sword in hand – in Tikrit's main square. Then there are numerous other Saddams – in linen suits, military uniforms and Arab headdress.

Outside Tikrit's football stadium there is even a mural of a paternal Saddam, with his arm round his elder son Uday.

As you drive into town, there is Saddam again – this time liberating Jerusalem from the back of a white horse. Yesterday, however, the man himself was nowhere to be seen, as American troops drove nonchalantly into his hometown, encountering little resistance.

Just before dawn US light armoured vehicles that had raced up from Baghdad arrived at Tikrit's main bridge. On the other side Kurdish forces advanced through the town's eastern suburbs. Three Cobra helicopter gunships circled above the shimmering blue Tigris, against the majestic backdrop of Saddam's presidential guesthouse.

It was a moment of sheer Hollywood, with more than a hint of *Apocalypse Now*. It took a while before anybody noticed that the war in Iraq had just ended.

But if Tikrit's residents did not stage the final apocalyptic *Götterdämmerung* that many had expected, nor did they greet coalition forces with flowers. The mood ranged from indifference to anger.

'The Americans are invaders,' Abdul Raouf, aged twenty-eight, said, staring sullenly at the American armoured vehicles, which had just turned up in Tikrit's main square, next to the black equine statue of a sword-holding Saddam. 'We love Saddam Hussein here. He was the only Arab leader who had the guts to stand up to Israel. He hit Israel with thirty-nine rockets. The other Arab countries didn't support him. I don't think Saddam has behaved badly towards his own people. He is a brave man.'

Seemingly oblivious to what had just happened, he added: 'Nobody can defeat him.' Mr Raouf said he had stood within five or six metres of Iraq's ex-leader, who visited Tikrit frequently.

What would happen now that America had occupied Iraq? 'Iraq will be another Palestine,' he predicted.

Few other Tikrit residents expressed much enthusiasm for their new American rulers. Scrawled on the wall of one of the town's housing estates were the words 'Down with America'.

On the central traffic junction, meanwhile, at the end of an avenue lined with tropical date palms, black banners proclaimed in Arabic the names of Iraqi soldiers. They had all been recently martyred in the war against America.

'Why shouldn't we like Saddam?' Rassan Hassan asked, as he wheeled his bike past a group of US marines. 'Saddam didn't hit us with aeroplanes. He didn't kill our children with bombs. He didn't shut down our schools.'

Mr Hassan said American planes had bombarded Tikrit for more than a week. There was now no electricity, no water and virtually nothing to eat. Everybody was fed up. Mr Hassan also defended Saddam's fondness for palaces. 'George Bush has got the White House. He has a palace as well, just like Saddam,' he pointed out.

Yesterday, though, it soon became clear that Saddam had many palaces in Tikrit. There were too many to count. Immediately above the town's half-shattered bridge, marines were yesterday setting up their new HQ in the grounds of the presidential guesthouse – a vast neo-Babylonian mansion overlooking the river.

Saddam's gardeners had clearly been at work until the last moment, watering the rose garden, and the neat flowerbeds of orange marigolds and daisies. Inside, though, it became clear the furniture removers had already been and gone.

The marble ballroom with the inscription 'Bless our people and bring justice' was cavernously empty. We tried to take the lift up to the third floor: it didn't work. Beneath the terrace, US armoured vehicles had blocked a bridge leading to what was clearly Saddam's private island – several more rococo apartments towering above an enclave of green.

Just down the road in the Farouk Palace, someone had planted a small American flag on top of its imperial gateway.

'There was minimal resistance,' Lieutenant Greg Starace explained, as troops relaxed in the shade next to the presidential guesthouse's twirling Nebuchadnezzarean pillars.

'We were here at first light. We came across a few pockets of three to ten guys. They popped their heads up and loosed off. Soon, though, they were running away, or were no longer in a position to run away.'

Lieutenant Starace said his 1st Army Reconnaissance Corps had swiftly achieved all its objectives, destroying only a single 'technical' – a pick-up truck with a machine gun – that fired at them from across the river. Not everybody yesterday, though, was unhappy with the arrival of US troops.

At 7 a.m. a group of marines burst into Tikrit's jail. They rescued its only remaining prisoner, Khalid Jauhr, a 36-year-old Kurd. Mr Jauhr said he had been captured last Friday by the Saddam fedayeen when he went to visit some relatives in a nearby village. The fedayeen had tortured him and shot him in the leg.

'They had been carrying out mock executions. I thought I was going to die. When the Americans turned up outside the door of my cell I was a very happy man,' he said.

Other Tikrit residents admitted that they had never liked Saddam very much but had been too scared to complain. 'We were compelled to love Saddam Hussein,' Abdul Karim, a 34-year-old Arab, said as a group of young men played football in a park across Tikrit's main boulevard, oblivious to the US warplanes flying overhead.

'He has done many bad things over the past thirty-five years. The worst thing is that we don't have any money,' Mr Karim said. 'People think that Tikrit is some kind of paradise. In fact, everybody is poor.'

A short drive south of Tikrit is Owja, the small village where Saddam Hussein was born on 28 April 1937. Nobody in Tikrit was yesterday able to shed much light on where Iraq's president is likely to celebrate his birthday in two weeks' time. 'God knows where he is,' one said. Yesterday the US military cordoned off Owja after reports that five Saddam fedayeen were holed up inside. They had apparently beaten up a local villager, unaware that US troops had already seized the town.

Tikrit traditionally holds a lavish celebration to mark the president's birth. Even Mr Raouf – a bitter critic of the US invasion of Iraq – yesterday conceded that the party would probably be cancelled this year. 'I don't think anything will happen,' he said. 'The game is over.'

28 April 2003

AUDREY GILLAN

If you cop it, can we have your shortwave radio?

The note from the Newspaper Publishers Association said: 'Women war correspondents: the MoD advised that the marines and the 16 Air Assault Brigade wished not to have women.' It came as a shock. After months of rigorous training, fretting over kit, getting fit and steeling myself for war, I was told that because of my gender I could not go.

As an embedded journalist, part of the British pool system, my lottery draw had meant that I was to be assigned to the Household Cavalry Regiment's D Squadron, a unit within 16 Air Assault Brigade. Their job is frontline reconnaissance and, for reasons that are the army's own, women are generally allowed nowhere near the frontline.

It had not occurred to me or my editors that being a woman would be a hindrance to me doing my job or to the army. In the end, it wasn't.

Some quiet calls were made and, while the marines held their line, someone in 16 Air Assault Brigade changed their minds. The Household Cavalry, one of the oldest and most traditional regiments in the country, made it clear that they would be happy to take a woman on board.

Within days, I found myself with the 105 men of D Squadron, the Blues and Royals, in Camp Eagle in Kuwait. Along with *Daily Mail* photographer Bruce Adams, the only other journalist with the squadron, I was shown into a large Bedouin tent filled with semi-naked, tattooed soldiers, men I would come to spend the next five weeks with. Towards the back were the officers and it was here that I found Squadron Leader Richard Taylor. He sat us down and said, in the politest of Household Cavalry tones: 'When we are out in our vehicles in the field we live together, eat together, sleep together, fart together and wash our bollocks together. Do you think you can handle it?' I shrugged, a part of me hoping he was pulling my leg in the way the regiment had when they hung up a picture of the Queen for the *Guardian*'s arrival.

But he wasn't joking. At that time, there were more important things to be thinking about, like how do I keep my head down if we are attacked, should I jump head first into a trench, would they leave me behind if I couldn't run fast enough or not carry my kit? Would they take me less seriously because I didn't have an interest in big guns and had never seen a Scimitar or Spartan armoured reconnaissance vehicle, never mind lived in one? Washing my bits seemed the least of my worries.

We were shown to our tent: a hot, sticky, odorous enclosure with sixty squaddies sleeping and snoring on rollmats on a wooden floor. As we walked through, there were smirks on the faces that greeted us – the soldiers had been told they were going to have to put up with two journalists for the duration of the war but they hadn't been told one was a woman.

Lugging a holdall on wheels filled with a flak jacket, helmet, respirator, camping stove and other bits and pieces, an 85-litre backpack, a day sack and my laptop, I was immediately told by Corporal Mick Flynn, one of the squadron's oldest and most experienced soldiers, that I was going to have to scale down my kit. The first thing to go was the one-man tent I had been advised to buy by the MoD – the Household Cavalry don't sleep in tents, they just bed down in the dirt next to their vehicles, so there went my privacy. I would be allowed my work equipment but not much else as there would be limited space on the vehicles. That meant taking just the day sack with two shirts, two pairs of trousers, four pairs of knickers (big, for modesty purposes), two sports bras, four pairs of socks and one pair of boots. My toiletries would be limited, my bars of chocolate were welcomed, but only because they would disappear quite quickly and therefore wouldn't take up space. I wondered if they were trying to scare me when they asked: 'If you cop it, can we have your short-wave radio?'

The shared showers and tents of the camp were soon to be looked back on as luxury as we moved into Iraq. The conditions were rough. We slept on the desert floor just inches from each other – a bonus on the freezing nights. The dust and sand went everywhere, into our kit and every crevice of our body, and we rarely got it out – we washed with a flannel in a bowl when we could and had to make do with babywipes when we couldn't, which was almost always. The soldiers gave me my space when I needed it and most of the time my wash was protected by the side of a vehicle and the modesty of a towel.

As they saw that I was prepared to muck in – and as part of a crew of five on a small vehicle, I had little choice but to take my turn at making the tea, heating up the boil-in-the-bags or laying down people's 'doss bags', I was shouted at and ordered around – I simply became 'one of the boys'. Learning to swear like a trooper probably helped too.

It was different when we came across soldiers from other regiments, who wolf-whistled and stared because they did not have a woman living with them. The two D Squadron guys, who had surrounded me with a poncho as I tried to have a quiet pee beside a wall when we found ourselves mobbed by curious Iraqis in one town, were outraged when a Para stuck his head through the hole and took a picture. I even had a guard when, on one occasion, a rare shower was to be taken fully exposed to all around – we crept up in darkness and those who approached were shooed away.

Of course, I was the butt of jokes, some of which were no doubt made out of my earshot. My nickname was 'Admin' – in the military, admin means almost everything: taking care of your kit, making sure you have nothing out you are not using, eating enough food, washing your clothes and yourself, just keeping everything in order. My ability to lose my Maglite torch, my goggles, at one point even mislay my helmet and a parcel just received in the post from my mother (we had just had to 'bug out' or run away in the middle of the night from rounds of incoming Iraqi artillery at the time), meant I was an 'admin vortex' and the source of much hilarity. *Admin in the Field*, they said, would be the title of my book on the war.

On one occasion, as the soldiers rooted around an abandoned barracks,

finding Iraqi chemical warfare suits and masks, the squadron corporal major told some American marines that I was there to make his 'brew' but he never treated me with any less respect – or indeed afforded me more privileges – than he did his own troops. My safety was one of his prime concerns.

The Household Cavalry found themselves leading 16 Air Assault Brigade in Iraq, coming under heavy attack from incoming Iraqi artillery, outgunned and fighting fierce battles with T55 tanks. They lost one of their men in the A10 friendly-fire attack, when two tankbuster aircraft turned their guns on their convoy. They lost two more in a tragic accident when a Scimitar overturned in a ditch, and had more injured.

I watched men desperately try to resuscitate their fallen colleagues and shake at their inability to fight with fate. I saw them weep as they learned of the death of men they had spoken to just that morning, men they had worked with for years, drank with, played football with. Sometimes, as we took incoming fire, they hugged me, but they hugged each other as well.

They spoke to me, sometimes as a journalist, sometimes as a friend, of their fears, of their grief, of their boredom, of their frustration and of their ultimate pride in what they had done in Iraq.

And I never had to worry about being left behind. On the first day, I met Corporal Craig Trencher, the driver of Spartan Three Three Alpha, the cramped vehicle that was to be my home, he said: 'Don't worry, I will never, ever leave you. I will pick you up and carry you if I have to.' On the day that our vehicle was 'bracketed' – we took incoming rounds at the front and back, which missed us by metres – Corporal Danny Abbott just looked at me, laughed and said, 'I think we are being shot at.' He squeezed my arm as if this was all part of a day's soldiering. It wasn't, but he didn't want me thinking it. On one gas alert – which like all the many others was false – one soldier handed me my respirator before picking up his own: when you have just nine seconds to get your mask on safely, that is quite a thing to do.

Yes, they said I was their 'little packet of morale' but they weren't being sexist, just including me in their gang. I came to them with my own prejudices, the ones lots of people have about squaddies being tattooed, farting louts. They had tattoos, they farted and their feet certainly smelled, but they were also gentlemen. They showed me that there are other more appropriate clichés, the ones about camaraderie, 'band of brothers', and dying for one other. They shared everything they could with each other and with me, sweets sent from home, toilet paper, news, secrets, tears.

On Wednesday of last week, I went to the funeral in Windsor of Lance Corporal Karl Shearer, who died when his Scimitar overturned in the ditch. Different men, from the regiment's other squadrons, were grieving. But they also had a chance to joke about me being a woman and how they had laughed when they found out. The commanding officer said he had informed the Queen, who had been surprised that a woman had been embedded with her own personal regiment.

Tonight, I am to talk to the soldiers' wives, telling them about a side of their husbands they will never see. Someone advised me not to wear nice clothes or make-up, to get into my smelly kit, put some sand on my face, be 'admin in the

field' again, because the wives might be jealous. Of course, I won't. My being a woman should make no difference to them either.

Yesterday, I phoned Bruce Adams and asked him what it was about me being a woman that got me by in a war, living together with more than 100 men. 'Balls,' he said. 'More than some of the soldiers.' So, that could be the answer, I didn't have the bollocks to wash in front of the squadron leader, but it seemed I had the balls.

HOW THE WAR
WAS SPUN

Austin

An aircraft carrier is a warship but it is misleading to call it a battleship. A battleship is (or rather was) a battleship.

Corrections and Clarifications, 1 November 2002

W. STEPHEN GILBERT

Letter: Born in the USA

Britain and the US intend to wage war on Iraq because they believe it holds undisclosed 'weapons of mass destruction' ('Iraq is lying', 19 December). When war begins, Iraq will naturally feel entitled to use its undisclosed weapons. Great. We'll all be dead, but we will have won the point.

27 January 2003

IAN MAYES

A crisis in its complexity

A special version of the editor's morning conference was called last week to discuss the paper's editorial line on Iraq. Because it demanded more time and space than the normal gathering, in the editor's office in the main building in Farringdon Road, could afford, it was held across the road in the Newsroom, the *Guardian*'s archive and education centre, the benefits of which become increasingly apparent.

About 100 journalists attended, a cross-section of the editorial staff, including the principal Comment page cartoonist. More than twenty people spoke in the hour-and-a-half or so made available. It was not an anti-war rally, either in tone or atmosphere, although there were perhaps speakers who had hoped it might be, calling for the paper to declare itself unequivocally against the war in the way that it had declared itself against Suez in 1956.

The leader then – taking a view shared only by the *Observer* among British newspapers – had begun: 'The world must be told clearly that millions of British people are deeply shocked by the aggressive policy of the Government. Its action in attacking Egypt is a disaster of the first magnitude. It is wrong on every count – moral, military and political.' That was the *Manchester Guardian* reacting to an event that had been planned in secret with the intention of presenting it to the public as a fait accompli. The case of Iraq, it was argued, was quite different, building over a long period of continuing crisis of greater complexity, which the leaders had tried to acknowledge.

The editor, opening the conference, made it clear that there would be no guarantee that the leader line would be changed or bound by the meeting. It was an airing of views, very much, he said, in the tradition of the paper.

But what is the leader line? The chief foreign leader writer opened the conference by summarizing the paper's position:

'We support a multilateral resolution, primarily through the United Nations,

involving the final, verified destruction of all and any Iraqi weapons of mass destruction, Iraq's compliance with other UN resolutions, the concurrent phased lifting of non-military sanctions, an end to the no-fly zones and to UN controls on Iraqi oil and the opening of Iraq's borders to free movement ...

'We have not ruled out our support for the use of force as a means of last resort ... We have condemned the Saddam regime on numerous occasions ... We support containment, deterrence, diplomatic isolation, targeted sanctions pending a change of government ...

'We do not support the US policy of forcible "regime change", we have condemned targeted assassination ...'

He reminded his colleagues that the paper had criticized the Blair government for its 'too unquestioning' relationship with the Bush administration, although the paper accepted Blair's argument that his support for Bush increased Britain's influence – up to a point. The paper believed that Parliament should debate and vote on any military action before it was launched.

Finally he reviewed concerns, expressed in leaders, that a war would have a deeply destabilizing impact on the region, intensify Arab and Muslim opinion at home and abroad, and possibly lead to further wars in the Middle East.

The discussion that followed considered, among other things, the position of the UN if the US acted without seeking a further resolution, the agenda of neo-conservatives planning to reshape the region, the possibility of stimulating and spreading terrorism further, the issue of human rights in Iraq and its consequences for the anti-war movement, and the suffering likely to be inflicted upon the Iraqi people.

In addition, the assumptions implied in statements such as 'I have not met anyone who is for the war' and 'Our readership is against the war' were questioned. In fact, we have no figures indicating the views specifically of *Guardian* readers. The ICM poll of 17–19 January found that 43 per cent of Labour voters and 62 per cent of Liberal Democrat voters disapproved of a military attack aimed at removing Saddam Hussein (52 per cent of *Guardian* readers are Labour voters and 34 per cent Liberal Democrat, according to Mori at the election in 2001).

An updated statement of the *Guardian's* position is likely this week to coincide with the Blair–Bush meeting at Camp David. It will not be plucked from thin air.

18 March 2003

JULIAN BORGER

Diplomacy dies

President George Bush last night gave Saddam Hussein and his sons forty-eight hours to give up power and go into exile or face invasion by more than a quarter of a million US and British troops massed on Iraq's borders.

In a televised address to the nation, Mr Bush urged Iraqi soldiers not to fight

for a 'dying regime' and said they would be given instructions on what to do to avoid being 'attacked and destroyed'.

The Iraqi regime quickly rejected the ultimatum, a response the US administration said it had expected. In effect, the president's fifteen-minute televised address to the nation from the White House was a declaration of war, which could come any time after tomorrow night.

'Saddam Hussein and his sons must leave Iraq within forty-eight hours. Their refusal to do so will result in military conflict commenced at a time of our choosing,' the president said. He warned foreigners, including journalists and weapons inspectors, to leave immediately.

Mr Bush also braced Americans for retaliatory attacks at home and abroad, and assured them that security measures were being taken to protect them, including the deportation of 'certain individuals with ties to Iraqi intelligence services' and higher security at airports and seaports.

As soon as the president finished speaking, the national alert level was raised to code orange, signifying there was a high threat of terrorist attack.

Mr Bush expressed regret that the United Nations Security Council had chosen not to back military action against Iraq, hours after the US, Britain and Spain decided to withdraw a resolution threatening military force in the face of staunch opposition from France and Russia, and deep reluctance among other Security Council nations. The president justified the impending invasion on grounds of pre-emptive self-defence, arguing that Baghdad could arm terrorists with weapons of mass destruction. 'The United Nations Security Council has not lived up to its responsibilities, so we will rise to ours,' he said.

As the Security Council broke up amid acrimony earlier yesterday, the UN secretary-general, Kofi Annan, questioned the legitimacy of such an attack.

Much of last night's presidential address was directed towards the Iraqi armed forces in an attempt to persuade them to stand aside rather than defend Saddam and his two sons, Qusay and Uday, who both hold powerful positions in the regime. He also told the Iraqi forces not to destroy oil wells or obey instructions to use chemical or biological weapons, or they would face war crimes trials. 'It will be no defence to say: I was just following orders.' His remarks came a few hours after Pentagon officials said they had intelligence that Republican Guard units south of Baghdad may have been issued with chemical munitions.

As for ordinary Iraqis, the president promised: 'The day of your liberation is near.' The assault would not be aimed at them, and US troops would bring food and medicine.

As the final countdown to war began, UN monitors on the Kuwait–Iraq border left their observation posts between Iraq's 350,000-strong army and a gathering force of 225,000 American and 45,000 British troops, supported by six aircraft carriers and more than 600 combat aircraft.

28 March 2003

FAISAL AL YAFAI

Trust the media

Somewhere amid the brick monoliths housing homes and minarets, sweeping up from one side of the city, the taxi halts. 'Why have you come to Blackburn?' the driver asks.

When told the reason is to hear Muslim perspectives on the media coverage of the war, his response is animated. 'Why Muslims?' he says. 'Why not Irish? Why not Hindu? It's not just Muslims who are sceptical. Everyone is sceptical.'

British Muslims have an awkward role in this war. Told repeatedly that they are not part of it because the war is not against Muslims, they are none the less linked by faith to many Iraqis – and have their faith linked by everyone else to their anti-war feelings.

Muslims are always singled out from the wider community, argues Ibrahim Master, a businessman and chairman of the Lancashire Council of Mosques. 'Our Britishness is always called into question.' He cites a newspaper report comparing Joseph Hudson, the American PoW who refused to answer questions on Iraqi TV, with Sergeant Asan Akbar, the GI who attacked his comrades with grenades at a US army base in Kuwait. 'The underlying message was clear. They were trying to insinuate how disloyal Muslims can be. Everyone highlighted the fact that he was a Muslim rather than highlighting his mental state as a reason. That sort of coverage makes people deeply suspicious.'

He worries about giving the impression that Muslims are disloyal, as if they are the only group that have reservations about the media and the war. 'I don't like the analogy that says if you're anti-war you can't be for the troops. I have sympathy for the servicemen and women but I'm against the ideology of war as such, especially if it's not a just war.'

He admits there have been improvements in the media. 'I get the impression the media are more anti-war on Iraq than they were on Afghanistan. They have backed anti-war marches more and some questions presenters are asking ministers are more hostile.' But the onset of conflict has weakened that resolve. 'Before war started they were fair, now they are under restrictions because of official secrecy. But with some of the broadcasters there's been a trend to be pro-war from day one. If you listen to some broadcast reports, they come across as very biased.'

Pro-war supporters are holding anti-war sentiment in the media to 'psychological ransom', he says. 'They're saying now war has started we can't have anti-war stories. I think there's an official line not to show these images [of civilian deaths] because they stir up more anti-war sentiment and the media is following that line.'

There is a widely shared view that the media may be deliberately withholding negative information. From the windows of a nearby community centre, Indian music coming from one side of the building competes with the

hip-hop of the streets from the other. Inside, Mohammed Anayat, a project manager in the Blackburn area, says despite the wall-to-wall coverage of the war, there is hardly any new information. 'We've been over-informationized. Even when there is no news they will find some story of a soldier cleaning his boots.'

He says that despite so many channels, the news is hardly balanced. 'The coverage is too sympathetic to the allies. To a certain extent that's understandable because they have that information more readily, but it gives the impression they were compelled to do this, that they are forced to attack because Saddam attacked them, which is not the reality.

'We see aircraft taking off but not the other side. I can't believe the press can't find the information to give us, especially when the media is aware of the depth of anti-war feeling. If all they are doing is reporting the war, I'd like to see more equal coverage. We are not told about bombs missing their targets or how extensive the damage really is. I do generally trust the media but not over this. The coverage borders on propaganda.'

This need for more information has led to people trying to access other sources. 'Lots of information comes from countries we have links with, like Pakistan and India. We have a lot of daily communication so we hear different things and get news from other countries.'

There may even be a generation gap between the kinds of information received – a gap that allows extreme views to flourish. 'Different factions in the community have different sources of information and process that information in different ways. The younger generation will rely on the internet and mainstream media, whereas older people rely on word of mouth and foreign language newspapers. So they have different views and may have developed ideas that are not accurate.' This confusion allows those who see sin in the Western media's omissions to be more easily believed.

The chief benefactors of this lack of trust have been alternative and non-Western media. The Arabic language TV network al-Jazeera has doubled its number of subscribers since the conflict started, and the Muslim Association of Britain (MAB) emailed members to encourage them to watch the satellite channel.

Ahmed Versi, the editor of *Muslim News*, a monthly UK-based paper, says his newspaper's website is getting extra traffic as a result of this lack of trust. 'We're getting an extra 2,000–3,000 hits a day. Many don't believe the media, especially the US news. They don't trust Western media's portrayal of the war. Even those who don't understand Arabic will watch the Arab channels just to see the pictures.'

Abu Dhabi TV has shown graphic images of demolished buildings inside Baghdad and al-Jazeera has courted criticism by showing footage considered too sensitive by Western broadcasters, including of Iraqi bodies amid rubble and one of a young child's head split open.

The MAB has posted many of these images on its website and emailed them to its subscribers. The reaction has been positive. Ihtisham Hibatullah, a spokesman, says it has received requests from all sections of the public for more information. 'Many were thankful for the true story. This is not propaganda, it

is the actual cost of war. Innocent people are dying and these images make clear the reality.'

When such images of civilian casualties are seen, they give credence to the idea of censorship. Anjum Anwar was deeply moved by the website's images of civilian casualties. 'I used to work with Kosovan refugees and all their stories have just come flooding back to me,' she said. 'The media have a concept of shielding people. I think if these photos were shown on the general media the anti-war movement would double.'

She feels frustrated by the one-sided nature of TV coverage. 'It's all very well showing pictures of soldiers with blood on their cheeks or nice photos of Baghdad but these are the real brutalities of liberation. I don't believe the mother of these children will feel any happier if she's liberated, because she's already lost everything. As a mother it makes me so angry. This is what should be shown.

'This is the real shock and awe.'

3 April 2003

RORY McCARTHY

The awkward squad

They call themselves the 'awkward squad' and their questions to the generals running the war in Iraq are starting to divide the sceptical press from their more loyal American colleagues.

The front row of the briefing hall at the central command headquarters in the deserts of Qatar is largely reserved for the American television networks. But frequently the toughest questioning has come from rows further back where there are the less accepting British, Arab and Chinese press.

After the US took its heaviest losses in battle for years on 23 March, an Abu Dhabi television reporter asked General Tommy Franks, the US commander: 'Are you practising a strategy of lies and deception, or have you just been trapped by the Iraqi army?'

When television showed the first American prisoners of war, Geoff Meade, the Sky News correspondent in Qatar, asked an American general how he would answer those in the Muslim world who 'may hail the first capture of American servicemen and women'.

A few minutes later an American journalist – Michael Wolff of *New York* magazine – took a different approach. He asked the general if he considered al-Jazeera as 'hostile media' for broadcasting the footage in the first place.

The milder style favoured by some of the US correspondents is reflected by a question posed by a presenter with the American network CBS, who asked at General Franks's first briefing: 'The campaign so far has gone with breathtaking speed. Has it surprised you, or is it going more or less as you expected?'

The apparent divide across the Atlantic may signal the greater support for the war in Iraq among the American public and the often more deferential nature

of their journalists. Correspondents corralled into a warehouse at the US central command camp outside Doha have frequently found themselves frustrated at the lack of information on offer.

Every second General Franks spends in the public eye is a painstakingly choreographed Hollywood moment. The US general's backdrop is a stylized $240,000 set, built around thick, tubular grey struts that hold up five large plasma display screens. A large US central command seal above the central podium delivers an unequivocal message of authority: an eagle sits on a Stars and Stripes shield with its wings outstretched to envelop a map of the Middle East and Arab world.

Planning for the media coverage of this war has been as intricately mapped out as the invasion itself. Both the US and British governments have promised that for this conflict they will give unprecedented access to the fight on the ground. But nothing has been left to chance and access to the smallest hint of information is tightly controlled.

However, despite the money and staff invested in the information operation, the picture of the war is rarely clear. General Franks talks in broad terms and reveals little. 'Our forces are continuing to move, they're moving in ways and to places that we believe are just exactly right, in accordance with a plan that is flexible,' was his impenetrable analysis of the war so far. His words are short on specific details: what the military likes to call 'granularity'.

The few detailed assertions of battlefield victories have proved embarrassingly overambitious. On 22 March central command announced that the small Iraqi port of Umm Qasr, on the Kuwaiti border, had been secured. The following morning live television footage from a reporter 'embedded' with the military showed heavy fighting in the town, which continued for two more days.

Also on 22 March the British Chief of Defence Staff, Admiral Sir Michael Boyce, announced the surrender of the commander of Iraq's 51st Division, which was holding Basra. Reports have now suggested the man who surrendered was a junior officer masquerading as his commander in the hope of better treatment.

Is this tendentious spin or the difficulties of assessing combat gains in the fog of war? 'This is not a video game where everything is clear and neat and tidy,' said Lieutenant Colonel Ronnie McCourt, who teaches communication studies at Sandhurst military academy in the UK.

Often for simple, practical reasons, reports from the battlefield, particularly during firefights, do not always reflect the overall situation on the ground, he says. News of British casualties is delayed to allow families to be informed first. 'The reason you have got disconnects is to do with imperfect knowledge. It is not deliberate,' said Lieutenant Colonel McCourt. 'I will tell you the truth and the absolute truth, but, for the reasons I have given, it may not be the complete and utter picture.'

The 900 journalists embedded with the US and British military have offered an unprecedented window on the campaign. The Pentagon must have cheered when it saw the first shaky videophone pictures of American tanks racing unopposed through the Iraqi desert in the first hours of the ground invasion. Footage

since then has appeared to challenge broad official statements from London, Washington and Qatar.

19 April 2003

BENJAMIN COUNSELL
www.arabmediawatch.com

Letter: Fighting the media war

If ITV news editor David Mannion takes praise from the notorious CNN and NBC as encouragement then perhaps the fashion for regime change should extend to newsrooms (Letters, 15 April).

He points out all the instances when ITV correspondents were the first to enter certain key areas. All this succeeds in doing is highlighting the level of embedding with the US military. Being there first is one thing, what you say when there is quite another.

He also relies on ratings as an example of why we should tune into ITV. If you applied the same logic to newspapers, we would all be reading the *Sun*. The real victor of the media war has been the web.

26 April 2003

LIBBY BROOKS

Guilt and innocents

The website for the BBC's *Newsround*, one of Britain's most popular children's programmes, has a special section devoted to Ali Ismail Abbas. There, children from around the world have posted get-well messages for the twelve-year-old Iraqi boy who lost both arms and suffered horrific burns when his home was bombed.

The talkboard is filled with kind thoughts but is not, the producer of the programme notes, as frantically accessed as those debating the pros and cons of war were before the conflict began. *Newsround* makes it its business to focus on the impact of global strife on the younger generation. Its viewers have been galvanized by reports on children in Rwanda, Somalia and Afghanistan. But Ali's plight has somehow failed to capture their imaginations. Perhaps because they recognize that his story isn't actually about children at all. Ali's is a story about grown-ups. There must always be one – and usually only one – child who becomes the face of a conflict. Ali, with his just-about-to-cry face and charred torso, is ours for Iraq.

Perhaps his image will become as universally iconic as that of nine-year-old Kim Phuc, photographed burnt and naked as she fled a napalm attack on her Vietnamese village in 1972. His case may spark an international humanitarian

campaign, as with Irma Hadzimuratovic, whose airlift from Sarajevo in 1993 prompted 'Operation Irma', bringing other sick children out of Bosnia. Or he may be adopted for a cause, as was twelve-year-old Mohammed al-Durra, killed by an Israeli bullet as he crouched with his father behind a metal drum in Gaza City two years ago and a cult figure in death as the first child martyr of the intifada. But whatever the boy's story becomes, it stopped being about the child himself the moment the first camera shutter fell.

A child in pain and distress personifies innocence abused. As yet untainted by the complexities that attend the colour of their skin or the affiliations of their parents, they bring moral clarity to a world of seemingly amoral confusion. They offer the opportunity to tell a story – perhaps even with a happy ending – in a context where no straight narrative exists. And that story prompts feelings rather than thoughts, along with the blessed relief that we still can feel.

Every victim needs a rescuer, who is transformed by their role as saviour without having to take responsibility for the circumstances that caused the victim-hood in the first place. The fundraising efforts in Ali's name allow people to contribute to all the other nameless child victims of the war in Iraq without ever being forced to acknowledge their hurt faces. Beyond sentiment, there is an instinctive adult drive to protect children, and to have failed to do so brings with it a particular adult guilt. But in granting ourselves the absolution that comes with witnessing their victimhood and acting upon it, we demand a clar-ity that doesn't exist. It is only the wholly blameless for whom our sympathy is culled.

War transforms some children into perpetrators as well as victims of violence. Human Rights Watch estimates that there are about 300,000 children serving as soldiers in armed conflicts. UNICEF notes that advances in the manufacture of small arms have turned the AK47 into a toy of choice in some places, and encouraged the widespread recruitment of child soldiers.

In the occupied territories, community groups note that the brutalizing effects of the intifada go far beyond malnutrition, loss of education and family breakdown. The Gaza mental health programme believes that the majority of local youngsters are suffering emotional problems as a result of the conflict. In early childhood, these may manifest themselves as speech disorders, bedwetting or crying. But as children grow older, their fear distorts into rage. Studies show they display far higher levels of aggression than those brought up in peaceful environments. Play mimics the activities of Palestinian fighters. Throwing homemade bombs at Israeli troops has become a rite of passage. In a place where ordinary dreams wither, children fantasize about martyring themselves for the cause.

Innocence is a quality we bestow upon those who have yet to work out why they should be disappointed by us. Brutalized children grow up. And how much harder to feel sympathy for that grown man with a gun.

4 June 2003

SALAM PAX

The Baghdad blogger

'Vacancies: President needed – fluent in English, will have limited powers only. Generous bonuses.'

This appeared on the first page of the *Ahrar* newspaper. Another new weekly. Newspapers are coming out of our ears these days. There are two questions no one can answer: How many political parties are there now in Iraq? And how many newspapers are printed weekly? Most of these papers are just two or four pages of party propaganda, no licence or hassle. Just go print. I am thinking of getting my own: '*Pax News* – all the rumours, all the time'.

On the first page of the *Ahrar* paper you will also see a picture and a column by the founder and chief editor. When the newspaper guy noticed how I was staring at the picture he said: 'Yes, it is the guy who sells Znood-al-sit [a popular Iraqi sweet].' From pastry to news, wars do strange things to people.

I got five papers for 1,750 dinars, around $1.50, and it felt like I was buying the famous bread of bab-al-agha: hot, crispy and cheap. When the newspaper man saw how happy I was with my papers he asked if I would like to take one for free. Newspaper heaven! It turns out that no one is buying any copies of the paper published by the Iraqi Communist workers party; he just wants to unload it on me. Look, I paid for the Hawza paper so why not take the commie one gratis?

Although the Ministry of Information has been broken up and around 2,000 employees given the boot, the media industry, if you can call it that, is doing very well. Beside all the papers we now have a TV channel and radio; they are part of what our American minders have called the Iraqi media network. My favourite TV show on it is an old Japanese cartoon (here it is called *Adnan wa Lina*). It is about what happens after a third world war when chaos reigns the earth. Bad choice for kids' programming, if you ask me. Some cities have their own local stations and there are two Kurdish TV channels. But the BBC World Service killed in one move a favourite Iraqi pastime: searching for perfect reception. The BBC Arabic service started broadcasting on FM here and it is just not the same when you don't hear the static.

The staff of the Ministry of Information is being given $50 as a final payment these days: lots of angry shouting and pointing at al-Jazeera cameras. Other civil workers had better luck – the people at the electricity works got paid by the new salary scheme suggested by the Bremer administration (the range is from 100,000–500,000 dinars, $100–$500: the people at the lower end got a raise and the people at the top got the cream taken off their pie) and as if by magic the electricity workers try a bit harder and the situation gets better.

Gas is still a problem. But if you drive fifteen minutes out of Baghdad you'll find gas station owners who would beg you to come and fill up. Down in the south of Iraq you will find Kuwaiti gasoline, but Baghdad is a mess. There is a

rumour that the gas rations given to stations here are being bought up and smuggled to Iran or Turkey. Not so strange. Looted cars were being smuggled through the same route – there was, in the middle of Baghdad, a huge parking lot where looted cars were being auctioned to be taken to the north. It took the Western media three weeks to find out about that.

But the main concern of people in all Iraqi cities is still security. You hear stories about day-time robberies in streets full of people. The newest method is to bring a kid along, get him to jump into an open window of your car and start screaming. Four thugs will follow, accusing you of trying to run the kid over, then they kick you around a bit and take the car. All the while, bystanders will be giving you the meanest looks, you child molester, you. You'll be lucky if they don't pull out a gun.

Actually, the coalition forces are coming down hard on people they catch in possession of guns. Car searches are more frequent and if they find a firearm they will cuff you, put a sack over your head and – here comes the question – what? We still have no laws. A couple of weeks ago it was said that they can only keep someone arrested for twenty-four hours. Now it is said that male, female and juvenile prisons have been opened. I don't want to be an alarmist and make it sound as if no one goes out on the streets. On the contrary, a lot more shops have opened. In Karada Street, where most of the electronic appliance shops are, the merchandise is displayed on the streets (14-inch TVs seem to be very popular), schools are open and exams are scheduled for July. The traffic jam at the gate of the University of Baghdad is like nothing you have seen before. The junk food places in Harthiya are open again and full of boys and girls. The streets of Baghdad are a nightmare to drive through during the day because of the number of cars. But this all ends around 7 p.m. when it starts getting dark.

The problem is that efforts to make Baghdad more secure are being really slowed down by the latest incidents in Fallujah, Heet and Baghdad.

I heard today that one of the infantry divisions is being put back in combat mode. The military presence has been increased in the streets and soldiers don't look as calm as they did a week ago. Al-Jazeera and Arabiya show angry Iraqis who say things about the promises that America has not kept and the prosperity of which they see no sign. Iraqis are such an impatient lot. How could it be made clear to these people that if they don't cool it and show some cooperation there is no way anyone will see this prosperity? I really don't want to see this country getting caught in the occupier/occupied downward cycle. I know it won't.

While talking to a very eloquent taxi driver the other day, he started accusing the media of not giving a chance to someone like Al-Sistani [one of the two leading Shia clerics] to show another, non-militant, side of Hawza [the influential college of Shia theologians in Najaf]. He was telling me of a Friday prayer *khutba* in which the imam told them to cooperate with the Americans. They did get rid of Saddam and they should be given a chance to prove their goodwill. He invited me to come and listen to the *khutba* next Friday. Maybe, maybe. My friend G might be right after all when he was trying to convince me that the sentence 'reasonable imams in Hawza' is not an oxymoron.

18 June 2003

ELEANOR ROBSON

Iraq's museums

What is the true extent of the losses to the Iraq Museum – 170,000 objects or only thirty-three? The arguments have raged these past two weeks as accusations of corruption, incompetence and cover-ups have flown around. Most notably, Dan Cruickshank's BBC film *Raiders of the Lost Art* insinuated that the staff had grossly misled the military and the press over the extent of the losses, been involved with the looting themselves, allowed the museum to be used as a military position, and had perhaps even harboured Saddam Hussein. The truth is less colourful.

Two months ago, I compared the demolition of Iraq's cultural heritage with the Mongol sacking of Baghdad in 1258, and the fifth-century destruction of the library of Alexandria. On reflection, that wasn't a bad assessment of the present state of Iraq's cultural infrastructure. Millions of books have been burned, thousands of manuscripts and archaeological artefacts stolen or destroyed, ancient cities ransacked, universities trashed.

At the beginning of this year, the staff, led by Dr Dony George and Dr Nawala al-Mutawalli, began to pack up the museum in a well-established routine first devised during the Iran–Iraq war. Defensive bunkers were dug in the grounds. Early in April, Dr John Curtis, head of the Ancient Near East department at the British Museum, described a recent visit to Baghdad during which the museum staff were sandbagging objects too big to be moved, packing away smaller exhibits, and debating 'the possibility of using bank vaults and bunkers if the worst came'.

The worst did come. On 11 April the news arrived that the museum had been looted. We later discovered that there had been a two-day gun battle, at the start of which the remaining museum staff fled for their lives. Fedayeen broke into a storeroom and set up a machine gun at a window.

While senior Iraqi officials were begging for help in Baghdad, the US Civil Affairs Brigade in Kuwait was also trying, from 12 April, to get the museum protected. They already knew that its most valuable holdings were in vaults of the recently bombed Central Bank. The museum was secured on 16 April, but it took until 21 April for Civil Affairs to arrive.

Captain William Sumner wrote to me that day: 'It seems that most of the museum's artefacts had been moved to other locations, but the ones that were looted were "staged" at an area so that they would be easier to access. It was a very professional action. The spare looting you saw on the news were the excess people who came in to pick over what was left.' In other words, there was no cover-up: the military were informed immediately that the evacuation procedures had been effective. Suspicions remained that a single staff member may have assisted the core looters. But Sumner says: 'It might have been one of the groundspeople, or anybody. I suspect that we will never know.'

Within a week the museum was secure enough for George to travel to London. At a press conference he circulated a list of some twenty-five smashed and stolen objects, which the curators had been unable to move from the public galleries before the war. They included the now famous Warka vase, which had been cemented in place. Last week it was returned in pieces. Other losses came from the corridor where objects were waiting to be moved off-site. George was understandably reluctant to reveal the location of the off-site storage to the Civil Affairs Brigade, as security was still non-existent.

Inventories of the badly vandalized storerooms finally began after the catalogues were pieced together from the debris of the ransacked offices. Dr John Russell, an expert in looted Iraqi antiquities, made a room-by-room report for UNESCO late in May. He noted that most of the objects returned since the looting 'were forgeries and reproductions'. Other losses, he reported, included some 2,000 finds from last season's excavations at sites in central Iraq. His summary tallied well with George's. 'Some thirty major pieces from exhibition galleries. Unknown thousands of excavated objects from storage. Major works from galleries smashed or damaged.' The unknown thousands are beginning to be quantified. Expert assessors in Vienna last week estimated the losses from the museum storerooms at between 6,000 and 10,000.

Outside the Iraq Museum, the picture is equally grim. At Baghdad University, classrooms, laboratories and offices have been vandalized, and equipment and furniture stolen or destroyed. Student libraries have been emptied. Nabil al-Tikriti of the University of Chicago reported in May that the Ministry of Endowments and Religious Affairs lost 600–700 manuscripts in a malicious fire and more than 1,000 were stolen. The House of Wisdom and the Iraqi Academy of Sciences were also looted. The National Library was burned to the ground and most of its 12 million books are assumed to have been incinerated.

In the galleries of Mosul Museum, cuneiform tablets were stolen and smashed. The ancient cities of Nineveh, Nimrud and Hatra lost major sculpture to looting. The situation is far worse in the south. Some fifteen to twenty large archaeological sites, mostly ancient Sumerian cities, were comprehensively pillaged by armed gangs.

It will take years of large-scale international assistance and delicate diplomacy to return the Iraq Museum to functionality. The process is deeply charged with the politics of occupation and post-Ba'athist reaction. The Civil Affairs officers are discovering that senior staff are not necessarily enamoured of the American way, while junior staff are testing their new-found freedom to complain about their bosses. One insider commented: 'George might make them work instead of read papers. And that is what all the fuss is about.'

The British School of Archaeology in Iraq and the British Museum now have staff working in the Iraq Museum, while other organizations worldwide are fundraising. George, Mutawalli and his colleagues have achieved the extraordinary in preserving as much as they have. We now need to help them salvage as much as possible from the wreckage and re-establish the country's cultural infrastructure so that Iraqis can plan their future knowing their past is secure.

19 July 2003

HUGO YOUNG

Frenzy at Number 10

We have to remember that this tragedy began with something utterly unworthy of such an outcome. It was an extremely trivial point. It wasn't about life and death in war. It didn't deal in official secrets. It wasn't a case of espionage, betraying the security of the country. The point at issue was a story quite marginal to these things that might have mattered. It was: could Saddam Hussein have launched weapons of mass destruction in forty-five minutes? The point that was stirred into turmoil, and then driven towards tragedy, was even narrower: whether Saddam could do this or not, who was the source of a BBC story saying some knowledgeable insiders did not believe it?

This is trifling stuff. In a normal political world, where top people had not taken leave of their senses, it would not produce a crisis. It certainly would not push anyone over the brink to suicide, if that's what happened to David Kelly. So you have to look further and see what made a triviality achieve all that.

The answer is regrettably simple. The 45-minute detail was hyped by Tony Blair into the essence of the foulest charge against his sainted integrity, and therefore had to be squashed by every means. The smell that's left behind is even more odious: that of a state – executive and Parliament combined – willing to abandon all sense of proportion to score political points against its critics.

How a small detail, a sideshow, billowed into suicidal crisis is the government's work from start to finish. It alone put forty-five minutes into the public realm, last September. Blair projected it further, in his introduction to the dossier. This was meant to shock, and it did so. Some of us thought and wrote that it sounded incredible. But there it was, doing the work it was designed to do: scare part of the country into supporting a future assault on Saddam Hussein.

Stage two of this infamous and potent – if virtual – forty-five minutes came later. As war got closer and another dossier appeared, rumblings emerged from the intelligence world. There were reports, not least in the *Guardian*, indicating dissatisfaction among the friends at Vauxhall Cross, where MI6 is located. They didn't like the way politicians were turning the sceptical speculations of intelligence into firm public assertions, designed to play the same role as the forty-five minutes: to scare us witless into war.

But only when the main war was over did the notorious forty-five explode to the top of the agenda. Again this was the government's doing. Andrew Gilligan, on the *Today* programme, reported, as an item of anxiety in the intelligence world, that one knowledgeable insider thought the September dossier had over-hyped the forty-five. Because the forty-five had been so graphic – the crown jewel in the glittering propaganda for war – maybe its tarnishing caused special pain.

Whatever, this was the moment at which Blair and Alastair Campbell decided to begin an exercise in hyperbole that soon swept every available particle of state power into the defence of their integrity. This involved them in several degradations. Here are some.

One, refuting charges that were never made: that Campbell inserted the forty-five into the dossier knowing it to be false, whereas the real issue was one of presentational nuance, not overt falsity.

Two, using this minor issue to blur the far greater question overhanging the government at the very time the Gilligan story came out: did Blair tell the truth about why we went to war, and would WMD ever be found?

Three, insisting that the source of the story was what mattered, and squeezing every air pipe to get the BBC to disclose it – as if this mattered more than the manifest post-war fact that the forty-five was always a myth, and the WMD probably no longer exist, for all of which, the prime minister now tells a confessional Congress, 'history will forgive us'.

A source, a source, my kingdom for a source, said Blair and his people. Once the source appeared, and so long as he was sufficiently unimportant, the credence of the critics of forty-five would be destroyed. Enter David Kelly, an obscure though not unimportant consultant to both the Foreign Office and the MoD, who volunteered to his bosses that he had talked to Gilligan and maybe helped him on the story, without being his prime source. The honourable act of a man who had no idea he would shortly be thrust into the maelstrom that uniquely surrounds a prime minister who has decided that his integrity, if not his political life, is under threat.

There are secondary players in this sordid game. The BBC's and Gilligan's performance on the question of the source has been shifty. No doubt they had to be careful. Confidentiality is a sacred and essential rule. But when Kelly first appeared, they said the real source was in a different department, implying an intelligence official rather than a defence consultant.

Later they refused even to confirm or deny anything. This left the impression with some people that Kelly might indeed have been the source. Kelly himself, a man unaccustomed to the limelight, may have had the same sense that he was being fingered. If so, the BBC did its bit to add to the hideous pressure a delicate man was already feeling as the source Campbell/Blair needed and were imposing maximum pressure to unearth.

The recent behaviour of the foreign affairs committee of the Commons has been more ignominious. Its first report on the origins of the Iraq war was measured enough. It did not deliver all the exonerations for which Downing Street was looking. But then its chairman and Labour members seem to have got caught up in the frenzy of Number 10, suddenly calling Gilligan for a second interrogation and coming out from behind closed doors to smear his reputation. Coupled with their gratuitous bullying of David Kelly to name himself as the culprit, these second-division politicians showed little respect for natural justice. Most of the Labour ones sounded like agents of Number 10. They now seek a statutory ban on journalists having the nerve to conceal their sources from so august a body as a Commons select committee.

But the most eloquent message concerns the Blair government. It must be

right at all times. Above all, the integrity of the leader can never be challenged. He never did hype up intelligence. He didn't take Britain to war on any other than the stated terms. Any suggestion of half-truth, or disguised intention, or concealed Bushite promises is the most disgraceful imaginable charge, which deserves a state response that knows no limit.

That's how a sideshow came to take over national life. Now it seems to have taken a wretched, guiltless man's life with it. Such is the dynamic that can be unleashed by a leader who believes his own reputation to be the core value his country must defend.

UNDER FIRE

JOHN GITTINGS

A hint of détente

The Dalai Lama's special envoy spoke for the first time at the weekend of an historic meeting between Chinese officials in Tibet and the Tibetan spiritual leader's government in exile, the first direct contact between them for twenty years.

In a statement from the Dalai Lama's seat at Dharamsala in India, Lodi Gyari said he hoped the visit to Lhasa would open 'a new chapter in our relationship' [with Beijing].

The sixteen-day visit last month was the first of its kind since the mid-1980s and has raised hope of an opening up of relations between the exiled Tibetan community in India and their homeland, and for China to introduce real autonomy in the region.

Mr Gyari said the talks were frank and cordial, and that Chinese officials had shown greater flexibility than before.

'There is something on the move,' said Thierry Dodin, director of the Tibet Information Network in London. 'Both sides are testing each other to see whether it is possible to have real discussions, though the Chinese are still ambiguous.'

Mr Gyari, another envoy, Kelsang Gyaltsen, and two aides were the first officials from the exiled government to visit Tibet since 1985. Mr Gyari left Tibet when the Dalai Lama fled in 1959. This is the first time he has returned.

China has engaged in secret talks with the Dalai Lama's brother for many years, but he has only visited the Chinese capital. Beijing has been cautious about the latest talks, presenting the visit as a private one and not reporting it in the press.

But Mr Gyari was received in Beijing by senior Chinese officials dealing with the country's national minorities. In the Tibetan capital he and his colleagues met the two leading ethnic Tibetans in the regional government, Legqog and Raidi, who are also senior Communist party figures.

Legqog, chairman of the regional government, said after the meeting: 'I didn't know they were private representatives of the Dalai Lama.' He is one of several senior Tibetan officials in Lhasa who have advanced their political careers by taking a hard line against reconciliation with the Dalai Lama, and may now feel threatened by a hint of relaxation in Beijing. China has made a number of concessions recently, releasing prominent political prisoners and allowing more Western journalists to visit the region. Some observers regard these as limited gestures aimed at improving US–China relations before President Jiang Zemin's visit to the US later this month.

In Lhasa, meanwhile, the political agitation of the early and mid-1990s has subsided. Younger leaders in Beijing appear to recognize that Tibet represents a serious image problem for China abroad. China's new policy of 'developing the

West' also requires more foreign involvement in Tibet, which is largely shunned by foreign investors.

In his statement, Mr Gyari paid a significant compliment to the Tibetans working for China in Lhasa, and spoke positively about Beijing's plans for economic development. 'We have been impressed by the dedication and competency displayed by many of the Tibetan officials,' he said. 'While encouraging and admiring their efforts to develop Tibet economically, we drew their attention to the importance of paying equal attention to preserving Tibet's distinct cultural, religious and linguistic heritage.'

China maintains tight controls on Tibet's monasteries and refuses to acknowledge its repressive policies of the past.

Mr Gyari admitted that the visit had been closely controlled by Beijing and that he had 'little opportunity to interact with ordinary Tibetans'.

30 November 2002

SAM WOLLASTON

The dancers of Msumarini

Yesterday morning, in the village of Msumarini, Kadzo Masha sat on the red earth under a cashew nut tree and wept. Huge tears rolled down her face. Gathered round her on straw mats were the women of her family – her sisters, daughters and cousins. But one was missing: her daughter Kafedha.

Kafedha was one of the unlucky ones. 'Twenty good years old' and, according to everyone in the village, very beautiful, Kafedha was part of the five-strong Grianna dance group who performed for tourists at the Paradise hotel.

Three women and two men, they danced in traditional costume, mostly in the evenings but also on Thursday mornings, to greet the new arrivals from the airport. They were there this Thursday when the green Mitsubishi drove through the gate and exploded. All five were killed: Kafedha, Riziki, Safari, Margaret, and Jaraya. All were from the village of Msumarini.

'She loved her job, she loved dancing,' said Kafedha's mother. 'She only wanted to dance. She had nothing to do with Israelis or Palestinians, or al-Qaida. Now she's gone.'

A few yards away, Rehema Matin, mother of Margaret, was with her ducks outside her thatched adobe hut, washing clothes in a plastic bowl. She looked sad and confused. 'Very, very bad. Very, very bad,' was all she said, as she shook her head. Her husband had gone to Mombasa to collect her daughter's body. Margaret was also in her twenties, and not married.

Fraha, at ten the youngest member of the family, stood in the shade, looking as if something had been stolen from her. Something had: her big sister.

They were angry in Msumarini. Angry that some of their children had been taken from them, caught in the crossfire of a war that had nothing to do with them and which few of them had much idea of. And also angry that while the world was focusing on the smouldering remains of the Paradise hotel a mile

away, where newly arrived Israeli troops, local police and the media of the world were jostling for control, they appeared to have been forgotten.

Three Israeli tourists were dead, but what about the nine Kenyans? What about Kafedha and her fellow dancers? Were they the oppressor, the evil infidel Osama bin Laden wanted to do away with? It was not just the five dancers from the village they had lost: Ibrahim the gardener was dead as well, his head blown open. Msumarini was a village in mourning.

They had also lost one of the village's main sources of income. About 100 did some kind of work for the hotel. Mathias Dickhams used to work in the hotel but is now a pastor.

'Not only have the local people lost their people, they've lost their incomes,' he said. 'And the way the Israeli people have been working, they were not regularly paying the salaries. Some of these people worked five or six months without payment. Now they will get nothing.'

Nyale Charo's house, where he lived with his wife and seven children, and his shop and café were next to the Paradise hotel. Now they are gone, the walls crumbled, the roofs vanished. Yesterday he stood on the embers that covered what was once the floor. 'This was where the freezer was, and here was the box where I kept the money, a wooden box.'

There were a few coins in the ash, still hot twenty-four hours after the blast, but the notes were all gone. On the floor were the smashed remains of Coke bottles and a case for spectacles. The other rooms were the same: a blackened corn on the cob the only clue that one room was the kitchen, and in the bedroom just the springs of the mattress remained.

All his documents had gone too. He has nothing to prove he is who he is. But it was the fire that followed the blast which destroyed Nyale Charo's house, not the blast itself, so he, his wife and seven children got out in time.

Now they are staying on the floor of his brother's house. Hardly lucky, but luckier than Kafedha and her friends from the Grianna dance group.

7 February 2003

JONATHAN WATTS

Daily drills, nightly blackouts

The dress rehearsal for the apocalypse begins at 10 a.m. sharp in Kim Il-sung Square with a terrifying wail of sirens. As a cacophony of loudspeaker warnings of enemy attack echoes from revolutionary war murals, Pyongyang citizens flee for cover.

Fraught-looking women and cloth-capped workers break into a run as they head across the broad square, down misty streets and into the bowels of the earth. Once the citizens are huddled in the cavernous subway platforms more than 100 metres underground, the warnings are replaced by the rousing strains of martial music assuring them of the ultimate victory of the motherland.

This has become a daily routine in North Korea, along with nightly blackout

drills that plunge this city of millions into an eerie darkness through which even the trams ghost along without lights.

While the world has its eyes on the steady march to war in Iraq, the people of Pyongyang are also bracing for conflict.

Tension has been a fact of life in this country, the most militarized on the planet, with an army of 1.1 million soldiers and vast arsenals of weapons of mass destruction.

But it reached a new pitch yesterday when the US defence secretary, Donald Rumsfeld, labelled the north a terrorist regime, raising fears here that this country will be next after Iraq in Washington's war on terror. Reports claim that the US aircraft carrier, *Kittyhawk*, has sailed into a 'strike position' off the country's east coast. Certainly, Washington has put two dozen bombers on alert for deployment to the region. But yesterday the *Kittyhawk* received deployment orders for the Gulf.

The north restarted full operations this week at Yongbyon nuclear plant, at the centre of the crisis. Washington believes the facility's five-megawatt reactor is being used to produce plutonium for warheads, a conviction that has grown since the north expelled international inspectors and withdrew from a global treaty to stop the spread of nuclear weapons.

The plant was last up and running during the previous stand-off of 1994, when the Pentagon drew up plans for a surgical strike on the reactor.

Pyongyang warned yesterday that an attack on Yongbyon would spark 'all-out war' – the latest in a long tirade of threats by a small, impoverished nation whose people apparently claim they would rather commit suicide than surrender to the world's superpower.

'The United States aggressors will never diminish the spirit of our country. We are ready to sacrifice ourselves for the great leader Kim Jong-il,' said Kim Mi-yong, a worker at the Victorious Fatherland Liberation War Museum.

The same refrain is heard again and again, though in a country with such strict media controls it is hard to be sure that everyone thinks the same way. I was unable to find anyone willing to talk other than those introduced by government minders.

A siege mentality is undoubtedly useful for North Korean leaders who would otherwise have to answer difficult questions about the country's shattered economy. Under Kim Jong-il's 'military first' policy, everything is subordinate to national defence. The city is filled with military posters and each morning its residents wake to the sound of martial music. Primary schoolchildren are taught martial songs such as Little Tank Rushes Forward.

American cuts of vital heavy oil and a shortfall of international food aid have confirmed North Korea's image of itself as a fortress being starved into submission. This is one of the coldest winters in recent times, with the Taedong River freezing amid temperatures as low as -21 degrees celsius. The electricity shortage is apparent in classrooms where students wear coats and gloves, in apartment blocks where all lifts are out of action and in dimly-lit museums and universities.

Food rations have been cut as United Nations appeals for donations have passed unheard in Washington and Tokyo. Government officials say school-children now get just 300 grams of food a day, down from 500 grams. The

situation is not yet as bad as the famine of the late 1990s, but world food programme stocks are due to run out within weeks.

'We would like full cooperation from the outside world but not if it is being used for political purposes,' said Ri Pyong-gap, a foreign ministry spokesman. 'We don't worry even if we don't get food. We have been through an arduous march once and we can do it again.' The government in Pyongyang has shown a recent willingness to engage and communicate with the outside world, particularly with Britain, which opened its first embassy here a few months ago.

The rare glimpse of the country granted to the *Guardian* is a product of this new approach. But the mood in the city is far more hostile than just nine months ago, when Pyongyang was in a festival mood to celebrate the anniversary of its founder's birth amid a warming of relations between the north and south of this divided peninsula. Now mobile phones are confiscated at the airport. On a night ride through the city, our car was stopped by soldiers every few hundred metres for ID checks.

Kim Jong-il may be playing a game of nuclear bluff to win economic concessions and political revival, but the people are deadly serious about the risks they take. North Korea knows it can never win a war, but it will never surrender. They are staging a daily dress rehearsal for the apocalypse, ending at 7 p.m. sharp, when the dim lights of Pyongyang go out and the city of millions disappears into darkness.

13 March 2003

IAN TRAYNOR

The murder of Djindjic

The two bullets that killed Zoran Djindjic at lunchtime in Belgrade yesterday cut down a politician who had just begun to exercise power after a couple of decades of opposition, jail, exile and power struggles.

His murder, and the boldness with which it was executed, in broad daylight outside his office in the centre of Belgrade, raise the question: who is really running Serbia?

It is only two weeks since Djindjic narrowly survived an earlier attempt on his life when a well-known Belgrade gangster tried to drive a lorry into his convoy on the motorway to Belgrade airport. Again, in broad daylight.

Extraordinarily, the arrested gangster was released by a Belgrade court after four days, and has disappeared.

That Djindjic should be killed within a fortnight of the road crash shows extremely lax security arrangements, as well as the impunity with which war criminals and mafiosi operate in the Serbian capital.

For months Serbian commentators and Western diplomats in Belgrade have been talking darkly about the 'capture of the state' by an alliance from the security services and the underworld. In the Serbia bequeathed to Djindjic by

Slobodan Milosevic it is often difficult to tell where state security operations end and gangsterism begins.

Djindjic himself walked the fine line between fighting and co-opting the mafia leaders. His government has a poor reputation for unsavoury profiteering at the cost of delayed reforms. Its performance has given democracy a bad name in Serbia. Just when it seemed he was beginning to move against the sinister power-brokers, they appear to have got him first.

Djindjic brushed off the murder attempt a fortnight ago, saying it was a 'huge delusion if someone thinks the law and the reforms can be stopped by eliminating me'.

He had just appointed a new chief investigator to concentrate on rooting out organized crime. But Jovan Prijic is said to have been the last choice for a job turned down by a host of other nominees.

Djindjic led the uprising on the streets of Belgrade, which deposed Mr Milosevic in October 2000, and then proceeded to fight the president of Yugoslavia, Vojislav Kostunica, throughout the two years of his premiership, a battle that paralysed government and left Serbs disillusioned with democracy.

Mr Kostunica bowed out last month, temporarily at least, when Yugoslavia was dissolved, leaving Djindjic in control and able at last to get down to the business of reforming and democratizing a country struggling with Mr Milosevic's legacy of crime and lawlessness.

He was under strong US and EU pressure to clean up government, start arresting indicted war criminals, and close down the criminal channels which make Serbia a haven for people-traffickers, the sex trade, drugs and violence. Most of the thugs controlling organized crime are veterans of the Yugoslav wars of the 1990s, in which they served the Milosevic regime as paramilitary leaders and ethnic cleansers, committing atrocities in Croatia, Bosnia and Kosovo. With the wars over, they moved into smuggling and crime, making fortunes from the privatization of state enterprises and forming alliances with the political elite and the security services.

Djindjic took the risky decision, vehemently opposed by Mr Kostunica, to turn Mr Milosevic over to The Hague tribunal in the summer of 2001, to be tried for genocide. That apart, he did not do much to arrest the war criminals and gangsters, not least because he owed his premiership to some of the thugs who had served the old regime and then switched sides.

In October 2000, when Mr Milosevic was deposed, the real surprise was that the 'revolution' was so bloodless. But Mr Milosevic went without a fight because Djindjic persuaded some of his henchmen to change sides. In consequence, the army and the paramilitary police did not turn their guns on the demonstrators on the streets.

Foremost among the security service officials who sealed the victory of the anti-Milosevic forces was the feared paramilitary boss known as Legija, the former French foreign legionnaire Milorad Lukovic, who headed Mr Milosevic's Red Berets, the special operations unit of the Interior Ministry, which served as shock troops in the wars and carried out repeated atrocities.

Legija emerged last night as a leading suspect. Belgrade had already been buzzing with rumours that he had been secretly indicted by The Hague. Western

diplomats in Belgrade describe him as one of the most powerful men in Serbia. Djindjic and Legija publicly praised one another during the revolution, and Legija helped Djindjic get Mr Milosevic arrested.

In recent months the Belgrade media have been reporting a feud between Legija and another underworld boss, known as Buha. The unusual public slanging match suggested that attempts were being made to curb the powers of the gangsters. But the prompt release of the lorry driver and yesterday's shooting show how powerful the bosses are.

There is no shortage of suspects for yesterday's assassination, for Djindjic had plenty of enemies and murder is not an uncommon way of settling political scores in Belgrade. The Milosevic camp nursed intense grudges against Djindjic, who was being told by the Americans to get General Ratko Mladic – the Bosnian Serb commander and indicted war criminal, who is said to be protected in Serbia by military colleagues – on an aircraft to The Hague.

Djindjic's death leaves a vacuum in political power in Belgrade and it is not clear who will fill it.

19 March 2003

CHRIS McGREAL

Arafat's powers

The Palestinian leader, Yasser Arafat, last night signed into law legislation surrendering most of his powers to a new prime minister, and opening the way for US President George Bush to meet his commitment to release the US-backed 'road map' for a Middle East peace settlement.

Earlier in the day, the Palestinian parliament rebuffed an attempt by Mr Arafat to cling to some of his powers. Instead it invested in the new prime minister what legislators described as the 'real authority' demanded by Mr Bush as a condition for reigniting the peace process.

The US secretary of state, Colin Powell, said he would have liked the new prime minister to have more power. 'We would have preferred to see even greater authority vested in a prime minister, but it is nevertheless a positive step,' he said.

However, Britain can be expected to put pressure on the White House to follow through swiftly on Mr Bush's commitment to release the road map, crafted by the 'quartet' of US, European Union, Russia and the UN, which envisages a Palestinian state within three years.

On Friday, the US leader abandoned his recent insistence, at Israel's urging, that the plan would have to wait until after a war in Iraq. In an apparent attempt to bolster domestic political support for Tony Blair, he said the route to a Palestinian state would be released when a new Palestinian prime minister with 'real authority' was confirmed in office. Yesterday, Mr Blair told Parliament that the release of the road map was imminent.

All that is left is for Mr Arafat formally to nominate his choice of prime

minister. He has already named his deputy in the Palestine Liberation Organization, Mahmoud Abbas, also known as Abu Mazen, as the candidate.

Mr Arafat surrendered most of his powers, with the exception of controlling security and being the final arbiter of any peace agreement, under pressure from the US, Britain and other European states after the Israelis said they would no longer deal with the man they called the 'godfather of terrorism'.

The defeat of Mr Arafat's bid to retain authority to approve ministerial appointments and call Cabinet meetings represented a further waning of his political influence, and a strengthening of a legislature that has grown increasingly critical of his leadership.

'It's the beginning of a transition, a turning point and a qualitative shift in the political culture,' said a legislator, Hanan Ashrawi.

The Israelis have praised Mr Abbas as a man committed to ending violence and corruption. He has long been a critic of the intifada. The government had previously denounced him for 'supporting terrorism', and he was widely vilified as a 'Holocaust denier'. But now the Israeli army has suddenly removed from its website extracts from a thesis and book by Mr Abbas that question whether the Nazis used gas chambers to exterminate Jews, and which said that the number murdered was 'less than a million'.

Mr Abbas also suggested that the extermination of Jews was a conspiracy between Zionists and the Nazis. 'The Zionist movement led a broad campaign of incitement against the Jews living under Nazi rule to arouse the government's hatred of them, to fuel vengeance against them and to expand the mass extermination,' he wrote.

While bolstering Mr Abbas, Israel yesterday continued its pursuit of those who take a harder line. The army killed another two prominent Hamas figures as the military continued its hunt for leaders of the Islamic fundamentalist group. Soldiers shot Ali Alian, the Hamas chief for the southern area of the West Bank, in a dawn raid on a village near Bethlehem. The army accuses him of masterminding a suicide bombing in Haifa a fortnight ago that killed seventeen people. Hours later, the army shot dead a Hamas leader from Nablus, Nasser Assida. The Israelis accuse him of a role in the killings of twenty-five people.

The detention on Sunday night of a prominent Palestinian legislator, Hussam Khader, an outspoken critic of corruption and Mr Arafat, indicates that the Israelis are also trying to neutralize political rivals of the new prime minister. Officially, the Israelis say Mr Khader 'directed and financed terror in the Nablus area'. But he is the first Palestinian legislator detained since the arrest of the West Bank Fatah leader, Marwan Barghouti, in April.

Some of his Palestinian colleagues believe the Israelis wanted to remove a strident critic of the new political set-up. Mr Khader argued that the new prime minister lacks power to negotiate a fair settlement for the Palestinians.

10 April 2003

JAMES ASTILL

Congo's war

A total of 4.7 million people have died as a direct result of the Democratic Republic of Congo's civil war in the past four and a half years, according to a report released this week by the International Rescue Committee, a leading aid agency.

By the IRC's methodical calculations, Congo's convoluted war – one barely mentioned in the Western media – has claimed far more lives than any other conflict since the Second World War.

'This is the worst calamity in Africa this century, and one which the world has consistently found reasons to overlook,' David Johnson, the director of IRC's operations in eastern Congo, said on Monday. 'Over the past three years our figures have been consistent and clear. Congo's war is the tragedy of modern times.'

With a margin for error of 1.6 million – a standard proportion is applied to areas too dangerous for researchers to reach – IRC admits its estimate is approximate. Yet few aid workers in eastern Congo doubt that a total death toll of 4.7 million is possible.

'With an almost complete lack of medical care, as well as food insecurity and violence over a vast area, this number does not seem exaggerated,' said Noel Tsekouras, the UN humanitarian coordinator for eastern Congo. 'Even the fact that we are wondering how many millions have died is mindboggling.'

Only about 10 per cent of the war's victims have died violently, according to IRC: the majority succumbed to starvation or disease as a multitude of armed groups sprang up and marauded their way through the villages and fields after Rwanda's invasion in 1998 drew seven other national armies into the conflict on Congolese soil.

In eastern Congo, from Ugandan-occupied Bunia in the north to Rwandan-controlled Bukavu, the scenes of destruction – the torched huts and weed-choked fields – are as ubiquitous as the country's green hills.

Last week 966 villagers were massacred outside Bunia, in north-eastern Ituri province, according to UN observers.

17 May 2003

STEVEN MORRIS

Dragged off and deported

The *Guardian*'s Zimbabwe correspondent, Andrew Meldrum, was deported last night even though three separate court orders were made prohibiting his expulsion.

After spending twenty-three years reporting on the country, Meldrum was manhandled into a car outside the offices of Zimbabwe's immigration service, driven to the airport and put on a plane to London.

The foreign secretary, Jack Straw, led worldwide condemnation, saying: 'I'm very concerned at this case. Petty and vindictive actions like this simply expose the Zimbabwe regime for what it is.'

Michael Ancram, the Shadow foreign secretary, said: 'This is yet another disgraceful action showing the lack of respect for freedom of expression and speech of Robert Mugabe's evil regime. This is the act of a dictator.'

A US State Department spokesperson said the treatment of Meldrum, an American citizen, 'reflects ongoing erosion of basic rights and the rule of law, and is yet another example of the intimidation faced by journalists in Zimbabwe, who have endured threats, arbitrary arrests and violence at the hands of the government and its supporters.'

Meldrum's wife, Dolores, spoke to him on his mobile phone. 'He told me the immigration officials had covered him with a jacket, hooded-style, and drove him around a dirt road. When they got to the airport he was locked up in an underground room,' she told Reuters. Meldrum's lawyer, Beatrice Mtetwa, claimed his deportation signalled a 'complete breakdown of the judicial system and the entire state machinery'.

The disturbing sequence of events began yesterday morning when Meldrum, aged fifty-one, presented himself at the headquarters of the immigration service. He was told that he was considered a 'prohibited immigrant' and 'an undesirable inhabitant', and would be deported. He emerged from the building surrounded by officials and police.

Meldrum shouted to waiting reporters: 'I'm being deported. This is a vindictive action of a government afraid of a free press.' He was manhandled by police officers, one of whom grabbed him by the collar, and bundled into an unmarked police car before being driven to the airport.

During the day the high court in Harare issued three orders at three hearings that Meldrum should not be deported. At the second of the hearings yesterday afternoon Ms Mtetwa argued that the immigration officials were in contempt for ignoring Meldrum's right to appeal a previous deportation order last July to the Supreme Court. That appeal has still to be heard.

The state attorney, Loice Matamba-Moyotold, said she did not know why the home affairs minister, Kembo Mahadi, issued the deportation order because he had said it was not in the public interest to disclose why Meldrum was deemed an 'undesirable'. Judge Charles Hungwe said he saw no reason why the reporter should be detained. 'He must be able to enjoy his freedom,' the judge said. He said the state's reluctance to give reasons for Meldrum's deportation left 'suspicions in one's mind'.

After the third hearing yesterday evening, Ms Mtetwa raced to the airport and served the new order prohibiting Meldrum's deportation to Air Zimbabwe staff. Though immigration officials rushed away when they saw her, she also managed to serve the order on them. Nevertheless, Meldrum was put on a flight to Gatwick. He managed to wave to friends and make a phone call to reassure them that he was all right. Ms Mtetwa said it was clear the state attorney and the

immigration officers were not acting independently.

The editor of the *Guardian*, Alan Rusbridger, said: 'The deportation of our reporter Andrew Meldrum from Zimbabwe is a political act, which should invite the strongest possible condemnation from the international community. The Zimbabwean authorities have been persecuting Andrew for the past twelve months and their determination to deport him can only be interpreted as a concerted effort to stifle any free press within the country. This is an extremely grim day for Zimbabwe.'

The latest attempts to deport Meldrum began last week when immigration officers arrived at his home after dark and said he was wanted for questioning.

On Tuesday Meldrum voluntarily went to the immigration offices, where he was told he had been writing 'bad stories' about Zimbabwe. His residence permit and passport were confiscated. He was subsequently told to appear at the immigration offices yesterday.

Johann Fritz, the director of the International Press Institute, said: 'Meldrum's illegal and unwarranted removal is yet another example of the ongoing attempt by the government of President Mugabe to prevent information on the appalling situation in Zimbabwe finding its way out of the country.'

Paul Themba Nyathi, secretary for information and publicity for the opposition Movement for Democratic Change, described the decision to deport Meldrum as 'another nail in the coffin for press freedom in Zimbabwe'.

13 June 2003

CHRIS McGREAL

Total war

Israel declared total war on Hamas yesterday, with the Islamic resistance movement responding by ordering all its fighters to immediately mobilize and 'blow up the Zionist entity'.

The threat of escalation in an already bloody week for Palestinians and Israelis alike came hours before the army launched its fifth helicopter missile strike since Tuesday, killing a Hamas activist and six civilians. Among the dead were the man's wife and two-year-old daughter.

It brought to thirty-five the number of Israelis and Palestinians killed in violence over the past two days alone.

The US secretary of state, Colin Powell, announced plans for a meeting of other members of the quartet backing the US-led road map to a Palestinian state – Russia, the European Union and the United Nations – in an attempt to save the process. The talks will probably take place in Jordan, the scene of last week's summit between President George Bush, the Israeli prime minister, Ariel Sharon, and the Palestinian prime minister, Mahmoud Abbas, which briefly revived hopes that conflict might give way to negotiation.

But they are unlikely to happen for at least ten days, and a lot more blood is likely to be spilled before then.

Israel's defence minister, General Shaul Mofaz, yesterday ordered his forces to 'use everything they have' against Hamas following Wednesday's suicide bombing on a Jerusalem bus, which claimed seventeen lives.

That attack came in retaliation for the Israeli army's botched attempt to assassinate Hamas's political leader, Abdel-Aziz al-Rantissi. That, in turn, was prompted by the killing of five Israeli soldiers to demonstrate Hamas's opposition to concessions made by the new Palestinian leadership at the Aqaba summit, including declaring an end to the intifada.

Hours after General Mofaz' order, Hamas responded with its own escalation. 'We call on all military cells to act immediately and act like an earthquake to blow up the Zionist entity and tear it to pieces,' it said in a statement. 'The Jerusalem attack is the beginning of a new series of revenge attacks ... in which we will target every Zionist occupying our land.' It warned foreigners to leave Israel for their own safety.

The British government announced yesterday it is to crack down on organizations in Britain raising funds for Hamas. The foreign secretary, Jack Straw, is discussing with the US ways to squeeze countries and individuals funding Hamas, especially wealthy individuals in Saudi Arabia who provide the bulk of the money, channelled through Damascus to Gaza and the West Bank. He is also to discuss a clampdown with other European Union countries. Although Hamas is a proscribed organization in Britain, the government has been holding back over the last year to see whether the Islamist organization would sign up to a ceasefire.

Mr Straw seemed to concede yesterday that this approach had failed, saying the chance of a ceasefire from Hamas was limited. 'One of the things that has to come out of this appalling outrage is a greater determination by the international community to clamp down on funding and support for organizations like Hamas,' he said.

At an emergency Israeli Cabinet meeting, Mr Sharon vowed to stick with the road map but derided Palestinian leaders as 'cry-babies who let terror run rampant' and then complained when Israel retaliated against attacks. Mr Sharon described Mr Abbas as a 'chick without feathers'. 'We have to help him fight terror until his feathers grow,' he said. 'The state of Israel will continue to pursue the Palestinian terror organizations and their leaders to the bitter end.'

But a Palestinian Cabinet minister, Yasser Abed Rabbo, dismissed Mr Sharon's comments as duplicitous. 'His aim is to discredit the Palestinian government and to assassinate his real enemy, which is the road map,' he said.

Mr Abbas said he would renew efforts to persuade Hamas to agree to a ceasefire, but Palestinian sources said the chances of fresh talks in the short term were dim.

The Palestinian president, Yasser Arafat, who unusually described the Jerusalem bus bombing as 'terrorism', called on the US, Europeans and United Nations to intervene to halt the escalation. 'We are in need of strong pressure to stop this aggression against our people,' he said.

The latest Israeli assault on Gaza City came when helicopters fired a barrage of rockets into a car, killing a senior Hamas activist, Yasser Taha, his family and four other people. Mr Taha was an aide to another prominent activist,

Mohammed Deif, who was assassinated last year. About forty people were wounded.

Mussallam Amaireh, a guard at a neighbouring mosque, said the car was engulfed in flames. 'It was so terrible to see. People were burning in there,' he said.

Furious Palestinians waved one of the dead infant's shoes and her feeding bottle, and screamed abuse about Mr Sharon.

'If Sharon wants blood, we are prepared to shed ours to spill his,' shouted an enraged young man called Yusuf.

The car was hit close to a cemetery where a few hours earlier funerals were held for eleven people killed in the previous day's Israeli missile strikes. Thousands of Palestinians marched through Gaza's streets ahead of the funerals chanting, 'Bombardment for bombardment and blood for blood'.

But not everyone was enthusiastic about an escalation in the confrontation.

'We have our children to consider,' said Mada Jabali, a middle-aged woman with four children in tow. 'We don't want them to go on living under occupation but we do want them to live. There have been too many martyrs and too many of them have been children. We don't want more.'

30 June 2003

DAN DE LUCE

Free speech in Iran

Student leaders, defiant after a wave of street demonstrations, are warning Iran's political leadership that they will face full-blown confrontation unless political prisoners are released and a protest rally is allowed to go ahead.

'We openly declare that these words are the final words of dialogue between the student movement and the ruling establishment,' a group of students said in a letter addressed to the reformist president, Mohammad Khatami.

Signed by 106 prominent students, the letter condemns the arrest of dozens of student activists and a ban on street rallies to mark the anniversary on 9 July of a raid on a Tehran University dormitory four years ago. Following protests, which erupted across the country earlier this month, the letter sets the stage for further possible unrest as the 9 July anniversary approaches.

The students are also running out of patience with President Khatami, once hailed as their hero but now increasingly considered too timid to stand up to the conservative clerics who wield real power in Iran. Mr Khatami's failure to speak out clearly about the suppression of the student movement was 'painful and disappointing', the students said.

The letter told him: 'We call on you ... to react before it is too late and adopt a reasonable solution, or otherwise have the courage to resign so that you do not justify oppressive policies and allow students to settle their accounts with the establishment.'

While city streets have returned to normal, the protests that erupted on 10

June and persisted for more than a week shocked the authorities in the level of anger that they expressed against the country's clerical rulers.

'The protests were a serious alarm bell for the system,' Abdullah Momeni, a prominent student leader, told the *Guardian*. 'Two years ago, it was an open secret that the system was dysfunctional. Now people are saying it openly.' The disorganized and chaotic nature of the protests showed the need for a coherent opposition leadership that could harness public anger, he added. 'The authorities have to learn to allow people to voice criticism or there will be more protests. The huge number of arrests they have carried out shows how nervous they are,' he said.

A day after speaking to the *Guardian*, Mr Momeni was detained when he walked out of the university campus in Tehran's city centre.

In an apparent attempt to pre-empt rallies on the 9 July anniversary, some 1,000 people – including dozens of student activists and the son of an MP – have been arrested in the past week. The detentions are carried out by plain-clothes security agents operating outside regular legal authority, reformist MPs say. Most of those detained are being held without access to lawyers or their families, and their whereabouts are unknown.

'I am worried my husband is being tortured right now,' said Aidin Hassanlou, who is twenty-six years old. Her husband, Mehdi Aminzadeh, is another student leader who was arrested a week ago and has not been heard from since. 'I am really anxious about this situation. I don't know where he's being held. After seven days they won't let me see him or talk to him,' said Ms Hassanlou, who was warned by the authorities not to speak to the press.

Initially reported as a demonstration by university students, this month's protest was more of a family event, with teenagers leading the way while Iranians of every age came out to watch and blare their car horns in solidarity.

As quickly as they exploded on 10 June, the protests faded after ten days. The demonstrators had no leadership and no clear demands. A newspaper story that helped spark the protests, which suggested that privatization of universities might be in the offing, turned out to be inaccurate.

But the tidal wave of frustration continues to grow among a new generation who are less willing to tolerate a theocratic system that they believe is defying the popular will and the modern world.

Conservative officials and police say the protests do not represent any serious political protest, but are merely acts of 'hooliganism' orchestrated by foreign governments. They have no shortage of evidence, if the statements of the White House are anything to go by. The Bush administration has accused Tehran of helping al-Qaida, of developing a clandestine nuclear weapons programme and of undermining US attempts to rebuild Iraq – all claims that Tehran has denied.

The clerical leadership in Iran does not deny the existence of protest. Rather, they point to the sharp political disagreements between the conservatives and reformers as proof of the country's democratic credentials.

Unlike in previous street protests, the club-wielding, bearded vigilantes who came out to crush the demonstrators met fierce resistance. Instead of running away, teenagers fought back, throwing stones and torching the militia's motorbikes.

While previous demonstrations had called for free speech, this time there were hostile chants against clerical rule and even the Ayatollah Ali Khamenei. Criticizing the Supreme Leader, who wields ultimate authority, is normally a taboo that risks imprisonment. For the first time, demonstrators also openly castigated President Khatami, who was elected six years ago amid high hopes for dramatic change. He and his allies in Parliament have tried to introduce democratic and social reforms, but have been repeatedly blocked by unelected clerics who wield blanket veto power.

To distract a restive young population, state television has announced an extensive schedule of Iranian soap operas and European football matches. Free outdoor concerts, with free food, are also being organized in the capital to coincide with the 9 July anniversary.

COLLATERAL DAMAGE

18 February 2003

SARAH BOSELEY

Saving Grace

Grace has a little place in the suburbs. It's not much, perhaps – the whitewash is coming off the walls, the red-baked ground is stony and the persistently cheerful rhythms thumping from the bar round the corner look set to go on all night – but it's impossible to be lonely in her one-room house in a block of four, surrounded by friends and their children, and it's a short walk to work across the fields. She says she's happy. She's just thirty, she's single and she has a good job selling luxury shoes from a shuttered wooden kiosk in the Central Market, the exuberant commercial hub of Lilongwe. All her life should be spreading out before her, but a glance into the future shows death staring back, just a few years on.

Like every fourth young man or woman in Malawi's towns and every sixth in the villages, Grace Matnanga has the HIV virus running like a slow and silent poison in her veins. You can't tell who most of them are. They teach children, they police the streets, they work in hotel receptions and bring up children. They laugh and smile like every other Malawian. For months or years, they appear well.

Then the downward spiral begins. Maybe next year, maybe in five years time, depending on how well she eats and how healthy she keeps herself, Grace will begin to lose weight. She will get an infection – it might be just a minor one – but after that she will get another, more serious. It could be pneumonia, it could be TB or it could be meningitis. There are drugs in Malawi's hospitals to treat all three successfully, but each time she recovers, her immune system will be that little bit more battered, her weight lower and her chances of surviving diminished. The curves of healthy flesh will disappear. She will begin to look wasted and everybody she knows will understand why. Eventually her body will give up the fight, the pain and fever will engulf her, and Grace will become just another Aids statistic.

She doesn't think about it, she says, with a smile and a slight shrug, as she looks out of her kiosk at the vitality and the colour of the market, where brightly dressed women sit among their sacks of mint leaves, tomatoes and red aduki beans, tailors peddle sewing machines and heat flat irons on open fires to repair old clothes, and everything from door handles to dried fish to pineapples is for sale. But she knows too well what is in store. Her freedom and independence were wished on her like a curse. Once she had a husband. Once she had a child. Both are dead.

'I was married for eight years,' she says. 'My husband passed away in 1998. He collapsed and was taken to the Central Hospital and put on oxygen.' Like most of the young people who die, he had not been tested for HIV, but there's little doubt that Aids killed him.

He survived longer than their little daughter. Tiyajane was born in 1993, the longed-for fulfilment of marriage in Malawian society, where almost every young woman has a baby strapped to her back. Tiyajane appeared to be healthy at first, but then the weight gain slowed. She stopped thriving. She began to get sick. She picked up infections. When she died, aged three, she was a pitiful, wasted scrap, the ulcers in her throat and mouth making the pain of swallowing more vicious than the pangs of hunger.

Grace will never marry again, she says. 'I have got HIV so I will not get married or have any more children. I would adopt some, but I will never have any of my own.'

So she lives alone, with a small radio and her friends, and says she is content. She eats as well as she can afford to, which is not as well as she should, but better than many Malawians in the year after massive crop failure, exacerbated by the permanent absence of so many young women and men who should be working in the fields. Grace knows that nutrition is important to staving off illness. She buys vegetables, eggs, soya beans and milk to supplement the inevitable Nsima, a meal of maize flour, which is the nation's staple diet. So long as she keeps her job she can afford the 650 kwacha ($7.38 or £4.67) rent each month on her house and her food because – unusually in Malawi, where extended families are the norm – she has nobody else to support. If she becomes sick, she will lose her job and her home, her diet will deteriorate and so will her health.

If she were living in a bedsit in Clapham on the fringes of central London instead of a bedsit in Mwenyekondo, just outside the old town of Malawi's capital, Grace would not have to face this imminent downhill dance to death. She would see her GP, who would send her to a consultant, who would put her on antiretroviral drugs (ARVs). Three drugs in combination, taken every day for the rest of her life or until such time as the scientists find a cure for Aids, would keep her alive, active, healthy and working. There are lots of people in the UK with HIV. They teach children, they police the streets, they work in hotel receptions, they bring up children. You wouldn't know who they were, and you won't, because they are on ARVs.

Grace knows about ARVs. She knows that they could save her. And she knows that they cost 2,500 kwacha a month – around $28 or £18. That's almost twice the $170 per capita income in Malawi for a year's supply. It's an unimaginable sum of money, even for a single, working girl with no dependents.

It's an even more fantastic sum for Dessa Chidhedza, who is twenty-nine, just a year younger than Grace, and in very much more urgent need of the drugs. Dessa is Grace in a few years time, if not before. She lives in a bungalow in Kawali 1, a pleasant, tree-fringed area a few miles outside of the city centre. A cane fence separates the garden from the neighbours and the hard red earth road. It's Dessa's mother's house and there are sixteen mouths to feed – eleven of them children. Two of Dessa's own three children have been sent to cousins in Blantyre, 360 kilometres away, since she fell ill and lost her job as a cashier in an Indian shop and the family had to face its financial inability to cope. It's hard to imagine she will see them again.

Dessa sits on the edge of a large wooden double bed, where at night she sleeps

with her remaining daughter, twelve-year-old Chirinde. It's the best room, hung with paintings of Christ and children, and crowded with furniture from a more hopeful time – a dresser, a dining table with six chairs and a red three-piece suite hung with fancifully embroidered cloths to hide the holes and rips in the arms. Dessa is slight and fragile against the heavy darkness of the room and moves with slow pain.

'I'm not well,' she says quietly, but it doesn't need to be said. Her husband died in 1997. Suspecting it was Aids, Dessa went for a test and found she was HIV positive. She has had many infections in the four years since then, treated in the hospital. Now, however, she is weak and frail, and there is little they can do.

'I have no hope of ARVs,' she says. That doesn't need to be said either. Her mother, Rose, in better times brewed the local Chibuku beer from maize and sugar out at the back of the house. Today there is no Chibuku because they can't afford the maize flour or the sugar. There's very little out at the back of the house. Only a single small supper pot bubbles on a tiny fire while Dessa's brothers sit in the shade, hammering out a discordant song as they reshape an old metal hubcap in hopes of bringing in some money.

Most people in Dessa's weak state are reluctant to talk about their impending death for superstitious fear of hastening it. She looks at the floor for a while. 'I'm not sure how long I can go on because my immune system is declining,' she says finally. She also understands what is happening to her body and is only too aware that the sole chance of thwarting the virus lies out of her reach. 'We have no money to spend on ARVs.'

This is not only the story of Grace and Dessa but the story of every Malawian. Everybody knows someone who has lost several members of their family. Everybody wonders who in their own family will be next. Aids has brought average life expectancy down from fifty-three to just thirty-nine. The whole of sub-Saharan Africa shares Malawi's tragedy. There are 29.4 million infected with HIV, 60 per cent of whom are women. Last year alone 2.4 million died. Four million are in urgent need of drugs, but less than 50,000 are getting them.

The most thriving businesses in Lilongwe are those of the coffin makers – you see them everywhere, the bright metal handles and plaques on the boxes catching the sunlight to call out of the workshop gloom. A short distance down the road from Dessa's mother's bungalow, hundreds of people are sitting on the ground, lining the courtyard of a house and the road in front of it. An achingly melodic Gospel chant rises from their ranks. It is the funeral of a fourteen-year-old boy. Nobody ever told him, says a local man, that he was HIV positive, even though he was tested in hospital. How would it help him to know there was no hope?

Malawi is running with children – ragged, dusty-footed children with large inquiring eyes and shy smiles. More and more of them are orphan children who have lost either both parents to Aids or just one – usually their mother, leaving a father who is unable to cope. There's never been any question over the future of a motherless child in Malawi. Grandmothers, aunts and uncles take him in, share the maize porridge and the rice, clothe him and send him to school. Until now.

Aids is taking not only the mothers and fathers, but the aunts and uncles as well. It is striking down those who should be working the fields. Aids has played a dire part in the food shortages caused by crop failure last year, so that no family has enough to eat. The villages do their best to absorb the bereaved children but they are at saturation. There are officially 475,000 orphans among Malawi's 11 million population, but it's hardly an official census figure, and many believe there could be as many as one million. The dangers should be obvious. Those who guide children – the parents and the teachers – are dying. Those who feed these children are hungry themselves. Even the CIA has acknowledged Aids could breed a new generation of terrorists.

In Tilerane, still in the district of Lilongwe but part of the countryside, is a school set up for some of these orphans by local people. It's midday. Children of all ages are spilling out of the door of the schoolhouse, tumbling down the few steps like a waterfall. A small child in a dirty pink T-shirt is trying to pick up a toddler in an identical dirty pink T-shirt who is stuck halfway down, like the wrong shaped stick in a bend of a stream. The wave of Lilliputian humanity parts around them and forms again on the other side, until a teacher picks up the tiny one by the arms and swings him easily to the ground.

The orphan centre does what it can. There are 500 children registered at Tilerane, although not all of them come to the school. Volunteers visit the surrounding villages to help and support others. The school gives them love, care, very basic education and – fundamentally important – some food. When they arrive at around 7.30 a.m., they get tea and rice or maize porridge, which allows them to learn their ABC and do a few sums without the familiar, distracting cramps of hunger. But the children have to be sent home at midday because there is nothing more for them to eat.

'In the afternoon, if we have something, we give them maize and rice. If not, they go home but they don't eat there either,' says Chitekwele Phiri, who started the centre in 1995 after his own sister and mother died and he was left looking after his little brother and his sister's two children. Three friends in similar situations, with dependent nephews and nieces, helped him get it off the ground. Two of the three are now also dead.

In Salima, near the vast and beautiful Lake Malawi, small children, big children, children carrying much smaller children, walk as far as 10 kilometres to reach an orphan centre, which opens every Saturday morning. There's Jolam Mwale, aged twelve but as small as an eight-year-old, with the extended belly of hunger. He's twisting on the spot with shyness, wearing blue shorts and a cut-down man's faded blue striped shirt, just about held together with a safety pin. 'I live with my grandmother,' he says. 'My mother and father have passed away.' He comes, he says, to learn about HIV. Undoubtedly he also comes in order to eat.

Andrew Kayinga, fifteen, had polio as a baby, which affected his legs and made it a slow and arduous 5-kilometre pilgrimage to the Salima Aids Support Organization until SASO arranged transport for him. He lives with his aunt and her husband, who are good to him, he says. His father died when he was five, followed by his mother four years ago, coughing and in pain from the TB that infects 70 per cent of those with HIV and Aids. He knows the future is loaded

against him. 'I am facing so many problems that I think if I go to school it may help me in the future to get employment,' he says gravely. 'I would like to be a typist or do driving. Now in Malawi jobs are scarce but you can get a job if you have trained.' His faith in life is moving in the face of such short odds. Well, he explains, because of his polio, he did not walk until he was four. 'In the village, they say God is great because they thought I might never walk at all.'

Malawi is full of such hope, but the dice are loaded heavily against its people. Prevention efforts, such as HIV education and the use of condoms may help slow the infection rate, but only treatment with unaffordable drugs that a Londoner, Mancunian or Glaswegian would pick up for free on the NHS can check the tidal wave of death that is set to overtake so many like Grace.

As she sits among her smart sandals and a tiny mock-leopard skin handbag, doing very little business because it is the quietest time of year, when families have just scraped together every last kwacha to pay for school fees, Grace's cheerful serenity slips just for a moment. 'If ARVs were available and they were here, I would take them,' she says. She is no more indifferent to her life than her contemporary in an up-market shoe shop in Durham or Leeds. She's just living on the wrong side of the global divide.

1 March 2003

DAVID TEATHER

Columbia's final moments

A wrenching thirteen-minute video tape of the last moments of the crew of the space shuttle *Columbia* shows them joking, waving at the camera, and talking excitedly of experiencing re-entry to the earth's atmosphere.

The tape, released by NASA yesterday, takes on a bitter irony with hindsight. As the crew talk of the heat building around the nose cone, Commander Rick Husband jokes, 'You definitely don't want to be outside right now.'

Shortly afterwards, *Columbia* broke apart above Texas, killing all seven crew. The partly scorched video cassette was found three weeks ago near Palestine in Texas, among wreckage strewn across several US states. It was said to be 'a miracle' that it survived. Normally, the entire re-entry of a shuttle is recorded, but what is left of the heat-damaged tape spares relatives by ending four minutes before the first sign anything was wrong.

Four crew members are shown: Commander Husband, pilot Willie McCool, and mission specialists Laurel Clark and Kalpana Chawla. The other three were on the lower deck.

Much of the thirteen minutes is painfully mundane. Chawla talks about putting on her gloves, McCool moves a clock out of the way and Husband sips a drink. At one point, Clark, dressed like the others in an orange spacesuit and helmet with the visor up, picks up the camera and films herself and Chawla smiling and waving in the cramped deck.

The tape begins nine minutes before re-entry. As the shuttle hits the atmos-

phere, orange and yellow flashes appear outside the windows, a normal sight, according to the space agency. 'Looks like a blast furnace,' Husband said.

'Yep, we're getting some Gs [gravity],' McCool replied. 'Let go of the card and it falls.'

Husband then added, 'You definitely don't want to be outside right now.'

Clark, seated behind him, joked, 'What, like we did before?' drawing a big laugh.

Relatives saw the footage before release. Jon Salton, Clark's brother, said, 'Seeing them, it's obvious how much they cared for each other. The dedication all of them showed was remarkable.'

NASA said the tape added nothing to its continuing investigation of the accident.

Frustration was evident at the space agency yesterday when its head, Sean O'Keefe, angrily rejected comments by the shuttle director, Ronald Dittemore, that nothing could have been done to save the crew even if mission control in Houston had known.

'To suggest we could have done nothing is fallacious,' O'Keefe said. 'If there had been a clear indication of problems, there would have been no end to efforts.'

O'Keefe also said that he had learned only on Wednesday of NASA email conversations in which engineers discuss, a day before the re-entry attempt, whether chunks of insulation that hit the shuttle at take-off might cause failures in Columbia's landing gear and hydraulics.

On the tape, as re-entry approaches, one astronaut says, 'It's really neat, it's a bright orange-yellow all over the nose' – a reference to plasma, or super-heated gas, that envelops a shuttle as it hits Earth's atmosphere.

The noticing of the plasma has poignancy, because investigators have said the extreme heat observed on *Columbia*'s left side in its fatal re-entry might have been hot plasma penetrating the wheelwell.

However, O'Keefe, speaking at NASA HQ, commented, 'It's like a lot of the footage you see for every other flight, and that's the part that's most emotional about it. There is not even a hint of concern, anxiety, nothing ... It's a very emotional piece, because of what you already know, and what they don't.'

9 April 2003

RORY CARROLL

Africa starves as the world watches Iraq

Forty million Africans are at risk of starving but are not getting enough aid because the world is distracted by Iraq, the World Food Programme has warned.

In an impassioned appeal to the United Nations Security Council, James Morris, the UN agency's executive director, accused the West of double standards. 'How is it we routinely accept a level of suffering and hopelessness in Africa we would never accept in any other part of the world? We simply cannot let this stand.' The agency was $1bn (£640m) short of the $1.8bn it needed for emergency food, he said. 'We urgently need more funds in the next several

months to avert severe hunger among refugees. The mid-February shortfall was $84m. Some refugees are already receiving only half their monthly food rations.' Africa's need for humanitarian aid was greater than Iraq's, yet it was receiving less attention and less money. 'They are struggling against starvation, and I can assure you these 40 million Africans, most of them women and children, would find it an immeasurable blessing to have a month's worth of food.'

Mr Morris contrasted the British and US governments' pledges to feed Iraqis with what he considered fading concern for Africa. 'As much as I don't like it, I cannot escape the thought that we have a double standard.'

According to the agency, food shortages threaten 14 million in Ethiopia, 7 million in Zimbabwe, 3.2 million in Malawi, 2.9 million in Sudan, 2.7 million in Zambia, 1.9 million in Angola, 1 million in Eritrea, as well as millions more in Swaziland, Lesotho, Mozambique, Uganda, Congo, Democratic Republic of Congo, and the western Sahel – those countries in the dry belt south of the Sahara. Causes ranged from bad weather to warfare, but hunger had been compounded by the HIV/Aids pandemic. By weakening the immune system, the disease could turn malnutrition into a killer, one that targeted breadwinners, leaving fields fallow and families impoverished. In fewer than twenty years, the disease is estimated to have killed more than 8 million farmworkers and orphaned 4.2 million children in Africa.

'The stark message is this crisis is not going to go away. We will have a perpetual crisis,' said Brenda Barton, an agency spokeswoman in Kenya. 'We are seeing a redefinition of famine, of humanitarian crises as we know them.'

The outskirts of Kanywambizi in western Zimbabwe illustrates the point, with fields of shrivelled maize amid huts of sick, enfeebled farmers. 'All we have to eat are these watermelons. Once they are finished, that's it,' said Ngululeko Sibanda, who is twenty-three and a father of two, yesterday.

However, there is hope in the short term. Despite turmoil in Zimbabwe and fighting in Congo and western Africa, crops were planted and harvests are due. By June Zimbabwe's government expects the number in need of food aid to more than halve, to 3 million, a view shared by several aid agencies and diplomats. Once harvests are consumed, the numbers will rise again.

Malawi's needs have dwindled due to a good harvest, and some aid agencies say too much food aid has been imported. The government has been allowed to sell part of its grain reserves, though there is fear that local farmers will be ruined if food is dumped on the market.

The WFP's decision to step up its appeal is partly a political calculation: Africa's food shortage will last for years. Because aid has so far averted horrific scenes of hunger, there is a risk donors will consider the crisis resolved, especially with the distraction of Iraq. Since 11 September and Washington's war on terror, the agency has learned to shout louder in order to gain attention and funds.

'I am very concerned, because the world's attention is so focused on Iraq, that from Afghanistan to South Africa, funding for these real ongoing crises could be put in jeopardy,' said Carol Bellamy, director of UNICEF, the UN children's fund, in Johannesburg.

28 April 2003

SARAH BOSELEY AND TIM RADFORD

Aids relief for Africa

GlaxoSmithKline, the British pharmaceutical company, has slashed the price of its Aids drugs to sub-Saharan Africa and the rest of the world's poorest countries, it announces today.

The cut almost halves the annual cost of treatment with its drug Combivir to £206, which is within sight of the low price offered in the past couple of years by the generic 'copycat' companies in countries unconstrained by international patent laws.

Ranbaxy in India offers a World Health Organization-approved version of the same combination of Zidovudine (AZT) and Lamivudine (3TC) for £167 a year. Aurobindo's version, without the WHO stamp of approval, costs £128.

GSK will be hoping that the UN Global Fund for Aids, TB and Malaria, which is raising money for poor countries to buy drugs, will now allow that money to be spent on Combivir. The fund has said that its stretched resources have to be spent on the cheapest good-quality drugs. GSK may also have an eye on the new money for Aids announced by George Bush in his state of the union address. When he promised $15bn (£9.4bn) for Aids, of which $10bn was new money, he referred to Aids treatments costing less than $300 (£189) a year. At the time only the generic companies sold their drugs at such low prices.

Jean-Pierre Garnier, GSK's chief executive, emphasized that this was not its first price cut. 'These price cuts demonstrate our commitment to making vital medicines more affordable through sustainable preferential pricing,' he said. 'In June 2001, when we expanded our access programme, we promised to continue to find ways to reduce costs and pass those savings on to patients. We did that in September 2002, and today we are again delivering on our promise.'

Campaigners welcomed the decision but questioned why GSK was cutting its prices so dramatically now. 'What has happened to their existing offers?' Sophia Tickell of Oxfam said. 'I think we will find not very much when there are generics being offered at lower prices.'

GSK said it had trebled sales from 2 million people treated to 6 million in the sixty-three poorest countries between 2001 and 2002. Sales had not increased much since the last price cut, but manufacturing processes had improved.

Nathan Ford of Medecins sans Frontières put the cut down to the effect of competition from generic companies. 'It is important to point out that this wouldn't have happened in a vacuum,' he said.

Meanwhile the European Commission has been accused of giving in to pressure from pharmaceutical companies in preventing a US expert from addressing developing countries on cheap drugs. James Love, of the Consumer Project on Technology, which was set up by the radical American campaigner Ralph Nader, had been invited to a Beijing conference on patent rights and public health. 'I was told by the Chinese government that the European Commission objected

to my participation in the programme,' he says in a letter to Pascal Lamy, the EU trade policy commissioner.

He was replaced by an adviser to US drug companies. Mr Love also accused the US government of putting pressure on UN agencies to prevent him offering technical advice to poorer countries.

'I assume that the commission and my own government are doing this at the request of the European and US pharmaceutical industry,' he says in his letter, passed to the *Guardian*. 'I can only imagine why the European and US governments believe developing countries should not be permitted to hear from experts of their own choosing.'

Pharmaceutical companies agreed to allow the use of cheap copies of anti-Aids drugs in the poorest countries under the World Trade Organization's Doha declaration, which also applies to diabetes, asthma, cancer, heart disease and a number of other afflictions.

At the heart of the issue is a technical instrument called 'compulsory licensing', which enables national public health objectives to override patent interests. The legal implications have still to be explored.

Mr Love meets the Brussels commissioners to discuss Doha today. An international meeting in Geneva tomorrow will tackle the problems of financing research into the illnesses of the developing world.

29 April 2003

JOHN AGLIONBY AND SARAH HALL

The war against SARS

The world appears to be winning the war against SARS, the World Health Organization announced yesterday, though China's outbreak is still cause for major concern.

The organization declared Vietnam to be the first country officially to have contained the virus. Its impact has also peaked in Hong Kong, Singapore and Canada, the three countries affected after China. But WHO's chief of communicable diseases, David Heymann, said that the global battle was far from over.

'China will make or break this outbreak,' he said in Bangkok on the eve of an emergency East Asian leaders' summit on Severe Acute Respiratory Syndrome. As of yesterday, it has killed at least 333 people and infected more than 5,000. 'We do believe the Chinese are reporting what they know. The problem is China doesn't know a lot of what's occurring in some of the provinces, because health care is decentralized.'

China reported 203 new SARS cases yesterday, half in Beijing, and eight deaths.

Dr Heymann admitted that the WHO was still uncertain how the outbreak started, and how the disease could properly be diagnosed or treated, and said that why some countries became badly infected, and others escaped unscathed, appeared largely to be down to luck. 'We're still learning,' he said. 'We're building the ship as it sails.'

Woodhill Prison, Milton Keynes – dubbed 'Britain's Alcatraz' – where Ian Huntley, accused of murdering Holly Wells and Jessica Chapman, is held. Huntley attempted suicide in June. (David Sillitoe)

The end of an era: Brighton Pier's storm-damaged Concert Hall. (Roger Bamber)

Railway tracks, Kings Cross Station. A points failure on 16 September caused a train to derail – the day that Tony Blair opened the first section of the high-speed Channel Tunnel rail link. (Sean Smith)

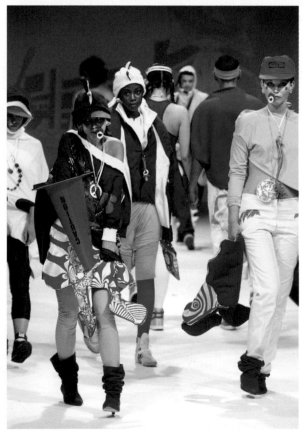

Westminster College graduates' fashion show. (David Levene)

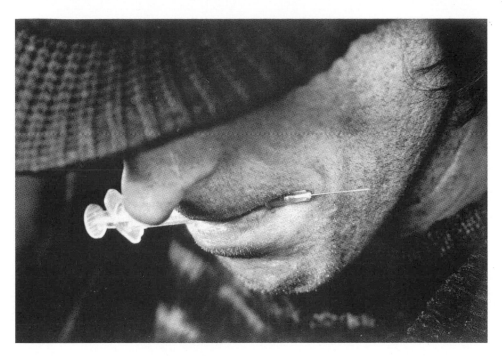

Drug addict, Glasgow. The government declared that they had increased their budget to combat drug abuse from £791,000 to £1,132,000. (Murdo MacLeod)

The 156th – and possibly the last – Waterloo Cup hare coursing event took place in Lancashire in February. (Chris Thomand)

The Conservative Party. (Martin Rowson)

Vietnam got a clean bill of health after no new cases were reported for twenty days, twice the maximum incubation, and its statistics were verified by WHO experts. The daily number of new cases is also starting to decline in Hong Kong, Singapore and Canada.

China, where SARS is thought to have originated in November, is so far a completely different situation. The WHO admits that it has no firm idea as to the scale of the China crisis or how it is spreading.

'Our major concern is that, if this disease arrives in the western provinces, where healthcare is less available than in other parts of China, it may do considerable damage,' Dr Heymann said.

Beijing, where 8,000 people are quarantined, has become a virtual ghost city in recent days, while the government has been racing to finish building what it calls a hospital but which looks more like an isolation camp for SARS victims.

Taiwan yesterday began quarantining for ten days all people arriving from SARS-affected countries.

In the last week China has become much more transparent in its reporting of cases and more draconian in stamping out the spread. Its new premier, Wen Jiabao, is attending the SARS summit in Bangkok today, along with Hong Kong's chief executive, Tung Chee-Hwa.

The heads of government are expected to endorse and perhaps expand on the recommendations made by their health ministers on Saturday: screening all departing passengers, and banning any traveller showing SARS symptoms, putting all suspects under surveillance, making all travellers from infected countries complete health declarations, and improving facilities on planes and ships to deal with SARS cases should they arise.

Passengers flying to Britain from SARS areas could also be screened, the health secretary, Alan Milburn, announced yesterday. Specific flights could be checked and passengers asked to declare they have had no contact with the disease, he told the Commons. But identifying cases was 'looking for a needle in a haystack'.

2 June 2003

LARRY ELLIOTT

Pull the plug on the G8

Remember Kananaskis? No? Course you do. It was that resort high up in the Canadian Rockies where the G8 ponied up for their talkfest last year. Nice scenery, vacuous communiqué. The one where Oxfam International described the outcome for Africa as 'recycled peanuts'. Remember it now?

If that still doesn't ring any bells, then how about the previous year? Who could forget Genoa? Yes, you've got it – the tear gas billowing through the streets, the anti-globalization protester shot dead by the Italian riot police, the city sealed off and turned into a ghost town. Good TV pictures, shame about the communiqué.

And so it goes on. When the summit was last in France seven years ago, the Michelin-starred chefs of Lyon were wheeled out to do the cooking. A year later Bill Clinton shamelessly used the gathering in Denver to boast about the glories of America's new paradigm. The 2000 summit was in Okinawa, chosen by the Japanese to be as inaccessible as possible – and sited on the same island as a US military base – while the one before that was in Cologne.

To be fair, that was the last time the G8 did anything of note, but only because it could no longer ignore the public demands to cut the unpayable debts of poor countries. Needless to say, the promise of a $100bn package was a smoke and mirrors exercise, inflated by debt relief already in the pipeline. Equally predictably, less money has been delivered than was pledged. Even so, it was better than nothing.

To understand how G8 summits have become exercises in political opportunism, you need look no further than last year's farce in Kananaskis. In the build-up to the event, aid agencies and African governments were convinced the meeting would herald a breakthrough. It was billed as a 'something for something' occasion, in which the West and Africa would sign up to NEPAD – new partnerships for Africa's development. The Africans would clean up their governance, root out corruption and pursue sound economic policies, while the West would front up with some serious dosh. Delegations from Africa duly turned up, bent the knee to the G8, and went away with an extra $1bn to top up the global fund for debt relief, plus a few extra billions that had already been pledged at least once.

This was the cue for Oxfam to put out its soundbite about recycled peanuts. It was also the cue for Downing Street to go ballistic, complaining that the prime minister felt personally let down by the criticism after all the political capital he had expended. The source of the 'recycled peanuts' gibe was particularly hurtful: Oxfam tends to be the NGO that prefers to get things done by schmoozing with politicians rather than hurling brickbats at them. If not tamed, Downing Street at least believed it had the charity house trained, but it was wrong.

This year's event is much healthier. The bad blood between George Bush and Jacques Chirac means that the pretence has been stripped away. There is little virtue in a talkfest if the participants are not talking to each other, and the fact is that Bush can barely bring himself to talk to Chirac and Gerhard Schroder. The feeling is almost certainly mutual, despite the stiff greeting Chirac gave Bush when he arrived yesterday.

There are big issues for the G8 to confront, but it is even less likely to do so this year. It could call for coordinated action to boost the global economy, putting pressure on central banks to intervene to bring order back to currency markets. It could admit the global economy is in a mess and that securing low inflation is no longer the yardstick of success in a time of deficient demand. It could grab the Doha round of trade negotiations by the scruff of the neck, with the four European members of the G8 agreeing to support the phasing-out of export subsidies in exchange for a US commitment to do the same with export credits. It could – after all the years of faffing about – provide the resources the UN development programme says are necessary if the targets for human development are to be met by 2015.

A handful of African leaders were invited to dinner with the G8 last night but

once again, are likely to leave with only crumbs from the rich man's table. Crumbs are no longer enough. As Mark Malloch-Brown, the administrator of the UNDP, said last week: 'There has to be a serious commitment to finding a mechanism for doubling aid.'

The G8 could do all these things but will do none of them. Instead, there will be the traditional platitudinous communiqué, cooked up by sherpas in advance, barely looked at by the summiteers themselves and forgotten the moment their planes take off. They will pledge themselves to non-inflationary growth, fighting terrorists, tackling money launderers, getting tough with drug smugglers and providing the necessary resources for education, health and nuclear safety. It will, of course, express horror at the spread of HIV/Aids. None of this matters, because the G8 has long ceased to be relevant.

Back in 1975, when Valéry Giscard d'Estaing organized the first summit, a combination of the Vietnam War, Watergate and the first slump in the global economy since the Second World War was putting the international system under considerable strain. There was a justification for Western leaders getting together to find common ground.

Over the years, however, it has become clear the G8 has become a talking shop. In recognition of this, the duration of the summit has been cut from three days to one and a half, and an attempt has been made to 'get back to basics' by dispensing with finance ministers, foreign ministers and many of the bag carriers, pen pushers and other officials who turned up for their annual jaunt.

But the reality is that anything the G8 can do some other body can do better. Managing the global economy can be left, in theory at least, to G7 finance ministers and central bank governors. The WTO does trade, the IMF and the World Bank do debt relief, the UN does security. Only if the G8 talkfest produces a political pay-off in one of those bodies can it justify its existence. But a talkfest where the participants are not on speaking terms is hardly worth the bother, not to mention security costs now the occasion has become a focus of protest.

In retrospect, the G8 should have called it a day after Genoa. It was evident two years ago that a couple of photo opportunities and some political grandstanding was a poor return for all the hassle. Kananaskis was an attempt to see whether in a remote hideaway, the G8 could get back together. But sadly, this was not like The Beatles coming up with *Abbey Road* after the shambles of *Let It Be*. Kananaskis showed the limitations of the G8 approach, and Evian will finally expose it as an exercise in posturing and political cynicism.

One way for the G8 to reinvent itself would be to change the membership. The idea, for instance, that the summit could be representative of what's happening in the age of globalization without including China – and perhaps India and Brazil as well – is laughable. A summit that included African countries as equal members rather than second-class citizens might have merit, because in a talking shop, imbalances of power and wealth between developed and developing worlds matter less.

Who knows, before Bush makes an early departure today, the summit may have cracked trade talks, delivered for Africa, settled its differences over Iraq. But don't bank on it. Expect instead the same old guff, followed by the depressing news that the party will reconvene next summer in the US. Which it will, unless

Bush decides he has better things to do than to host the diplomatic equivalent of *Abigail's Party* at a luxurious log cabin on top of a mountain, and pulls the plug. It would be a blessing for us all.

6 June 2003

GARY YOUNGE

Scandal at the *New York Times*

The editor of America's most venerated newspaper, the *New York Times*, resigned yesterday after one of the most embarrassing journalistic scandals in American history prompted severe criticism of his managerial competence and abrasive style.

In a hastily arranged and highly emotional ceremony in the paper's third-floor newsroom, during which some reporters sobbed, Howell Raines, sixty, announced his resignation, picked up his straw hat from the office he had just vacated and left the building with his wife. According to the *New York Times* website, Raines told his former staffers: 'Remember, when a great story breaks out, go like hell.' The paper's managing editor, Gerald Boyd, fifty-two, who was appointed by Raines, also resigned.

The paper's publisher, Arthur Sulzberger, told the staff: 'Given the events of the last month ... Howell and Gerald concluded that it was best for the *Times* that they step down. This is a day that breaks my heart.' He wanted to thank the pair 'for putting the interest of this newspaper, a newspaper we all love, above their own'. Raines's predecessor, Joseph Lelyveld, will take over while a replacement is found.

The paper's top two editors are the most senior casualties to date of a scandal that erupted five weeks ago when the *Times* discovered that Jayson Blair, a 27-year-old reporter, had 'committed frequent acts of journalistic fraud'. An internal investigation of Blair's work revealed a litany of plagiarism, deception and inaccuracies relating to thirty-six of the seventy-three articles he had written between October 2002 and April this year.

Blair's resignation on 1 May was followed by a front-page story and a humiliating correction inside detailing his fabrications in more than 14,000 words on four broadsheet pages. Blair would later boast that he had 'fooled some of the most brilliant people in journalism'.

In a journalistic culture that worships at the altar of objectivity and prides itself on accuracy and accountability, one cannot overestimate how deep a blow the Blair ordeal was for the *Times* or how widespread the ramifications of it would be. In a world where factcheckers are commonplace and corrections columns have been in place for decades, this was regarded not as an individual aberration but as a systemic failure. The scandal has caused other newspapers, including the *Chicago Tribune* and the *Buffalo News*, to call staff meetings to examine their working practices.

The investigation made it clear what Blair had done; the more difficult

question was how had he been able to get away with it for so long. Many fingers pointed at Howell Raines. The mood in some parts of the paper after the debacle was a mixture of sombre and seditious. Some reporters and editors argued that Raines's bullish management style, crusading editorial approach and desire to promote youth and energy over age and experience had all contributed to Blair's promotion and the paper's failure to prevent his fraud.

A few days later Mr Sulzberger held a staff meeting at the Astor Plaza Theater, just around the corner from the *Times* offices, so employees could question Raines and Boyd in person. One of the paper's writers, Joyce Purnick, described it as a 'raw, emotional and candid session'.

'I believe that at a deep level you guys have lost the confidence of many parts of the newsroom,' said Joe Sexton, a deputy editor of the metro section, which covers the New York area. 'I do not feel a sense of trust and reassurance that judgments are properly made ... People feel less led than bullied.'

Questions were also asked about the paper's affirmative action policies. Blair is black and some journalists argued that he had been overpromoted because of the paper's desire to elevate reporters from ethnic minorities.

Raines entertained the suggestion: 'You have a right to ask if I, as a white man from Alabama, with those convictions, gave him one chance too many,' he said. 'When I look into my heart for the truth of that, the answer is yes.'

The meeting offered Raines, not known for being self-effacing, a rare opportunity for contrition. He took it. 'I'm here to listen to your anger, wherever it's directed,' he told his staff. 'To tell you that I know that our institution has been damaged, that I accept my responsibility for that and I intend to fix it ... I was guilty of a failure of vigilance that, since I sit in this chair where the buck stops, I should have prevented.'

But if the meeting provided the opportunity for a post-mortem examination on the Blair scandal, Raines also saw it as a chance to acknowledge concerns about his editorship after almost two years in the chair. He took up the post, with the official title of executive editor, in early September 2001 – a week before the terrorist attacks on the World Trade Center. The paper's coverage of the attacks was lauded and won six Pulitzer prizes. But his management style, at times insensitive and autocratic, alienated many. Several senior national correspondents left – one, Kevin Sack, went on to win a Pulitzer for the *Los Angeles Times*. Raines wanted to make it clear that he was aware of the criticism.

'You view me as inaccessible and arrogant,' he said. 'I heard that you were convinced there's a star system that singles out my favourites for elevation. Fear is a problem to such an extent, I was told, that editors are scared to bring me bad news.'

A business reporter, Alex Berenson, asked him if he had considered resigning. Raines said no, or at least not unless he was asked to by Mr Sulzberger, who was sitting next to him. He would not accept the resignation even if it were offered, Mr Sulzberger said.

Quite what happened in the intervening three weeks to change their minds is not clear. An internal review of reporting practices and management checks and balances was ordered, but the paper started to implode under the weight of internal rancour and frustration.

More scandals and scalps followed. Last week one of Raines's favourites, the Pulitzer-winner Rick Bragg, resigned days after the editor suspended him with pay. Bragg admitted that an unpaid assistant had done virtually all of the reporting for a story on oyster fishers in Florida for which he took full credit. Bragg said such practices were commonplace; his colleagues publicly disagreed. Other freelancers who had worked for the paper said they too had been denied bylines. It also became apparent that the main source on Iraq's weapons of mass destruction programme for the paper's bioterrorism expert, Judith Miller, had been the Pentagon's favoured Iraqi, Ahmad Chalabi. That in turn suggested that the Pentagon and Mr Chalabi had used the paper to help create the justification for war.

Raines spent the past few days trying to win over some of his sternest critics within the paper, arguing his case over dinner and in private.

'Everyone is kind of stunned,' said one reporter. 'These are two guys who put their whole life into the paper and they certainly didn't set out to do anything bad. My first reaction was maybe this would allow people to move on, but none of it's good really.'

Whether the resignations will quell the controversy remains to be seen. 'I think the focus now becomes Arthur Sulzberger,' said the *New York* magazine critic Michael Wolff. 'And, in fact, I think that's the root of what's happened here. It's all about survival of the publisher at this point.'

21 June 2003

JOHN GITTINGS

Goodbye to China

I thought for a moment that I was going to be 'liberated by the masses' from my temporary jail in the north Chinese countryside. The wooden doors to the courtyard where I was being held were flung open by three or four broad-shouldered peasants, who advanced upon my captors. A crowd of murmuring villagers followed them. Their advance slowed to an uncertain halt. Faced with the village policeman and some junior police officers from the nearby town, my new friends hesitated and, without a word on either side, drifted back outside again.

I was left to contemplate my crime: I had not applied for permission (which I knew I would be refused) to visit this village. I would have to wait for more senior officials to arrive so that I could be interrogated, sign a ritual confession and be put back on the night express to Beijing. It was dark before they came, and we had to do the stern questioning and the confession by candlelight. When I finally left, the peasant crowd was still milling restlessly outside under the stars.

The villagers' silent protest reflected the deep hostility felt by many rural Chinese towards the cadres who so often bully and over-tax them. They did not know whether I had broken the law or not, but they were on my side.

Yet the lesson is not that China is ruled by a totalitarian machine with an all-powerful grip. If I had not lingered in the village too long and been caught by

the local cop, no one in Beijing would have complained about the story that I wrote afterwards. Chinese bureaucrats usually do not want to be bothered – and many believe the rules are outdated anyhow. One young official with the job of monitoring what the British press writes about China regularly tones down his summaries: 'There's no point in upsetting some old guy among the top leaders,' he explains.

A quarter of a century after Mao Zedong died (and since I began to report regularly from China) the country is still in a process of uneven transition where the reality is often not what it seems. Trying to understand this is made harder by the wooden propaganda in which the Communist party is always 'great, glorious and correct'. It is equally complicated by the crude stereotypes – often dating back to the Cold War – that still mould many Western perceptions of China.

Too often the complexities of life in China are reduced to what I came to call, during my last five years' reporting from Hong Kong and Shanghai, the 'babies-in-ditch' cliché. Yes, babies, especially unwanted female ones, do get abandoned: they also get sold. (The village where I was arrested was a baby-selling centre: the story had already been exposed in the Chinese press.) Yet babies also get rescued from ditches and from the dealers, by passers-by and by dedicated welfare officials and police. Many of them get adopted too – often by couples who 'want a girl'. In a village outside Beijing, disabled children from a city orphanage were fostered by rich farming families who did not really need the modest subsidy they gained. Once the kids reached sixteen, they were supposed to go back to the city, but the house mothers had a different idea. 'They've become part of the family now: we can't let them go!'

The foreign media exposes – rightly – the plight of the millions of Chinese workers laid off with miserable benefits from failing state-owned industries. Yet for years, Western diplomatic sources, quoted by the same media, have insisted that China's readiness to dismantle its 'unprofitable' state industrial sector is a key test of its 'commitment to reform'. We have drawn attention – correctly – to the pitiful state of China's rural medical services, which would be quite unable to cope if the SARS virus spread deep into the countryside. Yet when China took the quasi-capitalist road under the rule of Deng Xiaoping, there was widespread applause for its wholesale rejection of the socialist values of the past – including the rural 'barefoot doctors' whose absence is now deplored.

In judging Chinese foreign policy too, Beijing's 'rationality' is too often measured by a partisan pro-US yardstick. In 1999 it was accused of stirring up xenophobia when many Chinese objected loudly to the American bombing of their embassy in Belgrade. Their genuine anger at the US spy-plane episode in April 2001 was also said to have been orchestrated. The real surprise should have been the speed with which Beijing patched up the dispute with a new US administration that had already sounded an unfriendly note towards China.

On the night of 11 September, China was accused of reacting callously because the state TV did not carry live coverage from New York (though several provincial stations that I watched in Shanghai pirated CNN to do so). The reality was that China joined the US-led 'war on terror' very quickly, and has kept its criticism of the Iraq war strictly muted. In Beijing I witnessed recently how the only Chinese demonstration against the war was squelched by police, while

a march by foreign residents was tolerated for just twenty minutes.

China's missile deployment and its formal refusal to 'renounce the use of force' are cited as a threat to Taiwan. Again, the real story should be Beijing's failure to do more than verbally denounce the pro-independence government.

Many Chinese who are critical of their own government still find Western coverage unbalanced. 'I object strongly to the persecution of the Falun Gong and other human rights abuses,' says a graduate from an MBA programme in the US, 'but I simply did not recognize my country in the one-sided reporting there.' Chinese officials tighten a vicious circle of misunderstanding further by blocking the kind of access that would give a more balanced picture. A foreign NGO working in Yunnan province on HIV/Aids tried for nearly a year without success to get permission for the *Guardian* to cover its project. 'The irony is that the authorities there are doing really good work,' said the project director.

I believe, however, that the speed of change in China is now so fast that within the next decade the stereotypes will be shattered – on both sides.

Many aspects of emerging capitalism in China are as raw and bloody – and as historically inevitable – as when Marx chronicled them 150 years ago in Europe. Western manufacturers (and consumers) benefit from the comparative advantage of cheap Chinese labour, while shaking their heads when another sweatshop with barred windows catches fire and a dozen more workers die. Yet the migration of between 70 million and 100 million migrant workers to the cities will create a reverse flow of social awareness transforming rural life. Many young rural women are already less willing to accept the male domination of family elders.

We frown on the ugly glossiness of the new urban China, with its extremely rich who build replicas of the White House on their estates and squander millions in the casinos of Asia. More significant in coming years will be the growth of a better-educated middle class with more modest aims and a much greater social identity.

Foreign China specialists are wary of making predictions about the future – we have often been wrong in the past – leaving the field to a small number of doomsday forecasts about the 'collapse of China'. Certainly the Communist party is still moving too slowly and its brutish instruments of repression remain mostly unaccountable. Yet a series of shocks, from the 1998 floods to this year's SARS crisis, have already forced the leadership to show more concern for the rich–poor gap, the deprived inner provinces and the environment.

I believe that younger forces in the party and outside will prevail and that China has a better chance of making a peaceful transition. The determined young journalists whom I got to know and the cheerful students my wife taught offer the best hope for the future.

John Gittings has recently returned from Shanghai, after twenty-five years reporting for the Guardian *on China.*

SKIRMISHES AT HOME

Austin

20 September 2002

POLLY TOYNBEE

Tories on the march

Class war breaks out on Sunday when toffs in pink with hunting horns ride into town in their hundreds of thousands and the gentlemen's clubs of Pall Mall throw open their doors – just as they once barricaded them against the Jarrow marchers. Boys of Harrow and the Eton College Beagles will be let out for the day. A wild bunch of right-wingers of various demeanours will join the affray, from Jim Davidson, Vinnie Jones and Frederick Forsyth to Roger Scruton and Simon Heffer. Even the white farmers of Zimbabwe yesterday said they would join their kith and kin. Townies besieged by the braying class enemy have only their window-box trowels to do battle with these marauding aristos.

The Vesteys (27,000 acres), the Devonshires (12,000 acres) and other gentry have thrown down the gauntlet: these outlaw barons will defy the law and carry on hunting within their own great estates. The *Daily Mail* is urging its readers to march, the *Telegraph* is calling its old folk out with the squirearchy. *Country Life*'s clarion call is 'People of the countryside unite!' (They have nothing to lose but the 90 per cent of Britain's landmass that they own.) This is the Tory rump on the hoof.

But times have changed. Remember how shaken New Labour was by the first countryside march. Yet more farm subsidies were hurriedly strewn in their oncoming path. Michael Meacher, in his best working-class agrarian flat cap, was sent out to pretend to be one of the hunt servants. When they besieged the Labour party conference the next year, the Cabinet trembled. But this time the government is not in the least rattled. Battalions of Barbours marching down Whitehall will make no blip on Downing Street's radar: Desert Fox is more pressing that foxhunting. Why should the government worry? Banning hunting is hugely popular – that is why they are doing it. A touch of class war before the party conference helps remind the troops who the enemy is. Rabid press notwithstanding, the great townie majority will look on bemused at these Don-Quixote-like anachronisms.

There is something almost touching about the Countryside Alliance's ineptitude. It does not help that their most just cause is also their least popular – the liberal-minded should recognize that banning hunting is illiberal and unfair. Even townies who despise hunting should not stop other people doing it, any more than banning lap dancing. (Eating an indoor-reared ham sandwich or a battery-laid omelette causes more prolonged cruelty than the grisly but short death of a free animal). Sentimentality and class hatred are not good enough reasons, enjoyable though class war can be. If only it was war over something that mattered, such as robust taxing of incomes over £100,000 and an inheritance tax to sting the great estates and distribute land to the National Trust (which owns just 1.3 per cent).

Liberty (the hunters), starting out at Hyde Park have been separated out from Livelihood (the farmers), to divide the hated hunters from the nation's supposedly beloved Farmer Gileses. But farmers have even less purchase on public affection: the landed toffs who run and fund the Countryside Alliance are the same people who fought against the right to roam, still strictly limiting access. Three-quarters of farmers own their land – and they can hardly claim poverty while land values continue to soar. There are worthier causes for public sympathy than farmers who own land collectively worth £38bn in 1991, £84bn in 1997, £93.5bn in 2000 and still rising fast. It may be sad when old farming habits are no longer profitable, but landowners ought to be taking their march through some of London's worst housing estates to get things in perspective. They are among the worst Nimbys when it comes to townies building new estates in their treasured villages, yet they eagerly sell up to developers for vast profit if they can get planning permission on their own land. They even have a unique tax break rollover deal, worth over £1bn a year, which ensures they never pay capital gains tax on the land they sell to developers.

Poor farmers, the 30 per cent who are tenants with no land of their own, are another matter. No doubt the Countryside Alliance will push them forward whenever possible, for their plight is hard. Average agricultural incomes have sunk to under £10,000 a year – many far lower, below the minimum wage. A world glut has produced the worst recession since the 1930s. But already their £3bn CAP subsidy outstrips anything other struggling industries get. With farming worth only 0.7 per cent of GDP, no government will offer more.

As for the 'rural way of life', for the great majority, it's pretty good. Only 2 per cent of them work in agriculture, only a fifth of those are tenant farmers. Rural poverty is less pro rata than in cities. There is rural crime, but far less of it. Country dwellers are statistically richer, happier, better educated and the envy of city dwellers, most of whom dream of retiring there but will never afford to. Meanwhile more new money is flowing into rural areas for buses and keeping Post Offices and schools open. Farmers are inclined to forget that their incomes can go up as well as down. Between 1990 and 1995 agricultural incomes boomed by 100 per cent. Since 1995 they have dropped by 71 per cent, crippling many. They have to diversify to survive a world glut. They have to start producing food as attractive as the French, Italian and German delicacies that fill supermarkets.

I asked the National Farmers Union what was the most important remedy for the current recession. Their economist gave one overriding solution – joining the euro and bringing sterling down, in line with mainland Europe, which takes most agricultural exports. Every 1p that sterling rises above the euro loses the farmers £100m. 'Joining would see the farmers through this. Agriculture has lost £5bn as a result of not joining.' So why are the farmers not marching for the one thing that would save their bacon? Will there by any banners demanding immediate entry to the euro now? The NFU economist sighs. 'Farmers are also citizens, and they are, well, Conservative. It's a political and social issue as well.'

And that sums up the Countryside Alliance's many problems. They are Tories on the march, outraged and uncomprehending at how Labour holds power while they own the land. They are rightly distraught at a recession harming their industry yet they avoid calling for the euro, the one thing that would help

them. They are right about their right to hunt, wrong about their right to more subsidy. Townies are their customers, yet they bar them from their land and hold them in contempt. They may own the country, but it's just as well they no longer run it.

21 September 2002

MARTIN WAINWRIGHT

Heroin fills the void

A roomful of ex-miners and their families sat in tears this week as a neighbour haltingly described the latest agony to befall Britain's former coalfields. Five young people have died from a 'modern plague' of heroin abuse in the string of villages round Worksop whose names, such as Manton and Shireoak, recall the lost battles of the 1984–5 coal strike.

Across the road from the town hall, the People's Place drop-in, founded to help young homeless, reports that 492 of its 546 users are on the drug. So are 92 per cent of clients brought before magistrates by the probation service. The town's Labour MP, John Mann, reckons that every third constituent is affected by either heroin abuse in the family or the crime wave needed to meet dealers' bills of – at the minimum – £16,000 per addict per year.

Mann's unique three-day public inquiry at the town hall laid bare what he described as 'communities which have had their pride and prop removed'. As he and a panel including a clergyman, a young councillor, businesswomen and a grandmother took evidence, a picture emerged that set conventional assumptions about regeneration aside.

'Jobs are not the point,' says Mr Mann during one exchange, when it emerges that Worksop's pretty, tree-lined streets have only 3 per cent unemployment, which would be nil if so many potential craftsmen and technicians were not knocked sideways by unmanaged heroin. The new MP has encountered this directly as an incomer from Leeds. 'I've been through the whole thing setting up my office,' he says. 'It's been a struggle to find a plumber, an electrician, a joiner.'

The weak spot, relentlessly targeted by pushers from Nottingham, Doncaster and Leeds has been psychological, not economic, agrees Sandy Smith of Hope for the Homeless, which runs the People's Place. She says: 'There's a failure of aspiration in families where dad, grandad and great-grandad were miners, but now there's no pit to go to any more. There's no tradition of moving away to try something else. And this is a generation which saw its parents very obviously defeated.'

A fat file of research compiled for the inquiry, whose written submissions include one from Tony Blair, paints the pit villages (in reality monotonous housing estates) as islands with 'a cohesion, a reliance on a single industry and an independent existence. That was their greatest strength when the mines were producing and is now their greatest weakness.' Everything collapsed with coal.

As Mr Mann puts it: 'We've got inner city problems but we haven't got a city to deal with them.' The gaps in provision will be the second lesson to go from the inquiry to the Home Office.

As for official provision, Mr Blair's sympathetic letter speaks hopefully of the local drug action team, one of 150 that are the government's main structural weapon for combating drug abuse. Its budget, he says, has increased this year from £791,000 to £1,132,000. But problems between its multi-agency members (councils, health authorities, police) leave the inquiry wondering how much of this money is going to estate agents and surveyors: three years after starting to look for a local anti-drugs base in Worksop, the team still has not found one.

'If this was a business, it would have gone bust,' says Mr Mann, to growls of approval in the town hall's assembly rooms. 'If I hadn't found myself an office here after three years, people would be looking for another MP. What's going on?'

A witness from Bassetlaw district council answers haplessly but honestly: 'We're in the middle of a statutory public consultation, which means we haven't got an official policy on anything at the moment.'

The funding context is meanwhile a government-required system of bidding for extra provision, which leads to lurches between sudden extra resources and equally sudden gaps. An addict can be released, heroin-free, from well-funded Ranby Prison to nothing, says Mr Mann. 'Without help, the first thing they do is buy a wrap. For God's sake, do we have to bid for GPs or elderly people's services? Why for dealing with drugs?'

Meanwhile at the People's Place, where the roomful of addicts get a steaming hot pie with potatoes and veg for 10p, talk is of 'vigilantes' who ambushed and beat up a series of heroin abusers. The criminal damage inflicted by addicts, who need an estimated £70,000 in stolen goods to make their annual £16,000, causes fury in the wider community. The drugs inquiry is not popular with many passers-by, who see resources going to wastrels.

But the report will ask less for money than for organization. 'Above all, we need seamless treatment,' says Mr Mann. The panel will also call for raising aspirations in local primary schools, expanding them into village centres to replace dead King Coal, and try to prevent a second lost generation.

10 February 2003

RAEKHA PRASAD

Refugee camps don't work

Labour's new colonialists have conquered another territory: asylum policy. With immigration surging up the political agenda, Tony Blair wants to establish and fund UN 'protection areas' for refugees so that Britain can deport most of the 100,000 asylum seekers that arrive here each year.

Such areas, officials claim, will be temporary shelters erected in countries next to states that generate human traffic. Countries producing refugees will be

encouraged to desist – first by using diplomacy, then with aid and finally with force. The thinking is clear: if the prime minister cannot control this country's borders, he will control somebody else's.

Yet history has already shown that such efforts are misguided – as Ruud Lubbers, the head of the UN High Commission for Refugees, could tell Mr Blair when he meets him today. To suggest that asylum seekers would stay in UN special protection areas for only six months while, as the plan states, 'the position in their home country stabilizes' is to ignore the facts.

For decades, from sub-Saharan Africa to Sri Lanka, more than 6 million of the 10 million refugees in UNHCR care have been trapped in exile, unable to return home or settle in their country of asylum. Sending more people back to poor nations will only add to the burden on developing countries, which already cope with 72 per cent of the world's refugees.

In all but name, Britain is proposing a new network of refugee camps – designated areas where those inside have different rights from those outside. To envisage such a plan is to imagine ghettoes created by the world's most peaceful and richest countries in some of the world's poorest and most unstable regions.

Mr Blair's ambition is impressive. His officials openly call for the UN refugee agency, weakened over the years by dwindling contributions from the West, to be 'moulded ... more as we wish it to be'. To do so, cash will be offered to Mr Lubbers by like-minded nations from Europe. But Australia, whose 'Pacific' solution is to keep asylum seekers off the country's shores and threaten military action against its Asian neighbours, emerges ominously in the plan as Britain's most wanted partner.

The scheme to undermine the UNHCR and to wage war is coated with the words of benign intent. Leaked Cabinet Office papers have civil servants talking of 'not washing our hands' of genuine refugees and not 'dumping' asylum seekers on the developing world. Yet once refugees were out of the public's sight and mind, there would be little political or legal pressure to keep sending cash abroad so that potential immigrants could be fed and sheltered.

British politicians might well water down vague promises to take back people whom they had sent away. The developed world's track record on repatriation and resettlement is marked by self-interest and political expediency. Refugees from the world's forgotten wars – the 250,000 who fled Azerbaijan or the 1 million living in camps in Tanzania – will remain unseen and unhelped. Refugee camps become easy targets for military strikes from neighbours, which consider them fertile ground for rebels, and there would be little impetus for Western powers to intervene in these remote, low-level conflicts.

Even where the West has created the problem, there is little sign of the great powers riding to the rescue. The tragedy of 350,000 stateless Palestinians in Lebanon was created with the help of British hands. The result is enmity between people who previously had none, leading to an Israeli invasion and a civil war. As with the new plan, the twelve camps in Lebanon were never intended to be permanent. But four generations of refugees have now been born there, segregated from the people and economy of the host country. Even when the new interventionism has apparently triumphed, populations remain

displaced – afraid to return to the scene of conflict and massacre. Despite efforts to encourage 250,000 Serbs to return to Kosovo, there has been little take-up of the right to return. Two million Afghans have gone home after two decades away, but 4 million remain abroad, unconvinced that the West will stick around to rebuild a nation it reduced to rubble.

Mr Blair's plan reflects not others' preferences but his own. The rationale is that once Britain has transported its Kurdish asylum seekers to Turkey or sent Algerians to Morocco, its populace will no longer seethe with resentment against newcomers. But other poorer people's will.

The paradox of an interdependent world – one of Mr Blair's favourite themes – is that the ability to control immigration has decreased as the desire to do so has increased. This fact lies unrecognized by the government. Instead, its proposals for changing the European convention on human rights float the idea that the 'notion of an asylum seeker in the UK should die'.

New ideas are needed to tackle the inequality and hopelessness that drive people to risk death by crossing borders, but meddling in the affairs of sovereign nations and creating no man's lands in some of the world's poorest regions is not the answer.

17 February 2003

RICHARD WILLIAMS

A flood of feeling

Somebody called it a movement. It was not a movement. It was a feeling. A feeling that drove wave after wave of people in a great river, which began to flow a few minutes before noon and was still in full flood long after nightfall.

What astonished everyone who marched on Saturday – let's settle on a million, shall we? – was the apparently limitless variety of those with whom they shared the roads of central London. Not just a diversity of banner-bearing interest groups but of individuality, brought into focus by the single underlying feeling that gave this day its resonance.

That feeling was one of a generalized dismay directed squarely at the country's leadership. If you wanted to attempt the impossible task of identifying a typical marcher, you would probably settle for the middle-aged white man who marched past the barricaded end of Downing Street at about 1 p.m. carrying a hand-lettered sign. What it said, in neat black letters about six inches high, came closest to summarizing the message of the day: 'Labour Party member no. A128368 against the war'.

For although the river of people carried all kinds of flotsam and jetsam, the undercurrent was a mighty dissatisfaction with the performance of a leader who, 400 miles away in Glasgow, was at that very moment attempting to justify a stance that few appear to comprehend.

Whatever else it may have been, the march was a great shout of protest against a man for whom most of those present had voted in the last two general

elections. After the long, alienating years of Thatcher, Tony Blair presented himself as one of us, part of the culture of modern Britain. But now one piece of foreign policy has provided the catalyst for the release of pent-up disenchantment. On Saturday all the dinner-party groans of anger – at the failure to restore the public services to something approaching a source of pride, at the corrosion of public trust by the incessant use of spin and at the publicity conscious consorting with charlatans and conmen – finally merged with the dismay over Iraq in this long warning cry.

Slogans dominated the day, but they were beside the point. Simple answers will not do, and the hundreds of thousands of placards distributed at the starting points served to diminish rather than amplify the impact of the gathering of so many people on a single pretext. In themselves, the people were enough. As Lambeth College students came into view, marching past the Houses of Parliament behind a black banner 30-foot wide, their faces were a snapshot of modern Britain, no two seeming to share the same pigment or physiognomy. This is today's reality, a London where three of your next four transactions are likely to be conducted with people for whom English is not their first language. Disturbing to some, this astonishing diversity contains the potential for great beauty, and it was the beauty that revealed itself on Saturday.

The echoes of history were everywhere, many of them relevant to the subject of the day. On the Embankment we awaited the noon start in the shadow of Cleopatra's Needle, presented to the British nation in 1819 by Mohammed Ali Pasha, an Albanian army officer who had appointed himself viceroy of Egypt. A year later Mohammed sent his army to invade and enslave Sudan, with British approval. His great-grandson, Said Pasha, ordered the construction of the Suez Canal, the location of Britain's last great imperial misadventure.

Around the foot of the Needle, and up and down both sides of the boulevard, the preparations were under way. Vendors sold whistles and hooters for a pound apiece, their faces familiar from less exalted events. Stalls were offering the literature of the Global Women's Strike, the Movement for a Socialist Future, the Palestine Solidarity Campaign. Stacks of placards waited to be picked up, advertising the movement's organizing bodies: the Stop the War Coalition, CND, the Muslim Association of Britain and the *Daily Mirror*. But it was the homemade banners that bore the most striking messages. 'Peace and justice in east London' said one, carried by an elegant woman in a long black cloak. A white dove and a green olive branch adorned the violet silk banner hoisted by the Worthing and Lancing branch of the Women's International League for Peace and Freedom. Two middle-aged men carrying the bright red banner of the WRP Young Socialists were being followed by a dozen boys of mixed ethnicity, their faces half-obscured by scarves in the manner of the intifada or Italian football hooligans. Humour broke through, much of it very English: 'Make Tea Not War', 'Who Do You Think You Are Kidding, Mr Blair?', 'Stop Mad Cowboy Disease', 'Down With This Sort Of Thing', 'Peace Not Slogans'.

As we shuffled under Hungerford Bridge shortly before noon, a sustained cheer rang off the stone arches. Behind us hundreds of thousands were still making their way to London in coaches and trains, some of them listening to radios as Blair explained why they were wrong.

The first bottleneck came beneath Big Ben, the chimes of democratic free-
dom striking twelve times as we wheeled through 180 degrees into Whitehall,
stepping around photographers lying on the asphalt, looking for shots of ban-
ners and the clock tower clustered together against the sky. A chant of 'No war!
No war!' rose as we passed under the blank gaze of the mother of parliaments.

Beyond the memorial to the glorious dead of wars whose origins are now cut
and dried, the barricades narrowed and the pace slowed again as the march
ground past Downing Street, guarded by twenty policemen and one police cam-
eraman, the high steel gates and the raised traffic barricade a reminder of other
domestic conflicts. Spontaneous cheering and whistle-blowing now swept
through the crowd, a kind of Mexican wall of sound.

Turning into Trafalgar Square, past a man standing on the steps of a bank
holding a large piece of greenery and a sign reading 'English Bush – Harmless',
there was the first glimpse of the march's other column, which had descended
from Bloomsbury and along Shaftesbury Avenue. On Cockspur Street a red,
heart-shaped balloon with white doves hand-painted on its sides escaped its
owner's hand and soared gracefully beyond the roofs and into the sky, a
moment of wordless poetry watched by a thousand pairs of eyes.

As the columns merged at Piccadilly Circus, the colour and the noise redou-
bled. The contrasts between the non-aligned and the activists sharpened, and
sudden eddies of activity began to agitate the flow. Outside St James's church,
the banners of the Spartacist League proclaimed the many priorities of all good
Revolutionary Trotskyists. Two dozen young men and women carrying red flags
stencilled with the word 'Revolution' moved into a jog as they passed the Royal
Academy, chanting, 'Who let the bombs out? Blair-Bush-Shar-*on*!' and a varia-
tion on an old Vietnam jingle: 'Blair, Bush, CIA – how many kids did you kill
today?' Throughout the march the chants were seldom spreading beyond their
groupuscules, emphasizing the diversity.

At Hyde Park Corner the column halted for many long minutes. Then pass-
ing through the Queen Mother's jolly wrought-iron gates, we were serenaded by
an elderly couple with an accordion and a tambourine, singing 'Give Peace a
Chance'. Apparently they kept it up all day, which would have amused and
delighted its composer.

Inside the park, suddenly feeling the bite of a chill wind under a slate-grey sky,
the marchers stood and listened to speakers whose delivery seldom lived up to
the occasion.

What we wanted was Hans Blix, with his calm, methodical recitation of facts.
What we got was Tariq Ali, his flamboyant silver hair set off by a pink pashmina,
declaring that Britain was the country in need of a regime change. And Tony
Benn, telling us that we were founding a new worldwide political movement,
while Charles Kennedy eschewed populist soundbites in favour of a standard
Lib-Dem party political broadcast. George Galloway told us that he would rather
be eating cheese and reading Sartre on the banks of the Seine than taking pop-
corn with the born-again, Bible-belting, fundamentalist (remainder drowned by
hoots of glee).

We got Bianca Jagger, sandwiched between Harold Pinter at his most mina-
tory – 'American barbarism will destroy the world!' – and Ken Livingstone at his

most genial, dealing with a congestion-charge protester. And we got the star guest, the Reverend Jesse Jackson, who was presumably invited to remind us of the great civil rights marches of the 1960s but who is to the Reverend Dr Martin Luther King as Gareth Gates is to James Brown. Eventually, he gave way to Ms Dynamite, who sang one of her hits, the lilting 'Dy-na-mi-tee', to a backing track after reading a poem in which she reminded us of previous US debacles in Vietnam, Guatemala and Nicaragua. It wasn't exactly 'Masters of War' (also written by a 21-year-old), but its directness suited the day.

As the first arrivals turned for home in the gathering gloom, some pausing to make bonfires from heaped placards, tens of thousands were still making their way towards the park. Too late for the festivities, they were none the less a part of the biggest political demonstration ever seen in Britain, an event that went beyond slogans and positions to expose something deep in the nation's core, a cast of a million playing to an audience of one.

18 February 2003

ANDREW CLARK

The congestion charge

When Ken Livingstone stepped into the pre-dawn freeze outside his Cricklewood home yesterday, he was prepared for a 'bloody' day. It never quite materialized.

Greeted on his doorstep by a clutch of photographers, the mayor took the tube to Victoria. He arrived at London's hi-tech new traffic control centre ten minutes before the capital's £5-a-day congestion charge came into force at 7 a.m. His senior staff gathered in front of a bank of screens showing London's most jam-prone junctions. They were watching for the 'nightmare scenario' – complete gridlock on the inner ring road surrounding the central charging zone.

Instead of gridlock, they watched free-flowing traffic at the city's busiest junctions and, in some cases, barely a car at all as cyclists and buses whizzed past. Mr Livingstone remained cautious, insisting, 'I'm just waiting for things to go wrong.'

By the middle of the morning rush-hour, it was clear that Londoners' behaviour had been as fickle as ever. Defying predictions of civil disobedience, avoidance tactics and tube chaos, many had simply decided to stay out of the centre. At 7 a.m., the RAC – no fan of the congestion charge – said traffic across the city was 'extremely quiet'. By the end of the rush hour, its monitoring staff had become lyrical, reporting that Elephant and Castle, where the charge begins in south London, was 'deserted, like 5 a.m. on a Sunday morning'. At one key entry point at Warren Street, north London, half-empty buses sailed past a gaggle of 'Ken-gestion charge' protesters. Tower Bridge, which critics feared could be damaged by the weight of extra traffic, carried hundreds of extra bicycles but unusually few cars.

By lunchtime Transport for London's automatic counting machines showed

traffic levels 25 per cent lower than on a normal working day, compared with the usual drop of 10 per cent to 15 per cent for half-term week.

The RAC said this was an underestimate, claiming the drop was more like 60 per cent. Its monitors said 75 per cent of the vehicles passing its cameras were buses or taxis. A spokeswoman, Rebecca Bell, commented: 'It's astonishing – London is like a ghost town.'

By 6 p.m. more than 80,000 people had paid their £5 charge, though Transport for London had forecast 100,000 a day. Michelle Dix, the director of congestion charging, said contingency plans to rephase hundreds of traffic lights had been ripped up. The AA's spokesman, Richard Freeman, said: 'It's unnaturally quiet – it's almost like a Sunday morning.'

Concerns that tens of thousands would squeeze on to the London underground proved unfounded. A spokeswoman reported no 'significant' increase on the 3.25 million journeys on the network every day. Mainline train operators were similarly unaffected by 'C-day'. South Central, Connex, WAGN and South West Trains all said they were carrying the same number of people as usual. Even the buses, which Mr Livingstone predicted would take the strain, saw no sign of a surge in passengers. A London Buses spokeswoman said: 'We've had people monitoring queues at bus stops and nothing out of the ordinary has been reported back.'

On the leading anti-charge protest site, Sod-U-Ken, the unusually quiet streets cut little mustard. One of a number of messages addressed to 'Leninstone' doubted radio reports of transport harmony, asking: 'Is this all true or are the radio stations getting a backhander from Ken?'

The Conservatives were equally sceptical. Mr Livingstone's newly anointed mayoral challenger, Steve Norris, suggested the roads were quiet because thousands had been unable to log on to a website taking payments for the charge. 'If I thought every day was going to be like today, I might be persuaded that this would work. But I just don't believe it will be,' Mr Norris said.

As it was, call centres, staffed by 800 people, were operating well below capacity as the number of people calling to pay the charge fell short of expectations.

By mid-afternoon there were the first murmurs from business leaders that the capital could suffer if congestion charging was too successful – as fewer people would shop in the West End.

But one business was thriving. Capita, the controversial outsourcing company running the charge, saw its shares soar by 12.75p to 210.25p as the City took an early view that the scheme appeared a success.

But even environmentalists, the biggest tub-thumpers for the scheme, urged caution in jumping to rapid conclusions. A Friends of the Earth spokesman, Paul de Zylva, said: 'It's good that some of the media hysteria has proven unfounded. But I don't think you can judge it on the basis of just one day.'

17 April 2003

ERWIN JAMES

A life inside

It was the end of the first really warm day of the year. My head was still full of my day's work – enquiries received, information retrieved, letters written. I had never considered before that 'office work' could be so demanding – or so satisfying. Not for the first time, as I made my way to the station through the crowded and anonymous streets, did I take a deep breath and wonder at my good fortune. Then I heard the man's voice. It was so close it had to be directed at me. 'Excuse me, can I interest you in some life insurance?' I smiled inwardly, pleased that I'd been mistaken for a regular citizen.

'I'm sorry,' I began, turning to politely dismiss my accoster, before confusion stopped me saying anything else. His appearance was not what I expected. He was tall and young, no more than nineteen or twenty years old. Despite deep pockmarks, the pink skin on his face had a fresh glow about it, though sleep residue remained clogged in the corners of his smiling, bright green eyes. Most telling were his ill-fitting clothes and his recently hacked red hair, which sprang from his head like the contents of a burst cushion. He was obviously homeless and begging, and the life insurance quip was his in-line. I hadn't heard that one before.

'No thanks, pal,' I said, acknowledging his sense of fun. By now he was striding alongside me, grubby paper cup held hopefully in front of him. 'My life wouldn't be worth your trouble,' I added. Pleased that I had engaged with him, he stepped up his pace and his grin broadened. 'What about double glazing then?'

I thought that was funny and I laughed. But then I felt uneasy. Such encounters have become regular occurrences. Too regular. Responding to people who survive in this way is getting harder. Only the other week I talked about it to the Celtic Poet. Like me, he had lived on the streets on and off for a number of years before his life sentence. He is philosophical about those times now, but he hasn't forgotten.

'I never pass by a *Big Issue* seller without buying a copy,' he told me. He said he often takes the time to stop and chat with vendors and he's happy to reveal his own experiences. 'I don't lecture anybody,' he said, as we strolled around the football field, 'but if I pick up that they're prepared to listen, then I try and introduce the idea that whatever happens to us, we can still lift ourselves. We mustn't ever give up.' He turned and prodded his chest before adding, 'Don't forget, I was on the streets long before the *Big Issue*.' That was another thing the Poet and I had in common. And the main reason for my discomfort in these situations.

For how could it be that my life should have been so chaotic and meaningless all those years ago? Yet here I am now after almost nineteen years in prison, with a job, a direction and a purpose. I told the Poet that I rarely gave money to

people on the streets. 'Why not?' he asked. 'Because it's never going to be enough,' I said.

But back to the station and the red-headed young man, who persisted. 'So no double glazing?' he said. 'Well, how about ...' At that moment I decided to talk to him – and however unwisely, to reveal my circumstances. 'Hang on a minute,' I said, stopping on the pavement and turning to face him. On either side of us people streamed by. I pulled a handful of change from my coat pocket and dropped it into his cup.

That should have been the end of our encounter. But before he could walk away I said: 'Actually, I do have double glazing already – in my prison cell.' This revelation seemed to have no effect on him.

I went further and told him how long I'd been in jail and that the reason that I was out and about and able to stand talking to him was because I was being prepared for release. He stopped smiling and dropped his eyes. He thought I was kidding him on. 'Look,' I said and produced my prison ID card. 'That's me – Convict 99.' His green eyes widened. 'I don't know what's happened in your life,' I went on, 'but what I'm trying to say is that broken people – people like us – we can be fixed.'

Of course, I hadn't taken into account the possibility that he might not want fixing. He had a right to give me some abuse if he wanted and I waited for it. Instead he suddenly thrust out his free hand and said: 'Fucking hell, man!'

I shook his hand and smiled. And on that salubrious note, we parted.

18 April 2003

LEADER

The dirty war

The third Stevens report is one of the most shocking commentaries on British institutions ever published. It is necessarily brief for fear of prejudicing any number of possible future criminal prosecutions. But even the sparse nineteen-page document released yesterday tells a shameful story of state-sanctioned murder, collusion and obstruction more commonly associated with South American dictatorships than with Western parliamentary democracies.

Some of the events in the report date back fifteen years, at a time when the IRA was waging a bitter war against the British state. In the view of some, even today, it was legitimate for the forces of the state to fight dirty in return – 'big boy games where big boy rules prevailed'. Sir John Stevens, who was brought in to investigate these big boy games fourteen years ago, begs to differ. He assumes that those involved in policing and security duties in Northern Ireland 'work to, and are subject to, the rule of law'.

It is not an academic point. Sir John, the most senior policeman in Britain, is one of those most directly involved in a new, and even more dangerous, fight against terrorism. Politicians need to level with us about the nature of that fight. Is the state going to get down in the gutter with the terrorists, or is it going to

operate to clearly defined and properly monitored standards? There are few more fundamental questions for a civilized democracy.

It is now clear that, for a period in the 1980s and early 1990s, a small group of policemen and army officers decided the normal rules did not apply to them. A few people within the force research unit – a firm within a firm inside a force within a force – decided to team up with loyalist terrorists in targeting and assassinating people they decided were IRA terrorists. It is likely that dozens of victims – some involved in terrorism and others not – were killed through this unholy alliance between the state and terror groups.

Apologists for this dirty war – including Brigadier Gordon Kerr, once of the FRU, now military attaché in Beijing – have argued that hundreds of lives were saved by preventing attacks, or simply by murdering suspected terrorists. Even if it were true, this would still be no justification for this kind of unapproved, unsupervised, freelance killing spree. In fact, Sir John's team can only identify two occasions on which murders were prevented.

Almost as shocking as these killings has been the subsequent cover-up. The RUC, the army and the Ministry of Defence have used every possible weapon – including obstruction, intimidation and arson – to prevent Sir John and his team from discovering the truth. As recently as last November the MoD reluctantly handed over a mass of documents it knew were central to the case.

Geoff Hoon owes Parliament an explanation for these disgraceful delaying tactics. Those responsible should be sacked. The former defence minister, Douglas Hogg, should identify the RUC officers who briefed him and they should be brought to account for the repulsive smear that led – directly or not – to the murder of the solicitor Pat Finucane. Hugh Orde, the chief constable of the Police Service of Northern Ireland, needs to act quickly to reassure Catholics that rogue elements – particularly within the old RUC special branch – have been purged from his force. The director of public prosecutions should expedite all the cases referred by Sir John. And Tony Blair should not only ensure that Sir John's recommendations are implemented in full, but that he can finish his inquiries with no further obstruction – wherever they may lead.

18 April 2003

BRYAN HOPKINS

Letter: State-sponsored assassination

So we now officially live in a country where state-sponsored assassination squads murder people opposed to the government. Does this mean we can soon expect to be liberated by the US?

2 May 2003

DAVID WARD AND NICHOLAS WATT

English local elections

The British National Party last night made significant gains as it more than doubled its number of councillors in England and became the second largest party in Burnley.

But fears that the far right party would sweep to victory across northern England failed to materialize as it suffered a series of setbacks in key areas it had targeted.

Nick Griffin, the party's Cambridge-educated leader, failed to win a seat in Oldham, where the BNP mounted a strong campaign after coming second in four wards last year.

The party also failed to win a single seat in Sunderland despite fielding twenty-five candidates in the town – more than 10 per cent of the record 221 seats it contested overall.

The BNP took 13,652 votes from a total of 99,288 cast, a 13.75 per cent share of the poll.

'No one can afford to be complacent about the BNP but they have not done as well as I feared they might do,' said Chris Mullin, the Labour MP for Sunderland South. 'I am delighted that the people of Sunderland have decided they do not want to be represented by fascists.'

But the BNP made significant progress in Burnley, where it strengthened its grip on the council by snatching seven seats. This took its total in the Lancashire town to eight, to make it the second largest party. The success – almost certainly far greater than the party expected – builds on the party's shock victories in the town last year, which may in turn have been helped by the riots on its streets in 2001. The BNP made gains from Labour, the Liberal Democrats, and independents. It now has eight seats on the council and becomes its second-largest party, with the Liberals pushed into third place. Labour remains in overall control. With this result, Burnley has become the party's national stronghold. The seven new councillors will sit for four years and will have a taste of real local government power. Labour's biggest loss was Andrew Tatchell, deputy leader of the council, who was defeated in Hapton with Parkward by the BNP's Leonard Starr.

'I'm absolutely elated,' said Mr Starr, as BNP cheers echoed round the sports hall at Burnley Football Club where the count was held. 'This is a stepping stone. Last time we kicked the door open. This time we are going through it.'

Peter Pike, Burnley's Labour MP, described the result as a 'kick up the behind' for the main parties. 'I would prefer the BNP not to be represented on the council. They are a racist, divisive party.'

The party saw its number of councillors increase from five to thirteen across England. Other gains came in Stoke, where a BNP candidate, who failed in his bid to become one of the new-style mayors, won a seat.

Trevor Phillips, head of the commission for racial equality, blamed right-wing

tabloid newspapers for scaring people into voting for the BNP. He told the BBC: 'Peddling nonsensical stories on asylum has had an impact on people's views. Papers that have peddled these stories should look into their hearts and see what they have done.'

8 May 2003

JOHN VIDAL

The rural life is perfect for bankers

Meet the new English 'countryman'. He is as likely to be in insurance or banking as in farming, he worries far less about income, world problems and relationships than his urban counterpart, is probably over forty-five, and his views are more likely to be influenced by his family than the media or advertising. Moreover, he spends almost half his income on his mortgage and is likely to have moved to the countryside in the past twenty years. He probably works in a small business, his children may be expected to move to the city, but he can be expected to live eighteen months longer than his urban counterpart.

A report by the government's countryside agency on the state of the countryside, collating and interpreting rural 2001 census figures for the first time, throws up the kind of statistics that both undermine and confirm old attitudes to people living in the countryside. Any lingering notions of the countryside being full of ill-educated bumpkins should be consigned to history. Rural adults and teenagers have higher levels of educational attainment than their equivalents in urban areas, according to the report. Overall there are rising standards in the countryside. On average, people in rural areas are more likely to have an NVQ Level 3 or above than their urban counterparts, and young adults are less likely than urban residents to be without formal qualifications, says the report.

But it notes that one in fourteen countryside pupils leaves education with no qualifications, and that there may be pockets of educational disadvantage and wide regional variations.

The report shows that life in the countryside is generally good for many people but too often problems lie behind the overall favourable picture. One in four people living in low-income households are in rural areas and housing continues to become less affordable, particularly for first-time buyers, said the countryside agency's chairman, Sir Ewan Cameron.

In a surprising finding, the report says that 49 per cent of people living in the English countryside get their personal opinions about life in Britain today mainly from their families, far more than in urban centres, especially London, where only 38 per cent say that they are mainly influenced by family. Friends shape the opinions of those in the countryside more than television, and only 2 per cent said that advertising campaigns or community leaders had a significant effect on what they think. While health and employment are more or less equal concerns, people in the countryside worry far less about crime, discrimination and world issues than people in urban areas.

The report underlines the fact that life in the countryside has less than ever to do with farmers. At the last count, out of 14 million people living in rural areas in England, only 174,000 of them were in full time agricultural work, 0.3 per cent of the population. However, while farming lost 33,000 full time jobs from 1998–2001, it gained 10,000 part-timers, and there are now 150,000 occasional farmers and labourers in England.

The role of farming needs to be put into perspective, suggests the report. Its share of the English economy is now only 0.8 per cent and far more people (91,787) lost manufacturing jobs in the countryside than farming jobs in the past three years. Rural areas have diversified their economies and 87,000 more people work in country hotels and restaurants than in 1998. The figures cannot be fully broken down, but it is probable that more people now work in finance industries in the countryside than in full-time farming.

Rural England, says the report, has been heavily repopulated in the past twenty years, but the move out of cities is thought to be slowing. Since 1981, England's rural population has grown by more than 12 per cent, or roughly 1.5 million people. In the same period, the urban population grew by 813,000, or 2.4 per cent. England also has a landscape of increasingly older people. Some 45 per cent of people in the countryside are now over forty-five, compared with 37 per cent in urban areas. Half of all pensioners live outside urban areas.

Meanwhile, the countryside is being used more and more for the recreation of people from urban areas. The report suggests that 70 per cent of visitors to Britain's national parks are over thirty-five. However, these are practically all-white zones, with 3 per cent of visitors non-white. Almost half of all visitors went to the Lake or Peak districts. Day trip tourism is now an essential for rural areas, says the report, and is thought to be worth almost £9bn annually, about £2bn more than agriculture.

The report also tries to quantify how much agriculture costs the economy. Environmental benefits are estimated to be approximately £600m a year but damage is costed at between £1bn and £1.5bn. Soil damage, flooding and the cost of removing nitrate fertilizers from drinking water are all linked to bad farming practices.

But in many areas, life in the countryside is increasingly like life in urban areas. Median incomes are similar, although 5 per cent of rural English wards had average income levels of less than £20,000, compared with 14 per cent in urban wards.

House prices, too, are now broadly similar to urban areas. However, average earnings are slightly lower in rural areas than urban areas and have grown at a slower rate in the past few years, according to the report. Remote rural districts, it says, have the highest proportion of working age adults receiving in-work tax credits.

More than 90 per cent of people polled for the report thought it was important that the English countryside is kept the way it is now. However, this conflicted with other findings: while 23 per cent thought it important to keep the landscape and to stop development, only 17 per cent of people thought farms and farmers were important.

The report paints a picture of a countryside that is only good in parts and

increasingly mainly for the better-off. 'It is becoming ever more difficult for the less-well-off to live and work in the countryside and this in particular could be very bad news for the upkeep of the land itself,' said Richard Burge, chief executive of the Countryside Alliance. 'But it confirms that one of the great strengths of rural communities is that they still think and act as communities.'

21 May 2003

GARETH McLEAN

Big Brother

Rebekah Wade, editor of the *Sun*, has shown her largesse by offering 'a fantastic £50,000 prize' for the first bonk on *Big Brother*. Terms and conditions apply. The paper doesn't care where contestants get jiggy, but *Sun* readers will be asked to vote on whether the couple were making it for real or faking it. The readers' decision will be final. Additionally, the lovebirds will have to agree to tell their story, upon eviction, exclusively to the paper. No correspondence will be entered into.

It's tempting to dismiss this as a tabloid stunt, an attempt by the *Sun* to steal a march on its rivals in pursuit of silly-season stories. If people do have sex for the first time in British *Big Brother*'s salubrious history, the *Sun* can take the credit.

But as the Consumer Association would advise, read the small print. The *Sun*'s bounty is only on offer for the first 'boy–girl bonk', and the cute phrasing doesn't disguise the intent. In the (admittedly unlikely) event that two male contestants are overwhelmed with passion for each other, they wouldn't be eligible for the paper's prize. Similarly, girl-on-girl action is disqualified.

We shouldn't be surprised, of course. Under its previous editor, the *Sun* tried to be nicer to everyone, but lately it has reverted to type. With this prize, it has cemented homophobia as a core *Sun* value. Rebekah, some of whose best friends are gay, must have trouble explaining this at dinner parties. At least, you would hope so.

Leaving aside any discussion of contestants' dignity (or the lack thereof), and ignoring the dubious morality of a newspaper promoting promiscuity by offering people money to have sex on television, the *Sun*'s stipulations regarding sexuality reveal a wider truth: we're not as cool about gayness as we'd like to imagine. In principle, equality for gay men and lesbians is a basic tenet of liberal thinking. We agree that they are entitled to live their lives as they choose and that discrimination on the grounds of sexuality is wrong. There are more openly gay men and women in the public eye than ever before. This, we think, is a Good Thing.

And so it is. Except there is a proviso. We don't like our gays to be too gay. Camp we can handle; in fact, the camper, the better. Brian Dowling, previous winner of *Big Brother*, was taken to the nation's heart for his giddy – and decidedly asexual – persona. (As a children's TV presenter, he is effectively neutered

in his latest project, *Brian's Boyfriends*, where he takes on the role of honorary girl, giving makeovers to the partners of disenchanted women). Had Brian had sex with Josh, the other gay 2001 housemate, he would not have won. Such a rampant display of desire would have been crossing the line.

Similarly, if Graham Norton had been caught in a love triangle à la Sven, you can bet the tabloids wouldn't have been quite so laddishly approving of his exploits. If Will Young were to emulate the lovin' generosity of his straight counterparts in the pop world, he would be castigated. They are studs, he'd be Aids-in-waiting.

Like most things, this double standard comes down to sex. Specifically, two kinds of gay sex. First, there is the acceptable kind. This involves two women who don't conform to the stereotypical image of lesbians. They are Tatu, or *Brookside*'s Beth and Margaret, the stuff of the straight man's masturbatory fantasy. Indeed, if the *Sun* could guarantee the conventional attractiveness of *Big Brother* lesbo lovers, it would likely pay a lot more than £50,000. As it can't, it won't, and Tatu will do for now.

Then there is the unacceptable variety of gay sex. This can be further divided. There is sex between women who conform to dykeish lesbian stereotypes, and therefore are not attractive to the male gaze, and there is sex between men. This is the scariest sex of all. Even otherwise liberal straight blokes can't hide the fear in their eyes when they meet gay men. From this springs mistrust and guilt. It's all very tedious.

Three years ago, Jonathan Freedland wrote in this paper that younger Britons were at ease with sexual difference. He was, unfortunately, being overly optimistic. True, we are more relaxed about sexuality, but even in the most liberal circles there is an attitude of 'so far and no further', and it's not half as far as the heterosexual equivalent. A gay snog at a party would still attract disapproval where a straight snog would not. I don't want to see sweaty man-on-man action on Channel 4 in prime time, but I don't want to see sweaty man-on-woman action either. So long as one is frowned upon and the other is not, we've still got a long way to go.

27 May 2003

DAVID AARONOVITCH

A message for the left

Thinking about it now it must have taken some courage for the blonde, middle-aged woman to approach me, as I sat with friends in the restaurant marquee at Hay-on-Wye last Saturday night. At the time I was aware at first only of her anger, and then – subsequently – of mine.

Hay is a gentle festival. Disagreements are generally handled with regretful qualifications, as in, 'I loved your piece on the Tories, but I'm afraid I didn't altogether agree with what you said about Iraq.' But from the moment the blonde woman bore down on me it was obvious that she was too cross for all that.

'You're David Aaronovitch,' she said, 'you write all those articles about anti-Semitism.' I agreed on identity but said I was puzzled, because I hadn't written much about anti-Semitism. Why, I asked, did she think I had?

She carried on, with vehemence. 'Being critical of Israel isn't anti-Semitic, and many of us are fed up with being told that it is.' I agreed that being anti-Zionist wasn't the same as being anti-Semitic. 'And,' she added, unmollified, 'if the American neo-conservatives are all Jewish, it isn't anti-Semitic to say so, it's just telling the truth!'

I said that that depended on why you felt obliged to 'reveal' the religious or racial identities of a group of people. What, in other words, was she trying to say? 'I'm not anti-Semitic, I'm in PR,' she replied, adding, 'and a lot of my really good friends are Jewish.' And she stomped off.

These days, when I look in the mirror I see my father's face and when I speak, I hear my father's voice. From somewhere, God knows how, I have inherited a few inflections that Henry Higgins would recognize as being London Jewish. Apart from that, no synagogue, no briss, no Hebrew classes, no bar mitzvah. Yet in the past year these small things, and people like the blonde woman, have begun to make a Jew out of me, whatever I think about it.

After all, what had I written in the previous six months? An attack on conspiracy theories, one reference to receiving the occasional anti-Semitic letter or email, an objection to being called 'pro-Israeli' and a worry about an audience member on BBC1's *Question Time*, who referred to there being 'so many Israelis in the American government' (there aren't any, of course). In the previous year I had argued that it wasn't per se anti-Semitic to deny the right of Israel to exist, and pointed out that the real victims of racism in this country tended to be asylum seekers and Muslims. So why did the blonde woman come after me?

Why did Pardeep call me a Zionist on the Medialens forum? (Medialens is an organization devoted to putting the official media right about the world.) I emailed Pardeep to ask him, but this very vocal man suddenly went quiet. Why did a questioner in an *Observer* online session refer to my support for the Iraqi war as being occasioned by loyalty to George Bush 'and Ariel Sharon'? I can see the rhetorical point of the Bush jibe, but the Sharon quip only makes sense if you read it in a particular way.

Last March an Ian Henshall, who describes himself as 'chair of the UK's alternative media umbrella group, INK', wrote an open letter to the editor of the *Observer*, to complain about the journalist Nick Cohen's support for an attack on Iraq. 'Cohen,' said Henshall, 'has written publicly about his loyalty to his Jewishness, so is there any connection between this and his apparent support for the coming war?' Henshall continued: 'Just before anyone calls me anti-Semitic, could I point out that my current hero is Uri Avneri, and the bravest people in the world are the Jews who are resisting the occupation and Sharon's ethnic cleansing.' Henshall, incidentally, is also a disseminator of internet stories with headlines such as, 'What were 120 Israeli spies doing in America a few months before the 9/11 attacks?'

This month J. Hall suggested to me that the infamous Galloway documents could have been the work of 'the Jewish lobby'. A Medialens regular, David

Bracewell, posts this week to criticize 'Israeli fascism' and adds, 'If ever there was an inflammatory, racist, insidiously exclusive term, "anti-Semitism" is it. It baffles me why the supposed victims of racism would want a term all for themselves.' Supposed? And not one of the assembled lefties took him up on it.

When Tam Dalyell accused Tony Blair recently of being in the pocket of Lord Levy, Peter Mandelson and 'the Jewish lobby', he defended himself against charges of anti-Semitism by recalling that his daughters had visited kibbutzim. Notwithstanding Jonathan Freedland's devastating and factual demolition of Dalyell's slide into anti-Semitic stereotyping, Paul Foot – veteran left-winger and campaigner – defended Dalyell, suggesting that Tam was merely 'wrong to complain about Jewish pressure on Blair and Bush when he means Zionist pressure. But,' explained Foot, 'that's a mistake that is constantly encouraged by the Zionists.' Clever bastards, they even manipulated poor old Tam into looking like the anti-Semite he isn't.

R. G. Gregory wrote to this paper to attack Freedland. He particularly objected to Freedland's mentioning the BNP's similar-sounding assaults on Zionism: 'Why has the BNP been dragged into the matter? Has that party been against the Iraq war, sympathetic to Arab suffering, able to put itself in Palestinian shoes? Does the BNP in fact hold one view that concurs with those of Tam Dalyell?' To which the answers were, if Gregory had but researched them, Yes, Yes (in rhetoric, anyway), ditto and – regrettably – Yes.

So here's a danger alert. The blonde woman was stupid, but it was her stupidity that was allowing her to say what many others are thinking. Too many left-wingers and liberals are crossing the magic line right now. Let me spell it out for you. There is no all-powerful Jewish lobby. There is no secret convocation. Most journalists with Jewish names do not write the things they do because of loyalty to their race or religion. Nor can you simply change the word 'Jewish' to 'Zionist' and somehow be exempt from the charge of low-level racism. And it's no good wiffling on about your Jewish friends or trying to slip your prejudices past the guards by boldly proclaiming your refusal to be intimidated. There are no Elders and there are no Protocols.

5 June 2003

TANIA BRANIGAN

The Iranian poet ends his protest

The Iranian Kurdish refugee who sewed up his eyes, ears and lips and went on hunger strike last month to protest against the treatment of asylum seekers in Britain agreed last week to have his stitches removed.

Eleven days after beginning his hunger strike, Abas Amini heeded the pleas of friends and abandoned his protest. But he said he had done so only because he had accepted there were other ways for him to fight for the rights of asylum seekers worldwide. 'I have ended this because I have come to realize that this is

a very important struggle to be continued,' the poet said in his first interview since ending his strike. Friends said he had accepted that individuals could only do so much.

The 33-year-old poet appeared gaunt but healthy and almost ebullient as he spoke with the aid of a translator. He was still unable to drink because he had gone so long without water. Angry red lumps marked the needle piercings on his eyelids, and his earlobes and lips appeared sore. But the stabbing pains that had made him flinch from the hugs of friends had dwindled.

'I'm very happy, because I have shown what those people [the Home Office] are like, and how they abuse people,' he said. 'Even if it hasn't changed anything – and I think it has – we will continue to fight for the changes of attitudes towards asylum seekers.'

What seems to have begun as a personal gesture of outrage – for the first few days Mr Amini swore friends to secrecy about his actions – attracted international attention. Although Mr Amini's protest was triggered by a Home Office decision to challenge his successful asylum claim because they had failed to send a representative to the hearing, he always said he was making a statement on behalf of all refugees, and remained stitched up even after an independent tribunal ruled that he could stay.

'This is not the first time that something like this has happened,' said Reza Moradi, the director of the International Federation for Iranian Refugees in the UK. 'An Afghan asylum seeker two months ago threw himself off a motorway bridge because he was refused asylum. An Iranian man last year hanged himself because his application was rejected. These people have come here because their lives are in danger. But then they become very isolated. They are making another class in society – a rightless class that has nothing.'

Mr Amini fled to Britain two years ago after escaping from prison, where he had been repeatedly tortured.

10 June 2003

HUGO YOUNG

Treasury fist grips our European future

Gordon Brown laid down his platform for the great euro pronouncement on Sunday. 'Tony Blair and I have decided,' he told David Frost, 'that we should put the pro-European case. I believe we can unite the British people around a pro-European consensus, which I believe is vital to the future of this country.' This sounded like a vaulting promise of a new direction. In fact it was an epitaph on six years of timidity, deception and failure.

Given the history, they were words of blithe effrontery. Brown repeated them in his statement yesterday. 'A modern, long-term and deep-seated pro-European consensus' would now be built, he said. This he offered as a brilliant plan, not hitherto available, which is going to change the politics of Britain, in the service of an economic policy – joining the euro – to which the government remains

committed, however, in roughly the same cautious and contingent language it was using in 1997.

Consider what happened in 1997. Then too, Blair and Brown proclaimed themselves pro-Europeans, and vowed to put Britain at the heart of Europe. Blair was determined, he said, to end decades of British indecision and finally banish doubt about where this country belonged. All right, we were not ready to join the euro. This would be left to the second parliament, by which time there would have been a concerted effort to prepare both economically and politically.

But there was no such effort. Nothing happened. There wasn't the faintest attempt to achieve a national consensus. The leader made occasional forays into the subject, always to Continental not domestic audiences, but no other minister spoke about Europe at all. On the euro itself, Brown imposed oaths of *omertà*, lest even a small sign of didactic enthusiasm be mistaken for serious intent to enter.

That decision was to be left to the chancellor alone. No economic policy was directed specifically to achieving the famous convergences that were said to be so regrettably out of reach. Housing and mortgage reform, which he yesterday put at the top of the list of anti-convergent items, surfaced for action only in the last few weeks. The entire possibility of directing public opinion towards the patriotic case for European integration was stymied by the rule of silence.

For Brown to start warbling yesterday about his desire to build a consensus therefore invites various responses. One might be sheer cynicism. His warm words, including a line construable as retaining the possibility of a referendum before the election, were perhaps just a sop to frustrated pro-euro people in his party, in business and on the Continent. But let's acquit him of that. He thinks of himself as a genuine European. There remains the political incompetence of it all. Here is a promise that should have been made and acted on six years ago. Instead, those years were surrendered to a Europhobic discourse that has deepened obstruction to the consensus Blair and Brown want to create.

The pro-euro language did begin to inch forward yesterday. The Treasury studies made plain some big advantages Britain would gain from a properly functioning single currency. In the long term, they said, there might be great gains to British prosperity through inward investment, currency stability and lower interest rates. It wasn't all black, which had been the impression the Treasury long gave out. These are findings that give the lie to the more excessive propaganda of the sceptic press.

But a tight Treasury fist remains locked round future judgements. Having found only one of the five tests definitively passed, Brown continues to insist that any revision shows 'clear and unambiguous' proof of economic advantage: a test attainable only in the eye of the beholder. A minister who sincerely wanted to signal new momentum towards entry would have taken the chance to soften those words, which are ridiculed by economists on all sides. But thrice did Brown repeat them.

The structural reforms he demands of his country, or requires of the eurozone, are similarly formidable. The mortgage market and the labour market won't be turned over in a day. The regime of the European Central Bank is open for lively discussion now, but is a factor unlikely to be influenced at the insistence of a

chancellor who has made clear his continuing determination to remain outside for the indefinite future. All these issues offer any British politicians who have their own reasons for postponing entry all the pretexts they need to cite the principle of unripe time.

Mr Blair, we keep being told, is determined this should not happen. But if yesterday's statement was the best he could achieve in all those hours of haggling with the chancellor to ensure a 'positive' outcome, one has to wonder at the limits of his ability to impose his will.

I'm reminded of the Thatcher years, when there was a similar disjunction between words and deeds – but with an opposite effect. Mrs Thatcher spent her time taking Britain deeper into Europe, a process that climaxed with the Single European Act, while talking the British people ever further out. It was a disastrous failure of statesmanship, deepening the angst of a divided nation. Tony Blair goes on talking us further in. But he acts at decisive moments – the currency, the convention – in ways that tend to leave Britain outside the mainstream. If this continues, his could be an even more damaging betrayal of leadership than Mrs Thatcher's.

Perhaps I am being too pessimistic. Maybe, within the caveats and let-outs that Gordon Brown left himself yesterday, there's a serious shared plan leading towards a gamble on a euro referendum early in the next parliament. One positive outcome of the laborious build-up to the great statement was the appearance of a larger number of keen pro-Europeans in the Cabinet. One consequence of the campaign now being permitted to begin will surely be that Brown's solitary command is offset by the words of other ministers released to make an unsceptical case.

Many people, not least on the Continent, are looking for the last shred of credibility in Blair's claim to be a committed European. All one can say is that to keep this shred alive the campaign for the euro will need to be extremely serious. Six years of silence have stoked the phobic fire and sceptic propaganda so high that the task may be impossible. The great victory for anti-Europeans that Brown's statement represented will be followed by wider assaults on the European project. All this Labour has brought on itself, while adding its own contribution to the perverse history of Britain and Europe.

In what other country would the government choose to launch its campaign for a pro-Europe consensus on the day it withheld support from Europe's main economic and political project?

13 June 2003

LEADER

Revolution by reshuffle

Even in this age of meticulous spin, media grids and policy rollouts, some of the biggest things in politics can still come untrailed from out of a clear blue sky. At quarter to six yesterday evening, in an exchange of letters with Lord Irvine, Tony

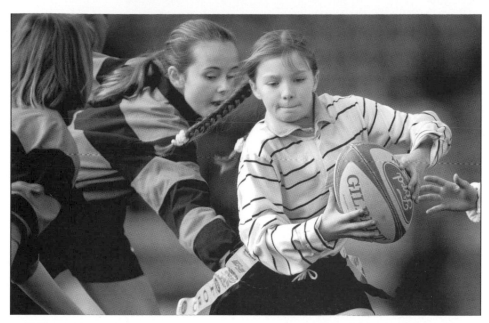

Girls tag rugby at Twickenham. The girls from Wisewood School, Sheffield played before the England v South Africa Rugby Union International in November. (Tom Jenkins)

Andre Agassi loses to Mark Philippoussis in the fourth round of Wimbledon in June. (Tom Jenkins)

Finishing touches are added to Bridget Riley's 'Rings', part of her retrospective at Tate Britain. (Eamonn McCabe)

Rachel Whiteread's 'Untitled (Pair)' on display in Ely Cathedral, Cambridge as part of the Extraordinary Art series of installations in July. (Graham Turner)

Lou Reed, on tour promoting his new albums, talks to Simon Hattenstone in May. (Eamonn McCabe)

Ian Hamilton Finlay in his celebrated garden of poetry and sculpture – Little Sparta in Scotland. He accepted a CBE in May. (Murdo MacLeod)

The Red Hot Chili Peppers on tour in Milan in February. (Sarah Lee)

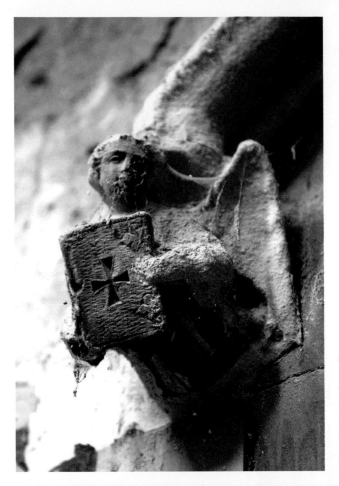

A carved angel from the Franciscan monastery in Gorton, Manchester. The building, derelict since 1989, is now being converted into a community hall. (Don McPhee)

Detail of Rodin's *The Burghers of Calais*. The sculpture is being restored to celebrate the centenary of the National Art Collections Fund. (Martin Argles)

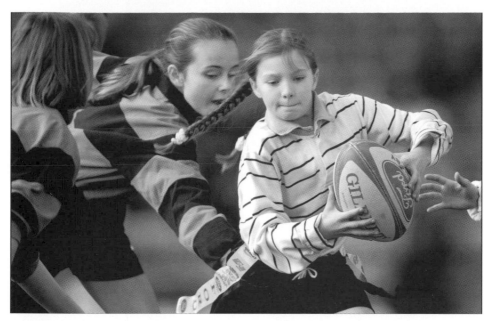

Girls tag rugby at Twickenham. The girls from Wisewood School, Sheffield played before the England v South Africa Rugby Union International in November. (Tom Jenkins)

Andre Agassi loses to Mark Philippoussis in the fourth round of Wimbledon in June. (Tom Jenkins)

Finishing touches are added to Bridget Riley's 'Rings', part of her retrospective at Tate Britain. (Eamonn McCabe)

Rachel Whiteread's 'Untitled (Pair)' on display in Ely Cathedral, Cambridge as part of the Extraordinary Art series of installations in July. (Graham Turner)

Lou Reed, on tour promoting
his new albums, talks to
Simon Hattenstone in May.
(Eamonn McCabe)

Ian Hamilton Finlay in
his celebrated garden of
poetry and sculpture –
Little Sparta in Scotland.
He accepted a CBE in
May. (Murdo MacLeod)

The Red Hot Chili
Peppers on tour in
Milan in February.
(Sarah Lee)

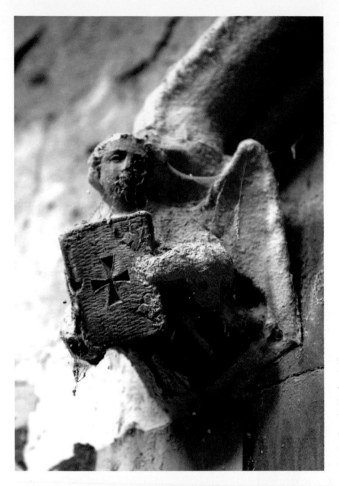

A carved angel from the Franciscan monastery in Gorton, Manchester. The building, derelict since 1989, is now being converted into a community hall. (Don McPhee)

Detail of Rodin's *The Burghers of Calais*. The sculpture is being restored to celebrate the centenary of the National Art Collections Fund. (Martin Argles)

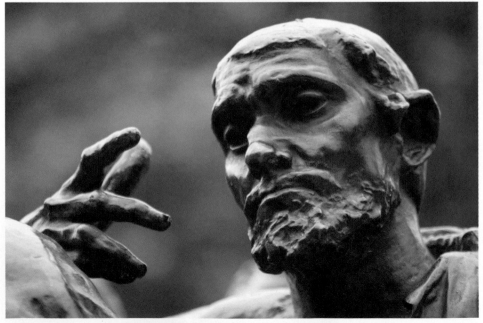

Blair launched something that may eventually be remembered as the largest single legacy of his premiership. The Lord Chancellor of England, an office almost as old as that of the monarch, has existed in one form or another since 605. The holders have ranged from the first incumbent, Angmendus, through such resonant names as Thomas Becket, St Swithin, Cardinal Wolsey, Sir Thomas More and Lord Halsbury (in 1075 there was even a Lord Chancellor called Baldrick). Yesterday, just in time to catch the six o'clock news, and after 1,398 years, Mr Blair abolished the post altogether. As Lord Irvine departed into retirement as the last holder of this most venerable title, England was handed an instant constitutional revolution.

Until yesterday, the Lord Chancellor uniquely combined the offices of head of the judiciary, head of the House of Lords and member of the Cabinet. But Lord Irvine has been itching to disentangle this integration of politics and the judiciary, and yesterday, without any wider consultation, he persuaded Mr Blair to do just that. The functions that Lord Irvine combined will now be parcelled out in new ways. The administration of justice will pass from the Lord Chancellor's department to the newly created Department for Constitutional Affairs to be headed by Lord Falconer. Judges will henceforward be appointed by an independent judicial appointments commission (similar to the body that already exists under Northern Ireland law), with no ministerial involvement. The law lords will become a Supreme Court, hearing cases referred up from the Court of Appeal, but without the Lord Chancellor (or his successor) as a member. The House of Lords will get its own Speaker, based on the Commons model.

There is a temptation, seeing the responsibility for this bundle of activities pass so hurriedly from Mr Blair's cheery former mentor, Lord Irvine, to Mr Blair's equally cheery former flatmate, Lord Falconer, to say that all this adds up to no real change at all. True, there is a real question-mark over whether, and for how long, it will be appropriate for the new ministry to be headed by a member of the House of Lords and not by an elected MP. With Baroness Amos in charge at the Department for International Development, and Lord Falconer in charge of Constitutional Affairs (including the residual post-devolution aspects of Scotland, Wales and, putatively, Northern Ireland), this is not a minor question. We must hope that the longer-term question of radical reform of the House of Lords is one of the beneficiaries of this reshuffle. It will certainly be one of the first challenges facing Peter Hain in his role as the new leader of the House of Commons. It cannot be left to fester. The impression that the new arrangements are a back-of-a-cigarette-packet job would be greatly eased by an early decision to remit some of the implications of the creation of the new ministry to a wider constitutional convention, similar to that on devolution.

But make no mistake about the importance of what happened yesterday. Reshuffles normally matter more to those who are directly involved than they do to the public at large. For ministers, days like yesterday are full of triumph or disaster. For most people, though, Cabinet ministers come and go, they strut their hour upon the stage and then are heard no more. That holds for some aspects of Mr Blair's latest redealing of the cards – even the unexpected change

that saw the admirable Alan Milburn leaving the Health Department, and a man who has something to prove in senior office, John Reid, taking his place. But it does not apply to this truly fascinating challenge to the traditional relationship between the government, the legislature and the courts embodied in the abolition of the post of Lord Chancellor. As a piece of planned policy-making and administrative change, it has broken all the rules of good practice. But the net result is that this is, or could be, the biggest single step towards the separation of powers in Britain since the Glorious Revolution more than 300 years ago. It is a huge change, which has long been championed by many reformers of different political loyalties. If the law lords are to be separated off from the legislature, then can the lords spiritual – the bishops – be far behind? Mr Blair blows hot and cold on many constitutional reform issues. But he has now taken another few hurried steps in a process that could eventually lead to a wider reconsideration of the relationship between Church and State, of the completion of the reform of the second chamber, and ultimately to a modern re-examination of the constitutional position of the monarchy itself. Little of this is on Mr Blair's own agenda. But a great step has been taken towards bringing British institutions into the twenty-first century. More must follow. Fourteen centuries swept away in a day. Bravo for such boldness.

1 July 2003

NICHOLAS WATT AND MICHAEL WHITE

The end of fox-hunting

Tony Blair last night suffered a humiliating rebuff when more than 300 Labour MPs, including seven members of the Cabinet, ignored Downing Street to vote overwhelmingly in favour of an outright ban on fox-hunting.

In an embarrassment to the prime minister, who had been pressing for a compromise to preserve a handful of hunts, MPs across the chamber voted by 362 to 154 to ban the ancient sport. The rebels' majority was 208.

Labour whips last night played down the defeat, which came a day after ministers warned that a vote for a total ban would 'wreck' the government's hunting bill.

A government source said: 'This shows that the government is listening to the Labour party. That will help us in the weeks ahead.'

Such remarks show that ministers are hoping that last night's vote will improve the government's relations with backbenchers, thereby reducing the chances of a rebellion over foundation hospitals in the Commons next week. Downing Street was warned by government business managers that any pressure on Labour MPs, who were entitled to a free vote last night, would have caused the government a headache.

The government signalled it was in trouble when Alun Michael, the rural affairs minister, withdrew a compromise motion minutes before a lengthy debate was due to end. This would have tightened up the bill to ensure that all

but a handful of hunts would have been banned. Under the original bill, some hunts would have been allowed to continue if they could show they were not cruel and were the only means of pest control.

The government performed its climbdown when it became clear that Labour MPs were abandoning the government in droves. Charles Clarke, the education secretary, and Ian McCartney, the Labour chairman, led the unofficial Cabinet rebellion on the free vote. In all, sixty-two ministers and whips voted in favour of the outright ban, which was proposed by the former minister Tony Banks. Five ministers and whips backed the prime minister's preferred compromise. In an embarrassment to the environment secretary, Margaret Beckett, whose department is piloting the bill, the 'rebels' included her deputy, Elliot Morley, who sat on the frontbench during the debate. Mr Blair, who did not vote last night, will dismiss talk of a rebellion because he will insist that he was living up to his pledge to give Labour MPs a free vote.

Last night's vote guarantees a bruising row with the Lords, where peers are determined to preserve fox-hunting. But the bill will first have to return to a Commons standing committee because the measure has been so radically altered. Ministers had hoped that the prospect of this unusual move would persuade Labour opponents of hunting to back their compromise because the delay might have jeopardized the entire bill. But this tactic collapsed when Mr Michael said the amended bill would be finished in the Commons by the July recess.

The government has promised to use the Parliament Act to enforce the will of the Commons if peers vote down the bill. Initial doubts that the act could be used were allayed when the Speaker indicated the delay is unlikely to cause a problem. The bill has to be presented to the Lords a month before the end of the parliamentary session in November for the act to be enforced.

Mr Banks warmly welcomed the vote. He said: 'It is excellent news. We have got some tidying up to do, which we will do in committee, and hopefully we have achieved a total ban on the hunting of wild mammals with dogs.' But he warned: 'We have promises that the Parliament Act will be used, but until the piece of legislation is signed off by the secretary of state, we can never be certain of anything.'

Anti-hunting groups also welcomed the vote. Phyllis Campbell-McRae, the UK director of the International Fund for Animal Welfare, said: 'The vote means that the House of Commons has signalled a total end to this barbaric activity. The government has made a firm commitment to allow this legislation to be enacted, and we fully expect it to meet its promise to end hunting with dogs.'

But Simon Hart, head of the Countryside Alliance's campaign for hunting, said: 'Rather than the death of hunting, this is the death of the hunting bill. The bill is in complete chaos and is now terminally damaged.'

8 July 2003

JULIAN LE GRAND

Letter: Private schools

I was sorry to read about D.D. Guttenplan's decision to move his child from what seemed to be an excellent state school to the private sector ('Why my little girl is going private', G2, 4 July). Sorry because not only will he be considerably poorer, but he will also be deeply disappointed – although it will be his 'little girl' that will suffer the most. She will be exposed to snobbish and reactionary peer pressure that will be almost impossible to resist. She will not escape the tyranny of exams, since private schools, driven by value-for-money conscious parents, have to do ever better in the league tables than their competitors.

Moreover, although all the cramming may eventually result in her obtaining slightly better A-level results by the time she applies for higher education, research shows that she will perform worse at university than her state school contemporaries with similar grades. Saddest of all, as the child of a family whose motto is clearly 'do as I say, not as I do', she will have acquired a profound understanding of the depths that parental hypocrisy can plumb.

11 July 2003

LEADER

Injustice behind bars

On page eight today we carry an adjudication from the Press Complaints Commission against the *Guardian* for paying a former criminal £720 for offering an alternative view of Lord Archer's time in prison. On the same day the PCC also considered a complaint against the *News of the World* for paying £10,000 to the alleged instigator of the collapsed Victoria Beckham kidnap trial. The decision in the Beckham case before the PCC has yet to be announced formally, though it is sure to be intriguing. A little background on the former may be helpful.

Last October Jeffrey Archer published some prison diaries, which were serialized in the *Daily Mail*. The *Mail* did not pay Archer, but it is a safe assumption that the book sales (and hence Archer's royalties) benefited considerably from this exposure. Many prisoners were offended by Archer's version of his time inside. Some of them felt that it should not be regarded as a wholly reliable account of events. Among them was John Williams who – in between spells in prison – has established something of a reputation as a published author. In April we carried a piece by Williams, for which we paid him a standard freelance fee for 2,600 words.

No one seems to have minded this piece very much. We did not receive a

single complaint about making a payment to a criminal; nor did the PCC. It should be emphasized that we would never have published an inside account about Archer's time in prison had he not himself placed the subject firmly in the public domain. He apparently intends to do so again. We applaud Archer in this venture. Anything that shines daylight into the hidden world of penal life in this country is valuable.

The PCC is not known for being pro-active. In a dozen years – according to its recent evidence to Parliament – it has stirred itself perhaps six times to raise its own complaints where there has been a 'wider public interest'. Indeed, over the years, it has shown itself remarkably unwilling to look into aspects of press behaviour, which, on the face of it, raise rather more troubling issues than Mr Williams and his modest payment. Among the issues the PCC has recently declined to investigate are: payments to policemen, the apparent bugging of celebrities' phones, the bribing of solicitors' clerks to steal photographs of bodies, payments to criminals for information about Archer and Jonathan Aitken while in prison, and the use of private detectives to get the phone records of actors and news readers.

The original purpose behind banning payments to criminals was to prevent them from glorifying their own crimes. This week's adjudication strays dangerously close to extending this ban on payments for writing to other prisoners or former prisoners on the grounds that they only came to be in prison because they committed a crime. Editors will in future have to double-guess what view of the 'public interest' the PCC might take. This has the alarming implication of stifling the work of such writers as our own Erwin James, whose much-admired 'Life Inside' columns have just been published as a book. The PCC has pointedly declined to offer any view as to whether James, like Williams, is now threatened. It goes without saying that no newspaper could remain part of a body that sought to prevent James, or other such prisoners, from writing about prison life, nor to deny them the honest rewards which they are entitled to expect (in James's case, with the full agreement of the prison authorities).

More troubling still is the PCC's cursory nod towards the Human Rights Act and its protection of freedom of expression (absent altogether from the first draft of the adjudication). Article 10 could not be clearer – freedom of speech is the trump card except in exceptional circumstances, such as national security. Although the PCC pays lip service to the HRA, it has, by this adjudication, introduced a degree of uncertainty, which is bound to have a chilling effect on freedom of expression.

Readers should be reassured that the *Guardian* will continue to write about prisons and penal policy. Among the voices that deserve to be heard in this debate are prisoners and former prisoners. Where it seems to us appropriate that they should be paid for their work, we will pay them.

THE STATE WE'RE IN

Austin

In an article about the adverse health effects of certain kinds of clothing, pages 8 and 9, G2, 5 August, we omitted a decimal point when quoting a doctor on the optimum temperature of testicles. They should be 2.2 degrees Celsius below core body temperature, not 22 degrees lower.

Corrections and Clarifications, 7 August 2003

JOHN O'FARRELL

Disgusted of Highgrove

Part of the process of ageing is realizing that you are gradually turning into one of your parents. Fine for some of us, but incredibly bad luck if your dad happens to be the Duke of Edinburgh.

Over the years we have become used to the dim-witted saloon bar bigotry of Prince Philip: 'I mean, these foreigners, they come over here and marry our women – oh no, hang on, that's me, isn't it?' But now there's a new right-wing cabbie sounding off from the driving seat.

Prince Charles is alleged to have repeated – and thereby given credence to – the opinion that Cumbrian hill farmers get worse treatment than black or gay people. And apparently, if you're a black gay Cumbrian hill farmer you have a really terrible time. Honestly, you trying getting on *One Man and His Dog* – if you are a wildly camp Jamaican in tweeds and green wellies, the casting directors are just not interested.

Charles was also quoted as saying: 'If Labour ban hunting I'll leave Britain and spend the rest of my life skiing.' Oh no! How will we manage? Who's going to provide the organic oatcakes for the Royal Windsor Polo Club? Where will Britain's most exciting and innovative architects get their ideas?

Charles's family have always had very strong views about hunting. William the Conqueror, for example, got so cross about who should be permitted to hunt on royal land that anyone who went against his views had their eyes gouged out with a blunt spear. He rode around killing bears and wild boar while the local hunt saboteurs stood by and applauded his excellent sportsmanship. Back then life in rural areas was even tougher; the countryside march of 1078 was finally abandoned when they couldn't find any cities to walk through.

The royals have always enjoyed hunting because it is the sport of the upper classes. There were rumours last week that Prince Harry actually joined the countryside march in a badger costume. He would have blended in perfectly if it hadn't been for the six SAS bodyguards disguised as otters and voles on either side of him.

There is a time and a place for a member of the royal family to break with convention and protest against the government, and that is when Mrs Thatcher is in power. During the 1980s the occasional royal criticism of Tory policies was entirely justified and welcome, but now that the royals are openly supportive of the Countryside Alliance such impartiality represents a serious breach of constitutional principle.

Over the years the liberal mask has gradually been slipping from the spiritual leader of Britain's long-term unemployed as he's taken to scribbling nutty letters and making embarrassing public outbursts on bizarre and irrelevant subjects. His favourite targets are 'political correctness', 'red tape' and the fact that when

the sun is shining you can't read the instructions on the cash dispenser. Yes, Charles has turned into a crank caller on a late-night radio phone-in.

What will it be like when he's finally King and every year we have to listen to his Christmas broadcast. 'At this festive time one's thoughts turn to how annoying it is when teenagers press the button on pelican crossings when they've no intention of crossing the bloody road, I mean, the traffic lights go red and you have to stop the car for no reason, what is the point of CCTV cameras if they're not going to stop these bloody tearaways?'

This will follow the embarrassing departure from the script at the state opening of Parliament: 'My government will take steps to reform the civil service – although what they really ought to do is pass a law so that there's a separate queue for stamps at the Post Office, I mean, they've got all those bloody windows there with no one on them, I mean, it can't be that bloody difficult, we've put a man on the moon, for goodness' sake, and while they're at it they should make things easier to find in the supermarket, I mean, why can't they put the bloody fromage frais with the yoghurt instead of with the cheese?'

The subtext of Charles's latest rant is that it would be all right if black and gay people were being persecuted but these farmers are upstanding white Englishman and that's just not on. Frankly, the remark does not stand up to a great deal of scrutiny. The EC does not pay £6bn a year to Britain as part of the common homosexual policy. And when was the last time the police pulled up a farmer in the Lake District? 'All right, honky white boy, this is a bit of a flashy tractor, isn't it? How did you pay for that then, eh? We know you're growing stuff in your fields.'

Next time Charles feels the urge to repeat such a stupid bigoted remark he should do so anonymously. Maybe he could put on his son's comedy badger costume. And that's when we shout: 'OK, hunting isn't banned after all. Release the hounds *now*!'

29 October 2002

Pass notes: Inflatable tank

Status: The British army's latest hi-tech military hardware.

Appearance: Tank-like. Except lighter.

Special features: Small plastic valve allowing ingress and egress of air. Small pool of rancid saliva collected in interior. Smells of armbands.

Operational benefits: Unlike traditional tanks, the inflatable tank is full of air, so it is considerably more lightweight than steel-construction tanks. Plus you can bounce on it.

Operational effectiveness: While the inflatable tank is, strictly speaking, less than useless in a combat situation – carrying no armaments and being vulnerable to bullets, safety pins, sharp twigs, etc – the inflatable tank is proud to boast a combat record superior to that of the standard issue SA80 rifle. Now that really is crap.

Location: God knows.

You mean 'classified': I mean we haven't the baldiest. It blew away.

Blew away? Alas yes. Apparently this is a particular risk with inflatable tanks (though something that steel tanks, having a weight of several tons, usually avoid). It is particularly bad in blustery weather conditions, like those over the weekend, according to manufacturers.

It blew away? Look. The army has borrowed six inflatable tanks for 'training purposes', the advantage apparently being that they are 'considerably less lethal' than the old-fashioned kind that come with guns attached. The tanks were then hidden in woodland in Wales as part of a training exercise. But over the weekend, one blew away. 'If anyone has seen a flying tank,' said a spokesman, 'please contact us.'

Oh dear. How would we know? Put it this way, if you live near the Brecon Beacons and you see a tank flying over the top of your house, it's likely to be the inflatable one that just blew away from the army.

Not to be confused with: The 25-foot inflatable Ronald McDonald that blew away from a Newport restaurant last week. It's equally bouncy, say its owners, but doesn't look like a tank, so you should be able to tell the difference.

9 November 2002

JULIE BURCHILL

The Blair stitch-up project

I blame *Lady Chatterley's Lover*. Those old, lemon-sucking lawyers were right when they said it would seriously warp people's thinking if they read it. But it wasn't wives and servants who should have been shielded, oh no. It was middle-class nancy boys who got their sticky paws on it at prep school and, ever since, have been so terrified by the idea of British male working-class potency that they have sought to belittle, divide and castrate the dreaded beast in any way they can.

Some were so obsessed with their crusade that they even sought to enter and destroy the very heartland of these calloused Casanovas: the Labour party. Oooh, the very name shrieks red-blooded, no-nonsense shaftings on tap. (Hard Labour!) Millions of bodies made strong and fit by toil finally banding together to take back what was rightfully theirs – and with it a swathe of frustrated, middle-class totty, who would be impregnated with future class warriors while hubby was out pushing paper around at the office. (Labour Pains!) The party of Keir Hardie and Aneurin Bevan became the party of Tony Blair (nicknames at school: Emily and Miranda) and Peter 'Hyacinth Bucket' Mandelson. It became the limp and lite New Labour, symbolized not by a nasty threatening red flag, but by a wussy rose that could have come straight off a packet of Andrex toilet tissue (extra soft, and moisturised with aloe vera).

Well, they say if you're going to tell a lie, tell a big one, and the same goes for entryism and hijacking. Militant were too moderate, that was their problem. People such as myself, who were lucky enough to grow up in the hardcore, out-

brothers-out union culture of the 1970s – imagine, the workers having a say for once, where will it all end?! – not to mention the activists and leaders themselves, were completely wrong-footed by the full-on prancing narcissism of New Labour, especially their deranged belief that they could throw away everything the movement stood for, declare Year Zero and do it their way.

It wasn't long before New Labour's courting of the rich, famous and big business made them look like a bunch of silly, starstruck girls, and the alleged evil geniuses behind The Project now look about as threatening as a gang of Beanie Babies with their heads on back to front, succumbing to therapy, vanity and soft furnishings. The idea that people used to be scared of these clowns is almost surreal now – the final straw came last year, when the awful, outdated unions had to step in and bail out the puffed-up poltroons, even paying the Millbank electricity bill! For all their fancy friends, £500-a-head dinners and talk about the importance of wealth generation, New Labour couldn't even keep its own financial house in order.

From salt-of-the-earth stewards to serial shaggers to superior sugar daddies, no wonder the working man remains a source of confusion to sheltered, unimaginative Blair. And as people who feel threatened often do, it has made him adopt a deeply condescending manner to cover his confusion. Whatever the firemen decide to do this month, the problem New Labour have with them – and with the doctors, nurses and transport workers, for that matter – will continue until Blair learns to talk to them as grown adults, rather than naughty children.

Blair deals with his terror by turning them, in his mind, into not-quite-real people. He deals with the fear of the havoc that these key workers, if they were not so ludicrously decent, could wreak on his house of cards by making their jobs into not-quite-real jobs – not really essential to the running of the country, unlike, say, a lawyer, a quango-man or a CEO. In a logic-leap of *Alice Through the Looking Glass* proportions, Blair really seems to believe that people should be 'grateful' for being allowed to be nurses, train drivers, etc, as those are the jobs children always say they want to do, so they must be the best ones. There's some sort of mass delusion among white-collar workers, even liberal ones, that we're carrying them – all those idle nurses and firemen, blowing the hard-earned cash of us journalists, lawyers and MPs! I was amazed during that case about the poor teacher threatened with death that liberal broadsheets thought nothing of telling teachers how to do their jobs. How dare they? No journalist could last a day in a comprehensive school, but most teachers would make decent journalists – Chris Woodhead apart, obviously.

Do MPs really believe they're worth an annual salary of £55,000, while firemen have to make do with £21,000? What a strange, warped world they live in, and how weirdly they must calculate their worth. Blair should get out there and meet some real people – not his constituents at Sedgefield Labour Club, who see him as their clever child and would never be honest with him about the great wrong he has done this country's most valuable people, simply because they know he would be devastated.

At one fire station in Brighton, only three of the thirty firefighters can afford to live in the city they protect, the rest commute from places that are an hour or more away. But every actor, web designer or journalist who wants to live here

can – and that, more than anything, demonstrates the filthy inequality that has grown worse, not better, under Blair.

Archaic though the term seems, Bob Crow, Mick Rix and Andy Gilchrist are real men and their opponents are not – they are unreal, hollow men, and they have ruled the roost with their sleight of hand and slippery ways for too long. Let it come down.

12 December 2002

DAVID McKIE

Nothing like a dame

December is the month for dames. Dames of two kinds: those whose dame-hoods, courtesy of the Queen and prime minister, will be announced to the nation at the end of the month and those who are just now starting to caper about on the stages of our theatres, dressed in the worst of all possible tastes, failing utterly to disguise the fact that they're really men in disguise, and doing strange things with sausages. Do those in the first of the categories, I wonder, sometimes resent those in the second? It would be understandable if they did, for the image of dames needs all the help it can get, and it doesn't get much of a boost from Widow Twankey.

Damehoods for women are intended to be the equivalent of knighthoods for men, though dames seem to be far fewer. The Cabinet Office can provide no precise figure of the numbers of knights and dames now roaming the country, but if precedent is anything to go by, knights will outnumber dames on 31 December. And knights, I think, have a far more glamorous and romantic ring about them than dames. Knights saddled their prancing horses and galloped off into the misty distance in defence of God and their masters, leaving weeping wives at the castle gate to face unspecified terms – an eternity, even – of knight starvation. They were Galahad and Lancelot and Lamorac and Tristram and Gawain. They were Knights of St George and Knights of Christian Charity and Knights of the Garter, whose honour, it used to be said, 'exceeded in majesty, honour and fame, all chivalrous orders in the world'. 'So faithful in love and so dauntless in war,' wrote Scott, 'there never was knight like young Lochinvar.' On the contrary, Walter: the literature of romance is full of them.

In honest, dingy real life, the knights one meets nowadays are just as likely to be portly businessmen who have taken vast pay rises unrelated to recent achievement, with bonuses and inordinate pensions to match, yet somehow, awareness of that does little to damage the image. Some celebrated knights at the court of King Arthur were vicious, unprincipled backstabbers and no kind of suitable role models for the youth of today. And some knights, like the white knight in Alice, were gentle, unworldly, impractical creatures incapable of stirring the hearts of fair women. But on balance, the thought of a knight on a fine white horse heading off to the west is a more exciting concept than a dame doing likewise.

There's Dame Fortune, of course, but I guess most people see her as essentially benign and cuddly most of the time, before suddenly snarling and doing you down. There's Dame Partington who, faced with great floods at Sidmouth, came out with a broom and tried to drive them back into the ocean and in nursery books there's Dame Trot, who liked to chat with her cat, and that other anonymous dame who has lost her shoe and doesn't know what to do – marking her down as an even more confused and bumbling individual than the white knight in Alice.

The one unequivocally romantic dame I can find is the one in the poem by Keats whose allure and subsequent cruelty accounts for the wan condition of the knight who's alone and palely loitering. His romantic status is never in doubt: the knight whom Keats portrays does not summon up an immediate vision of, say, Sir Patrick Cormack. As for the poet's dame, she is 'full beautiful: a faery's child'. 'Her hair,' the knight recalls, 'was long, her foot was light, and her eyes were wild ...' so much so that he feels inspired to make a garland for her head, and bracelets too, and to take her on his pacing steed all the way to her elfin grot, where he shuts her wild, wild eyes with kisses four. But note that throughout these processes the knight never calls her a dame. It is the pale kings and princes and warriors – here previous victims – whom he later encounters who identify her as 'La belle dame sans merci'. The images work because 'dame' is in French – the story comes from Provence. Substitute 'dame' in English and the magic would dissipate.

Clearly, if dames are ever to achieve a suitable parity they need some kind of makeover. We need children's stories in which dames ride to the rescue of princes in distress while knights run boring companies or make orotund speeches in Parliament. We need pantomimes in which dames are the heroes and Aladdin and Crusoe are figures of fun, in which Jack's mother, reclassified as a dame, climbs the beanstalk and slays the ogre while Jack is watching the football.

Either that or a change of designation. If actresses are now to be known as actors, should not dames become knights? Please don't feel obliged to answer that question.

19 December 2002

MICHAEL HOWES

Letter: Degrees of hypocrisy

I can't stand mobile phones, most of the royal family, football, TV makeovers, Ariel Sharon or George Bush, or telephone polls (Letters, 18 December). But I love a drink and my daily *Guardian* crossword. What's to become of me? Abroad does not appeal.

13 January 2003

IAN MAYES

Between Cilla and Charybdis

Throughout last week the cover of G2, the tabloid second section of the *Guardian*, was given over to a leading British artist, starting with David Hockney, who provided a self-portrait. Nothing very controversial there. The following day, however, the Turner prize-winning artist Gillian Wearing, working to a piece about the increasing nastiness of British television, came up with a page scrawled, graffiti-like, with just three words: Fuck Cilla Black (hereafter known as FCB).

It provoked an unprecedented (in my experience as readers' editor) and over-whelmingly condemnatory response from readers. By early morning complaints appeared to be coming into the *Guardian* through every crevice, 'like snow under the door', as one colleague put it. By the end of the week I would say close to 1,000 emails, telephone calls and letters had arrived.

Some had perhaps been stimulated by a radio phone-in programme, but the vast majority it was clear came from the *Guardian*'s liberal – one might say noto-riously liberal – constituency, a significant section of which was seriously offended. (I should point out in passing, however, that during the day of publi-cation 2,700 people entered a competition for a special signed copy of the cover.)

A large number of those of you who made adverse comments by post did so on the torn-off page itself. One ringed the words 'TV gets nasty' in a sub-head-ing and added: 'So does the *Guardian*.' Another reader wrote across the page: 'This is so dishonest – being nasty while describing others being nasty.' She made a number of other points common to a lot of the correspondence: that the cover was spiteful to Cilla Black ('she is a real person') that it trivialized, and that 'if the article is worthwhile the cover puts one off reading it'.

By Tuesday afternoon the *Guardian* website was running two reports, the first headed '*Guardian* cover outrages readers', the second headed 'Wearing apolo-gizes over cover furore'. The report identified her as a fan of Cilla Black and of *Blind Date* and quoted her as saying: 'I thought people would laugh at it and not even look at it for long. It just shows you cannot predict what people will think.' (In this case, I think it could have been predicted and I believe to some extent it was.) 'I am sorry if I have offended people.'

In Wednesday's G2 three pages were devoted to the controversy. There was a piece in favour of the FCB cover by the *Guardian*'s art critic, another putting the case against by the editor of *Jackdaw*, the arts magazine, and a substantial article by the features editor who commissioned the cover, acknowledging that the power to shock of the word 'fuck', used in this way, was seriously misjudged. He concluded with the words: 'To all those whose breakfast was spoiled yesterday ... I'd like to extend a sincere apology.' There followed a whole page of readers' letters, mostly condemnatory. In the circumstances this seemed to me to be a

fair and frank way to address the readers.

On the letters page of the main paper the following day several correspondents supported the paper's decision to publish the FCB cover, and these letters in turn brought in another wave of protest. By now a two-page letter from the editor of the *Guardian* was going to readers, reminding them that the week as a whole was 'in a long tradition of the *Guardian* working with poets, novelists and artists to respond to contemporary issues'. He concluded: 'You were upset by Gillian Wearing's G2 piece and I apologize for that. But in general, I am pleased that the paper has, over many years, encouraged artists and writers to work with us, even if, on occasion, the result can, in the judgment of many, disappoint or offend.'

The editor told me: 'I was thrilled with the ambition, imagination and energy of the whole project.' Of this particular cover he said: 'I wasn't entirely happy with it in retrospect, although I would much rather we were over-ambitious and occasionally slipped, than safe. I think the vast majority of readers like the fact that we push boundaries. There will always be protest but it doesn't mean you are wrong to do it.'

I conducted a poll of the *Guardian's* journalists and editorial assistants, asking for a simple yes or no answer to the question: Was the paper right to publish the FCB cover? A total of 228 people responded. (When I carried out a similar exercise to test the opinion of staff on the paper's Middle East coverage, thirty people replied.) In the FCB poll, 140 (or 61 per cent) thought the paper was wrong to publish and eighty-eight (or 39 per cent) thought it was right. Women were almost evenly divided: thirty-nine thought it was wrong and forty-one right to publish. There were no clear divisions in terms of age or between departments of the paper.

Are *Guardian* journalists more or less liberal than the paper's readers?

The Poet Laureate was quoted on the front page last week, saying: 'My underlying feeling is that poetry ought to be part of general life rather than being ghettoized.' The *Guardian* took the laudable step of inviting a group of artists out of the ghetto. It was the art historian R.H. Wilenski who said (long ago): 'The only art which can teach us to understand art that was ever alive is the art of living man. If we fail to understand that art we fail to understand all art – always inevitably.'

A number of things fuelled the response from readers: the billing on the front page, 'Gillian Wearing bids farewell to Cilla Black', invited the wrong reading of the cover itself; there was inadequate explanation inside G2 of what the artist was seeking to do; the feature itself was not strong enough to justify the headline; the *Guardian* guidelines on swearing – written in response to reader complaints – were apparently flouted; publication of the FCB cover coincided that day with *Guardian* Education. A number of teachers were outraged and rang to say so.

The artist said that had she been told, 'We can't do that' she would have come up with something else. That, it is perhaps easier to see now, is what should have happened.

8 March 2003

CHARLIE BROOKER

Screen burn

Attention, attention. This is not a drill. I repeat, this is not a drill. Go to your shelters. Do not stop to retrieve belongings. Do not venture out until instructed to do so. We have reached Imbecility Event Horizon. Clouds of noxious thickery are billowing across the nation: do not risk exposure. If you have a television, smash it now. It is acting as a conduit. On no account switch it on. On no account watch *Boys And Girls* (Saturday, 9.35 p.m., Channel 4). Even a fleeting glimpse can cause inoperable brain damage.

A nightmare vision of the future, folks, but one I fear could come true at any moment. Let me explain. The shelves of Waterstones are littered with breeze-block-sized sci-fi novels with the following premise: a group of scientists attempt to create a black hole in their laboratory. They succeed. Planet Earth is engulfed by an out-of-control vortex of nothingness. The end.

Well, that's what's happening with *Boys And Girls*, Channel 4's new Saturday night bozo-cast. It's not so much a TV show, more an organized attempt to create a newer, more toxic form of crap – one that can eat through the screen and pollute the human brain within minutes, leaving the victim unable to perform anything but the most basic motor functions, such as chewing cud or masturbating.

And it's in danger of going wrong. I'm scared. They're meddling with things so far BELOW the realm of human comprehension, they may inadvertently create a swirling portal to a whole new dimension of stupidity. All solid matter in the universe may get sucked in. For God's sake, Blair, send the troops in now.

What follows is an excerpt from notes I made during last Saturday's edition. Please excuse the scrappy nature of the text. I was undergoing heavy exposure at the time.

'*Boys And Girls*: awful. No, worse: possibly illegal. Vernon Kay must be liberated. Man looks lost. Send search and rescue team immediately. Audience consists of opposing teams of 100 men and 100 women. Bellowing cow people. Mass outbreaks of hollow-skulled whooping. The noise, the noise. Going to be sick. Going to [text unintelligible]. Please God, stop the noise. Taliban definitely right. Is this an al-Qaida recruitment film? Sheer level of witlessness terrifying. Quantities of tackiness not balanced by equal quantity of sly intelligence, leading to potential China Syndrome of Shitness. Reminded of difference between *Wayne's World* and *Dude, Where's My Car*? – both puerile, but the latter rendered unwatchable by utter absence of clever: *Boys And Girls* even worse.

'Getting worse. Jade Goody cackling, 'Sex or beer, sex or beer?' as audience bellows around her. Consider possibility this is live-action version of Hieronymus Bosch triptych.

'Cannot believe this cost half a million pounds. Must call Hans Blix and request immediate dismantlement. More cackling. Can sense idiocy piercing

own brain. Must look away. Must look away. [Remainder of text obscured by blood.]'

The time has come to protect yourself and your family from the *Boys And Girls* menace. Collate a survival kit: you'll need books, magazines, paper, pens, an old Nirvana CD and videotapes of *24* and *Curb Your Enthusiasm*. Detach the aerial lead from your television set and establish a protective cordon around it on Friday and Saturday nights. If anyone goes to switch the TV on during this time, shoot them.

Fortunately, early data indicates far fewer innocent viewers than anticipated have been exposed to *Boys And Girls*. Best-case scenario is that this trend continues until it withers away, at which point field operative Vernon Kay can be scrubbed, defumigated and returned to active service.

Do not be fooled. This is not, repeat *not*, a harmless exercise in feelgood nonsense. It is a cynical, hateful, nauseating and witless insult to humankind. It is sub-ITV. It is sub-ITV2. We *must* act now, lest it destroy us.

Return to your shelters, beloved populace. And may God be with you.

19 March 2003

NANCY BANKS-SMITH

Once more unto the breach

You didn't have to welcome me back with gunfire. No, honestly, you shouldn't have bothered. As the editor of the *Observer*, the last of several, remarked on being handed his hazardous chalice, he felt like the troops in a TV documentary he had just seen. The moment they landed, they had their heads blown off.

Among the soaps, only *Coronation Street* (ITV1) acknowledged the present unpleasantness, popping it into the pudding like a current currant. Watch out for Shelley, the barmaid at the Rovers, quavering to her betrothed, Peter Barlow: 'I've been thinking about this business with Iraq. What if you were called up or something?' Peter, who is upholding the finest traditions of the Royal Navy by promising to marry two women simultaneously, looked, I thought, a little wistful at the prospect of this escape clause. Like a man who finds a file in a wedding cake.

You could say that Roy in *EastEnders* (BBC1) was called up. At least one hopes so. A decent man, as second-hand car salesmen go, he died of a heart attack to the sound of sweet, boozy music from the Queen Vic. As a signal sign of mourning, Pat, his wife, did not wear earrings for one whole day. Roy was carrying a donor card, so she agreed to give his body for transplant surgery, although, as he had a weak heart and impotence problems, you did rather wonder which bit they wanted. I favour his chest hair, which was visibly thriving and enviably lush, a waving forest of kelp though which his substantial son, Barry, kneeling by his bed, could occasionally be seen like a questing sea elephant.

Barry, who has carelessly lost his father, his wife and his child in as many

days, has now gone the whole hog and thrown Pat out of the house as well. Into the snow. As the weather is exceptionally mild and Pat is built on monumental lines, this is an achievement to make lesser men whistle. I am not accusing the scriptwriters of having a laugh, but, if you fancy one yourself, don't miss Pat trudging through a snow-covered square tomorrow, like a polar bear with icicles on her ears.

I have been quite seduced by a mesmeric little series, *This Model Life* (Channel 4). It seems rude to stare and impossible not to. The catwalk model Erin is barely six feet tall but so stick thin that, illuminated by the headlights of traffic far below, she looks like a giant insect and the traffic seems terrified. The artist sketching her said: 'Erin is a genetic accident. She's a human being but very few people look like that.' Erin cackled and waggled her arms at entomological angles. She makes a great deal of money and husbands it carefully, collapsing her giraffe legs in economy class to bank the difference. Jane Treays, who produced and directed, regularly makes a point of asking, 'How much?'

Ruth, who looks like a charming rodent, spent £3,000 looking for work in New York and made nothing. Her only friend was a tiny turtle, saved from Chinese soup. They sweltered together. Anna, discovered at eleven ('We sat on her for four years'), knocked the socks off a susceptible sculptor who saw her as an angel: 'I get goosepimples when I think of her and butterflies between my fingers.' Anna's mother heard this with pursed lips. 'He was quite over the top. I found it a bit ... mmm.' She did not see Anna as an angel. She accompanied her everywhere.

The Mummies of Cladh Hallan (BBC2) was memorable, well, unforgettable actually, for the contribution of Robert Crowson, who runs a smokehouse in Blubberhouses. He was consulted about the feasibility of smoking a dead body, because skeletons found in the Outer Hebrides seemed to have been mummified by artificial means. A man who has smoked crocodile, ostrich and kangaroo, and is currently pondering the problem of smoking a camel (getting the humps in the oven without profanity and all that), is not fazed by a corpse. You would expect someone in his line of work to be smudgy. Not at all. He sparkled in a white hat like a Daz ad and he gave the question his serious consideration. 'To have a go at smoking a whole body ... it would be interesting to see if it could be done. They would have constantly to turn the body round, upend it and make sure the smoke got into the cavity.' Yes, quite. I think I've got the hang of it.

What a man. He will smoke your camel but will not split an infinitive.

9 April 2003

DAVID MUNK

Death to the hedgehogs!

I'm a vegetarian. I don't wear leather shoes, belts or coats. I usher wasps out of my flat rather than swat them with my copy of *Bean-Eater Monthly*. I used to listen to The Levellers and remember once arguing I would rather sacrifice a mem-

ber of my family – my sister – than allow an innocent rabbit into the clutches of a cosmetic scientist. In short, I'm probably an averagely committed veggie. But now I'm pretty certain the hedgehogs have got to die.

Some bizarre malaise has afflicted a sector of our population – a malaise so frustrating that when I first heard it it made me want to eat my radio. A collective waywardness of mind has skewed all sense of proportion, leading people to raise a reported £75,000 to relocate hedgehogs from islands off the coast of Scotland to the mainland.

Why? Well, here are the crazy facts if you don't already know them. Four hedgehogs were introduced to the Western Isles in 1974 to control garden slugs. They are now a ground force of 5,000. Scottish Natural Heritage says they are a major problem, eating the eggs of rare wading birds. Some colonies of birds have been reduced by up to 60 per cent. So the conservation agency wants a cull. Get rid of the hedgehog – plenty more where they came from, population up to 5 million on the mainland – and save the indigenous birds.

A veritable no-brainer, you would have thought: start with North Uist where the problem is in its infancy, and cull the entire population of 200 as hibernation ends. After all, fencing off the hogs doesn't work. Nor does contraception.

But SNH has run into human problems of campaigning groups and knee-jerk do-gooders. A coalition of the silly has formed between charities and advocates of animal rights: normally my kinda people. They want a non-lethal solution and have despatched eleven volunteers – and even two trained nurses – to the islands. The idea is to pay £5 for every hedgehog found by a local and fly or boat them to safe havens.

SNH claims the relocation would be cruel. The hedgehogs would die painful deaths. The isles' hogs are free from fleas and have no immunity to disease carried by mainland bugs. Also, any hedgehogs re-released into the wild would probably starve or cause other resident hogs a similar fate: SNH claims studies show hog populations are determined by the availability of food. Most crucially – and this is most bizarre – campaigners are removing hogs from islands where the cull is not even being carried out this year. The SNH says by the time the cull gets to those islands, animals rescued would have died of old age anyway. So what we have, then, is tens of thousands of pounds being spent to save an abundant animal that is a serious threat to a habitat and would itself have died a natural death if it had been left alone in the first place.

Now the campaigners deny many of the SNH's claims, saying they would be able to look after the hogs very well. And I guess there would be an excuse for a smidgen of outrage if those nasty agency folk were using clubs to slaughter the unfortunate hogs. But no, they are given the finest drugs available to man and then humanely disposed – a blessing rarely afforded humans.

Let's imagine these campaigners – and more importantly donors – explaining this all to a mother in Malawi: 'I was going to give you £10, which would keep your family from starvation for a couple of weeks, but instead I put it towards flying a hedgehog club class to the Maldives for a bit of sun.'

She would be right to be angry. They do have warped priorities. On their planet every hedgehog has a name. There's Harry, Harriet and Humphrey

Hedgehog. Anthropomorphic alliterations to make us dewey-eyed and reach into our pockets.

Maybe it's a guilt thing. Here we are doing horrible things to cute animals, so let's throw some money at them. But the truth is, if they aren't cute forget it. Cows and chickens are fair game to be put through the mincer. Indeed, take the case of the mink. Somewhere in the UK in November 2001, 200 mink were culled because they were eating rare birds' eggs and crofters' animals. Where were these mink culled? North Uist, home of Henrietta and Harold Hedgehog. Poor old Mindy the Mink and her cubs just weren't cute enough to be given a ticket off their island.

Nor I guess are the 40 million Africans the World Food Programme worries are about to starve to death, nor were the 4.7 million who died in the hell of the Congo. And there is no ticket out for Iraq as war continues to devour lives and livelihoods.

So should we really worry about the hedgehog of the Western Isles? Well, I'm not worried. I know my priorities, and they should die.

17 April 2003

RICHARD BARRY

The wee mystery of asparagus

The English asparagus season is upon us again. Which means it is time for the question that 40 per cent of us are too shy to ask, while the other 60 per cent have no idea what it's all about. The question is: after eating asparagus, why does one's pee smell so extraordinary?

It doesn't depend on age, it doesn't depend on gender, and it doesn't depend on race – although it may have something to do with heredity. But 40 per cent of the population have the most weird-smelling urine soon after eating asparagus – and that is really soon, certainly within fifteen minutes.

The heavenly spears contain all sorts of nutritional goodies, including plenty of sulphur-containing amino acids, and for many years it was believed that only the 40-percenters had the gene to break down these amino acids into – among other things – methyl mercaptan (a chemical similar to the one that gives a skunk its smell).

The smell may be odd but not everyone finds it unpleasant. Proust famously remarked that asparagus 'as in a Shakespeare fairytale, transforms my chamber-pot into a flask of perfume'.

Then, in 1980, some inspired research was carried out (I'll leave you to imagine what an unpleasant experiment it must have been to undertake). The results suggested that everybody produces methyl mercaptan – it's just that the 60-percenters have noses that can't detect it. Evidently, the poor old 40-percenters can smell not only their own output, but that of the 60-percenters too.

The truth remains unclear. Are the 40-percenters blessed with special kidneys or special noses? It is sad to learn that no further research is under way on this

fascinating topic – presumably no one has been able to work it up into the sort
of health scare needed to attract research funding these days.

So it doesn't seem to matter whether we produce mercaptans or not – except
perhaps socially. One London club – rumoured to have been the Garrick – had
for many years a notice saying: 'During the asparagus season, members are
requested not to relieve themselves into the umbrella stand.' One does rather see
why.

13 May 2003

SIMON HOGGART

The wrecking machine careers out of control

Personal statements to the Commons are traditionally heard in silence, but not
Clare Short's. There were gasps and whistles, half-stifled cries of 'Whaaa?', deep
racking sighs and, I swear, something that sounded like a very gentle death rat-
tle from the Labour benches.

The small handful of Cabinet members who were present sat staring ahead
like firing squad victims who've refused the blindfold.

For the former international development secretary had arrived, as the hunts-
men say, loaded for bear. They winced as they heard each shot echo round the
woods, then relaxed for the briefest time while she reloaded before pulling both
triggers again.

Think Jack Nicholson waving his axe about in *The Shining*, Norman Bates
during the shower scene in *Psycho*, Kathy Bates torturing the helpless author in
Misery. This wasn't just a cool assessment of the story so far; it was hatred,
scorn, revenge and contempt, and it came welling up from the core of her
being.

As for the prime minister – who was not there – he must have felt like a dad
who's left his teenager at home for the weekend and come back to find the detri-
tus of a party. Except that this lot, instead of merely puking on the stairs and
drinking his best wine, brought a wrecking ball and a crane.

Crash! The cast iron thumps into the conservatory: 'It is the style and organ-
ization of our government which is undermining trust and straining party loy-
alty in a way that is entirely unnecessary ... accompanied by control freak
problems that have created many of the problems undermining the success of
our public sector reforms,' she said, as the ball walloped into the bedroom and
the elegant en-suite bathroom.

She frantically manipulated the levers, swung the ball back, then pushed the
knob to send it flying into the Cabinet room. 'Diktats in favour of increasingly
bad policy initiatives come down from on high ... Those who are wielding
power are not accountable and are not scrutinized,' she went on, the Brummie
accent giving her a slight whining tone, as a circular saw. Think James Bond,
legs apart, strapped to the work bench by whichever evil megalomaniac it was
in that film.

How could these appalling people get away with all this? 'They have the powers of a presidential system with the automatic majority of a parliamentary system.' Whew! What an indictment! No wonder she could bear to serve in such a dreadful administration for scarcely more than six years!

By this time even her natural supporters were beginning to wonder. Had she gone just a teeny-weeny little bit too far? And since the Machiavelli, the poisonous spider sitting in the centre of this web of undeserved and misdirected power, is the prime minister, how is it that he successfully begged her – several times over the past year, she claimed – to stay in her job?

But in spite of his loyalty to her, it was for him she saved the unkindest swing of the ball, the one meant to bring the chandelier crashing down. 'To the prime minister I would say that he has achieved great things since 1997, but paradoxically, he is in danger of destroying his legacy as he becomes increasingly obsessed by his place in history.'

The man sounds like Blofeld. It was not hard to imagine the roof of Downing Street opening, klaxons sounding, as the nuclear-tipped missile rises up, trained on Birmingham Ladywood.

On the other hand, we might have forgotten the whole thing by the end of the week.

17 May 2003

JULIAN BARNES

The pedant in the kitchen

'Help!' began the email. 'What's a 20-gram egg-yolk? How do I weigh it? If it's too heavy, do I cut it in half?'

Can you guess which cookery writer set off this wail in my inbox? That's right, it's Mr Heston Blumenthal. Do you read his recipes every week? Do you, at least, read their titles? Crushed meringue and pistachio with soya-sauce mayonnaise? Does that make you feel bracingly challenged or hideously inadequate? Do your salivary glands throb and your feet make pawing gestures in the direction of the kitchen, or do you find yourself musing on the attractive blue neon signs of Pizza Express?

Don't get me wrong. I am in awe of Mr Blumenthal. I once had dinner at his restaurant, The Fat Duck, at Bray, and by ordering very conservatively, had a wonderfully exotic meal. He is a disciple of El Bulli, the staggeringly innovative restaurant north of Barcelona, and this is a brave thing to be in the Home Counties. He is also one of the few restaurateurs in his class and price range who lets you bring your own wine in exchange for a corkage fee. He is that rare mixture of a supreme gastrotechnologist who understands the twitch and flex of every muscle, and a cook who is rococo in his imaginings. If you gave him a human brain he might poach it lightly in a reduction of 1978 Cornas and top it with a mortar-board made of liquorice; but he might not understand all that had been going on inside it before he popped it into the pot.

Again, don't get me wrong. I quite want to cook some of what Mr Blumenthal proposes: though when he tells me that the best way of cooking a steak is to flip it every fifteen seconds, making thirty-two flips in all for its eight-minute cooking period, I am inclined to wonder who will be minding the chips and mushy peas while I flip four steaks 128 times, so I say Pass. As for the chips – did you see his recipe for chips? He takes the 'pause' technique – whereby you lift out the frying basket and let the oil regain its initial temperature before the final browning plunge – to its logical conclusion (or fantastical extreme). The Blumenthal method is to par-fry the chips and then shove them in the fridge to chill out. After a couple of hours or so, you heat up the oil all over again and complete the cooking. I have given this much thought and cannot imagine anyone – *anyone* – ever doing it.

However, his emphasis on slow cooking seems to me salutary and admirable. And by slow he means very slow. I was cooking oxtail stew the other day and in the usual way found myself checking half a dozen recipes for how long to give it. Alastair Little: two hours (you're joking); Fay Maschler: three; Frances Bissell: four (getting warmer). I think I gave it five, and two subsequent re-heatings of forty-five minutes each only enhanced the tail's fork-meltingness. Mr Blumenthal probably has a recipe that involves giving it the full cycle of the moon.

The sticking-point, however, came fairly early. I had read several of his recipes for slow cooking, in which he gave oven temperatures in centigrade. I have a standard oven with gasmarks, and we were clearly talking gasmark 1 and below; the temperature-conversion charts that preface basic cookbooks didn't even start at the temperature (65 degrees) that Mr B was proposing for one particular recipe. In any case, he said an oven thermometer was essential; you also had to make sure the heat had stabilized before putting the meat in. Guessing was simply not an option.

Then I remembered that I did actually own an oven thermometer, bought on one of those scavenging trips to a kitchen shop where you go in search of a brave new machine and come back with a paring knife and a questionable gadget. It was, inevitably, in that drawer where you stow such things and then forget about them, where everything is tangled up – whisks with chopsticks through their wires – a shameful place. I dug it out; 65 degrees, I said to myself dreamily. Six hours, seven hours, a day-and-a-half, with cooking odours wafting gently up to my study. I took the thermometer out of its packaging. And its lowest marking was 75 degrees.

Mr Blumenthal is off my radar, as well as my oven thermometer, and that's all there is to be said. His cuisine is Olympian, fit for gods who have become sated and fractious after millennia of ordinary perfection. The more immediate problem of conscience comes with writers who are similarly high-minded, but more accessible. I revere Elizabeth David, yet don't cook from her as often as I know I should or even as often as I want to. Why not? Because she seems to have her admonishing eye on me, because I feel that if I get something wrong I will have offended her shade. Lo, I have been sloppy; and the temple of cookery has been profaned.

Or take the case of the American food writer Richard Olney (1927–99). Like

Mrs David, he was a powerful force for good, a fine and evocative describer who put food in a wider cultural context. *The Times* obituarist rightly said of Olney's *Simple French Food* that it was 'one of the very few cookbooks everyone should have'. He was also a man of incorrigibly high standards. Years ago I was a restaurant critic and invited to a grand celebration of French cuisine at the Dorchester Hotel. A banquet for 200 or so, prepared by a bucketload of starry Michelin chefs. General bonhomie and savoir vivre. Olney was one of the guests, and I later heard that when the waiter poured him a glass of red wine, he sipped it and sent it back. Not because it was corked, but because it was a couple of degrees too warm.

Simple French Food. Be careful: the first of those three words is booby-trapped. Towards the end of a six-page rumination on the term, Olney comes to the conclusion that 'simplicity is a complicated thing'. The modern mantra goes, 'If food is not simple, it is not good'. Olney prefers its inversion: 'If food is not good, it is not simple'. Thus everything from peasant cooking to classic haute cuisine may, by this definition, be accounted simple. We are not talking about ease of preparation. What we are after is 'purity of effect' – which (you will have guessed by now) may involve considerable complication of means.

The publisher of *Simple French Food* meanly had the book glued rather than sewn, and the pages you use regularly just fall out when you open it. What falls out in my case are gratinéed cauliflower loaf, courgettes gratin, pommes paillasson (the recipe is alone worth the price of the book) and marinated leg of lamb. Clearly, I have stuck to the simplest of the simple.

The reason is easy to explain. Like most people, I annotate my cookbooks – ticks, crosses, exclamation marks, emendations and suggestions for next time. In certain cases, next time is never. My annotation of Olney's courgette pudding soufflé (and I apologise in advance for the language) goes as follows: *This dinner for two took me four hours. The mouli doesn't work as he says, and on turning out, the soufflé collapses flat and the sauce became a quarter deep layer on top of it, i.e. a fucking disaster. But all the same fucking delicious!* One of many possible mistakes on my part was that I did not own a savarin mould. Own? I didn't even know what one was. Overleaf, where Olney mentions this item, I see I have underlined his words and written: *Why not explain what this is somewhere in the bloody book, matey?*

As you can see, I emerged from courgette pudding soufflé in a somewhat conflicted state of mind. And no, I didn't go out and buy a savarin mould. I just went back to gratinéed cauliflower loaf. It's partly about admitting the limits of one's ambition; but it's more about one's attitude to failure. And here most people, and certainly most kitchen pedants, part company with Messrs Blumenthal and Olney, and also with Mrs David. It's not that these experts don't think failures occur – they are aware of them. Elizabeth David writes: 'In cooking, the possibility of muffing a dish is always with us. Nobody can eliminate that.' But she would agree with Richard Olney when he writes: 'A failure is no disgrace and may very often be more instructive than a success.'

Yes, I can see that in utopian theory. But in practice, most domestic cooks feel that failure is indeed a disgrace, and that it would take some years of therapy to

convince them otherwise. So we have over the years developed a very good system for cutting down the likelihood of failure. If we make a dish once, and it turns out anything from a serious muff to a complete hash, then we don't cook it again. Ever. It's natural selection in the kitchen. And as a system it is – in the very ordinary sense of the term – simple.

18 June 2003

BRIAN PENNEY

Letter: Community work

Orange bibs for offenders doing community work as a penalty ('Prisons chief says future is orange', 17 June). Better yet, get some boiler suits with black and white horizontal stripes or, better still, white suits with black arrows on. That'll make 'em think twice!

12 August 2003

Pass notes: Dik-dik

It is an antelope that stands 14 inches tall on pencil-thin legs and weighs no more than 13lbs. And Prince William?

He stands 6ft 3in tall on Eton-thickened legs and weighs considerably more. And the dik-dik?

Eighty per cent of its diet comes from the leaves of trees and shrubs, the rest from grasses, herbs and sedge. It inhabits arid parts of eastern Africa and Namibia. William?

More than 80 per cent of his diet is funded by you and me. He likes barbecues and lavish parties. His pastimes include playing polo and supporting Aston Villa. He inhabits royal palaces, expensive schools and the African homes of friends such as Jessica Craig, from whom he is learning Swahili. The dik-dik?

It has big, Bambi-like eyes and doesn't have time for pastimes, perhaps because it is increasingly killed for its bones, which are used in Kenya to make traditional jewellery. William?

He is a protected species with royal bodyguards, yapping corgis, press corps, etc at his disposal. And the dik-dik?

It is a gentle species, but is not protected in its natural habitat. When startled it races off in a series of zigzag leaps, calling 'dik-dik', hence its name. William?

He killed a dik-dik during a recent hunting trip with Masai warriors by throwing a 7ft-long spear at it. He picked the corpse up by the tail and presented it to Legei, the warrior who had taught him how to use the spear. He was 'blooded' at Balmoral when he killed his first stag aged fourteen. The dik-dik?

It doesn't hunt. It has a large and flexible nose that is adapted to help keep it

cool in the heat and when it suffers great stress. William?

We don't know what noises he makes when under great stress or whether his surprisingly large proboscis has an inbuilt cooling mechanism.

15 August 2003

PETE MOSS

Letter: Ringtones

Re your leader (13 August): where I can get hold of the Blondie version of 'The Tide is High' as a ringtone, not the Atomic Kitten one?

CULTURAL MINEFIELDS

27 November 2002

JUDITH MACKRELL

Growing old disgracefully

Dancers from all over the world make the pilgrimage to the industrial town of Wuppertal in Germany in order to audition for a place in Pina Bausch's company. So it's not surprising that when Bausch advertised in 1998 for a new cast to revive her show *Kontakthof*, 120 men and women showed up. The difference was that all the applicants were local, most were over sixty and none had ever appeared on the professional stage before.

Even though Bausch was specifically looking for older, untrained people, most of those attending the audition had small hopes of success. Edith Rudorff, one of the twenty-six finally selected, had gone along because she was passionately interested in Bausch's work. For a long time it had been her 'wish to set foot in the Lichtburg [rehearsal room], to see where these pieces had their beginning. I did not even dream of being part of *Kontakthof*.' Werner Klammer, a man who simply liked to get up and dance 'when there occurred an opportunity', also came with 'no hopes, fears or expectations'. Jo Anne Endicott, who joined Bausch's company in 1973 and led the original cast of *Kontakthof* in 1978, was in charge of rehearsing the chosen cast. 'They all had some kind of shimmer in their eyes,' she recalls. 'They saw this as the chance of a fabulous new life experience, a new adventure.'

Bausch's idea of assembling an elderly cast was not as bizarre as it sounds. *Kontakthof* is one of her most confessional and intimate works, exploring in crazily paved scenarios the angers and desires that drive our adult relationships. The piece is as much about the personalities of the performers as about their dance techniques. And, as Endicott comments: 'Pina has always had a fantastic sense of what is "in". At the moment, old is "in". And this piece is so much about tenderness and aggression. These men and women have had these emotions their whole life through.'

In order to perform the work, however, these ordinary men and women had to learn to strip themselves metaphorically – and sometimes literally – naked. During the work's three hours the cast pair into couples, dance together and compete in solo routines. One man and a woman display an ambiguous tenderness for each other by slowly taking off most of their clothes; another couple act out their hostility by poking each other in the groin, nostril and chest. Performers have to reveal disturbing details of their past lives and loves. They have to throw tantrums and race around like hyperactive children. All this is hard enough for seasoned performers with perfectly honed bodies. For anyone with a complex about being unfit or overweight, or for the shy, it is agonizing exposure.

Endicott says that many of the cast were deeply embarrassed when they attempted some of the material: 'It took a lot of talking to get them into the

right state of mind.' For Jutta Geike (at fifty-four, by far the youngest performer), the most awkward thing was 'getting so close with the other performers', while for Klammer, aged seventy-one, the hardest moment is the sequence in which he has to line up with the other performers and narrate a love story about himself. For Rudorff, who takes Endicott's original role, the beginning of each performance is always the worst. 'I have to go to the front of the stage as the first of the performers. The first time I had to do it I did not know if I was going to collapse in the middle of the stage.'

Sometimes the seniors feel as if they are performing material that is at odds with their own temperaments – most of the show is danced and spoken exactly as it was created around the original cast. But there are passages, such as the love story section and the 'gossip/bad talk' duet performed by Rudorff and Geike, to which they have contributed some of their own memories and feelings. 'This is the most exhilarating scene,' says Geike. 'We can give way to our imaginations.'

If the senior dancers had to be coaxed into shedding their inhibitions, they also had to be drilled mercilessly. In pure dance terms, *Kontakthof* is one of Bausch's most minimal pieces and none of its steps is beyond the older cast. But even if full-bodied virtuosity was never required of them, the seniors were still expected to acquire scarily professional levels of accuracy and coordination. Endicott does not gloss over the problems she had in getting them all 'to count, stay in formation, learn not to fidget and remember their steps. The learning process starts to slow down as you get older and we needed a lot of patience. There were some furious rows – I guess we all got a bit frustrated.'

But nobody dropped out, and Endicott says she is very proud of how much the cast have improved since their debut in 2000. Even watching the performance on video, it is evident that some of the dancers' displays of emotion are made all the more touching by their instinctive reserve, that moments of vulnerability are intensified by their ageing bodies, that sparks of larkiness and eroticism appear all the more reckless because they are unexpected. Endicott believes the current cast get closer to the spirit of the original production than many younger dancers who have revived it in the intervening decades.

Bausch's instinct that 'old is in' has also proved spot on. Although she had always intended to disband the senior cast after a short season in Wuppertal, several theatres around Europe were soon clamouring to present the show. They accept only a few invitations per year. And this week's three-day run in London sold out in July.

Endicott says that apart from losing two or three of the original cast through sickness, the dancers 'seem to have got younger rather than older'. For all the performers, the piece has been an unlooked-for kick, a radical turnaround in their expectations of growing old. And for Jutta, it has been nothing less than a revelation: 'I really enjoy being on stage in front of the audience. I did not know this before.'

30 November 2002

DAVID HARE

Letter: Putting the boot in

I read your obituary of Karel Reisz (28 November) with resignation and disbelief. Why, when the most gifted pioneer of the English social realist cinema dies, do you get someone who hates social realism to write his obituary? I knew Karel Reisz no better than to say 'Hello', but there wasn't a person who worked with him who didn't speak of his exceptional warmth, wisdom, kindness and humanity. I watched *Saturday Night and Sunday Morning* only three weeks ago, and it remains what it has always been – the single blazing masterpiece of the social realist movement. Compared with the films of today, it's like being kicked in the face.

Is there no one at the *Guardian* who even recognized that film's deliberate disparagement as a piece of 1950s critical axe-grinding, which has no place in what is meant to be a record of an artist's life? It used to be the *Independent* which specialized in hiring self-hating intellectuals to put the knife into artists when they die – Nureyev couldn't dance, Louis Malle wasn't much good, etc. Now the *Guardian* wants to take over as the most bigoted and philistine rag on the rack. When journalists die, knives stay conspicuously sheathed. The death of a journalist is greeted with fair-minded encomia. It's only artists who get the boot put in. Perhaps someone at your paper should be asking why.

30 January 2003

EMMA BROCKES

Sister act

In the film *The Banger Sisters*, Susan Sarandon and Goldie Hawn play women whose friendship works despite their differences. This seems to be true of them personally. The movie was shot two years ago, which Sarandon says feels like a lifetime. 'Really?' says Hawn, absent-mindedly scrunching up a fistful of hair. They are in full battle-dress for a day of TV interviews: boots and bangles and hard, sheer varnish. 'A lifetime? It doesn't feel like that to me. I mean, I have a very vague appreciation of time. I've realized that recently. I never notice time passing.'

'Like Richard Gere when he gave that speech at the Globes,' drawls Sarandon.

'Oh, God, yeah,' screeches Hawn. 'It was like, "Wrap it up, wrap it up!"'

They pitch forward in their seats and hoot with laughter.

This is how we imagine them to be from their films: Sarandon, nasal and New York, sarcastic and business-like, all gorgeous buggy eyes and gravitas, and Hawn, the Californian, shrewd disguised as dippy, her head perennially cocked

to one side and laughing. During the interview she periodically levitates from the sofa on wild fits of enthusiasm. Sarandon could stand for office; Hawn is like a radio dial travelling through frequencies, catching the occasional station, or a gecko, pretending to be asleep until its whip-like tongue flies out to eat a passing fly.

'My daughter had just turned sixteen,' Sarandon continues, 'days before we started the shoot. Remember? And now she's turning eighteen.'

'Oh my God!' says Hawn.

'Remember?' says Sarandon.

'Un-be-lievable!' says Hawn, and collapses into the sofa, seemingly astonished.

As it turns out, the women's differences are mainly superficial – both are smart and liberal, and have resisted the worst excesses of the industry they work in – although a forced comparison like this is a weird way of measuring them. Still, they have a surprising amount in common. Hawn, fifty-six, and Sarandon, a year younger, both have two sons and a daughter, and both daughters are actresses (Hawn's daughter is Kate Hudson, Sarandon's is Eva Amurri). They are both, in Sarandon's words, married to 'jocks, masculine guys, who are in the business' (she to Tim Robbins, Hawn to Kurt Russell). 'We came of age at the same time, a time of music and drugs and spirituality and searching, and empowerment. That really was an area where you felt that you could make a difference as a person. We both went to college in DC, we hit New York at about the same time and we both married early.'

'And our first husbands were both Greek,' says Hawn. 'Weird, huh?'

'What else?' says Sarandon.

'Ice hockey,' says Hawn. 'We're both into ice hockey.'

This is a neat tie-in with *The Banger Sisters*, in which, beneath the beige trouser suit, Sarandon's uptight mom is spiritually kindred with Hawn's ageing but still crazy rock chick. The synopsis of the film makes it sound terrible – two former rock groupies are reunited for one last journey of self-discovery – but it is actually very funny. There is one false note, a yukky high school graduation speech at the end, which includes an entreaty from the teenage valedictorian to 'do true'. Both actresses pull faces.

'I know,' says Sarandon.

'Initially the speech was longer,' says Hawn, drily. 'You were spared.'

They talk about their kids a lot, about how, in a perverse way, they owe the success of their careers to the fact that work never took priority over family. Both took years off work to bring up the kids, both insist they are too secure to be competitive. 'Every time I took a year off I thought there was a good chance that I wouldn't work again,' says Sarandon. 'But I had more important things in my life. And you figure, you can always do something. You have to be ready to let it go. Maybe a lack of desperation has helped our careers.'

A lack of desperation, of course, is easy to cultivate when there is no financial necessity to work. Both women were aware of the danger that they would turn out nasty Hollywood brats. 'You know, raising my children in Los Angeles has had a lot to do with just really, seriously, being present,' says Hawn. 'I always threatened to move them out of town if they behaved like spoilt, blah blah, I

won't name the type of children. So it's really how you raise them and not where. That's not the real deal.'

'I'm not interested in normalcy,' says Sarnadon. 'I think it's highly over-rated, and I wouldn't pretend to my kids that they're not privileged. But my approach is to tell them that they are privileged, and let them take responsibility for it.'

So far, apart from diverging over the passage of time, the two women have been overtly keen to endorse each other's views. On the subject of politics, however, they go their own ways. Sarandon is never so fluent or engaged as on the subject of the coming war with Iraq. Hawn is never so bored. This gap is exemplified best by the brushes each woman has had with the law: Sarandon and her husband Robbins were very publicly arrested four years ago during a demo in New York against police brutality. Hawn has also been arrested, at the age of fourteen, for the less activist pursuit of joyriding through a graveyard. 'I was in the back seat. I had no control, I was saying, "Get me out of here, this is terrible." I was crying. Finally we were pulled over by the police, and you know, I'm Jewish, but I was saying Hail Marys, and they pressed charges.'

'Really?' says Sarandon, mouth open. 'What, for vandalizing it?'

'I guess, for desecration, which was a terrible thing to do. Well, the irony of it is that I buried my mother exactly in that same cemetery.'

'How awful.'

There is a short pause. We talk about the principles behind Sarandon's arrest. 'It's difficult to be political in the United States,' she says. 'It was made very clear in the beginning that you're either with us or against us and if you have a different opinion, or you even have questions, you're anti-American. The emotions surrounding the eleventh have been hijacked by this administration for their own agenda.'

Hawn leans back into the sofa and ostentatiously closes her eyes.

'Hundreds and thousands of people have been turning out [against the war]. But the problem is you don't really have, ah ...'

'Coverage,' murmurs Hawn.

'TV,' says Sarandon, 'has turned into a PR firm for the administration. So a lot of Americans don't have the information to make the decision.'

I tell Goldie there's a man waiting outside who wants her to sign his anti-war in Iraq petition.

'A what?' she says, opening one eye.

A petition. Against the war. Will she sign it?

'No.' She languidly draws herself up to a sitting position. What are her thoughts on the conflict? Hawn scrunches her hair again, and angles her head to one side. 'Well, I have my own private views.' She sniffs. 'I don't really care to ... I mean, I'm an actress and a mother and a citizen, but I don't want to be identified as a political figure.' But then she changes her mind and says, 'I think there definitely should not be a war. I think Saddam should be taken out, as I think Hitler should've been taken out. I mean, Saddam Hussein has the same psychological profile as Hitler. The same kind of family, same kind of lack of love, a father who left him. He's damaged. What do you do with that? We shouldn't do anything unless they find weapons of mass destruction.'

Sarandon looks diplomatically at the wall. 'Well, we gave it to them in the

first place. All we have to do is look at the receipt.'

'Yeah,' says Hawn. 'But we also gave to Afghanistan. We've made a lot of mistakes. And so has everybody else. We're right now, trying to work out, how to make a safe world for our children. We're at a crossroads right now.'

'Mmm,' says Sarandon. 'Well, it's interesting, because after Saddam Hussein gassed his own people, our vice-president was in there making deals with him. Why now? What is the urge to get in there so quickly? I can't wait to find out what the secret information is that's coming in on the fifth and why they've waited so long to give us this information. It's like some kind of new reality TV show that they're spacing out. And if they do find something, I don't see why you have to go to war to remove it. The Cuban missile crisis, when we knew they had weapons, we didn't go in and bomb them. We know there are cells in Canada, we're not going to bomb Canada. You have to come up with a new, more intelligent way to solve these problems. You can't go around using violence ...'

'Well, that's just the question, I mean you look at a child –'

'North Korea!' says Sarandon.

'So you want to eliminate weapons of mass destruction, with weapons of mass destruction, it's a very odd equation.'

'I'd like a regime change in the United States,' says Sarandon, 'but I would really resent Iraq coming in, throwing out Bush and then telling us who to have. If we react unilaterally, I think it's going to set a very bad precedent. We have to go through the legal system. We have to have an international body that governs the world. I worry about the destabilization of the world with this invasion.'

Hawn's eyes are shut again. 'There's a lot of repression going on and I don't like it,' she says. 'It's scary.' She opens them and winks at me. Sarandon smiles indulgently.

13 February 2003

MICHAEL BILLINGTON

Edna O'Brien takes the knife to Euripides

Edna O'Brien has taken the knife to Euripides's *Iphigenia in Aulis* but with infinitely happier results than in Agamemnon's sacrifice of his daughter. Though one may quibble at some of O'Brien's choices in this free adaptation, she gives force and clarity to a notoriously corrupt text, and rescues the ending from bathos.

The narrative outline remains much the same as in Euripides: Agamemnon is instructed to sacrifice his daughter for the sake of the Greek expedition to Troy. But O'Brien builds up both the cosmic and domestic pressure on the hero. She reminds us, through the interpolated figure of a witch, of the divine injunction laid upon Agamemnon, and reinforces the back story of the curse on the house of Atreus. But she also enormously strengthens the figure of Iphigenia, whom

we first see as a pillow-fighting teenager experiencing her first period and who later, at Aulis, movingly reminds her father of their former intimacy.

The effect of all this is not strictly Euripidean: his is a more political play about the way mob rule and manipulative power mongers drive Achilles to a war-initiating sacrifice. What O'Brien gives us is a stark, traditional tragedy in which fate intersects with human flaws. Her Agamemnon is both divinely doomed and a moral hypocrite who combines protestations of paternal love with dalliance with a Greek war widow. But O'Brien's most radical change is to the climax where, in place of a *dea ex machina,* the death of Iphigenia ushers in a blood-soaked cycle of revenge.

You could argue with some of O'Brien's alterations: Achilles loses whole speeches showing him mired in self-regard. But what impresses is the swift narrative drive of this 75-minute version and the vigour and irony of O'Brien's language. 'It's out of my hands,' says Agamemnon at one point, before realizing that his daughter's fate lies literally in his hands. And when he cries, 'She shall rest upon the cenotaph,' that last word unerringly drives home his rhetorical inflation of an ugly deed.

Played on a virtually bare stage against Hayden Griffin's honeycombed back wall, Anna Mackmin's production matches the directness of O'Brien's text. Lloyd Owen, his voice cracking as he calls himself 'a broken king', also successfully brings out both the helplessness and the hubris of Agamemnon. Strong support too from Susan Brown as a vehement Clytemnestra, who ends surrounded in a pool of prophetic blood, and from Lisa Dillon, who, in her stage debut, lends Iphigenia a touching filial trust. Eight young Sheffield women also rescue the chorus from the usual deadly sing-song in a first-rate production that may not be *echt* Euripides but that is very good Edna.

1 March 2003

MARK LAWSON

A new dream rises from Ground Zero

The argument over what should be built on the mass-murder scene where the World Trade Center once stood was, in essence, a fight between selling and telling. The property developers wanted prime office space; the families of the 11 September victims sought a memorial. Daniel Libeskind's winning design – in which a new business complex rises around a still centre of remembrance that preserves the blackened grave – satisfyingly resolves the conflicting demands of real estate and reverence.

A riskier aspect of the planned rebuilding is that, while telling future generations the story of terrorist slaughter in Manhattan, it also seeks to send a message of American indomitability. Sense seemed to dictate that the sky should not be scraped again by whatever replaced the Twin Towers. Raising another space-rocket office block in New York risks simply creating another target for Bin Laden or his successors.

But a huge tower, planned to be the tallest in the world, rises at the heart of Libeskind's design. America could not take the symbolism implied in building low. She needs to give the big finger to her enemies. Though psychologically satisfying, that aspect of Libeskind's plans is, in practical terms, a big gamble.

Yet so long as it survives terrorism, and providing that his concept is not reduced or brutalized too much by the site's owners, this new building will help to ensure that Daniel Libeskind becomes one of the legends of architecture, regarded in this century as Le Corbusier was in the last.

Libeskind's story is an odd and moving one. An academic theorist who was deep into middle age before one of his designs actually troubled the clouds, he has become the art's new superstar in the past few years through two completed buildings – the irregular, metallic, haunting shapes of the Jewish Museum in Berlin and the Imperial War Museum North in Manchester – and another that is beautiful but still merely mooted, his spiral extension to the V&A in London.

As well as making skylines more exciting, however, Libeskind's greatest achievement has been to rebuild the public image of the architect. The people who dream our cities into being had come to be regarded as arrogant, rich and egotistical. Libeskind lacks neither cash nor self-belief, but he is a warm and brilliant public performer.

A man of broad interests – a good enough musician to have conducted orchestras – he speaks in a rush of ideas and chuckles. I once interviewed him for radio in front of a live audience and it was immediately clear that he had a politician's power over a crowd without a political candidate's stench of self-advertisement. A half-hour talk about architecture and music he gave on Radio 3 last year was an awesome display of friendly erudition. This easy charisma will bring him envious enemies – especially now that he has won the biggest competition of them all – but it is a special gift.

So, as soon as it became clear that the Ground Zero competition would make such a point of public consultation and town hall meetings, it seemed to me that Libeskind could be the only winner. Norman Foster, the British representative among the bidders, has many great skills, but in a contest that increasingly came to resemble a political campaign, Libeskind v Foster was like Reagan v Mondale when it came to the ability to communicate.

The key to Libeskind's success is not merely that he can speak brilliantly to the public but that his buildings do as well. Crucially, his successful designs all tell a story. In the past, theatre, cinema and literature have saved themselves from periods of public neglect or disdain by a return to compelling narrative. Libeskind has popularized modern building through narrative architecture.

Taking its strange shape from tracing a line around the historic Jewish quarter of Berlin, his Holocaust Museum dramatizes absence: an empty space at the heart of the building is symbolically filled with the spirits of the millions killed by the Nazis. In his New York design, Libeskind has ensured that the thousands of ghosts from 9/11 have a similar sacred space.

The intersecting fragments of his Imperial War Museum North – which Libeskind, characteristically, researched by throwing his practice's teapot out of the window in a plastic bag – speak, quite as eloquently as the military exhibits inside, of a globe broken too often by conflict. As a Jew of Polish descent, he

carries the tragedies of the modern world in his memories and his genes, and in every space he fills, he tells that tale.

Narrative architecture obviously has its limitations. If all bank headquarters curved and twisted like dollar signs and railway stations were shaped to resemble a train, the capitals of the world would start to look like Toy Town. Storeys that tell stories only truly work if the building stands to serve as a memorial or warning. That made Daniel Libeskind the right man for Berlin and Manchester, and gave him an unbreakable claim on the New York commission.

Culture's new architect-superstar has the personality and charisma to become one of the rare members of his profession to be loved. It's common to accuse architects of having too much power. But as Manhattan's money men and landowners peer coolly at Libeskind's blueprint, we may come to feel that, on this occasion, the man with the plan didn't have enough influence. He deserves, though, to go from Ground Zero to hero.

8 March 2003

FRANCIS WHEEN

Andrzej Krauze

At a party in the spring of 1990, I was accosted by a morose-looking journalist from the newly launched *Independent on Sunday*. 'Got a bit of a crisis on our hands,' he mumbled, taking a hefty, anaesthetizing swig of red wine. 'We need someone to come in tomorrow and write the diary column. Don't suppose you could do it, could you?'

The crisis had been prompted by the paper's eccentric decision to entrust the diary to Edward Steen, who had worked with great distinction for many years as a correspondent in central and eastern Europe. After only a few weeks in the job, he was already yearning to be in Vienna, Budapest, Warsaw – anywhere, indeed, except in London, turning out brief items that might amuse the liberal middle classes over their Sunday breakfasts. When I arrived at the office two days later, Steen was clearing his desk. 'Don't worry,' he said, happily brandishing his air-ticket to Vienna. 'I've left quite a few stories to help you fill the column for the next week or two.' Not so: the file named 'Diary Ideas' on his office computer was all but empty. But Steen left me a far more valuable legacy from his brief and ill-advised foray into gossip-writing: he had persuaded the editor to have the column illustrated by Andrzej Krauze, a Polish émigré of his acquaintance who had taken refuge in London after General Jaruzelski's declaration of martial law in 1981.

I had seen some of Krauze's work, and was vaguely aware of his reputation as a courageous satirist whose drawings for the Polish weekly *Kultura* had infuriated the Communist censors. A good man, clearly but how could he possibly understand the political and cultural references in a British newspaper diary? Had he ever heard of Lord Goodman, Lady Olga Maitland, Jeffrey Archer, Edwina Currie or Kingsley Amis? Would I be obliged to include a weekly item

about the latest scandals and feuds in Warsaw so that Krauze had something to illustrate?

All such worries evaporated when this beaming, bear-like figure came into the office on that first Friday afternoon. Cheerfully ignoring my nervous, apologetic stammerings ('Er, this is a story about Margaret Thatcher – she's the prime minister – and Prince Philip – he's the Queen's husband'), he gathered up a sheaf of copy and departed to a distant desk in the art department. Minutes later he returned with three or four sketches, each of which not only caught the flavour of my text but added extra seasoning that transformed a mere snack into a classy *bonne bouche*.

He treated my diary stories as if they were fables by Aesop or La Fontaine, seeking out the essential moral or the universal theme and thus giving them a resonance and depth they scarcely deserved. What I had feared would be a problem – Krauze's unfamiliarity with our parochial minutiae – turned out to be a virtue. His Friday visits became the highlight of my week.

Since 1989, he has worked for the *Guardian*, which has turned out to be his natural home: like Araucaria's crosswords or Steve Bell's cartoons, his illustrations both reflect and enhance the paper's enduring, distinctive characteristics. In politics and journalism, the mark of true intelligence is not what you think but how you think, and although the *Guardian* has certain essential ideals (a hostility to 'antiquated and despotic governments', a commitment to 'just principles of political economy', a zeal for 'civil and religious liberty', to quote the summary from its 1821 prospectus), what inspires the readers' loyalty and affection is not so much the paper's editorial stance on particular issues as the style in which those issues are reported and discussed – cool, sceptical, free-thinking, sometimes wry or whimsical, yet also passionate when roused by folly or injustice. Like the Enlightenment, the newspaper is not a manifesto but a state of mind, and whatever Krauze's subject – from New Labour to the New World Order – his ironic, cosmopolitan intelligence never fails to enlighten.

The gorgeous catalogue for a Krauze exhibition held in Warsaw two years ago includes an essay by the French publisher François Maspero, who mentions that the book *Andrzej Krauze's Poland* has a preface 'by the celebrated English writer George Mikes'. This ought to raise a guffaw from admirers of Mikes, a Hungarian journalist who came to London for a fortnight in 1938 to cover the Munich agreement and never left. True, he became very Anglicized indeed, but he never lost the outsider's eye that made his book, *How to be an Alien*, an instant classic: even after four decades here he would observe, with incredulity, those characteristics the English never notice since they take them for granted. ('On the Continent, people have good food; in England, people have good table manners … Continental people have a sex life; the English have hot water bottles.') Mikes also noted, in the introduction to *How to be an Alien*, that although a foreigner in this country 'may become British he can never become English'. Even without knowing Krauze's background, I think I would be able to guess from his drawings that he hadn't been brought up in England – and not merely because their bold lines and cross-hatchings are so distinctively 'Continental'.

Some English cartoonist-illustrators rely on a talent for caricature, others on a

facility for one-liner gags. Krauze can do caricatures and jokes, of course, but his real genius lies in the creation of vivid metaphor: not just the weary old short-hand of Fleet Street cartoonists down the ages (the TUC carthorse, the British bulldog) but absurd, sometimes scary imagery that owes more to writers such as Bulgakov or Alfred Jarry than to Jak or Mac. It is no surprise that Krauze has illus-trated Kafka's short stories and Bob Dylan's lyrics, nor that in the late 1970s he drew the pictures for an underground Polish edition of *Animal Farm*. Don't be misled by his relaxed demeanour and warm smile: this is a man who both works hard and thinks hard, as proved by his dozens of brilliantly apt drawings in the book *Introducing the Enlightenment*. Maybe he hasn't heard of Lady Olga Maitland, but he can hear deeper echoes that might otherwise have been inaudi-ble to the author whose article he illustrates.

In short, Krauze is both an artist and an intellectual, but he wears his learn-ing lightly. Like all good intellectuals, he keeps Occam's Razor within easy reach, ready to slash through obfuscation and reveal a plain truth in all its simplicity – or perhaps one should say 'in black and white', since he employs black ink more tellingly than any other illustrator I know. Leafing through his portfolio, I happen upon a picture that illustrated a *Guardian* feature on press coverage during a General Election. Three figures are standing on ballot boxes in an empty landscape, each reading a newspaper in search of illumination but from the centre pages comes only a torrent of black ink, spattering and indeed blind-ing the hapless electors.

There is no question where Krauze's sympathies lie: whether in Communist Poland (whose citizens he regularly depicted as unhappy sheep led by hungry wolves) or in the groovy modern democracy of New Labour's New Britain, this remarkable artist has always accepted the duty that is more traditionally assigned to journalists, though many of them prefer to duck the challenge: he speaks truth to power.

10 April 2003

LEADER

Unquenchable flame

Shortly before he died, William Hazlitt told friends he would like to live long enough to see the restored Bourbons overthrown in France. When that hope was fulfilled in 1830, Hazlitt felt a thrill that reminded him of the storming of the Bastille in his youth. It was, he wrote, 'like a resurrection from the dead, and showed plainly that liberty too has a spirit of life in it and that hatred of oppres-sion is 'the unquenchable flame, the worm that dies not.' Such was Hazlitt's pleasure that the news from France was inscribed on his tombstone, along with the words 'Grateful and Contented'.

That same unquenchable flame still burns in Baghdad, as yesterday's events showed. Hazlitt would have approved. 'He lived and died the unconquered champion of truth, liberty and humanity,' says his memorial. Whatever his view

of the war, he would have had no regrets at the fall of Iraq's tyrant. All in all, it makes an unusually appropriate day for the unveiling of Hazlitt's splendidly restored memorial in London.

14 April 2003

FIACHRA GIBBONS

The André Breton auction

'Monsieur, you are a traitor, a traitor to France, and a philistine!' The last word was spat out in a venomous ball of phlegm. Then, without so much as an *en garde*, I felt the stab of a cigarette holder in my stomach.

Never, ever pick a fight with a surrealist. Not unless you are packing a kipper yourself, and are prepared to use it. That much I now know. But at lunchtime on Monday, when I tried to slip through the surrealist blockade of the André Breton auction at the Hôtel Drouot, I assumed a black polo neck was protection enough against accusations that I was a bourgeois lackey bent on picking the bones of the great man.

I had gone to Paris to witness the 'death of surrealism', to watch what was being called 'a great national humiliation', the Passion of André Breton. That is how French intellectuals see the sale and dismemberment of the astonishing collection of surrealist masterpieces, letters, books and bric-a-brac the leader of the twentieth-century's most important art movement crammed into his small apartment above the clip joints of the rue Fontaine.

Dalí, Miró, Duchamp and Max Ernst all climbed the stairs to Breton's studio, hard by the Moulin Rouge, to take part in surrealistic experiments and pay homage to the man who wrote *Manifeste du Surréalisme* in 1924. All left work behind on the walls next to the Picassos, the Magrittes, and the photographs and collages by Man Ray and the rest of the gang.

The dreams and fantasies that poured out with the absinthe were recorded and stacked away alongside Breton's collections of curiosities, religious kitsch and 'object poems' made from bottles, buttons and bits of string. By the time he died in 1966, and the door of 42 rue Fontaine was locked, there was only room inside for two people. It had become a museum to a man and a movement that loathed museums. It was the perfect surrealist conceit – a museum no one could enter except in their dreams.

For years Breton's family assumed that one day the French government would take the flat and its contents off their hands. This was a national treasure, after all, worth many millions, and pride demanded it. Didn't it contain the desk from behind which France last led modern art? But the government never did. The famous 'wall' of paintings, cartoons and Polynesian masks that hung behind that desk was taken in lieu of death duties, but that was it. Even Uli, the four-foot wooden ancestor statue from New Ireland in the South Pacific, whose spirit Breton claimed inspired his '*art magique*', was left behind. Breton's daughter Aube finally snapped as she neared seventy, the age at which her father died.

Now she is getting shot of the lot, piece by piece, in an 'ordeal by capitalism' lasting ten days.

The gannets had gathered in their thousands all last week – 50,000 by Friday – to pore over the odds and sods in the Hôtel Drouot's slightly battered red-plush salerooms before popping down to the glorified house clearances in the basement, offering chamber pots, gilt furniture and hideous 1970s settees. The auctioneers call it 'the sale of the century', and expect to make £25m. The French left, with typical understatement, call it a catastrophe, and blame Jacques Chirac.

So emotions outside were high. But the last thing I was expecting was Surrealism's Last Stand, or that I would play a part in that resistance. Nor was I expecting a fight. But then I wasn't to know that the ruck outside the saleroom had been organized by the philosopher Jacques Derrida, the big dada of decon-struction. In leaflets handed out by protestors, he lamented the destruction of this 'space made up of creation and desire, the witness to a new form of thought being generated ... When you went into the flat, you discovered both the secret of a life and a movement of thought.'

I tried to find him among the mass of grey heads blocking the door and jostling bemused dealers back into the street. 'I am Jacques Derrida,' said a man too big and fat to be the philosopher, when I asked where he was. 'I am Jacques Derrida,' his friend repeated. This Spartacus chorus continued for a few more minutes, until it became clear he wasn't there.

But the joking stopped when a dealer in an Asterix moustache and a tweed jacket tried to storm the barricade. 'Fight your way through,' he shouted, bran-dishing his cane, as the surrealists locked together like a well-drilled front-row. Someone shouted, 'He shall not pass!' – Marshall Pétain's war cry at Verdun – but he did. 'Pigs, communists, homosexuals, sons of whores,' the reactionary replied, I following in his wake, and that's when the stabber with the cigarette holder struck.

But the protest outside was only the *amuse bouche*. As soon as the auctioneer, Cyrille Cohen, started bidding on the first lot – a book by the playwright Arthur Adamov, dedicated to Breton ('a very rare man who remains pure') the main course began. A stink bomb was crushed underfoot and a pale man to my right began to read in wavering monotone from a tightly typed manifesto, quoting Trotsky and Cocteau. Then all round the room, surrealist infiltrators began to throw fake money around. Each doctored 10-euro note carried Breton's head and the legend 'Your money for the stinking corpse of a poet that you didn't dare become'. (It's better in French.) The heavies were called but dogged resist-ance continued at the back.

Then, as Monsieur Cohen worked his way through Breton's library of Apollinaires – the man who coined the term surrealist in the first place – a par-ticularly incensed aesthete at the back began to cry: 'You are killing the poet! You are killing the poet! This is a scandal against humanity!' He would not be silenced. Then a new corps of cultural nationalists began to show themselves. 'I buy this for France, to the shame of France!' one man announced to loud applause as he paid 13,000 euros for another first edition of Apollinaire. Another woman two rows in front secured a Hans Arp novella with the cry: 'It's a scan-

dal! Forgive me, André, forgive me, France.'

I too had been instructed to buy, to take a relic back across the Channel before the French slammed on an export bar. But what should I buy? I tried a surrealist method: automatic writing.

Breton, Breton, Breton. Well, he died in 1966 – the same year I was born. Was I his incarnation? Nonsense. He was a miserable git, an inveterate feuder who excommunicated anyone who disagreed with him from the movement. He so loathed Dalí's sluttish commercialism that he would only refer to him anagramatically as Avida Dollars. Quite clever, that. Hold on, what was this book by Louis Aragon doing here? Hadn't Breton purged everything by the poet from his library when he and Aragon, one of his oldest friends and co-founder of surrealism, fell out over Stalin? Maybe Dalí slipped this Russian translation of Aragon's *The Red Front* back into the library to upset Breton's psychic balance. He'd never have known. He couldn't read cyrillic.

I would have to bid surrealistically, of course. With the price at 300 euros, I bid 250. Monsieur Cohen acknowledged my bid and then paused for a second, perplexed. 'Two hundred,' I said, dropping my bid again. 'Monsieur, monsieur,' he said, before calling for 350 euros. A bid came. I topped it at 400 and the book was mine. Roland, a writer and theorist who was sitting in front of me, was disgusted. 'They may as well give it to the dogs in the street. Surrealism is not dead. They just refuse to publish our books and show our art in the galleries any more. There is a conspiracy, a very big conspiracy against us. I have written a book about it. It starts with the government …'

I went with my chit to pay, and proffered three vacuum-packed smoked mackerel I had grabbed from a cockney cockle-and-eel stall on the way to Waterloo. He was all out of kippers. (What was it with the surrealists and cured fish and female genitalia?) Since they already had my credit card number, I knew it was an empty gesture. But they took the mackerel anyway. 'Mackerel means pimp in slang, you know,' the teller said. I didn't know that. Bull's eye. Here was proof of Breton's belief in 'petrified coincidence'.

I was their first fish of the day. No one else had tried to pay with anything but cash. 'We French are always protesting but we are always bourgeois when it comes to art,' she said. 'Everyone wants what they can get.'

I returned to the saleroom, but the fight seemed to have gone out of the surrealist guerrillas. One, who had been filming the 'atrocity', had stopped to flirt with one of the girls taking telephone bids; there was even a round of applause when someone paid 243,000 euros for the Magritte collage Breton had used for the cover of his book, *What is Surrealism?*

I walked back out on to the street and let coincidence guide me. I soon found myself on rue Lafayette where Breton met the beautiful actress who became the model for the girl in his novel *Nadja*. I opened a page of *Nadja* at random. It was one of the plates, a collage called 'The Agonizing Journey' or 'The Enigma of Fatality'. It pointed up the hill towards Sacré Coeur. After a few minutes I was on rue Fontaine itself, a street of dives, goth cafés and seedy bars where peroxide blondes with voluminous thighs perched on bar stools by the door. And then I was outside number 42 itself, squeezed between a burlesque theatre where a show called *The Bathroom* was playing, and the Carrousel de Paris – 'cabaret

and dîner spectacle'.

The door was locked. I tried to force it. It wouldn't budge. So I waited. A fat boy on one of those foot scooters eventually turned up and tapped out the combination. The door opened. I followed him into the gloom of the tatty lobby. It took a moment for my eyes to adjust, but there, nearly thirty-seven years after his death, was Breton's postbox, with his name typed out in clean capitals as if he had just popped out for lunch.

I pulled up my sleeve and squeezed my hand inside, half expecting to find a scorpion. There was only emptiness and dust. I scooped some out on to a tissue. I took the book from my bag. Four hundred euros, 471 with tax. Bugger it.

I tried to read a few lines of *The Red Front*. One stanza had CCCP five times. Aragon obviously had Communism bad. I slipped it into the postbox and left.

Today I wrote a letter to Breton's book. Bids on the dust start at £250.

8 May 2003

ALAN RUSBRIDGER

Who's to blame for Britney?

Last autumn I spent a couple of days at the *New York Times*. The staff (not to mention several thousand readers) were still recovering. On the paper's sober, hallowed front page – the nearest thing journalism can boast to a tablet of stone – there had recently appeared a story about Britney Spears. The Manhattan sky had fallen in. Fights broke out among *Times* staffers. The paper's switchboard was jammed. The editor was denounced the length and breadth of the Upper East Side. It had finally happened: the great *New York Times* had dumbed down.

To visiting British eyes, the debate seemed a little old hat. I thought back to raging rows we had had back in April 1994 over the death of Kurt Cobain. There were some on the staff who thought Cobain beneath the attention of *Guardian* readers – no matter that half their children had been up all night in tears.

In the end we carried hundreds of words on the suicide. Part of our thinking was, to be frank, strategic. How could we convince the next generation of readers that newspapers were relevant to their lives if we ignored stories that were, well, relevant to their lives? But actually, it was right in news terms to cover Cobain's death properly. However you look at it, it was a significant story about the world as it was. Not as we would like it to be, but as it was.

And of course we were accused of dumbing down. The same furious fights they've been having in New York over Britney. And this same debate has raged not only in newspapers, but in more or less any organization that deals in creative and intellectual property.

You might say two things about this current debate. One is that it is utterly understandable. We've all seen enough dumbing-down in our lives to want to be on guard against any more manifestations of it. The other is that the debate is a terribly confused one. One in which we can't quite find even the right language to describe our fears. Concepts such as elitism, a canon of works, access,

diversity and standards clash into each other – or, worse still, miss altogether.

Would many of us prefer to live in a world in which Britten or Birtwistle out-sold Britney or Limp Bizkit? Of course. But if you're running a newspaper – notionally there to report the world as it is, rather than the world as we'd like it to be – you have to make tricky decisions about how much you can skew your coverage towards cultural forms that, however important, do not seem terribly popular in relative numerical terms. Certainly, any newspaper that had the same age profile as the audience for classical music concerts would be thinking about filing for chapter 11 protection.

Surveys suggest that you have a 4 per cent chance of finding anyone under the age of twenty-four at an average classical music concert, and a further 6 per cent under thirty-four. Young people appear overwhelmingly to find other sorts of music more appealing – and it's not dumb to explore that, or even celebrate it. The Britney Spears phenomenon is an interesting one. It was reported at one point that she even stirred the flinty heart of the prime minister's official spokesman. It would be perverse of the NYT not to write about her.

How ridiculous *The* (London) *Times* of the 1960s now seems. There it was at the heart of the most extraordinary cultural explosion – the music Tony Blair grew up with, The Beatles, the Stones, Pink Floyd, The Who – and barely a word about any of it was allowed into the paper.

The official history of *The Times* speaks of this period under Sir William Haley in these terms: 'Though The Beatles' music was discussed by the paper's music critic, and reference made to the "chains of pan-diatonic clusters" discernible in it, Beatlemania and all that it represented was beneath Haley's notice.'

This was a paper that sold itself under the slogan 'Top People Read *The Times*'. It was unashamedly elitist. A paper run by the same man who, when he was running the BBC, said of the Third programme that it should aim at people 'of taste and intelligence and education … it need not cultivate any other audience'.

But I've just stubbed my toe on that problem word 'elitist'. The lowest term of abuse for some, the highest accolade for others. Should we accept that classical music is an elite art form and stop fretting? Or should we do everything in our power to cultivate the widest possible audience for it, regardless of the compromises that might involve? Even, as Sir Tom Allen shuddered last year, to quartets in wet T-shirts.

It is evident that many people working in – and treasuring – the serious arts still feel embattled. It seems to them as if there is a widespread philistinism around, a remorseless drive in favour of the predominant commercially successful mass culture.

Anyone with teenage kids will know how overwhelming the influence of a few gargantuan entertainment companies is today. The sums ploughed into creating, promoting and selling particular strands of popular culture – and the overwhelmingly effective marketing of celebrity – are simply staggering.

So who to blame? The media? People usually do. But musicians are asking themselves enough searching questions to suggest that there is no knee-jerk attack on this perennially convenient punchbag.

Should we then blame the big entertainment corporations? That seems a little harsh. You might, I think, reasonably accuse them of a failure of nerve over

more serious forms of music. But they have shareholders. They have to make money, and they have perfected (we're talking pre-MP3) ways of catering for – or manipulating – mass tastes.

What about publicly funded organizations that – precisely because they don't have the pressure to turn in quarter-on-quarter growth – might have been expected to do better? This is nearer the mark, I think. There are two in particular that, it seems to me, had some sort of duty to champion forms of culture not simply in deference to that rather grim piece of accountant-speak, 'market failure', but because they are intrinsically valuable and glorious.

One is the BBC. There has, until very recently, been a terrible failure of corporate nerve over the televising of serious arts programmes for mainstream audiences. How on earth did it happen that for so many barren years the BBC governors nodded on the job while the arts output all but withered away?

It can't be that the governors don't like art or music. It's an interesting exercise to go through the *Who's Who* entries of the people in charge during the mid- to late-1990s. Nearly all of them indicate some sort of professional or personal interest in the arts. Yet, collectively, they never stamped their feet and said the BBC's commitment to the arts was verging on shameful.

The other obvious target is government. Again, how did it happen that music education in this country – full of significant and exciting initiatives – was decimated? How did it happen that our politicians – a quarter of whom (read *Who's Who* again) boast of their love of music – presided over the gradual destruction of a system, which, if not perfect, was pretty good? When you have loved something yourself, how can you pull the ladder up on the next generation?

Destroying things is notoriously easier than rebuilding them. So, though we finally have real signs of progress at the top, there are mountains to climb.

Many people will have been struck by the story of the tank outside the Baghdad Museum a little more than three weeks ago. The museum – which holds one of the greatest collections of antiquities anywhere in the world – knew what was likely to happen when civil order broke down. As they knew it would. They warned the world. The world didn't really listen. The nearby American tank crew shrugged off frantic appeals from museum staff to move a few yards and block off the entrance. They had no orders. It was not enough of a priority.

Again, you wonder, how did this happen? Washington is full of wonderful museums. The war planners doubtless spend weekends in them with their families, to learn, to be enriched. Just like politicians and BBC governors love their art and their theatre and their music.

It is an interesting question: how can priorities in the personal lives of those who have the power not translate into priorities for others?

So, yes, newspapers do have a duty. Not only to nurture, explain and report on all aspects of our culture, from Britney to Britten. But also to question and hold accountable those who know the importance of art and have the power actually to do something. To report when they do something. And also to report when they do nothing.

Sometimes it doesn't take much. The tank in Baghdad needed to move 60 yards. Because it wasn't anyone's priority, 14,000 priceless artefacts were lost. On such small decisions – to act, or not to act – hang extraordinary consequences.

19 May 2003

SIMON HATTENSTONE

Lou Reed

Lou Reed is a bit of a hero of mine. When I was nine, 'Walk on the Wild Side' was number ten in the charts, and there had never been a record so languid and funky and cool and sexy. Doo de doo de doo de doo ... So many of us wanted to be Lou with his shades and leathers, making out with the he's-that-were-she's and the she's-that-were-he's in the happening New York. A few years earlier, as the boss man in the Velvet Underground, he became the godfather of punk. Some songs, like 'Heroin', screeched with feedback, talked about the desire to nullify life and struck a chord with so many young people. Others, such as 'Sunday Morning' and 'Pale Blue Eyes', were so tender, so ethereal, they barely existed.

Thirty-plus years on, he is one of our more unlikely survivors. He has seen off heroin and alcohol, and outlived his mentor Andy Warhol, heartbreak chanteuse Nico, and Velvet Underground guitarist Sterling Morrison. He restricts himself to water and Diet Coke, t'ai chi and wholesome foods, and he is still making records. Many of them are about loss and memory, growing old and evaluating life. A few months ago he released a double CD, *The Raven*, based on Edgar Allan Poe poems: although it was widely derided for its pretensions, the crystalline purity of a handful of songs touch the soul like in the old days. Now he has released a double-CD collection, *NYC Man*, which takes us from year zero to the present, and he is touring Europe to promote the albums.

Today he is in Stuttgart. It's not quite Berlin, where Reed made probably the most depressing album ever and named it after the city, but downtown Stuttgart is pretty bleak in its own right. I've heard bad things about Reed being uncooperative in interviews, but it's probably apocryphal. After all, I've been vetted by his people, and the sun is shining blissfully.

Reed is playing at the local concert hall, which looks made to measure for Reed in its concrete misery – the Barbican meets Belmarsh Prison. We wait expectantly. Eventually, a people carrier draws up. A man in hooded sweatshirt jumps out, shadow boxes and runs inside: the camouflaged Reed makes it inside unimpeded. There's only the photographer, Eamonn, and me waiting, but Reed has lost none of his star quality.

After a quick snack, he is ready for a photograph. He's a small man but well-built – big pecs, big belly, tight T-shirt. He's sixty-one years old. He grips my hand and eyeballs me. 'Hi,' I say. He stares. 'He's not doing the interview in here, is he?' he asks the PR. No, she says. 'So he doesn't need to be here for the pictures.'

I'm sent off upstairs to a sterile, empty room to wait for him. He's not been that friendly, but once I tell him how I grew up to 'Walk on the Wild Side', we'll bond. There is so much to talk about: the smack years, if he can remember them; flirting with death; how his parents sent him for a course of ECT when they

thought he was gay; how his relationship with a transvestite inspired *Transformer*; how he went back to live with his parents after he quit the Velvets and worked as a typist for his accountant father; how he interviewed celebrity fan Vaclav Havel; how he recovered his karma thanks to t'ai chi and his love for partner and performance artist Laurie Anderson.

I hear footsteps. It's the PR, Ginny. Bad news: Lou wants to soundcheck before we talk. Good news: we can listen. On stage for more than an hour, he drives his band relentlessly towards perfection. I'd forgotten what a great guitarist he is. After the soundcheck, I'm packed off back upstairs.

He walks in silently, with swaggering B-movie menace. Of course, he'll act the hard man, but my copy of *NYC Man* is on the table and once we start talking about his greatest songs he'll relax. I know he will. 'Hey,' I say, 'when I look at this record it makes me feel nostalgic for my youth, and I didn't even write the songs, so God knows what it does for you.' He gives me a withering look. 'No, that's not what occurred to me. I was interested in making them sound as good as I can make them because the original mixes really hold up because they are recorded on to tape and they sounded really good.'

Ah, typical Reed – hiding his heart behind the technobabble. So didn't it take him back, remastering all these classics? 'I told you, I was interested in the sounds. There are things on some of these tracks that have bothered me for ever.' He sounds as if he means it. Good actor, this Lou Reed.

I tell him I've been listening to *The Raven* and couldn't help noticing how reflective it seems. On one song he says one thinks of what one hopes to be and then faces up to reality; on another he asks if he had a chance to converse with his former self, what would come of it. They are familiar themes. In 'Perfect Day', written in 1972, the apparent idyll is undercut by the line: 'You made me forget myself, I thought I was someone else, someone good.'

'You can't ask me to explain the lyrics because I won't do it. You understand that, right.' He gives me another look. 'Anyway,' he says, 'this is just the character talking.' Yes, but has he ever considered what his older self could teach his younger self, and vice versa? 'I can't answer questions like that. What is it you really wanna know, because if it's personal stuff, you won't get it. So, you know, whaddya want?'

Reed has said in the past that he may as well be Lou Reed because nobody else does it better. I ask him if he thinks of Lou Reed as a person or a persona. 'I don't answer questions like that.'

'Fine,' I say, 'you tell me what we can talk about.' But I don't feel fine. I feel unnerved and upset.

'We can talk about music, is what we can talk about,' he says.

But we can't, because if I ask what he felt like when he wrote 'Heroin', or what the line 'shaved his legs and he was a she' was inspired by, that would be an encroachment. For Reed, everything is personal, except the mixing desk.

So I press ahead with the music. Back in the 1970s, he and David Bowie and Iggy Pop were regarded as an unholy triumvirate. They broke down all kinds of barriers – between pop and performance art, male and female, lyricism and cacophony. There was a fluidity in their world, nothing was strictly defined. 'I don't know what you mean,' Reed says. Again, he stares me out, his tired eyes

the colour of blood and chocolate. 'I haven't a clue what you're talking about.'

But I bet he has. Reed makes me feel like an amoeba. I want to cry. 'Look, I was a huge fan of yours,' I say.

'Was?' he sneers.

I still am, I say, but I'm less sure by the second. I desperately try to stick to the music. Soon after his most commercial album, *Transformer*, Reed made his least-commercial record, *Metal Machine Music*, an album of feedback. Some critics said it was his joke on the pop business. Is there any validity in that? 'Zero.' Is it something he can enjoy? 'Well, I can.' Which of his songs does he like best? 'I don't have a favourite.' Favourite album? 'I like all of them.'

Warhol, the Velvet Underground's mentor, believed that art shouldn't be tinkered with to appease the market. Did he teach Reed to value his own work? 'It was great that Andy believed in us.' Warhol fell out with Reed before his death, complaining that he never gave him any video work. I ask Reed if he wishes they could have made up before he died. 'Oh, personal questions again.'

But isn't the music shaped by his experiences and relationships? 'Don't the people you're around shape the music, is that what you're saying? Everything does.'

So why won't you talk about them? 'You're not going to leave off that, are you? OK, let's not do it. We're not getting along. OK. You want to ask questions. I told you I can't do it so I can't do it. Thanks a lot. So I'll see you.' He's off.

I shout after him, thank you, I've come all the way from England to see you, let's talk about what you want to talk about then. He sulks back in, and walks around me, as if weighing up whether to hit me. He sits down. 'You wanna talk about music or not?' But, of course, he doesn't want to talk about anything.

I tell him that he's intimidating. (Actually, he's like the class nerd who worked out obsessively and graduated into the playground bully.)

'I'm not trying to intimidate you,' he says, mock softly. He looks pleased. 'I said don't ask me personal questions.'

OK, then, can he explain *The Raven* to me? He tries and fails, but he does manage to say it took four years to make. Did it upset him that, after all that time, so many critics slated it? 'I don't know anyone actually who does care what a critic says. Y'know, I was with Warhol, with Andy, and, the things they would say about him, up to and including when he died ... and, of course, now he's quite possibly the top American painter.'

The Raven features a singer, simply called Antony, with a wonderful, shimmering voice – almost castrato. I ask Reed where he discovered him, and say that he looks as if he could have popped out of Warhol's Factory forty odd years ago. He says that his producer Hal Willner found him at the Meltdown music festival on London's South Bank. 'After fifteen seconds we thought, "What an amazing voice." Now, typical of you as an interviewer to say something as cheap as, "Oh, he looks like somebody who could have been around the Factory," as opposed to, "What a great voice."'

'I was going to come to that.'

'Well, you could have started there.'

'You never gave me a chance. Why are you so aggressive to me? What have I done to you? Why are you being so horrible?'

'I'm just pointing things out to you.'

I'm lost for words. 'I used to buy your records,' I say pathetically.

'You used to.'

'Are you really this aggressive in real life?'

'Didn't we just go through this? OK, fuck, you don't want to talk about music. "Antony is someone who could have been in the Factory,"' he mocks. 'You don't say what a beautiful voice, my God!'

'Have I got to sit here and fawn to you? I was going to say he could be in the Factory because he's an original and his voice is stunning and ghostly. But you didn't listen long enough before attacking me.'

'I didn't attack you. As attacks go, that is pretty mild. Come on! Come on! Stop! Who you kidding?'

I ask him if he's happy. Listening to his bile, I can't help thinking this is one unhappy man. I apologize for the personal question.

'Jesus Christ!'

'I'm not a music interviewer. I do general interviews.'

'Hahahahaaa!' And he is really laughing – even if it is the cruellest laugh I've heard. 'Well, that explains it!'

'OK, who's your music hero?'

'I love Ornette Coleman. I love Don Cherry. I love the way those guys play. Just my God!' For one second, he seems to be engaging. But only a second. 'If you want to know records I like, on the web pages there is a top one hundred or something like that.'

I ask him whether we can discuss martial arts – strictly in the context of music. (There is a martial artist in his show.) He nods. 'I always thought martial arts was the most modern choreography we could have right now, and I always wanted to put it to music.' What does t'ai chi do to his head? 'I try to do it three hours a day. It does a lot of things. Mainly focus.' And calmness? 'I call calm focus.'

Reed and Laurie Anderson were vocal campaigners against the war. How does he define himself politically? 'I don't. I'm a humanist.' What does he think about America at the moment? 'These are really terribly rough times, and we really should try to be as nice to each other as possible.' I think he's being ironic, but there's no hint of a smile.

27 May 2003

DAVID PESCHEK

Björk

Björk walks on stage wearing the kind of dress – garish pink, outsize rosettes on one shoulder, asymmetric puffball skirt, pink and black leggings – that the people who compile fashion pages like to laugh at, not realizing she dresses that way because she finds fashion funny. She seems to have reached some kind of watershed in her career: while *Vespertine*, her glorious last album, is easily her

best, it sees her continuing her retreat from pop music into an esoteric nether-world. Now that pop music has been reduced to stage-school MOR, corporate punk or testosterone-drenched R&B, her eccentricity and otherness are missed all the more. The new territory she is charting, however, is extraordinary, unlike anything else in contemporary music.

Tonight, with a comparatively small band – a handful of string players, a gifted harpist, Drew Daniel and MC Schmidt (work and life partners otherwise known as playful avant-electro duo Matmos) – she draws largely on 1997's *Homogenic*, with a tantalizing selection of new songs. There is more rhythmic invention in this show than in the rest of current electronic music. Björk has become a curator of exotic, alien sounds, the latest in a rare lineage that includes Martin Denny, Esquivel, Lalo Schifrin and Yello. Truly, though, this music sounds like nothing but itself.

'Hyperballad' (the nearest thing to a proper hit on show tonight) and 'Joga' are key: they are songs in which the vicissitudes of love are the spur of poetic experience, songs that crave the inspiration of extremes. When, in 'Joga', she sings, 'This state of emergency – how beautiful to be,' it is both infinitely moving and genuinely brave. In the little-heard B-side 'Generous Palmstroke', against some breathtaking harp playing, she makes public the most intimate, child-like dialogues of lovers – the genius of much of her writing.

'Desired Constellation', the first of half a dozen new songs, is accompanied by a film of what appear to be stars, then become a swarm of tadpoles that dart and shimmer past before transforming into fantastic aquatic chimeras with polar-bear heads, each propelled by a pulsating human hand.

Björk is joined by maverick, long-time collaborator Leila for 'Nameless', an unearthly swoon of refracted wails, sampled live and played back to create a choir of keening Björks. Then 'Crave', deliciously obscene with thunderous, rupturing electronics, morphs into the relentless, pulsing detonations of 'Pluto'. Finally – what else? – fireworks. A thrilling night, exhausting in absolutely the best way.

6 June 2003

ALEXIS PETRIDIS

Rolling Stones

The Rolling Stones European Tour comes with staggering statistics. We are informed that it takes fifty-three trucks and a staff of 260 to transport the enterprise around the Continent and, inscrutably, that the tour weighs 350 tonnes. But one figure is more mind-boggling than them all. The collective age of the four remaining Rolling Stones is 237. They are, as Jagger unironically sings during a version of Muddy Waters's 'I'm A Man', 'way past twenty-one'.

For the band's live show to work, the audience is required to suspend their disbelief and swallow the line that the Rolling Stones themselves have been peddling since the early 1970s – that they are the world's greatest rock 'n' roll band.

Sometimes, that's hard to do. As the show opens, they seem shambolic and rusty. They thrash sloppily through 'Heartbreaker' and 'It's Only Rock and Roll', the sound muddy and indistinct. When the Rolling Stones play badly, you are left with a pantomime of leathery skin, terrible clothes and ridiculous behaviour. These days, Keith Richards has the sort of face you normally see halfway up a church wall with water gushing from its mouth. He sports a variety of hideous shirts, which flap open as he bends over his guitar to solo, and what looks like a vast white bandage over his thinning hairline. He seems a model of dignified maturity next to Mick Jagger, who gropes a backing vocalist during 'Honky Tonk Women', and rushes around the stage with his arms extended, flapping his hands, like a man in the gents who has just discovered the hand-drier isn't working.

However, as you are preparing to write the Rolling Stones off as a superannuated embarrassment, something gels. 'Tumbling Dice' staggers forth, still charmingly louche. Richards's appearance gives his solo spot, 'Before They Make Me Run', an added degree of defiant poignancy. Better still, they repair to a tiny stage in the centre of the arena, and begin playing for their lives: 'Brown Sugar''s arrogant swagger, a ferocious 'Neighbours'. At moments like that, you can almost believe the hype.

21 June 2003

JAMES GAUSSEN

Letter: Doublethink over Orwell

Graham Taylor (Letters, 18 June) says George Orwell's *Nineteen Eighty-Four* 'if it is anything ... is about how it is possible to make people believe things that are not true in a world permanently geared for conflict. The message is thus applicable to both totalitarian regimes and parliamentary democracies.'

Mr Taylor is entitled to believe whatever he wishes, but I doubt whether Orwell would have agreed with his interpretation. In a letter written in June 1949, Orwell says the book was 'a show-up of the perversions to which a centralized economy is liable and which have already been partly realized in communism and fascism ... I believe also that totalitarian ideas have taken root in the minds of intellectuals everywhere, and I have tried to draw these ideas out to their logical consequences.'

Although firmly of the left, Orwell was no pacifist, and although he would doubtless have strongly disapproved of aspects of the war against Iraq, it is by no means self-evident he would have opposed it. (Although I agree that he would have detected 'doublethink' in the arguments about the war, I suspect that he would have found it on both sides.) To imply that his views were typical of the average middle-class, *Guardian*-reading, left-inclined intellectual is, quite simply, wrong – as anyone who reads Orwell's essays, journalism and letters of the 1930s and 1940s would quickly ascertain.

24 June 2003

ADRIAN SEARLE

Bridget Riley

Bridget Riley's Tate Britain retrospective begins as it ends, in black and white, in the same large room. This place is electrifying. It is as if the show gives everything essential away at once. There at the end of the room is the still strange little painting *White Discs 2*, from 1964. The discs are black, and the eye invents the white discs of the title as after-images, floating on the white screen of the painting's ground. The white greys as one looks, and the black circles bore at you, each with its own luminous penumbra. On the opposite wall, *Breathe*, from 1966, is just like a sharp intake of breath. I turn away, winded, and discover *Exposure*, from 1966, a cinematic wide-screen painting of repeated curving diagonals, which invents its own colour in the spaces between the black and white lines. I can't look for long. There are too many jolting flashes in my eyes. It is too much.

Nor can I tear myself away. Delacroix wrote in his journal about looking at the sea, and having to wait for just one more wave before leaving. This is the effect many of Riley's paintings have. They keep coming at you. Facing the entrance is her newest work, an enormous drawing of circles filling the wall, floor to roof height, from one end to the other. It is huge. The circles – I guess – are each a little under a metre in diameter, the radius being something like the distance from elbow to fingertip. They are drawn or painted with absolute precision directly on the wall. Get up close and you just see black and white. The wall itself disappears.

Since 1998, Riley has made other versions of this piece in Bern and New York. The circles meet, overlap, part, create twining patterns and petal shapes. You want to follow their order, find the grid of their centres, but you can't. They invent your reverie. The whole thing is clear and very direct, but you can't follow the complications of the mind that made it. You lose yourself as you scan the wall. I think of Sol Lewitt's wall-drawings, but none has this effect. I'm sure he would applaud that Riley, over seventy, could have come up with something so fresh. The wall makes you think about how you look at all her work – how you stand before it, or glance at it, live with it, feel its presence even when it is behind you, like a breeze coming in at the window, or like the feeling you get when someone is looking at you across a room.

'The spectator becomes enveloped and taken to the brink of being overwhelmed by an almost impenetrable multi-layered complex of information.' This is not a quote from an essayist on the work of Bridget Riley, but Riley herself, writing on a video installation by Bruce Nauman, an artist we might hardly expect her to find fellow feeling for. She has written on Cézanne, Mondrian, Seurat, Poussin and Matisse, but Riley's short 1999 essay on Nauman is one of the best things I have read, either about the American artist's work, or about Riley's own. Bringing herself to bear on Nauman, she says of his later works that

'the power of their presence is firmly rooted in rigorously formal articulation'. This is true of all of Riley 's own work, from the very beginning.

Such an attitude often leads to dull and self-serving pedagogy. In Riley's case her rigour leads us somewhere else. Richard Shiff says in the current Tate catalogue that Riley's work 'can be laborious to write about'. Laborious to read about, too: descriptions of her technical minutiae, and of the formal topographies of her paintings, accurate though they may be, can be as indigestible as the prose of a car-repair manual. Description tends to deaden a body of work that at its best is full of life, sensation and a fugitive equivalence to the visual world in which we live. Her paintings aren't 'like' anything.

A Riley is a Riley, a chunk of sensation, a singular field, an event, an encounter. A Bridget Riley painting is not a depiction. This singularity is peculiar, given that her paintings are made by other hands. From the early 1960s, she has used assistants to manufacture her paintings, after her own production of numerous studies, drawings, variations, diagrams and colour swatch tests, in which every colour relationship is fine-tuned in terms of its hue-value, saturation, its place on the tonal scale, as well as in terms of its opacity, its flow, its gloss or mattness, its malleability as a semi-liquid material. Every single element of every work is premeditated, every painting planned to the last detail. There is a fascinating room of Riley's studies here. However methodical and cold-blooded they are, they are often great drawings – precisely because they have no self-regard or affectation of style.

A consistent feature of her works is their disinterestedness. There's no pawing about of the surface, no expression, no reworking, no accidents. In fact, the paintings themselves can barely be said to have any painterly touch at all. I ask myself, as an aside, why it is that while people complain about art being made or fabricated by others, as though the artist were somehow cheating, no one ever levels this accusation at Riley? Is it because the suppression of any signature touch is an essential feature of her paintings? Like the wall-drawings of Lewitt, Riley's paintings could, in theory, be made by anyone, given a full set of instructions and the right technical expertise. Riley, however, has remained uninterested in this possibility. Issues of authorship and authenticity are not her territory.

While the smallest variations of touch are crucial to a reading of, say, Agnes Martin's work (as signal to her sensitivity), in Riley it is crucial that there is no touch, nothing physical for the eye to pin itself to on the surface. Even the nub of the canvas is sanded down and coated over. There is a surface there, but it needs to be sheer. The painting is not the surface, though physical flatness is an absolute essential to it. She takes it that we are sophisticated enough to understand its primacy, and doesn't need to restate it. In the same way we don't need to be told that Riley's hand has crawled all over the surface, smearing it with her personality.

If her paintings often resist description, so too do they resist being looked at in the way most paintings do. The late David Sylvester remarked to Riley that the painting of hers he owned hurt his eyes. Other viewers have experienced vertigo in front of her paintings, and no one can be immune to the optical flickers and perceptual disturbances of her paintings up to the mid-1980s. But with

Riley one encounters more than one kind of resistance. Her vertical and hori-
zontal stripes, her twined and twisted paintings with their insistent, undulating
rhythms, force one to look only intermittently. They fill you up quickly. You
want to look round them, or over them, rather than into them. They seem to
fill your visual space, to inexorably squeeze you out after a while, leaving you
with a resonance, like a scent, or a lingering sense memory, which you want to
return to, to repeat the sensation. You end up contemplating your own con-
templation. This is paramount.

But I have another kind of difficulty with her paintings from the mid-1980s
onwards. It is not just that they eschew the kinds of effects that, like a drug or
a strong drink, you want to return to in order to get another pleasurable hit, so
much that their tessellated play of verticals and diagonals, then of verticals and
curves, and then of compound curves and hidden diagonals, actually seem to
resist me, or I them. I find myself not wanting to look at them. My eye scans
them, following their rhythms and interlockings, and filling up on their apricots,
pinks and greens, their off-ochres and near Naples yellows, their blue blues and
violet blues, and my brain somehow refuses the engagement. My eye slides off
these paintings, for all their slivers of patterning, those generous pinched and
furled quantities of colour. I begin to ask if such orchestrated, active forms repel
me, or if perhaps the diagonals upset me. (I am left-handed. Perhaps if the diag-
onals went the other way I'd be more receptive to these paintings. Looking at a
reproduction in a mirror, I find that I am marginally more open to them.) This
raises interesting questions, but it may well be that I am happier when her paint-
ings are frontal, and when my physical relationship to them requires a more
mobile way of looking at them – glancing at them, approaching and stepping
back from them, inhabiting their space as much as they occupy my own.

Back in this first and last room, the past and the present of Riley's art come
together. There's a risk that the rest of this chronological show, which, like all
retrospectives, must tell a story as much as it must be an installation of individ-
ual works and groups of works, of key moments and examples, will be a let
down. From the classic 'Op' (how she must hate the term) paintings of the
1960s, through the vertical and horizontal stripe paintings that followed, into
the recomplications of the 1980s and 1990s, there are more than forty years of
painting here, beginning and ending in the same place. Not ending. Beginning
all over again every time I look.

11 August 2003

JONATHAN GLANCEY

Scottish parliament

Climb to the top of Arthur's Seat, look down on festive Edinburgh and you will
see one of the world's finest cities shimmering on both sides of the railway
ravine that saws through its green, granite-lined chasms, those glorious, man-
made punctuation marks: castle, university, cathedral, school of divinity, North

British Hotel, Calton Hill. Here, like almost nowhere else, architecture, engineering, town, gown and landscape seem all of a piece.

But step slowly down to the old town, and further on to the new, and the reverie is broken several times by new developments that seem far bigger and bolder than they should be. Edinburgh is changing and, sadly, there is little or no gentility in the changes. Not only are its fine, eighteenth-century shopping streets now lined with the glib chain stores, bars and cafés you can find anywhere, but its latest architectural adventures seem overweight, overambitious, out of scale and out of place.

If you are here for the festival, take a look at the new Calton Square office and leisure development at the foot of Calton Hill. Or make your way to the new row of stone-clad offices and steely restaurants and bars that culminate in the *Scotsman*'s ambitious new home on one of the sloping ways from the Royal Mile to Holyrood Palace.

There is, though, one new building, still largely under wraps, that is a masterpiece in the making. Not just a great building, but one that addresses Edinburgh specifically and offers something out of the ordinary.

This building is, of course, the new Scottish parliament. It is a glorious design, but derided by the press for being costly and late. True, its cost has risen from a nominal £10m at the time it was first seriously mooted in 1997, to £40m when its design was approved, to £100m when its scale was tripled, to £300m more recently, and to £345m today. This is a lot of money – but what a building. When completed, some time next year, it will be the finest new building in Scotland for many years. And, it needs to be completed to be seen. This is a rich, complex and crafted design, as much landscape as architecture, a building that will connect the city centre emotionally and physically to the hills beyond, expressing Edinburgh's embodiment of Scotland's political and cultural will.

These are big claims. While the parliament building has been (slowly) rising, those muscular commercial developments have been invented, designed and built, no doubt on time and to budget, yet without showing more than a cursory delight in Edinburgh itself. History mattered, though, to Enric Miralles, the big-spirited architect who won the competition to design the new parliament in summer 1998. Miralles, a Catalonian architect practising in Barcelona, died, aged forty-five, in 2000. So, too, did Donald Dewar, the force behind the new building and the Scottish parliament itself.

Dewar wanted something special, and Miralles and his wife, Benedetta Tagliabue, made sure he got it. Working with Scottish practice RMJM and engineers Ove Arup, Miralles developed the design of a building and landscape (the two will be inseparable) that take their cues from sources as diverse as upturned boats along the Scottish coastline to the delicate flower paintings of Charles Rennie Mackintosh. In fact, if you can imagine the new parliament building as a successful amalgamation of the work of Scotland's architect-hero, Mackintosh, and Catalonia's architect-saint-in-the-making, Antoni Gaudí, shot through with the originality and sensitivity of Miralles, you will have at least some idea of what to expect.

Every day that passes reveals some new and unexpected detail of Miralles's

posthumous masterpiece. Here, an extraordinary courtyard, there, a wall with windows like you have never seen before. It is hard to make sense of such an original design. Luckily, Murray Grigor, director of some of the best contemporary films on architecture, has made a short video on the creation of the building on show daily at the Tun, the swish new Edinburgh home of the BBC and some smart restaurants and bars.

Grigor's film offers an intelligent appreciation of Miralles, Dewar and the unbridled quality of the architectural designs. Surrounding the film screen are models of the building and some of Miralles's magical coloured drawings. This is no soulless, commercially driven, computer-glossed monument in the making, but one that will yet win all brave hearts.

Which makes it all the sadder that, however hard they may have tried, Scotland, and even Edinburgh's own architects, continue to display less sensitivity towards the capital than Miralles, the outsider. Calton Square, the titanic new £100m office and leisure development designed by architects Alan Murray and newly completed at the foot of Calton Hill, may boast handsome roof gardens. And it may well be a big improvement on the kind of poor, post-modern offices that have disgraced the city in recent years. Yet it feels too big and blustering. From pavement level, its two powerful buildings seem to be squaring up for a fight. Perhaps Calton Square is redeemed by its five-star hotel, health and fitness clubs, twelve-screen multiplex, 190,000 sq ft of offices and, above all, its roof gardens. It is good to look down on modern buildings and not see clumsy clusters of rooftop air-conditioning equipment, lift motors and the like. How much better, though, if the site had been broken down to a more intimate scale and the buildings had been made more a part of Edinburgh's ceaselessly intriguing cityscape.

Equally, the big, new, late-flowering post-modern buildings by architects CDA that include the new headquarters of the *Scotsman* are too big and wide-mouthed for the city. These architectural guppies belong more to the 1980s and appear to ignore the landscape. True, the *Scotsman* building is generously built, well-finished and boasts ocean liner-like balconies from which journalists can gaze lovingly at the hills beyond. But how much more in tune with those hills is Miralles's design, featuring garden paths that appear to lead beyond the city and into the stirring landscape beyond. It is nice to know, too, that the parliament gardens will bring sweet-scented Scottish flowers to the heart of the city. Miralles was entranced by plants with names such as Sticky Catchfly, Tufted Loosestrife and Biting Stonecrop.

The Scottish parliament is growing from its site like some memorable flower. Branches, tendrils and shoots can already be seen. Hopefully, it will create what Miralles liked to call a 'dialogue across time', an 'extended conversation' between the city, its citizens and the buildings. 'It is not,' he said, designed to be 'a building in a park or garden, but of the land.'

As the burghers of modern Edinburgh race towards a new horizon emblazoned with the alluring colours of big business, bigger money and buildings that might belong almost anywhere, they might yet stop to take a leaf, albeit an expensive one, from Miralles and RMJM's fine garden. One day, they will all feel very much better for it.

TURF WARS

Numerous campanologists rang (and emailed) to challenge the following statement in a cricket report (Sport, 7 September): 'Nasser Hussain rang the changes like campanologists sounding their Steadmans across the Fens. A full peal of eight bells calls for 40,230 changes ...' It was Fabian Stedman not Steadman – he was the author of *Campanologia* (Cambridge, 1677). A Stedman is an odd bell method – there is always an odd number of working bells.

Corrections and Clarifications, 12 September 2002

ROBIN OAKLEY

Pipe dream of a must-win rider

A tall, white-faced figure comes down the weighing-room steps, lean as a junk-yard dog, his wide shoulders hunched in his silks against the wind. After pausing to sign a few autographs on the way to the parade ring, he swings into the saddle and takes his mount on to the course. The leathers are up high, at Flat jockey length, seemingly making it impossible to maintain the balance needed to drive half a ton of horse over the big fences ahead.

They jump off in front and the mount feels the strength of his rider's clamping legs. Decisions are made firmly for him, allowing the horse a little breather round the final bend. With two to jump, a rival looms and the rider's legs squeeze harder as he gets down further into the horse's neck, keeping a firm hold of his head and imparting momentum. As the two tired horses come into the last fence, the leader is asked to stand off for a big one. It is a demand, not request.

The horse lands two lengths clear of his rival, who has taken the safety-first approach. The rider's iron legs and remorseless will ensure the margin is maintained to the line. Tony McCoy has ridden another winner. The hunger that drives him has been satisfied for a few more minutes – until he gets back into the weighing room and begins concentrating on the next ride ...

In A.P. McCoy, racing is blessed with its own Tiger Woods, Carl Lewis or Steven Redgrave. The man who has rewritten the record books of National Hunt racing has the strength of Fred Winter and the all-round canny horsemanship of John Francome, the relentless energy of Peter Scudamore, the cool-headed professionalism of Richard Dunwoody. There seems to be no chink in his armour, so much so that the former jockey turned trainer Christy Roche says: 'It's not his horses but McCoy himself who should be handicapped.'

First the statistics. When the Andover trainer Toby Balding signed him from Ireland as a twenty-year-old conditional (apprentice jumps jockey) in August 1994 to replace Adrian Maguire, McCoy had ridden only thirteen winners, not one of them in a chase. At the end of that season he was champion conditional with a record seventy-four winners. By the end of the next he was champion jockey with 175 and he has been champion ever since. In 1998 he beat Scudamore's jump record of 221 wins in a season. In April this year he beat the Flat jockey Sir Gordon Richards's record of 269 and in August he passed his hero Dunwoody's record of 1,669 lifetime winners.

McCoy is no braggart. But the comment he made on passing Scu's record on Petite Risk at Ludlow at the age of twenty-four was worth noting: 'I couldn't imagine it would happen so quickly.' The last two words tell us a lot.

Confidence is crucial in the saddle and McCoy has a confidence sustained by being first jockey to the remorselessly successful and equally dedicated Martin

Pipe. If there is a bad patch there is bound to be another Pipe-trained winner along in a day or two to stop any self-doubt creeping in. But riding for Pipe brings stresses and strains too. Scudamore, Dunwoody and David Bridgwater all quit the job prematurely. McCoy somehow lives more easily with the pressure of riding so many short-priced favourites.

Courage is part of it. McCoy rides as fearlessly as a man with a spare neck in his pocket and he seems impervious to falls that would sideline others for weeks. But perhaps his ability to get up after a cruncher and take the next ride owes something as well to a determination to prove himself to the first big trainer he worked for in Ireland, Jim Bolger. As an eighteen-year-old McCoy smashed his left leg badly. When the other lads fetched Bolger, the agonized teenager could see a second kneecap where the splintered bones were poking through his breeches. 'Are you sure you've broken it?' asked the trainer. A few months later, when increasing weight forced McCoy to give up hopes of a Flat career and seek a jumping licence, Bolger, for whom he retains a great regard, told him: 'You want to be a jump jockey? You're some fool. I heard you crying like a baby with a broken leg and jump jockeys get that every day of the week. You're not hard enough.' McCoy has made his point. He says he is not brave, it is just that he has never been frightened.

Balding, who hired McCoy on their first meeting as much for the character he detected as for what he had then seen of his riding, says: 'He gets up and shakes himself and off he goes. He seems to get away with fall after fall, which for someone constantly starving himself and almost too tall [McCoy is 5ft 11in] is amazing.' He attributes McCoy's durability to an amazing athleticism and to his dedicated single-mindedness.

At the end of their first hectic season together he told his young jockey: 'Go off and have a holiday. You need a break. I don't want to see you for a fortnight.' The rider agreed. 'Then I looked in the paper the next day and he had three rides booked at Kilbeggan. His appetite for winners is voracious.'

Hunger is the key word in McCoy's life, hunger for winners and a very real, basic hunger. What makes him so special as the fittest and strongest sportsman in his field is that he achieves that while wasting a protesting 11st 7lb body down to a few pounds over 10st. Day after day he boils himself in scalding hot baths like a lobster. Many days are survived on a single Jaffa cake, a small piece of chicken and mugs of sweet tea. Some days you see him on the racecourse with sunken eyes, sucked-in cheeks and a pasty white face that makes you wonder how he will survive the afternoon, let alone the season. As the Jockey Club's doctor says, if horses were doing what McCoy was doing they would never run. So why does he endure it? 'Because it would kill me to see someone else riding the horse if it wins.'

McCoy neither drinks nor smokes and the only thing that has ever been up his nose is a decongestant. But he is, he admits in his new autobiography, an addict: 'If I went to any meeting of the anonymous variety I could stand up, hand on heart, and say: "My name is Anthony, and I'm addicted to riding winners."'

Hunger can lead to greed. There have been clashes with trainers when McCoy has broken gentlemen's agreements and taken another ride he sees as having a

better chance. He justified that to Claude Duval, author of an earlier biography: 'I work hard, travel 70,000 miles a year and risk life and limb virtually every half-hour, every afternoon throughout the year. I feel very strongly that you have to get greedy while you have the chance.'

McCoy's lifestyle is honed down as sparely as his frame. He has an agent, Dave Roberts, to book his rides, an assistant, Gee Armytage, to organize his life and a driver to take him to the races. Unlike many jockeys McCoy is not out schooling regularly in the early morning for his yard. 'Tony comes down at the start of the season and he sits on them to finalize things,' says Pipe. 'But we have a good team to do the schooling.' McCoy's energies are conserved for what he and Pipe live for, to drive more and more horses past the winning post first.

The champion jockey is, he admits, a bad loser. He hates getting beaten and he is no fun to live with when he has been. The ideal McCoy evening is at home watching a video machine with a worn-down replay button, analysing that day's rides for things he could have done better. In the past there have been some famous sulks, and a little more readiness to congratulate others on their successes would have been welcome.

But he came through a bad period of troubles with authority, over his use of the whip, by remodelling his technique and emerging an even better jockey, thinking more about how he could help as well as dominate a horse.

Some of the heaviest criticism that AP has taken, for his black moods after the Cheltenham falls of Gloria Victis and Valiramix, the first with a chance of winning the Gold Cup, the second ready to take the Champion Hurdle, was overdone. Both horses had to be put down and McCoy's grief on those occasions was as much for the passing of two fine equine athletes who were willing to meet every call he made on them as for his own lost share of winning glory.

McCoy is not a hermit. Nor is he a sporting hero on a lonely pinnacle. Nursing his Diet Cokes, he is often the last to leave a party and his success is not resented in the weighing room, where they understand his particular dedication. He is a generous friend and landlord to his fellow jockeys. When I asked the equally voracious Pipe what makes McCoy special, his answer was: 'He's got dedication, balance, determination and a racing brain. But above all he's a nice guy.'

His relentless focus on the track makes McCoy less than cuddly. But punters have developed real regard for the professionalism of a jockey who they can be sure is always trying. And heaven help his competitors: the perfectionist McCoy reckons he is three years short of his peak.

11 January 2003

HARRY PEARSON

A cunning plan for the Ashington Olympics

In the future everything will be an Olympic sport for fifteen minutes. These days even bridge is campaigning for Olympic status (a friend of mine feels this is ridiculous, saying that nothing can be a sport if you can smoke and drink while

doing it – a statement that proves he has never watched parks football or played in a works cricket team).

Oddly enough, all these sports (even bridge) want to be in the summer Games. This leaves a gap in the winter Olympiad into which I believe Britain could force-march some winter sports that we are really good at, alongside curling and the skeleton bob.

A heavy fall of snow here in the north-east this week has allowed me to observe the British at winter play and formulate the following proposals. To impress the IOC, I have embraced the wise words of the great Pakistani cricket commentator Omar Kureishi: 'Nothing has a greater hold on the human mind than nonsense fortified by technicalities.'

The first sport put forward for winter Olympic consideration is the MTV-friendly discipline of sledge-standing ('ss-ding'). If snowboarding is skiing on dope, this sport is snowboarding on Lockets.

Invented in Yorkshire in the 1960s by kids who wanted something that reflected their eco-friendly lifestyles more fully than the highly commercialized world of poly-bagging. ('Every poly-bag comes with, like, the name of some massive agro-chemical company written all over it,' observed pioneering ss-tander Carl Smith of Stokesley, North Yorkshire in 1971. 'It's so totally commercial – and besides, sometimes the farmers put muck in them and stuff.')

Instead these radical dudes and dudesses took to standing up on old-fashioned wooden toboggans ('woodies') and clutching the string. They quickly discovered that by yanking their woodies from side to side they could take them through a complicated series of wild acrobatic manoeuvres that nowadays see ss-tanders 'goofy teething', 'ripping fresh kex' and 'breaking clean wind'.

Since those crazy pioneering days sledge-standing has developed into a sport that encompasses five very different but equally spectacular and testing disciplines: the Martin Pipe (heading down the slope at top speed while smacking your right buttock with an imaginary jockey's whip and yelling 'And with two furlongs to go it's Cherry Tunes from Victory V with Fisherman's Friend coming up on the stand side'), the Half-Pipe (as above but crouching), the Rodeo (rider makes his woodie buck up and down by pulling on the 'reins' while simultaneously waving his balaclava in the air and bellowing, 'Yee-hah! Ride him cowboy!' in what he imagines is an American accent) and finally the Dad (rider sets off on an erratic, bobbing course and says, 'Stop panicking, woman, I used to do this all the time when I was a lad' and is then flown by air ambulance to the nearest spinal injuries unit).

Next up is sign-luge ('sluge'). This is an exciting urban answer to the winter biathlon that culminates in competitors descending a grassed-over slag heap on one of those striped plastic bars local councils use to fence off holes in the road. First, however, the slugers must locate a suitable bar using their skill, judgment and bits of information passed on by 'that fat kid whose grandad works on the bins'.

Next they steal the sign and smuggle it to the downhill course, evading police patrols and council workmen, and stopping every kilometre to let off a volley of abuse at anybody who asks 'And where d'you think you're off to with that, you little hooligan?'. Time deductions are awarded for accuracy and the closeness of

F-word clusters (or 'wearings' as they are known to the sluge fraternity).

Once at the course the competitors bend the front of the bar up to form a streamlining shield, sit on it and slide down the slope repeatedly, the winner being the one who wears a groove in the snow so deep that mud shows through it in the shortest time.

Slightly less physically demanding than sluge but infinitely more artistic is the ancient sport of sliding. Carried out on a specially prepared piste, tradition- ally located directly in front of a row of old people's bungalows, sliding – or bi- pedal para-linear shoe-blading as it is known in the US – is a breathtaking fusion of speed and grace. Shoe-bladers attempt to impress the judges with complex manoeuvres such as 'Little Woman' (during which the competitor drops into a crouch at the start of the slide and pulls his jumper over his knees to give the impression of a pint-sized lady with a large bosom).

Marks are awarded for difficulty, artistic impression and the ability to swerve round recumbent pensioners, yellow pools of dog pee and salt sprinkled by greengrocers because 'some old dear will come a cropper on this'.

Finally comes windscreen-scraping, a simple event in which competitors attempt to remove ice from a car window using a broken cassette case in the fastest possible time. Difficulty is added by having passers-by shouting out advice such as 'You'll find cold water's as effective as boiling' and 'I always put newspapers over mine if the weather forecast says frost'.

Under this intense pressure even experienced pros have been known to crack, yelling, 'My finger ends are numb and if you say another word, big mouth, I'm going to defrost them by ramming them down your throat' and earning instant disqualification.

An impressive list I'm sure you'll agree and one which, if embraced by the IOC, offers up the tempting prospect of Ashington hosting an Olympic Games before London does.

14 March 2003

SCOTT MURRAY

Sympathy for the devil

Preamble.

It's really simple: India are already through, New Zealand have to win.

Meanwhile, have you ever thought WHAT SORT OF LIFE IS THIS AND WHAT THE HELL AM I DOING BOARDING A TRAIN FOR MOORGATE AT 6.30 IN THE MORNING AND THEN STAND- ING AROUND FOR AGES WAITING FOR A TUBE WHILE STARING AT A SIGN TELLING YOU THAT IF YOU WAIT FOR FOUR MINUTES YOU CAN BOARD A TRAIN TO UXBRIDGE I'D RATHER WAIT FOUR HOURS FOR A JOURNEY WITH THE GRIM REAPER QUITE FRANKLY AND THEN YOU GET TO WORK AND THEN THERE'S THIS AND I KNOW THE CRICKET'S GOOD AND ALL THAT BUT I'VE GOT OUT OF THE WRONG SIDE OF BED THIS MORNING AND IN ANY CASE IT'S NOT AS IF I'LL WRITE A CRACKING MATCH REPORT AND THEN GET REWARDED BY BEING SENT ON A WONDERFUL ASSIGNMENT AROUND THE WORLD BECAUSE I'LL BE VERY SURPRISED IF ANY OF MY BOSSES WILL

READ ANY OF THIS LET'S BE HONEST THEY WON'T ALTHOUGH ON THE OTHER HAND THAT'S PROBABLY JUST AS WELL HEY I WOULDN'T BE ABLE TO GET AWAY WITH TYPING THINGS LIKE THIS KIQL!UYS^%$DFLI ZSDSAFC SFE4O92)(^(*^O'$ BBLKU E875O3 96*&^%O*'$OGB LOOK I'M SORRY THIS ISN'T EXACTLY THE SORT OF QUALITY EDITORIAL COPY YOU EXPECT FROM THE *GUARDIAN* BUT LOOK AT THE FACTS I'M ADRIFT IN THE MIDDLE OF ONE OF THE WORST CITIES IN THE WORLD SITTING IN FRONT OF THE SAME COMPUTER SCREEN I FACE DAY AFTER INTERMINABLE DAY HELL I COULD BE WAKING UP IN SAY THE MALDIVES OR SYDNEY OR COPENHAGEN OR A CROFTER'S COTTAGE IN SKYE AND GOING FOR A WALK IN THE CRISP MORNING AIR?

No? Only me then. Good.

(Edited.)

16 April 2003

MATTHEW ENGEL

Farewell to an icon

The last home game of a dead season was already won and lost, so with almost two minutes left the old man trudged off the court and allowed himself to be substituted. At that moment, the cheering started. It went on, and on, and on. The game resumed but the rest of it was lost amid the tumult for the man with the towel on the bench.

That was Washington on Monday night. But tonight, at some point, the cheering really will fade away, for ever. After one last otherwise meaningless fixture – the Philadelphia 76ers against the Washington Wizards – Michael Jordan, the greatest basketball player who ever lived, will retire for the third and final time.

The first time he gave up was to make a short, unconvincing but very touching attempt to make it as a professional baseball player. The second retirement came in 1998 after he had led the Chicago Bulls to the NBA championship for the sixth time, having won the Most Valuable Player award for the finals all six times.

From the point of view of story line, that should have been it. On the one hand Jordan is the greatest brand name any sport has ever seen, and packing in then would have protected his reputation. But Jordan is also a human, and a fidgety, obsessive one at that. He really does love playing basketball. Having left the Bulls and bought a slice of the unsuccessful Washington franchise, he decided, as the Wizards vice-president of basketball operations, that the best signing he could make in 2001 was Michael Jordan.

So for two far-fetched, fascinating and frustrating seasons Jordan has been battling – at times it seemed alone – to get the Wizards into the end-of-season play-offs. Sisyphus had a comparatively cushy number. This season, the forty-year-old Jordan, in contrast to the kids around him, has played in all eighty-one of the Wizards' games and been the star more often than not.

In strict playing terms his comeback has been a failure: the Wizards failed to

make the play-offs either year, although half the teams in the league win a place. And after Monday's cheers there was a nasty scene backstage when some of the team's obvious inner tensions spilled over into recriminations. The Wizards' homage to Jordan was a 93–79 defeat: 'We stunk,' said the coach Doug Collins, and hinted that Jordan might not be the only player to vanish before next season.

Artistically, there are two opinions about Jordan's return. Some think he has tarnished his legacy by playing as a gifted mortal rather than an immortal genius. This view is not much held around Washington, where people have just loved having him around. Commercially, it has been a rip-roaring success: there has not been an unsold seat in Washington for two years and the team has been by far the biggest draw away as well.

Five years ago, there was a piece in *Fortune* magazine by Roy S. Johnson, who tried to measure Jordan's effect on the global economy, including everything from sales of tickets to those of shoes, drinks and cereals. Johnson reckoned the figure was around $10bn, but has now updated that to $13bn. 'The ripples from Jordan's presence, by all indications, show little sign of falling flat any time soon,' he wrote, 'in large part because his comeback allowed another generation of fans, many of whom had never seen him play in person, to witness a glimpse of the legend at work.'

It is very American to try to quantify the unquantifiable: Jordan's place in the sporting pantheon will be on the top-most level, where figures cease to have any meaning. Like Babe Ruth, Don Bradman, Muhammad Ali, Joe Davis and maybe Pele and Tiger Woods, he has both transformed and transcended his own sport. This is less obvious in Britain, where basketball has never taken off, than almost anywhere else. But the National Basketball Association is now big in China and talking seriously about having teams in continental Europe, at least when the words France and Germany are no longer mud in the US. This would have been unthinkable before Jordan.

What made him unique was that he combined three entirely separate social elements, two of which go way beyond sport. Firstly, of course, he was an utterly brilliant player. Three centuries after Newton was hit by the apple, Jordan abandoned gravity and took wing with an extra aerial kick that produced the mysterious phenomenon of 'hang time'. But that was only the beginning.

'He was probably the only American athlete who was always better than his hype,' said Jack McCallum, the senior basketball writer for *Sports Illustrated*. 'He did things in the air that no player had ever done, and he did it all with an incandescent smile.

'Then as he grew older, and couldn't do all the aerobatic bit, he changed his game. He became the best jump-shooter in the league. He became the best defensive player. And pound for pound he became the strongest player in the league.'

This combination of amazing skill and personality came into basketball at the perfect strategic moment. Jordan made his debut in 1984, the year a young lawyer called David Stern became the NBA commissioner, and saw a sport ripe for transformation. In 1979 Stern, as a junior employee, had negotiated basketball's first cable TV contract – for $500,000. The figure now is $223m.

Self-portrait, 2003.
(Andrzej Krauze)

A.KRAUZE

Fist. (Daniel Pudles)

Cloning. (Jim Sillavan)

The Literary Three. (Posy Simmonds)

The Queen at Christmas.
(Nicola Jennings)

Susan Sontag. (Clifford Harper)

Everyone rose together on Jordan's athletic body: the sport, Stern, the ESPN sports channel and, above all, the once-unglamorous footwear company, Nike, that signed Jordan up. Nike's ad agency stuck him together with a young film-maker called Spike Lee to make commercials that miraculously distilled the essence of urban lifestyle. That miracle is still defying commercial gravity. Jordan-branded Nike products are expected to bring in $320m this financial year, a rise of 40 per cent.

It was not just shoe culture that was ripe for exploitation it was black culture. The US had had black sporting heroes before, but Joe Louis and Jackie Robinson, the pioneering baseball player, were palpably second-class citizens, successful in spite of their race. Then there was Ali. 'But Ali,' says McCallum, 'was a revolutionary. As many people hated him as liked him. Jordan never said anything controversial. He was just this smiling athlete who was smart and fair-minded and not arrogant. He was the first athlete we were truly colour-blind about.'

The consequences were perhaps even more staggering than most people have yet realized. In a remarkable 1999 book, *Michael Jordan and the New Global Capitalism*, Walter LaFeber threw together the names Jordan and Osama bin Laden and named Jordan as the innocent chief representative of an American 'soft power' that he saw as both dominating and antagonizing the rest of the world.

Do we blame Jordan for 11 September? That might be pushing it. But tonight, when he makes his last elegant pass and makes his last elegant bow of the head, we should be aware that here is a man whose impact on the world has almost certainly gone beyond that of any other sportsman.

22 April 2003

REGINALD SMITH

Letter: Blair v Becks

So the producers of *The Simpsons* do not plan to offer a role to David Beckham, unlike Tony Blair, on the grounds that he is not famous enough ('Blair gets role in Simpsons', 12 April). In fact, Beckham is probably better known around the world than the prime minister – but he is not famous in the US, a view which merely reflects that country's own rather narrow and parochial sporting interests. The US holds a baseball World Series every year, with participating teams from two countries. The other 6 billion of us prefer football, where teams from over 150 countries enter a real World Cup.

29 May 2003

ELLEN GOODMAN

Annika Sorenstam

I first got involved in integrating golf last summer, as a member of a small feminist subcommittee at a quirky nine-hole course in Maine. We quietly liberated a Ladies' Tee with a sign renaming it the Forward Tee.

This was not done, I hasten to add, because the committee women longed to play from the Men's Tee. It was a subtle boon to older island men who could no longer make it over the gully from the greater distance and who also wouldn't lay a club on anything labelled Ladies. In short, it was a ploy to make the game unisexually easier.

This is what distinguishes me from Annika Sorenstam: I think golf is waaaay too hard already. Of course, what also distinguishes me from Annika is about 90 yards on our best drives. But let's not go there.

It's the search for a challenge that brought this champion of the Ladies Professional Golf Association (the Forward PGA?) to the Colonial Country Club in Fort Worth, Texas. She is the first woman to play in the PGA since the redoubtable Babe Didrikson Zaharias in 1945.

Annika has won forty-nine LPGA tournaments and once turned in a score of 59. With that record, no one surely would deny her the chance to test herself against the PGA. Well, Vijay Singh would, but the Fijian bowed out of the tournament after wishing her ill. And pro Fred Funk sounded like Fred Flintstone when he grumbled: 'She'll be taking a spot from somebody who's trying to earn a living.'

What's intriguing is not the remarks of men whose handicaps are higher off the fairway than on. What's notable is that Annika did not get the attention of the world until she was picked to play with the boys. Before that, she was arguably the least-known best athlete around. She earned $2,863,904 last year, which isn't exactly peanuts, but it was 41 cents for every dollar Tiger earned. That's worse than the average working woman's 76 cents to the male dollar.

Now she's had gigs on *60 Minutes* and *Jay Leno*. *Sports Illustrated* said she had the best head in the game, and hundreds of reporters went to record her every shot.

There is something a wee bit familiar about all this. We all know that women get more attention – criticism and respect, money and status – when they compete on male terrain in the work world. But it seems true as well in professional sports. A lightweight boxer doesn't have to 'move up' to the heavyweights to get the same status, but in many sports women are still dubbed second class as long as they are a separate class.

This puts us in something of a pickle. We're watching a generation of remarkable women athletes. Today's female stars, like the buff Annika, would wallop yesterday's male superstars.

There's no reason why women can't compete on the same turf in sports such

as horse racing or stock car racing when, as Donna Lopiano, the head of the Women's Sports Foundation, quips, 'the athlete is the horse or the car'. We have, as well, a growing list of sports such as mixed doubles in tennis that are constructed for co-ed teams.

But in sports where strength matters, what happens if the exceptions, such as Annika, move 'up'? Does the number one woman become the number twenty-eight man? Does she leave a void in the LPGA?

I've wondered about that from time to time as I've watched school sports. I have cheered the new girl on the boy's team. 'You go, girl.' We applaud the individual athlete. At the same time, I'd rather the entire girls' team moved up a notch in skills and status.

Ultimately, Lopiano suspects, we'll have three categories of professional sports: his, hers and theirs. The real fun of sports, she adds, is competition between equals. It's more fun seeing Serena against Venus than against André Agassi.

So, Annika – you go, girl. Playing the PGA is probably a one-shot thing and a publicity shot thing. But all in all, it would be better to find the competition growing and the spotlight glowing on the women's own turf.

That's my idea of a forward tee.

25 June 2003

MARTIN JACQUES

The Williams sisters

When Serena Williams was beaten by Justine Henin-Hardenne in the French Open semi-final, she was booed every time she questioned a decision – even when she was clearly in the right. And, towards the end of the match, every first serve she missed was greeted with loud cheers.

Unsurprisingly, Williams was reduced to tears. At the end, she was booed off, just as her sister Venus had been after her defeat by Russia's Vera Zvonareva in the fourth round. Various explanations were offered to explain the crowd's hostility to Serena, including support for the underdog and the number of Belgians there. Both were no doubt part of the explanation but the most likely – racism – barely got a mention.

The antipathy of a tennis crowd is hardly a new experience for the Williams sisters. In the semi-finals of the US Open last year, the American crowd supported Amelie Mauresmo of France rather than Venus: for the overwhelmingly white, middle-class crowd, the bond of colour clearly counted for more than the bond of nation.

During a second-round match at this year's Roland Garros, when a blonde American teenager, Ashley Harkleroad, knocked out Daniela Hantuchova, the Eurosport commentator, a former player, excitedly declared that perhaps America had found the women's champion it was looking for. And the Williams sisters, pray? Sorry, wrong colour.

At the Indian Wells final in 2001, Serena was jeered the moment she appeared on court and was booed throughout. Her father, Richard, described how, as 'Venus and I were walking down the stairs to our seats, people kept calling me nigger. One guy said, "I wish it was '75" [alluding to the Los Angeles race riots] we'd skin you alive."'

None of this should be surprising. Tennis is an overwhelmingly white middle-class sport, both in those who play and those who watch. Until the Williams' emergence, the only previous black grand-slam champions were Althea Gibson, Arthur Ashe and Yannick Noah. Western societies – be they European or American – are deeply racist: notwithstanding that veneer of politeness and refinement, the middle class is certainly no exception.

Although Venus and Serena got a warm reception in their opening matches at Wimbledon, the fact is there will be few brown or black faces in the crowd, and little understanding or sympathy for what it is like to be black from spectators, commentators or tennis reporters. For the great majority, the sisters are from an alien world compared with their white opponents.

The extraordinary thing is that this is hardly ever written or said. As race courses through the veins of tennis, people pretend it doesn't exist. Instead, the Williams sisters, together with their father, are subjected to a steady stream of criticism, denigration, accusation and innuendo: their physique is somehow an unfair advantage (those of Afro descent are built differently), they are arrogant and aloof (they are proud and self-confident), they are not popular with the other players (they come from a very different culture and, let us not forget, there is plenty of evidence of racism among their colleagues: comments made by Martina Hingis spring to mind, not to mention the behaviour of Lleyton Hewitt towards a black linesman in last year's US Open).

And Richard, a man of some genius, is painted as a ridiculous and absurd figure, match-fixer, Svengali and the rest of it.

Most racism – especially middle-class racism – is neither crude nor explicit but subtle and nuanced, masquerading as fair comment about personal qualities rather than the prejudice it is. The achievement of the Williams sisters is towering. Coming from a black ghetto in Los Angeles, riven by drugs and guns, they have scaled the heights of what their father has accurately described as a 'lily-white sport', with enormous verve and skill, and in the process have dealt with the prejudice of the tennis establishment, the players, the crowds and the media with great grace and dignity.

It is often said that one of the reasons crowds favour their opponents is that they like to side with the underdog. Yet, when the Williamses arrived on the scene, they rarely received support, even though they were the underdogs. And, by any standards, given what and where they have come from, Venus and Serena remain just that.

Now that sport has made the transition to the mainstream of society and, by the same token, from the back to the front pages, it is not good enough to pretend that sport – any sport – is a culture-free, value-free zone. The ubiquity of racism in football is just beginning to get the attention it deserves. And so it should: football houses the biggest single manifestation of racism in most

European societies. And the same goes for other sports. It is no longer good enough for reporters and commentators to turn a blind eye to racism. Tennis – including lily-white Wimbledon – should be no exception.

2 July 2003

JILL TREANOR AND JULIA FINCH

Chelski

In a surprise move last night Chelsea football club was sold to a 36-year-old Russian oil billionaire after intense and secret negotiations, in a deal worth £140m.

Ken Bates, the club's chairman, struck the deal with Roman Abramovich, who is also an influential politician, and has deep pockets. According to *Forbes* magazine he is Russia's second richest man with a fortune of $5.7bn (£3.4bn) and a wide range of business interests, including the Russian airline Aeroflot.

His deal to buy Chelsea Village, the overall owner, values the Premiership club at £60m. It follows months of speculation that Mr Bates had been looking for a financial injection for the loss-making club, with debts thought to be in the region of £80m. In the six months to the end of December, Chelsea Village lost £11m on a turnover of £53m.

Mr Bates, who owns at least 29 per cent of Chelsea Village, is staying as chairman as part of the deal and insisted last night that it would be good for the club. 'We have achieved an enormous amount over the past twenty-one years, building a fantastic new stadium and a talented team, which is firmly established as one of the top clubs in Europe. In today's highly competitive football market, the club will benefit from a new owner with deeper pockets to move Chelsea to the next level,' he said.

Mr Abramovich is a keen sports fan but not a particular Chelsea supporter. He decided to approach Chelsea after running the rule over a number of English clubs, including Manchester United, which has itself been the subject of takeover rumours. Last night he said he was 'delighted' with his deal, which will stun football fans. 'We have the resources and ambition to achieve even more given the huge potential of this great club,' he said.

He is a major shareholder in Sibneft, one of Russia's largest oil firms, which is conducting a merger that will turn it into the world's fourth largest oil company. He is offering to pay Chelsea Village shareholders 35p a share, 15 per cent above the closing value of the shares last night at 30.5p. The stock market was closed when the deal was announced.

He has bought almost 85 million shares and has the support of shareholders controlling 50.09 per cent. His offer will be extended to the rest of the shareholders when the stock market opens this morning.

Mr Bates, a high-profile figure in English football, has transformed Chelsea since buying it for £1 in 1982. He has turned it into a business empire centred on its west London ground but built up debts in building a hotel, restaurant and

leisure facilities. Chelsea's ownership structure has always caused controversy because of stakes held by unusual offshore companies.

4 August 2003

LOUISE TAYLOR

Beckham turns heads

If the sight of around fifty white-capped nurses pursuing David Beckham on to the pitch at the Beijing Workers' Stadium on Saturday night was not sufficiently bizarre, his reception in Tokyo yesterday proved positively surreal.

Whereas those nurses, evidently refreshed after duties on the springtime SARS wards at Beijing Hospital, greeted Beckham with flowers and kisses ahead of Real Madrid's 4–0 friendly victory against the Chinese Dragons, 45,000 adoring Japanese fans had paid a minimum of £15 simply to watch their idol being put through a gentle training session last night.

Some of those who had failed to snaffle the original £15-seats invested up to £115 on the black market – and all to witness what amounted to a glorified warm-down at the National Stadium preceded by a kick-about with 600 local children.

Afterwards, at an adjacent hotel to promote tomorrow's match with FC Tokyo, Beckham was asked if the frenzy was out of proportion. 'We've really had nothing to do with it,' he replied, somewhat disingenuously. 'But I've been happy to see all the fans.'

Sitting alongside him – and perhaps significantly having commandeered the seat bang in the middle of the dais, leaving Beckham seated on the side – Luis Figo possibly harboured alternative thoughts.

'This is very different from the sort of pre-season we have had in the last few years,' said the Real winger, who has spent recent summers limbering up in Austria. 'In the last few years we've had a lot of good physical training but this time it's different; we're not used to all these ceremonies.'

Beckham evidently has no such qualms. 'Making my debut in an historical place like Beijing was an amazing feeling, it was a great honour. We were pleased with the performance and I really enjoyed myself.'

And so he should, having been saluted by chants of 'David, David' at the Workers' Stadium. It was ironic that an arena constructed to celebrate communism was so unreservedly paying homage to a man who symbolizes the sort of ostentatious individualism that the Cultural Revolution had intended to eradicate.

Indeed Chairman Mao would probably have turned in his grave had he heard the 80,000-strong crowd, 60,000 more than the average for most football fixtures in this stadium and many wearing T-shirts emblazoned with either Beckham or 23, boo the Chinese Dragons, a side comprised of players from four of the country's leading domestic sides. This was because no player from the Beijing club featured during the first forty-five minutes but it was still rather

shocking to witness such a lack of patriotism.

Similarly, a casual visitor dropping in from Mars or Jupiter would surely have been shocked that Beckham rather than the excellent Zinedine Zidane was the player causing all the fuss.

So how did Real's number 23 do? He was neat and tidy during his seventy-seven minutes of action but, bar one stunning long ball to Ronaldo and a couple of near misses from hallmark free-kicks, there was little more.

For a footballer causing such a commotion it was extraordinary that, from his station wide on the right, Beckham never once managed to beat the Dragons' left-back, the doughty Wu Cheng Ying.

Unfortunately his first touch, which coincided with an excited 'Bravo, bravo, Beckham' from the PA announcer, was swiftly followed by Wu Cheng's first block. It seemed to set a disappointing precedent and, even worse, his shadow's subsequent success in persistently steering him infield highlighted just how one-footed the England captain is.

Of course, that one is pretty useful but in Beijing it merely dispatched a single cross – comfortably headed clear by a Dragon. Real are a significantly less cross-centric side than Manchester United but Figo nevertheless conjured a few decent centres from his new left-wing beat. Afterwards Figo said he was not upset at having ceded his preferred flank to the new boy but he spoke with a scowl.

The expression on Roberto Carlos's face when Beckham delivered those dead balls – one acrobatically saved by the goalkeeper and the other bent fractionally wide – was one of intense interest and it will be intriguing to watch how the issue of who takes what when and where unravels.

In open play Beckham did unleash that apparently laser-guided 50-yard pass, which presented a tubby-looking Ronaldo with a definite scoring chance that his reactions proved unequal to. Generally, though, number 23 did the simple things well enough to leave the Spanish press reasonably content but without seeing quite as much possession as they might have hoped.

Tellingly, Beckham was fed few outlet balls. Perhaps if he had proved he had Wu Cheng's measure his team-mates might have reacted a little differently. Or perhaps he is in the wrong position in his new team? Maybe Beckham would, after all, be better used directing his passes to Raul and Ronaldo from the central midfield station he craves.

Encouragingly, though, he played appreciably better in the second half, which possibly had something to do with his decision to tie his hair in a ponytail, possibly the Beckham version of rolling your sleeves up. It was a small ponytail because his hair had been trimmed in Beijing where, surprisingly, the cut was executed in the hairdressers' at the Beijing Hotel, presumably guaranteeing the salon's solvency for years to come.

Although he had, disappointingly, rearranged it in an unflattering double ponytail involving two thin bunches yesterday, the cut was good, Beckham's first-half appearance in China almost transporting him back to the floppy pre-France 1998 look, even the pre-Posh era.

Back then his presence would not have necessitated a touring football team visiting the Forbidden City at midnight on Friday. This nocturnal trip by Real

was made at the insistence of the mayor of Beijing after it had been cancelled amid security fears that morning. Sadly it ended in argy-bargy when a VIP female sponsor was pushed over by an over-zealous official.

Caused by Real's objections to the mayor inviting sponsors and Chinese journalists through the specially unlocked city gates, it was the sort of minor diplomatic incident which punctuated the Chinese leg of this tour, straining relations between Real and their hosts.

The portents seem more promising here in Tokyo but, when asked if he had briefed his new team-mates on Japanese culture, Beckham admitted: 'Not many of them speak English, so it's been quite difficult for me to pass them the ball, let alone discuss Japan.'

Just for a moment he looked like a man badly missing Gary Neville.

LOST IN ACTION

18 September 2002

FIONA MacCARTHY

Mary Stott

I arrived in Manchester in 1964, as Mary Stott's assistant on the *Guardian* women's page she had, by then, been editing for seven years. It would be no exaggeration to say she had invented a page whose content had previously been in the remit of the night editor, along with letters, travel and obituaries.

Mary set out to create a page that 'depended mainly on warmth, sincerity and personal involvement'. With extraordinary speed, it established its identity, reflecting, to an uncanny degree, the attitudes and personality of Mary herself. I can think of no other editor who built up such direct rapport with her readers, or who saw such possibilities in them as contributors.

At a time when feminism in Britain was just dawning, Mary was acute in her judgment that what women cried out for was the sharing of experience, the sense of real people writing on her page.

How did she get away with it? Here, in a national newspaper (the *Guardian* had recently dropped 'Manchester' from its masthead and was expanding its London operation), Mary established her own power base, an influential and idiosyncratic female sub-state. She knew from her own experience the struggle women had in balancing love, family and their professional lives, and she ran her page with a dogged sense of purpose in opening out the possibilities for women, forming supportive networks, creating solidarities.

It operated as a community noticeboard on a giant scale. Mary believed in the special authenticity of amateur contributors, arguing that readers could often identify more closely with a non-professional writer. She backed her hunch – with sometimes riveting results – from the stack of more than fifty unsolicited manuscripts that arrived every week. Betty Thorne describing life in a Sheffield two-up, two-down, Betty Jerman on being 'squeezed in like sardines in suburbia': these were classics of their time.

Such missives from the coalface of female deprivation drew an enormous correspondence, and started the whole journalistic genre of personal unburdening. Mary's women were the first of the Women Who Told All.

At her best, she was also a first-class columnist. But she preferred a more self-effacing role, proud of her page make-up skills and working hard to build up a nucleus of trusted contributors, who inevitably also became her friends.

Sometimes, you could accuse her of an excess of loyalty to columnists whose day was done. But the calibre of her regular writers in the 1960s – Shirley Williams, Lena Jeger, Marghanita Laski, Taya Zinkin, Gillian Tindall, Margaret Drabble – made the *Guardian*'s weekly 'Women Talking' feature one of the most widely read and avidly discussed newspaper features of its period.

Mary encouraged her writers to sound off on the whole human condition: ways of living, relationships and morals, education, social services and gaps in

the welfare state. One of her great crusades was for women's financial independence, as the basis of real equality. For her, the most successful of all 'Women Talking' articles was E. Margaret Wheeler's case history of a woman's dependence on her husband, the 'Tale of a five-bob-a-week wife'.

The voicing of a social problem often led to direct action. In 1961, the Housewives' Register was formed after a letter pointed out the social and intellectual isolation of so many 'housebound housewives with liberal interests and a desire to remain individuals'. The Pre-school Playgroups Association was launched when another reader, Belle Tutaev, drew attention to the total inadequacy of nursery education. Ann Armstrong's vivid account of life as a responaut, paralysed from the neck down, led to the formation of the Invalids at Home Trust. Then there was Single Women and their Dependants, the Welfare of Children in Hospital, and the Disablement Incomes Group – the potential good causes, and Mary's enthusiasm for them, seemed unlimited. By the end of the decade, the term *Guardian* women' had entered national consciousness, soon to spawn the less respectful 'Guardian wimmin'.

An interesting development was the eagerness of readers to parody themselves. An article by John and Elizabeth Newson suggested that, in primitive societies, the problem of sleepless babies did not exist 'because the baby sleeps snugly against his mother's body, and so allows her to sleep too'. A famous spoof reader's letter claimed that her bed was capacious enough to hold her family of seven, and very often did.

Mary delighted in the female clubbishness her pages generated. But her success was rooted in her moderation. In feminist terms, she was never an extremist; she found the aggressiveness of Betty Friedan's *The Feminine Mystique* baffling. Until the Lady Chatterley trial enlightened her, she did not know the meaning of the word 'fuck'.

The 1960s' women's page was an onslaught on old-time suburban female values from within. The silence of women in those days was pervasive in a way incomprehensible to women living now.

Mary's zest for discussion was what made her a great editor. She provided a platform for all ages, classes and persuasions. By giving us encouragement and space, she helped an awful lot of women – myself, gratefully, among them – to acquire the confidence to say the things we wanted. Her subversive brilliance was in persuading women other choices were available.

Gradually, women talked, and even men began to listen. Mary Stott created a new climate of argument and restlessness. She helped a generation find its voice.

Charlotte Mary Stott, journalist, born 18 July 1907, died 16 September 2002.

26 February 2003

MARTIN KETTLE

Christopher Hill

Christopher Hill, who has died aged ninety-one, was the commanding inter-preter of seventeenth-century England, and of much else besides. As a public fig-ure, he achieved his greatest fame as master of Balliol College, Oxford, a post he held from 1965 until 1978. Yet it was as the defining Marxist historian of the century of revolution, the title of one of the most widely studied of his many books, that he became known to generations of students around the world. For all these, too, he will always be the master.

It would be a pardonable exaggeration to say that Hill created the way in which the people of late twentieth-century Britain – and the left in particular – looked at the history of seventeenth-century England. As he never tired of pointing out, some of the themes he illuminated so richly had already been explored by left-wing scholars in the 1930s. But from 1940, when he published his tercentenary essay, 'The English Revolution 1640', his own voluminously expanding and unfailingly literate work became the starting point of most sub-sequent interpretation, even for those who rejected his method and conclu-sions.

No historian of recent times was so synonymous with his period of study; he is the reason why most of us know anything about the seventeenth century at all. He was, E.P. Thompson once said, the dean and paragon of English histori-ans.

Hill was born in York, where his father was a solicitor. His parents were Methodists, a fact to which he attributed his lifelong political and intellectual apostasy. Though his life was to be the embodiment of a secularized form of dis-sent, his high moral seriousness and egalitarianism surely had roots in this rad-ical Protestant background.

At St Peter's school in York, his academic prowess was immediately evident. It is said that, when Hill was sixteen, the two Balliol dons – Vivien Galbraith and Kenneth Bell – who marked his entrance papers agreed to award him 100 per cent, before travelling to York to capture him for the college and prevent him going any further with a Cambridge application. Galbraith, in particular, was to remain an immense influence.

Hill's association with Balliol was to continue, with only brief interruptions, from his arrival as an undergraduate in 1931 until his retirement as master forty-seven years later. Academic honours regularly fell his way, starting with the pres-tigious Lothian prize in 1932, and continuing with a first-class degree in 1934 and an All Souls fellowship that winter. But he was a successful rugby player too, the scorer of a famous cup-winning try for Balliol. Even more lastingly, he had become a Marxist.

Exactly when and why this happened is uncertain, since Hill was always noto-riously inscrutable about discussing his personal life. He once claimed it came

about through trying to make sense of the seventeenth-century metaphysical poets, but although he read Marx as an undergraduate, the moment of his conversion to communism is elusive.

His contemporary, R.W. Southern, once teasingly remembered 'a time when Christopher was not in the least bit leftish', but Hill was an undergraduate during the period of the Great Depression, the hunger marches, the New Deal, Hitler's rise (he visited the Weimar Republic before going up to Oxford), and the first (favourable) impact of Stalin in the West. He was a regular attender at G.D.H. Cole's Thursday Lunch Club, where, as he once put it, 'I was forced to ask questions about my own society which had previously not occurred to me.'

Certainly by the time he graduated, Hill had joined the Communist party. In 1935, he spent a year in the Soviet Union, during which he was very ill, but also formed a lasting affection for Russian life – and a somewhat less lasting one for Soviet politics.

After Moscow, he had two years as an assistant lecturer at University College, Cardiff, before returning to Balliol as a fellow and tutor in modern history. In 1940, he was commissioned as a lieutenant in the Oxford and Bucks Light Infantry, before becoming a major in the intelligence corps and being seconded to the Foreign Office from 1943 until the end of the war. This was, to put it mildly, an intriguing period, about which he rarely let fall much detail.

By this time, he had begun to publish, at first pseudonymously, articles and reviews, which, among other things, did much to draw attention to the burgeoning Soviet school of English seventeenth-century studies. Then, in 1940, arising out of intensive debate among a group of Marxist historians, who included Leslie Morton, Robin Page Arnot and – particularly influential on Hill – Dona Torr, came the decisive 'The English Revolution 1640'.

The essay was originally published as one of a collection of three reflections (the others were by Margaret James and Edgell Rickword). Hill's contribution, which was subsequently published alone, was a no-holds-barred assertion of the revolutionary nature of England between 1640 and 1660, and an assault on the traditional presentation of these years as an aberration in the stately continuity of English history.

'I wrote as a very angry young man, believing he was going to be killed in a world war,' Hill later told an interviewer. The book, he said, 'was written very fast and in a good deal of anger [and], was intended to be my last will and testament.' It has rarely, if ever, been out of print since.

The discussions surrounding Hill's essay also produced, in 1946, the Communist Party Historians Group, an association he regarded as 'the greatest single influence' on his subsequent work. This formidable academy, which included Edmund Dell, Maurice Dobb, Rodney Hilton, Eric Hobsbawm, James Jeffreys, Victor Kiernan, George Rudé, Raphael Samuel, John Saville and Dorothy Thompson, has a good claim to have redefined the study of history in Britain, especially after the launch, in 1952, of the journal *Past and Present*, of which Hill rapidly became the moving spirit and, later, the doyen. It also generated the path-breaking collection of documents, *The Good Old Cause*, which he edited with Dell in 1949.

The active, twenty-year involvement with communism, which also led to his

short biography, *Lenin and the Russian Revolution* (1947), came to a crisis after the Soviet invasion of Hungary in 1956. Along with many in the CP, Hill had become disenchanted with the party's lack of democracy and its reluctance to criticize the Soviet Union. Both issues came to a head in the late weeks of 1956, though his own break did not come until the following year. He was appointed to a CP review of inner-party democracy, but the rejection of the critical minority report, written by Hill (with Peter Cadogan and Malcolm MacEwen), precipitated his final departure.

These were watershed years in Hill's personal life too. A wartime marriage to Inez Waugh, the former wife of a colleague, produced a home life that combined the high seriousness of Balliol Marxism with an extravagant bohemianism. It also produced their daughter Fanny Hill, later a dashing figure on the Oxford scene, who drowned off the Spanish coast in her forties. The marriage collapsed early and, in 1956, he married again, this time to Bridget Sutton, then a history tutor with the Workers' Educational Association in Staffordshire. Turbulence was replaced by the single greatest happiness of Hill's life. With Bridget, who died in 2002, he had a son and two daughters, one of whom died in a car accident.

After 1957, Hill's career ascended to new heights as he began the remarkable output of books on which his reputation will rest, and which continued undiminished until he was well into his eighties. Hill always argued that the connection between leaving the CP and his wider fame was post-hoc rather than propter-hoc, and it is certainly true that 1956–7 caused no revolution (let alone a counter-revolution) in his analysis of the English revolution. On the other hand, the Bridget effect can hardly be underestimated.

If the steady flow of books, which began with *Economic Problems of the Church* (1955), can, to some extent, be seen as a succession of more scholarly explorations of the themes sketched out in the early didactic essays, they also reflect the extraordinary sweep of Hill's interests and mind. Central to the whole project was a patient fascination with religion, represented, in particular, in his attempt to understand the revolutionary power of puritanism.

But Hill's explorations were in no way bound by traditional or preconceived theories. The single, most striking and controversial aspect of his method was the way in which he subtly identified intellectual connections, currents and continuities between the most unlikely pieces of evidence – from scraps of court records to *Paradise Lost* and *Pilgrim's Progress*. His use of literary sources was one of his most fascinating characteristics.

Many of the tasks he set himself were laid out in his next book, *Puritanism and Revolution* (1958). They were further explored in *Society and Puritanism in Pre-Revolutionary England* (1964) and the remarkable *Intellectual Origins of the English Revolution* (1965, and extensively revised thirty-one years later), this last based on his 1962 Ford lectures. Alongside came more popular works of exegesis – an Historical Association pamphlet on Cromwell (1958), the bestselling (but not adulatory) biography *God's Englishman* (1970), the textbook *The Century of Revolution* (1961) and the hugely successful Penguin economic history, *Reformation to Industrial Revolution* (1967).

Those who heard Hill deliver the lectures on which it is based – lectures delivered in a nervous, slightly stuttering voice – will always reserve a special place

for his 1972 study of radical and millenarian ideas, *The World Turned Upside Down*. Not only was this one of the very few history books to be turned into a play (at the National Theatre), it was also a work made more exciting by the time in which it was written, an era of counter-cultural energy, which Hill observed (and quietly celebrated) from the Balliol master's lodgings.

This was a period of immense academic daring (and, thought some, of over-reaching) as Hill scythed through received tradition in his study of *AntiChrist in Seventeenth-Century England* (1971) and his controversial study of *Milton and the English Revolution* (1977), which, like many of his later works, was written at the plain but lovely house in Périgord, which Bridget badgered him into buying in 1969.

Meanwhile, in 1965, Hill had defeated Ronald Bell in the election for master of Balliol, a success that caused raised eyebrows (it was only ten years or so since academics with Hill's politics had been, to all intents and purposes, blacklisted from many posts) and much press attention. His tenure was deft and collegiate, and he tried to maintain his teaching and research amid the administrative and ceremonial duties. He never seriously hid his enthusiasm for the two main inno-vations of his mastership – the opening of male-only Balliol to women, and the representation of students on the college governing body. 'Common sense varies among the young,' he admitted, 'as among the old.'

Retirement found his productivity undiminished. He moved to Sibford Ferris, on the Cotswold hills, and, for two years, worked as a visiting professor at the Open University, an entirely characteristic effort to bring his learning to a wider audience. Then he settled down to further books: *Some Intellectual Consequences of the English Revolution* (1980), *The World of the Muggletonians* (1983) and *The Experience of Defeat* (1984), an account of the Restoration made poignant by the reverses twentieth-century left-wing politics were suffering at the time.

A marvellously vivid study of Bunyan followed in 1988, before *The English Bible in Seventeenth-Century England* (1993) and *Liberty Against the Law* (1996). Three volumes of essays were published in the 1980s – throughout his life, Hill wrote some of his most challenging and original work in articles and reviews.

Hill was honoured by an OUP festschrift, *Puritans and Revolutionaries*, when he retired from Balliol in 1978, and Verso published a series of tributes and criti-cisms, *Reviving the English Revolution*, ten years later. Yet, for the last twenty years of his life, he became once again a more controversial figure.

His methodology was famously assaulted by J.H. Hexter in a *Times Literary Supplement* review in 1975, and his assessment of Milton was powerfully denounced by Blair Worden. A reaction against his big reading of seventeenth-century history took root in the work of Conrad Russell, John Morrill and oth-ers. Yet Morrill's tribute in 1989 – 'If we can be sure that the seventeenth century changed England and Englishmen more than any other century bar the present one, we owe that recognition to him more than to any other scholar' – shows how, even in relative eclipse, Hill remained the central point of reference in sev-enteenth-century studies.

People always felt there was something enigmatic about Hill. Whether as a friend walking through Oxfordshire or the Dordogne, as a tutor hunched in his armchair discussing an essay – and still more on formal occasions – he kept his

cards close to his chest, forcing you to do the talking, making you listen to what you were saying in the way that he was listening too. But then he would make a joke, often just a pointed ironic observation, which made you love him. As someone once said, although he affected to be severe, he could not help being benign.

But tough, too. Always. Hill once gave a radio talk marking the centenary of the publication of *Das Kapital*. He ended it by telling how, in old age, Marx had bumped into a fellow revolutionary from the 1848 barricades, now prosperous and complacent. The acquaintance reflected that, as one got older, one became less radical and less political. 'Do you?' Marx replied. 'Do you? Well, I do not!' And nor, he clearly intended us to understand, did Christopher Hill.

John Edward Christopher Hill, historian, born 6 February 1912, died 23 February 2003.

15 March 2003

RONALD BERGAN

Stan Brakhage

Those who consider cinema a narrative art form, and believe that films should have a beginning, a middle and an end – in that order – will have problems with the work of Stan Brakhage, who has died aged seventy. His films were difficult also for those not willing to shed the conventionalized illusion, imposed by rules of perspective, compositional logic and 'lenses grounded to achieve nineteenth-century compositional perspective'.

For Brakhage, the goal of cinema was the liberation of the eye itself, the creation of an act of seeing, previously unimagined and undefined by conventions of representation, an eye as natural and unprejudiced as that of a cat, a bee or an infant. There were few filmmakers – film director is too limiting a description – who went so far to train audiences to see differently.

'Imagine an eye unruled by man-made laws of perspective,' he wrote in 'Metaphors On Vision', first published in the journal *Film Culture* in 1963, 'an eye unprejudiced by compositional logic, an eye which does not respond to the name of everything but which must know each object encountered in life through an adventure of perception.

'How many colours are there in a field of grass to the crawling baby unaware of "green"? How many rainbows can light create for the untutored eye? Imagine a world alive with incomprehensible objects, and shimmering with an endless variety of movement and innumerable gradations of colour. Imagine a world before the "beginning was the word".'

To a large extent, Brakhage realized this innocent world in his films, restrictively labelled avant-garde or experimental, existing in a parallel universe to the multiplex ethos. His signature was as figurative as it was literal – he would scratch his initials directly on the film's emulsion at the end credits. Like a

painter or sculptor, he worked manually on his material, often scratching, dyeing and altering the celluloid itself, making today's push-button digital technology anathema to him.

He would hand-paint blank frames of 16mm film, and glue objects to them in a collage. In *Mothlight* (1963), for example, he pasted moth wings on to strips of film and, when projected, the bright light seemed to bring the insects back to life.

Brakhage was born Robert Sanders in a Kansas City orphanage, and adopted two weeks later by Ludwig and Clara Brakhage, who named him James Stanley. He performed on radio as a boy soprano, attended high school in Denver, Colorado, and, at nineteen, dropped out of Dartmouth College after two months to make films.

Among his early influences were Jean Cocteau and the Italian neo-realists but, after arriving in New York in 1954, he joined the flourishing avant-garde scene, drawing inspiration from artists and filmmakers like Maya Deren, Marie Menken and Joseph Cornell. He admired Ezra Pound, and was a close associate of poets like Kenneth Rexroth, Robert Creeley and Robert Duncan, and abstract expressionist painters such as Willem de Kooning, with whom much of his work has an affinity.

In 1957, he married Jane Collom, and the details of their lives together figured prominently in his work. In *Window Water Baby Moving* (1959), he unflinchingly and poetically documented the birth of the first of their five children.

In 23^{rd} *Psalm* (1966), he contrasted scenes of his tranquil life in rural Colorado with footage of the Second World War. The quick cuts of the first part, depicting a world menaced by chaos, give way to the contemplative passages of the second, suggestive of a quest for the roots of war – particularly the Vietnam War, then at its height.

Brakhage's most famous film, *Dog Star Man* (1964), one of the key works of the 1960s American avant-garde, experimented with the use of colour, painting on film and distorting lenses, while depicting the creation of the universe. It ends with superimpositions of solar flares and chains of mountains over his wife, as she gives birth to their child.

During five decades, Brakhage made nearly 380 films, most of them shot in 8mm or 16mm, and ranging in length from nine seconds to four hours. With a few exceptions, they were made without sound, which he felt might spoil the intensity of the visual experience. He preferred to think of his films as metaphorical, abstract and highly subjective – a kind of poetry written with light.

Brakhage taught film history at the University of Colorado from 1981 until last year, when he retired to Canada with his second wife and two sons, who survive him along with the five children of his first marriage. It is a tragic irony that he seems to have been killed by the art he loved. According to his widow, doctors believed that the coal-tar dyes he used in his filmmaking may have contributed to his bladder cancer, which was diagnosed in 1996.

James Stanley Brakhage, filmmaker, born 14 January 1933, died 9 March 2003.

22 April 2003

RICHARD WILLIAMS

Nina Simone

Nina Simone, one of the most original and influential African-American singers of the past fifty years, has died at her home in the south of France. She was seventy.

The general audience knows her best for her version of a Broadway pop tune, 'My Baby Just Cares for Me', which became a worldwide hit in 1987 after it was used in a television advertisement for Chanel No. 5 perfume.

She took little pleasure from the immediate cause of her new-found celebrity with a younger audience. Thirty years earlier she had signed away the rights to that recording, and others, for $3,000 (£1,900). The memory of that piece of Tin Pan Alley exploitation fuelled her resentment against the music business for the rest of her life.

She was a favourite of the British beat groups of the early 1960s, including The Animals, who borrowed her arrangement of 'Don't Let Me be Misunderstood' for one of their early hits. But her true significance lay in her influence on subsequent generations of women singers. Erykah Badu, Cassandra Wilson and Alicia Keys are among the many who benefited from the example of Simone's pioneering fusion of blues, soul, jazz, folk and pop, and from her uncompromising stance against racism, sexism and other discrimination.

Her involvement with the civil rights movement provided the material for such songs as 'Mississippi Goddam', 'Backlash Blues', 'Four Women', and 'To Be Young, Gifted and Black', which became an anthem of the movement. Her friends included the Black Muslim leader, Louis Farrakhan, the singer, Miriam Makeba, the Black Panther activist, Stokely Carmichael, and the writer, James Baldwin.

Born Eunice Waymon in Tryon, North Carolina, in 1933, one of eight children, she sang in church from infancy and began playing the piano at the age of two. 'Everything that happened to me as a child involved music,' she wrote in her autobiography. Studies at the Juilliard Conservatory in New York were intended to preface a career as a concert pianist, but the need to earn a living diverted her into work as a nightclub accompanist. Before long, she was an attraction in her own right. A concert at New York's town hall in 1959 turned her into a star.

Listening to her was never easy. Club and concert audiences were often exposed to the sharp edge of her tongue. At her best, however, she was a peerlessly commanding performer. Her show-stoppers ranged from 'I Loves You, Porgy' (her first million-seller), through 'I Put a Spell on You', 'Black is the Colour of my True Love's Hair', 'Here Comes the Sun' and 'Baltimore'. As her friend, Duke Ellington, would have said, she was 'beyond category'.

Nina Simone (Eunice Waymon), singer, pianist and composer, born 21 February 1933, died 21 April 2003.

13 June 2003

JANE O'GRADY

Professor Sir Bernard Williams

Professor Sir Bernard Williams, who has died aged seventy-three, was arguably the greatest British philosopher of his era. He revivified moral philosophy, which had become moribund, and pioneered the current debates on personal identity and the self, and on the notion of equality.

Dazzlingly quick and devastating in discussion, he was famously able to summarize other people's arguments better than they could themselves, and anticipate an antagonist's objections to his objections – and, in turn, his objections to hers before she had even finished her sentence. Utterly rigorous, yet wonderfully non-academic, his philosophy is permeated by a distinctive philosophical voice – witty, erudite and humane – and by a sense of his own humorous and tragic view of life. He always, as one of his devoted ex-students observed, did philosophy as a whole human being.

Philosophers, Williams said, 'repeatedly urge us to view the world *sub specie aeternitatis*, but for most human purposes, that is not a good species to view it under'. His honesty, subtlety and scepticism compelled him to eschew monolithic system-building, eluding labels and being labelled.

This has led some to query what exactly his contribution consists of, but they have simply missed the point. Wanting to find a new way of doing philosophy, Williams simultaneously exploited and undermined established philosophical boundaries. He deconstructed, as Derrida would do if he were cleverer and more pledged to truth. Exhuming moral philosophy from a no man's land of logical, ahistorical analysis, into a sort of moral anthropology, he saw moral codes and writings as essentially embedded in history and culture, and questioned the whole 'peculiar institution' of morality, which he considered a particular (modern Western) development of the ethical.

So nuanced is his treatment of moral relativism as to incur speculation over how far he himself was a relativist. But he also infuriated philosophers by applauding the Enlightenment aspiration to scientific objectivity and 'the absolute conception of reality'.

Urging the neglected claims of emotion, motivation and sheer luck in morality, the importance of 'internal' as well as 'external' reasons, Williams extended moral philosophy from an over-theorized obsession with moral obligation into the Hellenic latitude of ethics – living a whole life well. Both Utilitarianism and Kantianism, usually seen as opposite moral theories, were equally his target, for each similarly claiming objective universality and a single calculable principle for morality. (Utilitarianism ceased to be the paradigm moral theory after his critique.)

Yet Williams was an iconoclast of iconoclasm: while previous great philosophers had each claimed to produce a method that would end philosophy in a generation, he revealed the folly of such attempts. Dedicated to pluralism, and

to freeing philosophy from preconceptions, he focused exquisitely on the richness of how things actually are.

Williams was born in Westcliff, Essex, and educated at Chigwell school. While reading Greats at Balliol College, Oxford, he was already a golden boy. Politics, philosophy and economics undergraduates, who fashionably scorned tutorials with the dons as a waste of time, gathered in the junior common room to take notes while their fellow student conducted impromptu seminars on philosophy. He concentrated on the philosophical side of Greats, neglecting the historical element to such an extent that he claimed to need part of his history finals' time to learn history; he arrived 29 minutes late for the examination (any later would have been inadmissible) wearing a white magnolia buttonhole.

After graduating with congratulatory honours, Williams did his national service in the RAF – the year he spent flying Spitfires in Canada was, he sometimes said, the happiest in his life. He was reputedly a very skilled fighter pilot, and also loved driving fast cars. On his return to England, at the age of twenty-two, he was elected a fellow at All Souls, but left Oxford for University College London, and subsequently Bedford College, mainly, it was said, in order to accommodate his politician wife, Shirley Williams, later Baroness Williams of Crosby.

They, and soon their daughter, lived in a large house in Kensington with the literary agent Hilary Rubinstein, his wife, their four children and various lodgers, for what sounded like a halcyon seventeen years, in which the only (ephemeral) friction was over what colour to paint the basement. Williams was a riveting party guest, often causing a logjam round the fridge as the entire gathering struggled to get into the kitchen to hear him discussing metaphysics.

In 1972, Williams (by then Knightbridge Professor at Cambridge) published his first book, *Morality: An Introduction to Ethics*. Excoriating the emptiness of moral philosophy as it was then practised, he diagnosed its 'original way of being boring, which is by not discussing moral issues at all'. Using trivial or non-contentious illustrations, he argued in a radio talk, is fine in a branch of philosophy like the theory of knowledge, but not in moral philosophy, where 'the category of the serious and the trivial is itself a moral category'.

The following year, he brought out *Problems of the Self*, a collection of papers, several of which had been written when he was in his twenties. Like the great David Hume, Williams conveyed an exhilarating and exhilarated sense of a young man thinking unhampered by preconceptions and formulae with a vertiginously free deftness.

In the same year, he also produced his critique of Utilitarianism, which contained two famous examples, now the subject of innumerable Ph.D theses. In one, he imagined a man, Jim, who finds himself in the central square of a small South American town, confronted by twenty trussed Indians. The captain who has quashed their rebellion declares that if Jim, as an honoured foreigner, kills one of them, the others will be allowed to go free; if he does not, they will all, as scheduled, die.

According to Utilitarianism, which considers the goodness of an action to reside in how much it increases the overall sum of happiness, there is no problem for Jim – he should simply kill one of them. But as Williams's illustration

and argument showed, there is a problem. The 'distinction between my killing someone, and its coming about because of what I do that someone else kills them' is crucial, but for Utilitarianism, each of us is merely an impersonal pipeline for effects in the world. It thus strips human life of all that makes it worthwhile, failing sufficiently to take account of each person's integrity, the projects central to their lives, the especial obligations and loyalty owed to family and friends.

For Williams himself, these were paramount. Liable to quash pomposity and bad argument with daunting acerbity, delighting in scurrilous gossip, he was also a tolerant, assiduous friend, a devoted father and a wonderful teacher, much loved by his graduate students. He helped Shirley Williams in her campaigning work, continuing to be generous of his time to political service after their marriage broke up in 1974. He sat on several public commissions covering most human vices, including gambling, misuse of drugs and pornography. Somehow reconciling the views of the twelve disparate members of the committee on obscenity and film censorship, he managed to produce a beautifully dispassionate, shrewd, pragmatic report on this most emotive issue in November 1979, much of which he wrote himself.

The committee's recommendations would, Williams claimed, if implemented, clear up pornography in Britain. Among other things, they simultaneously outlawed pornography from shops entered by children and unsuspecting members of the public, while allowing it to be shown in designated cinemas under a special licensing system.

Unfortunately, Mrs Thatcher had just come to power, so the committee's proposals were ignored as too liberal, although ultimately most of them were implemented piecemeal. Williams was never given due credit for his work, nor, during the Thatcher years, was he used on public commissions again.

He was, however, on the board of the English National Opera for eighteen years, until 1986. He wrote about music with characteristic insight and erudition, his piece on opera in the Grove dictionary being considered by cognoscenti the best of its kind. What he loved about music, he said, was its capacity to produce, by means of abstract structures, stuff of great beauty and expressiveness that can actually convey human feelings and things that matter terribly. He read *Anna Karenina* over and over again and, in some ways, his own work should be regarded as, like music or literature, bringing the reader to a new vision of the world.

Williams pooh-poohed the incessantly-made antithesis between the rigorous analytic and the literary Continental styles of philosophizing, saying you might as well compare a four-wheel drive with a Japanese car (a category confusion of methodology and geography). Michael Tanner, the Cambridge exponent of Nietzsche, remembers how, in the 1960s, Williams picked up his copy of *Beyond Good and Evil* and demanded, 'Why do you waste time over rubbish that Joad could have refuted?' But he was always able to change his mind, and soon became besotted with Nietzsche, saying that he longed to quote him every twenty minutes.

Still more unusually, Williams admired Foucault and Derrida, but equally he was an early enthusiast for the American analytic philosopher Donald

Davidson, anticipating what he called 'the Davidsonic boom – the noise a research programme makes when it hits Oxford'. He was both instigator and bell-wether for what was important in philosophy.

From 1979 to 1987, Williams was Provost of King's College, Cambridge. In the late 1980s, disgusted at Thatcher's philistine destruction of Britain's academic life, he decamped to a professorship at the University of California, Berkeley, claiming that serious intellectual work could not be pursued in this country, despite having recently produced his own best books, *Moral Luck* (1981) and *Ethics and the Limits of Philosophy* (1985). His riposte to the obvious accusation was that not only rats but also human passengers were entitled to leave sinking ships. Ultimately, however, he returned to Oxford, saying he did not feel at home in America.

One of Nietzsche's aims that Williams avowedly emulated was to say as much in a page as most people say in a book. He was sometimes accused of unduly compressing (which he acknowledged) and of having a clarity of style that belied an underlying obscurity. Perhaps a disadvantage of his quickness and flair was an impatience with thorough, painstaking argument, a reluctance to linger, preferring to gesture at ideas economically and wittily, without precisely stating, defending or developing them. He therefore lays himself open to interpretation – and misinterpretation.

One of his greatest contributions to moral philosophy, the notion of internal and external reasons, is (as he complained) much misunderstood. So is the treatment, in *Ethics and the Limits of Philosophy*, of the vexed issue of whether ethics is objective, which is often taken for simple moral scepticism.

In this, his greatest book, Williams argued that fact resembling, 'thick' ethical concepts ('courage' or 'cruelty', say, as opposed to a 'thin' ethical concept like 'good') were so much part of the world picture of traditional societies as to count as 'pieces of knowledge'. But, he said, reflection and theory, by showing them to be ungrounded in scientific fact, have diminished the 'confidence' that once made them so. Thus 'there is knowledge that can be lost, but not by its being forgotten', knowledge that one society cannot share with a society that is historically or culturally remote.

Yet, according to Williams, even if we cannot share another society's knowledge, we can, to some extent, understand it, and even, in the case of the Ancient Greeks, arrive, through studying it, at a better understanding of ourselves. His scholarly examination of Ancient Greek thought in *Shame and Necessity* (1993) was primarily an attempt to 'distinguish what we think from what we think that we think' (just as his meticulous study of Descartes was simultaneously a study of the theory of knowledge).

Hellenic ethics, Williams argued, affords an arena for praise and blame, which is wider than Christian-based moral theories (stiflingly concentrated on free will, obligation and personal responsibility), and more accurate to our intuitions. Shame can be more sophisticated, internal and honourable than moral guilt, which is standardly lauded over it. Luck and beauty, not merely motive and duty, are, however unfairly, essential to our estimation of action.

Gauguin's desertion of his family, although arguably it merits reproach, is also arguably justified because he succeeded in producing beautiful pictures. Had he

failed to, he really would have done the wrong thing. 'While we are sometimes guided by the notion that it would be the best of worlds in which morality were universally respected ... we have, in fact, deep and persistent reasons to be grateful that that is not the world we have.'

With his eye for non-academic significance, Williams latterly tackled the contemporary relativist tendency to undermine the notion of truth. His last book, *Truth and Truthfulness* (2002) analyses the way Richard Rorty, Derrida and other followers of politically correct Foucaultian fashion sneer at any purported truth as ludicrously naive because it is, inevitably, distorted by power, class bias and ideology. It explores 'the tension between the pursuit of truthfulness and the doubt that there is (really) any truth to be found', and, unusually for a philosophy book, it makes the reader laugh aloud or want to cry.

Williams is often considered an 'anti-theory' philosopher, but paradoxically, while saying that moral philosophy cannot change anything, he showed, by changing the way we do it, that it could. Reflecting on how moral reflectiveness kills moral knowledge, he nonetheless hoped that moral philosophy might in some way help us to live. In speech and writing, his controlled imagination cast sidelong shafts of brilliance on unexpected areas, and his erudition was enthralling because it was graceful, never pompous, always tied to life and illumination.

Williams himself, said a friend, was a life force beyond (assessments of) good and evil. After talking to him, you went away enchanted but also dissatisfied – determined to live more intensely and alertly, as he did. Yet although he appeared perpetually amused at life, there was a discontent and despair at the core of his philosophy and himself. His speed of intellect and awareness put him in a different gear and speed than others. For all his gregariousness and hilarity, he was solitary.

He is survived by his second wife, Patricia Law Skinner, his daughter Rebecca from his first marriage, and two sons, Jacob and Jonathan, from his second.

Bernard Arthur Owen Williams, philosopher, born 21 September 1929, died 10 June 2003.

13 June 2003

DUNCAN CAMPBELL

Gregory Peck

When there was talk earlier this year of the Oscars being postponed because of the war in Iraq, there were many references to a previous cancellation, in 1968, following the assassination of Martin Luther King.

The then president of the Academy of Motion Picture Arts and Sciences, who announced the postponement, said that it was 'the only appropriate gesture of respect' and made it clear that a film awards ceremony paled beside the tragedy of Dr King's death.

The president was Gregory Peck, whose espousal of liberal causes and opposition to racism and anti-Semitism were reflected in a number of roles he played.

Throughout his life, he always stressed that his roles on screen were just parts that he played and did not compare with the true heroics of such men as Dr King whom he admired so much.

Now he has died, aged eighty-seven, fellow members of the industry around the world have paid tribute both to his body of work and his modest and laconic style.

Peck was already in his mid-twenties when he finally decided to embark on a career in acting. Born in southern California, in La Jolla, his father was a pharmacist of Irish descent, who separated from his mother when Peck was only six. He spent part of his childhood at a Roman Catholic military academy.

He graduated from San Diego state college and headed on to Berkeley to study English. Having decided to try his luck on the stage, he moved east and made his debut in *The Morning Star* by Emlyn Williams with the New York Neighborhood Playhouse in 1942.

Because of a spinal injury suffered as a student during a rowing accident, Peck was excused military service and was thus on hand when Hollywood needed to fill the gaps left by some of their stars who had joined up.

It was his second film, *The Keys of the Kingdom*, made in 1944, that was to turn him into a star. He played the part of a Scottish priest – he always made much of his Celtic background – working as a missionary in China. It drew Peck to the filmgoing public's attention when he was nominated for an Oscar, the first of five nominations.

During the 1940s, Peck was active in organizations that were sometimes later denounced as Communist fronts. He was a member of the Hollywood Democratic Committee, formed in 1943 to give backing to Roosevelt, and his commitment to the liberal wing of the Democratic party remained. One of his more controversial roles was that of a journalist who pretends to be Jewish to experience anti-Semitism first hand in the 1947 film, *Gentleman's Agreement*. He took the role although his agent warned him: 'You're just establishing yourself and a lot of people will resent the picture. Anti-Semitism runs deep in this country.' It won Peck an Oscar nomination.

It was not until his fifth nomination for *To Kill a Mockingbird*, the 1962 film with which he is perhaps most closely associated, that Peck was finally to win an Oscar. The film came at a time when equal rights were still far from accepted in the southern states, and Peck always said that he was proud to have played such a part as that of Atticus Finch, who challenges the jury in the trial to face down racism.

Some of his admirers wanted him to run against Ronald Reagan when the latter ran for a second term as governor of California but Peck made it clear that he would not welcome that sort of a role, although he had often been involved in political campaigns.

His acting range was wide: from Captain Horatio Hornblower in the 1951 film of that name to General Douglas MacArthur in *MacArthur*, and from the Nazi Josef Mengele in *The Boys from Brazil* in 1978 to novelist F. Scott Fitzgerald in *Beloved Infidel* in 1959. His career was long enough to allow him to appear in two

versions of *Moby Dick*, more than forty years apart, the second a television version in which he had a cameo role.

Other notable films included everything from *The Guns of Navarone* to *Arabesque*, *Cape Fear* to *The Man in the Grey Flannel Suit*. His career included fewer dud films than many other actors of his generation, not least because he was discerning about what sort of parts he would take. Off-screen, he was active on both the arts and health issues. He was at one time chairman of the American Cancer Society.

In 1942, Peck married his first wife, Greta. They had three children, Jonathan, a television and radio journalist who committed suicide at thirty, Stephen and Carey. The couple divorced in 1954. Peck then married Véronique Passani, a French journalist. They had two children, Anthony and Cecilia.

Elfred Gregory Peck, actor, born 5 April 1919, died 12 June 2003.

27 June 2003

SIMON HOGGART

Dear Bill

The received wisdom now is that Denis Thatcher was far from being a gin-soaked old bigot. Well, up to a point. But he certainly relished the world of the golf and rugby club bar, the just-time-for-a-quick-sharpener, the jovial trust-you-to-walk-in-when-it's-my-round culture.

Or as he once put it to his wife when she queried his request for a stiff drink on a morning flight to Scotland: 'My dear, it is never too early for a gin and tonic.'

'He had,' said an appreciative lunch guest at Chequers, 'a very sharp eye for a refill.'

And if the term means anything at all, he was a bigot. Or at least he had the kind of views that make *Guardian* readers' teeth fur over and fall out.

His considered advice to the Swiss president was to 'keep Switzerland white', he talked about 'fuzzy-wuzzies' in Brixton, and he happily dismissed any other nation that did not meet his exacting standards – China and Canada among them – as being 'full of fuck-all'.

In fact, he was the classic type of old-fashioned Englishman you often find in families who came from the colonies, as he would have called New Zealand where his father was born. His views were unreconstructed and largely unchallenged. 'Who do you think is worse,' he asked at a Commonwealth conference, 'Sonny Bloody Ramphal or Ma Sodding Gandhi?'

'He was the kind of man,' said one of Mrs Thatcher's more left-wing ministers, 'who would never dream that a woman might become prime minister, still less lead the Tory party. But of course when she was there, he believed passionately that no one could possibly take her place.'

He articulated what were her most basic instincts. It seemed to him outrageous

that something as unimportant as the plight of black South Africans under apartheid should cause the cancellation of a rugby tour. He loathed the unions. Like many people of extreme views, he assumed that those who saw life in more muted shades must be zealots on the other side. So the BBC was the 'Bolshevik Broadcasting Corporation' and its channels were 'Marxist One' and 'Marxist Two'.

(Though he could demonstrate unexpected wisdom. In 1982 he told her she should be generous to the Argentinians in defeat, since otherwise they would become long-term enemies.)

He was her greatest support, the only person she could always turn to and always trust. It was often wrongly thought that he was under her thumb. The broadcaster Jim Naughtie tells of chatting to Denis at a Number 10 reception. She was running late. When the Special Branch officer came up and murmured, 'The boss is here, sir,' he was able to pour his gin into a plant pot with one hand while reaching out to greet her with the other.

But this is the natural defence mechanism of any man who, married to an assertive woman, wants a quiet life. He was capable of barking, 'For God's sake, woman!' at her.

He hated the image of a bumbling old soak, though the *Dear Bill* column in *Private Eye* was quite affectionate, awarding him a sharp eye and a tart tongue. He used to point out often that a silly old tippler could hardly have run a multimillion-pound business for several decades.

He was the one-man claque, usually a few feet behind her. At press conferences – applause is as unexpected there as party poppers at a Japanese tea ceremony – he would clap and cheer whatever she said.

Margaret Thatcher, far more often than the public knew, could collapse in a heap behind the scenes like a burst football.

We all caught one glimpse in 1990 when she left Downing Street for the last time. He often saw it. As one minister and friend of the couple said: 'He's great when she's down. He can really lift her mood. But he's dangerous when she's on a high, encouraging her to yet more loopy ideas.'

He once said: 'For forty years I have been married to one of the greatest women the world has ever produced. All I could give – small as it may be – was love and loyalty.'

Now that support has gone. She is succumbing to what used to be known as senility, and is nowadays usually called Alzheimer's. Her short-term memory is fading rapidly. Friends find her decline almost too painful to watch.

Denis would have been there to the end, Nancy to her Ronald Reagan. It is almost impossible for us to realize how distraught and bereft she now will be.

Denis Thatcher, company director, born 10 May 1915, died 26 June 2003.

16 August 2003

FRANCIS BECKETT

Diana Mosley

The death of Lady Diana Mosley is a reminder that Britain is still a deeply snob-bish country. Working-class racists – skinheads who beat up Pakistanis, British National Party councillors from northern towns, poor eastenders who attacked Jews in the 1930s under the leadership of Lady Diana's late husband Sir Oswald – become untouchables. But this rich, stupid, superficial, selfish woman, who sneered at Jews and blacks in an upper-class accent, was fawned on by the estab-lishment right up to her death.

A glance through her dreadful, snobbish biography *A Life of Contrasts*, revised in 2002, offers the languid reflection that Jews should have left Germany qui-etly in the 1930s, so that Hitler would not have been placed under the regret-table necessity of exterminating them: 'World Jewry with its immense wealth could find the money, and England and France with the resources of their vast empires could find the living space.' The tragedy was that 'world Jewry did not make a greater effort in the 1930s to accommodate its co-racialists from central Europe elsewhere in the world'. And those Jews who did manage to leave Germany should have had the good manners to be polite about Hitler: 'Their virulent attacks on all things German ... hardened the hearts of the many Germans who were well-disposed towards them.'

The Jews, she believed, had asked for what they got by going to Germany. After the eastern European pogroms at the end of the nineteenth century, 'thou-sands of Jews poured into Germany from the east, making an acute Jewish prob-lem there'. She also sneered at black immigrants to Britain, and at the race relations laws designed to protect them against people like her.

The book and the author received lavish praise from establishment writers, but I found not a single sentence that showed evidence of humility or human-ity. Writers have preferred to dwell on her aristocratic charm (which passed me by, on the one occasion I met her) and on the upper-class eccentricities she shared, apparently, with the other Mitford sisters.

In recent years, there has been an appalling TV biopic portraying Mosley as a heroic figure, their affair as one of history's great love stories, and fascism as a tremendous lark. Lady Diana was interviewed by Sue Lawley on *Desert Island Discs* and by James Naughtie on *Today* with a level of indulgent respect that nei-ther of these interviewers would have summoned up for a working-class fascist. And four years ago, Jan Dalley's biography whitewashed Lady Diana and her husband.

Like Mosley's biographer Robert Skidelsky before her, Dalley fell for the cen-tral post-war Mosley lie: that anti-Semitism was confined to his proletarian fol-lowers. She repeated uncritically the Mosley version that William Joyce, a leading fascist who broadcast for Hitler during the war, inspired fascist anti-Semitism, and that Mosley was 'unwise' to let Joyce edit his newspaper. But it

was Mosley, not Joyce, who said during the Abyssinian war: 'Greater even than the stink of oil is the stink of the Jew.' It was Mosley who talked of German Jews as 'the sweepings of continental ghettos hired by Jewish financiers'. The only difference is: Mosley was rich and well-born; Joyce was proletarian and poor.

It was only after the Second World War, when the Holocaust had so discredited anti-Semitism that no politician could hope to benefit from it, that Mosley started to express well-bred distaste for his movement's wilder excesses, and to blame people like Joyce. By then Lady Diana was used to the idea that her wealth and social position would cushion her from the consequences of her views. During the war, hundreds of Mosleyites were interned without trial. But while humbler fascists were put in dank prisons and prison camps, and husbands and wives separated, the Mosleys were allocated a little house in the grounds of Holloway prison, where they hired other prisoners to wait on them.

After her death, historian Andrew Roberts in the *Daily Telegraph* called her 'funny, charming, intelligent, glamorous' and thought the question of how to deal with an unrepentant Nazi was a 'curious question of British upper-class etiquette'. His question could only be asked in class-conscious Britain, where we seem to be unable to apply the same standards to well-connected, well-heeled aristocrats that we apply to ordinary men and women.

Diana (Mitford) Mosley, born 10 June 1910, died 11 August 2003.

BRICKS AND MORTALS

The dreams of the 80s and the nightmare of the 90s: the inside story of the property world

ALASTAIR ROSS GOOBEY

CENTURY
BUSINESS

First published in Great Britain in 1992 by
Century Business
This paperback edition published in Great Britain in 1993 by
Century Business
An imprint of Random House UK Limited
20 Vauxhall Bridge Road, London SW1V 2SA

Random House Australia (Pty) Limited
20 Alfred Street, Milsons Point, Sydney
New South Wales 2061, Australia

Random House New Zealand Limited
18 Poland Road, Glenfield
Auckland 10, New Zealand

Random House South Africa (PTY) Limited
PO Box 337, Bergvlei, South Africa

Set in 10½ pt Garamond by Deltatype Ltd, Ellesmere Port
Printed and bound in Great Britain by
Mackays of Chatham PLC, Chatham, Kent

British Library Cataloguing in Publication Data
A catalogue record for this book is available from the British Library

ISBN 07126 599 6 X

Contents

———

Introduction

So Foul and Fair a Day

THE WEATHER IN the first week of December 1991 had been resolutely dull and overcast above London. Together with the late sunrise and early sunset, it made an imperfect backdrop to an event which encapsulated all the excitement and change of the 1980s property boom and its consequent collapse. As Thursday 5 December progressed, the cloud began to break up and by the time the guests had begun to assemble in Exchange Square, Broadgate, on the northern fringes of the City of London, the sky had become dappled, although no sun penetrated into this new open space. The ceremony that was to be held marked the effective completion of the most striking piece of urban generation of the 1980s, Broadgate; over three million square feet of new offices spanning the tracks of Liverpool Street railway terminus, covering the site of the defunct Broad Street Station and running North along Bishopsgate.

At 3.45 p.m. the trumpeters of the Household Cavalry signalled the arrival of Her Majesty Queen Elizabeth II. To greet her, both wearing well-cut dark blue overcoats, were the two protagonists of the joint company set up to create this development: Stuart Lipton and Godfrey Bradman. The first cheerful, tall, and heavily built; the second a small, balding, bespectacled figure, every inch the accountant he had qualified as. It was symbolic of the state of the relationship between the two companies, Lipton's Stanhope and Bradman's Rosehaugh, that Lipton seemed to have taken on the role of the senior partner. He it was who escorted the Queen past the standing guests, among whom stood the Secretary of State for Northern Ireland, Peter Brooke, who was also the local MP, together with many luminaries of the British property industry: developers, agents and those precious beings, the tenants. Godfrey Bradman scuttled behind the towering Lipton and the tiny Monarch, unable to find space to walk on her other side.

Stuart Lipton made the first speech, typically praising 'good architecture' as 'good business'; Her Majesty the Queen then opened the development in two sentences, before Godfrey Bradman also spoke.

Then followed a spirited and professional representation of The Twelve Days of Christmas. To understand the flavour of this event you need to know only that it was compèred by singer/dancer Roy Castle and among the characterizations were can-can dancers as the 'three red hens', knees-up pearly queens as the 'four calling birds' and the Peggy Spencer Ballroom Dancers as the 'nine ladies dancing'; enough said. The climax of the entertainment came as fireworks rained silver confetti onto the audience and a giant star lit up the side of Exchange House.

So much for the fair part of the day, but what of the foul? For both Lipton and, particularly, Bradman, the inauguration of Broadgate was a bitter-sweet affair. Lipton knew that, the next day, Nigel Wilson, the 35-year-old managing director of his company, was to announce his departure to become chief executive of another interesting cash-flow critical business: GPA, the world's largest aircraft leasing company. Ironically one of that company's non-executive directors was Nigel Lawson, the Chancellor of the Exchequer who had created the conditions in which developments such as Broadgate had been possible; he has also, unfairly, become the scapegoat for the high inflation and recession which followed and pulled the rug from under both Rosehaugh, and to a lesser extent, Stanhope.

At least Lipton could look forward to a continuing future for his company. On 6 December it was reported that Rosehaugh had lost £226.6 million in the year to 30 June 1991, beating the £165.5 million loss reported in the previous year; the company was now in breach of some of its borrowing covenants and the auditors qualified the accounts. It was also announced that Godfrey Bradman, the symbol of finance-driven property development in the 1980s, was to step down as Rosehaugh's chairman, and it was widely believed to be only a matter of time before he relinquished his new post of vice chairman. On the same day it was reported that Greycoat, the development company headed by Geoffrey Wilson, an ex-colleague of Lipton's and another leading character of the 1980s property market, had also reported a loss. In this case it was only £5.8 million for the six months to 30 September 1991; the company's shares recovered marginally on the day, having fallen by two-thirds in the previous nine months.

If two days epitomize the 1980s property cycle, the 5th and 6th of December 1991 have a strong claim. As one who was present both at the ground-breaking of Broadgate by Margaret Thatcher in July 1985 and at the royal opening in 1991, I have been a witness and occasional participant. Like all good stories, the characters are as fascinating as the events. It is not too extreme to count the story as a tragedy. Tragedy involves people perhaps with heroic visions but certainly with fatal failings, and that is as good a definition of the property boom's participants as I can elicit. *Si monumentum requiris, circumspice*; Wren's epitaph will apply to most of these characters even when the companies they formed and deformed and they themselves have long passed into this history.

Introduction

Property developers do not usually evoke the interest, still less the sympathy, of the average citizen. They tend to be faceless names behind companies with unknown names; they are thought to be slightly shady operators, foisting ugly buildings on our environment and walking away with unheard-of wealth. As with all caricatures, there are recognizable elements of the property market in this view. Yet the property men I have tried to describe, with the history of their companies over the past fifteen years or so, are a diverse and interesting group. Their activities infect our everyday life: where we work and what we see around us are dictated largely by their activities. For those reasons alone, they are worth study.

As a participant and observer of this area of activity over the past twenty years, I awaited with interest a chronicle of the 1980s to augment histories of previous property booms and busts, but 1990 arrived and no such volume had appeared. At that stage I mentioned this omission to Gill Coleridge of literary agents Rogers, Coleridge & White. She responded with a challenge to me to write a synopsis of what such a book would cover, and succeeded in interesting Lucy Shankleman of Century Business in such a project. Thus it has fallen to me to write what I had wanted to read – shades of Disraeli: 'when I want to read a good book, I write one'. As a result I have spent evenings and week-ends and the occasional holiday both researching and writing this book. That has required great forbearance on the part of my wife Sarah and my children Charlotte and George, for which I thank them.

I have felt reasonably well qualified to write these chapters. As an investment manager I have invested both in property directly and in the shares of many of the companies which are mentioned in these pages. As a result I have met most of the protagonists. They have proved very willing to share with me their thoughts and reflections about the events covered. I have quoted extensively from their interviews with me, and from contemporary newspaper and magazine interviews, but, where they have given their personal views of some of their contemporaries and competitors, I have allowed them a veil of anonymity. I thank them all for their kindness and patience. I hope they will feel that where I have been critical, at least I have been fair. To those whom I have left out, I apologize. A mercenary approach would have been to mention anyone who had participated in the market over the last twenty years, in the expectation that at least they would buy the book. My editors Lucy Shankleman and Martin Liu persuaded me not to create such a telephone directory.

Inevitably in an industry which is as large as property investment and development, I could not hope to cover all the events over a long period. I have concentrated on the particular attributes and outstanding participants of the 1980s property boom and its subsequent collapse. The giants of the industry, Land Securities, MEPC and Hammerson for instance, are mentioned only in passing, since they were already well established before the event and will emerge from the sector's recession bruised but unbowed.

3

As well as the interviews I have had with named participants, I have also spoken at length to other developers and investors, agents, investment analysts, corporate financiers and journalists. The industry's trade magazines, notably the *Estates Gazette*, the *Chartered Surveyor's Weekly* and the *Estates Times* have been important sources, as well as the prospectuses and annual reports and accounts of the companies covered. The published research of the agents, particularly that from Healey & Baker, Hillier Parker, Jones Lang Wootton, and Debenham Tewson has also proved a source which would have been unavailable twenty years ago.

I have not sought to embroider the story, since in my view it speaks for itself. There has been no need to seek an 'angle'; the varied character of both the men and their companies provides ample evidence of the collective myopia which affects all markets from time to time. Few indeed have been those who both invested at the bottom and sold at the top. Mistakes were made, not dissimilar in size and form to those made in previous cycles. I doubt whether this book will prevent similar mistakes being made in the future, even though the lessons and opportunities are clearly here to read. As always the opinions and errors are my own, and I must particularly emphasize that this work was entirely divorced from that of Her Majesty's Government and Treasury, for which I was working during a part of the time in which it was written.

1

The Ascent from the Abyss

THE BRITISH COMMERCIAL property collapse of 1974–76 came suddenly and late. The rest of the economy had already been sent into recession by the Heath government's introduction of a 'counter-inflation' policy in late 1972, compounded by the quadrupling of oil prices in the autumn of 1973, and the rise in the Minimum Lending Rate from seven and three quarters per cent in January 1973 to 13 per cent by November, but the property investment market seemed undisturbed by all these events until the very end of 1973. Even the standstill on business rents introduced on 6 November 1972, which had been part of the Heath measures, was not enough to calm the super-optimists. The Financial Times Property share index peaked at 357 in early November 1973; it fell 40 per cent in the following two months. Yet in February 1974 Town and City Properties was able to declare its profits for the six months to 30 September 1973 showing an increase to £3.4 million before tax and expectation of a 'very satisfactory' increase for the full year.

By March the problems were becoming apparent. Guardian Properties was admitting to 'liquidity problems' as its borrowings had risen from £10 million on 17 August 1973 to £48.5 million at the end of January 1974, and it simply did not have income to meet the interest payments on its burgeoning debt. The rent freeze together with rising interest rates and recession were combining to make it impossible for the ambitious developers to let their properties, and even if they were let, few pension funds or insurance companies were prepared to buy the resulting investments.

By May the Lyon Group was seeking support from its bankers following a 'technical default' on its loans, and by the end of the month, the most spectacular personal bankruptcy in British history began its inexorable progress when the property interests of William Stern had reached a state which necessitated talks with a committee of bankers to prepare 'a viable scheme for the orderly realisation of the group's assets as may be necessary to overcome its present liquidity problem'. At the

beginning of June the new Labour government announced that the statutory rent freeze would be eased by March 1976, but meanwhile the property market was simply at a standstill. In June Guardian Properties had a receiver appointed and Wilstar, the key company in William Stern's empire, went into liquidation with borrowings of £212.5 million. It is not the purpose of this book to describe the progress of the 1974–76 property collapse and the consequent financial crisis, which seemed at one time to threaten the whole British financial structure; this has been well documented in Margaret Reid's book, *The Secondary Banking Crisis*. This brief introduction to that episode is included both to establish a starting point of this story, that of the recovery from disaster and the 1980s property boom and bust, and to point to some similarities and differences between the previous property boom and that of the 1980s. The 1970s collapse claimed many corporate victims and some individuals whose lives might have been prolonged but for the strain generated. Gabriel Harrison of Amalgamated Investment and Property died suddenly on 4 December 1974 aged 53, fifteen months before his firm finally went into compulsory liquidation, and a more dramatic passing was that of Sir Eric Miller, previously head of Peachey Property and a beneficiary of Harold Wilson's retirement honours list, who shot himself on 22 September 1977, as the affairs of his company were under legal investigation.

The seeds of the property crashes of both 1974 and 1990 were of a simple strain. In both cases several years of rising business rents, good demand for space, moderate buying of the completed properties by the long-term investors in the pension fund and insurance fields, and some spectacular fortunes being made had created a surge of building, only for demand for space to fall and interest rates to rise. What is extraordinary is that, so soon after the worst property collapse of the post-war period, a complete cycle of recovery, boom and disaster should have followed, with so many of the same mistakes being made by developers, bankers and investors. It is true that the mistakes were not exactly the same, and the differences are as instructive as the similarities.

The 1972 business rent freeze had not adversely affected the level of rents achieved on new lettings of recent developments, but many properties which had reached or were shortly to reach their rent review dates could not be sensibly valued by the property experts, since such 'reversionary' properties are usually bought and sold making allowance for the new higher rent anticipated, and the rent freeze had completely undermined this element of valuation. Companies found it impossible to sell properties with imminent reviews, and since many property companies were depending on these sales to fund the new developments which were eating capital, this caused problems throughout the property market. William Stern felt that the only way to have survived this financial blizzard was to have a 'tooth fairy' who could have told his group 'whatever your cash requirements are, don't worry, finish the buildings

and as soon as the economy picks up, we'll wait until you rent it and let interest accumulate throughout the period. If that had happened, we would today be a very wealthy company. In the property world, Town and City is the only one I can think of [to which this happened].' (Quoted in *Minus Millionaires* by Jeffrey Robinson, Unwin, Hyman 1987).

The list of casualties in the property sector of the late 1970s is long, and would have been longer but for the Bank of England's lifeboat, launched to save the secondary banks who had been in the forefront of lending. Many companies came within a hairsbreadth of receivership, including some of today's giants. The other saviours of the system were the institutional investors, who both supported their development partners and, as the decade moved towards its close, bought substantial numbers of the properties which the property companies needed to realize to make repayments to the banks. Surprisingly enough the institutions began to buy fairly soon after the late-1973 collapse, and 1974 was not quite the black hole that William Stern later claimed: 'I challenge anyone to point to any deal done in 1974.' One of the most striking transactions in that year was the purchase of 36 per cent of the Commercial Union building in Great St. Helen's in the City of London by a consortium of the British Rail and Post Office pension funds with the Legal & General and the Commercial Union (CU) itself; in July CU sold its 44 per cent stake in the consortium to the Abu Dhabi Investment Authority. The CU building is perhaps the best example of the British-Miesian developments of the 1960s and 1970s. Some encouragement was taken from the statement by the new Labour government that after a continuation of the rent freeze there would be a gradual easing by March 1976, but this was not enough to revive the whole market. In the June 1974 edition of *Banker's Magazine* Gabriel Harrison, of Amalgamated Investment and Property, said it was imperative that rents be unfrozen as soon as possible. 'The pension funds and institutions will then be able to consider coming back into the market and purchase some of the £3 billion worth of property which is temporarily financed by the banking system.'

Most of the buying in 1974 came from the new sources of wealth, the oil producers, who could not absorb all the new-found income emanating from the quadrupling of the oil price in late 1973. The smaller nations particularly decided to invest their surplus funds in real assets in other countries, to provide income and capital when eventually the oil ran out. The Shah of Iran was thought to be the owner of a company named Evenrealm which bought two London office blocks and Blackfriars House in Manchester for a total of £15 million in September. The most spectacular example of this was the bid made by the Kuwaitis for the quoted property company St. Martins. In September 1974 the Kuwait Investment Office bid £91 million for St. Martins in cash, later raised to £107 million. St. Martins' largest asset was the Hays Wharf development on the south bank of the Thames between Tower and London Bridges.

Jeffrey Sterling, now Lord Sterling of Plaistow, whose career is more

fully described in Chapter Six, describes how the valuation process was in abeyance during this period. 'The banks found that they had lent over three billion pounds [equivalent in 1991 pounds to nearly £15 billion], but they lost their nerve. When the big surveying firms started to value, they would go to an investment house, like a big insurance company, and say "what are you prepared to pay for this property?".' The response would be that the institution was not really prepared to buy at all, but if pressed, would quote some very low price. 'The valuer would then ask whether anyone else had sold anything in the area of late. In practice, about a quarter of a mile away some small property would have been sold as a forced sale. So they took that as an example, put the two pieces of evidence together and took the valuation back to the bank. The bank would say "bloody hell, our security is down; we want more security".'

'I got all the major agents together and told them we must have a more orderly basis of valuation. Horace Temple, the valuation partner of Healey and Baker, came up with the wording that valuations should reflect the price achievable between a "willing buyer, willing seller in an orderly market".' This was not enough because many investment and development companies, including Sterling's own, had currently low yielding portfolios which depended for their viability on the rents being adjusted at the leases review dates to current, much higher market rents. 'In early December 1974 I wrote a letter to Harold Lever [then Chancellor of the Duchy of Lancaster, a sort of Minister without Portfolio in Harold Wilson's Labour government], which was delivered by hand. I said unless something was done about the rent freeze, it was going to be extremely serious. People were worried about the banks.' The people brought together to make the decision on the rent freeze included Lever, Anthony Crosland, Wilson himself and, reportedly, the scourge of capitalism, Tony Benn.

The first sign that the property market might be able to make a real recovery was the announcement on 19 December 1974 by the Secretary of State for the Environment of the recently re-elected Labour government, Anthony Crosland, of the end to the rents standstill. 'The government have considered further the freeze on the business rents, which is now regarded as affecting parts of the economy in ways that even the previous government can hardly have envisaged when they imposed it. Much savings and pensions money, for example, depends on the income from commercial property, which also constitutes an important credit base for industry.' The second factor which underpinned that recovery was that the previous ten years of planning restriction in the south, particularly London, had in agents Chamberlain and Willows' words, 'created an underlying shortage of new space.' At the same time, rents on prime City offices had fallen back to ten pounds per square foot at the end of 1974 from the £20 level of the start of the year, while building costs had rocketed with the general inflation rate.

The economic recession, particularly in the stock market related

industries, together with the completion of some developments started before the crisis, had increased the available office space in the City, where the greatest concentration of value was and is to be found, from some 637,000 square feet to 1,857,000 square feet in a year. By April Jones Lang Wootton was able to state in a report that 'there are signs that the confidence of the investor has been restored.' There was, as a consequence of both the high inflation rate and new pensions legislation, more money coming into the pension funds, and some of it continued to find its way into property investment.

The prime driving force in the recovery of the property market, as with all markets in 1975, was the fall in both short-term and long-term rates of interest. At this point it is vital that the practical functioning of the property market should be put in the context of its underlying economics. For those familiar with property investment, most of this will be only too well-known but it bears repeating none the less.

Many of the great fortunes of the twentieth century have been made where large capital projects and few people are involved. The Greek shipowners were famous for persuading some carrier to charter his unbuilt boat, ordering the ship from a yard on the back of the charter and only then raising the money from the banks on the security of the other two elements, putting up little or no money of their own. Banks like to lend money on large identifiable assets with an established second-hand market value; what they eschew, as one financier once put it to me, is lending on anything with wheels, as those assets have a nasty habit of disappearing if the bank tries to repossess. Commercial property is certainly one of the former types of asset; it is visible and unmovable and there is usually a second-hand market in it. As a result borrowing has always been the crucial feature of property development. If a developer builds a £20 million property and the sums are right, it is eminently possible for him to walk away with a two million pound profit; if the sums go wrong, the developer may have invested only a relatively small amount of capital in the project and it is the bank who ends up with egg on its face.

There are two elements to the mathematics of property: the world of the developer and that of the investor. The developer tends to be the person with whom this book is primarily concerned: he assembles a site, commissions an architect's design, obtains planning permission, finds the finance, employs the building contractor and lets the building. To cash in the profit made on his development and pay off the debts incurred in building it, the entrepreneur will need to sell the property to a long-term investment institution. This meeting of two rather distinct worlds is where the fortunes are made and lost. For the merchant developers, as they liked to be known in the 1980s, the costs may be divided into three broad parts: the land or existing building, the new building's direct construction costs and the interest cost of the whole. The investment institution will judge a completed development not on those criteria, but on the stream of income which it calculates will flow from the building's

tenants over many years. The brutal truth of property investment is that the immediate income on a development will rarely if ever cover the cost of borrowing the money which has financed it. The developer made his money by selling the completed property on to the investors who did not need to borrow and could wait until the rise in rents gradually made the income return on cost higher than that available on other possible investments, the pension and insurance funds.

The purpose of investment for these giants of the financial world is to achieve the greatest long-term flow of income for their pensioners and policy holders. It is often thought that the capital value of an investment is the only relevant consideration for such funds, but the market value of investments is only a potential opportunity for increasing the income from a portfolio: if one of your investments suddenly rises in value and you can replace it with a similar asset with a higher immediate income, then the fund will benefit. If this thought is extended to cover a whole asset class, such as property or ordinary shares, then there is scope for increasing the long-term income of the fund through judicious adjustment of the portfolio between asset types. The institutions may perceive UK company shares to be the most attractive investment one year, foreign shares in another, property in a third and at certain times cash may be preferred to any other asset.

Property probably has the longest history as a portfolio investment. In earliest times the landlord was the Lord of the Manor or the church, but as savings became more institutionalized in the nineteenth century, so life assurance companies, and in the twentieth century, pension funds, came to be the major acquirors of investments. In the first 150 years of the history of modern investment, inflation was not a chronic affliction. Indeed, agricultural land prices in the UK peaked in the Napoleonic Wars at a level not seen again until just before the Second World War. Investment in commercial real estate was seen to be reasonably secure, but not without risks, since the income depended on the survival of the tenant. For this reason, most investing institutions either lent money to other property investors for long periods on a fixed interest rate basis, or let the property they owned on long leases with infrequent rent reviews; there was no history of inexorably rising rents, so the security of income was deemed more important than its increase. This factor, the absence of a trend of rising income, also dissuaded the same institutions from buying company shares, which looked risky in the light of the experience of the whole economy during the Depression of the 1930s.

The adoption of Keynesian economic management techniques in the years after the war changed all this. Inflation was deemed to be less of an enemy to society than mass unemployment, and prices started to rise without a break. Whereas the cost of living had not risen between December 1918 and the start of the war, between 1945 and 1965 the general price level doubled. For property investors this change was profound: building costs, like all other costs, rose, and it was uneconomic

to build or refurbish a building at the old rental levels. As the economy expanded, demand for more commercial space, and of a better quality, also grew, but a combination of building controls and the unattractive economics of new building gradually drove rental levels higher. This cycle of the inter-relationship between building costs and rental levels is critical to an understanding of how the 1980s property boom both waxed and waned. New buildings can only be developed when rental levels are high enough to offer the entrepreneur the prospect of a profit when he comes to sell the completed project to an institution; the problem is that too much new development is then undertaken, outrunning the capacity of the potential tenants to absorb the new space. Rental growth slows, and may even reverse, leaving the developers with unlet buildings or lettings at rents which are not economic.

Since the investing institutions' main interest is long-term income flows, the critical variable from their point of view is the income yield on any investment. This is the annual income received from an asset expressed as a percentage of its capital costs or value. The various alternative investments open to the institutions have differing characteristics which are reflected in the yield basis on which they sell. Government securities, or 'gilts', have a fixed income but the ordinary shares of companies, equities, give an income which depends on the profitability of the underlying business. A diversified portfolio of equity shares will give a rising income over time, even if individual companies cut dividends or go bankrupt.

Similarly, a property portfolio's income will tend to rise, affected by building costs and the temporary shortages and gluts of space. An individual building may become vacant and non-income producing, but a well-spread stock of investment properties will not. As a consequence of this distinction between the profile of income between the different potential investments, the yield each sells on tends to be related, but usually in a clear order. Because the income of a pension fund is tax-free, it may be simply proved algebraically that a current annual yield of six per cent growing at six per cent per year forever is exactly equivalent in value to a fixed and perpetual initial yield of 12 per cent. For these reasons, gilts tend to sell on much higher initial yields than either equities or property, the latter two classes relying on income growth to make up the initial shortfall.

The important fact to recall which distinguishes the developer from the investor is that the former rarely has enough capital to finance a development without borrowing so much that the income available on the let investment does not cover the cash outflow on the debt; the investor will probably have no borrowings and may take the longer-term view that the growth of income over the years will more than compensate for the initial income he receives being lower than that on a fixed interest investment. The investing institutions carefully study the inter-relationships between the initial yields on all their potential investments,

and, taking into account their assessment of the potential for income growth, adjust their portfolios accordingly. Unfortunately for both the institutions and the property developers the pension funds and insurance companies have not shown themselves to be adept at making these relative judgements, and too many times they have been buying asset classes at the zenith of their valuation levels and selling them at the bottom. This action is both cause and effect, since unanimous purchases by the institutions will cause peaks, as their selling will cause the troughs.

The fact that the suppliers and ultimate investors in property view the value of the assets in entirely different lights causes all the problems which lead to bankruptcies. The very reason why investment yields go up, primarily a rise in inflation, will increase the interest costs of a developer and slow the economy so that demand from tenants may diminish just at the time the development is completed. Such a change in yields will also cut the final value of the property on a sale to the investor. At this stage it is worth showing how this potential mismatch can develop.

A developer decides to build a state-of-the-art office block in the City of London of 100,000 gross square feet, which translates into about 85,000 square feet that would be lettable to a tenant. The 20,000 square foot site on which it is to be built has cost ten million pounds and the building costs, including the basic fitting out of the client's space, might have been budgeted, for Central London and to the 1980's more demanding specifications, at £25 million. Professional fees, including architects and lawyers, would add another three million pounds and the interest on the bank borrowings would amount to a further five million, assuming ten per cent interest rates. The developer's total costs would then be:

	£ million
Site cost	10
Building costs	25
Professional fees	3
Interest @ 10%	3
Contingencies	5
TOTAL	46

Of this cost the developer may only be contributing only five million pounds, the rest being borrowed.

The letting market as the development starts suggests that the building may be let at £50 per square foot, giving an annual rental income of £4.25 million. Recent sales of such completed and let investments have been agreed on a yield of five per cent, which would give a sale price of £85 million and a profit to the developer of £39 million, a royal reward since only five million pounds of his money was at risk.

When things go wrong, they tend to go wrong together. Higher

inflation will inflate the cost of building; it will drive up short-term interest rates, which in turn will create a slow-down in economic activity and may make letting the property much more difficult, and perhaps not at the rental level anticipated originally. At the same time, the institutional investor will be taking a more jaundiced view of the valuation yield on which it is prepared to buy the completed and let investment. Let us see the effect of all these factors on the original calculation:

	£ million
Site cost	10
Building costs	30
Professional fees	3
Interest @ 15%	5
Contingencies	7
TOTAL	55

With the rent achieved on letting now only £25 per square foot, the rent roll is £2.1 million a year, and because the institutional investor will only buy on a yield of seven per cent, this translates into a value of £30 million, leaving a loss on the project of £25 million, the developer bankrupt and the bank with a big loss on its loan.

These compounding changes in the environment can create huge wealth as well as bankruptcy. In the late 1960s, the Labour government had placed a general ban on office development which created an artificial shortage of office space. In *The Property Boom*, Oliver Marriott describes how Harry Hyams and other developers with those rare planning permissions for office developments benefited from rapidly rising rental values even though the developments themselves remained empty for one reason or another. The rise in rental values created an increase in capital values far ahead of the extra interest costs of leaving the buildings unlet. Planning restrictions have always stood in the way of the market finding an equilibrium between supply and demand of its own accord. This has only been relieved to a substantial degree during the 1980s, when first the previous Labour government's Development Gains Tax and Office Development Permits were removed and the Conservative government introduced Enterprise Zones which removed almost all restrictions in various designated depressed areas.

There are two measures of the health of the property market which will drive values of investments up or down: rents and investment yields. A £10,000,000 property which has an initial rental income of £600,000 per annum, thus yielding six per cent, may, on a review of its rent after five years, increase its income to £900,000; if the yield does not change then the value of the property will rise to £15,000,000. If however, despite the rise in rents, the investment yield, related as it is to yields on other securities, rises to ten per cent, then the capital value of the investment will have

fallen to £9,000,000 (£900,000 income gives a ten per cent return on £9,000,000). It is this interplay between rents and yields which causes the cycles of investment interest emanating from the institutions.

As a consequence of the property crash of 1974–76 there had been scarcely any new development in the 1976–79 period, and as the British economy began to revive from the 1974–76 recession a shortage of space became apparent. This had the effect of driving up rents in all areas of the economy, first in retailing, then offices and industrial properties. As described in the next chapter there was simultaneously a great change in the type of property demanded by the tenants, technology friendly offices, out of town shopping centres and high-tech industrial units, and these were not readily available. For those who had developed such space the early 1980s were a period of great advance despite the onset of the worst recession since the 1930s, following the second oil shock and the new Conservative government's policy of withdrawal from the direct control of industry. As the economy began to recover from this second recession, by the end of 1981, overall demand for space began to rise, and this time the developers were in a position to provide the buildings now in demand. The financial institutions had recovered from the shocks of the 1970s and were again prepared to back entrepreneurial property developers. The institutions had made tremendous returns on the properties which they had bought while the cost of money was coming down and the planners were becoming more amenable to new development, especially in the City of London and with retail parks. There was also an important technical change in the planning environment, in the classification of buildings, which again we shall examine in the next chapter.

There is one other peculiarity about the English commercial property market which distinguishes it from almost all others around the world and has made it much more popular to investors, both domestic and foreign, than might otherwise have been; (Welsh law is the same but Scottish law is slightly different). The standard lease to a tenant is for 25 years, with no provision for the tenant to cease paying rent; furthermore the lease will provide for periodic reviews of the rent to current market values, but *upwards only*. In the pre-war and immediate post-war periods the major properties were let on 99-year leases with no provision for a review of the rent; grandually, as inflation took hold, landlords began to shorten the length of fixed rent they would grant.

A further feature of English leases is what is known as 'privity of contract'. If you, as a tenant company, decide to move offices and sell your lease to a new tenant, which the landlord cannot 'unreasonably' prevent, and if the new tenant cannot pay the rent, the landlord may pursue you in the courts, even if you no longer have any connection at all with the property. These factors make English commercial property leases very valuable to long-term investors. The *cliché* three rules of property investment are 'location, location, location', suggesting that a

well-located building will always have a premium value, and that should be the prime consideration when weighing up a purchase. The English investor may be confident of achieving his income for the length of the lease from even the worst located property provided that the covenant of the original lessee is undoubted. If the landlord is lucky, the rent of a badly-located property will be dragged up by better properties in the vicinity. The owners of those well-located properties will certainly have bought their investment on a much lower initial yield than the badly located one and if the tenant happens to go broke in a recession, they may be left with an empty building with no income. Even if the tenant of the badly-located property no longer occupies the building and it is empty, he is liable for the rent as long as the lease runs.

We left the property market in 1975 showing the first signs of recovery in capital values. That recovery was a consequence of yields on properties falling, but was soon augmented by a rise in rents as the recovery in the economy met a dearth of supply. It was the large pension funds and insurance companies who invested heavily in 1975/76. The Prudential, Legal & General, and Norwich Union insurance companies; the Post Office, Coal Board, Electricity Supply, ICI and Combined Petroleum (Shell) pension funds, these were the names that recurred as buyers of property from the distressed sellers. Institutions invested £800 million net in property in 1975 and a further £530 million in 1986.

The relatively better financed companies had also been able to raise some finance from the Stock Exchange in 1975. Law Land, English Property and Land Securities had all raised convertible loans in the year, totalling £40 million. In the first two cases the financial institutions had been very unwilling to put new money up and the stockbrokers who placed the underwritings had a very hard task, as I can personally vouch, since I risked the wrath of the mighty stockbrokers, Cazenove, by refusing to underwrite the English Property convertible.

By early 1976 investment yields had fallen sharply from the peaks of early 1975. According to Healey & Baker's graph, the yield on shops and offices had fallen from the peak of eight and a quarter per cent to six per cent by the end of 1975, a rise in capital value of 37.5 per cent for a property being valued on these 'prime' investment rates. There was even some sign that the developers were beginning to regain their confidence. MEPC announced the £20 million scheme that was to become the West One development over Bond Street tube station in Oxford Street. One of the biggest projected developments of this time was that on the Trocadero site just off Piccadilly Circus, which the Electricity industry pension fund, Electricity Supply Nominees, (ESN), bought advised by the agents Richard Ellis. As the economy began to recover from its oil trauma the schemes of the previous booms opened: Brent Cross and Eldon Square shopping centres, in North London and Newcastle respectively, both opened early in 1976.

The agony of the property developers was not yet over. In March 1976

15

the shares of Amalgamated Investment and Property (AIP) were suspended from dealing on the Stock Exchange and a week later the company was put into compulsory liquidation, despite the fact it owned £209 million of first class property. The receiver appointed was the firm of Hacker Young, the eponymous Young in question being the accountant who became Chairman of the BBC before his premature death, Stuart Young. His brother David Young had sold his property business, Eldonwall, in the early 1970s to Town & City, on whose board he sat as a director; he was later to become a peer and Cabinet Minister under Margaret Thatcher.

Other property companies which were having to sell to stay afloat were beginning to find buyers more active. In May 1976 English Property sold 39 properties to Eagle Star for £55.5 million, eliminating the company's short and medium term UK debt. The price achieved was still below that the portfolio was carried at in the books (£62.5 million at 31 October 1975) but was above the directors' estimate on the 31 March 1976 of £51.8 million. In May 1976 Berkeley Hambro sold its green-windowed tower at 99 Bishopsgate to the HongKong Bank for £32.4 million. Today the building is still worth some £100 million. Greater detail of how some of the notable survivors of the 1970s property crash managed to survive are given in a later chapter, but the next change in the economic climate almost killed off those companies which had thought the worst was past.

In October 1976, Denis Healey, the Chancellor of the Exchequer, arrived at Heathrow Airport to take a plane to the Commonwealth finance minister's conference. He was greeted with the news that there had been a serious run on the pound and that the foreign currency reserves were not sufficient to stem the tide. On his immediate return to Downing Street the Labour government had to abandon much it held dear, and was forced to apply for an emergency loan from the International Monetary Fund to tide it and the currency over. The conditions for that loan were painful: higher interest rates, including a Minimum Lending Rate of an unprecedented 15 per cent and swingeing cuts in public expenditure, particularly on capital projects. The Financial Times property share index fell to 95.95 on 27 October, a level only one quarter of that reached in late 1973, as investors feared that this new blow would finally put paid to the weaker companies. For Town & Commercial Properties, October 1976 did mark the end, as the company was put into liquidation that month. Unlike the previous crisis however the institutions did not withdraw altogether from markets. By the end of 1976 the Financial Times property share index had recovered to 142.69.

1977 was described by the *Estates Gazette* as 'the year when property as an investment medium came back from the dead.' The combination of a dramatic fall in short-term interest rates from 15 per cent in early December 1976 to seven per cent in December 1987, and a resumption of economic growth, drove rents higher and investment yields lower, a powerful combination for property values: the Jones Lang Wootton

Index of overall property performance gave a total return of 27 per cent between June 1977 and June 1978. The clearance sale continued for those companies which were still too highly geared, but the whole atmosphere had changed. The institutional buyers of property were strongly influenced by the small number of firms of agents who dominated the investment field: Jones Lang, Healey & Baker, Richard Ellis and Hillier Parker made sure that their clients were aware of this change and encouraged them to build up their property portfolios. One of the peculiarities of institutional property investment is that, apart from the very biggest institutions, such as the Prudential, Legal & General or the Coal Board pension fund, the fund managers might have no experience in the property world, and almost certainly would have no professional qualification in the field. As news of the property market's recovery became more widely understood, many institutions decided that they too should participate. The first act of such funds would often be to appoint one of the large agents as their property advisor. The agents would not normally be paid a fee based on the capital value of the property portfolio but would be remunerated through the commissions he would earn on buying and selling property for their clients. The agents thus had a vested interest in persuading as many funds as possible to buy property. Most of them used their position responsibly but it was very difficult for them actively to try to dissuade the clients from investing since their livelihood depended on such activity.

One of the great *canards* of property investment over the period between 1978 and the early 1980s was the pursuit of 'prime'. A prime property is one which, for the time being, meets exactly the requirements for the majority of the property investors: usually well located, let to one 100 per cent safe tenant, it would be a modern building with a modern lease pattern of five-year upward-only reviews of rent, and a covenant in the lease forcing the tenant to keep the property fully repaired and insured. The most modern leases even had the further imposition on the tenant that he would pay for the day-to-day management of the property, the upkeep of the common parts and so on, which would actually be the responsibility of the landlord. Such properties represented coin of the realm for the average property investor. It is on such properties that the yield charts and performance indicators are usually based, because they represent the nearest thing the property sector has as standard investments. They will be expected to achieve the fastest rental growth and therefore they sell on the lowest investment yields. The trap is that today's prime can soon become tomorrow's secondary property. A secondary, or even non-institutional property, will be valued on a higher yield, to reflect the absence of one or more of the characteristics which define the prime investment. Few agents will recommend their clients to buy a property in a poor location with a multitude of poor quality tenants let on a lease with one or more defects from the point of view of the landlord.

A prime property can become secondary and a secondary property can

become prime, which leaves the risk/reward equation all in favour of the buyer of the property currently out of favour, but this was rarely acknowledged in the late 1970s. Most institutions wanted to participate in the property market and, since many of them knew little about it, they preferred to buy what everyone else told them was the best bet. The major deals of 1977 and 1978 still involved the companies trying to rebuild their balance sheets and deals were done on first-class properties at less than prime prices as the sellers were weakly placed.

By 1977 and 1978 rents on shop properties had recovered sharply from the recession lows as the economy, particularly in the South, began to grow again, and the lack of new development since 1973, especially in the office market, had begun to exacerbate the shortages of space to let. The more farsighted of a new generation of developers began to put together the deals with which this book is mainly concerned. Tim Simon of agents Savills said 'the attractions of office property as an investment are based more on restrictions of supply than weight of demand.' At this time the combination of rising demand for space from tenants, which was pushing up rents, and the burgeoning demand from investing institutions, which was driving down yields, was forcing property values rapidly higher. A sharp rise in short-term interest rates from the middle of the year, with the Minimum Lending Rate surging from six and a half per cent to 12.5 per cent by the end of 1978, seemed not to deter investors, who saw this as a natural response to the recovery in activity.

It was at this point that property yields began to lose contact with the normal relationships to which they had adhered for most of the past 25 years, since the modern property lease became commonplace. Why this happened, and its consequences for the 1980s, is important to the understanding of what happened later. Investment institutions are very strongly influenced by the recent performance of the various investment classes in which they may invest. If equity shares have done well in the last two years, many institutions will want to increase their investment in those assets; if property has been the best performing asset class, then it is to property that new attention and money is given. You might think that the job of the institutional investor is to forecast which of the assets will perform best in the future rather than simply reflect the past, but the pressures investment managers are subject to makes them relatively cowardly when it comes to taking an independent stance. This began to be apparent in 1978, as property was perceived by institutions as the most certain of assets to hold in the pursuit of high returns. 1977 had been an *annus mirabilis* for equities, bonds and property, average portfolios of which had all risen in value by around 40 per cent, but in both 1978 and 1979 it was property which rose in value while other assets were adversely affected by the rise in interest rates. The WM Company has been measuring the returns achieved by Britain's pension funds for the past 20 years, and the table for the 1975–80 period shows how property suddenly seemed, in 1978–79, to be the answer to investors' prayers (Fig 1).

Figure 1 Rate of Return on Investments 1975–80

£%	1975	1976	1977	1978	1979	1980
UK Equities	151.2	2.2	49.0	8.5	10.5	35.2
Overseas Equities	34.1	36.3	− 18.8	18.4	−31.2	17.2
UK Gilts	39.0	13.2	50.9	−3.4	4.6	21.4
Cash	11.0	12.3	8.4	9.2	14.7	18.5
Property Unit Trusts	18.0	27.1	34.4	17.7	24.7	18.5

Source: WM Company

The rise in property rents alone could not account for this sudden enthusiasm for pension fund investment in property. Two other factors were at work: disillusion with fixed interest securities and an absence of opportunity elsewhere. Fixed interest stocks are only attractive if the investor can be sure that his interest return is not going to be totally undermined by a high level of inflation. Having had one shock during the 1973/74 oil-exacerbated inflation, and with no certainty that the then Labour government had determined to make beating inflation its priority, the institutions were abandoning their long-held commitment to bonds. However, many funds felt that they held enough UK equity shares, and foreign investment was constrained by the controls on foreign investment which existed until 1979. Property became the obvious answer.

The more cynical view of why property suddenly became the desirable asset to hold for the institutions is that the managers and trustees of such funds were most influenced by recent experience. Because property values did not collapse in the spectacular way equity prices did in 1973/74, falling by two-thirds at the worst point, but had recovered well in the period between 1975 and 1979, many investors felt pressured to increase their exposure to the sector. Almost inevitably, as soon as the last institution woke to this proposition, the picture changed again.

The 1980/81 UK recession was a serious blow to property investors. Not only did inflation and interest rates rise sharply again but the economy suffered its most severe set-back since the 1930s depression. Retail rental values had risen by three quarters in the three years between June 1977 and June 1980, according to the figures published by Healey & Baker, twice as fast as retail prices. In 1980 rental growth came to a grinding halt. It was five years before rents caught up with the rise in retail prices again. For industrial property the picture was even worse; as factories closed, rental growth stagnated completely for the next five years, rising only ten per cent while prices in the shops rose by a half. Offices were much the most resilient sector of the property market, benefiting from the absence of new development during the mid-1970s,

the Labour Party's new taxation on development gains and the continued expansion of service industries, even while the industrial recession was at its depth.

Unlike the 1970s recession, this combination of high interest rates and low growth in rents did not cause a collapse in property values. Although short-term interest rates were about 14 per cent from mid-way through 1979 until early 1981, yields on property did not rise at all. In fact Healey & Baker reported prime yields on shops continuing to fall throughout the period. The institutions continued to commit between one and a half and two billion pounds a year to property during this period. The relative stagnation in rental values was hidden by the falls in yields and the continuous round of rent reviews, which gave the erroneous impression that property was still doing well.

As the economy revived from 1982 onwards, the outlook improved again for rents as demand for property from tenants rose. By the second half of the decade, as the economy's growth rate averaged an unsustainable four per cent and more, rents began to rise very rapidly, driving up values and encouraging new development. Unfortunately, at the same time, investment yields were actually rising as the institutions abandoned their earlier enthusiasm for property. Why should this happen when the yields on all other financial assets were falling? The answer lies again in the unfortunate timing of the major institutions: having suffered the poor relative performance of property in the early 1980s, which had done even worse than stodgy gilt-edged government stocks, many institutions were actively reducing their exposure to the sector. Net investment by the institutions was lower in money terms in each of the years 1981 to 1986, by the end of which year there was barely any net investment by them in the area at all.

The classic case of an institution suffering from its exposure to property was the giant Legal & General insurance company. In the late 1970s the Legal & General had been a leader in the pensions market in both size and the performance of its pension fund unit trust. Much of the credit for this was attributable to the bold purchases that Legals had made of property at the nadir of the property bust of 1975. Unfortunately that very high exposure to property had been a serious handicap to performance in the 1980s and their clients were complaining, or worse, taking their money elsewhere. Legals could have battled on in the expectation that property would prove its value in due course, but the needs of running a business meant that the company simply couldn't take the risk of that not happening soon enough to keep sufficient clients.

Because most pension funds and insurance companies had sufficient new money to invest for most of the 1980s, the shunning of property did not necessitate large-scale selling. It was more that almost no-one put new money into the sector. The WM Company, which monitors where the pension funds put their money as well as how well they perform, publishes a table which demonstrates the effect of this on the average fund's holding of property in the 1980s, starting at the peak levels of 21 per

cent of the average portfolio at the end of 1979 and falling away to the derisory level of eight per cent by the end of 1990.

If it was not the investing institutions which financed the major investment projects of the 1980s, who provided the money? The answer, as it was in the 1970s boom, was the banks. This time however, it was the major clearing banks and foreign banks who supplied funds directly, rather than through their own clients, the fringe banks of the 1970s. The ability of banks to read investment cycles makes institutional investment managers appear to be relatively clairvoyant, and the banks' enthusiasm to lend to exactly the same areas as their rivals makes investment managers look like free-thinkers; by comparison to both lemmings seem positively rational. The American banks in the 1970s and early 1980s were drawn into a succession of lending crazes: oil, third-world governments and real-estate all took their toll. In the UK, the past twenty years has seen two booms in bank lending to property developers. The equivalent figure of £15 billion of lending to property companies which marked the peak of the 1970s credit boom in 1974, has been left behind by the £40 billion lent to property companies by early 1991, three times the level in real terms of the last peak. Fortunately the absolute size of the lending does not pose as great a threat to the system as the relatively smaller sum of the last boom. In that instance, the lending made up 20 per cent of total commercial lending; today the figure is about 12 per cent of the total.

Lord Sterling identified the potential danger of the late 1980s lending boom in 1987, telling the then Prime Minister and Chancellor: 'I sniff the same as happened before.' When he conveyed his suspicions to the Bank of England he judged that the Bank was unable to gauge the size of the potential problem because so much was being offered by foreign banks, off the balance sheets of the companies. This was the subtle difference between the 1970s and 1980s. In the more recent boom, the foreign banks were much more aggressive, accounting for about half the net lending to UK property borrowers according to research done by agents Debenham Tewson. Japanese banks increased their share of property lending from two per cent in 1987 to the current 26 per cent, often lent to the UK developments or joint ventures of Japanese companies.

The 'off-balance sheet' factor was also important. In the United States, it has been the rule that property borrowings are secured on individual buildings, rather than the assets of the company as a whole. In the 1980s, corporate structures were developed whereby the parent property developer might only show its interest in its biggest development in its balance sheet as a small equity investment in a joint-venture company. The advantage of this was that the borrowing associated with the property would not appear. If the parent company did not have any responsibility for the borrowings of its subsidiary, there was an argument which suggested that the shareholders need not know the full extent of the borrowing. This 'non-recourse' lending was a phenomenon of the 1980s. As we shall see, the idea that a really substantial investment company

could in practice walk away from the debts of its subsidiaries has not been seriously tested, and, if the principals involved wish to continue in the property business, they are unlikely to see whether they can or not. Nevertheless, the off-balance sheet lending gave both the lender and borrower a feeling of greater security about the debt: the borrower because such borrowing could not bring down his whole company; the lender because his security was specific and unable to be interfered with by any other borrowing that the group might have.

By the middle of the 1980s, the scene had been set for a property boom on a scale which exceeded that of the 1970s and probably surpassed that of the 1960s. In that boom the restrictions on development meant that relatively few companies made enormous amounts of money. In the 1980s everyone seemed to be developing property, and the cranes were looming over every city. The tale of the boom cannot cover all the participants, but the following chapters chart the rise, and sometimes fall, of the most active developers and investors of the 1980s property boom. The last chapter will try to identify what went wrong and what the prospects are for the future.

2

CHANGING THE FACE OF THE CITIES

THE HEAD OFFICES of some of the world's greatest companies are over-crowded, have no air-conditioning and are situated in narrow back streets; but this is not New York or London, it is more likely to be Toyko or Osaka. In Japan there are relatively few modern offices and even though the industrial economy of Japan has strengthened dramatically over the past 20 years, the factories in which some of the most advanced equipment is made can often seem as dilapidated as any of the relics of the Industrial Revolution in Britain.

In the 1980s the UK property world suddenly woke up to the fact that much of the accommodation for all aspects of commercial life had been made obsolete by the new demands of technology on both offices and factories and the trend away from the High Street in retailing. At the same time there has been a reaction against the concrete brutalism which characterized much of property development during the first boom of the 1960s, when the cities of Britain rose from the ashes of the Blitz. The pre-war face of the office, shop and factory was that of the late Victorians and Edwardians: Dickensian gloom on the inside of monumental exteriors; from the multi-storey Lancashire cotton mills to the curved double shopfronts of the High Streets and the labyrinthine and sometimes rat-infested offices of the average worker, there had been relatively little new development in the Depression years, and the immediate post-war period had been constrained by building licences, which were not finally removed until 1958, supply shortages and confiscatory taxes on new buildings.

As always the City of London presents the most obvious continuum of changing styles. Such buildings as the GPO headquarters in St. Martin's-le-Grand, constructed between 1890–95 to designs by Sir Henry Tanner, although using reinforced concrete, retained the classic lines of the past. Relatively little had changed in the style of building by the time Sir Henry's son, another Henry Tanner, designed 8–10 Moorgate in 1922. There were innovative buildings, such as Adelaide House on the approach

23

to London Bridge, which, built in 1924–25 to a design of Sir John Burnet and Thomas Tait, contains such improvements to the life of the City office worker as electic lifts, central heating and an internal mailing network, but real change had to wait until after 1945 and the introduction of both American ideas and more modern materials.

The first City office block in the style which became synonymous with the first post-war property boom was Fountain House, 125–135 Fenchurch Street, developed by the City of London Real Property Company, now a subsidiary of Land Securities, to a design by W. H. Rogers in 1954–57. Planning controls in the City of London have traditionally included a restriction on the amount of lettable space allowed to be built for every square foot of land covered by the underlying plot. This so-called plot ratio had varied at different times between three and five and in the 1950s the former figure applied. Fountain House did not simply cover the site on which it was built to a limited number of floors along the line of the street; instead it followed the New York idea of a low-built podium with a highrise tower covering only one end of the plot. According to Sir Nikolaus Pevsner in the volume of his *Buildings of England* covering the City, the development's design is derived from the Lever Brothers headquarters in Manhattan, which has now been declared a 'landmark building', equivalent to a British 'listing'. One of the other distinctive features of Fountain House is that it was built with curtain walls. In this building method the external walls are hung like curtains from the concrete floors; in most cases the curtain is made up of glass and some hard-wearing but lightweight material between the glazing. This was the commonest building method of the 1960s, in both senses of that word, since it was both prevalent and low quality; many of the curtain wall buildings of the period have either seen major rebuilding or demolition, and those remaining no longer fit into the category of building desired by the investing institutions.

For most of the next 20 years, these curtain-walled tower blocks were the norm in office design all over the United Kingdom. The name of Colonel Richard Seifert became synonymous with office developments in London, partly through his close association with Harry Hyams of Oldham Estates, one of the most prolific of the period's developers. Colonel Seifert's partnership designed its first City tower block in Drapers' Gardens (1962–65), the era culminating with their design for the National Westminster Bank's new headquarters between Old Broad Street and Bishopsgate; this is the apotheosis of the 1960s–1970s tower. Built between 1977 and 1981, at 600 feet it was, until the advent of Canary Wharf, the tallest in Britain, and is the highest building in the world with floors hung from the top of the building down, by cantilever. Most of these 1960s office blocks were developed piecemeal taking advantage of rarely gained planning consents, but there were some attempts to establish more thorough-going order to this redevelopment. The prime sites for these wholesale changes to the cityscape were those most badly affected

by the Blitz, notably the area just north of London Wall, known as the Barbican, and the neighbourhood to the north of St. Pauls.

On the former site the City Corporation, with encouragement from the London County Council, drove a dual carriageway road, dubbed Route 11 rather ominously since it suggested at least another ten of these urban motorways were planned. It runs between Moorgate and Aldersgate and was, until recently, flanked by a total of six tower office blocks, all built by different developers and looking like two lines of dominoes ready to be toppled. This vision of Le Corbusian breadth was tied in with the Barbican residential and arts development to the north of London Wall, with its 412-foot towers of apartments challenging the offices along Route 11; the comprehensive redevelopment took 17 years from 1962 to 1979 to reach fulfilment, just before the original buildings on London Wall themselves became obsolete. The Barbican development with its elevated walkway connections to and over Route 11 was described by the ex-President of the Royal Institute of British Architects Lionel Esher in 1981 as 'a credit to the boldness of the City's notoriously conservative establishment . . . the spaciousness and the achievement, after the claustrophobia of the inner City, after all the makeshifts and accidents along Gresham Street, are exhilarating.' Lord Esher admitted ruefully however that 'there is never enough traffic below . . . and never enough humanity above.' Most residents of the City and workers in it are glad that such total planned environments never replaced the chaotic juxtaposition of buildings which still makes the City resonate its earlier street plan. That such offices as were built along Route 11 have not taken over the whole area is accounted for by the change in demand for the type of space needed by the occupier, not just by a change in aesthetic taste.

Beside St Pauls, plans for the Paternoster Square development were finalized in 1961, but the precinct was not finished until 1967. The designs, co-ordinated by master-planner Lord Holford, were praised by Pevsner as an 'outstandingly well-conceived precinct', but these mostly low-rise buildings clustered around a notoriously windswept open space never met with public approval, especially Juxon House, the most westerly of the buildings which intrudes into the view up Ludgate Hill to the cathedral.

Probably the most Miesian building erected in this period was the solid black Commercial Union building in Great St. Helens. This, like the later National Westminster tower, has a central core and the floors were built downwards from the top level with a service floor halfway down. Designed by the Gollins, Melvin, Ward Partnership, it has survived better than many of the buildings of its time, even the IRA bomb of April 1992, despite inflicting on the inhabitants of the City another gale-blown paved area around its base. The Kleinwort Benson building in Fenchurch Street, completed in 1969, was another building designed with a central core and hanging floors. This building became notorious in the late 1960s as the 'leaning tower of Fenchurch Street' as structural problems held up work

on the site for many months. This was no disadvantage to Kleinworts since part of the space they had pre-let from the developers was surplus to their requirements, and while they waited for completion, the rental value of the building, under the influence of the Brown ban on office development, rose sharply, much as keeping Centre Point empty suited Harry Hyams' Oldham Estates for some time.

One of the most controversial proposals for the City which proved to be an idea whose time had passed was the Palumbo scheme for Mansion House Square, a development of a site bounded by Queen Victoria Street, Poultry and Bucklersbury pieced together over many years by the late Rudolph Palumbo and his son Peter, now Lord Palumbo and Chairman of the Arts Council. Their private property company, City Acre, is based in a Georgian annexe to St. Stephens Church, Walbroook; Peter Palumbo has endowed this church, the original home of The Samaritans and its founder the Rev. Chad Varah, with a massive altar sculpted by Henry Moore, confirming his aptitude for challenging classical form with modernism.

The Palumbo plan involved the building a 290-foot tall block designed by one of the fathers of modern architecture, Mies van der Rohe. The site is one of the most sensitive in the whole of London, facing as it does the junction of streets onto which the Bank of England, the Royal Exchange and the Mansion House all face. The proposed development was described by the Prince of Wales as a 'stump' and that prevailing, probably unjust, sentiment was reflected in the refusal of planning permission in 1985 after a public inquiry. Palumbo then accepted that such a stark development would not meet with approval and has achieved permission for an alternative development on most of the site, designed by James Stirling in the current genre which mixes the appearance of the old Cunard liners and Odeon cinemas. The Prince of Wales described the design as looking 'like an old 1930s wireless', and went on to ask 'why pull down one of the few remaining bits of the Victorian City, including no fewer than eight listed buildings?' Those who wish to maintain the existing buildings, including 2–10 Queen Victoria Street, designed by J&J Belcher in 1870 and long occupied at street level by Mappin & Webb, have to accept that such properties no longer meet the needs of the modern world, and mere refurbishment would not suffice to turn them into desirable offices.

The end of the 1970s marked the culmination of the rash of pre-Brown ban developments, typically in the tall, plain curtain-wall style, and by the end of the decade there had been a sea-change in architectural ideas. Perhaps the most striking of these new ideas was the property designed by Arup Associates in 1976, known as Bush Lane House, 80 Cannon Street. Suddenly a building appeared to have been turned inside-out, with a lattice of structural stainless steel supporting a curtain-wall on its inside. The idea was to provide more clear interior space without obstructing pillars.

In May 1978 Frank Duffy, senior partner of architects Duffy Eley Giffone Worthington, now known simply as DEGW, wrote an article entitled 'The Thinner the Better' criticizing the traditional design of British speculative office developments. These, he said, were both 'difficult to utilise effectively . . . avoiding columns' being 'too narrow or too deep – or both', and were 'by no means superior in environmental performance to pre-war offices'. Duffy pointed out that most British office developments, while copying many of the design features of US blocks, had one fatal difference: most of them, such as Fountain House or the buildings strung along London Wall, had been built as wings protruding off a core containing central services such as lifts and plumbing. They were only 45 feet deep, about the worst depth for configuring useful office space. This depth dictated two rows of cellular offices about 20 feet deep and a central corridor; as Duffy pointed out in *The Changing City*, (by Francis Duffy and Alex Henney, published by Bulstrode Press, 1989), unless the standard window width is great and the central core can be used, this produces long, narrow offices with tremendous waste of space. Closed offices need be no deeper than 16 feet, whereas in an open plan office, each workspace needs to be about six feet in diameter.

This critique was not the final death-knell for the post-war standard building. It was the work done by Duffy and others on the demands of changing Information Technology usage which caused the shape of new offices to change and brought premature obsolescence to so many of the 1960s buildings. Although the Duffy criticism of the shape of these office blocks was damaging to their long-term viability, it was the advance of technology which condemned them to the demolisher's swinging concrete ball.

DEGW was commissioned by far-sighted developers such as Godfrey Bradman of Rosehaugh and Stuart Lipton of Greycoat and, later, Stanhope, to look at the changing needs of likely office users. In the 1970s the conventional wisdom was that, with the advance of telecommunications and technology, there was likely to be a fall in the number of office workers needed in the centre of cities, and the amount of space required would be reduced overall. This argument was adduced particularly by those who opposed new office developments, such as Coin Street on the south bank of the Thames between Waterloo and Blackfriars Bridges. An article in 1979 by Richard Barras, principal scientific officer of the Centre for Environmental Research, pointed out presciently that whether the burgeoning property boom he identified would turn into a renewed bust would depend largely on final user demand and the financial conditions under which the new developments were funded. However he also predicted that the trend of the recent past would not be broken and that 'declining growth in office employment can be expected to continue' despite the fact that there would be 'a continued growth of the financial service sector relative to the national economy as a whole'. Barras

concluded that 'with less redevelopment of secondary offices and only selective growth in user demand, the pressure of institutional investment funds and the competition for development profits therefore seem certain to create a new phase of over-supply in the early 1980s, resulting in falling capital values and sharply reduced profits'.

The Inspector in the Coin Street inquiry seemed to accept the claim that technological advances would reduce office employment. It was certainly true that between 1961 and 1981 there had been a dramatic fall in the numbers of workers in the geographical confines of the City of London, from 385,000 to 300,000; it is estimated that office employment in the City rose by 20 per cent in the 1980s, while the new areas of office activity, the southern tips of Hackney and Islington, the western extremity of Tower Hamlets and the Thames boundary of Southwark have seen much greater increases. The reasons for this turn-around in demand for space are manifold and no single one takes precedent, but the developments unforeseen by the planners included the growing internationalization of financial activity, particularly after the removal of capital controls in most of the world, the liberalization of access to the markets, particularly 'Big Bang' in the Stock Exchange in 1986, and the growth on the other hand of more regulation covering these newly liberalized markets.

At the same time the demand for space per employee has risen markedly, partly as a response to demands for a better working environment but mostly as a consequence of the increased space taken up by technology and environmental equipment. Even between 1971–1981, when office employment in the City fell by 15 per cent, office space occupied rose by ten per cent, so that the average floor space per employee rose from 118 sq. ft. to 150 sq. ft., by roughly a quarter.

In 1981 Stuart Lipton argued that there would be a demand for large units over 100,000 sq. ft., that new office technology was generating a demand for new flexible office building and that deep plan office space would prove inefficient in the energy-conscious 1980s. Most of these views were contained in the publication Orbit 1 by Francis Duffy and Maryanne Chandor, published by DEGW and EOSYS in April 1983. ORBIT was an acronym for Office Research on Buildings and Information Technology. This view was widely ridiculed at the time and many developers and investment companies have paid a heavy price for ignoring the research. 1 Finsbury Avenue, developed by Rosehaugh and Greycoat, is generally accepted as the first of the new generation of buildings created for the new environment.

The change in the requirements of tenants coincided with a growing disillusionment among both architects and, more obviously, the general public, with the Modernist school of architecture. In the 1960s and 1970s the major commissions tended to come from the public sector. The building of new universities, leisure and educational facilities, from Leicester University to the National Theatre and the Knightsbridge Barracks, were more adventurous than the standard product of the

commercial developer. By 1976, when the IMF insisted on cuts in the capital expenditure programme of the Labour government and, in the words of Anthony Crosland 'the party is over' for local government spending, these commissions suddenly became scarce.

It was not until 1980 that the Department of the Environment listed the Jubilee Hall, one of the last critical sites in Covent Garden, in response to a strong conservation movement to save the old market buildings. The resulting development of the area into a copy of Faneuil Hall and the Quincey Market in Boston has been a popular transformation with the public and tourists and marks a clear break from the certainty of the 1970s that new development was necessarily an improvement. This feeling of certainty about schools of architecture has existed for some time, although in different eras various schools have been championed. For Pugin and Ruskin the revealed truth was the Gothic style, but by the 1960s Mies and le Corbusier had triumphed. Modernism brooked no opposition, and followed the Miesian stricture that 'less is more'. A consequence of this view was that buildings should not hide their purpose with superfluous ornamentation, and concrete should be seen and not screened. Public housing was perhaps the worst sufferer from this dogma, since the ultimate consumers, the council tenants, were not consulted on their preferences at all. No matter that the city dwellers liked their own front doors and a patch of garden; acres of small, and undoubtedly substandard, Georgian and Victorian housing were swept away in the name of le Corbusier and blocks of high-rise flats built in their place.

By the end of the 1970s, the taste of the consumer was turning against the new brutalism in architecture and some were bold enough to suggest that Modernism was not the only possible way forward. The revolutionary idea that there was no such thing as a morally correct school of architecture was promoted by David Watkin in his book *Morality and Architecture* published in 1977; this was an idea whose time had come.

During the period of Modernist supremacy there were some architects who persevered with the unfashionable. Quinlan Terry was one such. Terry had briefly worked with James Stirling, the architect of such classic public sector Modernist buildings as the Engineering Faculty at Leicester University, the History Faculty on the Sidgwick Avenue site in Cambridge and, more recently and in a more eclectic style, the Staatsgalerie in Stuttgart. The major part of Terry's career was with the idiosyncratic Raymond Erith, whom he joined in 1962. Erith acted as though Modernism had never been invented; he continued to design new private houses in the classical tradition. After Erith's death in 1973, Terry carried this torch alone. Terry's new gates for the Cutlers Gardens development was his first foray into the City of London. The first major urban design was for the well-known conservation-minded developers, Haslemere Estates, in Dufours Place, Soho. This is a seven-storey conversion in brick with Classical detail. Terry believes, with as much enthusiasm and conviction as the Modernists had pursued their credo,

that the classical architectural rules are absolute and inviolable. His most widely discussed development is that on the riverside in Richmond. This group of buildings has mixed new and old buildings cemented by strict adherence to classical tradition, at least on the outside. One architect told me that he thought this development was 'sad; you look through the windows and you see mile after mile of fluorescent lights. It is not truly classical.' Whatever the sneers of the architectural profession, the new buildings are popular with the locals, although it may well be that in 100 years no-one will be able to tell from what period they date. The now-defunct Cabra Estates had a Terry plan for the Fulham football ground site which is redolent of the Crystal Palace.

Terry is a tall, conservative Christian in his fifties, who looks oddly like the comedian Bob Monkhouse. His rebellion against the modernist orthodoxies started while he was a student at the Architectural Association. In an extensive interview with the *Evening Standard*, he claimed 'I started doing traditional classical Gothic buildings and I was told that, if I continued, not only would I fail my exams but I would undermine the foundations of the modern movement.' He dismisses modernism and post-modernism, willing to criticize openly his architectural contemporaries. 'You've got to realise that you have an architectural establishment which has a stranglehold on the taste of the profession. It is like Eastern Europe was. They put you through a five-year training course, and if anyone can come through that and think straight, they are pretty remarkable. They give awards and gold medals to all their sycophants and good boys. So someone who designs a building in oil-refinery style in the City of London gets a gold medal because he is abiding by their rules, he is a good boy.' The recent reaction in architectural taste has meant that Terry is now among the first names considered for commissions, with a new Roman Catholic cathedral in Brentwood and part of the most recent Paternoster plan benefiting from his idiosyncratic adherence to the classical forms.

The reaction from Modernism did not necessarily mean a rediscovery of the Classical. The two other major 'schools' which were defined in the 1980s were those of 'High-Tech' and 'Post-Modernism'. The former allowed the design of buildings to be dictated by their purpose; this followed the Modernist precept that things should not pretend to be something else, but the technology itself ensured that the buildings could not be the pure cubes and towers of Miesian modernism. Two examples already mentioned (Bush Lane House and 1, Finsbury Avenue) were both designed by notable proponents of the 'High-Tech' school, Arup Associates. Other well-known buildings of this type are the Lloyds of London building in Lime Street London, and the Pompidou Centre in Paris, both designed by Richard Rogers, and the HongKong Bank building built in that territory by Norman Foster. One commentator has dubbed these buildings as belonging to the 'bowellist' school of architecture, since so many of their vital organs are revealed on the

outside. Pipework and lifts both expose themselves to the public gaze. Another version of this school has been seen in the work of Michael Hopkins, who designed the Schlumberger Research Centre in Cambridge, which looks like a circus tent pitched on the Fens, the new Mound Stand at Lords and Ohbayashi Gumi's redevelopment of Bracken House behind its listed façade in Cannon Street. It is in buildings like these last two that modern architecture has been able to bridge the gap between the professional purists and the lay consumer. It is difficult to imagine a more conservative body of men than the members of the Marylebone Cricket Club, but the stand, again with a tented-style roof, is looked upon with general favour.

Perhaps the most influential voice raised in the debate about architectural styles was that of the Prince of Wales. Using his many public platforms and access to the media, Prince Charles led a layman's crusade against modern architectural orthodoxy. To some architects this smacked of a privileged amateur abusing his position to make ill-informed criticism of their profession. To the vast majority of the consumers of architecture, the general public, the Prince of Wales seemed to be expressing what they themselves felt, but were too intimidated to say: the modernist Emperors had no clothes. The problem of such a viewpoint is that contemporaries cannot be the best judges of what will last in architecture. If no daring experimentation or development of style can be allowed, then design will stagnate. Nevertheless, the Prince of Wales was a critical voice in determining the fate of at least three important developments.

As early as 30 May 1984 he made a dramatic intervention into the world of design in a speech to the Royal Institute of British Architects calling the winning design for the National Gallery extension on the so-called Hampton Site on the north-west corner of Trafalgar Square 'a monstrous carbuncle on the face of a much-loved and elegant friend'. The Hampton site, formerly occupied by a furniture store of that name, burned down in the Blitz, had been the object of many plans for a National Gallery extension since before the First World War. In the 1950s, the government acquired the site and the *Sunday Times* ran a competition to select a design for the new wing. Even the most avid supporter of modern design would be hard-pressed to support the brutalist winner of that competition, but fortunately it was never built. In 1981 Michael Heseltine, then, for the first time, Environment Secretary, commissioned designs which would enable commercial developers to provide gallery space in exchange for permission to build offices on part of the site. The competition was beset by disagreements and cries of 'foul' from the losing architects, but in December 1982 Heseltine announced that the design by Ahrends, Burton and Koralek, in association with developer Nigel Broakes' Trafalgar House, was the winner. After a year of further compromise and change, the new extension's design was unveiled and a public enquiry began in April 1984.

By this time, so much had been subject to compromise that scarcely

anyone was happy. The Prince of Wales' speech was a general critique of modern architecture, but he singled out the National Gallery extension, feeling that, as one of its Trustees, he had a locus in the case. He described the design as being like a 'kind of vast municipal fire station complete with the sort of tower that contains the siren.' This first public intervention into the world of architecture was greeted with headlines and a rush of agreement from architectural reactionaries who had been reluctant hitherto to express their reservations about trends in the profession.

By September 1984 the design of Ahrends, Burton and Koralek had been abandoned and a new building commissioned. It comes from the practice of Robert Venturi and his wife Denise Scott-Brown. Venturi, an American architect, has had the gall to challenge the wisdom of Mies van der Rohe that 'less is more' by countering that 'less is a bore'. The extension has been greeted with almost universal damnation by the architectural critics; for instance the architectural historian Gavin Stamp has called it 'a camp joke, pretentious architectural rubbish and an insult to London.' While the building is well-mannered, complementing both Wilkins' National Gallery and Canada House on the west side of Trafalgar Square, it does look as though a cardboard pseudo-classical facade has been erected like a film set to hide a more modern building. The Prince of Wales believes it to be 'a building of which London can be proud'; at least it is a building for which London does not have to apologize.

The Prince later intervened in the long saga of the Palumbo attempt to redevelop the Poultry site. His public utterances culminated in a television programme and accompanying book called *Visions of Britain* in which he roundly criticized much recent development as being out of sympathy with its surroundings. In this he was in harmony with the mood of the times and the public, and Modernism has continued its general retreat.

In its place there has developed an eclectic style which picks the acceptable parts of Modernism and blends with it the style and decoration of many previous eras of architecture. The term 'Post-Modernism' encompasses designs by many different architects, some of whom seem to have a sense of humour. Terry Farrell is perhaps the best-known of this group. His first substantial commission, in 1982, was the TV-AM building backing onto the Regent's Canal in Camden. This 1930s garage was dressed up in Art-Deco outerwear and topped by egg-cups to signify its use. Farrell, a beetle-browed man with a passing resemblance to the French actor Michel Lonsdale, has gone on to be one of the most prolific of the 1980s commercial architects. Among his larger buildings is Embankment Place, which rises like a cinema organ above Charing Cross Station, overlooking the Thames. This is the most complete example of the Cunard/Odeon school of architecture which has come to dominate the end of the 1980s. Multi-coloured polished granite and a broken pattern of roofs has replaced the bland orderliness of concrete and glass in

straight lines which characterized the earlier decades. Farrell is also responsible for the much less successful Alban Gate, built for MEPC astride Route 11, replacing one of the earlier 1960s dominoes, Lee House. The development of the Vauxhall Cross building, for so long the subject of planning blight, is also a Farrell building. In May 1991, Farrell unveiled his revised plans for rebuilding the South Bank Arts complex between Waterloo and Westminster Bridges but this scheme was abandoned in early 1993.

The return to the 'well-mannered' building, which sits easily with its neighbours, is the result of the pendulum swinging violently away from the conventions of the Modernist period. The third major project, in which the Prince of Wales' interest has led to at least a partial loss of nerve on the part of the developers, is the Paternoster Square redevelopment. The original owners, Stockley, in partnership with two pension funds and British Land, appointed Arup Associates as the master planners after a competition; among the designs rejected for this prime site were uncompromising suggestions from Norman Foster and James Stirling, which in the Prince's view 'demonstrated how wrong the original brief was.' When the Prince 'saw the developer's initial concept for a replacement, I must confess that I was deeply depressed . . . Paternoster Square was something that I felt I had to speak up about.' In a speech in the Mansion House on 1 December 1987, the Prince of Wales challenged the developers: 'Surely here, if anywhere, was the time to sacrifice some profit, if need be, for generosity of vision, for elegance, for dignity; for buildings which would raise our spirits and our faith in commercial enterprise, and prove that capitalism can have a human face.'

By this time, the ownership of Stockley, the leading partners in the Paternoster consortium, had changed hands with Tony Clegg's Mountleigh now in control. The Arup plans of 1987 were displayed in public, accompanied by an alternative scheme commissioned by the *Evening Standard* from the classic-revivalist John Simpson. Arup's scheme was taken away for re-thinking and re-presented for public scrutiny in November 1988. 'The new Arup scheme' says Jonathon Glancey, 'showed a more traditional approach to urban planning in its use of squares and crescents, stone and brick. Sensitive architects such as Michael Hopkins and Richard MacCormac were invited to design some of the individual buildings on the site.' Unfortunately for everyone concerned, the ownership of Paternoster had changed again. In October 1988, Mountleigh announced the sale of the site to the Venezuelan-based Cisneros group. The potential development moved no further forward until, in October 1989, the site was sold again.

Greycoat, which bought the site in partnership with American and Japanese investors, was initially reluctant to display its new plans, and brought in several architects, most of whom wished the site to return to a medieval road plan. The result was unveiled in May 1991. The Masterplan, drawn up by Terry Farrell, Thomas Beeby, Dean of the Yale

University School of Architecture, and John Simpson, has employed the talents of five other architects, all exponents of the classical tradition: Robert Adam; Paul Gibson, whose partnership Sidell Gibson has rebuilt Grand Buildings on the south-east corner of Trafalgar Square behind a reproduction of the previous facade; the American Allan Greenberg; Quinlan Terry and Demetri Porphyrios. The Royal Fine Art Commission has likened part of the development to Disneyland, but it is likely that something akin to the plans will be built in due course. In February 1993 the Government decided not to block the plans. Even the proprietors of those properties not owned by the Paternoster Consortium, notably Standard Life, which owns Juxon House, and Nuclear Electric which owns Sudbury House, currently the tallest building, have indicated their general support, although they have reserved their rights to redevelop their own sites. In the words of *Sunday Times* journalist Hugh Pearman, the artists' impressions of the new design 'suggest the kind of Utopian enclave where philosophers might hold forth to audiences, and where merry laughter and tinkling fountains are heard from crystal dawn to wine-dark dusk. Stuff and nonsense. These are office blocks. Very big office blocks.' The Porphyrios building has an Italianate tower on the corner looking into the new Square; Beeby's building at the western end of the Square resembles the Bank of England building without Soane's enclosing wall. There is a problem of matching the commercial requirements of lettable space and a pleasing environment, but this plan is more likely to command the support and eventual affection of the users than previous plans. Like Richmond Riverside or the Covent Garden Market, the lack of dramatic new initiatives will disappoint the profession, but may create another frequented space, rather than one which has only been used to scurry across for the past 30 years. The downturn in the property market has postponed the likely date of the new proposals getting under way.

On the south bank of the Thames the plan for the downstream stage of London Bridge City is also likely to be postponed. The Kuwaiti owners have other uses for funds over the foreseeable future and the prospect of seeing a London version of St. Mark's Square, Venice, designed again by John Simpson, has retreated.

Two of the largest district redevelopment schemes are also going slow. Both Spitalfields and Kings Cross were the subjects of bitter competition for the privilege of redevelopment. The winners, London and Edinburgh, now owned by a Swedish pension fund, and the London Regeneration Consortium, owned by Rosehaugh Stanhope and National Freight, are not likely to be committing scarce funds to grandiose projects until the economy has recovered. In May 1991 the Spitalfields Development Group appointed the American based architects, Benjamin Thompson and Associates, as master planners. Thompson was responsible for the pioneering regeneration work in Boston and Baltimore for the Rouse Company, where they used the existing old buildings as the keystone of

the development. Among the architects chosen to design the individual buildings of the scheme is Sir Norman Foster.

The 1980s were marked not only by a reaction in architecture but also a revolution in planning. For all the post-war period, planning had been a prize, anxiously sought and jealously given. The very award of a planning permission gave the developer the opportunity to turn it into a fat bank balance. The new Conservative administration was driven by a desire to deregulate and planning was one area in which it put its policy to work. Indeed, some inner city areas were designated Enterprise Zones in which all the traditional planning restraints were to be removed. At the same time it became apparent that, even if the new technology was not destroying office jobs or distributing them into smaller and smaller units, there was no need for these offices to be as close to one another as they had been. The traditional need for banks and brokers to be clustered around the skirts of the Bank of England and the Stock Exchange had been obviated by electronic communications. These factors had a marked effect on the attitude of the existing planning authorities. Faced with new competitors for new development, the City of London abandoned its previous development plan. In March 1986, the Corporation, by increasing the permitted plot ratios and relaxing some of their conservation measures, increased the allowable office space in the City by 11 million square feet. Since the City's existing stock of offices at that time was around 40 million square feet, this was a revolution in potential supply. It did not even include some of the large developments already under way on the City's fringes. Michael Cassidy, at that time the Chairman of the City Corporation planning committee, is still unapologetic: 'It was a window of opportunity.' He points to the undoubted gain in quality of the buildings, even if many of them today stand empty.

For many Londoners of a certain age, the funeral of Sir Winston Churchill in 1965 marked a rite of passage. As the coffin was borne up river on a barge, the cranes of the Pool of London dipped in homage; it was their last public act. Even then London as a working port had almost disappeared as containerization took the trade downstream to Tilbury, and the old docks and wharves of London were falling into disuse and dereliction. The Pool itself, between London and Tower Bridges, and St. Katherine's Dock by the Tower soon drew the attention of the developers, but the downstream docks, from the Isle of Dogs onwards, were left to rot. In July 1981 the government established the London Docklands Development Corporation, (LDDC), charged with the overall rejuvenation of the docks on both sides of the Thames: on the north bank from Tower Bridge through Wapping, Shadwell and Limehouse to the Isle of Dogs then on to the South from London Bridge through Bermondsey to the peninsula of Rotherhithe. Here the writ of the now-abolished Greater London Council and the Borough councils did not run. Instead the LDDC was the planning authority, and on the Isle of Dogs itself, a peninsula jutting into a loop of the Thames and

serviced by only two bridges, the government went one step further: in 1982 it made the Isle into an Enterprise Zone. In this area, as in several other derelict city centre sites around Britain, there were to be no planning controls, no local taxes for ten years and tax allowances against the cost of the buildings.

The architectural writer Stephanie Williams, in her book *Docklands*, describes the result: 'London's Docklands contains one of the worst collections of late 20th century buildings to be seen anywhere in the world. It is a marvel, if it were not so embarrassing, that so many very bad buildings from the same period can be found in such a comparatively small area of the city, massed so closely, and so incongruously together . . . And yet it is to Docklands that you must go to find some of the best British architecture of the 1980s.' Whatever the doubtful qualities of the buildings, it is incontrovertible that the kick-start given to the Docklands has revived the area more rapidly than years of careful strategic planning could ever have done. Developments of over 25 million square feet of commercial space have been planned and a substantial amount of that has been or is being built. A centre half the size of the City of London is being built in a commercial desert.

One of the early pioneers of the move east was Rupert Murdoch's News Corporation. As part of a carefully planned coup, News had taken a long lease of 13 acres in Pennington Street from Tower Hamlets council as early as November 1979. Its plans were to build nearly one million square feet of commercial space on the site, just south of The Highway in Wapping, no more than a mile from Tower Bridge. What was not apparent at that time was the intention to move all its production facilities for *The Times*, *News of the World* and *Sun* to the site from their traditional positions in and around Fleet Street. Not only would this prove to be the secret ingredient for unlocking the vice-like grip of the print unions, but the Fleet Street sites then became available for redevelopment. In March 1980, the Daily Telegraph paid £2 million for a similar site in Wapping Lane. Both these sites had previously been leased jointly by Town and City Properties, still selling non-income producing investments, and the Port of London Authority.

In 1984 construction began on the Docklands Light Railway (DLR). One of the greatest problems with the whole of the Docklands area, both north and south of the river, was the fact that there was relatively poor provision of public transport; the DLR was an attempt to create some in a hurry. Built with the latest driver-less technology, it was not planned to carry the volumes of passengers on its short, and unreliable, trains that subsequent events have suggested will be needed. In July 1991 the crucial extension to Bank underground station was opened; at last the Docklands transport system was linked directly with the rest of London's Tube. The government has also announced that the Jubilee Line is to be extended from Embankment across the river to London Bridge and then back again to Canary Wharf. Part of the capital cost of this project is to be borne by

the financial undertakers of that vast project on the Isle of Dogs, if they can find the money.

The transformation of the Isle of Dogs is the result of the dream of one man, G. Ware Travelstead. This American developer, backed by the leading American investment banks of First Boston and Morgan Stanley, produced a plan in 1985 for a development on the 71-acre site of Canary Wharf of 10 million square feet of commercial property, mostly in Brobdignagian office blocks. Although the two banks agreed to take space in the scheme, Travelstead was unable to secure sufficient pre-lettings to finance it. It was taken over in 1988 by the Canadian Reichmann family company, Olympia & York (O&Y). Their other successful schemes in North America were thought to be sufficient to see this new project through to completion. It was said that the developers had written into their financial plan the expectation of two economic recessions; they fell during the first. The idea behind Canary Wharf was to create a critical mass of tenants that would themselves attract others to the site. This was to be done by providing both the desired size of building, or of individual floors, with all the state-of-the-art technology, unavailable elsewhere and at a lower rental than that asked in Central London.

At the centre of the development is the 800-foot high pyramid-topped tower designed by Cesar Pelli. This is the tallest building in the United Kingdom, and can be seen from as far away as the elevated section of the A40 passing the White City in west London or the north end of the M2 in Kent. Unfortunately, it is also right in the line of sight when looking down the hill towards the Royal Naval College at Greenwich. The overall plan is under the control of Skidmore, Owings and Merrill, (SOM), who are also responsible for the later stages of the Broadgate development on the north edge of the City. By the summer of 1992 the developers had managed to let only 60 per cent of the first two stages, which were occupied in early 1992. The first contracted tenants were the investment bank backers, but O&Y made a decision to try to create a media colony in the area. Several advertising agencies have agreed to give up their West End offices and relocate to Docklands, although attempts to attract Saatchi & Saatchi proved unsuccessful. This was despite the fact that O&Y were prepared to offer substantial financial inducements to prospective tenants. These would include buying their existing property or taking over their tenancies. Among the companies which have relocated to Canary Wharf is the *Daily Telegraph*. The newspaper's offices had previously moved from Fleet Street to the Isle of Dogs, but to South Quay Plaza, a Richard Seifert designed office development further into the island. O&Y agreed to buy that *Telegraph* office.

Canary Wharf may yet prove successful as a property, but it has clearly failed as a property investment for its original owners. The whole Olympia & York group, in Canada, the US and the UK, was forced to seek protection from its creditors, and receivers were appointed in the summer of 1992. The over-supply of new space meant that the rent at which the scheme became

economic proved too high in a climate of retrenchment and falling rents in the City centre. Nevertheless, the area is becoming populated. Texaco and Credit Suisse First Boston had both moved over 1,000 staff to the site between the collapse of O&Y and April 1993, and the quality of the buildings is widely praised. The possible extension of the Jubilee tube line and the opening of the Limehouse road link will improve communications, the current standards of which are still a major disincentive to potential tenants. It is an interesting question whether the value of the buildings in the future will ever reach their cost adjusted for inflation, but some canny investors may be able to buy the development at well below its building cost and wait for better demand and higher rents to bring it to a point where they could claim to be the ones to have made money out of Canary Wharf.

The speed of development of such projects as Canary Wharf or Broadgate is in marked contrast to the traditional snail-like pace of British construction. The introduction of American methods of building has brought about major changes in the industry. Stuart Lipton of Stanhope, who has done as much as anyone to change the perception of British building methods and city architecture, keeps a copy of a book in his office sidelined in the margin by Peter Rogers, Stanhope director, project manager of the Broadgate development and brother of architect Richard Rogers. While this may not be a surprise, the fact that the book was published in 1934 and written by the English MP for Maidstone and architect Alfred Bossom, certainly is. (Apart from this book, Bossom is chiefly remembered for the remark Winston Churchill made of him on learning his name: 'I see, neither one thing nor the other.')

The reason for the presence of this arcane and long out-of-print book in Lipton's office is that it foreshadows many of the changes to British building practices which the 1980s developers introduced. Bossom had spent many years in the early part of the century working on the construction of skyscrapers, such as the 20-storey Chesapeake and Ohio Building in Richmond, Virginia. His book, *Building to the Skies*, drew attention to the differences between the planning, achitectural and, particularly, building methods of the Americans and the British; these differences persisted into the 1970s. The skyscrapers were designed down to the last detail before construction commenced; the architect's drawings were comprehensive: 'They show everything – every steel column, girder and plate, every pipe, every vent duct, every push button, every groove or chase for wiring or piping – everything.' The construction process too drew acute observations from the future Member for Maidstone. He noted that the building of a skyscraper was almost entirely a matter of on-site assembly of prefabricated components, organized minutely. 'It is thanks almost wholly to this scheduling of everything in advance and working to an agreed time-table that buildings in America cost no more to erect than in England, are completed far more quickly, yield larger profits both to the owner and the contractor, and at the same time enable the operatives to be paid from three to five times the wages that they receive in Great Britain.' The result was that the Empire State Building went from

the first upright steel member being put in place in April 1930 to completion before May 1931. Those of us who watched the hesitant progress of so many 20-storey buildings of the 1960s find it difficult to believe that the bricklayers on the New York project were completing a storey of brickwork every day.

It was the introduction of these methods which enabled Rosehaugh Stanhope to astonish Margaret Thatcher into keeping a promise made when she inaugurated the construction of the first phase of the Broadgate development (see Chapter 3). The then Prime Minister had promised to return to the celebration of the completion of the building if it was achieved within a year. So confident was she of that promise not having to be kept that she actually planned a trip to Canada. This had to be cancelled at short notice when it became apparent that her presence would indeed be necessary.

It should not be thought that the revolution in design and planning was confined to London offices, although that is possibly the most dramatic change, making obsolete a whole generation of buildings. The retail revolution of the 1980s was just as complete, both in the High Street and on the edge of town, involving the redesign of many of the familiar shop chains. The influence of Sir Terence Conran of Habitat, who took over the British Home Stores group and changed it into BhS, and of George Davis, who transformed Hepworths from a Yorkshire-based tailoring group into a design-driven group of retail and mail-order companies under the Next banner, is seen in the way that the fascias of British shops have been 'pastellized'. Even more striking is the plague of American town hall clocks to be seen on top of endless out- or edge-of-town Asdas, Tescos and Safeways. The growth of the shopping mall and groups of retail warehouses was predicted only by the prescient few at the beginning of the 1970s. Most observers believed that, Britain being an overcrowded island, such developments would not be possible, desirable or permitted.

The giant regional shopping centre, anchored by at least one large department store and food super- or hyper-market, although common-place in the United States, is a recent arrival on these shores. In the United Kingdom the large free-standing supermarket only dates from the mid-1970s. By 1976 there were only four supermarkets in Britain with a selling space of more than 50,000 square feet, a low threshold for the description hypermarket: Tesco in Irlam and Carrefour, a joint company formed with the French pioneer in the field, which had stores in Eastleigh, Caerphilly and Telford. Many new developments of city centre shopping had already taken place, such as the Victoria Centre in Nottingham, which Capital & Counties had built and sold most of to the ICI pension fund. The first true example of a regional shopping centre in Britain is the Brent Cross Centre in north London. Developed by Hammerson and Brent Walker with finance from Standard Life and built on the site of the old Brent dog-racing track, the centre opened on 2 March 1976. It looks unprepossessing from the outside, like a series of children's irregular building blocks

placed end to end, but inside is a veritable cornucopia of the traditional High Street emporia: John Lewis, Boots, Fenwick, Marks & Spencer, Waitrose, C&A and W H Smith were all represented in the centre at its opening, and their stores took over 580,000 square feet of the 800,000 square feet air-conditioned space. Six months after opening, Brent Cross was attracting 55,370 shoppers on a typical Saturday, each spending an average of £43.60 (in 1979 money), nearly 90 per cent on non-food items. By comparison after six months the Caerphilly Carrefour attracted 16,800 shoppers to its 100,000 square feet almost wholly given over to food, and they spent an average of £18.40 each.

The rise of the retail warehouse, selling Do-It-Yourself goods, furniture, electrical goods and carpets was consumer-driven and mostly carried out by owner-occupier retailers. Not until the late 1980s was the institutional investor generally prepared to finance or own these properties, neither pure warehouse nor pure retail store. The growth of the national chains of retail warehouses also stimulated the development of much larger warehouses from which operators distributed stock to far-flung stores. In 1979 MFI bought a 31-acre site outside Northampton on which to develop its main warehouse. The million square feet initial building has been added to over time, and the investment was eventually sold to John Ritblat's British Land Company. Asda opened a similarly vast distribution centre on a disused airfield outside Lutterworth in Leicester.

The retailers made their case in both economic and environmental terms. John Sainsbury, now Lord Sainsbury, speaking to the Oxford Preservation Society in 1981, said: 'Large stores with car parks cannot be accommodated in ancient cities . . . indiscriminate development of large stores in green fields is not acceptable.' The growth of car ownership had made these edge of town developments accessible and had created the environment in which they could be built: the by-pass or motorway created a natural barrier to town expansion but the immediate environs of these roads were unsuitable for residential development; the retailers filled the gap. By 1989 two-thirds of households had access to a car for their personal use, up from just over 50 per cent at the end of the 1960s. New operators were being attracted to these revolutionized shopping practices: IKEA from Scandinavia and Toys 'R Us from the United States were well established and, as had happened across the Atlantic, many retail parks now have a McDonalds as an added attraction.

The retail design and architecture revolution was matched by dramatic changes in the style of new factory development. Many of the dark satanic mills of the nineteenth century have been demolished and replaced by modern, light work-places, something between a laboratory and an office. This has again been a consequence of both technological and planning changes. The technology change has been the shrinkage of the traditional heavy industry with which Britain led the Industrial Revolution in the nineteenth century. This is not the place to discuss whether

this move away from low value-added industry to the less labour intensive industries of the late twentieth century was desirable or merely inevitable, but the effect on the workplace has probably been even more dramatic than the change in offices and shops.

The planning change came late in the period covered by this book, although the final alteration to regulations simply reflected a weakening of the relevance of the previous rules. Until 1987, the use of property in England and Wales had been ruled by the class into which the planning permission fell. In that year the Use Classes Order introduced the concept of B1 space. This permitted office, research and light industrial use to be carried out at one property with one planning consent. Hitherto, the planners had tried to separate the factories from the offices from the research establishments, in nice neatly coloured parts of their planning maps. As industries such as pharmaceuticals or computer software grew in importance, it became increasingly difficult and potentially highly damaging to distinguish between these uses. In fact, mixed-use property had been increasingly accepted by the planners before this; industrial units would have some office space tacked on to the front. The change in the Use Classes Order altered the balance, so that the percentage of offices in these later developments is much higher than on previous industrial areas. Three early and important examples were the Cambridge Science Park, Aztec West outside Bristol and Stockley Park near Heathrow. All predate the legal alteration to Use Classes, and are examples of how the changing needs of commerce forced the change.

The story of Stockley Park is told later in the book (Chapters 4 and 5), but the importance of both the Cambridge Science Park and Aztec West are worth more than a passing mention. Trinity College, Cambridge has for 35 years had as its Senior Bursar Dr John Bradfield. (Trinity has a tradition of long-serving Senior Bursars, there having been only three since 1900.) The Senior Bursar's job is to oversee the assets of the College so that its endowment income is maximized. Dr Bradfield was one of the first college bursars to understand the importance of equity investment for these funds, eschewing the higher immediate income available on fixed interest securities in the reasonable expectation that better long-term returns would be earned. Because Trinity has, like so many Oxbridge colleges, a large property endowment, the college has tried to manage that estate to the best advantage: new student buildings have been developed, (much like the similarly endowed St John's, Oxford), and other property improved.

Bradfield's predecessor, Tressilion Nicholas, who had taken over in 1929, followed a policy of buying farms during the Depression. One of these was a large estate outside the Suffolk port of Felixstowe; as Britain's trade with Europe began to supersede that with North America and the Commonwealth, so the amount of sea trade which went through east coast ports burgeoned at the expense of cities like Liverpool. European Ferries took the opportunity to expand Felixstowe, and as the port grew,

it needed the land that Nicholas had bought for Trinity all those years previously. So the idea that long-held land investments could suddenly become prime development sites was not new.

Trinity, inspired by a university committee, imported from the United States the idea that a university town could support flourishing commercial research and development centres. Route 128 around Boston is flanked by 'high-tech' industries attracted by the Massachussets Institute of Technology. Very much as the experts did not believe that edge-of-town retailing could come to Britain, there was great scepticism that the science park concept would translate well to a British city. In 1970, Bradfield began the planning of the Cambridge Science Park on land which had belonged to the College for centuries. The first units were begun in April 1973, and the park was officially opened in 1975. By June 1990, 875,000 square feet of space was complete, with a further 270,000 square feet planned. Trinity has not developed all the buildings itself, often preferring to sell building leases to developers, but it keeps a strict control on the Park as a whole: the use of buildings is limited to scientific research, 'light industrial production dependent on regular consultation with the tenant's own research, development and design staff established in the Cambridge area', and 'ancillary activities appropriate to a Science Park'. The building density, at one square foot of space for every six square feet of land, (16 per cent site cover), compares favourably with the traditional 50 per cent cover of many industrial estates. Although there are few formal links between the University and the Park, the fact that so many academics are either principals in or consultants to the companies means that the development has long passed 'critical mass' in attracting similar companies. Even in the 1990 recession, few of the tenants had gone out of business. Tressilion Nicholas was able to see the fruits of his successor's stewardship; he died in 1990 aged 101. Now Trinity is in the early stages of developing a successor, the Eureka park at Ashford, Kent, an important road and rail link to the Channel Tunnel.

Aztec West was a purely commercial venture. As land and buildings became more expensive and skilled workers more difficult to find in the south-east of England, developers sought to attract industry to other centres. The Electricity industry pension fund, Electricity Supply Nominees (ESN), developed Aztec West on a site bounded by the junction of the M4 and M5 at Almondsbury, north-west of Bristol. The initial buildings were simply industrial units with a higher-than-normal level of office space, and the architecture of the site was certainly no breakthrough. As the development proceeded, however, more enterprising designs were incorporated. At the same time the development changed hands, being acquired by Arlington Securities, which in turn was taken over by British Aerospace. In 1986 John Outram designed some small light industrial units and in 1987/88 CZWG, (Campbell Zogolovitch Wilkinson and Gough), produced some Art-Deco buildings of unusual form. Piers Gough describes the work of his partnership as 'B-movie architecture'.

In contrast to the dynamic changes in commercial architecture, there are few signs of any real movement forward in the large building projects of the state sector. Although the *Sunday Times* awarded its Building of the Year 1991 accolade to a Hampshire primary school with a block of six council flats in Walthamstow as close challengers, the Hyatt Hotel, part of Birmingham's new Convention Centre complex, won the wooden spoon. The whole Convention Centre, part of Birmingham's well-intentioned attempt to re-establish itself as England's second city, is pure state monolithic in design, as if the 1980s had not happened at all. Whereas the inside of the buildings may be perfectly suited to their roles, particularly the new concert hall with its meticulously adjusted acoustic, from the outside we are back to the uncompromising blocks of buildings that the 1970s led us to learn to loathe.

The property boom of the 1980s saw a dramatic change in the architecture of business premises. It is far too soon to make final judgements about whether the new styles will age well and be identifiable in a hundred or more years' time as a worthy testimony to a decade. There are some who are already condemning the new buildings as meretricious and appropriate memorials to the commercialism of the 1980s. Those who work in and around them would, I believe, prefer to let future architectural historians decide, and merely be grateful that fewer buildings of the 1980s than of the two previous decades are unpleasant to work in and a positive irritation to the eye. Some of the buildings from Modernists, Post-Modernists and Neo-Classicists alike may indeed become treasured legacies to future generations.

3

A STRONG BREW

IN JULY 1978 an obscure tea company, Rosehaugh, was re-listed on the London Stock Exchange having bought 28.3 per cent of an even more obscure company named Sunbourne Properties for the princely sum of £850, and 20 per cent of the altogether more substantial Tannergate, which had earlier bought a mixed property portfolio from the Legal & General for £15.5m; the shares of Rosehaugh had been suspended in May at the equivalent of seven pence a share. These modest transactions launched the public company career of one of the most complex characters in the British property boom of the 1980s, Godfrey Bradman, a soft-spoken accountant with a most unlikely background for a property tycoon.

Bradman's paternal grandparents were Jewish immigrants to England in 1902 who had set up a shop in Brick Lane, now the centre of the Bangladeshi community. Godfrey was born in Willesden in 1936. When he was only four he was evacuated with his mother to Long Melford in Suffolk while his father served in the RAF. He describes his 'very rural' life in Suffolk, where his brother and sister were born, as being 'in somewhat reduced circumstances'. Leaving the local school at 15 with no 'O' levels, he went to work as office boy in nearby Sudbury for the local accountants Bensusan, Butt Eves. Apart from the traditional task of making the tea, he also had to stoke the boiler, fetching the coal from the cellar, and collect parcels from the bus which conveyed documents to and from the partnership's head office in Colchester. Bradman describes it today as 'a Dickensian existence; you could only write in the clients' books with dip-in pens with steel nibs.' Being a bright boy with ambition, he set about gaining the qualifications necessary before he could be articled to the accountancy profession. He took his GCE 'O' Levels by correspondence course with Wolsey Hall, perhaps their most successful client ever. There were disadvantages to trying to pass exams this way, particularly in such subjects as Chemistry where opportunities for practical experiments were non-existent. Bradman showed his typical attention to the fine print and realized that to pass Physics-with-

Chemistry required a mark of 47 per cent and half the marks for the exam were awarded for Physics. Since this was a subject with a more theoretical bent which he was good at, he concentrated on that part of the exam, treating any marks he picked up in Chemistry as a bonus.

His employers would not take him on as an articled clerk without the traditional premium of 500 guineas, which he and his family simply didn't have, so he found a partnership in London which would take him and at the age of 19 he moved to the capital. While still an articled clerk he took an interest in property but it was not until he qualified that it played an important part in his life. As a newly minted 24-year-old ACA he set up as a sole practitioner, taking the lease of one floor in an office in Baker Street for £400 a year. He immediately sub-let part of the space to a firm of actuaries for £720 a year, leaving him with an office, which he lined with yards of books bought at Foyles, and an income of £320 a year. Since he had only three accountancy clients at the time, one paying 10 guineas a year, one £40 a year and the third four pounds per month, this was not going to be sufficient to fulfil Bradman's ambitions. Making something out of nothing is the hallmark of the Bradman story and his next step was a classic example.

As a professional person, he was entitled to commission on any life assurance policies he sold; these commissions, as the life offices are still reluctant to admit, often eat up the first year or two of the monthly premium payments. Bradman took out a £20,000 life policy on his own life, without-profits, for an initial monthly premium of £18; the commission receivable was two per cent of the sum assured, or £400, payable immediately to him. He then took out another policy for £110,000, the first premium being paid for with the commission on the smaller policy, and he had enough income from that commission to pay the premiums on both policies for some time and with cash to spare. He had also realized that, after a few years, there was a surrender value on the policies, which could be as much as one year's premiums. In the meantime he had use of the life offices' money to keep him going while he built up his accountancy practice and property interests. 'Armed with that I had enough income for two years and was able to spend them reading and continuing my studies. I had few clients but I gave them an extremely good service and so the practice quickly built up.' As it grew Bradman took on partners, initially Bernard Faber, who later became involved in property himself with a company called London & City, and Bradman's younger brother.

The Bradman family had not allowed their modest background to hold them back: Bradman's brother had qualified as a biologist and taken a degree in parasitology but, while studying for his PhD, also qualified as an accountant. Part of the practice was repeating the cash-flow ploy of the life policies for clients, on whose lives they wrote tens of millions of business. Bradman understood that while there were plenty of efficient 'tickers', keepers of proper books of accounts, his clients were interested in practical applications of accounting expertise.

By 1963 property was already an important part of Bradman's business. He bought a lease at 4–6 Savile Row from lessees who thought that their lease prevented them from sub-letting at a rent lower than that which they themselves were paying. 'But they hadn't read their lease properly. They paid me £30,000 to take the lease off their hands and we were able to sublet it in ten days at the market rent, slightly less than they were paying.' With the profit from that deal Bradman then bought a 20-year profit rental on 18/19 Savile Row for 'a very small amount of money.' By now the size of the deals was beginning to escalate, since the next purchase was of a lease on 29/30 Leicester Square for £550,000 from the industrial company BICC. The superior landlord of this property was Max Joseph, the entrepreneur who built up what is now Grand Metropolitan, and who was John Ritblat's [of British Land] property sponsor. Joseph held a 986-year lease on the property at £13,000 a year payable to Legal & General, the freeholder. The two men put their interests together and sold them for £1.35m; 'quite a nice deal' says Bradman today, especially for one who had so recently been a mere articled clerk. By this time Bradman had moved offices to 83 Wigmore Street, over a restaurant called Platos.

Property was not the activity in which Bradman made his name and first fortune. His skills at understanding the detail of any transaction had built him a reputation as a master of tax planning, which evolved into the tax avoidance industry of the late 1960s and 1970s. The subject is covered in great detail in Nigel Tutt's book *The History of Tax Avoidance*, but the art is worth describing since it demonstrates briefly how Bradman's obsession for detail developed. The UK had become, under Harold Wilson's Labour government of 1964–70, a high tax area, particularly on 'unearned' income and short-term capital gains, where, in one year the rate of marginal tax reached 137 per cent of earnings. As Godfrey Bradman comments this was 'quite a strong motivation' to minimize an individual's or a company's exposure to such tax rates. Tax law at that time was governed by the principle that, if the law did not specifically rule out a scheme by which the tax could be avoided or the taxable event postponed indefinitely, then it was valid. Tax evasion, the deliberate hiding of income or gains from the Inland Revenue was then, as it is now, illegal. Governments were aware of the problem and had introduced specific legislation to head off the most obvious sources of avoidance such as bond washing and dividend stripping; these were processes by which investors turned income, which was heavily taxed, into capital, which until the early 1960s had not been taxed at all. Similar schemes now surfaced in the 1960s whereby such pop stars as Tom Jones and Engelbert Humperdinck sold the rights to their future income to a company in return for a lump sum or shares in the company, which would also pay them a modest salary. Management Agency and Music and Hemdale were two companies which flourished in the late 1960s from such schemes, which were perfectly legal at the time. Bradman's schemes were simple in concept and entirely artificial but 'hideously complicated' in execution

according to Tutt. He describes meetings in Bradman's Wigmore Street office where the participants were sworn to secrecy, since the value to Bradman was in the fact that no-one else knew how to construct such schemes.

Tutt quotes a scheme as an example of how tax could be avoided involving the Rose brothers, well-known property investors, whose publicly quoted company owned the Woolworth head office in Marylebone Road. Just before the end of the tax year in 1969 the brothers and a third partner had sold shares in five companies to a Bradman company, Excalibur, for £471,998. They were not to receive that sum immediately however; instead they were to be paid £150 a year for 200 years and a final payment of £441,898 on 3 April 2169, together with interest charged at ten and a quarter per cent. On 8 April, in the new tax year, Excalibur leased the properties just purchased to another company, Geltan, for 999 years with an optional break at 49 years, Geltan paying £982,862, to be settled over the period of the leases. Geltan then sold its interest in the leases and Excalibur sold its interest in the remaining freeholds to another Bradman company called County. County then sold the remarried interest in the properties to a company, Central, controlled by the Roses and their partner, for £989,095. Meanwhile yet another Bradman company had bought the property owners' interest in the 200 years of payments from Excalibur for £471,848. The Roses had retained ownership of their properties but had received nearly £500,000 cash which the Revenue could not tax since it was in exchange for the deferred payments from Excalibur. The Roses had to invest the £472,000 straight back into Central as a loan to pay for the repurchase but a loan can be refinanced and its repayment does not give rise to tax. Confused? This is a very simplified version of the scheme which actually involved 25 separate transactions. The Inland Revenue tried to block the scheme, taking it to the House of Lords, but their Lordships ruled in the Roses' favour. Bradman had earned his £80,000 fee. In August 1971 the Inland Revenue announced that such schemes were to be stopped and legislation was introduced to give that intention the force of law in the 1972 Finance Act.

In 1974 Godfrey Bradman made his first appearance in the public eye. The coal miners had been on a go-slow since late in 1973 and the Heath government had imposed a three-day working week, with the use of electricity being forbidden at certain periods to preserve coal stocks. The government finally accepted the need to put the case to a special tribunal, but the miners' leader Joe Gormley would not postpone the all-out strike which the miners had voted for. Prime Minister Heath eventually called a General Election for 28 February, which he failed to win, allowing Harold Wilson to form a minority government. At the beginning of February, Bradman proposed to Joe Gormley that, in exchange for reconvening his National Executive and voting to postpone the strike until the tribunal's findings were known, a group of businessmen would pay the miners an extra sum during that period; the total cost would be

£2.4 million, 'modest money by today's standards. The slightest embarrassing thing was that the week before he had refused Edward Heath's request to reconvene the National Executive.'

The change of government in March 1974, after a week-end of comings and goings as Heath tried to save his government, which had actually won more popular votes than Labour, saw two notable changes in Bradman's life. On the one hand the even higher tax rates which Denis Healey the new Chancellor of the Exchequer brought in to make 'the pips squeak', increased the demand for good tax planning and avoidance; on the other hand the new administration was determined to act tough with the tax avoiders. One of the new Chancellor's first measures was to introduce interest penalties on late payments of tax. For most tax avoidance schemes this was a serious blow since they often relied on the complexity of the substance to keep the Revenue tied up for years before a final decision was made as to their validity. Meanwhile the taxpayer would have the use of his money. 'Ten years use of the money is almost as good as not having to pay it at all' said Bradman. By this time Bradman had a company which acted as holding company for his many interests, London Mercantile Corporation, and the tax avoidance schemes had moved onto a new footing. This time the idea was the 'reverse annuity'; a company, instead of paying a lump sum in exchange for a future flow of income, as is the case in annuities, would receive a lump sum and promise to make a series of cash payments in the future. The cash received would either be wholly or mostly exempt from tax, whereas the yearly payments would be deductible for tax by the payer, even if some would then be taxable in the hands of the recipient. However, increasingly tough legislation, coupled later with the progressive reduction of direct taxation by the Conservative Government elected in June 1979, meant that tax planning schemes were in less demand.

By 1977, Godfrey Bradman had had enough of tax planning as a career. 'To be honest I wanted to do something that was more productive.' His property interests were by now quite substantial, and they were structured in the typical Bradman fashion with plenty of partners who were prepared to put all the money up but to share the profits with Bradman's companies. In February 1977, Bradman bought the portfolio of 'probably 2,000 individual units' from Legal & General for £15.5 million through Tannergate, of which Bradman owned only 20 per cent. In the same year a company named Sunvale bought Maple House in Tottenham Court Road, now known as International House. Sunvale was itself a subsidiary of Sunbourne Properties, of which Bradman owned 28.3 per cent. Sunbourne took a lease on Riverside House, Wood Green, North London and sold the resulting investment with its continuing obligation to pay rent on the 85,000 square foot offices, to the Coal Board pension funds, 'for a profit of £5–6 million', (although since Coal Industry Nominees, the Coal Board funds, sold the same property in 1987 for only £6 million this seems an unlikely profit figure). The profit,

whatever it was, was the equity invested that same afternoon in Maple House, a 175,000 square foot office and shop development which cost Sunvale £11.25 million, the balance financed by borrowings.

It was in 1978 that Godfrey Bradman finally emerged as a public company director. The vehicle chosen could not have been more obscure: in May 1978 the Stock Exchange announced the suspension of the listing of shares in Rosehaugh, a tiny tea company with assets of 12.8p a share and no profits, trading at seven pence a share, (equivalent to under two pence in the share's current form). In July the shares were re-listed on the announcement of two acquisitions from London Mercantile of shares in both Tannergate and Sunbourne. Rosehaugh now held 20 per cent of Tannergate, which, over the year since its purchase by Bradman, had sold enough properties to give it net assets of £1.5 million, with the remaining properties in the books at £8 million but valued at £13.7 million. Sunbourne meanwhile had sold its major asset, International House, to the British Steel pension fund for £15 million. The purchase of 28.3 per cent of Sunbourne by Rosehaugh valued the shareholding at £850, each one per cent being valued at £30. Over the next three years Rosehaugh bought out its partners at prices which demonstrate the rewards of successful property dealing in companies where most of the purchase is financed through borrowings. In September 1980, Rosehaugh bought out two of its three partners, Henry Davis and Blackwood Hodge, for a total of £305,235, valuing their 16.67 per cent holding at £18,310 per one per cent, paid for in Rosehaugh shares. When Bernard Sunley Investment Trust sold out its 50 per cent interest in May 1981, the price Rosehaugh paid was £1.4 million, equivalent to £28,000 per one per cent share in Sunbourne, an immodest return on their investment only four years earlier.

Godfrey Bradman is far removed from the traditional picture of a property developer. A small, quietly spoken man, he has none of the bonhomous persona of so many of his rivals and colleagues. It is typical for instance that he has never changed the name of his public company vehicle, despite the fact that for the first few years of its existence investors could not make up their mind whether the pronunciation was 'Rosehuff' or the correct 'Rosehaw'; there was a cost and no particular value involved in a name change and Godfrey Bradman is not a vain man. What everybody agrees about is that he is clever. One investment man who became close to Bradman returned from their first meeting to inform his colleagues 'here you have the greatest money-making machine ever.' Another property man who has worked with him over many years described him as being 'a first class tax accountant with a very, very determined, persevering, precise mind. He is never happier than when he is working his way through tax and other mechanistic deals.' True property men speak rather disparagingly of his property acumen, as not understanding the concept of how property values grow. Indeed he is said to have confessed at one stage that he never goes to see a property because

he wouldn't know what to look for and he finds most of it appalling anyway. Nevertheless he built up one of the largest development companies in the UK and been party to some of the most striking developments. Unfortunately the locomotive became derailed at some stage and from being a man who could do no wrong he spent 1990 and 1991 striving, and failing, to save his company.

The early deals done by Rosehaugh after it came under the control of Godfrey Bradman were similar to its initial investments: low risk. In October 1980 a subsidiary, Bolansbourne, bought for £9.875 million a portfolio of six properties from the Coal Board pension fund's new subsidiary British Investment Trust, immediately selling two of the assets for £7.2 million, leaving properties in Hammersmith, Victoria, Old Street and Berkhamsted with a net cost of only £2.7 million and a rent roll of more than £750,000 per annum. The sellers insisted on receiving cash for their assets, not knowing too much about Mr Bradman or Rosehaugh and not wanting to depend on the company's shares for realizing value; this initially proved to be a poor decision.

In December 1980 came the transaction which set Rosehaugh on the way to the major league. Another company with an 'off-the-shelf' name, Jamplane, announced the purchase of two buildings in Wilson Street on the northern fringes of the City, actually in the Borough of Hackney, from National Freight and British Rail for £3.925 million. Rosehaugh paid only £5,000 for 50 per cent of this company and lent it £400,000. The other 50 per cent of Jamplane, later renamed Rosehaugh Greycoat Estates, was bought by Geoffrey Wilson and Stuart Lipton's company, Greycoat. There was a third equity partner, Ronnie Jarvis, whose company Ravensale took a 19.4 per cent share of the project, leaving each partner in Jamplane with 40.3 per cent. Jarvis, who had once been the owner of Conway Stuart, the pen company, earned his shareholding by producing the cash for the initial purchase of the development site. Even if Ronnie Jarvis took most of the risk in this way, his rewards have been handsome, since 19.6 per cent of Rosehaugh Greycoat was worth £34 million by June 1990.

The achitecture and building methods used in Finsbury Avenue were deemed to be the area of expertise of the Greycoat partners, and are dealt with in following chapters, but Godfrey Bradman's acumen with finance was to drive a coach and horses through conventional methods of raising development capital for a speculative office building project. Because both Rosehaugh and Greycoat were relatively small companies and the development was in an area hitherto unproven for offices, Bradman was advised that his proposition would be unlettable and he would also find it impossible to raise the bank finance necessary to build it. The longer-term institutions too were reluctant to join as partners for various reasons. Bradman recalls that 'I don't think the institutions had any money at that stage.'

The idea for a way around this impasse came to him in a meeting with

Eagle Star's David Jessel, who liked the idea but had no funds with which to participate. Bradman suggested that Rosehaugh Greycoat would issue a nil paid debenture stock, secured on the development, with a generous interest rate. The trick was that this debenture could only be called down three years after the initial issue date, before which time no money would change hands. The holders of the debenture would be obliged to provide the funds when they were called upon to do so. If the holders were not quoted investment trusts or acceptable insurance companies or pension funds, a guarantee that they would provide the funds would be obtained from a reputable bank. In June 1982 'we procured a number of debenture holders to subscribe for the issue, but no call was ever made. For the holders, there were no negative cash-flow implications, since no money passed, it didn't appear as a property since it was a security, it didn't appear in their balance sheets since it was nil paid; the only place it could be picked up was as a "contingent liability" in the notes to the accounts.' The reason why the debenture holders never had to pay the call was that Bradman, armed with their bank-guaranteed obligations, was now able to raise finance from more conventional sources. An American bank lent the construction finance secured only on the obligations of the debenture holders, not on the property itself. It remained the debenture holders who were secured against the development itself and a right to 30 per cent of the eventual net post-tax value of Phase 1.

The property was let at a higher rent than had been anticipated in the original plan and in November 1985 Rosehaugh Greycoat was able to issue a conventional 30-year debenture, listed on the Stock Exchange, secured on the completed and let investment, pay off the bank loan and not draw down the original debenture. The total cost of the development was £34 million, but the listed debenture raised £40 million, releasing some of the profit from the building of Phase 1 for reinvestment in the rest of the project. The debenture holders, British Land, Globe Investment Trust, Dixons Photographic and J. Rothschild, 'kicked up a rumpus' according to Bradman, because they were never required to provide cash at two and a half per cent over the London Inter-Bank Offered Rate (LIBOR), which would have made them a profit over their own cost of money. The 30 per cent equity interest they earned from subscribing to the nil-paid debenture at one stage was worth over £40 million, but it is only British Land which remains a shareholder, having bought out the other holders for £18.25 million in 1988 and 1991. This suggests that British Land almost doubled its total investment (including its own original entitlement) between 1988 and 1991. The other two phases of Finsbury Avenue were later successfully completed and let. The first rent review of Phase 1 took place in September 1989 and saw a substantial increase over the intial £19.75 a square foot rent paid by the tenants in 1984.

As well as this critical property development, Godfrey Bradman became closely involved in the revival of one of the dinosaurs of the High Street, Woolworth. The UK stores of Woolworth had been part of a

separate UK publicly quoted company for many years but the controlling shareholding was still held by the American parent. The UK Woolworth group was a byword for old-fashioned retailing, best known for its 'mix 'n' match' confectionery and its ability to offer anything from a can opener to child's clothing. Despite attempts to improve its image, ('The Wonder of Woolworth' was a prolonged marketing campaign), it was making a derisory level of profits for the capital it employed. Much of that capital was tied up in the many High Street stores which Woolworth, unlike most of its competitors, still owned. In 1981 Godfrey Bradman went to see the US Woolworth management with a proposition to buy their shares in the UK company. The US company was receptive to this idea since it too was under pressure to make its assets 'sweat'.

The deal fell through and a company name Paternoster bought the British Woolworth company in 1982. Bradman's reward for the original concept was an option on Paternoster shares and convertible stock which gave Rosehaugh a net pre-tax profit of £16 million by the time the options were fully exercised and the shares sold in 1985. Paternoster soon renamed itself Woolworth and then, after the take-overs of B&Q and Comet, its name was changed to Kingfisher. The success of the buy-in was in substantial measure a result of the breathing space afforded by utilization of the underlying property assets while a new and more specific retailing formula was developed.

The Finsbury Avenue development and the Woolworth transaction were the most financially important matters with which Rosehaugh became involved in its early years under Godfrey Bradman, and by 1981 the benefits had already become apparent to the company's shareholders. In today's price terms, adjusted for subsequent issues, the shares, which had reopened at 13p in July 1978, had risen to 48p by July 1981. Rosehaugh's advance was not restricted to the large projects. As well as making low-risk investments in portfolios of property, (as in the early Tannergate and Sunbourne examples), with Bolansbourne and Tolverne, the early development of new areas of activity may be discerned. In June 1981 Rosehaugh bought 90 per cent of housebuilder Pelham Homes for £458,000 from Ray Whatman, who joined the Rosehaugh team. At the same time another subsidiary, Copartnership, was being developed by Christopher Collins, an ex-executive of surveyors Montagu Evans, the senior partner of which, Jack Nardecchia, was and is on the board of Rosehaugh.

There were hiccups in this progress. One subsidiary failed to complete a contracted £2.28 million purchase of four acres of land for residential development from Camden Council in December 1981, a very rare circumstance for a subsidiary of a flourishing public company. In January 1982 Rosehaugh bid for the public investment company London Shop Property Trust, but failed in the attempt, and in March 1982 an 85 per cent owned subsidiary, Cardwool, was set up to buy two and a half acres of land at East Croydon railway station for £1.1 million. The projected

development on the site has yet to commence. In October 1982 the stockbrokers Bone Fitzgerald were suspended from trading; one of the company's shareholders was Godfrey Bradman. He had been a large client of the firm under its previous name and owner, Victor Sandelson, particularly in Treasury Bills.

These disappointments were as nothing against the successes, and by the end of 1983 the germination of Rosehaugh's greatest project was advancing. 'Armed with the success of Finsbury Avenue I had every year, probably two or three times a year, put to British Rail that they should let me get at the adjoining site.' The adjoining site was Broad Street and Liverpool Street Stations. In November 1983 Rosehaugh Stanhope was set up by Bradman and Stuart Lipton of Stanhope, ex-Greycoat, to bid on the development. 'There was a competition and I suppose that the submission I made to BR, which I wrote and did in a way which I don't think any competition had before, was the forerunner of the competition that took place for Kings Cross. It took me a month to write an analysis of every conceivable thing that affected their site, including the fact that their planning consent was very near, within 28 days, of expiry. We were selected and we had to move very quickly actually to commence the first phase within that 28 day period from the date of selection. Until that competition people had made submissions of 5 or 10 pages, but to make a submission which when you looked at it was that' (making a hand gesture indicating about one foot) 'deep, with bound volumes, reports from experts on town planning and engineering, was new. I suspect that there was really no competition, although Norwich Union were rather miffed that we got it and they didn't.'

Why was Stuart Lipton selected as his partner rather than continuing the successful partnership with Lipton's erstwhile colleagues at Greycoat? 'Stuart had expressed some interest (in the project) and rather than be in competition I cleared it with Greycoat that they would not object if I invited Stuart to join Rosehaugh on that project.'

Although at the time of the competition in March 1984 Rosehaugh Stanhope had only a sketch of Arup Associates' plans for the site, the next 12 months were a frenzy of activity, carrying out research into what the potential tenants of the proposed buildings wanted from the new generation of office buildings. It was determined by Frank Duffy's firm DEGW that clients needed floors of 15,000 or 20,000 square feet, rectangular and with as few columns as possible. Cores and lifts should be on the perimeter rather than in the middle of floors. Such space scarcely existed. The research did turn up some rather strange preconceptions from some of the prospective tenants. One bank thought that, since one of their dealers used 12 VDUs, maybe everyone will want to use 12 VDUs, and since some are in colour, perhaps everyone will want colour. They didn't want it cooled by chilled water in case of leaks, so they must have chilled air. The ducting and pipes for chilled air are about 17 times the diameter of water. If you go on this exponential analysis of what you need

you very quickly find that the tenants would have buildings designed which would hardly be affordable by anyone.

The letting of the initial phases of Broadgate, as the development became known, was made much easier by the fact that Finsbury Avenue had already proved a success. Broadgate was financed in almost as innovative a way as the neighbouring development. The first Phase was pre-let to Security Pacific, the Californian bank which had taken over the London brokers Hoare Govett, and Phase 2 to Shearson Lehman, the investment banking subsidiary of American Express. Phase 1 was financed through £4.25 million of capital and loans provided by Rosehaugh Stanhope and a £35 million 2½ year non-recourse loan provided by County Bank, the merchant banking subsidiary of NatWest Bank; Phase 2 by £5 million of capital and loans from the joint company and an £85 million loan from Amex Bank, another American Express subsidiary, whose associate company was to be the tenant.

Non-recourse loans were commonplace in the US but, prior to the 1980s, not known in the UK. The basic premise of a non-recourse loan is that, if something goes wrong and the borrower is unable to keep up the agreed flow of interest or capital payments, then the lender has no more security than that represented by the specific asset against which the money has been lent. In the case of Broadgate, therefore, the lenders have no recourse to the general assets of Rosehaugh Stanhope nor to those of the respective parents. Although this is true in law, and in the US it is by no means uncommon for an investor to walk away from an investment which is making losses without ruining his future in the business, (much as many home-owners in the UK have thrown their keys back at the building societies), it is far more questionable whether a British public company could abandon a property to the lender and hope to have future access to bank funds. Godfrey Bradman responds to the question of responsibility over non-recourse loans rather circumspectly: 'That's a big issue. It would be very difficult to walk away from a wholly-owned and managed non-recourse loan, but if it was in a company where you had only a 15 per cent interest then one has to consider what one's responsibilities are.'

Another feature of the Broadgate development and one which was crucial in persuading the British Rail Property Board to back Rosehaugh Stanhope rather than any of the other potential developers was the profit share deal agreed between the two parties. The payment to BR consisted of two parts, the initial purchase price and a subsequent deferred purchase price. On Phases 1 to 4 the initial purchase price was £87.8 million. The deferred element of the purchase price on these Phases depended on the cost of the development, the rents achieved and the time at which BR claimed its share. By 30 June 1990 BR had been paid £125 million as its share of Phases 1 to 3, with a further £40 million outstanding on Phases 4, 6, 7, 9/10 and 11 at that date. One other party has an interest in the Broadgate development, David Blackburn, who was director of

Rosehaugh until 1985 and previously an associate of Godfrey Bradman in his tax planning days. Blackburn resigned from the Rosehaugh board but maintained a consultancy with Rosehaugh Stanhope which gave him 5 per cent of the surpluses on all Broadgate's Phases except numbers 1 and 2. Outside observers have commented that the loss of the talented David Blackburn as a second voice at the top of Rosehaugh was a significant factor in the later problems that the company faced. Godfrey Bradman himself commented that Blackburn liked to 'work very intently on one single thing.' That single thing was Broadgate. By the end of June 1990, David Blackburn's company had received commissions of almost £12 million out of nearly £15 million which had been provided for in the accounts of Rosehaugh Stanhope.

By this stage Rosehaugh had begun to move away from the relatively focused approach to development, based on large, well financed projects, often in new locations. As well as Pelham Homes in house-building, Bradman had in 1984 set up a subsidiary to develop shopping centres. His partner was Ian Pearce and the subsidiary, in which Pearce had a share, was named Shearwater. Initially this subsidiary seemed to be following the successful pattern of Rosehaugh's office developments. A joint company was formed between Shearwater and Hepworth, the clothes retailer soon renamed Next, to redevelop Northampton's Peacock Way shopping centre, and in July a further joint company was formed with Associated British Ports (ABP) to create a new shop, office and housing project in Southampton to be known as Ocean Village. Smaller schemes included the new shopping centres in Kendal, Cumbria and Prescot, Merseyside, which received £3 million from public funds as a stimulus to development in such a run-down area. In the development of housing, Rosehaugh was the 50 per cent partner in a group which built 24 houses on the site of Witanhurst, one of the grand Highgate houses overlooking Hampstead Heath. Each of these houses was priced between £750,000 and £1.5 million in 1985, before the late 1980s housing boom took off; one of the partners in the scheme was the Finnish bank KOP. A company was also set up with John Duggan, the Irish property man, later to form Phoenix, which was in turn taken over by Tony Clegg's Mountleigh.

The joint venture between Bradman and Duggan did not succeed. Duggan's approach was to find a deal which would make money fast. Bradman liked a methodical and fully researched approach. Duggan makes a gesture with his hands to describe it, 'You have to have the book. At my first board meeting he turned down something that would make us an instant £500,000, and really it was over from that moment.' It did not help that Duggan was a keen shot and Bradman a vegetarian: 'The first lunch I had with him was a disaster' says Duggan. In Duggan's view Bradman 'didn't understand property feel. You can nickel and dime any deal, any piece of paper, but if you don't have a feel for it, it's no good.' After 14 months the two went their separate ways. The risk-averse,

methodical Bradman and the dealer Duggan were a strange mixture and it is surprising that either felt such chemistry would work.

As Rosehaugh grew, it began to need more equity itself to support the rising tide of development and in April 1986 the company raised £58.9 million through a rights issue, gratefully taken up by the growing band of Bradman admirers. Shearwater was proving to be an active developer, winning the right to redevelop the centre of Eastleigh in Hampshire and forming a joint company with Blue Circle Industries, the cement manufacturer, to develop a retail and leisure park on the site of one of the worked-out limestone quarries left by BCI in the green belt of Kent at Swanscombe. A further diversification was the setting up of another subsidiary, Rosehaugh Heritage, based in Bath, to redevelop architecturally sensitive sites.

Meanwhile Broadgate was continuing to advance with a further letting agreed before Prime Minister Thatcher returned to top out the first two Phases on 11 July 1986. Union Bank of Switzerland decided to take the 380,000 square feet of offices in Phase 3, facing onto Liverpool Street on the site of the old Broad Street Station buildings, for its newly acquired brokerage subsidiary, Phillips and Drew, on a rent of £35 per square foot. The bank agreed to provide the bank finance for the building of this Phase themselves, as Amex had done before them. By the late summer of 1986 Rosehaugh Stanhope had taken an interest in land in Docklands on which they planned a 3.8 million square foot development of shops, offices and homes designed by Richard Rogers. Rosehaugh's own trading subsidiary Baxtergate bought South Quay Plaza 2 on the Isle of Dogs for £22 million. The attraction was not wholly the building itself; the purchase enabled Rosehaugh to shelter much of its profit in that year from tax.

In December 1986 Rosehaugh entered into another joint venture to develop an office at the junction of Crosswall and Crutched Friars in the City with Wimpey and Haslemere Estates. This building has since had a chequered history. The consortium built and let the development to Jardine Mathieson, the company which was the model for James Clavell's book on Hong Kong, *Taipan*. The property was then sold in 1989 to Land and Property Trust, run by Berish Berger, a family member of one of London's foremost residential landlords, for £60 million. Land and Property was put into administration in 1991, but by then it had already sold the building to a 'European consortium'. The curse of Crusader House was then visited on those investors too as they defaulted on payments to their bank, Banque Bruxelles, which in 1991 took possession of its tainted asset.

Bradman was not content to be responsible for the biggest single development in London; he had plans to be involved in them all. In 1986 he became involved in the competition to redevelop Spitalfields market across Bishopsgate from Broadgate and by the end of the year Rosehaugh Stanhope had announced plans to develop one million square feet along the line of the railway which carried trains from South London between

Blackfriars and Holborn Viaduct. By 1987 Rosehaugh Stanhope was also showing interest in the redevelopment of Paddington Basin, a little known enclave of London hidden between the Westway elevated section of the A40 and St Mary's Hospital and the hinterland of Kings Cross Station. The propensity to think big was instilled into the management of Rosehaugh's subsidiary companies. Ian Pearce, who ran the Shearwater retail development subsidiary, was quoted in 1986 as having been told by Bradman 'You can lose as much on a small development if it goes wrong as on a major project, but the upside is not nearly as exciting.'

Godfrey Bradman had, by early 1987, established himself as perhaps the pre-eminent property developer in the UK, certainly amongst the quoted companies since Stuart Lipton, his only realistic competitor for the title in public eyes, had not yet brought Stanhope to the Unlisted Securities Market. His reputation was enhanced by his extra-mural involvement in many activities not usually associated with the property developer. As long ago as 1982 Bradman had financed the initial publicity for the campaign for lead-free petrol, CLEAR. He convened an ad-hoc committee of scientists which decided that it needed a professional campaigner as its executive director: Des Wilson, veteran of single issue campaigns such as Shelter, the campaign for the homeless, and the Liberal Democrat's 1992 election campaign director, was appointed by Bradman, the start of a long association between the two men. Bradman's initial £100,000 financing brought its reward in the 1983 government commitment to phase lead out of petrol and in the 1988 Budget when Chancellor Nigel Lawson applied the strongest impetus to the campaign by introducing an attractive tax differential to the pricing of lead-free petrol, since which time lead-free has gained over 40 per cent of the petrol market. Wilson and Bradman have been associated with various other public campaigns since then including the Campaign for Freedom of Information at a time when civil servants were being prosecuted for leaking confidential information to the press. Bradman was also closely concerned with the campaign to force the pharmaceutical company Eli Lilly to pay compensation to people who had suffered serious side-effects from its anti-arthritis drug, Opren.

As Chairman of Friends of the Earth Trust Bradman has also contributed to the development of environmental issues in the building trade. In 1985 he commissioned a study Hazardous Building Materials, edited by two lecturers at the University of Salford and published in 1986; in its preface he wrote 'In my own business, I have sought to ensure that great care be taken in the selection of safe and suitable building materials, and that it is recognized that we owe to people buildings which are safe environmentally as well as structurally.' In 1988 Rosehaugh itself published a guide to Legionnaire's Disease and Bradman organized a conference at the School of Hygiene and Tropical Medicine, of which he was also on the Council, to discuss the bacteria. In the same year he sponsored a study of the use of CFCs in Buildings. The culminating

publication in this area of interest was *Buildings and Health – The Rosehaugh Guide to the Design, Construction, Use and Management of Buildings* which was published by the Royal Institute of British Architects in 1990. This 520 page book contains all the information necessary to avoid threats to health in buildings, from CFCs to mice. Bradman has also concerned himself with many other health campaigns varying from Parents Against Tobacco to an Aids Policy Unit.

Although 1987 was a year of dramatic further progress for Rosehaugh, the stock market crash on 19 October sowed the seeds of the substantial problems the company eventually faced. Earlier that year the company had raised a further £82 million through the purchase for shares of General Funds Investment Trust, the portfolio of which was easily liquidated in the euphoric bull market which marked the first part of the year. Rosehaugh Greycoat's second and third phases of Finsbury Avenue were let, and Reuters contracted to buy a development in Docklands. Broadgate was letting well, with Japanese interest in Phase 4 (confusingly known as 6 Broadgate) and County NatWest took Phase 6. In December 1987 the Prince of Wales formally opened the Broadgate development, an occasion marked by a skating demonstration in the pouring rain by British Olympic gold medallists Torville and Dean on the ice-rink in Broadgate Circle. The Prince, the well known architecture critic, restricted himself to an anodyne comment about the redevelopment itself.

Perhaps the first sign of potential trouble for Rosehaugh was the rise in interest rates in August 1987, although this was quickly shrugged off by the markets. The effect of economic policy on the property market at this time is described in a later chapter, but the pace of lettings in the City, and in Broadgate, began to decelerate as a result of the crash, while building continued apace in all quarters of the capital. Rosehaugh's own share price was among those most severely affected by the market fall, and, although it recovered for a time, it never regained those levels. Bradman ignored the implicit warning contained in the market's gyrations and the company became involved in a veritable orgy of new projects. In February 1988 the American bank Bankers Trust actually bought Phase 5 of Broadgate outright for about £100 million which gave the Rosehaugh Stanhope company two years of large reported profits. Stockbrokers Laing and Cruickshank, which had recently been taken over by the French bank Credit Lyonnais, took the bulk of space in Phases 9/10. Rosehaugh Stanhope was selected by the LDDC as the developer of the huge Royal Albert Docks at the eastern end of Docklands and by British Rail, after a bruising contest with Speyhawk on which Rosehaugh Stanhope spent £6 million, as the developers of Kings Cross. The Kings Cross development created a lot of suspicion among local residents and politicians and drew the comment from Godfrey Bradman that 'If it were not for the (legitimate) desire for commercial secrecy on the part of British Rail and the other public owners of the site I would be happy, in principle, for the public to have access to the commercial calculations which will

determine the density and balance of development on the site. Otherwise people become suspicious. They ask "What are these chaps creaming off?".'

At the same time Rosehaugh embarked on the largest housing development in the UK, the 5,000 homes and related buildings of Chafford Hundred, a glamorous name for a rather dull piece of flat Essex land in Grays, built in partnership with Blue Circle (again) and the publishing and banking conglomerate Pearson. Shearwater too was wasting no time: new projects included retail developments in Trowbridge, Camberley, Newcastle and Caernarvon. It had not yet proved difficult for Rosehaugh to raise finance for its projects; in July 1988 County NatWest raised a syndicated loan of £350 million to finance the building of the later stages of Broadgate, just beating the £300 million loan raised by NatWest for Phases 6 and 7 in January 1987. The bank executive responsible for that deal, the funds for which were 60 per cent provided by Japanese banks, was Paul Rivlin, later to join the Rosehaugh board.

Although everything continued to progress along its normal ambitious path during late 1988 and into 1989, the rise in interest rates and, certainly from early 1989 the slow-down of parts of the economy, particularly retail sales, house price rises and the financial services sector, were starting to affect the outlook for property. By September 1989 Bradman was threatening to withdraw from the Royal Docks scheme as he was frustrated by the lack of progress with the LDDC and there was an uncharacteristic dearth of new projects announced during the year. Bradman had in fact agreed to step back within Rosehaugh: 'We did take on a number of people to deal with the expansion of the Group as a whole. I agreed to the idea of having joint chief executives with me being executive Chairman. If there's any idea I really regret it's for that period of time I was not chief executive and in retrospect it was not helpful.'

The fundamental strength of Bradman's concept for Rosehaugh was the 'principle that I had enunciated originally about minimizing and laying off risk. At a certain stage a lot of people tended to forget how important that was.' The secret of Rosehaugh's success was that it 'developed with someone else's money on someone else's land' as Trevor Osborne of Speyhawk describes the formula. The money came from the banks, who embraced the 'non-recourse' concept with enthusiasm, especially the US banks who were familiar with it at home and the Japanese banks who were so anxious to increase their market share for most of the 1980s.

By June 1990, Rosehaugh Stanhope had property assets of almost £1.7 billion, supported by only the £1,012,000 original cash equity investment from its two shareholders; a company with over £1,200,000,000 of borrowing on such a low investment is probably unprecedented in recent history, and is only possible because the properties threw up a valuation of £450 million more than their cost, including the £29 million after-tax profit taken on selling Phase 5 to its occupier, Bankers Trust. The

problem for the developer is that, even when the properties are built and let, there is still a deficit between rent and the interest payable on the loans. When much of the debt was taken on, in the mid-1980s, interest rates were in single figures for a time and it was possible to forecast that this cash shortfall might be quite small, but as rates rose to the 15 per cent level they reached in October 1989 and stayed at that level for exactly a year, then the cash-flow deficit became less manageable.

Other property developers insured themselves against such eventualities by buying a 'cap' on their interest rate costs, by which the banks, for a relatively modest payment, will not charge more than an agreed rate on the loan, a liability they themselves can lay off in the money markets. Rosehaugh chose not to do this with all its loans, and, as one developer says, 'Bradman got it wrong. He really thought interest rates were coming down to 6 per cent.' The accounts of Rosehaugh Stanhope show that the banks paid £5.9 million as a result of 'interest rate protection agreements', but this has to be set against total interest paid of £163 million. Although Rosehaugh and Stanhope seem to have invested only £½ million in their joint company, their involvement is much greater. They had lent the development company £187 million by June 1990 and they were owed a further £64 million on interest due to them but not paid over. In the restructuring of Rosehaugh Stanhope in November 1992, these debts were either written off or translated into equity investment.

Raising the further £45 million of capital that Rosehaugh effectively had to put into the joint company in the year between June 1989 and June 1990 was a serious burden. It was made worse because other areas of the business were not able to provide the resources. Although Pelham Homes had a very cheap land bank, house sales came to a grinding halt; many of the Shearwater developments proved impossible to progress with and it became known that Rosehaugh was an aggressive seller of assets. The final confirmation that all was not well was the announcement on 5 February 1990 of a rights issue to raise £125 million. The Rosehaugh share price was already very depressed, so that a rights issue at this price, well under half its peak level, was deemed a mark of weakness and the shares fell sharply towards the issue price. The issue was not underwritten by institutions in the normal way and there was no guarantee that the money would be subscribed by the existing shareholders, in which case the company would have received nothing, with incalculable consequences for Rosehaugh.

The following months contained little good news for the company. Rosehaugh was pulled out of the planned development of the Royal Docks, frustrated by the delays of dealing with the LDDC and leaving Stanhope still involved. Godfrey Bradman then confirmed what had been the talk of the industry in recent months, that the Ludgate and Kings Cross schemes would be the last to be carried out by Rosehaugh Stanhope; (Ludgate was the ambitious plan to build a string of offices down the line of the railway linking Holborn Viaduct and Blackfriars

railway stations). There has been a lot of lurid speculation about the reasons for the break-up of the most productive property partnership between two separate companies of the decade, but the truth is probably more prosaic. 'It's true to say that both companies did not originally have the full range of personnel to undertake such big developments and it was a marriage of convenience to share in the resources and skills, but as both companies grew neither company, frankly, needed the other', explains Bradman. There is no doubt too that the personalities of Bradman and Lipton are diametrically opposed, the former being relatively introverted and the latter being more characteristic of a property developer with his extrovert personality. Another close observer notes that by the end of the partnership each was encroaching on the businesses of the respective parent companies, which was unwelcome.

It was Shearwater's activities which were probably the most adversely affected by the economic recession which had finally taken grip in 1990 after nine years of uninterrupted growth. The subsidiary was sacked as developer of a Sheffield canal-side scheme for failing to come up with funding in good time, and the same happened in Camberley; of its own volition it pulled out of the Blue Water scheme, which was sold to the partner BCI for only £5 million. By the time the half-year figures to 31 December 1989 were announced in April 1990, the company had decided to take a £12 million write-off on 'projects which may not be progressed.' In October Ian Pearce of Shearwater and Ian Rowberry of Copartnership left Rosehaugh and the operations of those subsidiaries were cut back. Rosehaugh was forced to sell its own head office in Marylebone Lane just north of Oxford Street to a Swedish company for £23.5 million, and Rosehaugh Heritage was sold to a subsidiary of Kingfisher, the Woolworth holding company, for £35 million, incurring a further write-down of £16.5 million against the value at which the company was carried in the books.

The news was not universally bad for the company in 1990. The Ludgate development was given a welcome boost by the announcement that Coopers and Lybrand Deloitte had agreed to take over 500,000 square feet of the 600,000 square feet development, and project financing was secured for its completion. Coopers had earlier taken Greycoat's Embankment Place development, and, although they were now not going to occupy it, would still be liable for paying the rent on that property too until it found another party to take over the lease. In the event it became known in 1991 that Coopers had never signed a lease for Ludgate, leaving Rosehaugh Stanhope without an anchor tenant for the development.

Lettings in Broadgate continued, albeit at a slower pace, but no buyer appeared for Phase 6 (4 Broadgate), for which the developers were seeking over £200 million. During 1990 Rosehaugh acquired three important new shareholders: JMB Realty, Olympia & York and Ravensale. JMB is a privately owned American property investor with a $20 billion US property portfolio, and had previously bought the British property

trading phenomenon Randsworth; Olympia & York is the Reichmann's company, which owns a third of Stuart Lipton's Stanhope company and is developing Canary Wharf; Ravensale is the company in which Ronnie Jarvis, the original investor in Finsbury Avenue holds his property interests. The first rent review on 1 Finsbury Avenue also contained good news, with the rent rising from £19.75 a foot to £46 which will increase further the profit of Rosehaugh Greycoat. That company will soon be generating surplus cash at considerable rate, enabling it to pay back its bank loans. On 25 October 1991 it was announced that Rosehaugh had negotiated the sale of its interest in Rosehaugh Greycoat, the owners of the Finsbury Avenue properties, to British Land. In a complicated deal, both Rosehaugh and Ronnie Jarvis's Ravensale (now the owner of more than 10 per cent of Rosehaugh's shares), realized their interest in this successful development. Rosehaugh's share of the sale amounted to £44 million, because, on the same day, it also sold Rosehaugh Copartnership, its residential development company, to Ravensale, for the princely sum of two pounds. Jarvis's company took on that company's debts, and, as a result, Rosehaugh's proceeds from Rosehaugh Greycoat was a smaller proportion of the approximately £70 million total consideration paid by British Land than its 40 per cent shareholding (against Ravensale's 20 per cent) in the associate company would have suggested.

Bradman's future depended on several things. First of all he had to hope that interest rates would continue to fall back from the 1989–90 peak levels. The second potential saving grace might be the rent reviews on Broadgate. Phases 1 to 3 were let at rents of £35 a foot or below, but in today's depressed letting market, there was unlikely to be much, if any, immediate uplift. The third idea of hope was that the institutions would buy some of the group's assets, reducing debt, even at the expense of long-term benefit from its prime assets. The first breakthrough for the company was the sale in August 1991 of Bishopsgate Exchange, 155 Bishopsgate, Phase 7 of the development, not the widely marketed Phase 4 at 6 Broadgate. The buyer, for a reported £180 million, was the US Prudential Insurance's Global Real Estate Investment Programme. The European Bank for Reconstruction & Redevelopment (EBRD) finally chose 1 Exchange Square, 175 Bishopsgate, as its headquarters, leaving only 199 Bishopsgate as substantially unlet by the end of 1991. It is likely that the EBRD was able to negotiate a very attractive lease. None of these improved elements was enough to save Bradman or Rosehaugh.

Godfrey Bradman has, in the last ten years, been praised beyond his probable value and, more recently, unfairly criticized for a life-style which does not conform to the usual mould of the property developer. The property world is eager to hear the latest Bradman story, and it is certainly true that his lifestyle invites some quizzical looks. He is a vegetarian, a teetotaller and a rabid non-smoker. It is said that he will only turn off hotel lights using a handkerchief for fear of germs, and my visit to his office gave some more grist to the story mill. Bradman was suffering

from a cold and he refused to shake my hand, for fear of giving me his germs, claiming that he himself had been infected in this way. His office lavatory is mute witness to this obsession with cleanliness: the flush is a foot-pedal and the basin taps work by a magic eye, meaning that no human hand will touch anything that any future user of the facilities, including presumably Godfrey Bradman, will touch. Property men relish too the occasion on which he came to speak to an industry lunch, accompanied by someone carrying a tantalus in which there were his own bottles of purified water. Others tell of his rejection of several coffee cups as being cracked or not clean enough.

On one occasion, in the building Rosehaugh occupied before moving into its headquarters in Marylebone Lane, several people had gathered for a meeting and were waiting for Bradman to join them. The room was quite small, and there was a powerful wall air-conditioner at work: the visitors were cold. With great presence of mind one took a piece of plain paper and wrote in large letters 'OUT OF ORDER', placing it on the air-conditioner before turning it off. When Bradman eventually joined the meeting, he walked anxiously around the room before spotting the sign. 'It's a practical joke isn't it?' he said. Baffled, the visitors enquired how he knew that. 'The notice does not have a date on it' came the reply. Everything was properly ordered in the Bradman empire.

The merger discussions between Rosehaugh and Stanhope which began in mid-1991 were widely interpreted as a sign of the weakness of Rosehaugh. As the negotiations wore on it became clear that all the negotiating clout was in the hands of Stanhope. Bradman fought for his company and for a dignified exit for himself as the man so closely identified with the fortunes of the company. It did not happen. On 6 December 1991 Rosehaugh announced that it had made a loss, in the year to 30 June 1991, of £226.6 million, after providing for the decline in value of its portfolio; its borrowing limits had been breached and the accounts qualified by its auditors. Net assets per share fell to 130p against 373p at the end of June 1990. The company had sold £148 million worth of property in the year to June 1991, with a further £93 million by the end of that calendar year being realized. On 23 November 1992 Rosehaugh Stanhope was refinanced. In the year to June 1992 the company had let Phase 8 of Broadgate and sold Phase 7 (155 Broadgate) for £180 million but total debt was at around the £1.2 billion mark. The banks agreed to continue to provide a facility of £950 million and £263 million of debt was subsequently repaid by the sale of Phases 3 and 9/10 to their tenants Union Bank of Switzerland and Credit Lyonnais; the total received over and above the loans was a paltry £15 million. In the annual report of Stanhope published in January 1993, the company's Chairman, Lord Sharp commented that 'the rents from the investment properties at Broadgate now match their interest cost'. Only further falls in capital values now threaten the stability of the venture.

For Rosehaugh itself the problems proved more urgent. The declared losses and write-downs had given the banks the right to demand repayments of their loans, and all £300 million and more of net borrowing

needed to be renegotiated. The group still showed gross assets of almost £600 million, and the parent company had guaranteed only £82 million of the borrowing, but it was increasingly clear that it was indeed impossible for Rosehaugh to walk away from subsidiaries with non-recourse loans. Even a further fall in interest rates would not create a profit in Rosehaugh itself, since it had little in the way of a completed and let investment portfolio; that is held almost exclusively in its associated companies, such as Rosehaugh Stanhope.

To mark the end of the era, Godfrey Bradman stepped down as chairman of the company, and it was understood that he had no long-term plans to remain on the board. At his final annual general meeting in the slack days between Christmas and the New Year 1991, Bradman came in for criticism from shareholders who in earlier years would have been praising his unerring judgement. He even had to announce that Rosehaugh would be moving from the Marylebone offices which he had so carefully organized to suit his whims; although the freehold on them had already been part of the asset realization programme, this was an admission that Rosehaugh was a small company again.

On 23 January 1992, it was announced that merger discussions between Rosehaugh and its partner Stanhope had been abandoned, and the Rosehaugh share price dipped to under 5p. Stuart Lipton's Stanhope had become unwilling to take responsibility for a company which had already admitted that 'the Directors have assumed that their negotiations with the Group's bankers will result in the provision of sufficient facilities after 31 January, 1992 to permit the Group to pursue its business plan.' As Arthur Andersen, Rosehaugh's auditors, put it 'Should the negotiations not result in such agreement, the going concern basis [on which the accounts had been prepared] may cease to be appropriate'. Receivers were appointed on 30 November 1992 but there was little prospect of any value remaining to shareholders.

Bradman has proved that he has vision, having believed in Finsbury Avenue, Broadgate and Ludgate when many wise souls were shaking their heads knowingly. His original *modus operandi* was truly low risk, high reward and it is a shame that the group lost sight of this in the later years. It is not enough for him to say that he blames the people he put in charge of the operating companies. At least part of the trouble was attributable to him telling them to think big, and another part is a result of his not protecting Rosehaugh from the risks of suffering higher interest rates (and for longer than almost any analyst was forecasting in 1988). Perhaps he did not have anyone who could tell him he was wrong and he began to believe his own publicity as the genius who could do no wrong. As one developer said to me of Bradman 'I do not believe in wizards'. Bradman was still active in property in 1993, advising the Forth Ports Authority and investing in Berlin. It remains to be seen whether this idiosyncratic character can again become an important participant of the property market.

4

CREATING SPACES

NOT MANY MEN can lay claim to have changed the environment of a city to any lasting degree. Some have achieved it through acts of vandalism, such as Nero setting fire to Rome or Hitler to the cities of Europe, but others have made a more positive contribution. Christopher Wren and Nicholas Hawksmoor changed the skyline of London after the Great Fire in the late seventeenth century; Baron Haussmann in nineteenth century Paris drove his boulevards through the slums of the Right Bank. More controversially, Colonel Richard Seifert could boast that his designs in the 1960s and 1970s changed the face of London more than those of any architect since Wren. Not many voices were raised to suggest it was for the better. Stuart Anthony Lipton, an unqualified property developer, might reasonably claim to have been involved in the creation of more high quality working environments than any of his contemporaries, as a director of Greycoat, Stockley and Stanhope.

Lipton was not in fact the name he was born to in November 1942; his father, Bertram Green, and mother were divorced and Stuart took his mother's maiden name. After a middle-class upbringing he entered the property industry in 1960, working for agents Yeates & Yeates. After a period with Chamberlain & Willows and another firm, in 1966, at the age of 24 and the year he was married, he founded his own firm, Anthony Lipton & Co. One of his most vivid memories of this period was marvelling at the sheer size of the sale the site of what is now the Mirror Group Newspapers building at the corner of Fetter Lane and Holborn; it changed hands for what seemed the astounding sum of £1 million.

At Anthony Lipton he was still learning his trade. Something his partner Mike Gilbert had learned while at agents Donaldson was the value of short leaseholds. This arcane subject had been a closed book to most investors; it involved the purchase of the tail-end of a lease before it reverted to the landlord. The investor receives a flow of income for a period, at the end of which he is left with nothing. It is the property equivalent of buying an annuity, but the property market was not looking

at the value of these interests in a rigorous fashion. For instance valuers would take no notice of the fact that, since rents are paid quarterly in advance, the initial purchase price of such a lease is effectively reduced by the quarterly rent received immediately. The problem is simply one of calculating accurately the internal rate of return, but most agents relied on a set of valuation tables which gave a much lower value than the true one. Gilbert and Lipton quickly understood the concept, which was introduced to Gilbert by John Smith, descendant of Captain John Smith of Pocahontas fame and sometime Conservative MP for the Cities of London and Westminster. His Manifold Trust became the biggest investor in such leases, and John Smith was later a significant supporter of Lipton and Gilbert's property ventures.

The biggest client of the new firm was Amalgamented Investment & Property, the company headed by Gabriel Harrison. Among the executives Lipton's company dealt with were Geoffrey Wilson and Peter Olsberg. In 1971 these two left Amalgamated to join Lipton and Gilbert to form Corporate Estates, backed by the then-ubiquitous Jim Slater of Slater Walker, which held a quarter of the company. It was quickly backed into the tiny quoted company Sterling Land in a deal worth only £3 million, and before long, in June 1973, was subject to an agreed bid worth £28 million from the rapidly expanding Town & City Properties. The Sterling Land board was 'totally unaware' that Barry East, the head of Town & City, whose board colleagues at that time included David, now Lord, Young, and Elliot Bernerd, was simultaneously negotiating the purchase of the much larger Central & District Properties portfolio from fringe merchant bank Keyser Ullman. This excessive expansion at the top of the market was almost to cost Town & City its existence. The sale of his company, 'more by luck than judgement probably' according to Lipton, was mainly for shares. The management of Sterling Land was retained to give advice on its old portfolio and it still had shares in Town & City. In September the Sterling Land directors resolved to sell most of their shares and Joseph Sebag, Town & City's stockbroker, apologized for only being able to achieve a price of 75p per share. In the next 12 months they were to fall to 10p.

Although Stuart Lipton was able to extract himself from his first public company with aplomb, the property crash of the next three years did not leave him unscarred. Together with Peter Olsberg he then started a company named Westwood. Although Lipton today says that this company did not actually go into receivership, it was not a success and the memory of it is clearly not a happy one. Olsberg had been called back by Jessel Harrison to try to rescue the doomed Amalgamated Investment and Property which he had left only a few years before. Gabriel Harrison had died suddenly in December 1974, and in the event no-one could save the company; those who looked at a rescue suggest that the book-keeping and records of the company were in a chaotic state.

Lipton rebounded with a company set up in 1976 with his old colleague

Geoffrey Wilson and Ron Spinney, Greycoat Estates. The company was named after one of its initial projects, a refurbishment of 16,000 square feet of offices at Townsend House, Greycoat Place, Victoria, let to London Transport; another project was the refurbishment of Country Life House in Tavistock Street, the first Lutyens office building, commissioned by his long-time patron, Hudson. The four initial deals were financed by Standard Life Assurance with Greycoat making relatively little from the properties.

It was at this stage, in 1977/78, that Lipton sought to put into action some of the lessons he had learnt from close observation of the US development and construction industry over the previous decade. On his initial visits he was largely 'watching with amazement' at the quite different techniques employed in the US industry but now there came the opportunity to put the idea that they were indeed exportable to the UK to the test. The test-bed was a range of eighteenth and early nineteenth century warehouses on a 5-acre site to the north of the traditional limit of City buildings although administratively still part of it. Cutlers Gardens had been built by the East India Company as its Treasure-House, designed by Richard Jupp and his successor Henry Holland. Latterly the property had been owned as the upstream warehouse of the Port of London Authority (PLA), and as the sea cargo trade moved further and further down the Thames the more dilapidated the old buildings became. In 1973 the PLA exchanged contracts with Ramon Greene and Jack Walker's company, English & Continental, for the sale of the site. An Office Development Permit was obtained for the resiting of the Baltic Exchange, the centre of merchant ship chartering, which had threatened to leave Britain unless the permit was forthcoming. The 1974/75 property collapse prevented Greene and Walker from completing the deal and in 1978 Greycoat stepped in with its partner Standard Life Assurance, paying £5 million for the site. The developers inherited Richard Seifert and Partners as architects; they had been the architects retained by the Baltic Exchange, who no longer wished to move to the new location.

There was substantial irony in the combination of Seifert and Greycoat, since Lipton later became notorious for his criticism of the traditional 1960s 'rent slab' buildings, many of which had been designed by the Seifert partnership. The new partners had to gain planning permission within six months, after which time the ODP expired and, with a Labour government in power, there could be no certainty of another being issued. For all his later criticisms, Lipton found Seifert to be 'a master planner.' Four ground plans were seriously considered before planning consent for 790,000 square feet of offices was granted in November 1978 by the City Corporation. The development was the first which London had seen in recent years which, as Lipton expresses it,' 'created a place'. Paternoster Square and the Barbican were earlier attempts to create a coherent new city area, but they failed to gain acceptance with the general public. Cutlers Gardens established new courtyards and walkways, with arches

inserted in the ground floors of the old buildings. New blocks were also built in the complex and these caused controversy. Conservationists were aghast at the demolition of the massive warehouse which backed onto Middlesex Street, (the famous Petticoat Lane), 'one of the grandest pieces of street scenery in London', but the construction began.

The new buildings were designed to blend with the cleaned Georgian brickwork. The granite needed to achieve this match was found on a mountain on the Rio Grande in Brazil. With an attention to detail which was to become a trade mark, some would say obsession, of his developments, Stuart Lipton flew to Brazil to see the rock for himself. The granite was transported to Italy for polishing and now sits easily in its environment, although polished granite soon became the cliché of 1980s development. As well as refurbishing two Georgian houses guarding the entrance to the development, Quinlan Terry, the classical revivalist, built two pillars to support the wrought-iron gates. The project won over most critics and is a popular office location, despite the fact that is not built to any revolutionary ground plan. The criticism of the standard 45-foot wide office had begun but the technological revolution was far enough in the future to allow serious debate between Greycoat and Peter Henwood of Standard Life as to whether the building should even have the extra cost of air-conditioning. That question was resolved in the affirmative by a survey of the possible tenants by the Economist Intelligence Unit.

The widest building, only 55 feet, was the controversial new one at the rear of the site replacing the original blank warehouse wall. The developers expected this to be the most difficult building to let and bear the lowest rent. It was the burgeoning American presence in the London financial markets which revealed a new demand: Lehman Brothers were among the initial tenants of the rear block and proceeded to build one of the first modern dealing rooms in the City of London. They were joined by other US investment banks. Letting the development was something of a problem. Creating a new place was fine in theory but Cutlers Gardens was well off the beaten track for the financial services industry. Most companies at that date would not think of moving operations out of a rough square bounded by Bishopsgate, Cannon Street, St Martins-le-Grand and London Wall. Cutlers Gardens was even more off-pitch in that it backed onto the distinctly scruffy Petticoat Lane.

The solution was to market the buildings at lower rents but promote the location. In 1981 when the development was well advanced the agents quoted £18.10 per square foot for the new space and £17.50 per square foot for the refurbished buildings, against the rents on prime City offices at the time of something approaching £25. A video featuring the TV personality James Burke asked: 'What do the Guildhall, Bank of England and Stock Exchange have in common? They are all within easy walking distance of Cutlers Gardens.' The proximity to Liverpool Street Station and the working environment eventually won over the sceptics. Another achievement of the developers and contractors, Sir Robert McAlpine, was the

sheer speed with which the building work was done. The 27 months which the work took was found, in a study by the University of Reading, to be the fastest 'spend', (the running cost of the construction work), of any contemporary development. Greycoat's reward for the project was a six per cent interest plus a management fee for overseeing the development.

In June 1978, at about the time that the contract to develop Cutlers Gardens was signed, Greycoat became a publicly quoted company. This was achieved by the reverse takeover of a small company named Chaddesley Investments, which was effectively controlled by the South African Schlesinger family. The deal valued Greycoat at only £560,000, since the quoted company issued 3.42 million shares to the Greycoat shareholders and those shares were quoted at 16½p each at the time. Lipton and Wilson also subscribed for a further 1.4 million shares at the same price, ending up with 68 per cent of the newly merged company. Under the rules of the Stock Exchange the shares of Chaddesley were suspended while the transaction was ratified by both sets of shareholders and when the shares' quotation was restored in August they immediately rose to 44p. Geoffrey Wilson made clear what the Greycoat team had already determined as its credo: 'We have a commitment to high standards of design and construction which enables us to attract first-class tenants at good rents.'

Two other buildings developed over the four years 1978–82 justified this claim and established the reputations of both Greycoat and, separately, Stuart Lipton, as imaginative leaders of a new generation of developers. The first was an office block at Hammersmith commissioned by Sir William Halcrow & Partners, the consulting engineers, for their head office. Halcrows appointed Greycoat as their developers after a competition, and Lipton claims that the resulting building is the first of the new generation with a really efficient floor-plan and is 'the best building in Hammersmith'. Again, as Greycoat could not afford the building themselves, they funded the construction by a forward sale to Norwich Union, leaving the company with only a small interest in the ultimate investment.

The second building was on an even more controversial site, on the corner of the Euston Road and Hampstead Road, backing onto Tolmers Square. This site had been fought over long and hard in the 1970s with Camden Council anxious to create council flats but developers Stock Conversion seeking permission for offices. By the time Greycoat came along in January 1979 with Sir Robert McAlpine, with whom it set up a 50–50 company, Greycoat London Estates Investment, both Council and developers were ready to compromise. The partners were granted permission for 200,000 square feet of offices and agreed to fund a new Tolmers Square residential development for the Council; the Council received £2.25 million on granting the developers a building lease of 99 years with an option to extend for a further 26 years, and would receive 50

per cent of the net profits on completion. The reflective glass building is not deemed by Lipton to be one of his successes, although he remains content with the interior; 'not great' is his verdict. It was initially let to Davy Corporation but is presently occupied by Prudential.

By now the old Chaddesley company had been renamed Greycoat Estates and profits were benefiting from Wilson and Lipton's involvement; pre-tax profits in the six months to September 1978 rose to £200,000 from £6,000 a year earlier even though the new management had been in place for only three of those months. The management was taking forward agreed developments and adding properties to the portfolio such as Imperial House and Regent Arcade, Regent Street, bought for shares from Rank Organisation.

The major new project of Stuart Lipton between 1979 and 1983 focused on another important site, the Coin Street development on the South Bank of the Thames between Blackfriars and Waterloo Bridges. This site became notorious as the scene of a show-down between commercial and community development. On the one hand was Greycoat, with its Richard Rogers plans for a 'new place' rather than a succession of office slabs; on the other were the political activists who believed that the only development possible for the area was of new low-cost housing and related infrastructure. After a protracted series of enquiries Greycoat finally decided to withdraw from the scheme in January 1983.

Coin Street was not the only important development in which Greycoat was involved during this period. Two which broke new ground in terms of design and building techniques were the offices above Victoria Station and the Finsbury Avenue development. In February 1981 the joint Greycoat/McAlpine company submitted a planning application for 220,000 square feet of offices to be built on a raft over the tracks of Victoria Station, the first of BR's stations to see such a development; at other stations buildings had risen over the concourse or on peripheral bits of land. The techniques for building floor-plates on rafts bearing the weight of large offices had been developed in the US by a contractor named Schal which had built the Sears Tower in Chicago, the world's tallest office building, and had worked for the legendary Harold Diesel. As Lipton says, they had the technology which 'allowed me to turn the dream into reality'. This building was also a ground-breaker in another sense. One floor of the building was 75 feet wide, far above the convention of 40–45 feet. Sam Levy of agents Jones Lang Wootton, the doyen of office lettings, was convinced that such a wide building would not let. It did prove difficult, but it was finally selected by Salomon Brothers, the US investment bank, as its new European headquarters, and plays a starring role in that memoir of the yuppie 1980s, *Liar's Poker* by Michael Lewis. The second development in this period became the precursor to a project which was to dominate Stuart Lipton's life for most of the next ten years: Finsbury Avenue, next to Liverpool Street Station.

The Finsbury Avenue development, as we have seen, was the brainchild

of Godfrey Bradman of Rosehaugh. He had seen what Greycoat had been achieving in its other developments and invited it to join him in this new investment. The site was certainly a fringe one, like Cutlers Gardens. Next door to a bomb site used as a car park and without a frontage to the only street in the area which could be considered at all respectable, Eldon Street, the northern boundary, on Sun Street, was in that area of light industrial buildings which throng the streets of Hackney, and was not even in the City of London. Despite the innate suspicion with which the Hackney Council viewed speculative office development in their borough, outline planning permission was obtained on 6 October 1981 for 501,360 square feet of offices, to be built in three phases, and detailed planning permission for Phase 1 with its 295,000 square feet of offices came in late 1982.

The architect chosen for Finsbury Avenue was Arup Associates, who had at that time designed very few speculative office developments. Arups, like Sir Denys Lasdun and other prominent partnerships, had relied for a living in the 1960s and 1970s on the patronage of the public sector. The partnership had seen set up in 1963 by Ove Arup, the renowned consulting engineer, who died in 1988, and Philip Dowson, the architect, and had specialized in university buildings. The partner to whom Stuart Lipton turned to realize all the aspects of the demands for new-style offices built in new ways was Peter Foggo, with whom he was to work closely for much of the next seven years. By this time Lipton had developed what one observer has called his kitchen cabinet, a team of ad hoc advisors on whom he relies and with whom informal discussions on all aspects of design, building and legal matters are often held. Among this group are Frank Duffy, the architect head of DEGW, Gary Hart of lawyers Herbert Smith, and executives from the Economist Intelligence Unit and Schal.

The principles on which the developers worked were very much those which had been researched by Lipton and others in previous years. Eight floor-plates were looked at, including a tower, before the team settled on twin buildings linked by an enclosed atrium, a feature that was to prove ubiquitous in 1980s office design. 'It became the definitive building' says Lipton, with metal-tiled ceilings, movable air-conditioning and proper services. The exterior was a lattice of steel, less 'inside out' than the Arup Associates designed building at 80 Cannon Street or Richard Rogers's Lloyd's building. Architectural journalist Jonathan Glancey comments: 'A stern building, 1 Finsbury Avenue nevertheless displays a certain flamboyance with its dramatic courtyard roof and its sequence of steel struts and braces that further echo the architects' passion for the great engineer-designed structures of the high-Victorian era.' The design was also dictated by the technical needs, and ceiling heights reflected the new demands for cable ducts under the floors and air conditioning.

The building was contracted to Laings and budgeted to cost £70 per square foot over 21 months. In the event the first tenant was in the

building only 15 months after construction began, and the cost was £60 per square foot. Again, because the building was 'off-pitch', rental values were expected to be low, and the project was deemed economic at £14.50 a square foot, against rents which were now approaching £25 in the best areas. The letting of the building, primarily to stockbrokers Rowe & Pitman, (part of Warburg Securities), at £19.75 was a great bonus. Incongruously, Rowe & Pitman, the blue-blooded firm said to be stockbrokers to the Queen, tried to recreate the atmosphere of the panelled partners' room on the top floor of the building where the lunch and meeting rooms were situated. Rosehaugh Greycoat presented the building to tenants as 'shell and core' with no internal fittings, and paid an allowance of £5 per square foot to the lessees for those costs rather than wasting its money and that of its clients by building fittings which the tenant would then rip out. Such an idea became as commonplace in Britain in the late 1980s as it had been in the US for many years. Stuart Lipton is still clearly pleased with his award-winning development: 'An innovative building, it's still one of the best buildings I ever built.'

By the time both Victoria and Finsbury Avenue were completed and let Stuart Lipton was no longer involved either in their future, or in the death throes of the attempt to develop Coin Street. In March 1983, he resigned as joint managing director of Greycoat, although he stayed on the board for a brief period as a non-executive director. 'I wanted to stop the world and wanted to get off' is the simple explanation for this dramatic move. Lipton and Wilson had worked together since 1969 and had been seen very much as a team, although Lipton was gaining more media attention. Lipton would not say there was a disagreement between the two men: 'I just wanted a change of scene and I was getting more and more involved in the detail and I wanted to have the opportunity of thinking what to do.' Wilson too maintains that this was a perfectly friendly parting: 'We have different working styles but we work together very well. I have a great admiration for Stuart, he is a most professional developer.' Lipton had no specific plans: 'when I left I had no idea; I just took a tiny office in Stanhope Gate.' He was not idle for long. His new company, named Stanhope after its location, was soon involved in two important new projects.

The first was an investment brought to him by agent Elliott Bernerd and banker Jacob, now Lord, Rothschild. The project was to take control of Trust Securities, a company with a large scale project at Stockley Park north of Heathrow Airport. Trust Securities had come to the stock market in October 1980. Its chief executive was Peter Jones, who had been a leading light in 1970s developer Compass Securities which had been taken over by Guardian Royal Exchange. Earlier that year Jones had been fined £500 and given a 12 month prison sentence suspended for two years after being convicted of plotting to defraud the Inland Revenue. This fact was not disclosed in the original prospectus, although the issuers claimed that every potential investor had been told orally.

In February 1981 Trust Securities' shares were suspended on the Stock Exchange pending details of a substantial acquisition. This proved to be the purchase of the Nearcity Group which controlled W. W. Drinkwater; that company in turn was the parent of a group of businesses in the waste and ballast business. The reason why it was attractive to Trust Securities was its vast holdings of land, some 900 acres in all, including 247 acres north of the M4 currently used as a rubbish tip. Trust was able to buy Nearcity for only £75,000 together with its matching assets and liabilities. By May Trust had sold off the major operating subsidiaries of Drinkwater for £2.4 million, leaving it with the 247 acres near the M4, known as Stockley Park, 63 acres at Denham and 22 acres at Hayes for an all-in net cost of £975,000. In October 1981 Peter Jones took over as chairman of Trust Securities and in December it was announced that the Universities Superannuation Scheme (USS) had agreed in principle to provide £50 million for the first phase of a development of 500,000 square feet of industrial and office space at Stockley Park.

By 1983, when Bernerd and Rothschild came to Stuart Lipton, Trust Securities was finding the going difficult. The problems of building a high-tech industrial park on a rubbish dump were formidable, and Trust's other development projects had not made enough to finance the scheme. The consortium formed by Bernerd, Rothschild and Lipton was able to persuade the major holders of Trust Securities to grant them options on Trust shares, or sell them shares in exchange for shares in a new company, to be named Stockley, valued at 15p, well below that then prevailing on the market of 45p; the whole company was worth only £4.7 million. This recognized the fact that Trust could not sustain its plans on its own; Peter Jones kept some shares in the new company but did not remain as an executive of the reformed company. The role of managing director was taken by Michael Broke, who had been working for Jacob Rothschild, but the major shareholders were the new non-executive directors, Bernerd and Lipton and the various Rothschild interests.

The Stockley development was originally conceived as a 'high-tech' estate; this was a light industrial or research facility with ancillary offices, with two storeys of offices at the front and a single storey at the back. The new owners decided instead to create an American-style office park, although they maintained flexibility by making the ground floors higher than other floors and a floor-loading limit of 600 lbs per square foot, 'so that anybody who wants to use high-tech space can do so.' The blueprints were the many business parks established in the US, particularly by Stanford University in California which had managed to attract precisely the type of tenants that Stockley was targeting. The change in Use Classes Orders, the technical definition of what businesses may be carried on with what planning consents, did not come about until 1987, but the new description of the space which Stockley was building is B1, office space interchangeable with industrial space, an idea which proliferated as the 1980s progressed.

Stuart Lipton looks upon Stockley as his 'most interesting' development. Because the site was a recently used rubbish dump, known as 'stinky Stockley', there was an enormous amount to do before construction started. Trust had originally planned to build directly on top of the old dump but engineers Ove Arup suggested a more satisfactory long-term solution, albeit at higher initial cost. The dump was at the south end of the site, while the eastern side was virgin Green Belt scrub land. Arup discovered a gravel deposit under the clay and planned the wholesale removal of the rubbish to a temporary position to the west, filling the resulting hole with the gravel from the east, covering it with clay, and removing the rubbish again to the now-empty gravel pit before covering that in turn; after contouring, a golf course will be built on top of the rubbish.

Despite all the scepticism, which included doubt that office-type rents would be achieved in this quasi-industrial location, (although only a stone's throw from the M4, M25 and Heathrow), the first phase of the project was well on the way to completion by the time the Prince of Wales officially opened the development in June 1986. The Prince, already known for his interest in architecture, was relatively complimentary about the project in his speech, calling it 'an international showpiece in an international location'. The roads and three buildings totalling 350,000 square feet of the USS-funded portion had been completed in a year, and lettings to companies such as Fujitsu had been agreed at around £13.50 a square foot, a premium level for an out-of-town office park. Lipton had another interest in Stockley as well as a direct shareholding: his company, Stanhope, had been appointed project manager of Stockley Park in early 1984, its fee rising to 2.4 per cent of the cost of the development.

The other development which rapidly filled the gap in Stuart Lipton's diary was the massive Broadgate project. British Rail had existing plans for developing the site of Broad Street Station and the surplus land around Liverpool Street Station in conjunction with Taylor Woodrow and Wimpey, but by 1983 had decided that progress had not been rapid enough. They put together a tender list of potential developers and suggested to Lipton and Godfrey Bradman, with both of whom BR had worked previously, that they should make a joint approach. The combination was seen as having clear synergy between a brilliant financier, Bradman, and a development manager of some panache in Lipton. There were 11 consortia in the original list of tenderers, reduced to a shorter list of eight. 'In the end it was between us and Norwich Union' says Lipton: 'Norwich were going to pay £75 million in cash for the front portion of the site; our deal was for £90 million in phases and a profit share.'

The Broadgate project led to the formation on 11 November 1983 of Rosehaugh Stanhope Developments (RSD) owned 50/50 by the two companies. In the first 14 months only £550,000 of equity capital was invested by the two shareholders and until 1991 the total equity

subscribed was only £1,012,000, against a total development cost of almost £2 billion. The initial phase of the development of Broadgate followed quite closely the pattern of Finsbury Avenue, with the exception that, in the case of Broadgate, the canvas was four times the size. The intention was again to 'create a place', but the size of the project enabled a rather more grandiose plan to be developed by RSD and its professional advisors. Arup Associates, in the person of Peter Foggo, were again appointed as architects but their designs were more American in inspiration than the Victorian engineer's building of 1 Finsbury Avenue. The steel-framed buildings were faced with a skin of coloured polished granite and the first four Phases made an arena in the centre of which was an ice-rink, used in the summer as a concert stage, after the example of the Rockefeller Center in New York.

Duffy's firm DEGW was employed over the next year to determine the needs of the likely tenants. Alexei Marmot of DEGW reported that 'financial service companies are increasingly dissatisfied with the buildings available to them in the City. They are very clear about what their premises should be like: prestigious, well-built, with large floor areas designed for maximum flexibility to accomodate frequent organizational and technological changes, especially in telecommunications.' Some clients would also like to occupy buildings finished only to 'shell and core'. The buildings were designed for speed: design was completed before work started, unlike the fashion for 'design and build' in which details are designed while the building is constructed. Most assembly is carried out off-site and parts simply bolted together. If all this seems familiar, it is very much the method noted by Mr Bossom who was an architect in the heyday of skyscraper building in America in the first 30 years of this century.

The 'fast-track' techniques were used to great effect: Prime Minister Margaret Thatcher and I were both guests, though not of quite the same importance, at a lunch in August 1985 to mark the ground-breaking of the first and second Phases, where she made a symbolic pass with a bulldozer, and promised to return in a year to mark the development's completion. This timetable was considered unsustainable by those used to British working methods, but it was beaten. On 11 July 1986, having had to cancel a trip to Canada to fulfil her promise, Mrs Thatcher returned to the Broadgate site, thanking 'Mr. Bradman and Mr Stanhope (sic)' for their efforts: 'We have everything here I admire – good design and superlative teamwork.' Foundation work took eight weeks, steel erection 14 weeks and 20 weeks were used for cladding the structure, a total of 42 weeks.

Stockley plc meanwhile had not been idle. In June 1984 it bought a row of unmodernized properties, 29–36 Sackville Street, W1, from the charitable Sir Richard Sutton Settled Estates for £12 million, paid in shares. This group of properties became a parcel bought and sold regularly in the late 1980s until the music stopped. Stockley gained planning permission for each house to be converted separately into offices

and then, in 1986, sold them to Tony Clegg's Mountleigh Group; this company in turn sold to Peter Taylor's now bankrupt Sheraton Securities for £13 million. In late 1990 it was announced that 36 Sackville Street had been bought by Genepierre IV, a French investor, from Mercury Asset Management. No. 36 thus had six owners between 1984 and 1990. Stuart Lipton regrets the Stockley sale, saying that he was 'chicken' to sell the development before doing the building work.

In March 1985 Unilever brought in a consortium consisting of Stockley, British Land and the Barclays Bank Pension fund to redevelop its property between Blackfriars and Fleet Street, to be known as Dorset Rise. A more important change was the purchase by Stockley of the European Ferries property portfolio in April 1985; this company was the Townsend Thoresen ferry operator, its fleet's ships often carrying explicitly in the names on their sterns the 'Free Enterprise' philosophy of the controlling Wickenden family, which had diversified into property. The company now took Stockley shares as its payment for its portfolio, becoming owners of 44 per cent of the enlarged Stockley, albeit being restricted to voting on only 29.9 per cent. The new shareholder also undertook not to sell these shares or make a bid for two years, giving Stockley a further two years beyond that in which they would have pre-emption rights over their holding. By this time the Stockley share price had risen to 70p and the market value of the company to £140 million. Later on in the month Stockley bought a 26.5 per cent stake in Stock Conversion Investment Trust, a veteran of the 1960s and 1970s development, which had given up trying to redevelop the Tolmers Square site that Greycoat had eventually turned into 250 Euston Road. There were long discussions between the two companies as to the possibility of some merger or deal, but they failed to come to a satisfactory conclusion. Stockley's holding in Stock Conversion was sold to P&O in April 1986 when that company made a full bid; the sale raised £100 million for Stockley.

In June P&O and Stockley announced that they were jointly to redevelop Beaufort House on the eastern edge of the City, backing, like Cutlers Gardens, on to Petticoat Lane. This monolithic 550,000 square feet building was another example of Lipton trying to 'create a space' since the architects made a piazza in front of the entrance and built a huge arch over the front doors, larger than Marble Arch. By now Stockley had become the sixth largest property company by market value.

By April 1985 Lipton's company, Stanhope, still privately owned, brought in three large institutional investors, the merchant banks Kleinwort Benson and Robert Fleming, and the investment trust Globe, as shareholders. These investors paid only £1 per share for their holdings, which amounted to 32 per cent of the company. This act of generosity on Stuart Lipton's part was not unqualified. The new shareholders had to provide loans totalling £10 million at a sub-market rate of interest and on which actual cash payments were postponed until Stanhope was

moderately profitable. Perhaps for this reason Fleming's investment was on its own behalf, rather than for its investment clients, unlike Kleinwort's. The £10 million was a useful addition to Stanhope's resources at a time when its net assets were still only £100,000, despite the fact that Broadgate was now under way.

In November 1985 Stockley, with its partners British Land and the Barclays and Unilever Pension Funds, (the Paternoster Consortium), won the closed tender to buy the bulk of the Paternoster Square development by St Paul's Cathedral. The vendors were the Church Commissioners, Laing Properties, Wimpey and Trafalgar House, who had been partners in the original development in the early 1960s. Stockley and its partners paid £80.25 million for the six offices and the shopping precinct. Part of the purchase price was immediately recouped by selling, for £14 million, to Charterhouse, the merchant bank, the office block it occupied itself. Stuart Lipton's private company was, as with Stockley Park, appointed as project manager. The debate over the plans for redevelopment of Paternoster Square is described elsewhere. The whole episode left Stuart Lipton rather bewildered. He went to great lengths to meet what he had understood the public to want with schemes such as these: an initial overall plan, not detailed design of buildings. 'It was a real taste of, if you give the public what they ask for, they don't understand it.' Stockley was a little coy about its initial plans, with Michael Broke even claiming that a complete redevelopment was only 'a possibility.'

Rosehaugh Stanhope's ambitious plans were not confined to Broadgate. With the architect Richard Rogers Lipton began to negotiate with the London Docklands Development Corporation for permission to redevelop the old Royal Docks, the eastern extremity of the area, to provide 1.5 million square feet of retail space. The joint company also made proposals for the Spitalfields fruit market site across Bishopsgate from Broadgate. These were designed by the classical revivalist Leon Krier and have been described by Jonathan Glancey as 'perhaps the most remarkable plan suggested by a commercial developer in the 1980s'. Krier's drawings suggested a recreation of the traditional narrow City street plan with crescents and squares. The buildings were an eclectic group of palazzos, basilicas and a campanile, introducing an Italianate touch to the granite-clad City. The plan lost out to one put forward by London & Edinburgh and, in early 1991, the produce market finally moved. The winning consortium has yet to start work on its development, although it now has planning permission for a scheme including a new building designed by Sir Norman Foster.

Discussions were held between Lipton and the board of Stockley as to whether Stanhope and Stockley should merge. With both sides knowing each other perhaps too well, it became a difficult negotiation, but in May 1987 Tony Clegg of Mountleigh told the Stockley board that he would like to buy the company. The bid put an implicit value of £150 million on the Paternoster Consortium's holding by St Paul's and an explicit price of

£365 million on Stockley as a whole. The board of Stockley accepted the bid, but this was not the end of Lipton's involvement. For the present at least Stanhope maintained its management contracts on Stockley Park and Paternoster as well as a supervisory role in the Beaufort House development.

Stuart Lipton soon returned to a role in a public company. 1987 was witnessing the most frenetic stock market boom for 20 years and property companies were the particular darlings of investors as rents rose rapidly around the country. On 8 October 1987 the subscription lists were opened and closed for investors wishing to buy shares in Stanhope on the Unlisted Securities Market. At the minimum issue price of 180p, each share the institutions had subscribed to only 30 months earlier had multiplied in value by 1,224. In fact the tender price struck was 250p so that Kleinwort's and Globe's investments of £17,000 each were now worth more than £28 million and Fleming's £13,000 had become over £22 million. This profit was more than adequate reward for the investors putting up £10 million of low-interest debt between them. Flemings, having pocketed the profit from this period of investment for themselves, now transferred all the holdings into the names of their investment clients. Stanhope had gone from being a high-risk speculation to an institutional investment in two and a half years. The issue also made Stuart Lipton even richer: his initial cash investment in Stanhope of £100,000, held by his wife and himself, was now worth over £130 million.

The issue prospectus of Stanhope gives a good flavour of the absorption of Stuart Lipton in the architectural and artistic elements of property as well as the purely financial facets. 'Stanhope's objective is to produce developments which combine aesthetic appeal and architectural merit with efficiency in construction and use, and which command premium rents in locations with outstanding growth prospects.' The latter has not yet been established in Broadgate, but few would dispute the superior qualities of a typical Stanhope development compared with its predecessors of previous decades. 'The Directors believe that the Group's insistence on good architecture contributes to its commercial success by satisfying the growing awareness of tenants that a distinctive building is an important aspect of their corporate identity. The requirements of major commercial tenants are no longer confined to location, size and cost, but also encompass configurations and flexibility of space to meet the changing needs of their businesses, together with suitable amenities and ambience.'

The prospectus also gave a detailed account of the Rosehaugh Stanhope finances. The tangible assets of Rosehaugh Stanhope Developments, (RSD), had risen in the year from 30 June 1986 to 30 June 1987 from £83 million to £388 million. The first two Phases, already completed and let, had cost £174 million but were now valued at £258 million, and Phases 3 and 4, costing £129 million to that date, were nearing completion; these figures did not deduct the payments due to British Rail of £120 million.

British Rail, as landlord of Phases 3 and 4, had imposed a rent of 'one red rose if demanded without review', a new twist on the traditional peppercorn rent. Debenham Tewson & Chinnock, the property valuers, opined that Phases 1–4 and 6–7 would have a capital value of £1 billion gross when complete. The first four Phases of Broadgate, like Finsbury Avenue, had been designed by a team at Arup Associates under Peter Foggo. They turned down the commission to design the other Phases, not wishing to distort a balanced partnership to meet the extraordinary demands the further Phases would make on their staff; RSD appointed the US architects Skidmore, Owings & Merrill instead. The facade of Broadgate seen from Bishopgate is by this partnership.

Other ventures were being undertaken by the Rosehaugh Stanhope joint company. In Docklands they had agreed to sell a quarter of a site at Blackwell's Yard to Reuters where a building designed by Richard Rogers and costing in all £35 million was to be built by the end of 1988; the electronic news group took options on the rest of the land. Adjacent to this site, in a joint venture with Berkley House, RSD had bought the 17-acre site of the old Brunswick Wharf power station. Another twinkle in the RSD eye was a plan to develop above the line of the railway which ran from Holborn Viaduct station to Blackfriars. British Rail planned to connect the north London termini to the Southern Region by driving a tunnel from Kings Cross to Blackfriars, rendering Holborn Viaduct station unnecessary and removing the railway bridge at the bottom of Ludgate Hill. Stanhope by itself had bought a leasehold interest in 1 London Wall, a 1973 building beside Route 11, which they planned to link to the Museum of London across the dual carriageway. The company had also been negotiating with the South Bank Board to improve the environment of the arts complex between the Shell Centre and the LWT building, which had turned into a free skateboarding park and haunt of the homeless. Terry Farrell, the Post-Modernist architect, was working with Stanhope to develop plans.

The Bradman-Lipton team had one other scheme on which they were working which could eclipse even Broadgate in terms of 'creating a space'. The hinterland of the main north London termini for the north and east of Britain, Kings Cross and St Pancras, was a derelict mess of railway lines, roads, the Regent's Canal, gas-holders and goods yards. British Rail and the recently privatized National Freight were the major landowners in the area and the government was anxious for all these wasted acres to be put to a better and more remunerative use. By the beginning of 1988 RSD had been confirmed as one of the two developers in the running for the comprehensive redevelopment of the whole area, the other being Speyhawk. In June 1988 British Rail announced that the London Regeneration Consortium, of which Stanhope owns one third together with Rosehaugh and National Freight, was the winner of the competition to build on the 100-acre site. The outline design for the project had been provided by Norman Foster's partnership, and this was revised on

October 1988 after local criticism. As well as bridging the road between the two termini, the plan creates an oval park using the canal as a focal point, with the housing and offices round it. The original intention was for Kings Cross to be the freight terminal for the Channel Tunnel route. The development will probably have to wait until the next property boom since speculative development on this scale in a recession is very difficult to finance.

Having tied in his company so intimately with Godfrey Bradman's Rosehaugh, Lipton now sought to create new ventures separate from that successful partnership. One important new project was developed with the Japanese construction company, Kajima, in March 1988. Kajima had already acquired 101 Piccadilly for the Japanese Embassy but now sought a British partner. Lipton had visited Kajima in Tokyo and his reputation was sufficient to convince the Japanese company that this was the right coventurer. The first project was the purchase and redevelopment of Hanway House in Red Lion Square, Holborn, which was sold on in 1989 to Cable & Wireless as the headquarters of their Mercury telephone network. (Stanhope's Chairman, Lord Sharp, had been, until 1989, Chairman of Cable & Wireless). Other projects undertaken with Kajima include 1 London Wall and the office blocks which face Euston Road in front of Euston Station.

The critical change in 1988 for the long-term health of Stanhope was the sale of one-third of the company in May to the Reichmanns' Olympia & York company (O&Y). This coup was a result of an earlier introduction from Stanley Honeyman, an old friend of Lipton's. Honeyman had been a director of English Property Corporation which the Reichmanns had bought in a bid battle in 1979 (described in Chapter Ten). He suggested that Lipton call on the Reichmanns who had just taken over the Canary Wharf project from the US bankers who originated it. 'I thought I was going for half an hour' recalls Stuart Lipton 'but stayed two and a half hours. I was interested in what they were doing because they were continuing the theme of building expertise. You can talk to Paul Reichmann about the cores, the toilet details, the floor plan.' In 1988 Michael Dennis of Olympia & York approached Lipton, expressing admiration for what Stanhope was doing and asking to do 'some kind of venture' with Lipton. Buying one-third of Stanhope cost £137 million, at a share price, 250p, which, though the same as the initial tender price, was well above that prevailing in the market at the time. The attraction from Stanhope's point of view was that this was a large equity injection at a time when the property boom was already faltering in the wake of the 1987 stock market crash and at the end of the trend to lower interest rates. Paul Reichmann was quoted at the time as saying that the investment was 'a way of helping Stanhope expand and was a major gesture of confidence in Stuart Lipton and his team and, through them, in their joint ventures with Godfrey Bradman and his colleagues at Rosehaugh.' It did seem slightly odd that the developers of Broadgate should now both have O&Y as large

shareholders since the Canadians were developing Canary Wharf which is competing with them for many of the same tenants. Lipton did not find this a constraint: 'Canary Wharf is a different product and London is a series of villages.'

A rapid use of at least part of Stanhope's new-found financial muscle was the repurchase in July of Stockley Park from Mountleigh by a consortium led by the Stanhope-Kajima joint company, for £200 million. Other members of the consortium of which Stanhope-Kajima holds 58 per cent are Chelsfield, the private company of Elliott Bernerd, which originally bought 16 per cent but has sold half to Shimizu, another Japanese construction company; the Prudential owns the other 25 per cent. This surprising reversal on the part of Mountleigh enabled Lipton to take back total control of the development of which his company had been project manager throughout. In September Stanhope announced two more important developments which would distance itself further from the perception that the company was merely a play on the RSD portfolio. ITN commissioned Stanhope to manage the development of its new headquarters designed by Foster Associates at 200 Grays Inn Road; Lipton had known ITN since buying its old Wells Street headquarters for it while he was still an agent. Stanhope bought the new site and leased the building back to ITN, with the intention of letting some of the surplus office space to provide an income for ITN with which to pay the rent. The development took only 21 months from start to broadcasting. Unfortunately for ITN much of the surplus space was still vacant at the end of 1992. The property had by then almost bankrupted ITN.

Another new joint venture partner was Trafalgar House, the entrepreneurial vehicle of Nigel Broakes and Victor Matthews in the 1968–1972 property boom, which had bought Cunard and Express Newspapers and moved away from direct property investment. This project is on London Regional Transport's Chiswick depot site near the M4 and the North Circular Road. Planning permission was finally granted in early 1991 for an office park development on the 32-acre site. Stanhope also built an office in Staines which has been let as British American Tobacco's worldwide headquarters, showing a yield of 10 per cent on cost.

Because Stanhope has operated mostly as a developer and in joint ventures, its profitability has not yet been high. Since the cost of money has almost always been well above the rental return immediately available on development, the goal of the company has been an increase in net asset value. The net assets at the time of the issue in 1987 were £135 million or 123p per share, well under half the price that investors were willing to pay for the shares. Over the three succeeding years, net assets rose to £458 million or 275.6p per share at the end of June 1990. Profits have been derisory, arising mainly from interest payments on loans made to related companies and on the capital subscribed by O&Y. Only in 1988/89 did real profits accrue from Broadgate, resulting from the sale of Phase 5 to Bankers Trust. If Stanhope manages to hold onto its portfolio, as rents

rise over time the profitability of the company will be transformed. This assumes that the company does not then seek more ambitious projects – a rash assumption.

Lipton and Bradman agreed that the Holborn and Kings Cross projects are the last on which they would work together. At the start the partnership was one of complementary skills: Bradman the financier and Lipton the developer. As both Rosehaugh and Stanhope grew each began to assimilate the skills of the other so, as Lipton puts it 'the rationale was less'. Although both men have a reputation for being blunt there is no suggestion that the partnership ended in a blazing row, even if there is little warmth between them now. Observers suggest that, as they grew to have some expertise in each other's original areas of strength there came a point at which each felt the other was treading on his toes. Lipton simply feels that, in joint ventures, two is probably the right number; being in a company together is a different sort of partnership. Bradman and Lipton had been involved together in Finsbury Avenue, the 12 Phases of Broadgate, (each like a separate project), the Reuters development, Kings Cross and Holborn. In joint ventures separated by many years, such as those Lipton has done with Jeffrey, now Lord, Sterling and Bruce McPhail of P&O, 'you don't get involved into personality' as Lipton puts it.

Stanhope appeared to be one of the few clear winners of the property boom of the 1980s. Although it announced a £77.4 million pre-tax loss in the year to June 1991, Lipton was able to say 'we remain confident that, when the current difficulties are over, Stanhope will emerge stronger, more competitive and better equipped to take advantage of the opportunities which lie ahead.' During the year Rosehaugh Stanhope became roughly cash-flow neutral, after the sale of Broadgate Exchange and the conversion of £100 million of its shareholders' loans into equity. Nevertheless, the company had to write down the value of its projects in Broadgate, Ludgate, Stockley Park, Docklands and elsewhere by £43.4 million. The net asset value of the shares fell back to 192 pence from 276 pence, and the shares fell to a distress level 37p. Making predictions in a book is notoriously dangerous, but my betting would be on Stanhope being, like British Land and Town & City in the previous property crash, a survivor. It has interests in some of the best developments and its finances are not in a truly distressed state. The company's shares remain difficult to value since there is only asset value to fall back on and many of the projects in which it is involved are in related companies. Its weakness is an inability to control directly most of its assets in these companies. While Stanhope and its partners were strong and operating in a growing economy all was well, but in periods of recession and high interest rates, doubts arise about short-term viability which may not be justified. As the company's ambitions moved from development to survival, Stanhope's managing director since 1988, Nigel Wilson, left to become a managing director of GPA, the Irish aircraft leasing group. He will join a board

which has on it, as non-executives both Nigel Lawson and Sir John Harvey-Jones, both commanders of thousands of column inches during the 1980s.

Stuart Lipton is a man who arouses strong opinions in most of those to whom I have spoken. One property man describes him as 'not a very sophisticated investor, a man who is very tough in business and hasn't made too many friends. He is very self-centred and doesn't give a damn.' Yet Lipton, who describes himself disingenuously as 'a bit player' of the 1980s property market, says that what keeps him in the business long after he feels any need to make more money is his relationship with his partners. 'I have tended to work for long periods with groups such as McAlpines and Bovis,' and there have certainly been long associations with Richard Rogers, Norman Foster, Arup, (particularly Peter Foggo), and Frank Duffy of DEGW. 'What drives me is the people and people relationships. People have been very kind to me.' This comment makes Lipton sound like an implausible Blanche DuBois, but the apparent contradiction is difficult to reconcile. While it is true that he has terminated relationships with two long-standing partners, Wilson and Bradman, he has also kept around him a loyal team of highly talented people. It may be that he is so tied up in his own affairs that he does not sense the unintentional slights which others feel. One competitor thinks he has become too big for his boots and dislikes the way he treats his staff, 'shouting at them in front of other people.'

It is certainly true that he has a reputation for being able to lose his temper. During one negotiation with John Ritblat of British Land, Lipton was due at British Land's office, at which he was confidently expected to tear a strip off the assembled company. John Ritblat, who knew his man, was prepared. On arrival, Lipton was greeted by a receptionist sporting a large button reading 'WE LOVE YOU LIPTON'; on being shown into the meeting room, he found that John Ritblat and his whole team were also wearing the buttons. Stuart Lipton may have a temper, but he has a sense of humour; he was totally disarmed and dissolved into laughter.

While Lipton and Elliott Bernerd were engaged, as directors of Stockley, in the discussions with Stock Conversion, a meeting was held one evening between the two sides at Morgan Grenfell. The negotiations were as close to success as they ever were, and at one point the Stockley team of Lipton and Bernerd left the Stock Conversion representatives to have discussions by themselves. The two partners in Stockley found themselves in the Morgan Grenfell partners' room, where the traditional high desks still stood. Before long Bernerd and Lipton were crouched under the desks, (not easy for a large man like Lipton), trying to throw paper darts into each other's waste paper baskets; which is how the Stock Conversion team found them when they emerged from their meeting.

Lipton has taken on many 'civic' duties, which he calls his 'pro bono stuff' and which he is anxious should not be forgotten. He was assistant building superintendent of the Hampton Site, (the National Gallery

extension), is on the DTI's Property Advisory Group, the governing bodies of the Royal Academy, Whitechapel Art Gallery, Imperial College, National Theatre, Glyndebourne and the National Fine Arts Commission. He likes to think of himself as a patron of the arts, filling his developments with sculptures and commissioning 150 paintings of the building of Broadgate by Robert Mason, one of which, 'Phase II (Rainy Day)', hangs in his office, alongside an architectural drawing by Norman Foster and an engraving of the Great Exhibition of 1851. But Lipton does not have to worry about what others think of him now. His reputation will depend on how his developments last. If in 20 years Broadgate is still seen as a desirable place to work rather than an ageing rent-block then he should be satisfied. The problem is that it is the name of the architect, rather than his own, which may be associated with developments for which he, as much as anyone in the decade, was responsible.

With the renegotiation of the borrowing of both Rosehaugh Stanhope and Stanhope itself, the latter was, by the beginning of 1993, in a more stable position. Provided that capital values do not fall so much further as to threaten the new banking covenants, it is now possible to see how Stanhope will eventually be able to trade its way out of difficulties. It certainly could not survive another year like 1991/92 during which over £270 million was written off its captial and reserves, leaving the company with only £42 million in remaining equity.

5

FROM RAG-TRADE TO RICHES

TWO OF THE new stars in the property firmament in the 1980s had their roots in the nineteenth century textile industry. Peel Holdings was the company on which the fortunes of the family of Prime Minister Robert Peel had been built; its story is told in Chapter Nine. The other textile company which transformed itself in the 1980s, at one stage becoming the fourth largest company in the quoted property sector, was Mountleigh, a company whose career was inextricably linked with its driving force, Tony Clegg.

Mountleigh was the direct descendant of a business named The North Warwickshire Worsted and Woollen, Spinning and Weaving Company, incorporated in Coventry in 1863, giving the company the statutory registration number 587; only 21 of the first 600 companies registered in England retained their listing by 1988. The second Lord Leigh (1824–1905) was the company's first chairman, which had been founded to relieve unemployment among Coventry's ribbon weavers. Six years after its foundation the name of the business was changed to Leigh Mills in the chairman's honour. Initially the cloth was spun in the north by other companies and woven in the Leigh Mills works in the Midlands, but in 1896 a new works was leased in Stanningley, Pudsey in Yorkshire. The business suffered the usual booms and busts associated with the textile industry: its centenary in 1963 was marked by one of the low points of activity and the original Coventry mill was closed. It was a merger in 1966 with Mountain Mills, a rival worsted manufacturer, which brought in Tony Clegg; the joint company was renamed Mountleigh, with Clegg's partner Ernest Hall as its chairman.

Tony Clegg is a short, stout man with a winning persona. Although he now lives in Yorkshire he was born in Littleborough on the other side of the Pennines in Lancashire. After National Service in the Army he worked as a merchant converter in Manchester, linking up with Ernest Hall when the latter bought Mountain Mills from the Francis Sumner Group in 1961. Clegg was then working for the Broughton Bridge Mill

Company, another part of the group, and Hall asked him to be production and administration director for Mountain Mills. Clegg moved to Stanningley in 1966 with the acquisition of Leigh Mills.

The worsted business continued to be an erratic performer; at its low point after a fire in 1971 losses mounted to £132,000 and the share price fell to 3p. Hall and Clegg set about diversifying the company into property. This happened, like most happy developments, through an act of pure serendipity: 'property chose me, I didn't choose property' says Clegg. Over the years Leigh Mills had assembled a substantial estate; in 1966 the company owned 137 acres of land of which only 250,000 square feet were occupied by mills and buildings. Other property had been sold by the previous management years before. One day Tony Clegg took a telephone call from agents Conrad Ritblat. They had found a buyer, an engineer, for the old mill adjacent to the Stanningley headquarters of Mountleigh. Although Mountleigh no longer owned the property, when they had sold it the previous managers of Leigh Mills had placed a restrictive covenant on the mill that it could only be used for textile manufacture. 'This was pretty surprising' laughs Clegg, 'I would have imagined that they might have put a restrictive covenant on that it couldn't be used for textiles; I can't think what their thinking was.' The agent asked for the covenant to be removed. 'I thought about it a bit and then phoned back and said I didn't think I really wanted to do that, but how much would they sell it for. I bought it for £24,000.' The old mills were demolished, at no net cost since the stone was sold, and a 12,000-square foot building constructed and let as a warehouse at £1 per square foot. This left seven acres on the site vacant for future development.

Before this Clegg had dealt in property only as textile man: 'I'd bought and sold a few mills but I'd probably done that pretty badly; I didn't know what I was doing'. From 1976 he decided to devote one day a week to property matters; on Tuesdays he would go round properties with a surveyor, Simon Duckworth. In the year which ended on 30 April 1979, Mountleigh's total turnover, including the worsted business, was £5.24m and the company declared a pre-tax profit of £347,000; of this £254,000 was contributed by the property development division. A year later the property division was able to help turn a loss of £86,000 on textiles into an overall profit before tax of £740,000. Only eight years later, Mountleigh had transformed itself into a company with a turnover of £529.5 million and pre-tax profits of £70.7 million. Mountleigh was a possible bidder for Sir Terence Conran's High Street Storehouse chain of Habitat, Mothercare and British Home Stores, and the company was mentioned in the same breath as the giant and venerable Land Securities. Yet within a year of the announcement of the record profits, Tony Clegg had sold control of his company to two Americans and the company had been dramatically reduced in size. How could have this happened so rapidly to a company and a man with no background in the property industry?

Tony Clegg's style in managing Mountleigh was not like that of the

merchant developers such as Stanhope, Rosehaugh or London & Edinburgh. Mountleigh's growth was almost all built on the facility for buying something which outside critics often thought overpriced and then selling it on, often before the original purchase had been completed. Clegg was unapologetic about this style of management. In an interview in May 1987 he complained 'People ask me how I can buy for £50 million and sell almost immediately for £60 million, but nobody asks Tesco how it can buy a case of baked beans at 10p a tin and sell them at 12p.' It would be impossible to count Mountleigh as a developer because the biggest deals and greatest profits the company generated came almost exclusively from trading rather than adding physical value to a site. Although many of the company's early deals were developments, particularly in its local Yorkshire market and Aberdeen, and Clegg constantly protested that he was interested in carrying forward developments such as Stockley Park or Paternoster Square, the headlines the company made were almost all about rapid dealing on of portfolios or companies which it had acquired.

Even in its early days of developing property in 1979/80, the trading mentality was apparent from the wide fluctuations in the turnover of the group coming from that activity. Among the first important deals was the development and letting of a 105,000 square feet warehouse at Benyon Park, Leeds to Hepworths, soon to become itself the temporary darling of the stock market under its transformed name and style of Next; this development had been financed by Hampshire County Council Pension Fund. The company also let an industrial development at Dyce Airport, Aberdeen. During the 1980/81 financial year further lettings had been agreed, of warehouse space on the Euroway Estate, Bradford as well as an office development in Golden Square, Aberdeen to the Royal Bank of Scotland; this latter was then sold to the Ready Mixed Concrete Pension Fund. These deals gave a property valuation surplus of £2 million, and the total value of property held had risen to over £6 million. In May 1981, the loss-making worsted interests were sold for around £400,000 and property became the only activity of the company; property assets had risen by the May 1982 year-end to a value of nearly £8.25 million.

It was a dramatic and slightly off-beat investment in November 1982 which transformed the finances and perception of the company in one deal. (It is symptomatic perhaps of the flurry of activity carried out by the Mountleigh Group in the 1980s that the company's own mini-history wrongly gives the date of this deal as 1981.) Mountleigh agreed to purchase from Possfund, the Post Office pension fund, (then incorporating British Telecom), for £5.25 million, three housing estates of a total of 800 houses, at Saxmundham, Lakenheath and Eriswell in Suffolk, let to the US Air Force. The purchase was financed by a rights issue of one million new shares, increasing the size of the company's equity share capital by a quarter, which raised a net £825,000, and a floating rate loan of

£4.5 million, on which interest of 2 per cent over the wholesale short-term money market rate was to be charged. Since at that time the interest rate would have been around 13 per cent and the net income to Mountleigh was estimated at £734,000 per annum, there was a profit after interest for Mountleigh of around £150,000 a year. The investment was immediately revalued by surveyors at £8.25 million.

There had been a potential risk in the USAF houses deal since it was possible that the USAF might not renew the leases on the estates which expired in 1982 and 1983. 'Over a period of time one would have made an awful lot of money out of those 800 houses had the Americans vacated them, but I couldn't stand the fact that there would be no income over the period, and my covenant was not good enough for somebody to lend me money without them being income producing.' The estate had been on the market for some time and buyers had balked at that possibility. Clegg had an ingenious solution: he bought, for £35,000, an option to insure against the possibility that the USAF would not renew its lease. The income he thus guaranteed enabled him to raise the necessary bank finance. The valuers had estimated these were worth 'considerably in excess' of their £8 ¼ million valuation should they be available for individual sale. Far from walking away from their estates however, the USAF renewed their existing lease for a further ten years and, in January 1985, commissioned Mountleigh to build and lease to them three further estates of 650 houses. The renewal of the existing leases increased the gross rents payable to Mountleigh to over £2 million from £1.2 million, and the company also received a maintenance charge; in exchange, Mountleigh was to spend about £1.5 million upgrading the estates. The contract for the new estates involved rental payments to the company of about £4 million, payable in Swiss francs, and the development was financed by a Swiss franc loan of £30 million with an interest rate of only 4.5 per cent per annum. In true 1980s fashion, this whole second phase of the USAF relationship was kept off the balance sheet of Mountleigh, since the lending was entirely secured on the houses and the banks had no recourse to the other assets of Mountleigh should things go wrong.

The relationship between Mountleigh and the USAF soured a little in later years when the USAF sued the company for non-performance of the 'build for lease' agreement of the second contract. 'We had such horrendous problems getting planning permission. I had an extremely good relationship with the Americans but they were very cross that we were finding it so difficult. So were we, since the rent was fixed and, as time went by, the contract was getting less and less interesting to us. On every occasion I had gone to Ramstein [USAF headquarters in Germany]. On the one occasion I didn't go one of my staff said we really wanted to pull out of the contract.' The USAF never pursued the writ, wanting only to have the houses built; eventually the two sides agreed not to try to build houses on the disputed site at Alconbury, but that more houses would be built on the Bentwaters estate.

The company's profits for the year to April 1983 had jumped to £811,000 from £554,000, helped by the absence of further losses on the worsted trade. Investment property assets had risen sharply to almost £23 million from the previous year's £8.2 million, helped by including the USAF estates at the valuer's figure of £8.25 million rather than its purchase price of £5.25 million; total debt had climbed to £12 million. In July Ernest Hall, Tony Clegg's partner for more than 15 years, resigned as chairman, taking a £75,000 ex-gratia payment, leaving Clegg in sole charge as chairman and managing director of the company. 'We'd worked tremendously closely and well for a long number of years' says Clegg about his ex-partner. 'It was unfortunate, but, by agreement, I looked after the property side and he looked after the textile business. The property side was pretty well all deal-driven and not at any time an income stream, and although the textile side was struggling like mad, I thought we ought to get rid of it. Ernest thought that this was the reason he was there.'

The second major deal establishing Mountleigh as a serious property investment company was the purchase, in January 1984, of Occidental Oil's European head office in Aberdeen from Jock Mackenzie's London & Northern Group. For a consideration of £6.4 million, the company bought a 122,000 square foot modern office block built on a ten-acre site by the Aberdeen outer ring road, let to the oil company for 25 years from November 1981 with five year, upward only, reviews.

There was an obvious advantage to Mountleigh in the purchase in that the surveyors valued the Aberdeen property immediately on purchase at £7.83 million, against its purchase cost of £6.4 million, which probably surprised the vendors. Since all that extra £1.43 million of value increased the shareholders' assets, Mountleigh was able to report a higher net asset value per share, which rose from 281.9p to 289.5p, even after taking into account the new shares issued as part of the purchase. Because the shares were trading at around 215p, the value of the company to potential investors was further enhanced. By the end of its financial year in April 1984, Mountleigh's investment property assets had risen to £39 million from the previous year's level of £23 million, with the Aberdeen office accounting for the bulk of new purchases; £7.7 million of the increase represented the transfer of property already owned from the 'dealing stock' of the company to the investment category. Smaller deals had included the redevelopment of a building in Glasgow, subsequently sold for £2.47 million to the BTR pension fund, the purchase of 44 houses in Maida Vale, London for £1.5 million and their subsequent refurbishment into 132 flats, a quarter of which were sold for £1 million within a year, and the inception of housebuilding in Scotland.

In the 1984–85 financial year several important acquisitions were made, and the figure of Paul Bloomfield becomes part of the Mountleigh story. Bloomfield was never mentioned in the publications which document Mountleigh's increasingly ambitious deals, but from 1985 he was a crucial element in the company's growth. Born in 1946, Bloomfield had been

involved with a subsidiary of E. J. Austin, a company which had been one of the great scams of the bull market of the late 1960s, early 1970s. Bloomfield's business, which had nothing to do with the scandal-ridden part of that group, was a building sub-contractor named Metropolitan Hardcore. Austin's downfall came over the claim that it had found a modern equivalent of the philosopher's stone: the ability to turn dross, or at least very low quality ore, into economically viable gold. At one stage a group of London investment analysts was flown over to the US to see the prototype plant in the desert. Low grade ore was fed into this shed at one end and gold emerged at the other. Despite the inherent unlikeliness of such a claim, many were hoodwinked. The company collapsed and was heavily criticized in a Department of Trade report.

Although Bloomfield was not involved in this particular disaster, he was to hit trouble himself with his own business. A motorway contract went wrong and that subsidiary dragged all Metropolitan down with it. His next venture was property investment, which had just commenced when the 1974–75 crash hit home; he was able to buy properties such as the Phillimore Court apartment block in Kensington when others were desperate for liquidity. In 1975 he was taken to court by a disgruntled solicitor over an unpaid account, and the Inland Revenue became interested in this apparently substantial property dealer who seemed to be paying little tax. The Revenue assessed Bloomfield for several years of unpaid taxes, and while he was abroad a bankruptcy order against him was served for the relatively small sum of £34,000. The Inland Revenue spent more than ten years investigating Bloomfield's tax affairs, rifling through his books, about which he admitted to having been irresponsible. An undischarged bankrupt finds it difficult to be involved in business. He cannot be a company director or even run a bank account; he can however give advice for fees, which is the life that Bloomfield lived for the next ten years. It was in such a role that Clegg and Bloomfield came across each other over the purchase and onward sale of a garage in Halkin Street on the Grosvenor Estate in Mayfair. Mountleigh managed to obtain vacant possession on the site and sold it to a buyer who turned it into what is now the Halkin Hotel.

Before further important deals could be concluded, the finances of Mountleigh needed to be put on a firmer long-term footing. In January 1985 the company issued £7 million of a 9¾ per cent convertible loan stock, raising £6.8 million to reduce bank borrowings, which had risen to £7.6 million out of a total borrowing level of over £30 million. Conversion of the loan into equity shares would eventually lead to the issue of a further 2.17 million shares to add to the 7 million already in issue and then trading at 290p per share. Because the major existing shareholders in Mountleigh, notably Clegg and his Jersey-based family trusts, were unable to subscribe to this issue, Mountleigh's brokers Phillips and Drew introduced new institutional investors, notably the Target life assurance and unit trust group and Phillips and Drew's own investment management

Canary Wharf (*photograph by Edward Bridger*).

LEFT Godfrey Bradman of Rosehaugh. BELOW
Rosehaugh Stanhope's Broadgate development
(*photograph by Peter Davenport*).

TOP LEFT Stuart Lipton of Greycoat and Stanhope. TOP RIGHT Tony Clegg of Mountleigh. BELOW Stockley Park.

ABOVE 17–22 Sloane Street. These shops were owned by six landlords in five years. BELOW These Sackville Street properties also had six owners between 1984 and 1990 (*photographs by Edward Bridger*).

TOP LEFT Elliot Bernerd of Chelsfield. TOP RIGHT Geoffrey Wilson of Greycoat. BELOW Cutlers Gardens, Devonshire Square, the Greycoat/Standard Life development showing Quinlan Terry's entrance gate.

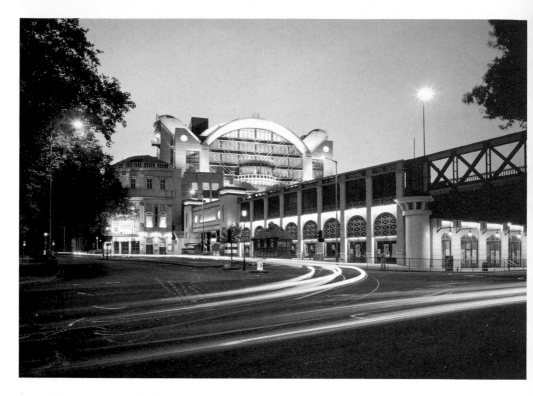

ABOVE Terry Farrell's Embankment Place development for Greycoat (*photograph by Alan Williams*). BELOW Route 11 – London Wall. The slab blocks to the left and right are now being replaced, for instance, by Terry Farrell's Alban Gate astride the road (*photograph by Edward Bridger*).

ABOVE The Richardson twin's Merry Hill Centre in Dudley (*photograph by Edward Bridger*). BELOW Sir John Hall's Metro Centre in Gateshead (*photograph by Edward Bridger*).

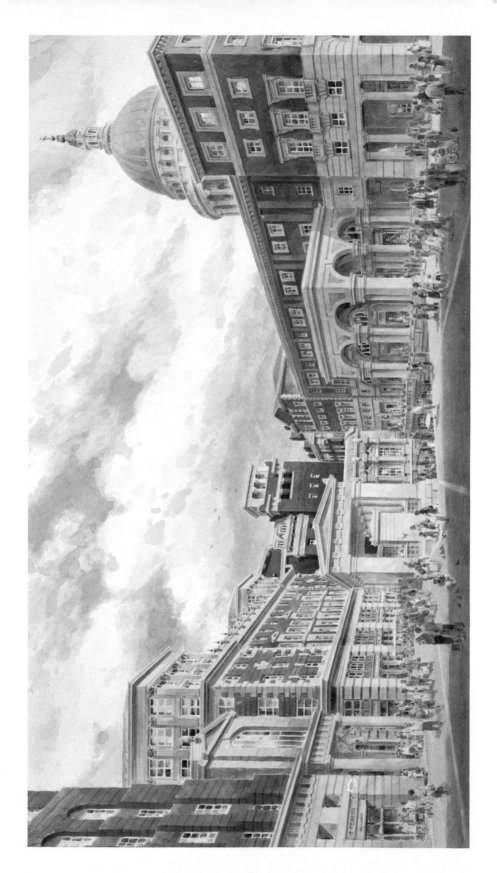

The Paternoster Consortium's proposed development of St Paul's.

subsidiary. A medium term loan of £10 million was also arranged.

The Annual Report issued in August 1985 showed the 1984/85 financial year to have been one of relatively little action for Mountleigh. Shareholders' funds had only grown by £3 million to £25 million, scarcely the pace expected of a dynamic company, even if the share price had now risen to 465p, well above the asset value of 359p. Fortunately Tony Clegg was able to report two substantial new transactions. The first was the acquisition in May 1985 of 42–70 Kensington High Street in west London for £6.5 million from the Imperial Tobacco pension fund. This was a row of shops, one of which had previously been a Woolworth store, plus 32,000 square feet of office space and 45 flats. Mountleigh's declared intention was to refurbish and let the retail and office space, which was expected to bring the property's value up to £14 million. In the event numbers 42–60 were sold for £8.2 million in early 1986 and Mountleigh let the major part of the rest of the development to Tower Records at £210,000 per annum. The second deal announced was the purchase in June of industrial land at Dagenham, east of London, variously reported by the company itself as 164 and 178 acres, for £3.15 million, on which there was a rental income of £250,000 per annum. In typical Mountleigh style, Clegg was able to reveal that 60 acres of this land had already been sold for more than the purchase cost of the total site and leaving the rental income almost intact. Both these property deals had been introduced by Paul Bloomfield. Bloomfield had identified the fact that Mountleigh was active and rapid in its decisions. His style and Clegg's fitted well: 'He has a very big vision of what you can do with property but he's not a detail man at all', says Clegg. 'That's why we worked well together. I was always a detail man and he can always see a very big picture.' One observer likened their relationship during this period to that of a father (Clegg) and his son.

The summer of 1985 marked the start of the most active period of dealing for Mountleigh, which pushed Tony Clegg and his company into the limelight as one of the most active property traders in the country. Clegg was by now known to be interested in deals so that all sorts of ideas were brought to his attention. His hyper-activity became legendary; he worked 16 hours a day but still insisted that he should be at home in Yorkshire with his family for Sunday lunch. He recalls that one year he reached the month of June having had at least one night a month in which he had failed to go to bed entirely.

Clegg was notorious for having meetings at night, and through the night; expensive lawyers and accountants would be lined up outside his office in the small hours waiting for his previous meetings to end. Business contacts tell of breakfast meetings with Clegg during which he would conduct three or four other meetings over his portable phone. Most of the proposals brought to him ended in the waste bin, but many deals were done. In September 1985 the company announced the purchase of 17–22 Sloane Street from Eagle Star Insurance for £6.75 million, partly financed by the issue of another one million shares, placed at 440p each. This

property, a concrete monstrosity on the west side of Sloane Street, was held on a long lease from the Cadogan Estate, expiring in 2091. It occupies the roadside under the Chelsea Holiday Inn, as well as high fashion shops let to such names as Joseph Tricot and Kenzo. Even more gratifying was the fact that Peachey Property, an old-established investment company with large holdings around Carnaby Street, the famous 'Swinging London' fashion centre of the 1960s, was a tenant of the office portion of the investment. Peachey had been built up by Eric Miller, who had benefited from the famous lavender note-paper resignation honours list of Harold Wilson in 1976. In 1977, Sir Eric was the subject of scandal about personal expenditure made by him using the company's money. In April that year the board of Peachey announced 'that they have asked Sir Eric Miller to resign as director, but that he has refused to do so,' a very rare occurrence. Sir Eric was eventually voted off the board and on 22 September he shot himself, leaving Peachey in a sorry state. By 1985 it had been substantially rebuilt, but for a parvenu company to be their landlord gave a special pleasure to Mountleigh. The history of 17–22 Sloane Street in the 1980s is typical of the trading mentality of the 1980s property boom. In the space of five years the property was owned by six different companies: Eagle Star, Mountleigh, Randsworth, Next Properties, City Sites and Power Corporation. In all that time the property did not change physically; only the rents rose, and with it the value these various companies were prepared to pay for it.

In November Tony Clegg linked up with Brian Wolfson, then Chairman of Anglo-Nordic Holdings plc, to buy effective control of Wembley Stadium. A consortium which as well as Wolfson and Clegg included Throgmorton Investment Trust, London and Continental Advertising, C. H. Bailey and Meridien Holdings bought London Leisure and Art Complex (LLAC) from the Gomba Group for £10 million. Gomba, run by Abdul Shamji, was one of the companies which brought the Johnson Matthey Group to its knees, and the group's assets were all up for sale. LLAC owned 66 per cent of Arena Holdings and that company owned 51 per cent of Wembley Stadium itself, with the other 49 per cent of the Stadium company owned by the conglomerate, BET. A further 34 per cent of Arena was owned by another consortium, of Stockley plc, Harry Goodman of Intersun and Jarvis Astaire, the promoter of Viewsport. Stockley, as we shall see, became the eventual Achilles heel for Mountleigh, but at this stage they were no more than a potential partner for Clegg, whose 10 per cent investment in Wembley Stadium would cost £4 million.

The final, and largest, deal done by Mountleigh in the hectic closing months of 1985 was the acquisition of the privately held property company R. Hitchins for £28.4 million, again brought to Clegg by Paul Bloomfield. The selling Hitchins family were paid in 10% loan notes maturing in December 1988, guaranteed by the Royal Bank of Scotland, but Mountleigh decided that its balance sheet would become too highly

geared after such a purchase and the year's second call on existing shareholders, in the form of a rights issue of 2.9 million shares at 475p, was made, bringing the number of shares in issue to 11 million from the 7 million extant as recently as April. Hitchins owned only one building which was fully developed and let, a Fine Fare supermarket in Luton, which accounted for about £5 million of the total purchase price. The rest of the portfolio consisted either of properties under construction but not let, four sites with planning permission around Luton and 60 acres of land on the Cote d'Azure in southern France with permission to build half a million square feet of a mixed residential and commercial development. Despite this rather speculative portfolio (which one property analyst admitted to me he didn't really understand), and the fact that the income received was only £480,000 per annum at the time of purchase, the valuers, Jones Lang Wootton and Hepper Watson certified the properties to be worth £49.25 million, well above the purchase price of the company, even taking into account the £4 million outstanding purchase commitment for land which Hitchins had undertaken.

By the end of 1985, Mountleigh had established itself as a rising star of the property world, but still capitalized at only £65 million, it could not be considered in the same league as the first division companies such as Land Securities or MEPC. Its great strength was in trading properties, but the company had now made a rod for its own back in leading the investment community to expect a rising trend of profits made from this source. There was little in the way of long-term investment apart from the USAF estates; trading profit in the 1985/86 year reached almost £10 million against the £5 million of net rental income. Investment property assets had risen in that year from £45 million to £79 million, but only £13 million of that increase came from investment properties acquired in the year; the rest came from transfers from the trading stock and a revaluation. Investment income is repeated, but every sale of a trading asset has to be replaced by profits on new assets. The Hitchins deal took into the trading account properties which were in the books of Mountleigh at £27.5 million but had been valued at the time of the deal at £39.5 million, so that Mountleigh could earn a pre-tax profit of over £12 million if it was able to sell those properties at the valuation estimates. Mountleigh was unable both to generate these trading profits and keep for itself investment properties of any significance as a result of the income shortfall between the cost of money and the rents earned. To achieve the sort of profit growth to which its shareholders were becoming accustomed, the company could simply not finance both investment and trading.

As a result in 1986 and 1987 Tony Clegg was forced to find larger and more spectacular trading coups to keep the show on the road. The first of these deals was the £58 million purchase from Samuel Properties of a portfolio of 180 properties, mostly in the south-east. Mountleigh paid for this purchase with a further issue of 1.05 million shares, this time issued at

805p a share, and a loan from the HongKong Bank of £50 million, secured on the properties purchased and with recourse to Mountleigh itself for only £10 million, so that if the company raised less than £40 million for the portfolio, that risk was borne by the bank, not Mountleigh. A fall in values of about 30 per cent may have seemed a distinctly unlikely turn of events in 1986, but four years later it may have been something a lending bank was faced with. Mountleigh stated that 'a substantial proportion of these properties will be disposed of within the foreseeable future providing significant profit contributions'; about £8.7 million of the portfolio was intended to be retained as an investment. By September it was reported that the company had indeed contracted to sell two-thirds of the portfolio for £60 million.

In addition to the properties bought there was included an option on the two sites by the south end of Vauxhall Bridge; these plots were on either side of the road. The northerly one became known as the Green Giant site after the physical attributes of an office block proposed and rejected for the area, and the southern plot is known as the Effra site. These empty sites had been the subject of several schemes over the years. David Goldstone of the Regalian Group eventually bought the northern plot and has developed an office block designed by Terry Farrell in the style of a D. W. Griffiths film set. The property was sold for £130 million by Goldstone to the government's Property Services Agency in early 1989 as a home for MI6, just as the property market showed signs of imminent distress.

In August 1986, Mountleigh published its annual report and accounts for the year which had ended in the previous April. These showed pre-tax profits up to £9.25 million from the £2.5 million earned during 1984/85; of the total for 1985/86 £3.5 million came from the sales of the Hitchins portfolio in the four and a half months since its acquisition, part of the £12.5 million profit implicitly stacked up in the trading account at the time of the take-over. Net assets per ordinary share in Mountleigh had risen from 344.15p to 548.83p. Tony Clegg had also seen a substantial increase in the beneficial interest held by him in the company during the year, increasing his holding from 477,308 to 1,492,683 shares; only part of this increase was attributable to the year's rights issue, which would have cost him over £1.25 million to take up. Since he did not have the personal resources to fund these purchases, Tony Clegg was putting someone else's money, the bank's, where his mouth was. The balance of the increase was the reversion to his own hands of the shares hitherto held by the HongKong and Shanghai Bank Trustee (Jersey) which was the nominee for Clegg family trusts.

The new deal which definitively took Mountleigh and Tony Clegg into the first division was the successful bid for the quoted United Real Property Trust. On 7 August 1986 it was announced that Mountleigh had agreed terms with United Real whereby their board would recommend Mountleigh's offer to buy for £117 million, quite a step for a company

capitalized at £110 million. United Real was a company built up in the post-war boom by Maurice Wohl, which first went public in 1961, although only 26 per cent of the shares ever reached the hands of the general public. Wohl's intention had simply been to remove his company from the tax regime which, at that time, condemned it to paying 91.25 per cent tax on its income. United Real had built up a portfolio of 13 typical 1960s curtain-wall office blocks in London, one property in Birmingham and one in Sydney, Australia. At the time of the bid only one was being actively developed, in Victoria Street, SW1. Maurice Wohl had built United Real in a period during which investors were still very sceptical about property, and preferred to back those developers who had negotiated long leases with reputable tenants, even if the leases had no reviews for many years. At that time it was possible to raise long-term debt whose interest rate was below the income yield on the property investment. Many of the properties in the United Real portfolio were rented at well below the current market rents, but no review was in the offing. A shrewd investor could see that paying the tenants a capital sum to surrender their existing leases and either agreeing new leases at a market rent with regular reviews, or redeveloping, would turn these properties into marketable securities, well above the value attributable to them in United Real's books. State House in Holborn was typical, having been let to the government for 25 years at a rent of £1 per square foot without a review. When Clegg asked the United Real Chief Executive why this was, he was told it was only because the government wouldn't take a 35 year lease.

United Real had not been actively managed for many years because its effective owner, Maurice Wohl, had no reason to maximize his short-term income. Wohl had in fact become a tax exile and an absentee landlord, leaving England for Geneva in the mid-1970s at the time a Labour government had increased the marginal tax rate on investment income to 98 per cent. None of the directors other than the Chief Executive was a full-time employee at the time of the Mountleigh bid and there were only four administrative employees. United Real had not commissioned a valuation of its properties for over three years, (and no valuation was commissioned during the bid), but many analysts and companies had cast envious eyes over the portfolio for several years and some had made the journey to Geneva to try to persuade Mr Wohl to sell his company to them; all had failed hitherto. Maurice Wohl's advisors were J. Rothschild, in the person of Jacob, now Lord, Rothschild, Stanley Berwin of solicitors S. J. Berwin, and Morgan Grenfell Laurie, the surveyors headed by Elliott Bernerd. They had met Tony Clegg during Mountleigh's growth phase of the past two years and they gave him a fair wind with Maurice Wohl. As Clegg himself was quoted as saying, during the period between the announcement of talks and agreement of terms, 'The determining factor will not be price; the decision will be whether he wants to sell. He has had approaches before and has never got round to selling his stake.'

What would determine the outcome would be the emergence of a buyer dedicated to meeting Maurice Wohl's particular needs. One person who was close to this and many other transactions maintains that it was in this particular skill that Clegg excelled. 'He was very good at listening to people he wanted to do business with and finding out what it was they really wanted to do the deal', unlike many property entrepreneurs. 'A lot of people assume that what they [the sellers] want is the highest possible price', but there is often a personal factor to finding the key to unlocking a deal. Clegg puts his success in clinching the deal down to the fact that 'I was the first person who didn't argue with him. The whole market would have given pretty long odds that I wouldn't do the deal with him, and it was a very, very difficult negotiation. I had to go to Geneva to meet Maurice Wohl and set aside two hours, including getting to and from the airport. After that meeting it came back to me that he had wondered how this guy could think he was going to buy his company in an hour, so I pretty hastily reconvened a meeting to last the whole day.'

The form of the bid was cleverly packaged. Maurice Wohl wanted cash for his stake, and he wanted foreign currency, fearful that sterling would fall again, particularly if the bid was delayed at all and a General Election intervened with a Labour government taking over. On the other hand, the market was already beginning to suffer from indigestion with the weight of new Mountleigh shares that had been issued over the past two years and the bid could not be financed entirely from new borrowings. Clegg's solution was to issue 83 million £1 convertible preference shares, which count as equity in a company's balance sheet rather than debt, but might introduce a new group of investors attracted by the 5.25 per cent net dividend payable on the preference shares, equivalent to pre-tax dividend yield of more than 7 per cent at the basic rate income tax rate of the day; the balance of the purchase was financed through a £35 million one-year loan from The Royal Bank of Scotland, parent of Mountleigh's merchant bank, Charterhouse Bank, who themselves loaned another £5 million on the same terms.

The greatest coup over the acquisition of United Real may have been that in early 1987 the property portfolio, on the advice of the company's lawyers Berwin Leighton, was transferred to a Dutch subsidiary, renamed Mountleigh International, and could be realized free of capital gains tax. This was managed despite a similar case when the Daily Mail and General Trust, which controlled Associated Newspapers and other quoted shares, tried to do the same thing only to find themselves prevented from proceeding by the Inland Revenue. Clegg recalls that 'we identified from the very beginning that the big downside on the whole transaction would be the capital gains position. The whole deal was structured on the basis that it would be offshore at the point we bought it.'

Before the end of this important year for the company, Mountleigh refinanced some of its short-term debt through the arrangement of a syndicated loan from 27 banks of £110 million organized by Union Bank

of Switzerland, the parent of brokers Phillips and Drew. There were also further large purchases: the Hoover building on Western Avenue was bought by Mountleigh's subsidiary Fanebrook for £10 million. This famous art deco facade fronted 440,000 square feet of factory on a 8.6 acre site, and was again brought to Clegg by Paul Bloomfield; there were to prove to be great planning difficulties with this building. Two other notable purchases were firstly the acquisition from the Electricity industry pension fund for a total of £22.5 million, partly financed by the issue of almost six million shares at 255p, (equivalent to 1530p in the old form), of the old *Times* offices, New Printing House Square in Grays Inn Road; secondly from a Docklands developer, the nearly completed and part pre-let Hertsmere House on the Isle of Dogs for £12 million.

There were two other transactions in the first few months of 1987 which were to be precursors of important future developments in the history of this extraordinary company. Another off-balance sheet company named Eagerpath had bought a wide range of assets, including Adnan Khashoggi's marina development in Antibes. Eagerpath was not apparently majority owned by Mountleigh and, therefore, the total assets and liabilities of the company were not included as if they were Mountleigh's. Only the net equity invested in it by Mountleigh was presented as an asset. In fact the other shareholders of Eagerpath were all close associates of Mountleigh. 'We took advantage of the model code as it stood then; you could not have done Eagerpath today' confesses Clegg. The company sold, for £9 million, a portfolio of properties in Eagerpath to Phoenix Property and Finance, headed by Irishman John Duggan, and entered into a joint venture with Phoenix to develop 24 acres of residential land at Hounslow Heath, West London. This land had no planning consent when the two men bought it for £7 million. Within two weeks of purchase the partners were given the planning permission they sought and within two months the estate was sold to Crest Homes for £14 million. John Duggan's first deal with Tony Clegg was to prove important to both men. Duggan had established his credentials to Clegg as a man with an eye to a good deal.

The portfolio sold to Duggan was part of a group of investments bought by Mountleigh the previous December from Stockley plc, the developers of Stockley Park, just north of Heathrow Airport, a company central to the story of both Stuart Lipton and Elliott Bernerd. This portfolio, bought for £25.25 million and sold for about £30 million, was turned round in rapid order, even for Mountleigh.

The snapshot of Mountleigh afforded by the year-end of 30 April 1987 shows how much was ventured and how much achieved in the previous 12 months. Reported pre-tax profits rose from £9.23 million to £33.57 million; £139 million of properties had been sold, £142 million bought, in addition to the purchase of United Real for a further £121 million. Of the profit, £3.76 million arose from United Real and a further £3.8 million from related companies which only paid cash dividends of £20,000 to the

parent company. The great bulk of profit again came from trading, where £125 million of sales gave rise to a surplus of £32.86 million (up from £9.66 million the previous year), whereas the net rental income from investments only rose to £9.47 million from £5.1 million. The major achievement noted in the annual report was the sale of £120 million of the United Real portfolio, realizing an after-tax surplus of £26.77 million over the 'fair value' attributed to them at the time of the take over. The big buyer from this portfolio was the Norwich Union; they paid £20 million for a development in Victoria Street SW1, bought the minority interest in their own development over Moorgate station and the long lease of Clements House in Gresham Street in the City. This latter 130,000 square foot office building was one of the classic examples of a dated building with old-fashioned leases which would benefit from active management, and was valued at about £40 million. One of the most attractive features of these sales was that, thanks to the change in domicile of Mountleigh International, they had attracted tax of only £828,000. Norwich Union had engaged in a substantial spending spree on City of London office blocks in 1986/87, buying 120–125 High Holborn for £55 million and the architectural pattern-setting Fountain House in Fenchurch Street for £27.5 million as well as funding the development of properties in Liverpool Street, Holborn Viaduct and, as we shall see, Beaufort House on the eastern edge of the City.* The other substantial sale from the United Real portfolio achieved before the year-end was of 10/14 Stratton Street W1 to Elliott Bernerd's Chelsfield group. One further sale in the new financial year confirmed the success of the United Real purchase, when State House in Holborn was sold to interests of Robert Maxwell for £40 million, bringing the total realized to date to £160 million against the £120 million paid for the whole company.

The annual report also showed several other interesting snippets of information. Not only was Eagerpath a 'related company' but Clegg had indulged in some tax avoidance by buying two merchant ships, later added to, with borrowings of £6.8 million 25 per cent guaranteed by the parent company. The investment in Wembley was now accounted for in the same way. Tony Clegg's personal investment in Mountleigh and his rewards from the company had also risen during the year. Clegg's shareholding in the company had increased again, mostly through the exercise of stock options and conversion of his holding of convertible loan stock, but he had also purchased two million of the convertible preference issued on the take-over of United Real. Although his salary from Mountleigh had now risen to £169,000 per annum, there was no possibility that this could have been financed other than through further personal borrowing. With the shares standing at 288p (equivalent to

* In April 1992 it was reported that Norwich Union was intending to sell much of this portfolio at the depressed prices then prevailing: its late 1980s purchases had turned out very badly.

1728p in the pre-capitalization form) on 30 April 1987, Tony Clegg was worth over £30 million before netting off the loans he had taken out, and his company's ordinary shares were capitalized at more than £265 million.

Even before these 1986/87 results had been announced, the hyperactive Clegg had announced the deal which was not only to create the fourth largest UK property group but also expose a running sore which was to prove ultimately fatal to his plans. On 6 May 1987, the boards of Mountleigh and Stockley announced that agreement had been reached over an offer by the former for the latter. The early story of Stockley is told elsewhere in this book, but at this stage the greatest risk period had passed; the development at Stockley Park had begun to attract substantial tenants at rents which fully justified the initial concept, although most of the benefit was then accruing to the Universities Superannuation Scheme (USS), the pension fund for university staff, which had been the financier of the development. The board of Stockley was partly composed of the men who had undertaken the reverse take-over of the then Trust Securities, notably Stuart Lipton and Elliott Bernerd, as well as representatives of J. Rothschild, and two directors of European Ferries, whose portfolio Stockley had bought for shares in the year ending in November 1985. Although non-executive, these gentlemen all had other direct interests in the well-being of Stockley. Stuart Lipton's own company, Stanhope, had a management contract with Stockley to supervise the Stockley Park development. Elliott Bernerd's firm, which had now been taken over by Morgan Grenfell to form Morgan Grenfell Laurie, was retained as agent for parts of the Stockley portfolio and European Ferries had an effective shareholding of about one third of the fully diluted share capital of the company as a result of the earlier swop of properties for shares. Another Stockley non-executive director was Roger Seelig, a corporate finance director of Morgan Grenfell who was later to become embroiled in the Guinness affair. One of the factors which clinched victory for Clegg in this bid was the fact that he agreed to buy European Ferries' investment in Stockley, which was hedged about with restrictions as to voting and transfer, largely for cash at a lower overall price than available in the general offer. Although the Stockley board could in theory have blocked this purchase, they clearly thought the overall price was satisfactory for all shareholders, and agreed to the transfer.

The bid for Stockley would cost Mountleigh £365 million bringing in assets of £261 million, against the then market capitalization of the company's outstanding ordinary shares of £250 million and its gross assets of £367 million. Most of the acquisition was to be paid for by yet another enormous issue of 105 million new shares, to shareholders of Stockley who had no investment in Tony Clegg's record. These shareholders, particularly the USS, would prove to be constant suppliers of stock to the market over the next few years, making Mountleigh's ability to create new trading profits by taking over portfolios and companies for shares more and more difficult. Not only was this market problem created by the bid

but there was no doubt that the transaction proved to be the wrong one at the wrong price at the wrong time for Mountleigh. Ron Peet, the chairman of Stockley made a pertinent point in his letter to his own shareholders recommending the offer: 'Your Board considers that the Offers made by Mountleigh reflect not only the current value of the company's assets but also substantially reflect the further value that could be expected to accrue from the current development programme.' With such property experts as Lipton and Bernerd on the board this statement could not be laughed off. After all the addition of Stockley's assets to the group, at the value carried in Stockley's own books, net of the £118 million of borrowing Mountleigh would need to finance the cash element of the bid, would add only £62 million to equity assets, diluting the net asset value for ordinary shareholders quoted at 30 April 1987 from 157p per share to about 100p.

The whole strategy of buying property for shares depended on the purchase of assets which could be put into the Mountleigh books at their purchase price, but had been bought with shares standing at a substantial premium to the overall asset value per share; this of itself would always increase the asset value per share for Mountleigh's shareholders. To achieve this result, the assets of Stockley were written up in Mountleigh's books by £211 million to 'fair value', which added 110p per share to the apparent asset value of Mountleigh. You may recall that a similar device was used in the case of United Real, and Clegg had demonstrated that his perception of 'fair value' in that case was superior to most analysts. As one observer put it, at the time Clegg was like the largest market maker on the Stock Exchange, being offered a vast array of deals and prices being put on properties, so that his market intelligence was probably superior to any other property market operator of the time. There was no reason to suppose that his judgement was going to be proved wrong in this case.

One other indicator as to Mountleigh's intention towards the Stockley portfolio was its reclassification of its property assets in Mountleigh's accounts from investments to trading stock, which meant that any surplus over 'fair value' would be reflected in Mountleigh's profit rather than its balance sheet.

The logic for Mountleigh buying Stockley has never been entirely clear. The Stockley Park development was well analysed and only a very rapid rise in rents on the estate would justify taking a more optimistic view of the assets. The other major assets of Stockley were a 50 per cent interest in the Beaufort House development, the other 50 per cent being owned by P&O; 50 per cent of the Paternoster Square site to the north of St Paul's Cathedral, where plans to replace the wind-swept 1960s development were in hand, and two investments, both fully let, off Fleet Street and by Victoria Station. It is true that Stockley had £30 million of near cash in its hands at the time of the take-over, having sold to P&O for £100 million its investment in Stock Conversion, another star of the 1960s property boom. Clegg is honest about at least part of the motivation: 'The deals had

to get bigger hadn't they? It's impossible to change one's spots. We realized a profit out of the transaction.'

Trading in other property continued even in the wake of the Stockley deal. In June 1987 Mountleigh sold a portfolio of six properties to the quoted Control Securities, headed by Nazmu Virani, for £8.7 million, payable part in cash and part in shares making up eight per cent of Control's equity, which Mountleigh undertook to hold as an investment; the company also sold the 1960s office block Enford House in Marylebone Road to Sheraton Securities for £10.5 million in cash. In August it was announced that Mountleigh had sold 11 properties for £83 million cash to Randsworth Trust, one of the rapidly proliferating Mountleigh clones; included in the package was the Sloane Street property which Mountleigh had acquired for cash and shares worth £6.75 million as long ago as September 1985, a full two years earlier. The *Times* building in Grays Inn Road, which had originally been intended to be a substantial addition to Mountleigh's still small long-term investment properties was said to be subject to a 'stunning' offer for the property, generating the odd statement that 'current strategy planning may result in a rethink of this (original) decision'.

Tony Clegg seems at last to have fallen prey to the delusions of many of the initially successful subjects of this book: the idea that he had a formula for success which would enable him to make money in areas which were new to him. In September 1987 it became known that Mountleigh had bought several million pounds worth of shares in Storehouse, the quoted holding company of Terence Conran's retail empire of Habitat, Mothercare and British Home Stores (now modish restyled as BhS). 'I had the view, although of course it wasn't made particularly obvious at the time, that we could sell off everything except BhS, and then work BhS, continuing to run it. It's amazing how times change. There's no doubt that, at that time, the sum of the parts was considerably greater than the whole. People say now with hindsight "aren't you glad you failed?" The answer is that it was a bit closer call than I actually thought it was at the time, but we were in serious discussions with other retailers to sell off all the bits.' Fortunately for Mountleigh Clegg eventually thought better of making a bid for this group which would find the going even rougher in the years ahead. This had not prevented Benlox, a small company in the stable connected with Peter Earl of the mini-merchant bank Tranwood Earl and backed by Ashraf Marwan, from making a bid. Benlox and Tranwood Earl were to re-emerge in the story of Paul Bloomfield at a later date. For Mountleigh, the urge to move into retailing was not dormant for long.

In September Mountleigh launched another of its rapid strikes, buying the Pension Fund Property Unit Trust (PFPUT) for £271 million. During the early 1980s as described in an earlier chapter, pension funds' enthusiasm for property had diminished as the returns on that asset had paled into insignificance against that achieved on equity shares, both in

the UK and overseas, and even fixed interest securities had bettered the growth of property in the early 1980s. PFPUT had been an early example of a unit trust restricted to non-tax paying investors buying property with the agglomerated smaller sums invested by funds who did not feel that they were big or knowledgeable enough to buy property on their own account. One of the problems with these unitized vehicles was that, to be able to meet occasional redemptions from unit holders, a substantial holding of cash was necessary, even when the property market was very strong, and when the market was weak and redemptions accelerated, the only properties which the funds could sell were their highest quality ones.

The PFPUT acquisition was made through the 'related company', Eagerpath. Included in the PFPUT portfolio were 24,000 acres of agricultural land, which, it was widely expected, Clegg would immediately put up for sale. This was despite the fact that Tony Clegg was an enthusiastic breeder of pedigree longhorn cattle. In fact the reported seller turned enthusiastic buyer of agricultural land, and as early as November had bought a £15 million farm portfolio from Distillers pension fund; he had reportedly negotiated the sale for £35 million of the only farm that analysts had thought he would retain. This was astride the A12 in Essex with outstanding planning permission for various commercial developments. Mountleigh was the buyer of more than half the let agricultural land sold during 1987, stemming a fall in values which had been gathering pace since the early euphoria over entry into the EEC had driven land prices to unsustainable levels at the end of the 1970s. Mountleigh continued to be an important buyer and seller of farms in 1988.

One notable development of the period was the introduction of Mountleigh as majority partner with Trust House Forte in the redevelopment of the Criterion site on the south of Piccadilly Circus, one of the rare cases in which Mountleigh persevered as a developer. It is a feature of Mountleigh's history that the number of developments in which it was involved at one stage or another outnumbered those which it saw through by at least a 10 to 1 ratio.

The Stockley bid also marked a change in the rhetoric of Tony Clegg. Hitherto he had glorified in the description of property trader, but he now seemed to yearn for the respectability that development and investment might bring to his activities. In announcing the company's results to 30 April 1987, Clegg was quoted as saying that the market would now see Mountleigh taking on more development and investment work, using the Stockley team as the development arm. The Paternoster Square redevelopment was supposed to be one such example, and for a time it certainly seemed likely that Mountleigh would press forward with this highly sensitive development. Stockley and its partners in the scheme, British Land and the pension funds of Barclays Bank and Unilever, had appointed Arup Associates as master planners for the project.

The take-over of PFPUT also aroused suspicion that one of the attractions to Mountleigh was the fact that PFPUT's largest single

investment was City Gate House, a solid but distinctly old-fashioned office block in Finsbury Square. Its attraction to Mountleigh lay in the suspicion that there might be a mutually advantageous swap available between Standard Life and the company of that property and Juxon House, the major element of the buildings to the north of St Paul's which the Paternoster Group did not own, which was owned by the Scottish company. Juxon House, which protruded into the line of sight up Ludgate Hill towards the Cathedral, had itself changed hands regularly over the past ten years. In March 1979 the Prudential had bought, from the Church Comissioners, this 100,000 square foot office block, let to Barclays Bank, for £16 million; the Pru had in turn sold the property on to Standard Life. Standard Life angrily denied it had any intention of selling Juxon House or exchanging it for City Gate House which was next to two other buildings it owned on the corner of Finsbury Pavement and Finsbury Square. The property investment manager of Standard Life Peter Henwood said 'We have no interest in City Gate House. We looked at it three years ago before PFPUT refurbished it, but decided we weren't interested. I think if you tried to redevelop it you'd find that it would be listed and you wouldn't be able to pull it down.' As to the sale of Juxon House, Henwood claimed that the building was 'the front door' to the Paternoster redevelopment, while the consortium owned 'the back yard'. This was a little harsh but, undeniably, any rebuilding would be piecemeal without Juxon House. 'It is not for sale. It never will be', concluded Henwood. Those who have been involved in investment know that 'never' is a word that should be used sparingly if ever.

The interest in retailing as a business rather than as landlord resurfaced on 9 October with the announcement that Mountleigh had agreed to purchase, through its Mountleigh International subsidiary, the total equity of Galerias Preciados, the Spanish department store chain, for £153.4 million. While not on the same scale as the Stockley purchase, this transaction was to have equally damaging long-term effects on the company, and it is clear that the deal has not been a real commercial success. Galerias Preciados is Spain's second largest department store group, operating 29 stores of 2.9 million square feet in total at the time of the bid. The Spanish group had been in the ownership of the Rumasa family when they had their assets expropriated by the Spanish government in 1983. The buyers of the chain in 1984 were the Venezuelan Cisneros Brothers, the controllers of Organizacion Diego Cisneros, who were brought to Clegg by the ubiquitous Paul Bloomfield. After the October stock market crash the terms for the purchase were refined so that Mountleigh paid £72.5 million in cash plus £80.9 million deferred, interest free, until 3 May 1989. The purchase by Mountleigh from the Cisneros interests was peculiar in the sense that Cisneros immediately applied part of the initial down-payment of the sale to buying Mountleigh shares.

The unusual part was that by the time the Cisneros subsidiary was

paying 300p per share for their 16.7 million shares the stock market crash of 19 October had occurred, Mountleigh shares had suffered more than most, and were currently trading at 140p, well below its summer all-time high of 322p. A similar agreement for the seller to reinvest a substantial part of the proceeds in Mountleigh shares at this now ludicrous price was made with the vendors of the much smaller Dutch company, Coroco, whose primary assets were two office blocks in Rotterdam. Mountleigh International, whose Chief Executive was Michael Cook, bought Coroco from a company controlled by the same Michael Cook for an initial £7.5 million plus 20 per cent of any increase over eight per cent per annum in the net asset value of Coroco over five years. The relative performance of Mountleigh against the stock market as a whole had indeed peaked at the time of the announcement of the bid for Stockley. The discrepancy between the nominal prices paid for Galerias Preciados and Coroco and the effective prices reduced the overall cost to Mountleigh shareholders by about £25 million, but the market collapse had much more serious long-term consequences than this short-term benefit. For the first time in nearly four years, the Mountleigh share price had fallen below the published asset value. No longer was it going to be possible to issue new shares at a premium and so increase the underlying asset value per share. The Galerias and Coroco deals were the last that Mountleigh were able to finance on this basis, although this did not prevent the issue of more paper.

The Galerias purchase revived fears about Mountleigh's strategy. On the numbers, the company was buying a group of stores with a net asset value of £304.1 million, way above the effective £125 million that Mountleigh had paid. Unfortunately the stores were chronic loss-makers and had made a pre-tax loss of £45.5 million in the year to 31 August 1987. The Cisneros group had put in new management and spent £25 million on refurbishing the stores. For Mountleigh the biggest change would be that from employing only 77 people in April, the workforce would now expand to 9,500. Clegg's intention was to return the retailing business to profitability with the eventual goal of flotation of the revived company on the Spanish market, meanwhile avoiding the penalty to current profits by taking the investment in Galerias as an 'unlisted investment' in its balance sheet. The capital structure of Galerias was reorganized 'so as to allow Mountleigh International to have control . . . and to receive the dividends and surplus assets arising on liquidation, but so that (it) is not a subsidiary of Mountleigh for the purposes of the Companies Act 1985'. This initially enabled the company to reflect the value of the investment in Galerias in Mountleigh's balance sheet without taking the trading losses into its profit and loss account. At the same time a substantial new shareholder and creditor, Cisneros, had appeared on the scene and was going to play a crucial role in the future of Mountleigh.

Tony Clegg took an active interest in the management of Galerias. At one meeting in London, while discussing an important deal, he was being

shown racks of 'frocks', which he would either select or discard. He was helping select the dress ranges that Galerias would carry.

The purchase of Galerias and the stock market crash did not stimulate any obvious changes to the management of Mountleigh. At Stockley Park more prestigious lettings were agreed and the sale of elements of the PFPUT portfolio continued.

Mountleigh also announced its intention to seek planning permission for a new town west of Wetherby in Yorkshire and the option to purchase for a nominal sum a majority holding in the Norwegian developer Bygge Eiendorms, which had failed to raise new finance after the stock market crash; a conditional deal was concluded in March with Mountleigh paying £1 for 49 per cent of the parent company and £22.63 million for its British assets. More important, now that the share price had fallen below the quoted net asset value, Mountleigh began the process by which it could start buying in its own shares. Such purchases would increase the net asset value of remaining shares in an exact mirror-image of the earlier process of increasing asset value per share by issuing shares for a price above the quoted asset value.

Mountleigh's interim profit figures for the six months to October 1987 showed pre-tax profits up to £35 million, including a £14.2 million gain on sales of parts of the PFPUT portfolio, but there was a £7.7 million post-tax provision against the fall in value of the company's holding in Storehouse.

At this point, over the Christmas and New Year holiday there was the first hint of mortality for Tony Clegg, but in a literal rather than a merely business sense. He was rushed into hospital suffering from a gangrenous appendix, and, despite the public view that it was merely a standard case of appendicitis, Clegg was very ill for a week or so. 'Appendicitis can happen to anybody, but when I do anything, I do it in spades.' This may have been a substantial stimulus to the surprising move of the next month, the bid by Mountleigh for Phoenix. For an estimated £58.6 million, Mountleigh bought the smaller company for a combination of shares and cash, but the stated net assets of Phoenix, even including the assets of the recently purchased Rohan Group, were only £36.5 million. The logic for the bid was explained in the offer document: 'Over the course of the last 18 months, Phoenix and Mountleigh have been involved in a number of projects together; this has led to the belief of both Boards that the development skills of the Phoenix Group team and development opportunities already being held or being offered to the Mountleigh Group should be combined'. John Duggan, the Chief Executive of Phoenix, and Bruce Bossom, the property director of Phoenix and an ex-partner of Jones Lang Wootton, were to join the main board of Mountleigh and Duggan was to become Chief Executive of Stockley, 'the principal UK development arm of the Mountleigh Group'.

John Duggan's involvement with Phoenix had come about through an invitation by Professor Sir Roland Smith, the ubiquitous company director, who was non-executive chairman of the company, which was no

more than a cash shell. Duggan makes no bones about how Phoenix was able to be another of the successful property companies: 'It was a bull market'. Rather than succumbing to the substantial pressure simply to add highly priced property assets to the company's portfolio, Duggan took over the quoted Irish company, Rohan. It was an introduction from Professor Smith that brought Clegg and Duggan together for their early deals. Duggan says that Clegg 'always had time for people like me who brought him deals, that was his life blood. You had to be prepared to take the time to see him, so you had to fit in with his schedules. I used to wait for him until three in the morning and tell him what I was going to do. He was a tremendous partner, once he had said yes to you he was there 100 per cent. When Black Monday came we all suffered and Tony got the notion that he needed me to come on board.'

Whether Clegg really needed Duggan or not, he was certainly prepared to pay a very full price for the smaller company. By the time Clegg had suffered his illness, Duggan had become quite a close friend, and while Clegg was recovering at his home over Christmas 1987 Duggan spent some time 'talking, just talking. He decided to do it [make the bid] and we had to work out how to do it. One of his greatest failings is that you can only be in so many places. I took advantage of the fact that he was not at the table all the time in the negotiations.' As a result Phoenix was sold for a 'fantastic' price.

Duggan and his colleague Bruce Bossom moved into offices in Hill Street, Mayfair, away from Mountleigh's main office in Berkeley Square. The two men looked through the Mountleigh portfolio and marked out the properties for which they wanted to take responsibility. Among the investments they took were Stockley Park and the Criterion site in Piccadilly Circus, assets which they believed suited their skills.

The offer document gave little new information about the trading of either company but it did give up-to-date information about the directors' shareholdings. At 30 April 1987, the annual report of Mountleigh showed Tony Clegg's beneficial holdings at 10,070,874 ordinary shares and 2,000,000 5.25% preference shares. The offer document showed Clegg as having bought another 65,000 shares on 20 October, in the immediate aftermath of the crash, yet it also showed his beneficial holding as only 9,891,264 ordinary shares (180,000 fewer) but 3,000,000 5.25% preference shares (1 million more); there is no explanation anywhere for this dramatic discrepancy.

In March the sale of Beaufort House to Norwich Union for about £200 million was confirmed, a transaction which Tony Clegg claimed to be the largest single property deal in UK history. The sale of this ex-Stockley property would produce a profit of around £20 million; the price was however no higher than the deal which Norwich Union had offered in 1987, a time when there were no tenants. The Prudential, which had formerly held a freehold over part of the site, then sold its interest to Mountleigh for £25 million. Another sympton of the more cautious view

that Clegg was being forced to take over property values was the sale of New Printing House Square, 214–238 Grays Inn Road. In August 1987, Clegg announced that this property, which had been bought originally to add to the investment portfolio, was subject to a 'stunning' offer, and would now be traded on. The sale in March 1988 was for £28 million, a very acceptable return over the £22.5 million cost in April 1987, but not really justifying the hyperbole. The buyer was Elliott Bernerd's private company Chelsfield, whither Stockley's ex-managing director, Michael Broke, had moved. Another sale was of a package of 21 properties to Control Securities for £88 million, the third deal between the two companies within a year. Included in the portfolio were the original estates of houses let to the USAF which had put Tony Clegg under way six years earlier, and Hertsmere House, Mountleigh's purchase in Docklands. Control paid £68 million in cash and the balance in shares which took Mountleigh's holding to 17.5 per cent. Mountleigh was buying as well as selling in this period. One new development opportunity was the former Firestone headquarters on the Great West Road, bought from Royal Life for £20 million; a second was the partnership with the Leeds City Development Corporation, promising to invest £200 million in the City over five years (P&O signed a similar agreement). The new partners in Phoenix tied up the redevelopment of Camberley town centre, paying £31.6 million for a new 150-year lease, with the intention of spending £10 million roofing over the 1960s Arndale shopping centre.

The end of the year to 30 April 1988 gave no apparent signs of the imminent collapse in Tony Clegg's dreams for his company. The declared profit showed a pre-tax total 'on ordinary activities' of £70.7 million, up from £33.6 million in the previous year. £25 million of this total came either from the realization of the PFPUT portfolio or the acquired companies, particularly Stockley. The most startling figure of all was the trading turnover of the group, which sold almost £510 million of property in the year as well as a further £119 million from its investment portfolio. More worrying was the fact that, against the book cost of the property, (carried at cost or realizable value, whichever is the lower), Mountleigh managed a margin of just 12 per cent in the year, against a 36 per cent margin over cost achieved on a much lower level of activity in the previous year. The write-off against the decline in value of the Storehouse shares had risen to £13 million, which together with the loss realized on abandoning housebuilding in Scotland, gave rise to a total extraordinary loss of almost £18 million. Almost as extraordinary was the total of proceeds from the share issues that Mountleigh had made in the year, £337 million. The balance sheet issued in July showed the company still with a stock of £569 million of property held for trading purposes against £229 million held as investments. Stockbroker analysts were actually disappointed with the figures, which they had expected to show even higher profits, and the share price fell nine per cent to 156p in their wake. The mystery of Tony Clegg's shareholding was not clarified by the annual

report: as at 30 April 1988 it showed his beneficial holdings to be 9,657,712 ordinary shares and 3,000,000 5.25% preference shares. This would suggest that Clegg had sold over 230,000 ordinary shares in Mountleigh since the announcement of the Phoenix bid, despite having bought shares at a higher level. The 1988 annual report also showed that Clegg's shareholding a year previously, on 1 May 1987, was of 9,826,764 ordinary shares and 3,000,000 5.25% preference shares, whereas the 1987 report had showed him holding 10,070,874 ordinary and 2,000,000 preference shares, again with no intervening document explaining the discrepancy; such inconsistencies may be explained by the switching of beneficial interests between various accounts, and no sinister implications are suggested.

Before the date of publication of this annual report another series of changes had occurred to make it of only modest use in determining the outlook for the company. The first step was the sale of Stockley Park back to the entrepreneurs who had originally sold it to him only a year previously. There had been trouble over the development of Stockley. Lipton's company had continued as the project manager of the project, and, according to one observer, he was still treating it as if he was the owner. There were huge rows between Stockley and Lipton; at one stage the owners asked Lipton to go to the US to market the project, but he is said to have responded that he didn't have the time. If Lipton was biding his time so that Clegg would become frustrated and sell the project back to him cheaply, he succeeded. By October 1988 Mountleigh was due to repay a £100 million short-term loan, and Stockley Park was the obvious candidate for sale.

The buyer was a consortium made up of Stanhope, Stuart Lipton's newly public company, Chelsfield, Elliott Bernerd's private company, Prudential Assurance and Kajima Construction, the Japanese building contractor. The price paid by the consortium was £160 million, and the profit over the 'fair value' assumed by Stockley the previous year was measured 'in the millions rather than the tens of millions' according to Clegg himself, which suggested that the investment did not match the returns available from putting the money in the bank for the same period. More worrying for analysts was the fact that Stockley Park had been seen as the prime development in Mountleigh's portfolio and the prime reason why their shareholders had been asked to pay such a hefty transfer fee for the services of Phoenix's Duggan and Bossom. Mountleigh had also sold Stockley House in Victoria to Bernerd's Chelsfield, which in turn sold it on to City Site Estates for £30 million only months later. Together with the sale to Chelsfield of the *Times* office in Grays Inn Road and Bernerd's sale of a 634-home housing estate in Hounslow to Mountleigh for about £13 million, Bernerd and Clegg had spent much of the last 12 months in negotiation with each other.

The second startling change made in the Mountleigh portfolio was the buying out of the other 50 per cent in the Paternoster Square Consortium,

British Land and Unilever Pension Fund, each with 20 per cent and Barclays Bank Pension fund with ten per cent, for £73 million. John Duggan justified the further purchase of this development site: 'It has got to be easier to take (the development) forward when there is just one owner, rather than a committee.' Stuart Lipton's Stanhope was to be retained as project managers of the still embryonic scheme. 'We have no complaints with Stuart Lipton. The only difference will be that whereas he has been acting as if he owned it we will now have a more significant input.' At least Mountleigh was throwing itself wholeheartedly into the preliminary planning stages of the Paternoster redevelopment. The story of the architectural argument is told elsewhere but Clegg was clearly keen to meet many of the criticisms from the Prince of Wales and other anti-Modernists, providing of course that such strictures did not make the project uneconomic; he was reported as saying that 'We acknowledge the very special responsibility which we have for protecting the immediate environment of St Paul's and we are confident that modern architecture can, and will, complement this unique part of our national heritage.'

The avowed intention of Mountleigh to change from merely trading to development and the creation of a portfolio of investment assets was the justification of the bid for Phoenix, but, apart from Paternoster, these new-style projects had hitherto been hard to identify. A series of announcements now suggested that such a change was indeed under way. Mountleigh was to co-ordinate the development of 800 acres of Barking Reach, on the Thames east of Docklands; in Docklands it was to develop a 'China City' with Tianjin Municipal Government on 12 acres around Poplar Dock; in Leeds it gained planning approval for a 500,000 square foot office block and it bought 20 acres of land in Harrogate from ICI for a business park development; in Slough it sought permission for an office block on the Granada Cinema site; in Aberdeen it persisted with plans for an out-of-town retail development; in Ashford, Kent it announced a joint venture to develop a 158 acre business park with Eurotunnel and 1,200 homes (with Rosehaugh's Pelham homes). Unfortunately, despite the protestations, few of these developments ever progressed to completion, and even fewer in Mountleigh's hands.

In August 1988, for the second time in the year, Tony Clegg was in hospital. The operation was to remove a tumour from his brain, and outside observers were preparing themselves for the worst; in the event the tumour turned out to be benign and Clegg had actually been much iller with his appendix earlier in the year. Clegg himself treated the whole episode very casually. John Duggan had just gone on holiday to his French house when he took a call from Clegg. 'He said "By the way, I'm going in for a minor operation". When I asked him what it was and whether it was serious, he said it could be but he would be out in two weeks. He asked me to look after the company.' There are many who still cannot accept the idea that the operation was as minor as Clegg maintains, pointing out that he had substantial radiation treatment after the surgery,

and were amazed that he ever returned to business at all. Clegg explains the treatment: 'They leave an element of the tumour behind rather than damage too much inside one's head, and they kill it off with deep X-Rays. Every week-day for five weeks I had to go to the Royal Marsden. It was quite difficult because, although they had an appointments system, they never kept to them. I couldn't sit in a basement waiting for this machine, I was much too busy. I would phone up and find out how long they were running behind, then park the car outside. I'd wait for them to get nearer the point and send the chauffeur to find out when it was my turn. The poor people who were queuing in the seats thought I was queue-jumping, so the staff had to sneak me in the back way.'

The operation meant that Clegg was unable to be at Mountleigh's annual general meeting, which was chaired by Sir Ian McGregor, who had joined the board in April 1987. Sir Ian came under some probing about the investment in Galerias Preciados, which had been planned as a management turnaround and resale; the recapitalization of Galerias Preciados had involved the sale to Mountleigh of over £140 million of the stores which were then leased back. The interest saving for the stores group was substantial and McGregor could claim that the operation was now making a trading profit. This claim of good progress was not the first or last to be made on the subject of the Spanish stores, but the eventual flotation or sale is still waited.

On 13 October 1988 the end of the reign of Tony Clegg as king-emperor of Mountleigh seemed to be signalled by the appointment of John Duggan as Chief Executive of the group, leaving Clegg as Executive Chairman. Clegg sold his stake in Mountleigh to a consortium, represented by a company named Algver Investments of which he himself was a member, 'as a supporting gesture that I wasn't getting out completely'. The other members of the consortium were Duggan, Clegg's old friend Brian Wolfson of Wembley Stadium, and Geoffrey Simmonds, ex-chairman of Phoenix, who both then joined the Mountleigh board. The amount involved was £54.6 million, valuing Mountleigh's shares at 180p, well above the ruling price on the stock market. Duggan gave notice of his intention of taking charge: 'I don't envisage any sweeping changes. Only time will tell the difference in style between Tony Clegg and myself. One of my first tasks will be to make sure that, at a time when interest rates are high, our level of gearing is one we can feel comfortable about. Otherwise it's business as usual.' But it wasn't.

Duggan with his colleagues Bruce Bossom and finance expert Ioin Cotter looked for the first time at the totality of Mountleigh's position and were shocked enough to say to each other 'let's get out of here.' They decided to embark on an aggressive programme of sales. On Tuesday, 17 October 1988, Duggan announced the sale of Paternoster Square and other assets to Organization Diego Cisneros, who had sold Galerias to Clegg only a year before. On the face of it the £317.5 million transaction was a very good price to receive for Paternoster, together with Dorset Rise, another Stockley joint development with British Land and Barclays

pension fund, and three other substantial London office blocks. Paternoster was in Mountleigh's books at £288 million, but the inclusion of the other properties suggests that it was sold for substantially less than this. The sale was at least partly the result of the Cisneros group's fears for the outstanding £80 million payment due to it from Mountleigh the following May. Duggan's approach was to tell them 'you ain't going to get paid, so why don't we give you something?' It does seem rather odd however to splash out over £300 million in order to make sure that the company you have sold an asset to can pay you. It is made a little less odd when it is revealed that the deal involved the debt boot being put firmly on the other foot. Cisneros did not pay for its new assets in cash on the nail. The £80 million Mountleigh debt to them was extinguished, but the bulk of the purchase price, £160.3 million, was not to be paid until October 1989. Thus for a payment of £70 million, Cisneros became owners not only of Paternoster but of four other fully let and marketable properties, (Babcock House in Euston Road, Hoskyns House in Shaftesbury Avenue, Dorset Rise and 36 Hill Street, W1), from which it might realistically expect to recoup its initial cash payment; indeed by May 1989 Cisneros had reportedly sold £70 million of these other properties and had Paternoster in exchange for its position as creditor of Mountleigh.

There is another strange contradiction in the history of this deal. Although Hoskyns House was reported to have been sold to Cisneros in the transaction, in February 1989 Land & Property Trust was reported to have bought the building for £23 million, from Mountleigh. The eventual payment of the balance due to Mountleigh from Cisneros for the purchase of Paternoster was as uncertain as had been Mountleigh's ability to pay Cisneros for its purchase of Galerias. The balance of £150 million was due at the end of September 1989, and an American investment bank was charged with the task of finding a buyer for the development. At the very last moment, a consortium of Greycoat and Park Tower Realty, an American private investment company, bought the development and the Cisneros group was able to pay its debt to Mountleigh.

The initial payment to Mountleigh of £70 million of loan notes was made in Amsterdam and Ioin Cotter disappeared in notorious Amsterdam for most of the afternoon, much to the prurient amusement of his colleagues. In fact his occupation that afternoon was entirely innocent. Cotter had arranged to deposit the loan notes in the safes of several different hotels for the night, nervous that such sums of bearer paper should be all in one place.

Duggan also negotiated another sale in this period, of the Eagerpath 'related company', to a Swiss-based company, SASEA. This company was run by Italian financier Florio Fiorini, ex-chief of the Italian state oil company ENI, and was associated with Giancarlo Parretti, the media entrepreneur who had earlier rescued the Cannon Film group of the Israeli businessmen Golan and Globus, the so-called go-go boys. SASEA paid Mountleigh £37.8 million in cash and took over £120 million of debt.

Not included in the sale were City Gate House, previously sold to CIN, the Coal Board Pension Fund, for a rumoured £80 million, nor, as it transpired later, an office in Gracechurch Street, EC3; the remaining assets of the old PFPUT portfolio, including some farms, were sold. SASEA was advised by Paul Bloomfield and Tranwood Earl, the mini-merchant bank of Peter Earl. SASEA had other fish to fry with Mountleigh: Fiorini and Parretti had joint interests in Spanish commercial property.

While this deal was being put together by Duggan, he was surprised to read in his week-end newspaper that the company of which he was managing director was in talks which could lead to a bid being made for Wembley Stadium, now a publicly quoted company after it had been reversed into the dog-track company, GRA. These talks had been carried on principally by Tony Clegg and his old friend Brian Wolfson. The price mentioned in the press, £180 million, surprised all the analysts of the situation, since the published net assets of the smaller company were only just over £100 million at the time. Duggan couldn't see value in such a deal and could only make it work financially at £75 million. 'I could see a tide running where I couldn't have stopped it. You look around a board table and say "who's going to be with me?" and I could see the Wembley deal going through. It was obscene, but I knew that, if I killed it, I couldn't survive at Mountleigh. Macgregor, [Mountleigh's Chairman] was a formidable opponent.' The talks were aborted, partly because their early revelation had been unwelcome, but Mountleigh promptly ordered its brokers, Phillips & Drew, to buy 18.5 million of its own shares (five per cent of the total outstanding) in the stock market at a price of 167.5p.

Then on 13 November came public news of two stunning developments. The SASEA investors announced that they had formed a new company which was bidding for Mountleigh International, the holding company of Galerias Preciados, and to give an edge to their negotiations, they had taken an option to buy the 7.6 per cent held in Mountleigh by Cisneros, and, amazingly, had bought at 200p each the shares in Mountleigh, another 5.4 per cent, held by the consortium to which Tony Clegg had sold his shares, and of which he himself was a member. The second announcement was just as dramatic: John Duggan was fired. The roles of Clegg and Duggan had not been established satisfactorily to either man, as Clegg was later to confess: 'I suppose both he and I read the cards wrong. I assumed that I was going to be an executive chairman and he assumed that I was going to be a non-executive chairman. It was a misunderstanding between us that needed clearing up.' Duggan agrees: 'Truthfully there's no place for a John Duggan in Mountleigh; Tony is a one man band in so many ways.' Clegg agrees at least to some extent. 'I can't say whether he [Duggan] was surprised [about the Wembley deal] or not. It would be very dificult, if one replayed the whole thing again to understand absolutely what did go wrong. It was bound to be difficult from his point of view, and mine, because I somewhat passed my baby to

him, and so maybe I was over-sensitive. I certainly wouldn't apportion blame.'

By the end of November the Swiss-Italian Galerias Consortium had built up its stake in Mountleigh to 21.5 per cent through further purchases, at 200p, from some of the loose large shareholders introduced to the Company's share register in the take-over of Stockley. In this way the remaining credibility of Mountleigh was eroded. The bid for Stockley, not itself an obvious success, brought in large uncommitted shareholders and the Paternoster development. The bid for Galerias brought in the Cisneros interests, both as shareholders and as creditors; the deal over Paternoster was done by both sides from weakness and allowed SASEA to find a large shareholding which it could bring into play for its own reasons.

In January Mountleigh's interim profits and Chairman's statement were published. This is a very odd document since it refers to the events of the previous November only tangentially as 'some highly publicised disappointments'. The half-year profits, which included two months of Galerias Preciados as a subsidiary and were therefore not directly comparable, showed a fall to £24.8 million from £35.4 million on trading turnover up from £96 million to £450 million but rental income up only to £15.5 million from £7.8 million. Since most of that rental income would come through as profit, this suggested that the company made only £10 million on its massive programme of sales (including Stockley Park and Paternoster), barely any margin over cost. Another £6.7 million after-tax had to be written off the investment in two per cent of Storehouse. There was also a warning that the tax change might be much higher than that published in the statement since the sales of property had taken place well above the tax base price, even if the profit over Mountleigh's book cost was relatively modest. After Duggan's departure, not accompanied by his ex-colleague from Phoenix Bruce Bossom, business continued in a similar fashion to before but at a less hectic pace. Clegg added to Mountleigh's shareholding in Control Securities by spending another £20 million to buy a stake held by British Land; this 22.7 per cent was seen as a long-term investment. A Swedish investment group bought the unlet West Cross Centre on the A4 for £40 million, and Mountleigh abandoned a long-held development site in Gloucester.

The SASEA saga finally ended in March 1989 when, having failed to agree a sale of Galerias Preciados to the Italian entrepreneurs, Clegg personally bought back the SASEA 14 per cent stake in Mountleigh, SASEA having not exercised its option to buy the Cisneros's seven per cent holding. Clegg claimed that SASEA had indeed made a bid for Galerias but had not given enough further information for the deal to go through. There were some concerns whether the SASEA group was acceptable to the Spanish authorities and whether they had sufficient resources to complete the deal. This was a reasonable question since the Gracechurch Street property, which had originally been in the Eagerpath

package sold to SASEA was now sold to another buyer, Culverpalm, for £40 million, and speculation suggested that this was the reason for the change in the contractual arrangement with SASEA for that portfolio, reducing its overall cost to the Swiss-based company. Parretti was to face similar questions when he bid for the MGM studios in California; (in April 1991 he was removed from control of his media empire by his major bank backer, Credit Lyonnais). How could Clegg afford to buy 14 per cent of Mountleigh when he had only owned just under five per cent when he sold in the previous autumn? Clegg was now a very highly geared investor. 'It was just a stake that was around. As I had ended up back as Chairman owning hardly a single share and this stake was loose, I thought it should be bought.' Clegg later added to his position by taking an option on the stake still held by Cisneros.

Paul Bloomfield was again involved on the other side of a deal when his new vehicle company, Benlox, offered £18 million for the Hoover Factory on Western Avenue which he had introduced to Clegg three years earlier at a price of £10 million, but on which the desired retail development with Tesco had at that stage failed to receive approval. The deal was never completed. In October 1992 Bloomfield was forced to enter a voluntary arrangement with his banking creditors, for whom he had guaranteed loans of £60 million, to avoid being made bankrupt a second time. Mountleigh then sold the Beaver housing estate, previously bought from Elliott Bernerd, to a housing association for £16 million, the price paid to Bernerd's company for it. This property had caused Mountleigh embarrassment when it tried to impose an increase in the ground rent on the estate; the adverse publicity from this apparently rapacious action persuaded Mountleigh to cut and run. Markheath, associated with Australian 'entrepreneur' John Spalvins of Adelaide Steamship, and headed by Paul Bobroff, who later became better known as chairman of Tottenham Hotspur football club, bought another office park site on the Great West Road from Mountleigh.

The final act in Clegg's involvement in Mountleigh was not long delayed. On 8 November 1989 it was announced that he had sold his 22.6 per cent interest in the company for £70.4 million to two Americans, Nelson Peltz and Peter May. Peltz and May had been one of the most successful teams which exploited the junk bond boom of the late 1980s in the US. They had made hundreds of millions of dollars through buying the major companies in the can business, taking the company private and selling it on to the French company, Pechiney. Peltz came to the UK to use Mountleigh as his vehicle for a similar success in the European market. He believed that Europeans were relatively unsophisticated investors and that the opportunities were now greater than in the well picked-over bones of American industry. He misjudged his market.

There is no doubt that Clegg was suffering tremendous pressure from the size of the bank debt he had taken on in order to buy his substantial holding in Mountleigh. His frustration at the inability of the shares to move to what he considered to be a reasonable reflection of the value of

the company led him to seek a price for his holding which would enable him to close the position at a modest profit and remove the risks of such a highly geared investment.

Among those aware of Clegg's position was John Duggan. Duggan, who knew more than most about the promise and pitfalls of Mountleigh, told Clegg that he could not justify paying more than 175p a share, even though Clegg was asking 200p. Duggan worked on a bid for his holding, and sought a partner. The man he found was Werner Rey, the Swiss financier who had completely undermined the reputation of Swiss businessmen as being conservative, slow and cautious. Rey was as much a trader as many of the British property men; he believed that, having agreed with Duggan to make the offer, it was as good as done. He was not pleased to find himself outbid by the Americans. Rey and Duggan instead put their joint funds into a small company, Conrad, which, after a bid for Marler Estates and Rohan (bought again by Duggan, this time from Mountleigh), changed its name to Cabra Estates. Its major interests are in the football grounds of Fulham and Chelsea, on which planning permission exists for redevelopment. Werner Rey, meanwhile, has suffered the fate of many of the 1980s super-novas: his Omni group has had to seek protection from its creditors.

Why did Tony Clegg suddenly decide to sell, so soon after taking back the reins? 'My wife put a lot of . . . pressure is the wrong word. Both my wife and a number of my friends told me to get out simply because of my health. My eyesight was affected by the brain operation. There's a lot of nonsense talked about me working 18 hours a day; well, most of it is true. When you phone up the family lawyer to make sure that he phones the hospital just in case you can't talk to your wife. . . . The opportunity came along to sell my stake. It was fair and reasonable to assume that if the right offer came along I would probably look at it seriously.' Clegg does not deny that the level of borrowing he was carrying was a heavy burden, and he needed a reasonable price for his shares to be able to exit with a comfortable margin.

The final departure of Tony Clegg from Mountleigh was not a bang, more a whimper. His concrete achievements are difficult to identify. Very few of his projects were developed by him, the profits he made for Mountleigh in the good years were transitory and proved impossible to sustain. Yet Clegg was undoubtedly a phenomenon of the 1980s. As one of those who worked closely with him has remarked 'They thought it was a real business, but it was only a business in the context of the times they were in.' Clegg began to believe he could do anything, from taking over Galerias and bidding for Storehouse to buying ships, and he thought that it would never stop. Yet he has generated nothing but personal affection, even from those whom he crossed. The partnership between Clegg and the (then) undischarged bankrupt Paul Bloomfield is one of the more extraordinary of the decade. The deal finder Bloomfield with the deal maker Clegg were the property market for a period of the late 1980s.

Clegg is now working again in a company, United Dutch Holdings, backed by Danish businessman Jan Bonde Nielson. This latter man once owned 25 per cent of the Wembley company, and has faced charges of bribery in his native land, of which he was cleared, although he still faces appeal proceedings in Denmark, to which he has so far refused to appear. Much as Bloomfield was the *eminence grise* in the property dealings of Mountleigh, so has Nielson been a shadowy financial part of Clegg's life. It will be interesting to see whether Clegg defies precedent and becomes a significant factor in the property market as it recovers in the 1990s.

Mountleigh continued to struggle under its new owners. The Peltz-May combination also found it more difficult to turn Mountleigh into a money-maker than their previous ventures together. In May 1991, half their shares in Mountleigh were sold to the Gordon P. Getty Family Trust for 100p each, half the price paid to Clegg 22 months previously. The idea was to enable Mountleigh to raise funds for the continued investment needed in Galerias. Only two months later Mountleigh announced a huge loss and that it was raising funds through a rights issue priced at only 25p a share, with the Getty Trusts and two other foreign investors underwriting part of the issue. The Stock Exchange also investigated the circumstances in which Peltz and May had sold shares in the 'close season' for director dealings: the two were censured. The rights issue was left almost entirely in the hands of the underwriters, who, in addition to Peltz and May and the Getty Trust included a Bahamian partnership of the US Pritzker family, builders of the Hyatt hotel chain, and Accumulator, a Danish property company. In May 1992, Mountleigh went into recceivership, unable to raise funds to repay its Swiss loans. Its attempts to do so were finally frustrated by its inability to sell the Merry Hill Shopping Centre (see Chapter Nine).

Does Tony Clegg have any regrets about Mountleigh and his meteoric career? 'There have got to be things one regrets. But much, much more there is a feeling of enjoyment than regrets one might have had. Part of the problem of the business we were in was that we were really commodity traders. Commodity traders cannot walk around like Stuart Lipton and say "I built this and I did that." We didn't change the face of the UK. That was one of the difficulties of Mountleigh, and the reason I was interested in Storehouse and Galerias. I actually wanted to change the way forward for the company and I would have turned it into a retailer with strong property overtones. I saw it as a way of making the shift, because if one extrapolated Mountleigh's future, one had to take over Land Securities or the Pru and flog all that. And then what? I suppose the only thing one might have done with hindsight, and then one doesn't know how long the window of opportunity is, we might have taken it slower and create a larger investment portfolio behind the trading; to try to steady the thing a little bit and get to a point where one had a decent income.'

In April 1987, at the height of his success, Tony Clegg had spoken the

words which best describe both the reasons for his rise and for his ultimate fall, in an interview with Jane Roberts in the *Chartered Surveyor's Weekly:* 'I think the Land Securities of this world are good for the industry, they underpin the market. It may seem a bit boring when inflation is low, but I believe those companies will perform well in the long term. I admire them, but I don't deny I don't want to be one of them. I don't have that mentality.'

6

THE SURVIVORS

THERE WERE FEW, if any, companies which came through the 1974–76 period in anything like as healthy a state as they went into it; almost everyone had been caught up in the euphoric phase of that boom and everyone paid the price. There were even fewer managers of property companies who survived that period still in charge of their diminished empires, and only a handful went on to be significant participants in the 1980s property boom. Two who did survive and go on to greater achievements were John Ritblat of British Land and Jeffrey Sterling who, with his close colleague Bruce McPhail, progressed from the rescue of Town & City Properties to managing the fortunes of the venerable Peninsular & Orient (P&O), the shipping line which transported the Empire.

John Ritblat was born in 1935, the son of a dental surgeon from North London. Although like Godfrey Bradman he was evacuated during the war, to Warminster in Wiltshire in Ritblat's case, his upbringing was fairly typical of a middle-class boy: prep school at The Hall in Hampstead, where he is now on the governing body, followed by Dulwich College. His maternal grandmother had given him a little capital which was invested in shares. Young John could see the benefits accruing from these shares which seemed to provide him with a rising flow of pocket money, and when he was about to leave school he thought he would be a stockbroker, and having been to the offices of his own broker 'thought it was a marvellous business.' It happened that his uncle was Dudley Samuel, the eponymous head of property agents Dudley Samuel, Harrison of Bruton Street in the West End of London, where it still has offices today. Dudley Samuel was the doyen of his profession, if a little eccentric, and most of the successful property agents of the 1950s and 60s, such as Edward Erdman, Marcus Lever and Joe Gold, had passed through his office at some time to learn their trade at the feet of the maestro. Just before making his decision John Ritblat had lunch with his uncle who took him for a walk down Bond Street. In 1951 Bond Street still looked

like an old hag with missing teeth, the bomb sites having not been filled in the post-war austerity period of building licences and other restrictions. 'We're not going to leave it like this' said his uncle surveying the sorry mess. 'If you become a stockbroker you'll know nothing about anything. I'm absolutely sure that if I send you along to Edward Erdman and he sees you have a twinkle in your eye, he'd be delighted to take you.'

In fact Erdman initially rejected the young man, saying in his memoirs that 'I thought he would be far too ambitious to settle down patiently to the disciplines and rigours of a professional career'; eventually he was persuaded to change his mind. John Ritblat became articled to Edward Erdman in 1952, and, in his own words 'I could see I was going to be quite good at it. I was a fully-fledged negotiator by the time I was 21.' While he was attending the College of Estate Management in the evenings to gain his surveying and auctioneer's qualification he met another young student, Neville Conrad, who was articled to his uncle's firm. In 1959, at the tender age of 23, he and Conrad set up their own agency, Conrad Ritblat. Their clientele was drawn from the people he had met at Erdman's. This was the big boom of the 1950s, with the names of Cotton, Clore, Fenston, Wolfson and Max Joseph prominent. 'All the developments were rubbish' says Ritblat today, 'in the 50s we were still putting up 30s buildings, while in the 60s we were putting up Paternoster and the things that are so ghastly.'

Ritblat had become very friendly with Max Joseph, the financier who used to run a business empire from an office with no staff. Joseph used Ritblat to run most of his property interests and in 1969 called on him to repair the fortunes of one of his companies, Union Property, which had fallen to a share price of six old pence, having been as high as twenty-one shillings. Ritblat warned Joseph that solving the company's problems was not a ten minutes a week job, so Joseph told him that he didn't care what was done, 'you've got to sort this out.' Joseph suggested that he buy the Conrad Ritblat practice or some part of the property assets that Ritblat and Conrad had by this time built up for themselves. Ritblat agreed to buy a large stake in Union, partly for cash, partly in exchange for his property assets and the agency practice, the two younger men ending up with about half the company. Conrad soon went on his own to build up Regional Properties, but Ritblat set about restoring the fortunes of Union. One of the early deals was the purchase and onward sale of the Classic Cinema chain, an asset deal, thereafter bidding in 1970 for British Land, a relatively small company with a worthy history. It had been set up in 1856 by three Liberal MPs as a way of enabling men of modest means to gain the property qualification necessary to be on the electoral roll.

With the name of the group changed to British Land, Ritblat then did the deal which has maintained his fortunes over the past 20 years. The simultaneous bids for two quoted property companies, Haleybridge and Regis, brought into the group Plantation House, a large Edwardian style office block occupying most of a freehold island site between Fenchurch

Street and Eastcheap in the City. Although many other property assets were added to the portfolio at the same time, it was the continued ownership of this flagship building which enabled Ritblat to survive the later economic blizzard.

It was a deal in the US which distracted British Land from the growing problems in the UK. In 1972/73 New York was in extremis. The city's finances were collapsing under the strain of a social security system which was attracting the underprivileged from all points of the US and from outside its borders. Businesses were leaving the city and the State of New York as the local taxes levied to meet this burden rose inexorably. One of the largest owners of offices in New York was the Uris Corporation, control of which had recently been inherited by Harold Uris from the estate of his brother Percy, the creator of the portfolio. Harold proved a rather ineffectual custodian of the inheritance and the company was known to be available for sale. John Ritblat looked with anticipation at the potential which Uris represented. Its portfolio was larger than the largest UK company, totalling some 20 million square feet of offices and hotels. The borrowing which it had was all non-recourse, so that if Uris failed it could not bring down British Land. The problem was that there was a growing number of empty New York offices, but Ritblat took the view that he could afford to sit out the bad times and wait for the market to improve. He took the idea to the National Westminster Bank and Schroders, the merchant bank; Gordon Richardson, later Governor of the Bank of England, and James Wolfenson of Schroders were old friends of Ritblat's. He persuaded the two banks to subscribe to 25 per cent of British Land and 25 per cent of the Uris Corporation and to guarantee to raise the balance of the purchase price, the main debt being a $600 million 20-year amortizing note carrying a six per cent interest rate. Ritblat rationalized the deal: 'All we've got to do is to manage it adequately, sit there for 20 years and after 18 years we will own the buildings free and clear, free of debt. They're marvellous buildings, just square boxes ideal for modernization to keep them up to scratch.'

After a year's negotiation in July 1973 the conditional contract to purchase was signed, the finance package was signed and everything was ready for engrossment. Ritblat returned to the UK on Friday only to find by the Monday that two sons-in-law of the Uris family had managed to complete a deal for control of the company at a dollar a share more for Harold Uris. 'We couldn't believe it' says Ritblat. The new owners had raised the finance through the car-park company National Kinney with help from Steve Ross of Warner Brothers: 'They believed that, after a year looking, we had unearthed some incredible goodies and value. We hadn't, we had simply created an incredibly complex financing package.' By the end of that year, after the Yom Kippur War, interest rates rose sharply in New York and National Kinney found themselves in trouble; Warner Brothers had to find a further $200 million immediately and the Uris portfolio had to be liquidated. At the end of 1977 the rump of the business

was bought for $320 million by a little-known Canadian company, Olympia & York, run by the Reichmann family, 'with marvellous timing' says Ritblat, 'they made billions'. It was a critical element in the development of the global property empire now owned by the Reichmanns, whose development in Docklands has been described in Chapter Two. O&Y's involvement in British property is discussed further in Chapter Ten.

Ritblat still expresses real regrets over the failure of the Uris deal. 'We'd have made, we calculated, two billion dollars. It was the most exciting year and the best thing I ever conceived, but it was a disaster because it unhinged the finances of British Land. Everything had been predicated on the rights issue and we had left everything unfinanced.' By taking their collective eye off the position at home British Land's management had put themselves at the mercy of their banker, NatWest. Fortunately, since the bank had been party to the Uris expedition, it sympathized with British Land's plight when the UK property market collapsed in 1973/74. In March 1974 British Land gave the first hint of serious trouble. While reporting pre-tax profits of over one million pounds for the six months to 30 September 1973, it also forecast a loss for the second half of the year. This loss turned out to be over one and a half million pounds, as annual interest charges rose to £12 million from under six million pounds a year earlier. By September 1974 British Land shares had fallen to twelve new pence each and the whole company's equity was worth only five million pounds. 30 September 1974 was a critical day for the company as on that date it was due to complete the purchase of an office in Aldersgate Street on the western fringes of the City for four and a quarter million pounds, and there were real doubts whether the company was in a position to fulfil its obligations.

At British Land's Annual General Meeting that month, John Ritblat faced questions from anxious shareholders. He assured them that purchase and the payment of £1.3 million of interest due on 30 September would be 'made on the due date', but he accepted that discussions were necessary with the banks and that some investments would have to be sold. Ritblat is proud to claim now that British Land received 'no help from anybody. We rolled up a bit of interest but we paid every cent and didn't sell any property until after 1977.' The Ritblat memory seems a little faulty about property sales, since in April 1976 the company announced it had lost three million pounds in the six months to September 1975 and had sold properties worth £10.5 million in the year to March 1976 and negotiations had been completed for sales of a further £20 million. These later sales included two parts of the Croydon Centre, to Legal & General and Nestlé.

At the worst the company was down to the last eight million pounds in banking facilities. In August 1974 British Land had a facility to draw ten million pounds from the finance house Mercantile Credit, but their position was equally difficult and they could not pay the money over.

Ritblat threatened to issue a writ, which the Bank of England would not have welcomed in that environment. Instead John Quinton of Barclays, the lead banker to Mercantile Credit, gave Ritblat a new facility.

The process of selling some assets and waiting for the rents on the remaining portfolio to rise sufficiently to cover the interest costs was a slow one. It was made worse by the economic crisis of 1976 which drove the Minimum Lending Rate up to an unprecedented 15 per cent. The gradual reduction of short-term debt culminated in September 1977 when about £25 million of maturing debt needed refinancing. £10 million of this had been a loan from the Crown Agents, one of the odder participants in the 1970s property boom and one into which there was a government enquiry; the other £15 million was in the form of a nine and a half per cent unsecured loan stock. On 10 September British Land announced that it was to issue £21 million of a 15 per cent debenture stock and £7.7 million of a 12 per cent convertible loan stock. The interest cost on these new instruments was much higher than that on the debt they replaced, and set back further the time that British Land was going to be able to declare a profit, but it moved a substantial proportion of the company's £200 million debt burden further into the future.

The only reason British Land was able to secure such finance was because the company had, in Plantation House, a truly prime asset. That one property was valued for the purpose of establishing the security on the debenture at £51 million. The 515,000 square feet of offices were then producing rents of £2.7 million, well below the interest cost of the debenture alone, but rental values had recovered sufficiently to make it certain that rent increases were to be forthcoming. Modern air-conditioned offices in the City were now commanding rents of up to £16 per square foot, up from only £12.50 at the low.

John Ritblat then engaged in a succession of deals which represented a creative solution to his company's problem. Using British Land's shares, which had recovered a little by the end of 1977, he bought stakes in various quoted companies and sold them on for cash at a profit, usually over quite a short period. The first deals included a holding in Bridgewater Estates, sold on to Rothschild Investment Trust, and a 11.5 per cent stake in Property Investment and Finance Limited (PIFL). This was an investment trust, run by merchant bank Kleinwort Benson, which specialized in property shares. Both stakes, built up to 18.8 per cent in the case of PIFL, were sold in the spring of 1978. In the early summer British Land acquired a tiny unquoted property company, Wellingrove, and 15.6 per cent of the quoted Churchbury Estates. These deals added assets and income, especially when the holdings were sold at a profit, to the British Land balance sheet, without adding any debt. The consequence was that these transactions helped to reduce gearing and increase net income. By the end of March 1978 the company was able to report net assets of £62 million, and although borrowings totalled £145 million, that was well down on previous totals and was better financed.

Later in 1978 Ritblat announced the purchase of Kingsmere Investment for £4.2 million, paid for by the issue of 5.4 million shares and £2.35 million cash, (part deferred). Kingsmere was a relic of the 1960s property boom, having been controlled by Felix Fenston, who, with Jack Cotton and Charles Clore, was one of the fabled investors of the post-war period. At the same time British Land took control of the Langham Estate, a collection of properties to the north-east of Oxford Circus, the centre of the London rag trade, which was to prove another well-traded portfolio over the next decade.

The greatest coup in this series of deals was the purchase of 26.22 per cent of City Offices, a venerable company with interests as far afield as Lusaka, Zambia, from the Ellerman family company British & Commonwealth, for £1.52 million cash plus 6.7 million British Land shares, representing 8.67 per cent of the newly enlarged equity of British Land. British & Commonwealth had swopped its near-controlling interest in the solid but rather dull City Offices for a much smaller investment in the more highly geared British Land.

Further purchases brought the stakes in City Offices and Churchbury to 29 per cent and 20 per cent by the end of January 1979. Partly as a consequence of these share deals the company was able to report a return to profit in February 1979. In the half-year to September 1978 British Land made £255,000 against a loss in the equivalent period a year earlier of two million pounds. This was despite £15 million in property asset sales, which had reduced rental income from nearly £7.5 million to £6.8 million. Borrowings were down again to £127 million and profits had been boosted by the contributions from its new acquisitions. In March 1979 British Land sold its 29 per cent of City Offices to Legal & General for £6.6 million against its book cost of £4.57 million and in the next month the Langham Estate was sold to the Water Council pension fund for £9 million, and the holding in Churchbury to London Trust for £1.2 million.

One of the distinguishing features of British Land in the 1970s was its ownership of several trading companies. Between 1970 and 1990 the company has owned such diverse businesses as Dorothy Perkins, the High Street women's clothing store group, and Gripperrods, who make patented carpet-laying grips. The stockbroker analysts could never understand why Ritblat should be involved in areas which they could not analyse and in which they feared there might be some potential risk. Ritblat asserts that it was a perfectly simple theory. 'We bought companies at below asset value, managed the assets and kept them until the markets went up. Then we sold them on a high price-earnings multiple [a ratio between company value and profits which is the normal basis for valuing companies]. We made £50 million net out of our industries.'

Dorothy Perkins was sold in September 1979 to the Burton Group for just under £5 million in cash plus 74 properties valued at £10.5 million. 'We tripled our money on Dorothy Perkins, and it made £30 million profits while we owned it.' At the same time British Land was building up a share

stake in Hepworths, the rather old-fashioned, but asset-rich, tailoring group. 'We should have bid for it, but we didn't fancy a fight. An absolute fortune was made out of the properties.' It was left to others to revive Hepworths, which became the Next Group. 'The market refused to accept that we were good at [these non-property investments]. They didn't like the mix.' John Weston-Smith, Ritblat's right-hand man, describes the questions he suffered: 'What sort of company was it? Was it a property company, was it an industrial company, was it a retailer? They wanted a nice pigeon-hole to slot you into, and so they liked it when we became a pure property company. We were doing in a small way what Hanson does.'

In 1979 John Ritblat suffered a personal tragedy. His wife Isabel was travelling in a private plane, and as it began its landing approach, she fell out of the aircraft to her death. Interviewed in 1990, he confessed that the disaster had affected him deeply. 'When something like that happens it changes your perspective on life, you value your relations more.' He was left with three children, and it may be a symptom of the change in his attitude to life that his two sons are both now working for British Land; he also has a daughter. In 1986, Ritblat remarried.

By the end of 1979 the rehabilitation of British Land was effectively complete. The Australian investments were put into a joint trust with the Post Office Pension Fund and the Australian CRA company's pension fund, leaving British Land with a 24.5 per cent interest and a cash repayment of A\$19 million. By February 1980, John Ritblat was able to tell his shareholders to expect a dividend for the year which was to end in March 1980. Net debt had fallen to only £76 million by March 1980, against property assets of £192 million; at its peak level in 1976, British Land owed £152 million against property assets of £305 million. The dividend declared in July was the first since 1974. Ritblat was now in a position from which he could make his company grow again, rather than merely make sure that it survived.

In August 1980, British Land made two bids: for the Corn Exchange and UK Property. The former owned the eponymous building of more than 100,000 square feet in the City which had long since ceased to fulfil its original role; UK Property's prime asset was the Heywood Industrial Estate, now modishly renamed the Heywood Business Park, eight miles north of Manchester. It covers 166 acres with 1.4 million square feet of lettable space and room for a further 1.6 million square feet; this property was sold in 1988. UK Property also owned three engineering companies which could be merged into British Land's W. Crowther susidiary. The cost of the two bids, £32 million, was mostly met from share issues. At the same time British Land announced that 16 of the 74 properties acquired from Burtons on the sale of Dorothy Perkins had been sold for £4.4 million, a million pounds more than the value attributed to them at the time of the purchase.

One of the distinguishing features of British Land has been its approach

to financing its portfolio. It has always sought to raise unsecured finance; unlike mortgage debentures, such money is not secured on any particular asset and enables the company to take a much more flexible approach to its portfolio. It has not always proved possible to achieve this sort of financing: the refinancing of the company in 1977 depended crucially on the ability to borrow against the security of Plantation House. In 1981 British Land created another debenture, a 'drop-lock'. The concept of a 'drop-lock' debenture was not new; 'We had seen Birmingham do an issue, but we were not interested in following suit. Birmingham had to draw down the loan straight away. At that time we did not want to draw the money, it was too expensive; what was the good of 14 per cent money? I asked whether we could do this without taking the money, but holding an option to draw. Then we would have the credit. David Milne and Malcom Wilde of Guinness Mahon and Graham Axford of James Capel worked up just such a scheme. We were told that we were paying an eighth of a per cent too much for the money, but the big point was that we had a blue-chip letter of credit and we could tell the banks that they could have a power of attorney over that option and then lend to us at the very finest rates. The Bank of England then spotted that such a scheme would lose them control of the money supply, since they would not know when funds were going to be drawn down; we had a letter from the Bank that said we could do it. It was a marvellous innovation.' The maximum amount to be borrowed is £37 million, to be repaid between 2019 and 2024.

Such financial innovation made British Land an obvious source for Godfrey Bradman when he was setting up the finance for 1 Finsbury Avenue (described in Chapter 3). Much as Ritblat was able to secure longterm finance when he needed it without actually drawing it down, the provision of a debenture on Bradman's development was the key to achieving short-term finance for that building. In this case the providers of the guaranteed finance, British Land, Globe Investment Trust, Dixons and J Rothschild, were given a 29.9 per cent equity interest in the completed development. In 1987 British Land bought out the other minority shareholders in 1 Finsbury Avenue for £18.7 million, paid for in shares, and in May 1992 Greycoat sold its interest in Finsbury Avenue to Ritblat well below the value attributed to the investment as recently as June 1991. British Land is now the sole owner of the development.

By the mid-1980s, British Land was again among the leading property companies. In 1983 it acquired a 50 per cent interest in the Euston Centre, two 1960s tower blocks connected by a range of low-rise offices and show rooms between Camden Road and Regent's Park. This development had been the work of Wimpey and Stock Conversion under its prime mover, Joe Levy, and its history is well documented in *The Property Boom*. 'We bought it from Wimpey at an 11 per cent yield on cost. They were being squeezed at the time and were effectively a forced seller.' In 1986 the other half interest was bought from Jeffrey Sterling's P&O; the latter had acquired its interest by taking over Stock Conversion.

By 1984 Plantation House had become worth £116 million and the wisdom of Ritblat's fundamental principles was beginning to be apparent: 'British Land's philosophy is that the freehold is the most favourable condition of ownership, and the most reliable source of revenue and capital growth.' The trick is to be able to finance the portfolio while rents are still unable to cover the cost of money, and reap the benefits as rents inexorably rise, over long periods anyway. In this Ritblat has a lot in common with Geoffrey Wilson of Greycoat, who is one of the subjects of the next chapter.

There were mistakes. British Land's foray into the United States, was, like so many British investments in that country, less than a triumph. In November 1982, British Land bought 90 Broad Street, the street adjoining New York's Wall Street. This is a substantial building of 328,000 square feet. The company also owned the Central Savings Bank Building in Baltimore; this was a succesful investment, and was sold for $24 million, a surplus of $10 million over cost, in 1983. In 1986, Ritblat created a separate quoted vehicle for the American interests, British Land of North America, by reversing his interests into the American group Growth Realty Companies, listed on the New York Stock Exchange. 'We miscalculated. We owned too much of the company, but we had never dreamt that the minority shareholders and the Securities and Exchange Commission would effectively stop us operating the company.' The American authorities were keen to guarantee that outside shareholders were not unfairly disadvantaged. Ritblat sold the public company in 1988. British Land's overseas interests were not confined to North America. In Europe the company had several joint ventures with the Dutch company Wereldhave, which were sold in 1987, and it has developed the St Stephen's Green shopping centre in Dublin, next to the prime, and pedestrianized, shopping thoroughfare, Grafton Street. The company has also been part of the consortium developing the old Customs House in Dublin as the Financial Centre, a tax advantaged zone in Dublin intended to make that city a recognized financial services centre.

The major deal of 1984 was the purchase of Rank City Wall Properties from the Rank Organisation, which was disposing of its peripheral activities at that time. This portfolio brought several shopping centres. many of them in Scotland, to British Land. One of these, the Wester Hailes Centre in Edinburgh, was one of the very first new district, non-High Street covered shopping malls in the United Kingdom. A more idiosyncratic investment was that in the restricted voting shares of Stylo Shoe. This company is controlled by the Ziff family through a share voting structure which favours the family shares. Ritblat, like many before him, had identified the fact that, while the Stylo shoe business was not attractive, the shops from which they operated were often in prime retailing positions and owned freehold by the company. British Land gradually bought up a substantial holding in the restricted voting shares, but was unable to prise control from the Ziff family, and eventually sold

them on to Nazmu Virani's Control Securities, a company which seems to have picked up large numbers of unwanted trifles from the tables of the larger property companies in the late 1980s.

1985 was notable for British Land's involvement in the Paternoster Consortium, of which it held 20 per cent, and the parallel investment with Stockley in Dorset Rise, the refurbishment of Unilever's building near Blackfriars Bridge. Perhaps the strongest indication of the company's growing self-confidence was its dabbling in areas other than property. Not only had the industrial interests been augmented in the recent past, but now Ritblat was supporting new ventures. He bankrolled ex-Slater Walker investment man Brian Banks in a new investment management house, Guildhall, and began to finance films. Until the 1984 Finance Act, first year tax allowances against capital expenditure made it possible to avoid corporation tax. Many companies found themselves putting money into the film industry; the results were only partly successful artistically and no success at all financially, but then half the cost was effectively paid for by the taxpayer. Kingsmere Productions, British Land's subsidiary, put money into such artistic and financial successes as *The Sender* and *Top Secret*, neither of which registered on public consciousness. The last venture was different: *The Mission*, produced by Goldcrest Films, directed by Roland Joffe who had directed The *Killing Fields*, and starring Jeremy Irons, was a critical success and won the Palme d'Or at the 1986 Cannes Film Festival. It did not prove a box-office winner. The 1984 Finance Act has dissuaded British Land from continuing this interesting excursion into the arts.

In the two years leading to the peak in the market in 1988, British Land was comparatively conservative in its ventures. Purchases were largely confined to the high-yielding areas of activity, such as a portfolio bought from 3i, the investment capital group. This portfolio, mostly industrial units, cost £97 million but was to yield 11.25 per cent after only two years. Shares rather than cash were used to pay for the large purchases of the period: the other 50 per cent of Euston Centre, a £93 million portfolio from Legal & General and another property on the island site containing Plantation House. In 1988, Ritblat bought 20 Sainsbury stores on a 9 per cent yield for £90 million, and the giant one million plus square foot MFI distribution centre in Northampton for £35 million. Against these purchases, the French and Dutch interests were sold for £160 million and, in the run-up to the 1987 stock market crash, so were the industrial interests. The Paternoster Consortium was dissolved in May 1988 with Mountleigh taking out the minority partners including British Land for £73 million, which outsiders calculated gave British Land a 100 per cent profit on its three year investment.

The policy of buying only high-yielding, well-let property continued into 1989. One hundred and thirty-five million was spent on nine further Sainsburys stores together with four offices. But the most significant development for British Land was the attempt to restructure the

company. In December the management proposed to split the company into two parts: the investment part of British Land, which would own 80 per cent of the group's assets, would gradually realize its portfolio and distribute the proceeds to its shareholders. 'New' British Land would hold the lower valued assets and manage 'old' British Land. The idea was that the group had become too unwieldy to be able to offer significantly rewarding outperformance of the property market as a whole. The shareholders of 'old' British Land would, if they were non-taxpayers such as pension funds or charities, receive the true value of their investment rather than suffer from a share price which stood at a significant discount to that value. The proposals failed to win the support of the institutions which effectively control British Land.

John Ritblat long ago ceased to have a significant shareholding in the company; indeed, many of the investment institutions suspected that this was the true motive behind the proposal. 'New' British Land offered great incentives to its management, which could earn them a nearly 30 per cent holding in the new company. Ritblat is unrepentant about this rebuff. He sees nothing wrong with having tried to secure the future of his sons through the incentives offered. As he points out, to earn the shareholding, the other holders would have had to do very well indeed.

The rebuff has not lessened Ritblat's appetite for the property business. He has been one of the notable contrarians of the 1990/91 bear market in property, buying large properties regularly and being prepared to increase his debt to finance the purchases, the purchase of the Finsbury Avenue development of Rosehaugh Greycoat in 1991 and 1992 being perhaps the most notable coup. It cannot be said that he is not prepared to take decisions or put his company's money where his mouth is. If he is right, which I suspect he will prove to be, he will have created huge profits for his company. It is, as always, a question of timing. Although by 1993 the market had not justified the increased borrowing of the company and the level of gearing still caused some concern to analysts, as yields fall, rental values recover and interest rates maintain their recent much lower nominal levels, the gains will make Ritblat a hero. The markets this time give him the benefit of the doubt. Despite the heavy exposure to the struggling Gateway supermarket chain and the increased debt, the shares at the end of 1992 were trading around the 200p mark, a far cry from their level at an equivalent point in the last property bust. Many of the new generation of developers have gone to the wall; for a survivor of the 1970s experience has paid dividends.

Ritblat sees his company as 'the best long-term holders in the business'. Opportunistic? 'I should hope so' says Weston-Smith; 'and how' adds Ritblat. 'We have never had false pride or images or pretensions about holding things. If you've got the money, you can have Plantation House; it's not for sale, but it's available for sale. It now has planning permission for 850,000 square feet of offices along its quarter-mile frontage, but if Mr Nippon Life came along and said "I've got to have the best and most impressive site in London" we'd say "put your cheque down and its

yours". You don't know in this business; there's always some Napoleon who comes along and says "I want this asset" and we've got to be ready for him.'

The company has outstanding planning permission for one million square feet of offices for its investments in addition to Plantation House, although it has no intention of exercising it until the economics are right. In 1993 plans for the redevelopment of the Corn Exchange building were announced. 'We won't have a building that is not capable of redevelopment. Property has a life; there ought to be depreciation of bricks and mortar in Reports and Accounts. I hate building buildings' says Ritblat. His development of Rank-Xerox House in the Euston Centre has stood vacant for too long since its completion, probably confirming that prejudice.

John Ritblat is philosophical about the fact that property developers are unlikely ever to win popularity polls. Despite his company's support for many charities and the arts, he understands that the public appreciation of developers is not high: 'It's because people relate to it, and we've had huge riches made by lots of people who couldn't actually earn a living doing anything else, who've just been lucky.' Few, if any, would include John Ritblat in that category; his success has been deliberately sought and resolutely carried out. He is a true survivor.

So is his near contemporary, Jeffrey Sterling, ennobled in Margaret Thatcher's resignation honours list. There is a prevailing assumption that Jeffrey Sterling is an East End boy made good, apparently confirmed by his choice of title, Lord Sterling of Plaistow. Yet this Plaistow is a village in Sussex and not the East End district; his birth in Whitechapel was coincidence and 'I think I was in the East End for two days because I was born in a hospital there.' His father was indeed an East Ender, a second generation immigrant whose family had, at some time, changed their name from Steinberg. Sterling is a tall, dome-headed man with immaculate manners and dress. His voice, with a trace of an inability to roll his 'r's, is the only hint that he was not born to the purple. His father, Harry Sterling, built up a leisure business, Sterling and Michaels. Legend has it that Harry Sterling was a bingo hall proprietor, but his son never had to suffer the privations of the self-made father. Brought up in Surrey, he had a grammar school education, was a talented athlete and a serious musician. For two years he studied the violin at the Guildhall School of Music and Drama.

Instead of a career in music, Sterling has had a meteoric rise in the business world, combining a good strategic grasp with an almost Machiavellian ability to manipulate matters to his advantage. Anyone who has suffered his lobbying for a cause will vouch for the charming but determined juggernaut that he becomes. His success has also been linked with the formidable grasp of detail that his low-key partner, Bruce McPhail, has provided. Together they have moved from taking over a moribund investment trust to the management of one of Britain's largest and most venerable companies, P&O.

Sterling's initial break was to work for Isaac Wolfson, the founder of Great Universal Stores and notable benefactor to many educational and other causes. 'I worked with Wolfson for a couple of years. He was a very interesting guy, who always discussed his mistakes.' Sterling was then involved in a small property company, Gula Investments, in the 1960s. When Corporation Tax was introduced in 1965, Philip Shelbourne, the merchant banker, worked out that the company was worth more to its shareholders if it was liquidated. The scheme had originally been worked out for Maurice Wohl and his United Real, but 'he decided that he wouldn't, and so we did.' In that period Sterling met up with Oliver Marriott, then the property correspondent of the *Investors Chronicle* (and author of *The Property Boom*), and Bruce McPhail, who was then working at merchant bank Hill Samuel.

'We worked out a property unit trust, split into capital and income units. Then Oliver Jessel [of Jessel Securities] started a property unit trust which drove up the price of property shares.' The project had to be abandoned, although Sterling claims that the companies which Marriott and he had identified as potential investments have mostly gone from strength to strength since then. Bruce McPhail's role was to demonstrate, through complicated calculus, the potential returns on the two classes of share. 'He was a shock-haired youngster, just back from Harvard.'

'We bought control of Consumer Growth Investment Trust, which became Sterling Guarantee Trust, and then we were on our way.' In the late 1960s and early 1970s, the team acquired in quick succession companies which had a strong asset base and were service companies. Companies such as Buck and Hickman, which was a supplier of tools but had a potentially valuable property in East London, and the two London exhibition venues, Earls Court and Olympia. Oliver Marriott, a rather flamboyant figure, partial to a huge overcoat and wide-brimmed hat, went to check out one of these two properties 'incognito', a concept which makes Sterling laugh aloud. Only one of these acquisitions was traded on: Salisburys, the handbag retailer, was sold to Murray Gordon's Combined English Stores Group. The acquisition philosophy developed by Sterling at that time identified two potential weaknesses which he was able to exploit. 'If the management has no shares in the business and you emerge as the largest shareholder. On the other hand, large family shareholdings are not one holding; after several generations, people's needs are different,' something he and Elliott Bernerd were later able to exploit in their take-over of Laing Properties. 'There is very rarely an occasion where you need to make an aggressive take-over bid, because I think there is a price to be negotiated. If you're building companies, not trading them on, (and there is a tremendous difference in my view), the only thing you can say about the price you pay is that it's either far too much or far too little: nobody pays the exactly right price.' He gives an example of what he means: 'Sutcliffe Catering was a teeny subsidiary of Olympia when we bought it, and is now one of the biggest in Europe. If

we look back 20 years, whether we paid twice as much for it or another five or ten per cent one way or another, it would have been meaningless. It would have been meaningful only if we wanted to trade it on, a year or so after the event. If you're building something, all that's proven in the long run is whether it has gone successfully as a field of endeavour; in practice, if something goes sadly wrong, it doesn't matter how cheaply you think you bought it, you've overpaid.

'We did not have a property background; it was not the dominant factor. In practice, in the early days we pushed off the real estate side, on the basis that we wanted to concentrate on the acquisition and running of the companies. If you acquired companies with strong assets, first of all, if you make the odd mistake, which all of us make, it's not going to kill you. But if you bought something with an enormous amount of goodwill, you've got nothing.' With these purchases 'you have a combination of positive cash-flow companies building up profits on one side, and you've got strong assets being built up, either as investment portfolios or development, alongside and one feeds t'other. All strategies are found with the benefit of hindsight; it has also turned out by sheer chance that pretty well every company we own is either the leader or a leader in its field.'

It was the purchase of the old Gamages store on the corner of High Holborn and Hatton Garden which linked Sterling to his near nemesis, Town & City Properties. Gamages, remembered by many schoolboys as the publisher of a catalogue over which they could drool, was a victim of changing fashions in retailing. The property was valuable, but as offices. Sterling was not interested, as he says, in being the property developer so he went into partnership with Barry East of Town & City to redevelop both Gamages and parts of the two exhibition company sites.

Town & City had become the second largest UK property company by the end of 1973, having acquired since 1972 Charlwood Alliance, Sovereign Securities, Sterling Land, (Geoffrey Wilson and Stuart Lipton's company), Elliott Bernerd and Stephen Laurie's property interests, David Young's Eldonwall, and, finally and fatally, Central & District property from merchant bank Keyser Ullman, a deal completed on 3 September 1973. Not only had it paid cash for Central & District, but it also had a development programme costing £160 million. Town & City's major funding partner was the Prudential Assurance, and its banker Barclays. Barclays had unusually taken a direct interest in the portfolio of Central & District when it lent Town & City the money to buy that company.

With the collapse of the property market becoming apparent by the end of the first quarter of 1974, David Young and Elliott Bernerd approached Jeffrey Sterling to tell him of the crisis looming for the company of which they were directors. 'It had reached the stage of a rescue operation' says Sterling. Bernerd and Laurie had become convinced that Barry East would have to go, and the non-executives had become more and more involved in 'fire-fighting'. Although Town & City did not actually owe

money to Sterling Guarantee at the time, according to Sterling, the health of his group was inextricably bound up with the survival of the larger company. There were discussions between the Prudential, Barclays and the Bank of England before Town & City mounted a bid for Sterling Guarantee in April 1974. This was clearly a reverse take-over, with the Sterling Guarantee team taking over management with the support of the institutions. Barry East resigned in October 1974, one of eleven directors of the company to resign since the bid, leaving only four of the original Town & City directors, including David Young, still in post. 'Talk about angels fear to tread' says Sterling about his role in Town & City, 'we thought it would take about two years to sort out and it took about eight.'

The company had borrowings of £319 million and property assets of £541 million, of which £196 million was in 57 development properties around the world, totalling nine million square feet, on which a further £160 million would have to be spent. The Central & District portfolio, bought with borrowed cash costing 16 per cent, was then heavily reversionary (i.e. it had imminent rent reviews which would raise the income earned substantially), but currently had a yield of only three per cent, leaving an enormous hole in the income account; at the time, the reader will recall from Chapter One, there was a rent freeze and Town & City was unable to realize these rent reviews. Even after the rent freeze was lifted in December 1974, partly at least as a result of effective lobbying by Sterling, Town & City's interest bill was still massively larger than its rental income. The only way to remedy this problem, even partly, was to sell property in enormous amounts, even into an unwilling and weak market. The problem was exacerbated by the fact that Town & City's interest in many properties was not straightforward. Often they had a 'top slice' of the income, whereby the financier of the property was guaranteed a percentage of rental value, whether or not Town & City had actually let the property and were receiving such rents.

Between the end of March 1974 and October, Town & City sold £71 million of property, at only £2 million less than it had been carried in its books; a further £12 million was sold between October 1974 and March 1975, including £3 million to the Prudential itself. The critical support for the group came in May 1975 when Barclays and the Prudential agreed to subscribe £25 million in the form of a Town & City convertible loan stock. The strain on Town & City's finances at the time can be gauged by the size of its net interest bill in the year which ended on 31 March 1975, a sum of £25 million. The selling continued despite the greater security afforded by the long-term funds provided by the two institutions. Between February and September 1976 a further £47 million of property was sold, but even by August 1977, Sterling was still unable to say when the company would emerge from its slough: 'It is impossible to predict how long deficits will continue and how long it will be before a surplus is reached.'

One of the major sales made by Town & City in its recovery period was

of Berkeley Square House, the biggest asset in its portfolio at 320,000 square feet of offices, in January 1978. The Prudential were partners in the property, but even so, the sale netted Town & City over £16 million; so large was the deal for the time that the pension funds of two then-nationalized industries bought the property: British Rail and British Airways.

A further important step towards rehabilitation of Town & City was the conversion of the 1975 issue of loan stock to Barclays and the Prudential into a convertible preference share, paying no interest until 1982. The sweetener for the two investors was that the price of Town & City shares at which they could convert their holding was reduced from 40 pence to 20 pence, much nearer the prevailing level. For Town & City there were two critical advantages: the interest charge on the convertible was temporarily removed, and, just as important, whereas the convertible counted as a debt, a preference share counted as equity and the company's hair-raising gearing was dramatically reduced. By the end of the financial year to 31 March 1978, Town & City's pre-tax loss had reduced to £17 million, and borrowings were £255 million against property assets valued at £326 million. Four years into the rescue and Town & City was still hanging on by its finger nails.

In February 1980 it was announced that Jeffrey Sterling was to join the board of P&O as a non-executive director. P&O had been through a difficult period during the secondary banking crisis. In the period prior to the crash, it had made a belated attempt to diversify into secondary banking and contracting. At the end of 1972, it had bid £140 million for the Bovis contracting group, which had itself bought Twentieth Century Banking. The bid failed, but in February 1974 P&O renewed its approach and bought Bovis for the seemingly knock-down price of £25 million. Although Bovis struggled through the following recession, it was Twentieth Century Banking which brought P&O severe problems. By February 1975 it was announced that the bank was making 30 per cent provisions against its lending, a catastrophic order of losses for a bank. In April 1979 Sandy Marshall, the managing director of P&O, resigned.

Town & City emerged from its own nightmare at the end of 1981. In the seven years between 24 March 1974 and 1981, the company had sold property worth £409 million. Its net interest charge, on borrowings reduced to £177 million, was still £29 million a year, and despite the rise in rents on its remaining portfolio, the company still lost £11 million in the 1980/81 year. The final escape from the red ink came through a bid for the quoted Berkeley Hambro company. By using its shares Town & City was able to purchase, for £59 million, an ungeared property company. At the same time it announced the result of a property revaluation which gave a net asset value of around 40 pence. The combination enabled Town & City to repair both its revenue account and its balance sheet. The company had been rescued from the world of the zombie, the walking dead.

By the mid-1980s, Sterling had emerged as one of the most influential

businessmen of his generation. P&O took over Sterling Guarantee, which Town & City had renamed itself as a final divorce from its unhappy history. P&O was feeling vulnerable to an unwelcome bid, and considered it necessary to bring Sterling and McPhail on board as executives; Oliver Marriott, by now semi-retired in Yorkshire, joined the board as a non-executive. P&O did indeed receive a bid from Trafalgar House, another diversified company which was headed by an ex-property man of the previous boom, Nigel Broakes. The latter had taken over Cunard, and the two companies had a lot in common: contracting, shipping and property. But with Sterling's help P&O survived intact.

Sterling had by this time developed another string to his bow, that of adviser to government. His old friend David Young, who had run the Manpower Services Commission and been an adviser to Norman Tebbitt, had so captivated Margaret Thatcher with his 'can-do' attitude and business acumen that he had been ennobled and given a seat in the Cabinet. He recommended Sterling as his successor as industrial adviser to the Department. Over the next seven years he became an important figure to successive Secretaries of State, particularly since he was a constant presence while there were seven different holders of the political post in his time as adviser. Sterling soon came to be one of those with access to Margaret Thatcher; as any civil servant or politician will tell you, access is the critical factor in the influence anyone can have with senior decision makers. He still has the ability to request a hearing at 10 Downing Street and be fairly sure of being successful.

As head of a venerable British shipping company, Sterling has taken his responsibilities seriously. He has been President of the British Chamber of Shipping and is now to head the European equivalent. At the end of 1986, P&O bid for European Ferries. This company, built up by the Wickenden brothers, operated the Townsend Thoresen cross-Channel ferries and also had property interests. Only a matter of days after P&O gained control, the *Herald of Free Enterprise* capsized on leaving the port of Zeebrugge, its bow doors having been left open to the seas. Showing a moral courage which should not be dismissed, Sterling immediately went to Zeebrugge and talked to the survivors and relatives of the dead. It was scarcely his fault that the procedures of a company which he had so recently taken over should have been so fatally flawed, but as chairman of the company, he knew his responsibility. He recalls the experience with horror: walking through the temporary morgue and being the object of hate and insults from those who saw him seared his soul.

It was something of a surprise that a man who had spent most of the past ten years distancing himself from the property market should emerge in 1990 as one of the two protagonists in a joint company bidding £440 million for Laing Properties. His partner in the bid was his old colleague on the board of Town & City, Elliott Bernerd, and against most predictions they managed to wrest away the company which, with 40 per cent of its shares owned by the Laing family or its charitable trusts, was

thought impregnable. Sterling still remembered one of his two guiding principles about bids. A rights issue to raise £604 million, announced in August 1991, was at least in part intended to raise P&O's overt exposure to property: the Pall Mall joint vehicle with Elliott Bernerd was to be unwound and the assets split between the partner companies.

Today Lord Sterling has moved away from the property world onto the larger stage of business and politics. He is more than a survivor of the 1970s property crash; he is the man who took the opportunity offered to him to make a reputation on which he could build a career altogether more substantial in the public eye.

7

OUT OF THE BACKGROUND

AS WELL AS the two protagonists of the last chapter who had to manage public property companies out of the problems of the 1970s property crash and on to greater success, there are those like the two subjects of this chapter who came to prominence in the 1980s boom, even though they had been active in the 1970s. Neither man was actually responsible for managing a public or high-profile private company during the worst of the earlier crisis. Geoffrey Wilson and Elliott Bernerd did not command the attention of the media during the 1980s boom like many of the characters so far portrayed, yet their companies and activities were central to that story and, unlike some already described, they will certainly be important to the property market in the next ten years.

Geoffrey Wilson was born in February 1934, which makes him one of the senior participants in the property market. His early life followed what is clearly a pattern for several in this book. After school at Haberdashers' Aske's, he joined the agents Hamptons 'as post boy. Harry Hyams, [the central figure of the 1960s boom], was already a rising star there.' After the College of Estate Management, followed by National Service in the Royal Artillery, Wilson spent some years in private practice. One of his clients was Mason Pearson, the hairbrush king, who had a portfolio of properties in the Piccadilly area which he let on three- year leases, a very unusual procedure in the days of 21 year and more leases. Wilson then started his own practice, based at 33, Haymarket. 'This was a wonderful location but it had Railway Lost Property on one floor and a private drinking club on the next floor, with my office right at the top. You didn't dare let anyone visit you but it was a marvellous address for a letter-head.'

The big step in his career was going to work for Gabriel Harrison at Amalgamated Investment & Property (AIP), which he joined in 1961. 'I answered an advertisement in the *Estates Gazette*.' AIP had been floated on the Stock Exchange as a public company only a year earlier. 'Gabriel introduced me to the world of very good reproduction Queen Anne

furniture and plush Celadon green carpets; I suppose I got a taste for that too. Gabriel was a dynamic and charismatic character.' Wilson became a director of AIP in 1960 at the age of 26. 'I have been a director of a public company for 31 years, longer than nearly everyone else.'

In 1961 Peter Olsberg, Harrison's nephew, joined the company from agents Marcus Leaver. Wilson and Olsberg became firm friends and neighbours. 'We were doing quite a lot of business with Michael Gilbert and Stuart Lipton at Anthony Lipton.' In 1971 he and Olsberg teamed up with Gilbert and Lipton to form what became Sterling Land. The sale of Sterling Land to Town & City, described in Chapter Four, was fortuitous: 'there was no prescience' about the market. Sterling Land 'was a good company. Its development phase was over and Town & City sold virtually all its properties at more than they paid us for them; it was the company that kept Town & City afloat.'

Now without an executive role, Wilson sat out the 1974/75 property crash looking after his family interests in Equity Land, which, among other things had built houses in Hampstead, in one of which Wilson still lives. 'I had offices in Curzon Street and Stuart Lipton had the next office, but we had no property interests in common. Eventually we came together on Townsend House, Greycoat Place' which is whence the name of their new venture was derived. Greycoat's next venture, the refurbishment of the Lutyens designed Country Life House, exemplifies Wilson's claim that he has 'always been concerned about quality. We always had to go out to find or create our own opportunities' which included Euston, Cutlers Gardens and the Halcrow building in Hammersmith. 'At that stage everyone had forgotten about Sterling Land, and were confusing our record with that of Sterling Guarantee; Jeffrey Sterling had ended up owning both Sterling Guarantee and Sterling Land, and it was a waste of time explaining this to everybody. Since we didn't have the status, especially with local councils, we formed Greycoat London with McAlpines to give us presence.'

The story of Cutlers Gardens is told in some detail in Chapter Four, but the financing of the project was a critical factor. Geoffrey Wilson gives a lot of credit to Standard Life's Peter Henwood, 'a contra-cyclical investor prepared to back his own judgement. We needed financial resources, not knowing that Standard Life was looking at the project and we came together.' Greycoat's six per cent interest takes the form of one of the smaller buildings in the development, 5 Devonshire Square. Wilson reflects that the long letting period was not surprising to him, even if it concerned the market. He has a view of the larger properties which informs his development plans today. 'In big buildings there is seldom equilibrium between supply and demand; if you are looking for 250,000 square feet to rent as a tenant, there may be five buildings available at any one time. You discover that two are spoken for and, for some reason, the prospective occupier does not like one of the buildings, that leaves a choice between two. That end of the market is quite unlike the rest. I am

constantly amazed that occupiers do not plan ahead. They could do very much better transactions, since it is of great advantage to developers to have a pre-letting on a development, but it doesn't turn out that way.'

The Buckingham Palace Road development above Victoria Station was another which took time to let. 'It follows the same pattern in buildings of this size: in the early days you let 20,000 or 40,000 square feet and people say "you've got another 440,000 square feet to let"; once you get to the half-way stage, everyone says "we always knew it was going to be a great success" and it's downhill all the way. You may know that you have the right location and the right building but you may have to wait for the rent to move up over the cycle. Meanwhile you may have to tread water.' Again this comment is still relevant to the attitude Wilson adopts with his developments and is a reason why, as we shall see, his attitude to finance has sought to enable Greycoat to tread water, but keep its developments rather than be forced to sell them on. The letting of the Victoria development was the occasion of a public row between Greycoat and one of its prospective tenants, the oil company, Conoco. 'Conoco was making public pronouncements that we wouldn't take £19 per square foot, which I knew was absurdly low. North American tenants come from an oversupplied market where the tenant can always dictate his terms; they expected like treatment here, not realizing that this is a totally different market where the landlord or owner has a far stronger position.'

Geoffrey Wilson has two prime guiding principles in his strategy. The first is his belief in cities, and the continuing need for offices in cities, rather than the fantasies of office workers being at their homes at the end of computer and fax lines. 'Frank Duffy of DEGW says people need offices as a place of "intellectual exchange". We will all end up like the reading room of the Reform Club [the first atrium building according to Peter Foggo of Arup], with the mechanical implements physically divorced from the humans. Cities are where one intellect is honed on another. It is not the same in Potters Bar or Basingstoke, because in a city, at different times, different businesses and professions become pre-eminent' whereas, Wilson postulates, in smaller towns the local trade can be decimated by a change of fashion or technology.

The second principle which differentiates Greycoat from many other developers is its search for ways to maintain its interest in its projects. In Chapter One it was shown how most merchant developers sought to make their profits: building, letting and then selling to an institution, since the initial rent will not usually cover the interest cost on the development. Wilson feels that this traditional method is faulty, even if a forward sale to an institution is agreed when 'seemingly the risks are small. Your stock-in-trade is your time and skill. You could spend three years on a development; if you were wrong about development costs, I always felt that was your own fault, because those were the skills you ought to be offering as a developer. But if your development came onto the letting market at the wrong time, that was something you could not

control. Then you would have six months to lease the building, and if you didn't achieve that, or not at the expected rent, then your equity disappeared. Your partner would say "Well, you're a big boy, you knew what the deal was when you started", but you would have nothing for your time and effort.' Wilson has therefore been keen to build up the financial strength of Greycoat from an early date 'to be better equipped as a borrower.' There is no doubt that Wilson was upset by the combination of Rosehaugh and Lipton's Stanhope in the redevelopment of the Broadgate site. Greycoat and Rosehaugh had previously discussed the possibility of continuing their Finsbury Avenue partnership for the larger project.

The departure of Stuart Lipton was a surprise to Greycoat's investors, but both sides insist that it was a friendly parting. Wilson says that they have different working styles 'but we work very well. I have a great admiration for Stuart, he is the most professional developer. We always were a team, but he was a high-profile character, perhaps because he is taller than everyone else, so it masked the fact that there was a strong team.' After Lipton's departure, Wilson set about fulfilling his goal of being able to keep more of his company's developments. The first step was a bid for the quoted City Offices, an old established but rather sleepy company with interests as far afield as Lusaka, Zambia. Using Greycoat's shares to buy the other company reduced overall gearing.

Greycoat has been active in the US market, with more success than many. Its first investment, bought from the American Prudential Insurance, was an office on 6th Avenue, the Avenue of the Americas in New York. Later investments included a partnership with Sir Robert McAlpine and Lynton Holdings, the latter managed by Wilson's old partner in Sterling Land, Peter Olsberg. In the US it is often possible to cover the interest cost of loans used to buy a property with the income arising from its tenants. The US market has traditionally combined lower interest rates on long-term borrowing, a generous depreciation policy and higher investment yields. What it does not have is a pattern of long leases. The usual lease in the US lasts only three years, and the laxer planning laws, together with the vast size of the land-mass, makes it quite common for rentals to fall dramatically. A new building may spring up across the road from your investment to which your tenants will emigrate at the end of their leases, and there is nothing the landlord can do to prevent it.

In 1984 and 1985 Greycoat saw the completion of 1 Finsbury Avenue and Victoria Plaza. In neither case did the company have full ownership, but at least in the case of Finsbury Avenue, as was noted in Chapter Three, the issue of a long-term debenture enabled Greycoat to maintain its effective 28 per cent interest. Victoria Plaza was financed by Norwich Union and Greycoat London, the 50/50 joint venture between the company and McAlpine, has only a 12 per cent residual interest in the investment.

In 1985 Greycoat launched another bid for a quoted company, in this

case two at once. Churchbury Estates had been revitalized by Oliver Marriott and some colleagues backed by London Trust and the Courtaulds Pension Fund. The Churchbury management had then bid for Law Land, another apparently undermanaged company with large holdings of property between Waterloo and Hungerford Bridges on the north side of the Thames. The Churchbury team had not anticipated the persistence of Sir Henry Warner, who had a substantial holding in Law Land. In his view the offer was insufficient and he did not accept the bid, even though Churchbury won acceptance of more than 50 per cent of the holders. Unusually Sir Henry and his allies held more than 10 per cent of the company after the offer finally closed. Under British law this prevented Churchbury from compulsorily acquiring 100 per cent of its victim. Churchbury took over management of the company, bringing in John Evans, a previous manager of the Courtaulds Pension Fund, as Law Land's manager. The outcome was not ideal for Churchbury. It was unable to use Law Land's assets as security for its own plans, and it could not pay all its subsiduary's revenue out to its own shareholders. The offer by Greycoat, at a more generous level for the old Law Land shareholders who had refused to sell out, was a tidy final act to this unusual impasse.

Geoffrey Wilson had identified one particular attraction in the new subsidiaries' portfolios: they owned land and property in Villiers Street, running alongside Charing Cross station. As a result of this ownership, Wilson approached British Rail with a plan to develop a new office in the space over the platforms of the station, which abuts the Thames. The building which has resulted, Embankment Place, is one of architect Terry Farrell's most successful, adding real interest to the waterside. 'I've always been particularly pleased about Charing Cross because I think the concept was mine' says Wilson now. 'There is great advantage in being a landowner. It's almost the seventeenth or eighteenth century concept which enabled wonderful country houses to be built, even if it meant moving villages which were in the way of the view. Embankment Place is an entirely satisfactory building. It is not just liked by the architectural and property circle, but by the public at large. Its scale is right and it has filled the space very effectively indeed. The office building is the commercial centrepiece of a much wider development. There are shops, the Player's Theatre and all the work we did to Embankment Gardens.' Embankment Place is 345,000 square feet of offices, which were pre-let in 1989 to accountants Deloittes for about £45 per square foot. Before taking up occupation Deloittes themselves merged with Coopers & Lybrand and the new partnership was negotiating to lease Rosehaugh Stanhope's Holborn development, but this deal fell through.

The initial income receivable on Embankment Place is not enough to cover the capital cost of the development, thought to be around £162 million (including an initial payment made to British Rail for the long building lease). Many companies would therefore have sought to sell the property and take the developer's profit. This is not the Greycoat style.

The development has been financed by short and medium-term borrowings of £135 million plus a zero coupon bond for the balance. This latter debt, which raised £21.5 million, is repayable in 1995; since it pays no income in the meantime, it puts no strain on the cash-flow of Greycoat during the time the investment it is financing could not meet the full interest cost of normal borrowing in its early years. However, in 1995 Greycoat is due to repay not the £21.5 million it raised, but £50 million, the increase being the reward to the holders of the bond for not receiving any income during its life. Unless the value of the property is above £185 million at that time, Greycoat will have a deficit on its original cost. That could happen only if there is no rental growth between now and then and investment yields remain high. A gross rent of £15 million a year valued at 8 per cent would give a capital value of almost exactly the property's cost and, unless interest rates are much lower in 1995, Greycoat will merely have postponed its financing problem.

In March of 1986 the company further increased its resources through a rights issue raising £37 million to take its market value to £175 million. Wilson then made one of his few obvious mistakes: he bid for and failed to win control of Property Holdings Investment Trust (PHIT). This medium sized property investment company was not, like the pre-Churchbury Law Land, run by property entrepreneurs but by conservative property investors; in one of the circulars sent out during the bid by Greycoat, Wilson observed that the PHIT's board, until a recent change, had an average age of 63. The two companies had been in discussions but they broke down. Wilson protests that 'I had never planned it to be a hostile bid; I have a great aversion to hostile bids. It was an eleventh hour breakdown [in the friendly bid talks], about the role of management more than anything else. All our horses were champing at the bit and someone said "charge".' The debate over the relative merits of the two companies centred on Greycoat's financing methods and accounting practices, which enabled PHIT to take the attack to the aggressor. Since PHIT managed to retain the support of its two major shareholders, Pearl Assurance and Foreign and Colonial Investment Trust, and Greycoat refused to increase its bid, the battle turned out to be a relatively bloodless victory for the intended victim, and only a temporary reprieve for the victors, since PHIT eventually fell to another bid.

Greycoat moved away from its avowed speciality of central London offices through the acquisition in 1985 of Merevale Estates. Through this new subsidiary the company developed shopping centres, but unlike the offices, there has been no attempt to keep these in the investment portfolio; the securing of institutional financing has been important. The major schemes undertaken include the Alhambra Centre in Barnsley, financed by Eagle Star, The Chilterns in High Wycombe, funded by the Crown Estate, West Gate in Stevenage, backed by Norwich Union, and the Crawley development funded by Friends Provident. The last-named insurance company now has its investment headquarters in a building on

Holborn Viaduct which was originally a hotel and had featured in Geoffrey Wilson's younger life. At that stage, when he was still an agent, the old hotel was being refurbished to become offices; Wilson had noticed that the attractive original door furniture was still in place and was going to be scrapped. He determined to save it from the scrap heap and add it to his own fittings, and set off early one Saturday morning to liberate it. To his chagrin he found that someone else had already had the same idea. It is a good indication of Geoffrey Wilson's character that he can good-humouredly confirm this story, even though it embarrasses him still.

The retail development which embroiled the company for several years was the Town Hall site in Wimbledon. Greycoat made planning applications in 1986 for both that site and another nearby which they had acquired through Merevale. Although local residents and conservationists preferred the Greycoat scheme for the Town Hall, the local council, Merton, favoured the Speyhawk scheme, and granted them planning consent. This permission was thrown into confusion by the spot-listing of the Town Hall by the Department of the Environment. A public enquiry was then convened, in the course of which the local Conservative Party lost control of the council. The planning inspector found in favour of Greycoat's scheme, master-minded by Terry Farrell, and the Secretary of State, Nicholas Ridley, announced that he was 'minded' to refuse permission for the revised Speyhawk scheme, which now retained the listed Town Hall. In July 1988, Ridley finally came out in favour of both Greycoat's plans. This was not the end of the story, since Speyhawk resubmitted plans which were approved by the Council in March 1989, and Greycoat finally announced its withdrawal of its application in June of that year.

The story is a sorry indictment of the British planning process. Speyhawk were first given an option over the Town Hall site in late 1984. Their plan was approved by the Council in April 1986; the Department of Environment set up their enquiry in June 1986, which reported in September 1987. Not until June 1989 was certainty established. Defenders of the system will maintain rightly that the final Speyhawk plan is much more acceptable to the conservation lobby, but the costs involved for everyone, the planning blight and the sheer time elapsed cannot be defended. What might have been a great economic success had it been completed in 1987 is likely to find times hard as it comes to fruition in a recession.

Wilson is not particularly regretful: 'It's not such a sorry saga in the end. The Town Hall site is being redeveloped in a form which is very much modified; I think a great many of the suggestions that formed part of our planning application have been incorporated. We still have our land, [the other site], and in their fulness of time maybe we'll develop it. That's the planning system; it's a democratic system and that's as it should be . . . but it does take a long time.'

In 1987 Greycoat completed two deals which exemplify both strands of

its philosophy. It bought the ageing Moor House on London Wall, the infamous Route 11, and issued the zero coupon bond as part of the financing of the Embankment Place development. Moor House is one of the row of dominoes which flank London Wall and is clearly in need of renovation or replacement. Scottish Amicable had bought the property in only 1985 for £19.5 million from the Imperial Tobacco Pension Fund, had negotiated a new 125-year head-lease from the City Corporation and obtained planning permission for a new Farrell designed building of 450,000 square feet of offices and shops. Greycoat paid the insurance company £42.5 million for its interest, which certainly gave the Amicable a substantial profit. Payment was made in the form of Greycoat shares, which enables Greycoat to hold onto the building although its current income is only moderate. Greycoat are in fact asking Terry Farrell, whom in this case they inherited by chance as architect, to submit a completely new design for the new building for, as Wilson says, 'that design is five years out of date and we are looking for more flexible space.' In other words the years of vast open trading floors has, for now at least, passed.

1987 also saw the purchase of what is now Lutyens House on the Moorgate corner of Finsbury Circus in the City. In this instance Greycoat has reverted to its roots in rebuilding a property almost entirely behind its existing facade. This became, in the 1980s, a more acceptable form of development as opinion moved against the excrescences which had often replaced many humdrum but unobjectionable buildings of previous eras. Lutyens House was originally designed in 1925 by Edwin Lutyens as the headquarters of the forerunner of BP, the Anglo-Persian Oil Company. Greycoat had already rebuilt Country Life House, another Lutyens building. Wilson claims that the result 'is a demonstration that you can take an architecturally outstanding building and you can make it an efficient corporate headquarters. You also had the wonderful thing that BP have come back to it again.' BP had recently undergone a thorough purge of its head office staff, which had taken on some of the excesses of the meetings and memos culture which permeates the civil service, and was looking for a smaller corporate centre for itself, removing its staff from the massive Britannic House, a 1960s 'slab'. In 1989 BP agreed to lease Lutyens House's 192,000 square feet at an initial rent of £55 per square foot. The finance of this building is another example of Greycoat's distinctive style. The interim bank finance used to develop the building has been replaced by a stepped interest rate bond with a nominal amount of £150 million, repayable in 2002. The interest on a normal debenture of £150 million would be over £20 million a year at the rates of interest prevailing at the time the loan was raised, which would certainly not have been covered by the initial rent on the building, of under £10 million a year. The answer has been to 'step' the interest rate, like a low-start mortgage on a house. During the first six years of the loan, it carries an interest rate of only 6.25 per cent, rising then to 12.5 per cent; the initial rent now covers the initial interest charge. As a result of the stepped

interest rate, the bonds actually raised only £92.5 million for Greycoat, but even so this was more than the total cost of the building.

The *eminence grise* behind Greycoat's financing is Richard Guignard, a figure well known in the City of London, but not by those whose contact with the property world is in the glamorous world of grand architecture. Guignard was originally company secretary of Sterling Land and rejoined Geoffrey Wilson at Greycoat in 1982. A bearded accountant with a stammer and a taste for rose-hip tea, Guignard is the despair of many of the accounting profession to which he belongs, and of property analysts. His view is that property investment is not like other businesses. The cost of interest and specific internal costs such as the work of a development team on a new building are to him capital costs as much as any bricks and mortar; conservative accounting convention has it that these should be treated as charges against the current income of the investment company. 'The purists cannot see the wood for the trees', he protests, 'no company can carry assets above their real value so there is a secondary test: the cost or market value, whichever is the lower. There is no difference between bricks and interest.' He is as firm in his opinions about how property should be treated when it is completed and let. The value at which a property is carried in the balance sheet should reflect any permanent diminution in value. 'Property companies are valued on their assets, whether it's taken above the line [in the profit and loss account] or below the line [through adjustments to reserves]. The deep discount finance enables you to stay in the game. If there is no rental growth over a sustained period of time then there would be other events: the interest environment would be entirely different [reflecting much lower inflation-ary pressures] and one would refinance. The whole game is to stay in the market and respond. It's the tiller you have to keep twiddling round to get the ship at the sharpest angle.'

Geoffrey Wilson has used this philosophy to enable Greycoat to undertake over £800 million worth of development in central London alone, of which his company is now able to retain much more than the original 10–15 per cent interests it used to have to be content with. Even the second phase of development at Victoria Station, carried out with Sir Robert McAlpine, has not been financed by Norwich Union as was Victoria Plaza. Again, upon letting the property, partly to PA Management Consultants and partly to the Department of Trade and Industry, the bank loans were replaced by £100 million raised from the issue of £125 million of 8.25 per cent deep discount notes. Wilson is quite honest about how the business is structured: 'The whole business is predicated on growth. There will be growth ultimately; you can't say with precision when it will be, but if you think that property has no growth, and is never going to have growth, then you can move on to something else. We are in a particular type of property with a particular type of tenant, and we'll get the best and strongest. The purpose [of the financings] is to allow us to keep the developments – we're there when the building comes into value.

It may come into value when you complete the building, if you've got the right point in the cycle; or it may be coming into value by the time you've reached the first rent review.' This concept of 'coming into value' is an important one for a developer. As we have noted throughout the book, the problem for the developer is that the initial rent on a property almost never covers the interest payable on its capital cost; if, however, the developer can hang on until rents rise to cover any reasonable interest rate cost, then the building has 'come into value'. The alternative is that the building is begun just as rental values are rising fast, in which case the initial rent may indeed match interest costs, but this happens only for short periods before the general inflation drives up building costs.

The Paternoster Square redevelopment is the latest challenge that Greycoat has undertaken. The unhappy story of the site's long subjection to planning blight and indecision is told in Chapter Two, but the financial and business logic of the acquisition from Greycoat's viewpoint is worth mentioning. The site represents one of the three Greycoat megadevelopments for the next cycle: Moor House, together perhaps with Roman House, another building on the Route 11 site; the front of Victoria Station (currently the bus station) and Paternoster. Wilson will not start on them until he is satisfied that he has a good chance of completing them in a boom. By the end of 1991 the new wholesale development of Paternoster was thrown into confusion again by two decisions of the City Corporation. They gave support for a building planned for the Sudbury Site, on the north-west corner and not in the ownership of Greycoat and its partners, and sent back the master plan for reconsideration. 'They are the next cycle. A lot of the skill is planning for that. For 123 Buckingham Palace Road we had to tread water for two years, which is not easy to do when you have a partner. You are constantly trying to work out when you can come to the letting market again.'

Paternoster is a very complex development: important parts of it are not owned by the new partners. The cost is likely to be so great that even the ingenuity of Guignard and Wilson could not leave Greycoat as the only owners. The original cost of £160 million has been met by Greycoat in partnership with Park Realty, a New York investor headed by George Klein. Mitsubishi Real Estate joined as a third equal partner in January 1990. The complexity of all this leads Wilson to exclaim that 'sometimes there seem to be more people on the stage than in Iolanthe'; and in this case they are not all either Lords or fairies. In June 1991 Greycoat wrote off its £20 million equity investment in the development and said it would invest no further funds.

Geoffrey Wilson is still as enthusiastic about his chosen field as ever.

There's enormous enjoyment in what we do, I count myself lucky. I have to confess I have a love-hate relationship with architects; I say to my wife that I'm totally free of prejudice except against architects. There are not enough good architects to go round; you can name the

top half-dozen British architects and you're dealing with some fascinating people. Farrell is a brilliant contexturalist; Rogers' idea of context is a scheme which would have removed Charing Cross – he's Utopian.

You can always be a rational detractor to a developer. You can say 'How will it happen? How will you get planning consent? How will you get possession? How will you let it?' All of them are rational questions, and the only response is: 'I did it last time, and the time before, and the time before, and the time before.' You really have to make things happen, the circumstances may be auspicious or inauspicious, but there's a lot of will-power and persuasion and diplomacy. People have different ways of setting about this but you have to be able to negotiate. That's why there is this fascination.

Where we are different is that we are both the architecture and the finance. They are both enormously interesting in their own rights, and it was a long, long time before it was recognized. Stuart [Lipton] and Godfrey [Bradman] were the ones up in lights.

The financing problems that seemed only theoretical at the time of that interview in 1991 are now much more pressing. Current market rents on London offices fell by more than 50 per cent from the levels achieved when Greycoat achieved the highest published rent on a major City letting for its development on the corner of Cornhill. That 1989 letting to the Halifax Building Society was at £67.50 per square foot; some prime office space was being offered at the equivalent of £20 per square foot by January 1993. The theory that the rent on Lutyens House would rise sufficiently to pay the extra interest on the stepped loan after five years looks unlikely to be borne out. Greycoat's financing has depended on values and rents growing to pay burgeoning interest and capital liabilities. The share price of 10p in January 1993 indicated the extent of those doubts, even after the refinancing of the short-term debt on Embankment Place in 1992. Even the preference share dividend had to be foregone. Nobody doubted the quality of the properties, only the ability of Greycoat to remain the owner.

Geoffrey Wilson himself underwent heart by-pass surgery in January 1992. The operation was successful, but Wilson stepped down to become non-executive chairman and several other directors left at the same time. Wilson will have taken comfort from the announcement in January 1992 that Embankment Place had been awarded one of the Royal Institute of British Architects' National Awards for 1991.

Elliott Bernerd is another man with a long history of success in the property market in good times and bad. He started early, at 16, in 1961, leaving the educational 'crammer' he had fetched up in after an undistinguished educational career, to join Dorrington Investment Trust, a small property company, where he was the office junior. The big break

for Bernerd came when, at 17, he joined the minuscule partnership of Michael Laurie & Partners, two of whose four employees were the eponymous Michael Laurie and his son Stephen.

Stephen Laurie and Elliott Bernerd became inseparable friends and business partners, in a true business marriage. 'We were exceptionally close' says Bernerd. 'We used to work at either side of a dining room table in matching leather chairs', which Bernerd keeps to this day in his office. By 1970 the two young men decided to 'provide a pension for ourselves and decided that we should find a piece of property. We bought 15 Duke Street, St James's, which housed a tailor named Welsh & Jeffrey. It was an old property which needed either renovation or complete redevelopment. We put a new building on the site, let it and mortgaged it to the Legal & General. Having done it once, we decided to do it again and formed a little company which bought properties in New Bond Street, Oxford Street and Queen Street, Mayfair.'

Through most of his career as a property investor and developer, Elliott Bernerd has also acted as a property agent, advising clients on potential purchases and sales of investments and developments. Was it not possible for these roles to create conflicts of interest between those of the clients and those of Elliott Bernerd? Bernerd was aware of the dangers even in those early days and took care to meet that accusation: 'We bought nothing from any of our clients, they were arms-length transactions. In those days it was pretty frowned upon for a professional adviser to dare to have a position in property of his own. Senior partners of various partnerships had bought reversions on properties for their retirement' but, of the important figures in the market, only John Ritblat was simultaneously building up his property company and his agency. 'We decided that we would have a very up-front policy about this. We'd talk about it. One of the people we talked to was Hambros Bank. They thought about forming a joint company with one of their investment trusts: they provided us with what seemed to us in those days a substantial amount of money. We went off and bought things that we were used to buying except we bought more of them because we had more fire power.' The private company prospered with the property boom of the early 1970s and Bernerd and Laurie were thinking 'very, very seriously' about floating it or reversing it into a small listed company. One of the agency partnership's best clients was Barry East, then managing director of Town & City Properties. 'Following our policy of not being shy about what we were doing', East came to hear of the partners' plans. 'He said "don't do that, instead of going public, you're just what I need here. I'll take over your assets and I want you both to join the board and play whatever role you want within Town & City".' Already on the Town & City board was David, later Lord, Young, whose company Eldonwall had been sold to Town & City, on whose behalf Stephen Laurie had acted.

Although Bernerd and Laurie joined the board as non-executive directors, they were active in helping Barry East expand Town & City rapidly as the property boom gathered pace. In 1972 Bernerd negotiated the purchases of both Charlwood Alliance and Sovereign Securities, and soon after Town & City bought Sterling Land, Wilson and Lipton's company, and, fatally, Central & District. 'As the problems of 1973 continued into early 1974 it became clear that some management changes were needed: Barry had to go. It had got completely out of hand; our non-executive roles were becoming more executive, largely fire-fighting. It was quite clear that, if anything happened to Town & City, which owed quite a lot of money to Sterling Guarantee Trust, that company would go as well – it was a domino effect.' The result was the reverse take-over of Town & City by Jeffrey Sterling's company, described in the last chapter. 'There were great difficulties that had to be dealt with: the executive duties of Barry East had to be taken away, and most of the board left. We left with a long-term advisory contract with Town & City. It suited us to give up our non-executive roles for which we were not being paid. We became very close advisors to the company in a vigorous campaign to de-gear the company.' Among the deals brokered by Bernerd and Laurie was the sale in 1978 of Berkeley Square House to the British Rail and British Airways pension funds for £37.5 million. In fact by that date the contract with Town & City had expired, but they continued to act for the company as agents.

1979 brought tragedy to Michael Laurie & Partners. On 27 February 1979, Shrove Tuesday, Elliott Bernerd and Stephen Laurie agreed to meet at Wiltons restaurant for the traditional pancakes. 'He didn't turn up but went home with a migraine. I spoke to him that evening and was called over by his wife that night. He went straight into hospital, into a coma on Wednesday and died on Friday of a brain tumour. He was 42 and left three children.' Bernerd was shattered. 'I found it quite horrific, we had worked together across the same table for 17 years. I threw myself into work, but I've never had another partner like him; we had a very special relationship.' The two men had already started buying again by this time, 'the same sort of quality pieces. We had an assortment of property investments limited by what we could walk to; if we had to take a taxi, that was already something which we would have to consider very seriously.'

In the next few years Bernerd's property direct interests were not growing rapidly and he concentrated on rebuilding the agency. As the property market began to pick up again as the 1980s progressed, he began to consider becoming more active on his own account. 'One of the people I had been close to for some time was Jacob [now Lord] Rothschild. He had been trying to persuade me to go public in something for some little while. I remember looking at all sorts of vehicles with him, including the Corn Exchange [later bought by John Ritblat]. Nothing ever really

seemed to be right.' In 1983 Trust Securities came into view. Bernerd had met Peter Jones when Stockley Park was still a rubbish dump. He had also, like Stuart Lipton, spent time in the US and had become interested in the concept of the office park. While Trust Securities began its expansion, Bernerd 'took a cursory interest' in it. Then Peter Jones bid for the publicly quoted, but tightly family held Percy Bilton company. 'This was a grave error on Jones' part, and he was slaughtered in the press.' Trust, a small company already engaged in a very speculative and expensive development had tried to buy a large investor/contractor, which, although not the market's favourite company, had at least a reasonable track record.

Following the collapse of the bid for Bilton, Trust Securities began to meet difficulties. The merciless exposure it had been subjected to during the bid had weakened confidence. Elliott Bernerd began a discussion with them about perhaps buying out the Stockley Park project.

Jacob [Rothschild] had the same interest as I did, and liked the location. As the year went by, Trust Securities' problems became worse and our interest in the London Airport project [at Stockley Park] grew. We decided to bring someone else into the concept. Stuart Lipton had just walked out of Greycoat and had told me he was going on a sabbatical for a year. I asked him to come and look at Stockley Park. To his credit he took an immediate interest. We decided later on that the more sensible approach to adopt was not to go for the site, which was far too complicated, but to take over the company.

The company was recapitalized and the share price moved up from 15p to 40p very rapidly. Roger Seelig of Morgan Grenfell joined the board.

The work relationship between Stuart and myself went so well. There were acquisitions, joint-ventures, some quite good financings, some interesting developments and the company grew very, very strongly. We had originally hoped to achieve £8 per foot for the new space at Stockley, and now we achieve £32 plus. We did have difficulties with each other, but they were always settled behind closed doors, never publicly and we never had an argument at board meetings.

By 1986 the conflicts of interest between Stockley and Lipton's Stanhope were beginning to create problems in the mind of Bernerd. 'We had managed to avoid all traffic accidents but we instructed Warburgs and Morgan Grenfell to see whether we could achieve either: the acquisition of Stanhope, the removal of European Ferries as a major shareholder or an increase in my shareholding so that Stockley would be my full-time occupation.' At the time neither Lipton nor Bernerd were giving more than 50 per cent of their time to Stockley. In the latter part of 1986 and into 1987 the advisers were deep into investigations which were intended to see

whether any of these deals could be consummated. They could not agree.
'I think one of the problems we had was that we were too friendly' says
Bernerd. 'I was clearly interested in protecting the Stockley shareholders
and Stuart wanted to protect his Stanhope interest.'

The Stockley board then received an approach for the company from
the Hong Kong based Jardine Matheson trading house on behalf on its
associate, Hong Kong Land. They wanted to make an agreed acquisition
and the board of Stockley thought the outside approach might firm up
Stuart Lipton's intentions. Jardine instructed their London associates at
Robert Fleming and became more and more serious about the deal when
'up pops Tony Clegg, entirely out of the blue.' The fact that Stockley was
trying to restructure itself was 'one of worst kept secrets in London', as
was the fact that Stanhope and the company had not reached agreement.
Tony Clegg felt that it needed a third party to unlock the situation and he
was prepared to bid for the whole company. So Stockley was sold in May
1987.

The previous summer Elliott Bernerd had started a small family
property company called Chelsfield. Following the sale of Stockley, this
became his prime interest. In the period of financial gigantism which
culminated in Big Bang in 1986, Morgan Grenfell had bought Michael
Laurie & Partners, and Bernerd had been retained on a part-time contract
as chairman, and had been allowed to continue with his own property
investment interests. The relationship became strained, and when the
Guinness take-over scandal overwhelmed Morgan Grenfell and Bernerd's
old friend Roger Seelig, Bernerd left.

In December 1991, Bernerd appeared as a witness in the 'Guinness trial'
of Seelig. Bernerd had approached a Swiss investor, Victoria Seulberger-
Simon, who agreed to buy Guinness shares to support the bidder in its
attempt to buy Distillers. She later bought shares in the other participants
in the bid war, Distillers itself and Argyll, the rival bidder. When Mrs
Seulberger-Simon decided she wanted to sell the shares, Bernerd
informed the court, Seelig had asked that they be sold in an orderly
fashion by Guinness's brokers, Cazenove, and 'there would be a
satisfactory accommodation from her point of view'. According to the
Financial Times report of the trial, Bernerd understood this to mean that
she would be able to sell without loss; he had seen nothing unlawful in
Guinness reimbursing Mrs Seulberger-Simon £1.9 million for the loss she
sustained by holding on to the shares, or in the invoice for 'financial
services'. Bernerd had another connection with the trial: his associate at
Chelsfield, George Devlin, formerly a private detective, sat as a
'McKenzie friend' by Seelig's side for much of the trial. Seelig had decided
to defend himself, and, in such cases, is entitled to the assistance of a friend
who may make suggestions and notes. The trial was stopped after Seelig's
health collapsed.

One of the classic deals of the 1980s was the round robin in which
Chelsfield featured. Mountleigh had taken over 10/14 Stratton Street,

Mayfair in the United Real portfolio; the property was sold to Chelsfield in early 1987. Chelsfield promptly swapped this property with one in Berkeley Square owned by Eagle Star and sold the resulting acquisition to Mountleigh. This string of deals reveals Bernerd's great ability to see connections where no-one else does. It would have theoretically been possible for Mountleigh to carry out the swap between Stratton Street and Berkeley Square itself; it certainly would have saved that company some commissions. By late 1987 Chelsfield bought several properties from Mountleigh. Bernerd supports Clegg's assertion that the latter had turned cautious by the end of 1987; 'He had decided that he needed to liquidate quite a large part of his portfolio, for whatever reasons he had.' Bernerd took the view that markets would soon improve from their post-crash inertia, and bought 'a lot of properties from everyone' and traded them on.

Chelsfield had one prime object. Bernerd was determined to see how far he could go with a private company.

There was an intellectual challenge. I had more money than I thought that I would ever have in my life, but I wanted to see whether we could run a private company with the total disciplines of a public company. I also wanted the company to take advantage of markets when we thought they were there to be taken advantage of; to be able to hold and buy certain quality pieces of property which were capable of being developed for better purposes. There is an interest on my part in having a corporate team to look at corporate finance. The company expanded through the earlier period quite rapidly without the support of any outside shareholders. In early 1992 Chelsfield announced the introduction of new capital from institutional investors in order to complete the unwinding of the joint venture in Laing Properties with P&O. It now has activities in the UK, Europe and the US, where it has an office.

The group's managing director is Michael Broke, who had been seconded from Jacob Rothschild's activities to become the original managing director of Stockley before the Mountleigh take-over. Now that Chelsfield is part of the consortium which bought back Stockley Park from Mountleigh, he is involved in managing it again.

One rare failure in the Bernerd story was his involvement in Eddie Shah's ill-fated *Post* newspaper venture. It is estimated that Chelsfield lost over £4 million, as did Jacob Rothschild, Shah's other partner. The two deals with which Chelsfield has come to public notice could not have been more different. The first was the acquisition and development of Wentworth Golf Club. This prestigious club, at which the World Match-Play Championship is held every year, had for some years been in the ownership of the contractor AMEC. In August 1988 it was announced that Chelsfield and the quoted Benlox Group, one of the shooting stars of the 1980s bull market, had bought the course for £17.7 million, against the

value AMEC had carried the course in its own books at of £2.5 million. The acquisition bought in 800 acres of land in Virginia Water, Surrey, heart of the stockbroker belt, and a further 55 acres were optioned. By the end of the year Bernerd had bought out his partner's 40 per cent for £12.5 million against their cost of only £2.5 million. The total cost to Chelsfield, which, with expenditure on the estate and interest costs amounted to almost £30 million, raised eyebrows. Those disappeared into the hairline when it was announced in 1989 that Chelsfield was intending to sell off 40 one per cent shareholdings at £800,000 per time. These shareholdings would bear some playing privileges and, since the Japanese brokers Nomura Securities were involved in the placing of the shares, it was assumed that this quintessential part of England was to be yet another British asset to fall to the new-found Japanese wealth, with Elliott Bernerd being repaid all his initial investment and left with 60 per cent of the course at nil cost and worth £48 million. In January 1993 Chelsfield announced that it had agreed terms to lead a consortium of buyers for Mountleigh's Merry Hill Shopping Centre, despite the earlier fears of contamination in the land. It was too late to rescue Mountleigh, but it may be an indicator of the prominent role that Elliot Bernerd intends to play in the property cycle of the 1990s.

Elliott Bernerd has always been able to charm people, but this was probably his greatest challenge yet. A self-perpetuating group such as the members of Wentworth had always been, were not going to take kindly to some flash London property developer imposing privileged Japanese business members on them and 'destroying the club atmosphere' as the club captain David de Ville was quoted as saying. Bernerd's old colleague from Town & City days, now Lord Young and former Secretary of State for Trade and Industry, came to the rescue: a keen and good golfer, he returned from a trip to Japan with Prime Minister Thatcher with words of encouragement for both Japanese investors and the existing members. The Savoy Hotel invested in three one per cent stakes for its guests. Nevertheless, just before Christmas 1989, Bernerd went to the annual meeting of the club and addressed the hostile audience; it is no surprise to those who know him that he won them over. He reassured the members that their position was secure, and that his intention was to improve further the facilities. On way of showing the earnest of his intentions was the hiring as chief executive of the club of Willy Bauer, previously manager of The Savoy.

Bernerd's second coup of the late 1980s has yet to prove its worth. For some time he had been building up a share holding in Laing Property Holdings. This company, a sister to the contracting business, had substantial investments both in the UK and in the US, but had been assumed to be under the control of the Laing family and its various trusts, which between them owned 40 per cent of the shares. By the time Bernerd was ready to bid, Chelsfield had built up a shareholding in Laing of over

15 per cent. The over £400 million that Laing was worth was beyond the resources of even so resourceful a man as Bernerd, so his solution was to team up with Jeffrey Stirling of P&O, another ex-colleague, in a joint company, Pall Mall, which became the bidding vehicle. In terms of unlocking the existing shareholders, the timing of the bid could not have been better: on the same February day in 1990 on which the bid was made, a contractor/developer J. M. Jones went into receivership and Rosehaugh announced its heavily discounted rights issue. Investors were aware that the property market was no longer a one-way bet, and that risks were at least as great as the previous rewards. After a hard-fought battle, Pall Mall managed to prise away sufficient shares from the Laing trusts and other shareholders to take control. Whether this will prove to be a financial success will only become apparent in the fulness of time. It has certainly not proved possible for Pall Mall to pay off much of the borrowing it took on to bid for the company, as the cycle was by now clearly in its retreat phase. However good a deal Laing may turn out to have been in the long term, the further fall in values since the bid will have put some strain on the relationship with the bankers who financed the deal.

Elliott Bernerd is good at making friends. For a non-musical man, his chairmanship of the trustees of the London Philharmonic Orchestra may seem an anomaly. His enthusiasm and persuasiveness has carried all before him, and he has raised the funding of the orchestra sufficiently for it to bid for and win the residency of the Festival Hall. For a man who left a crammer at 16, he has certainly emerged from the shadows of estate agency into the bright lights of cultural patronage with gusto.

8

THE MERCHANT DEVELOPERS

THE 1980S WERE characterized by a new breed of property company: the merchant developers. In the 1950s and 1960s it was possible for a company to borrow long-term money at a rate of interest below the current yield on a property. It was probable that any rent review would be at least 21 years away, but it enabled the companies to hold portfolios of property. Even in the inflationary early 1970s it was possible for the developers to borrow short-term money at negative real rates, (below the rate of inflation), and let the resulting property at a rent which enabled them to hold onto their creations. By the end of the 1970s, the rigours of monetarism, followed by most of the industrialized world, meant that developers were paying very high real interest rates for long-term money. This made it impossible for developers to hold onto the completed developments. The much lower investment yields on which the completed properties could be sold to the institutions made it possible for a profit to be made by assembling, building and selling a new property. The problem for the developer was that there was no naturally recurring income, any more than Tony Clegg's successful trading in any year made it easier for him to repeat the exercise. Each development was a distinct profit-centre. As soon as one was sold, another would have to be found to take its place. As with Mountleigh, to show a profit progression, the number or size of these developments for onward sale would have to increase year by year.

Two of the largest merchant development companies of the era could not have been more of a contrast, either in their management or, ultimately, in their rewards to shareholders. London & Edinburgh Trust is the only company covered in this book whose management was run by Old Harrovians; the shareholder also benefited from the well-timed sale of the company to a foreign buyer. Speyhawk, on the other hand, was run by a man who had left school at 16, and just failed to be taken over by another foreign buyer, leaving its shareholders to go through the property recession on their own.

John and Peter Beckwith, the Old Harrovians, had each qualified, John as an accountant and Peter as a solicitor, at the end of the 1960s. In 1971 they met Arthur Bergbaum, who had been managing director of City Wall Properties, (later taken over by Rank Organisation and, in turn, by British Land). Together they set up a commercial property development company named Second City Wall; this name had to be changed in due course because everyone would ask 'what happened to First City Wall?' Later Bergbaum and the Beckwiths also formed a second development company, Lyndean. The timing of these ventures could hardly have been worse, since the business barely had time to start before the property crash happened. John Beckwith remembers those days with a wry smile: 'Christ, they were awful. Very quickly we had been up £3 million, then we we were down £3 million. We had to do crazy things. We had a line of credit from Twentieth Century Banking, [one of the leading fringe banks of the period], but they didn't have the money to lend us. We sued them despite the fact that we no longer wanted to do the development. They let us off a great deal of the existing overdraft which was secured on the land for this development.'

The Beckwith brothers had met an ex-patriate Romanian named Ion Ratiu, whom they helped with a property deal in Regent Street. As recompense Ratiu gave the brothers, as they thought, free office space in 54-62 Regent Street. As soon as things became really difficult, Ratiu presented the brothers with bills for the office space and the associated services. 'Instead of fighting him, we gave him shares in our company.' Ion Ratiu had acquired stakes in two other companies, Breakmate, the drink dispenser company, and Nissan UK. This latter was the company which, under its earlier Datsun name, Octav Botnar had set up to import these Japanese cars. At the time the idea that Japanese cars could take a substantial share of the market was as absurd as the thought today that Lada or Skoda might one day do the same. The investments that Ratiu's Regent House Properties made gave Ratiu a substantial fortune. No other property company can claim to have been at least partly responsible for the election campaign of a candidate for the Romanian presidency. In 1990, Ion Ratiu, by now well over 70, returned to his homeland to run as the candidate of the old Peasant's Party. Despite his obviously well-financed campaign, he made little impression.

In the mid-1970s the Beckwiths were forced to turn their hands to anything in order to try to earn a pound or two. 'We bought a lot of UN trucks and sold them to Egypt; we sent engines to Australia. We bought 45,000 pairs of boots from Brazil and opened a letter of credit to sell them to the Nigerian army. We went down to the container depot and opened the first container: they were all left-footed boots. We opened the second container: all left-footed boots. We didn't bother to open any more.' John Beckwith still doesn't know whether their pairs were in the other containers. A few years after this story had been published in a trade magazine, he was nervous enough not to want to find out whether his leg

was being pulled when a squash-playing friend told him that a six foot two inch Nigerian army officer was waiting to see him.

The Beckwiths owe their survival over this period to the Bank of Scotland, who stood by them. By 1976 they were able to buy a bonded warehouse in Leith, Edinburgh from British & Commonwealth. The plan was to turn this into a 60,000 square foot office building. They took the plan over from Izzy Walton, whose Glasgow-based Scottish Metropolitan Property could not finance the deal. The Beckwiths persuaded the Scottish Mutual to lend them money at 14 per cent, fixed, and to buy the resulting building, when completed and let, on an investment yield of 10 per cent. This agreement by an institution to finance and then purchase a development, 'forward funding', became commonplace at the end of the 1970s. The Department of Health took the building on a 60 year lease. 'This deal saved our bacon and repaid our borrowings; it was one of the first forward funding deals after the bear market. That's why the company is called London & Edinburgh Trust.'

The developments that London & Edinburgh Trust (LET) carried out over the next few years were mostly of these forward financed developments, often pre-let to major tenants, but by 1979 the company was still a relatively small one, making profits of £600,000 from turnover of under £5 million. John Beckwith is disarmingly frank about the relative inexperience of the two brothers: 'Having not known much about it, we didn't worry too much about the problems. Professional property people used to worry about what was under the ground and survey it too much. They also used to buy the same old crap. By doing something a little bit different, because we hadn't done it before, and by thinking about it' they found success.

The target of their developments soon moved south. 'We did a 50,000 square feet bottling warehouse for Allied-Lyons. They wanted a floor loading [weight capacity] of 2,250 pounds per square foot. It was eventually built for them at 400 pounds per square foot, simply because we got engineers to do tests off-site to prove that they didn't need the higher loading. When an engineer came up with a design and you would say that it was far too expensive, go away and redo it, he would look at you as if you were absolutely mad. The old-style developer would have just accepted it. We used to come up with really crass questions. That, in many ways, is the way to run a business.'

By 1980 the company had discovered a new way to finance the larger developments which on its own resources it could not have espoused. It formed joint companies with two building contractors, London & Metropolitan with Balfour Beatty and Macwall with Tarmac Construction. Balfour Beatty is a subsidiary of the BICC group and its activities had traditionally been based in Scotland. For the joint company Balfour Beatty, under its Chief Executive Bob Rankin, put up most of the cash and guaranteed most of the loans. The first major venture was the Woking Business Park, a site bought from the BTR industrial conglomerate. On

this 12-acre site the partners built 250,000 square feet of modern industrial space, which was subsequently sold to the joint Post Office and British Telecom pension fund manager, Postel. With Macwall the first major development was the rebuilding of the old Reckitt & Colman headquarters at Hogarth Roundabout on the Great West Road, Chiswick. This development, with a new business park behind it, was funded by Fleming Property Unit Trust, whose manager at that time was John Newman. In 1985 Newman joined the board of LET as director of retail development.

In November 1983 LET became the second merchant developer to be floated on the stock market. By now the company could show a record of 29 developments completed. Most had been sold on, but the company had managed to hold onto an investment portfolio worth £16 million, of which £7 million was the Ramada Inn in Reading, not the usual basis for a property investment portfolio, as the rent depended to a large degree on the future profits of the hotel. Since the company was to be worth a minimum of £27 million and had borrowings of over £10 million, it was clearly not the asset backing which supported the company's value.

The big carrot held in front of investors in LET was the profit it was going to make out of its developments. In the prospectus profits of £3.25 million were promised for the 1983 calendar year, and from those profits dividends would be paid which would give shareholders a return of 5 per cent per annum at the minimum issue price. With 20 further developments in hand, there was some expectation that the profits might be repeated. The potential home-run was the development of the now-empty Billingsgate Fish Market by the Thames in the City. The old market building and the lorry park beside it were ripe for an imaginative development, but in 1982 when the opportunity came to the Beckwiths the City was still recovering from recession and it was a huge contra-cyclical gamble. What is more LET could not hope to finance the development of 250,000 square feet of modern City office space, expected to cost around £70 million, out of its own resources or facilities. There was substantial risk involved. The tender price which LET had paid to the City Corporation could only be made economic if the new building was rented out at £20 a square foot. Beckwith and his advisers had noted that, since the onset of the mid-1970s crash, only Cutlers Gardens had been developed, and there was a dearth of good new space. However, prime rents in the area were then only £15, and it required courage to assume that rents would rise sufficiently to make the sums add up.

The Beckwiths were introduced to Ephraim Margulies, then the driving force behind S. & W. Berisford, a publicly quoted commodity dealing company. 'Marg' is a small, round, dark man with black-rimmed glasses, a strong contrast with the tall, lean and fair Beckwiths. Margulies and his company hit serious trouble in the late 1980s, with Marg himself being mentioned in the Guinness trial as another businessman who had been approached to support that company's share price. Eventually Marg was forced out of the control of the company which his drive and enthusiasm

had done so much to build. John Beckwith and Marg 'hit it off very well, and I'm very sorry what's happened. Marg was very gung-ho about property' and Billingsgate in particular. Being a commodity man, Margulies knew well the area between the Thames and the traditional City locations to the north of Eastcheap and Cannon Street. Berisford had recently entered the major league of property investment by buying another office block along the road from Billingsgate for £18 million. In the first few years of the 1980s, this represented an exceptionally large deal.

The negotiations between the two men took a strange form: Margulies suggested that the company should be split on the basis of how many children each man had fathered. Beckwith could come up with only three but Margulies told him with a laugh that he had 11 children. The original deal was for the venture to be 50–50, but when it came to financing, even that was too high for LET, and the property company eventually took a one-third interest, limiting its equity investment to £6.7 million.

The design of the new building constructed on the old lorry park was controversial for such a prominent site on the Thames. Restricted by the need to avoid overwhelming the old market building, Covell, Matthews Wheatley planned two connected blue-windowed offices stepping back from the old market building, which was itself to be converted into a trading floor of considerable size. The old fish market's walls and floor had to be coated with special material to seal in the smell arising from decades of fresh fish being deposited upon them. It was said that, even then, it might take ten years for the old smell to be dissipated. The new block did not break any particularly new ground in style, and Stuart Lipton of Stanhope is rather dismissive of it. The entrance hall is in the form of an atrium, the bank of lifts rising through that space, which narrows as the building rises. In the original artist's impressions there was the clear intention to drape the external ledges created by the stepping-back with plants, but this has not been followed through. The occupants, the merchant bank arm of the Midland Bank, seem content enough with the result. John Beckwith does not believe that many of the buildings created specifically for the City's 'Big Bang' work any more; the irony is that the renovated market building remains empty. This was not because the Billingsgate group failed to let it. Citicorp took the building for its stockbroking acquisition, Scrimgeour Vickers, but before the building was ready for occupation, the US parent had changed its mind about the shape and size of its British capital market subsidiary, which has been run down. Citicorp is still trying to find someone else to take the old market off its hands.

The financing of the Billingsgate development broke new ground. Even before Godfrey Bradman had discovered its joys, LET and its partner had arranged to borrow £47.5 million from a syndicate of banks headed by County and Chase Manhattan on a non-recourse basis. In fact this finance was never drawn down, since, armed with the facility, Margulies was then

able to borrow on more favourable terms on a normal short-term loan from his bank. The commitment fee on the non-recourse loan was £1 million, for money that was, in the event, never borrowed. The financing idea was similar to that used later by Godfrey Bradman on 1 Finsbury Avenue. Beckwith is sceptical about how non-recourse such finance truly is. Does he believe that a company can walk away from such a liability? 'You can as a very small player, but I don't think we can. A lot of these so-called non-recourse loans are really limited-recourse [whereby the lender has some limited further claim on the other funds of the borrower beyond the asset on which the loan is made]. The penalties for walking away are pretty harsh.'

The property was let at £27.50 a foot to Samuel Montagu, which had earlier considered doing the development itself. Both Beckwith and Margulies then needed to find a way of realizing the profit on the building, which was by now worth over £100 million; the number of buyers of individual buildings of that value was small indeed. For both parties, trading profits were an important ingredient. The US investment bank Goldman Sachs, familiar with such challenges in its home market, was retained to find a solution. The ultimate idea was the creation of a single property investment company, whose only asset would be the development. LET had already sold its minority in the joint company back to Berisford. 'Marg thought he could get a darn sight more than on my basis, so he bought us out on my valuation. At the time it made sense for us to take a profit.' In fact two potential buyers for the whole property were found, but Berisford persevered with its plan, selling equity in the development to a wide spread of institutions. In due course, Berisford bought out these partners too and sold the property to Samuel Montagu.

The public issue of LET was not a great success. Investors were not confident they knew how to value these new-style property companies. They feared that LET might find it impossible to repeat its undoubted success on a larger and larger scale every year, yet, on the profits forecast the shares looked cheap. In 1983 there was only Speyhawk to use as a comparator. One of LET's clearing bankers swore that if the issue was less than a triumph he would eat his hat. The issue was barely subscribed at the minimum tender price. Five years later, at a celebration to mark LET's anniversary as a public company, Beckwith commissioned a cake in the shape of a hat and put it in front of his banker.

The second large City development that the group undertook in its early years as a public company was in Ropemaker Street. Granada Group, the TV contractor and rental company, was the controlling shareholder of Barranquilla Investments; the major asset of this latter company was a rather dated office building, Britannic House North, tucked uneasily between the Barbican to its west and the BP head office complex of Britannic House itself to the south. Through London & Metropolitan, LET's joint company with Balfour Beatty, the property

was purchased with the intention of knocking it down and replacing it with a totally new building. At the same time it was decided to turn the entrance and orientation of the building, away from fronting the off-pitch Chiswell Street, so that it would now face towards Moorgate station, a much more commercial prospect.

The Ropemaker property was funded by Norwich Union, which had been frustrated in its attempt to be appointed as developer of British Rail's Broad Street station site (now Broadgate). The offices were rented to Merrill Lynch, the American 'Thundering Herd' stockbrokers, and London & Metropolitan (L&M) made a substantial profit on the scheme. In November 1986 L&M was floated on the Stock Exchange as a clone of LET, managed by Rankin and his team. Stock Exchange rules are that a quotation is not granted to two companies where the management is the same and the value of the companies is based principally on the same assets. Since a good portion of LET's assets were in L&M, the Beckwiths had to give up management control, although both they and Balfour Beatty still owned 20.5 per cent each of L&M, worth over £10 million to each company in addition to the £17 million they had taken from the new investors on the issue. L&M was as aggressive in its plans as had been its erstwhile parent: developments were planned for St James's Square, three offices in Uxbridge and the complete internal rebuilding of the faded Whiteleys Department Store in a cosmopolitan part of west London.

L&M was solely and simply a trader of developments. The company preferred to identify the exciting sites, obtain planning permission and gauge potential letting demand. The building contract would often be arranged before the project was sold on. The company would thus avoid the highest risk phase, when the construction was under way but before a tenant had been signed up. It did not eliminate all the risks, since the sites it purchased were often producing little income, if any at all.

The Whiteleys store redevelopment, like the Ropemaker Street one, was indeed successfully funded, this time by a sale to Standard Life. The company shares moved up sharply from their initial price of 145p, so that, by September 1987 it was able to raise a further £26.6 million through a rights issue at 275p per share. Neither Balfour Beatty nor LET took up their entitlement, and their shareholdings fell to 16.4 per cent of the company each. LET sold its remaining interest in 1988 at 200p, which looked modest against the recently prevailing levels, to two investment institutions.

By the time of this last sale, L&M had, in July 1988, entered into the transaction which well-nigh ended the company's life. The Thatcher government had abolished London's upper tier of local government, the Greater London Council, and charged the London Residual Body to conduct an orderly disposal of its assets. Prime among these was County Hall, a fine example of Council Classical architecture, on the South Bank of the Thames, kitty-corner to the House of Commons across

Westminster Bridge. The County Hall Development Corporation, consisting of L&M, Lazards (the merchant bank), Touche Remnant Property Investment Trust, and New England Properties, was thought to have paid £200 million for the existing buildings. For its money, the consortium hoped to win planning permission for about 1.5 million square feet of offices, a hotel and flats.

If a month can be said to mark the peak of the 1980s boom, July 1988 would be a strong candidate. From the end of 1988, as interest rates rose and the bloom came off the economic growth rate, L&M found that its calculations were going awry. Although the consortium paid the deposit on the purchase of County Hall, the partners decided that payment of the balance owing would be throwing good money after bad; the consortium company thus defaulted. Although the involvement was relatively small beer for most of the partners, L&M's loss on the project was enough to damage its balance sheet and credibility severely. In one of the earliest examples of the desperate measures required to keep property companies from the hands of the receiver, L&M's bankers converted some of their loans to equity, and the shares are still quoted.

The Beckwiths had meanwhile been concentrating on building new profit opportunities after their coup in Billingsgate. In the 1980s they were among the first British companies to make a foray onto the Continent, a graveyard for most British investors in the 1970s. Two important buildings in Amsterdam were followed by a development on Boulevard Malesherbes in Paris. John Beckwith rationalizes the move because, by 1985, 'there was a hell of a lot of rivalry between ourselves and Godfrey [Bradman] and Speyhawk, so we decided we ought to do something about that and go into new markets. The reason why people had not made a big success out of continental Europe in the 1970s is that they went in totally blind. Some of the British agents and lawyers from that period stayed on, so the quality of advice was very good. Richard Ellis, for example, are the biggest practice in Spain.'

The French redevelopment of the old headquarters of Empain Schneider was undertaken on the basis of a capital value of FF2,100 per metre, and the last phase was sold for FF4,600 a metre. 'We shouldn't have sold them, but we needed the profits, we were a trader/developer.'

In an effort to avoid the compounding problems of the merchant developer, always having to find bigger and bigger projects to beat last year's profits, LET invented its own solution. It launched a company named LETINVEST in 1987. This company was to be a vehicle through which LET could build up an interest in a long-term investment portfolio, financed by other people's money. The company's share capital was divided between ordinary shares, all owned by LET, and preference shares, mostly owned by investment institutions. The preference shares took 40 per cent of any capital gains, as well as a net dividend of just under five per cent a year. This was cheap capital for an investment company, and enabled LETINVEST to make a profit in its first year.

LET also picked up several other ancillary interests. It bought controlling interests in Kellock (renamed Rutland) Trust, a factoring company, and a quoted property company in Hong Kong. In 1988 the company acquired Owen Owen, the Liverpool based department store group from the Ward White Group for £35 million. The deal was property driven, but 'the idea behind it was that, when the property market did turn down we would have other profit centres, and if they could be property related, then so much the better.' Owen Owen had lost its independence to Ward White in the mid-1980s, and had rather lost its way in the department store market. LET sold the stores in Shrewsbury, Bath and Chester, thereby recouping all the purchase price, leaving 16 freehold shops still in hand.

One of the most notorious eyesores of the 1960s development boom is the Bull Ring Centre in Birmingham. Compared with the bustling street market to be seen in old photographs, this windswept, concrete island in the road system has long been deemed a failure. LET bought the property from Laing Property in 1987. There have been 33 designs for the redevelopment of the site, but none have yet been undertaken. LET is looking a few years into the future for the project, into which it intends to bring partners; meanwhile it is a high-yielding investment.

The other major development by which LET will be finally judged is Spitalfields. The old fruit market on the east side of Bishopsgate has now closed, and the competition to redevelop it was fierce in the height of the property boom. The two major competitors were groups headed by LET and one for which Godfrey Bradman of Rosehaugh acted as spokesman. Spitalfields has an extraordinary mix of residents. In some of the old Huguenot weavers' houses are bankers and the artists Gilbert and George. In the roads which flank the market there are the Bangladeshi immigrants who have taken over the old haunts of the Jewish immigrants of the turn of this century. The competitors for the Corporation of London's nod as developers were keen to be seen to be consulting the local residents and several public meetings were held. There is a story, no doubt apocryphal, that at one of these Godfrey Bradman rose to address the gathering: 'I was born in this area – like you. I went to school around here – like you. I am like you.' When it came to Peter Beckwith's turn to speak, he said: 'I was born in a terraced house – in Eaton Square, I was educated at the local school – Harrow; I am not like you at all.'

Whatever the truth of this, it made no difference to the Corporation's decision. In 1987, LET's Spitalfields Development Group was selected as the developer of the 11-acre site. LET's two partners are County & District, a subsidiary of the Costain construction group, and Balfour Beatty, LET's old partners in L&M. As mentioned in Chapter Two, the developer's most recent plans have involved Benjamin Thompson as master planner. This is likely to create a more classical centre to the site, with modern offices like a canyon on the western edge facing Broadgate. LET plan to start development on the project with an eye on the next

potential period of shortage of office space in the City area. Beckwith says that 'detailed research suggests that there will be a balance of supply and demand in 1995.' That may be optimistic, but, like Geoffrey Wilson of Greycoat, LET is thinking contra-cyclically, and it is likely to be around to benefit when rents do finally rise again.

The reason why that statement can be made with such confidence is because the Beckwith brothers executed one of the great coups of the 1980s property market: they sold their company at the peak of the market. John Beckwith tells how it happens: 'In October or November 1989, we had asked Lazards, [the merchant bank], to do an exercise to see whether it would be better to break LET down into different companies, or to find a very large shareholder. We had already been approached by Japanese companies. At the same time, SPP had asked Lazards to do a complete review of the London quoted property scene, because they had "x" amount of money which they wanted to put into continental property.' SPP is a Swedish mutual life assurance company with assets of over £12 billion; it is the largest provider of private pensions in Sweden. As described in Chapter Ten, Sweden relaxed its exchange controls in 1989, and Swedish institutions made the most of the opportunity. Lazards reported back to the Swedes that the only company they should buy was LET, because of its spread of European developments.

According to Beckwith, 'the Swedes said: "let's get on with it", but Lazards pointed out that they were already acting for us.' The bid was therefore made by Baring Brothers on behalf of SPP in April 1990, valuing the ordinary share capital of LET at £491 million, and each Beckwith brother's personal holding at about £40 million. The share price of 220p represented an almost ten fold increase over the narrowly successful tender price of the equivalent of 24p in December 1983: the brothers had timed both their entrance and their exit impeccably. Whether the company would command the same price today is altogether a different proposition. In April 1992 LET announced losses of £138 million, caused largely by a £121 million write-down of such investments as the Birmingham Bull Ring and Spitalfields. The Beckwith brothers' departure from their company was announced in late 1992.

The contrast between the Old Harrovian Beckwith brothers and Trevor Osborne of Speyhawk could hardly be greater. Osborne's father was a toolmaker who came from Northern England in the 1930s, and Osborne himself was determined to leave school at 16, in 1959. 'I didn't know what I wanted to do, and I hadn't reached any conclusion when my father saw me reading the local newspaper. "What are you reading?" he asked. "I'm just looking at the houses for sale". "You know you do that every week, don't you?" It was the first realization that I found property interesting, quite by accident. "Why don't you be an estate agent or valuer?" '.

The young Osborne promptly rang up to find out about the chartered surveyors. 'I found it quite difficult to get a job in property unless you

were either from a public school or Jewish; you didn't have to be very bright. I didn't have too many offers from the private sector, who were not impressed with my seven "O" levels.' His first job was with Middlesex County Council. 'I remember feeling that the public sector was a good place to train, and there wasn't a finer place to train than Middlesex.' Osborne found it easy to progress. 'Local government was being reorganized, and Middlesex folded in 1965. For the two years prior to that, many of the officers, concerned about their future or not wanting to work for the new GLC, began to seek other jobs. 'All I had to do was to find out who was going for interviews, then go off to see the boss. I'd tell him that I'd learned so much from working for Mr Jones, but now I would like to get experience of acquisitions or management of factories, and the person I would really like to assist is so-and-so, knowing full well that in three months he'd be off.' By being in the right place at the right time, Osborne would succeed to the post, if not the grade, of the pre-identified leavers. 'By the age of 20, I was South Area Estate Manager; the youngest anyone had been anything like that before was 38.'

Three days after his 21st birthday in July 1964, Osborne formed his first property venture. The first investment was a property backing on to the railway in Hounslow, owned by British Rail. It was a perfect place to build four maisonettes, but he bought it with planning permission for only a single house. At that moment a young man named Jeremy Denham, who had been seconded to the antediluvian Osborne at Middlesex, asked him whether he should buy some lock-up garages in Staines with the modest inheritance from his stockbroker father. Osborne suggested instead that his assistant's £5,000 would be better spent on his Hounslow project, splitting the profits. 'The art of development is to develop on someone else's site using someone else's money.' The off-the-shelf company used in this transaction, Glenglebe, was changed to Denborne, eliding parts of each principal's name. Even before the Hounslow deal was set, Osborne found the £5,000 burning a hole in his pocket. He bought a parcel of five freehold ground rents in Twickenham for £4,500. 'Before we actually exchanged contracts, I had set up the sale of three of them to the lessees for £5,000, so on our first deal we ended up with two properties and £500, less a few costs.'

The deal with British Rail in Hounslow was then consummated, and Osborne was successful in obtaining the much more valuable planning permission for four maisonettes. Having sold that on, the Denborne team bought a shop at auction for £6,000. The only problem with this was that there was only £2,500 in their account at Midland Bank, Carlos Place, Mayfair, and although that would cover the deposit, the balance was due in 30 days and there were no funds to meet it. 'I wrote a request for a loan and delivered it by hand the evening of the auction. To my surprise I didn't get a reply the next day, not even a phone call. The day after that there was still no reply, so I rang the bank manager. I wasn't even put through to him. After six phone calls and a week had passed and I

had still heard nothing at all, I realized that I had to do something about it.'

By this time Osborne had left Middlesex, and was working for Aviation Property Consultants, a company set up by Ken Joiner as a project manager for airports. Osborne's office was at Heathrow Airport, and in some desperation he went to see APC's bank manager at Barclays.

'Mr Fox, I have another business; would you like the account?'

'Yes, I would.'

'You've just got to lend me £5,000.'

'When have I got to do that?'

'I need the money in two and a half weeks.'

'I'll have to get approval for this. Can you give me more details?'

As Trevor Osborne walked back into his office at APC, the receptionist was answering the phone:

'Yes, Mr Osborne has just come in. It's Mr Fox for you, Mr Osborne.'

'I've got approval for your loan; when can we have the account?'

'When can I have the money?'

'Now?'

'Absolutely fine.'

Osborne did not even take his coat off but walked straight back, signed the papers and moved the account. 'I still bank with Barclays today.'

After Osborne had been at APC a year, Ken Joiner was re-recruited by BOAC, which he had left to form the company, and he asked Osborne to take a 30 per cent stake and build the company up. 'It was interesting, but was not what I wanted to do. After six months Osborne left. The next five years were spent in transacting relatively small deals in Denborne, but in 1973 the partnership with Jeremy Denham broke up. Osborne had bid Denham £1,030,000 for his half-share, (a reasonable return on his father's £5,000 legacy), but Denham insisted on a break-up of the company. At that moment the 1970s property collapse hit home. Osborne spent a fairly miserable three years building out the development sites he had acquired.

In 1974 Osborne bought the contractors, Tellings, which managed projects for other companies. One of the projects on which Tellings was employed was for Fortress Estates, a company supported by the ill-starred London & County bank; its managing director was Derek Parkes. Soon after Tellings had been bought by Osborne, Fortress went into liquidation and Derek Parkes started on his own, building houses in South London. His main contractor failed and when Osborne visited him one day, Parkes was acting as general site agent. When Osborne suggested lunch, Parkes retorted that he couldn't, as he was laying bricks. Osborne had a better idea: 'Let Tellings complete this for you at cost and join me.' By 1977, Osborne had perceived his way forward: 'There was definitely a move by pension funds into property, particularly by supporting developers. I knew more than the funds did. Whenever I talked to these pension funds, they'd had enough of the property chaps with mahogany desks in St James's, a telephone and a Gucci belt but who didn't know

which way up the bricks go. I knew about building and could manage construction. But the funds were worried that every company had skeletons in its cupboard from the crash, so I suggested that we start a £100 company with no history but a lot of experience. So that was Speyhawk.'

The first two years of Speyhawk's history, to 30 September 1978, is dominated by the activity of Tellings, but, thereafter, the Speyhawk development programme built up rapidly. At that moment, Speyhawk had a negative net worth, being in the process of developing some sites, but not having taken any profits from them. As a result, the company was in no position to hold onto the completed developments. Derek Parkes' role was to liaise with the banks and help find funds which would buy the completed and let developments. This deliberate strategy was distinct from that of, say Mountleigh, which rarely took a development through from site acquisition to completion and letting. Osborne saw his strengths as being a developer with an eye for a good prospect and the ability to build it to time and budget, for selling to a longer-term investor. The first deals were relatively small, among them 8,000 square foot offices in Teddington and Twickenham, parts of Osborne's old fiefdom as a Middlesex surveyor. Crown House, Windsor, one of two developments in that town, is a good example of these deals. The site was bought from the United Reform Church and planning permission obtained for a three-storey office building as well as a new church and offices for the vendors. The 11,000-square foot building was let to the Property Services Agency, still often the developer's friend, and sold to the Nestlé Pension Fund.

Speyhawk was among the first of the new generation of merchant developers to become a public company, in December 1981. The prospectus contains a list of 21 development projects on which the company was by now engaged. The largest, and most important, of these was the redevelopment of a bomb site in Jewry Street on the eastern fringe of the City of London. Speyhawk had negotiated the deal with the site's vendors, the Sir John Cass Foundation, and was under pressure to sign up, but 'we couldn't because we didn't have the cash.' The merchant bank, Kleinwort Benson, who managed the property portfolios of several pension funds, was introduced to Speyhawk. Tony Mortimer, who was responsible for this side of Kleinwort's investment business at the time, was well matched with Osborne. Another man born without a silver spoon in the family, let alone near his mouth, Mortimer had made his own way, and now cut a rather dashing Edwardian figure, with prominent side-burns and three-piece suits, from the waistcoat of which hung a gold watch-chain. Osborne, who is a similarly snappy dresser, was told that Mortimer was certainly interested in financing the development on reasonable terms, but needed to see some of the developments Speyhawk had already completed. Osborne remembers: 'He came to lunch and we were getting on quite well.' Osborne exuded confidence:

'Could we just have a little chat about the deal?' (implying that it was

more or less agreed, which, at that moment it certainly was not). 'We're very keen to do it with you, Tony. Are you broadly happy with the terms? Is the proposed yield all right?'

'Yes, I think we could do it at that yield.'

'Fine. Can I ask you when the next meeting of trustees of the fund is?'

'You've just missed one last Wednesday.'

'Oh, I see. Do you meet monthly?'

'No, quarterly.'

Osborne's face dropped at this news, since he had undertaken to exchange on the deal rather sooner. He explained the position to Mortimer: 'I think if I don't sign within two weeks, they will do it with someone else.'

'Two weeks is a pretty short time, but I think we could cope with that.'

'How can you do that, you won't have trustees' approval.'

'It's my decision.'

Osborne warmed to Mortimer at this news: 'You can take that decision?'

'Yes it's down to me' said Mortimer, adding realistically 'they take it rather badly if I make a mistake.'

'How does this deal rank in terms of the size of transactions you normally put the fund into?'

'This is the biggest they've ever done, the biggest I've ever done.'

Osborne grasped Mortimer's hand and shook it: 'It's the biggest thing I've ever done too, so we'll both better be sure not to make a mistake.' On such relationships are deals agreed. As a result Speyhawk built a 36,400-square foot office building costing £9 million, which was let to Thos. R. Miller, insurance brokers, for £20 a square foot.

Speyhawk soon had a loyal group of pension funds which financed most of the company's developments. Findus and Nestlé both financed more than one project and other blue chip names such as Boots, Pilkington and Hoover pension funds were also involved. Like other companies, to keep the profit flow rising, Speyhawk had to increase the size of its projects and the risks associated with them. The Wimbledon Town Hall site competition with Greycoat has been covered earlier, but, with McAlpines, Speyhawk was also one of the consortia which bid for the right to redevelop the hinterland of Kings Cross station; that failure cost the partners £1.5 million in design and planning fees. The essential nature of Speyhawk did not change, even if the scale of operations did. The company operates from offices in one of its own developments in Old Isleworth by the Thames: Trever Osborne sticks to his Middlesex training ground.

Among Speyhawk's successful developments during the latter years of the 1980s boom were 108 Cannon Street, and offices in Windsor, both sold to pension funds; the Jubilee Hall market redevelopment in Covent Garden was again financed by Kleinworts. The company's first large-scale incursion into the office park market, the 100-acre Thames Valley

Business Park on the outskirts of Reading, was partly sold to Digital Equipment and to British Gas, for the use of that company's exploration arm. Again Osborne was on home ground here; the development is actually in the Wokingham District Council's area. In the early 1980s Trevor Osborne had been leader of that council, although by the time the development was proposed, he was no longer even a member.

When the property market hit trouble, Speyhawk was still in bullish mode. Its largest development, 285,000 square feet of offices, over Cannon Street station in the City, was already under way, and, although 95,000 square feet of that was pre-let to the London International Financial Futures Exchange, the balance has proved hard to let. The problem was that against an investment portfolio valued at only £70 million in September 1989, there were development properties held worth a notional £140 million, with a further £105 million in joint ventures. Some of these projects were simply plans on the page, rather than buildings on the ground, and most of them were not offering income sufficient to cover their carrying costs. Against these assets was stacked £150 million of debt.

Osborne was not inclined to wait around for something to turn up. 'Nobody would have forecast the depths of this recession or interest staying at 15 per cent for so long. To all these people who have this wonderful, wonderful wisdom of hindsight I say, congratulations. I'm a market man. You have to face up to it: if the only act in town is a circus, you sell peanuts.' Osborne set about selling, not for prices he thought he ought to achieve, but for what the market would offer.

There were several large disposals in the 1990–1991 financial year. One Aldgate was sold to a Dutch pension fund for £45 million and One Hundred Square in Bracknell was bought by Middle East investors for £30 million. These and other disposals were not enough to solve the problem. Speyhawk's other plans, such as a shopping development on Sussex's old county cricket ground in Hastings, were lost by the company's unwillingness to progress in the market environment they faced. Even so, by 30 September 1990, Speyhawk and its joint venture partners had development properties valued at £200 million and borrowings of £150 million. Two development properties were written down in the balance sheet by £6.5 million; one was a West End development with unsatisfactory planning permission and the other was the development of a partly pre-let shopping centre in Weymouth. It would be well-nigh impossible by the date of the valuation to estimate what the 'open market' valuation of such properties was, there was so little appetite for development. In March 1992, Speyhawk announced a pre-tax loss of £217 million for the year to September 1991. Liabilities exceeded assets by £70 million after severe write-downs in the values of the company's empty or only partly let development properties, one of which in St Mary Axe was seriously damaged by the IRA bomb of April 1992.

All this misfortune was very nearly avoided for the Speyhawk

shareholders, and Trevor Osborne in particular. In June 1990 the Swedish company NCC, part of the Nordstjernen Group, bought a share stake and began talks which were expected to end with a take-over of Speyhawk. By the end of August, the Swedish buyer had withdrawn.

Trevor Osborne is another of the 1980s developer/traders who was simply unable to build up a steady flow of revenue sufficient to carry his company through the drought in the development market unscathed. Nevertheless, Osborne remains optimistic. 'Property companies and the individual entrepreneur will be the major forces in property investment and trading. All the institutions are concerned with is short-term measurement. Deals being done today are not related to the old criteria; they are related only to the cost of money. The time is right for the predator.' Osborne, in his role as president of the British Property Federation, made the wry comment which encapsulates the whole of the 1980s property boom and collapse. The chief guest at the Federation's annual dinner was Sir John Quinton of Barclays Bank. In proposing the health of the guests, Osborne said 'We in this room owe you more than we can ever possibly repay'. The gales of laughter with which this comment was greeted were reflected in a more gloomy mood in the light of day. In March 1993 Barclays declared its first ever loss (for 1992) and halved its dividend as a result of its exposure to property investors like Speyhawk. Yet that company was still being supported by its bankers.

Although there were many other merchant developers whose fates varied from bankruptcy to survival, two other specific examples give a good illustration of what was possible in the boom years. Helical Bar is not a name which suggests property; its name betrays its original business of steel fabrication and stockholding. By 1984 the company had fallen on hard times. In July of that year Helical announced its move into property through the formation of a joint company with Michael Slade, who was to be the 49 per cent owner of the venture with options to convert that holding into a 29 per cent holding in the quoted parent. The market value of the parent company at that time was around £1 million and the share price had just lifted from its recent low level, equivalent to 3.5p each in their later form.

Slade was no newcomer to the property world. His very first job, in 1965, was selling plots of land in the Bahamas. In an interview in *Management Today* in 1990, Slade described the job as slightly dodgy. He had to pretend to be a rich and idle Brit, offering to act as guide to holidaying Americans. 'After two days they'd buy anything just to get rid of me' he was reported as saying. He learned about serious property development as an assistant to Julian Markham of the private Glengate Property company, whose most notable achievement in the 1980s was the joint development of the old General Post Office in the City with the Japanese contractor, Kumagai Gumi. In the 1970s Slade had then set up a joint company with Equity & Law to invest in Continental property. This venture, Grandvista, found the going rather tough, and by 1983 Slade had resigned as managing director.

After a year acting as President of the British chapter of FIABCI, the

international property-owners trade association, Slade took his interest in Helical. If ever a merchant developer made its reputation with one deal, it was Slade and Helical. After two years of relatively modest property trading, Slade hit the jackpot. In April 1986 he bought the site of 48 Chiswell Street, Finsbury, from Whitbread the brewer. Planning permission was obtained for 100,000 square feet of offices in this fringe City location, facing the Barbican residential towers. The development had merchant bankers Lazards as minority partners, and finance was achieved through a non-recourse loan from the Californian bank Security Pacific. The total cost of the development, including site cost, was covered by this £24 million loan, and Helical's total investment was £100,000. The northern fringe of the City was then still considered a low rent area, even though Broadgate is only a quarter of a mile to the east on the same latitude. By November of the same year Helical had exchanged contracts for the sale of the development to BP Properties for a reputed £34 million, giving the company a clear £9 million profit on the project. For a tiny equity base this deal transformed both the profit and asset value of Helical. The share price responded with a rise to the equivalent of over 100p at their 1986 peak, up seven-fold on the year. Michael Slade's reward was a salary of over £1 million.

Helical's problem was then to convince investors that it was not simply another 'one-hit wonder'. The first move was to enter residential development partnerships in West London. On the commercial side Helical bought a £25 million investment portfolio from Allied Dunbar, and lined up developments in, amongst others, Leeds, Woking, Bristol and Cardiff. By this time in 1987, the share price had trebled again, to the equivalent of over 300p, which made Slade's shareholding, now converted into the parent company, worth over £20 million, not bad for an initial personal investment of £49. Slade had eschewed further deals in the City during 1987, preferring instead to diversify into industrial property, but, after the 1987 stock market crash, he showed that he could repeat the Chiswell Street coup.

Slade was in good financial condition at the time of the crash, since, only days before, Helical had secured the issue of £18 million in preference capital. His first two purchases after the stock market collapse were industrial estates, the Aycliffe & Peterlee New Town's portfolio and a property at Biggin Hill airfield in Kent. In June 1988, Helical returned to the fringes of the City of London for its second coup. The company bought, for £11 million, a development site from P&O, facing onto the roundabout where Old Street meets the City Road, well beyond the accepted location even for fringe City offices. The site was to bear offices of 165,000 square feet, but, before much work was done, Helical had sold the property for another remarkable and rapidly earned profit. Again the buyer was BP, which was leaving its base in Britannic House. The price paid by BP was a reputed £62 million, on the basis of the building work being completed. The profit to Helical Bar was £11 million. BP never

occupied the building, and, in late 1991, sold it on to Inmarsat for under £50 million.

The proceeds of Helical's deal were reinvested in more industrial property. To complete a hat-trick of deals with parts of BP, Helical Bar bought the South Wales industrial and agricultural properties of Western Ground Rents. This latter company had been acquired by BP's pension fund twenty years earlier, in one of the first forays by a pension fund into the market to buy a complete property company. By early 1989, Helical owned five million square feet of industrial space around the nation.

Even though the property market had by now clearly moved into its recession, there was little sign of it in either Helical's profits or its ambitions. In April 1990, Slade announced that profits of his company, for the year ended on 31 January, had risen to £14.5 million, and net assets had improved by 43 per cent to 429p a share. The company had acquired smart Mayfair offices for its own use, and borrowing had risen to £140 million, 150 per cent of the company's equity. The ambition was to sell enough assets to reduce this level of gearing to a more reasonable, but still high, 100 per cent.

The company proved not to be immune from the recession. Profits in the year to January 1991 fell to only £2.5 million, and net assets of this highly geared company fell by almost one third, leaving the gearing even higher at over 200 per cent. By October 1991, Slade was forced to announced a loss for the half-year to July. Although Slade had previously exuded confidence, claiming, with some justification, that the bottom of markets is the best time to be highly geared, he now blamed high interest rates for the set-back. Continuing asset sales suggested that the gearing of 170 per cent remained uncomfortable, and, despite the rising rent roll coming from the industrial investments, further sales would have to be made.

Helical Bar showed what could be done in the short term with a small, shell property company with some judicious gearing and one or two wonderful deals. There is no reason to suppose that Michael Slade's touch will not provide further stunning profits in a better market; meanwhile his company simply has had to cut its coat according to much less generous amounts of cloth.

Perhaps the most astonishing comet of all those that lit up the property heaven in the late 1980s was Randsworth. Randsworth's origins go back to a tea company named Kotmalie. In 1980 it had been bought into by new controllers who turned the company into a plant-hire group called Jayplant. Its arrival on the infant USM was not followed by great success, and in May 1986 the company had net assets of only £400,000. At that time a new management team arrived: David Holland and Andrew Nichols. Holland is a lawyer who had been involved with the Frost Group of petrol retailers, whereas Nichols had earlier been finance director of the Brixton Estate property investment company. Holland and Nichols sold to Jayplant, now renamed Randsworth, an oil company and some minor

property interests from their private portfolios. They toyed with the idea of specializing in the management of nursing homes, but the property development they were involved in, like Helical's Chiswell Street project, dwarfed all their other interests. Randsworth had bought a site in Wilson Street, on the edge of the Broadgate site, for a mere £1.4 million. The combination of achieving planning permission for 60,000 square feet of space, (initially not all of it for offices) and rapidly rising rents, created the sort of surplus which had set Michael Steel's company into orbit. The potential profit when completed and let was estimated to be over £15 million.

Unlike Helical, Randsworth became an aggressive buyer of other companies. In March 1987 Holland launched a bid worth £60 million for London & Provincial Shop Centres (LPSC). At the time Randsworth's own assets were worth only £10 million. LPSC was a company formed in the 1950s, but in recent years it had belied its name and become closely identified with offices in Slough. Much as Tony Clegg had convinced Maurice Wohl that he was the right man to sell to, David Holland learned that control of LPSC might be available from the original partners; Bernard Berrick was, by this time, like Wohl, a tax exile. Holland flew to see him in his retreat in Monte Carlo and convinced Berrick of his ability to underwrite a deal for cash. With the Randsworth shares standing so far above the company's asset value, any addition to assets paid for by shares would increase the bidder's overall asset value per share. This phenomenon was one recognizable to the asset strippers of the 1960s stock market boom. The American bank Chase Manhattan's British investment house underwrote the shares so that LSPC holders could either take cash of 325p a share or Randsworth shares worth a fraction more. Since LSPC's asset value was then 350p, the discount was relatively modest, and a sale was attractive to most holders. Taking Randsworth shares was a more doubtful prospect, since the company's asset value at the time of the bid was only 73p, but its share price was around 150p. The purchase of LPSC almost doubled that net asset value to 134p.

Not content with the LPSC acquisition, Randsworth followed it almost immediately with the purchase of Apex Property, a company firmly in the control of the de Vere Hunt family. In the early 1980s, Courtauld's Pension Fund, which this writer was then running, had built up a modest shareholding in Apex. This was not in fact too prescient a purchase because Apex had not benefited strongly from the property boom. Its major assets were two large office blocks at New Malden, near the Kingston by-pass in south-west London. Parts of these blocks had been untenanted for some time after their refurbishment. Between 1981 and 1986 the share price of Apex had more than halved; despite paying 135p per share, 60p above the low point, Apex cost Randsworth less than £15 million in cash. Randsworth's assets now totalled £60 million.

Randsworth soon used the asset base of LPSC to issue £50 million in long-term debt, giving the company more ammunition for its ambitious

targets. In July 1987, the group acquired several properties of that same value, the major asset of which was an office on the northern fringe of the City, between Greycoat's Devonshire Square and the Spitalfield site, for £20 million; the purchase was partly financed by a further issue of shares. By now the company was worth £120 million on the Unlisted Securities Market.

Holland and Nichols signalled their continuing interest in quoted companies by buying an eight per cent stake in Lynton. This stake was later raised to 19 per cent after the 1987 stock market crash. Lynton was eventually acquired by the newly-privatized British Airports Authority, BAA. Randsworth's next big property deal was worth £132 million, the purchase of two portfolios, from Mountleigh and British Land. Among the Mountleigh properties was the Sloane Street one which was now halfway through its six owners in five years. Most of the property was in the West End of London, (in Sackville Street and St Martin's Lane for example) or in Kensington (British Land's old Derry & Toms investment). To pay for this further substantial investment, Randsworth issued another ten million shares at 217p and £50 million of new convertible preference shares, but the total cash raised by this means, just over £70 million, left a gap which was filled by a loan from Chase. What was most striking about these purchases was that the income from the properties by no means covered the cost of the finance raised. Randsworth was thus forcing itself either to sell some of them at a profit fairly quickly, or to raise the rents on the properties.

September 1987 was also a busy month, appropriate for the last month of the great bull market in shares. The good news for Randsworth was that a tenant had been found for its initial coup, the Wilson Street development. In fact the tenant who was supposed to take the space never did so, but Randsworth found the International Stock Exchange was equally eager to take the space at a then record rent for the location, beyond even the purlieus of Broadgate. The property, which cost just over £1 million to buy and a further £12 million to build, was now valued at £40 million, justifying the initial excitement the development generated. By now, of course, Wilson Street was only a small part of Randsworth's assets. A further West End property was acquired when Randsworth spent £15 million buying Prospect House in New Oxford Street from the textile group Lister. The property was let to the Ministry of Defence, but their lease expired in 1990, giving Randsworth hope of either redevelopment or a new lease. Another development site acquired was Gotch House in Farringdon Street, the edge of the Fleet Street area, bought from the *Daily Telegraph* for £7 million.

The results of the frenetic activity undertaken by Holland and Nichols in their year of stewardship were shown in Randsworth's results for the 13 months ending 30 June 1987, announced just over a week before Black Monday. Pre-tax profits rose to £2.15 million from £700,000 and net assets from 110p to 161p. The balance sheet also showed that there was almost

£50 million of debt due to be repaid within 12 months. In January 1988 this problem was relieved to a degree by the arrangement of a £100 million five-year loan, secured on £160 million of the property portfolio.

In the immediate aftermath of the stock market crash, Randsworth continued to buy property. By March 1988 the emphasis of the company's activities had clearly swung towards selling. Some of LPSC's properties in Slough were sold, and at prices below book value. Andrew Nichols was unrepentant: 'When we bought London & Provincial Shop Centres we knew that the portfolio was fully valued.' He defended the purchase as the way in which Randsworth could be transformed rapidly from an asset poor, but high flying small company into a large property market player. Between December and March 1988 Randsworth sold £70 million worth of investments, and in April and May a further £46 million was realized. The group was able to increase its long-term debt still further through another issue of LPSC's debenture stock: £35 million was raised in June. By the end of the company's financial year in June 1988, over £150 million had been raised from property sales over the previous year. Most of the Slough properties of LPSC and all but two of Apex's investments were amongst those disposed of; the investment portfolio was now valued at £307 million. Randsworth's share price had been a notable casualty of 19 October 1987. At one point the shares fell to 80p, against the published net asset value of 215p, but by October 1988, it had recovered to over 180p again. Part of the reason for this recovery was the acquisition of a 5.1 per cent shareholding in the company by another of the decade's new property companies, Markheath.

David Holland then proposed to buy up half the outstanding shares of Randsworth at around the prevailing price. As this was well below the net asset value, every share bought would increase the assets attributable to the remaining shares, a sort of tontine. Unfortunately the purchase would have to be made with borrowed money, increasing both the gearing of the company and the interest burden. The scheme was a short-term psychological boost to the shares, but proved impossible to carry out in the event. Net sales of property seemed to be the only way forward: the Wilson Street development was sold to the Japanese for about £40 million.

By the end of 1988, despite the avowed intention of reducing the debt levels, Randsworth's shares had still proved to be one of the outstanding investments of the pre- and post-crash periods. From a price of 68p at the end of 1986 the shares had now recovered towards their previous high levels, and closed the year at 212p, at which level the company was worth over £125 million. In January 1989 £32 million more was raised through a further issue of LPSC debenture, and this money was soon put to work in an apparent reversal of the previous cautious stance. Randsworth bought St Christopher's Place, a shopping 'village' north of Oxford Street, which had been developed by Imperial Tobacco Pension Fund as an area of chic boutiques and restaurants with offices above them. A property adjoining St Christopher's Place whose façade is on Oxford Street itself was later

acquired for £17 million, increasing the possibility of widening the very narrow access currently available into the shopping village from the busy main street. Again the income from the investment, about £2 million a year, by no means covered the interest cost of the capital used. Andrew Nichols asserted that the development was 'quite under-let in our view, and there's quite a bit of redevelopment potential.' This purchase was followed by the acquisition of a fire station in King's Road, Chelsea for £6 million with the intention of developing a shop and office development. These purchases were not offset by a few sales concluded in addition to that of Wilson Street.

By the end of March, Markheath had sold its 10 per cent stake in Randsworth to the Swedish group Reinhold, which, as will be apparent from Chapter Ten, had substantial ambitions in the British property market. A smaller merchant developer, Priest Marians, had also bought a small stake. These new shareholders were greeted by the good news that the Ministry of Defence had agreed to take a new lease on Prospect House, New Oxford Street, at an initial £2.63 million a year, giving a substantial surplus income over the interest cost on the £15 million purchase.

May brought a shock: David Holland, one of the two principal protagonists of the transformation of the company, abruptly resigned for 'personal reasons', thought to be his failure to persuade the board to sell Randsworth to his favoured bidder. The share price of Randsworth had by this time recovered still further to almost £3, giving it a value of over £160 million. Reinhold took the opportunity of this surprise to increase its stake to 16.9 per cent of the company, and Randsworth was now clearly 'in play'. The *coup de grace* was executed in late July with an agreed bid for the company from an American property manager, JMB Realty. In April Randsworth had asked the American investment bank, Goldman Sachs, to search discreetly for a 'white knight', a friendly bidder for the company. 'We didn't want to end up waiting for bids and being raped by a hostile bidder, but wanted to find someone to work with us,' said Andrew Nichols at the time. The total value of the bid was £258 million including the preference shares, and priced the ordinary shares at 325p, almost five times the price at the end of 1986. JMB is a huge Chicago-based property investor, founded in 1968 by Robert Judelson, Judd Malkin and Neil Bluhm. The group was attracted to the UK by its unique lease structure and by the location of the Randsworth portfolio, almost exclusively in London's West End, an area with which most Americans are already familiar.

Randworth's story is one of perfect timing from the point of view of the British investors. The company made big gains when the market was buoyant, and, like LET, was able to attract a foreign buyer at a time, late summer 1989, before interest rates took their last upward lurch and the recession took hold. In March 1992 administrative receivers were appointed to the company which JMB had formed to make the

Randsworth acquisition, and into which the purchaser had injected a further £58 million in early 1991. In 1992 even the debenture holders had to accept a permanent reduction in the value of their bonds, an event unprecedented in the debenture markets in recent years. The comet had fallen back to earth.

David Holland soon resurfaced as the power behind Nash Industries, afterwards renamed Grovewood Securities, in which he hoped to repeat the success of Randsworth. Among his purchases for his new vehicle was Priest Marians, Randsworth's erstwhile investors. Grovewood had bought its initial 23.4 per cent stake in its target at 300p a share, but the balance was bought at a price which valued Priest at only £5 million in November 1990; this rescue bid came after the departure of Priest Marians' chief executive, Simon Fussell, in August 1989, at which stage he had sold his 25 per cent stake to JMB Realty at 375p a share. The final Grovewood bid was worth 36p each. Grovewood also bought Early's of Witney, the manufacturer of blankets and occupier of substantial development sites.

In this company, Holland had overstretched and, by October 1991, receivers had been called in to the company. The shares had already been suspended on the Stock Exchange and the company's borrowings, at over £100 million, had breached its banking covenants. The major problem for Grovewood had been the Priest Marians purchase. Although that company bought with it assets such as the Langham Estate north of Oxford Street, previously in the hands of both British Land and the Water Industry pension funds, it had itself previously bought another company, Local London, for £110 million in March 1989. Local London was one of the first developers to offer serviced office suites to small or new companies. The landlord would provide furniture and equipment for a weekly all-in rent. In the years of the late 1980s, many new companies were being formed and such office space suited the entrepreneurs well; LET had a similar subsidiary. The recession of 1990/91 both made new entrepreneurs a rarity and put many other recent venturers out of business. Local London then began to make substantial losses. Grovewood subsequently issued a claim for £57 million in damages from stockbrokers James Capel, who had advised Priest Marians in its purchase of Local London.

The ability of such merchant venturers as have been described in this chapter to create substantial public companies from empty shells is not unique to the 1980s property boom. This recent cycle was probably more extreme in its creation and destruction of assets even than the mid-1970s, and was certainly more concentrated in time span. There were many other smaller examples of both success and failure, often in the same companies at different moments, but these four examples show what was possible.

9

THE SPACE INVADERS

THE FOCUS OF most of this book has been London. The reason for that is simple: the value of London property, particularly of offices, is so much higher than in any other centre that property investment and development is peculiarly Wencentric. The exception to this general premise is in retailing, where high capital values can be created in provincial cities.

The 1980s saw a revolution in UK retailing, both in the High Street and in the periphery of cities. The High Streets of most cities had been dominated for all the post-war period by the department store chains, Debenhams and House of Fraser being prime among those, and the well-known multiples, with Marks & Spencer and Woolworths to the fore. The old food retailers, such as Home & Colonial and the Co-op, had already lost their position to the 'pile it high and sell it cheap' philosophy of Tesco, and the 'Fifty Shilling Tailor', Burtons, and Hepworths had been overtaken in their markets during the 1960s by the fashion boutiques. The 1980s witnessed a change of attitude among consumers which reflected the growing demand for a recognizable life-style to match their rising aspirations. Burtons and Hepworths fell under the spell of two aggressively expansive retailers, and the newer talents of Terence Conran and Laura Ashley drove style and design even higher in the priority of the shopper.

Although the late 1980s certainly saw a consumer boom, the previous decade as a whole had been a period of rising financial sophistication. While consumer borrowing, most of it against the purchase or remortgage of houses, had exploded in the de-regulated financial market, personal savings also rose dramatically. Many of the problems of 1990/91 recession were a consequence of the fact that these parallel increases were not made in the balance sheets of the same individuals: those who saved were not the same people as those who borrowed. But such an increase in both elements gave a fillip to those companies which acted as intermediaries between saver and borrower. The High Street had already become the

victim of the rapid increase in branches opened by the leading building societies during the 1970s, and the trend continued in the 1980s. At the end of 1970 there were 2,016 building society branches; by the end of 1980 this figure had risen to 5,684, and at its peak at the end of 1987 the total reached 6,962. Already in the early 1980s there were complaints that the High Street was turning into a string of financial office outlets, creating no pedestrian traffic of its own. Paul Orchard-Lisle of agents Healey & Baker was often to be found expounding the virtues of a shop investment being on the 'desire line', the most heavily trafficked path, usually between the bus station or car park and the most popular store in the area: in Oxford Street, a shop positioned between Bond Street underground station and Selfridges store was the acme of desirability, and commanded the highest retail rents in the nation in 1980.

By 1978, the retail warehouse was becoming a feature of the edge of towns. In December of that year Harris Queensway was floated on the stock market. Philip Harris had inherited a small carpet retailing business, which he had built up to 129 stores. He had recently purchased Queensway Discount, a furniture retailer, selling from non-high street positions. Queensway had only 23 stores nationwide. In November Associated Dairies, one of the originators of the discount food warehouse with its Asda stores, announced that it was to merge with Allied Retailers, the proprietors of Allied Carpets and Williams furniture stores, both of which had pioneered the same concept in their own areas. The following year Phil Harris rented a large warehouse for his carpet stocks in Swanley, Kent from Haslemere Estates. In April 1979 B&Q became a public company, selling do-it-yourself goods from 26 warehouses, averaging less than 20,000 square feet each.

The scene was set for a developer/investor with enough vision to see that this trend away from the High Street into bigger, edge-of-town units was not a passing fad, and that these properties would eventually be valued more highly by the institutional investor. Peel Holdings was the Lancashire-based textile company which filled that role.

Peel had originally been founded by Sir Robert Peel the elder, father of the Prime Minister of that name. The company had thrived as a calico printer and, at one stage in the early nineteenth century, had employed 15,000 people, but in the more recent past had been in the control of John Whittaker and had fallen upon hard times. Whittaker, who had made his fortune selling gravel for the construction of the M62, now lives on the Isle of Man, where his family's holding company, Largs, was also based. Peel was by no means the only old textile company of which Whittaker, then still farming outside Bury, had taken control. John Bright, another name redolent of nineteenth century politics, and Highams were two others. A third was Clover Croft, which Largs had taken control of in 1973, when John Whittaker was still only 30. There is a rather sad historical note appended to the prospectus issued when this last company was revived. After its take-over by the Whittakers, it was noted that

'Rationalisation of the production facilities followed in an effort to combat the pressures then facing the Company in common with the rest of the Lancashire spinning industry. But even reduced overheads failed to arrest the impact on the Company's business of the inflow of subsidised imported yarn. Diversification into synthetic product lines did not compensate for the decline in production. The Company was obliged to wind down the remainder of its business and sell its assets.' Clover Croft was revived, with John Whittaker on the board, as the ill-fated come-back vehicle for Ron Shuck, erstwhile head of 1970s quoted property company, Cornwall. His new company, Espley-Tyas, was an early casualty of the 1980s.

At the end of March 1980 Peel's total gross assets amounted to only £700,000, and the company made only £41,000 after tax. The company's old mills in Rochdale were being transformed by Whittaker into small industrial units. The initiative for becoming involved in retail warehouse development came in 1981 from Peter Jevans, who had previously worked for food retailer Keymarkets, and Tom Dootson. Dootson and Jevans were principals of Abbeygate, which in the early years of Peel's involvement in developing retail warehouses, 'sheds with shelves', managed all the developments. The first development, in Bury, showed how, by building relatively unsophisticated and cheap warehouses on inexpensive sites, yet achieving rents above that normally agreed on industrial buildings, the company would not only make a potential profit but could afford to hold on to the completed investment. If the building and land in a derelict part of the north-west could be completed for £20 a square foot and let, not at the £1.50 per square foot typical of industrial property in the area at the time, but at over £2, then only a relatively small equity investment enabled the development to show a positive cash-flow. It was still not easy to find an institution willing to take the completed investments. There were two constraints in the minds of fund managers: with what should these sheds be compared for rent review purposes and to what alternative use could the buildings be put? On the first, the solution was often that the rent would bear a fixed relationship to pure industrial warehouse rents, or to the shop rents in the adjacent town; as to the second point, the answer was of course that the building might revert to industrial warehouse use, in which case the premium rents would not be sustainable. The institutions had not understood that this would not be a problem for another seven or so years, since the demand for new space in such developments outstripped supply dramatically over the middle years of the decade.

In 1983 Peel bought out Dootson and Jevan's minority interest in the Abbeygate joint venture, as well as John Bright and other industrial property from Largs, further establishing the Whittaker family control. It is perhaps as well that the original Peel and Bright could never have imagined that their two companies would end up merged, out of textiles and into property development. Jevans was, by this time, gaining a

reputation beyond his base in Wimbledon for his ability to pre-let the developments, often before the planning permission on the site was finalized. By the end of March 1984, gross assets of Peel had jumped to £57 million and profit after tax was reported at £1.7 million.

The acquisition of Bridgewater Estates in the winter of 1984 was another example of Whittaker's Autolycus-like collecting of relics of the Industrial Revolution. The Bridgewater Canal, not in Somerset, but in the industrial north-west, connecting Manchester, Liverpool and a local coalfield, was the first commercially successful canal in Britain, built by Brindley for the Duke of Bridgewater between 1760–71. The Estates company was the remnant of the land once owned in the area by the Duke, whose canal had been the monopoly carrier of cotton between Liverpool and Manchester until the arrival of Stephenson's Rocket. Bridgewater Estates still owned 9,000 acres of agricultural land in the area, some of it near enough to the edge of conurbations to hold out the prospect of eventual development; for the rest, sales of the land would provide useful capital for the retail developments.

By the end of 1985, Peel's development programme was such that the company took the opportunity of raising £17 million through a rights issue; at the same time, Whittaker sold some of his family companies' property assets to Peel. In early 1986 Peel raised a further £35 million through the issue of the first debenture stock with an interest coupon in single figures for ten years.

John Whittaker was meanwhile involved in another attempt to buy part of Britain's industrial heritage: the Manchester Ship Canal Company (MSCC). This statutory company had an odd voting and board structure so that, although Whittaker controlled 48 per cent of the share capital of MSCC through his personal companies and another quoted vehicle, Highams, it had only 29 per cent of the votes. The MSCC board denied him representation among its number because the statute under which the company operated dictated that the total number of directors should not exceed 21, of which 11 must be representatives of Manchester City Council, and each quota was full.

Whittaker was not interested in the major responsibility of MSCC, keeping the Ship Canal navigable, but saw the potential of the company's extensive land holdings, totalling 6,000 acres. This included 300 acres at the evocatively-named Dumplington, which Whittaker saw as the perfect site for a regional shopping centre to rival Tyneside's Metro Centre and Dudley's Merry Hill. Whittaker made a bid for MSCC with his family money rather than through Peel. Because each shareholder was unable to vote more than a limited number of the shares in each name, it was not enough for Peel to buy or receive acceptances for more than 50 per cent of the votes, which is the normal criterion for control. The methods used by Whittaker's vehicle to overcome this technical drawback were eventually heavily criticized in a Department of Transport inquiry, set up at the behest of some dissenting shareholders, and published in 1989. Nicholas

Berry, the chairman of MSCC, had alleged that Peel had 'unbundled' its shareholding by trawling the council estates of Manchester for people prepared, in exchange for a £1 reward, to act as nominee holders of MSCC shares, who would then vote out the existing board. It was said that 30,000 such signatures were collected in this way. Whatever the method, Whittaker achieved his end and became controlling shareholder of MSCC. In March 1993, planning was granted for the regional shopping centre on the banks of the Ship Canal.

Peter Jevans and Tom Dootson left Peel in 1986. The relations between the two men and Whittaker had deteriorated. On the one hand there was the tangled complexity of the Whittaker family interests mixed with those of Peel and, on the other, Jevan's very high-profile image with investors and the media; some falling out was inevitable. Jevans went on to run a development company, Merlin International, which hit serious trouble in 1991, and was subject to what appeared to be a 'phantom' bid. 1986 was too late to enter and hope to leave the property cycle before it slowed.

At its March 1987 year-end, Peel could boast a profit of over £8 million and a completed retail portfolio of over 1.5 million square feet with total property assets of almost £180 million. In raising a further £24 million through the issue of convertible preference shares, Peel listed all its retail developments with their tenants, which shows how this sort of retailing was dominated by a few retailers in a limited number of sectors:

Location	Size Sq.Ft	Tenant
Completed		
Dundee	45,000	B&Q
Bury II	16,000	Terleys
Lancaster	22,000	B&Q
Larkfield	31,600	B&Q
Blackpool North I	38,500	B&Q
Torquay	34,250	WH Smith Do It All
Crewe I	30,000	B&Q
Crewe II	25,000	MFI
Bradford I	40,000	Harris Queensway
Bradford II	35,000	WH Smith Do It All
Bradford III	10,000	Currys
Bradford IV	6,000	Topps Tiles
Bradford V	4,000	Motor World
Keighley I	36,250	WH Smith Do It All
Keighley II	8,750	Harris Queensway
Bristol I	51,000	MFI
Bristol II	35,000	RMC Homecare
Rawtenstall	55,000	ASDA
Formby	28,000	Payless DIY
Blackburn	36,250	WH Smith Do It All

Paignton	24,200	Payless DIY
Lincoln I	30,139	Allied Carpets
Lincoln II	41,355	Texas Homecare
Lincoln III	12,000	Currys
Lincoln IV	13,000	Halfords
Lincoln V	20,000	Habitat
Ashford	32,000	RMC Homecare
Great Yarmouth	38,500	WH Smith Do It All
Hyndburn III	40,000	Harris Queensway
Hyndburn III	10,000	Wigfalls
Hyndburn III	25,000	Allied Carpets
Mansfield	45,000	MFI
Leicester	59,600	Allied Carpets
Bury I	36,530	WH Smith Do It All
Blackpool South	56,123	WH Smith Do It All
Southport	45,000	WH Smith Do It All
Rochdale	30,270	B&Q
Morden	36,000	Argyll
Morden	15,000	Business Press
Hyndburn I	51,225	MFI
Hyndburn II	36,105	Payless DIY
Folkestone	39,178	Texas Homecare
Bridgewater	25,560	B&Q
Barnsley I	30,053	RMC Homecare
Wolverhampton	39,705	Texas Homecare
Wolverhampton	39,470	MFI
Maidstone	31,200	WH Smith Do It All
Maidstone	36,265	Safeway
Maidstone	15,760	Multi-tenanted
Canterbury	33,500	Texas Homecare
	1,575,338	

Under Construction

Barnsley II	100,000	Under negotiation
Ellesmere Port	40,000	Argyll Stores
Hyndburn IV	30,000	United Co-operatives
Blackpool North II	12,000	Comet
Bradford V	14,000	Under negotiation
Dumfries	70,000	Under negotiation
Guiseley	110,000	Under negotiation
Halifax	47,000	WH Smith Do It All/ Graham Building Services
Lowestoft	36,586	RMC Homecare
Preston	40,000	Under negotiation

Rochdale II	10,000	Under negotiation
Slough	11,702	Halfords
Stockport I	110,007	Under negotiation
	631,295	

Building Commitments

Tonbridge	55,500	Under negotiation
Yeovil	65,000	Under negotiation
Cheetham Hill	25,000	Under negotiation
Bracknell	180,000	Under negotiation
Stockport II	67,250	Under negotiation
Epsom	120,000	Under negotiation
Wolverhampton	75,000	Under negotiation
Armley, Leeds	28,335	Under negotiation
	616,085	

The preponderance of do-it-yourself stores and discount furniture and carpet warehouses is striking. Although most of the covenants were absolutely sound, Harris Queensway, after its leveraged buy-out and change of name to Lowndes Queensway, went into liquidation. Furthermore, in a consolidation of the DIY industry, W. H. Smith and RMC merged their operations. If they are operating in the same towns, while the two lessees are obliged to pay rent throughout the lifetime of the original leases, the growth in rents may be more restricted. There will also be at least one fewer potential tenant to take the space of whichever of the stores is vacated.

Peel was undoubtedly the leader in this form of development and investment, and had spawned some imitators, most notably Citygrove, an early casualty of the later property crash. As so often is the pattern described in these pages, this was not enough, and in November 1988 Peel brought a 20 per cent stake in London Shop, the company which Godfrey Bradman's Rosehaugh had failed to win in 1982, from the British Steel Pension Fund. Within two weeks, Peel had launched a take-over bid which culminated in success for a total sum of £308 million, paid in cash, of which £121 million was raised through another rights issue.

Despite a move to reduce the debt level by selling off properties from both the original Peel and the newly-acquired London Shop portfolios, Peel had made its purchase just as the retail sector began to feel the early draft of recession. John Whittaker's further ambitions for take-over, of the Mersey Docks company and Trafford Park Estates, which owned most of the huge industrial park of that name in Manchester, had to be abandoned and the share stakes sold. The housebuilding activities were

closed down, although the land bank was retained. Finally, in May 1991, Whittaker was forced to sell his family holding of Manchester Ship Canal to Peel, which then bought its own holding company, the Isle of Man based Largs, for shares. The deals reduced the company's overall gearing and, according to Peel's managing director, Peter Scott, avoided the danger of breaching some banking covenants.

The company's results for the year ended in March 1991 confirmed how badly it had been affected. There was a pre-tax loss of £8.5 million and a 30 per cent fall in net asset value. Peel has bought itself time by the rejigging of the Whittaker family interests, but it will need a stronger investment market and a run of good rent reviews before it can begin its recovery.

About as far removed from the smooth, urbane image of the property developer as could be imagined are the West Midland's leading lights of the 1980s boom. The Richardson twins, Don and Roy, are Black Country boys from the accents in which they speak to the bootstraps by which they pulled themselves up. Not that they are shooting stars of the most recent property boom. The twins were born in 1930, and their father built up a business selling second-hand military lorries. This developed into a truck distribution chain; such a business had an obvious need of large areas on which to trade. The knowledge gained led Don and Roy to diversify into property, almost all of it industrial estates in the West Midlands, in the 1960s, and they were buyers in the depths and aftermath of the 1970s property crash. Always taking on projects which no-one else would touch, their first industrial development, in the 1960s, was on the site of an old ICI chemical tip, which no-one believed could be cleaned up. A typical investment in an existing property was the purchase, in 1980, of the 530,000-square foot Coventry Central City estate on which Ford were the largest occupiers. The ability to take a contrary view is crucial to all the really successful long-term property investors. Those who confuse a bull market in property with genius tend to be carried away with more and more grandiose schemes at the top of the market. The Richardsons had actually eschewed the possibility of making Richardson Developments a publicly quoted company in the 1960s, a decision they claim never to have regretted; they might well have found the pressures to offer shareholders ever greater projects too much, and, like others in this book, expanded at the peak. It is of course vital to have the resources to be able to take advantage of the depressed market, and this is only possible if they are not all used up in the upswing.

The Richardsons' 1980s coup was based on an assessment of the potential of derelict industrial land. The Conservative government created the concept of Enterprise Zones, the most notable of which was London's Docklands. In the West Midlands a large area in the borough of Dudley was selected for this experiment in 'unplanning'. As the twins were local men, Dudley Borough Council asked them to become involved in the new Enterprise Zone and 'create activity'. At the time, the metal-bashers on whom West Midlands industry so depended were suffering

from the worst recession in their industries since the 1930s, but the Richardsons took a cussedly more optimistic long-term view. They developed a 50-acre industrial estate, the Wallows, in the Zone; 'People thought we were mad'. The Round Oak Steelworks, a victim of the recession, began to sell land, also in the Zone, and when the works eventually closed, the Richardsons had accumulated 300 acres of waste land at Merry Hill and Round Oak, described by advisers as the worst site ever seen; 'There were no other buyers around. We were the only people with the courage to acquire the site' Don Richardson has been quoted as saying. The land stood above one of the thickest and most worked coal seams in the country, and ground preparation was an important and time and money-consuming business: 'We spent more below the ground than above it' said Richardson.

The critical inspiration was to believe this could be the site of a regional shopping centre. The catchment area is certainly big enough, with three million people within easy driving distance, and Birmingham has never been able to establish a shopping centre with the local reputation of, say, Nottingham's two main malls. In 1984 the twins commissioned a survey by agents Grimley J. R. Eve and Mason Owen to investigate the potential demand from retailers for such a regional centre on the Merry Hill part of the site. The response was enthusiastic both from the retailers, and, perhaps more important, from the consumers. The first four phases of the development were unexceptional in concept, being a series of warehouse-type retail units, such as Peel had been developing. The first phase was pre-sold to MFI, who took 40,000 square feet for themselves and let the rest to a selection of other, familiar, names: B&Q, Halfords and Queensway among them. Phase Two was the 'anchor' food hypermarket, surrounded by a mall of enclosed units. By 1986 Carrefour had opened, (now occupied by Asda), and the other units were quickly let. The next phase of retail warehouses attracted the largest Texas Homecare unit. Boots' first Children's World superstore and Pizza Hut's first free-standing unit in the UK.

The fifth phase of the Merry Hill development was the critical one which took the scheme out of the ordinary. Supported by the then-Conservative controlled Dudley Borough Council, the Richardsons drew up plans for a 1.2 million-square foot enclosed mall to add to the 600,000 square feet of space in the four earlier phases. This was intended, like Brent Cross, to attract the major High Street department and chain stores. Neighbouring Birmingham and other boroughs were outraged at this threat to their own shopping and tried by every means to thwart the development. Even Dudley council, which in May 1986 changed to Labour control, belatedly changed horses. It was too late: within hours the Secretary of State for the Environment, Nicholas Ridley, had taken the final decision not to 'call in' the plans for a public enquiry. In 1988 Debenhams agreed to lease the largest, 125,000 square foot, unit, and was rapidly followed by Sainsbury's, Littlewoods, BhS and C&A. Among the

total of 150 tenants are included Laura Ashley, Etam, Miss Selfridge, Wallis, Dorothy Perkins and the Early Learning Centre. This major phase of the centre opened in November 1989.

By this time the Richardsons had developed plans for the other end of the site, by the local canal. Here they planned an office, industrial warehouse and leisure complex, linked to the retail centre by a monorail. There were even plans for the tallest building in the world to be built, exceeding the height of Toronto's CN Tower. Merry Hill has become a local phenomenon. It has parking for 10,000 cars, there is a mini-bus service for shoppers within a ten-mile radius, a courtesy bus on the site and free wheel-chair loans. With a ten-screen cinema and a 350-seat food court, Merry Hill has developed as a place to spend a whole day, not just the average shopping expedition. There are even coach tours arranged to visit the development.

What was not known was that between October 1987 and October 1990, the Richardsons had been selling the giant Phase Five of the scheme piecemeal to Mountleigh. Only those properties in which the retailers themselves held the equity interest remained outside Mountleigh's control. Soon after, Mountleigh acquired Phases Two, Three and Four, ending up with what director John Watson was quoted as claiming as 'between 80 and 90 per cent of the value of the development.' Ironically, as described in Chapter Five, Mountleigh needed to sell assets to survive, and agreed the sale of Merry Hill to an investment consortium including American interests, but the sale was held up by doubts about the quality of the ground on which it stood, triggering that company's liquidation.

Although the Richardsons had shown great imagination and courage to develop both the industrial and retail elements within the Enterprise Zones, they too proved vulnerable to the bull market madness of the late 1980s. Having remained as a private company with their main interests, they bought control of the Belfast-based group Regentcrest in July 1985, for only just over £4 million. Regentcrest was to be their public vehicle, but it was not a marked success. In March 1990 the brothers came to the rescue of the company again with a £6.3 million bid, but this was simply throwing good money after bad. By October 1990, Regentcrest had £50 million in debts. Among the creditor banks was Den Norske Bank's London branch, one of many foreign banks which had joined in the fashion of lending on British property. Their loan for £8.75 million was secured on a property in Soho, owned by a Regentcrest subsidiary, Opecland, and said to be worth nearly £14 million. At the beginning of October, the bank appointed a receiver to the property on which they were secured, triggering off a partial guarantee from the parent company. A trade creditor of Regentcrest, reportedly the property agents Herring Son & Daw, then petitioned for the winding up of the parent company. The bank and the Richardson brothers proceeded to give their own sides of the story to the *Birmingham Post*. Brian Hudson, the Managing Director of Den Norske, London, stung by the

Richardsons' blaming his bank for the company's demise, wrote an open letter to the newspaper:

> We had a loan of £8.75 million which was due to be repaid in January [1990]. Regentcrest were unable to pay and asked for an extension. We readily complied and it was agreed that we would receive six payments of £500,000 following which the remaining loan of £5.75 million would be put on to a long-term basis with no further principal instalments.
>
> Five of the six instalments were paid, one of them in the form of a collateral deposit from one of the Richardsons' private companies. . . . They were negotiating to sell the building . . . for nearly £14 million, which would have given them a big profit over the amount of the loan.
>
> Unfortunately, the sale fell through. After that their attitude to the bank changed. They contacted us in mid-September to say that no further payments would be made to us, even though the loan was within only £500,000 of the level at which it would be converted into a long-term commitment. They said that interest for the next 18 months should be rolled up, failing which they would walk away and leave us with the property. . . .
>
> Despite the hard line taken by the Richardsons, Den Norske Bank was still willing to negotiate. My letter to them of September 28 made it clear that the bank would look willingly at a compromise involving, for example, a deferment of the last instalment of £500,000 while the affairs of Regentcrest were sorted out. . . .
>
> The olive branch we offered was rejected. I was told on October 2 that the Regentcrest board had no response to make to my letter and that their position remained exactly as before – not a penny more in principal to the bank, not a penny more in interest. This left us with no choice but to appoint a receiver to the property. . . .
>
> The truth is that if Regentcrest fails, this will be the Richardsons' choice and not Den Norske Bank's. I am sorry that they have sought to make the bank the scapegoat for their decisions.

The Richardsons certainly did blame the bank. Roy Richardson complained 'At the meeting of bank creditors [on 10 October 1990] the directors felt that, in view of the precipitous action of Den Norske, it was decided to allow the company to be wound up. It will be messy and there will be other banks involved. I am angry with Den Norske. It is all down to them.'

These extracts from a dispute over what was a relatively small company are included since it is very unusual for the mechanics by which a quoted company is put into liquidation to reach the public domain. By the end of 1991, similar angry disagreements over what might or might not have been done to rescue public companies had no doubt taken place, but no such dirty washing has been aired over those cases.

The Richardsons lost £10 million on Regentcrest, but they continue to

be the great promoters of the revival of the Black Country. Their project to turn Fort Dunlop, that familiar landmark by the side of the M6 in Birmingham, from a multi-story memorial to a once-great British company into a new business centre is still in the planning stage. At the 1991 Labour and Conservative Party conferences the chambers of commerce of Dudley, Walsall, Sandwell and Wolverhampton organized a joint lobby to create political support for further government spending on the local infrastructure and environment. It was widely believed that the catalysts behind this unusual co-operation were the Richardson twins.

The third out-of-town entrepreneur who made his name in the 1980s through a huge retail development is John Hall. Hall is a Northumbrian, born in 1932, whose father was a coalminer; he too worked in the coal industry, qualifying as a mining surveyor. His experience in the property industry began at Killingworth Development Corporation, but in the 1960s he went into business on his own. His first venture was taken over by London & Northern Securities, for whom he worked for 11 years. No sooner had he gone out on his own again than the 1970s property crash hit. His bank, the National Westminster, stood by him, building up a relationship and loyalty from its grateful customer reminiscent more of Japan or Germany than the 'transaction related' links typical of the United States or Britain.

Hall's place in the history of retail development in the UK is secured by his realized vision of a huge, American-style regional shopping centre. This has been built, not in the soft south, or even in one of the more prosperous areas of the Midlands, but in Gateshead, across the River Tyne from Newcastle. In the early 1980s, as its traditional industries of steel, shipbuilding and chemicals went through a depression comparable to that of 50 years before, it was considered ridiculous to contemplate a 'greenfield' retail centre in such a depressed area. In fact, as is often the case, the depression on the Tyne was much exaggerated. A local Porsche dealer, symbol of the southern yuppies, was said to be one of the most successful in the country. Newcastle itself already had one of the most successful of the 1970s shopping centres, Eldon Square developed by Capital & Counties and financed by the Shell Pension fund. The very existence of that retailing success brought into question even more starkly whether the area could support more shopping on the scale envisaged by John Hall.

The Thatcher government's introduction of Enterprise Zones could be said to have enabled the Richardson brothers to contemplate the development of Merry Hill, and the same is true for the Gateshead project, which Hall's company dubbed the MetroCentre. The 100-acre site was an ash tip when Hall first looked at it in 1979, waterlogged and with no access. To make the land fit for use would take £8 million, yet the asking price was too high. The area was one of the first to be designated an Enterprise Zone, and, in 1980, John Hall took an option on it.

Hall's company, Cameron Hall, is owned by his family, with the

Cameron half stemming from his wife Mae's maiden name; both she and their son Douglas and daughter Allison are directors of the company. In 1980 the two senior Halls wrote to all the major retailers with their idea for the site and asking for indications of interest. 'None of them wrote back' said Hall. Only the retail warehouse operators, who had supported John Whittaker's Peel Holdings, had any interest in the idea of out-of-town shopping, and then only for their sheds-with-shelves. Hall and his family persevered, and when he opened an exhibition of his plans in the Five Bridges Hotel, Gateshead in 198, '1,000 retailers came to see us.'

The change had come about as the High Street retailers had seen the success of the retail warehouses. The growing mobility of the average Briton, as car ownership spread, meant that most shoppers were no longer confined to what could be walked to or reached on the old bus routes. These shoppers had also travelled, particularly to the United States in the first two years of the 1980s; the strength of sterling had made that the cheapest and most popular destination for British tourists. They had liked what they had seen and demanded a similar standard of quality for their shops at home. Even the most modern of the city centre developments barely compared with the huge US shopping malls, and only out-of-town centres could offer the prospect of anything like the American experience. Many retailers had noted the success of the retail warehouses, with their longer hours and easy parking, and had set up task forces to investigate whether they too should succumb to these new retail trends.

The critical anchor tenant to be signed up for the two million-square foot scheme was Marks & Spencer. M&S had never taken a store out of the High Street; taking 90,000 square feet was a leap in the dark for them particularly since their Eldon Square shop was one of their most successful. Hall has been quoted as saying 'History will say I was in the right place at the right time, and I needed that piece of luck. My difficulties initially were in getting people to understand what I was trying to achieve in shopping and leisure.' The breakthrough of attracting Marks & Spencer was followed rapidly, and by the time the Centre was officially opened on 13 October 1986, there were about 200 tenants, including most of the well-known High Street retailers. In its first weeks, the Centre attracted up to 100,000 shoppers a day. The next phase of the development, opened a year later, includes a multi-screen cinema, cafes and restaurants, and, an idea of Allison Hall's, a fun-fair for children. By 1988 it was estimated that 16 million people had visited the MetroCentre in a year and spent £340 million.

Cameron Hall financed the centre partly through a partnership with the Church Commissioners. The latter were keen to make an investment in a depressed city-centre area, and could scarcely have been presented with a better opportunity of proving that doing good does not necessarily mean losing money. As a consequence of the Commissioners' involvement, the MetroCentre even has a visiting chaplain to add to all its other facilities.

John Hall has often made plans to duplicate the success of the

Gateshead scheme, but, to date, none of these has been completed. He was in competition to build a regional centre in Exeter, and was a putative partner in the proposed development of a competitor to the Richardsons, in the Sandwell Enterprise Zone in the West Midlands. There are also plans for similar developments in continental Europe. The other major scheme which has progressed some way is the plan to turn the grounds of Wynyard Hall, Teeside, into a business park. There is rich irony in the fact that the Hall family bought the 5,000 acre estate with its mansion in 1987. It was previously one of the homes of the Marquess of Londonderry, whose family fortune had been built on the very coal mines in which John Hall's father had worked.

The north-east has become proud of John Hall, the local boy made good. They cheered him on in his successful attempt to change the board of the faded, but still loved, Newcastle United football team. There was pleasure too in the award of a knighthood to Hall in the 1991 Queen's Birthday honours list. He and the other entrepreneurs in this chapter are certainly out of a different mould from many of the urbane property developers from the soft south.

10

THE BUYER OF LAST RESORT

THE BRITISH HAVE never been very sensitive about the ownership of their country by foreigners. Since the nation has been a colonizer for much of its recent history, any such sensitivity would seem hypocritical. What is more, for a country which has run a trade deficit for most of the post-war period, any attempt to prevent foreign ownership would be self-defeating. The simple truth is that, if you are running a deficit on trade, then that shortfall must be made good by capital flows. Either the deficit nation must sell its overseas assets or attract foreign investment. It is true that such inflows of capital do not have to involve any physical assets: many countries have prevented the foreigner from owning property or other real assets, such as companies. In those cases the capital inflows are in the form of borrowing. The problem with borrowing is that the more of it a country does, the more expensive it becomes and eventually the recipient of the capital has to spend so much of its national efforts simply paying the interest on the debt that it is unable to break out of the cycle of borrowing. The advantage of selling companies and property to the foreign investor is that he is being promised nothing: if the company fails, he has no claim on the country at large and similarly a poor property investment decision will rebound on the investor, not on the sellers. The problem that foreign purchases of property can bring is a resentment among the local population. In the US the purchase of the Rockefeller Center in New York by Japanese investors brought a storm of protest about selling the nation's heritage. It is actually in the deficit country's interest to try to persuade the foreigner to pay the highest prices possible for local assets, and this might seem the deliberate policy of perfidious Albion in the latter years of the 1980s property boom.

Foreign ownership of British property is not a phenomenon of the 1980s. In the 1970s the oil-rich states had become substantial buyers of British real estate, culminating in the puchase by the Kuwait Investment Office of the St Martins property group for £107 million in September 1974, as the property market fell into its worst depression. Also in 1974

the Shah of Iran was said to be behind Evenrealm, a company which bought Blackfriars House, Manchester, Britannia House, Old Bailey and an office in Rood Lane, London. The Arabs were also big buyers of hotels in London: the Dorchester, before its purchase by the Sultan of Brunei, the Park Tower, and the Chelsea Holiday Inn. This last is the hotel which forms part of the Sloane Street site bought and sold at regular intervals in the late 1980s, (see Chapter Five). Most foreign purchases were restricted to owner-occupation; in 1976 Mobil bought half of the building they occupied in Holborn from London Life, and in the next year the Continental Illinois Bank bought the old home of *The Times* for £7.25 million. The bank sold this building late in the 1980s boom to another foreign buyer, Louis Dreyfus, for about £52 million.

In June 1978 English Property Corporation (EPC), one of the many companies which had struggled to survive the 1974/75 collapse, announced that it was in talks with an unnamed 'continental buyer' about a possible take-over of the British company. Although that approach come to nothing, in December the Dutch company Wereldhave, which had earlier bought the much smaller Midhurst Whites, bid £40 million for EPC. This was part of a bidding war for EPC which involved several important names. The battle became a three-way tussle between Wereldhave and two Canadian investors, Olympia & York, and a company owned by the Bronfmann family, owners of the Seagram distilling empire. Olympia & York (O&Y) eventually emerged victorious, although it sold the company on to the British company, Metropolitan Estates & Property in 1985. The Reichmann involvement in Canary Wharf on the Isle of Dogs in London's Docklands has been described in Chapter Two, but the Reichmann story is such an extraordinary one that it merits further attention.

The three Hungarian-born Reichmann brothers, Paul, Albert and Ralph, together with their father Samuel and formidable mother Renee, were refugees from Vienna at the outbreak of the Second World War. Their property empire really only became significant in the mid-1970s. The company, Olympia & York, evolved out of the Olympia Tile company which the young Ralph Reichmann set up in the mid 1950s, and York Developments, a warehouse developer in Toronto which Albert and Paul built up in the 1960s. The early investments were bought from the legendary New York developer 'Big Bill' Zeckendorf, who went bankrupt in mid-decade. The Reichmanns' prime Toronto development, First Canadian Place, was completed in 1975. The purchase of the rump of the Uris empire in New York occurred in 1977, but their major coup in that city was the creation and development of the modestly named World Financial Center on the south-western tip of Manhattan in 1980. The Reichmanns developed this group of buildings on hard-core infill, said to be from the bomb sites of Bristol, in the Hudson River. It lies across the road from the equally reticent twin towers of the World Trade Center. This latter development was already thought to be a little 'off-pitch' for

the financial district, but the Financial Center is even more out on a limb. The great success of this massive development of eight millon square feet of offices was achieved through O&Y creating a critical mass of tenants and creating its own location. To do this the Reichmanns offered potential tenants either rent-free periods or concessionary rents in the new buildings while, in many cases, (and more importantly), buying or taking over the leases of the buildings some of their tenants already occupied. For the tenants the immediate boost to their cash-flows was very attractive and it enabled O&Y to let substantial proportions of the development, against the expectations of all New York's wiseacres. Norwich Union and Mountleigh used the same avenue to fill their Beaufort House development, buying office space in Austin Friars from C. S. Buckminster and Moore, and in Lovat Lane from Lloyd Thompson, both of which took space in the new office block.

It is estimated that the gross property assets of O&Y were once worth more than $15 billion. What has only recently become clear is what portion of that wealth is owned by the Reichmanns and what is owed to the banks. They also control the Canadian paper company, Abitibi-Price, Gulf Canada, an energy group, and they refinanced the North American store empire of fellow-Canadian Robert Campeau just before it sought protection from its creditors in the courts. The simultaneous collapse in the property markets of Canada, New York and London proved too much for the Reichmann empire. In May 1992, Canary Wharf was put into administration, following the moves taken in Canada and the US to protect O&Y from its creditors. The O&Y empire has fallen, and only time will tell whether the Reichmanns and their bankers will salvage anything from the ruins.

The UK was not considered a prime target for property investment by foreign investors until well into the 1980s. A Labour government which had imposed strict development criteria and taxes and exchange controls were hardly conducive to foreign confidence. The South African Union Corporation was an exception in its gradual accumulation of a large stake in the convalescent Capital & Counties, but then the political situation in its home base was even worse. The first foreign bid of the 1980s was that by St Martins, the Kuwaiti owned company, for The Proprietors of Hay's Wharf, a relic of the days when the Pool of London was the centre of world trade. Hay's Wharf owned most of the south bank of the Thames between Tower and London Bridges and had been the object of redevelopment plans during the 1970s boom.

These early players in the property boom were in time to benefit from the rise in values between 1987 and 1989. Most of the foreign buyers have not been in that fortunate position, since the great invasion of foreign property buyers really started only during this period and was itself a substantial cause of the rise in value. Among the earliest deals done by foreigners were the first two significant purchases by Japanese buyers of UK property in 1985. Mitsubishi Estate bought Atlas House in the City for £34 million and the construction group Kumagai Gumi, in partnership

with Glengate Holdings, bought both the old GPO headquarters in St Martins-le-Grand and the Bourne & Hollingsworth store in west Oxford Street; they redeveloped the former building as the new headquarters of the giant securities house Nomura. The official opening of the new building was one of the first public engagements undertaken by John Major in the week after he became Prime Minister in November 1990. Bourne & Hollingsworth has been translated into The Plaza shopping centre.

In 1985 the South-African controlled TransAtlantic Insurance took control of the still-quoted Capital & Counties group, whose net assets now amount to about £700 million; in August 1991, TransAtlantic agreed to inject a further £80 million into the company when it raised over £100 million in a rights issue. The Union Bank of Switzerland were also early participants with the purchase in 1985 of the P&O Building in Leadenhall Street, across the wind-swept paved precinct from the Commercial Union building and built in the same style.

The real explosion of foreign interest in British property came as the expectation and fact of a third Thatcher victory developed. In early 1986 the Dutch property investors, Rodamco, part of the giant Robeco investment group based in Rotterdam, (hence the 'Ro' prefix to its funds), bought the quoted Haslemere Estates. Haslemere had become synonymous in the property world with the refurbishment and redevelopment of old buildings; 'doing a Haslemere' was the expression used to describe such activity. The driving force of the company for many years had been Fred Cleary, who had been instrumental in preserving many of the small gardens which dot the City. His retirement allowed the Dutch the opportunity to buy the company, which cost them £245 million, but bought them control of £350 millions of real estate.

In 1987 there was the largest single transaction to date. Obayashi Gumi, another Japanese construction company, bought the *Financial Times* building in Cannon Street, Bracken House, for £143 million, with the intention of completely redeveloping the site. Only weeks after the transaction the Department of the Enviroment listed the building and it became impossible for the redeveloper to knock down its distinctive red-brick facade. The new building rising behind the old facade is designed by Michael Hopkins, the creator of the highly popular new Mound Stand at Lord's Cricket Ground. Another purchase of an abandoned newspaper building that year was that of the *Daily Telegraph* headquarters in Fleet Street by the American investment bank Goldman Sachs; this was later sold on to Meiji Life of Japan for a reported £200 million.

The buyers of British property in the late 1980s came from all three major investment areas: Japan, North America and Europe. The Japanese buyers included both developer/constructors (such as Kumagai, Obayashi, Kajima and Shimizu), institutional buyers, particularly the life assurance companies, and the speculative traders. Between 1988 and 1990 there were substantial purchases by Sumitomo Life, which bought Angel

Court, just by the Stock Exchange, for £81 million; it later followed this by buying, for £220 million, 53 per cent of the building which J. P. Morgan, the American bank, was developing on the site of the old City of London School for Boys on the Thames Embankment. Yasuda Life bought River Plate House in Finsbury Circus for £140 million; Asahi Life bought a lease on Leadenhall Court on the corner of Leadenhall Street and Bishopsgate for £118.75 million. It is confidently asserted that Nippon Life, the largest of all the Japanese mutual life assurance companies, was the buyer in August 1991 of 50 per cent of Wimpey's Little Britain development at the end of London Wall, (Route 11), for £110 million. Expectations have been raised that Dai-Ichi Mutual is to buy 50 per cent of the Prudential Group's pitched-roof extravaganza, Minster Court, for £200 million, and invest a further £150–200 million in buying 50 per cent of Milton Keynes' covered shopping centre. This would be in addition to its earlier purchase of Randsworth's Wilson Street development for £40 million in early 1989.

The Japanese construction companies have often preferred to develop in association with local experts. Shimizu Construction has invested jointly with Godfrey Bradman's Rosehaugh in a redevelopment in Chiswell Street, and has a share in the development of 1 America Square, as well as an eight per cent stake in Stockley Park. It is also the redeveloper of a property on the corner of Bond Street and Piccadilly, and has ventured into residential development with a very expensive conversion of apartments in Belgravia. Kajima Construction has been a partner of Stuart Lipton, with investments in Euston Square and London Wall, both of which were intended as future redevelopments, but on which the shadow of the property collapse has fallen. The partnership did complete and sell one highly successful development, in Red Lion Square, which realized a profit of more than £8 million.

Kumagai Gumi, being among the first into the British market, has been more adventurous than some others in its solo efforts. It went so far as to buy a small developer, Ranelagh, as well as developing the old *News of the World* building in Fleet Street, for which it paid £72 million in 1987. The resulting investment is now known as Whitefriars and is let to solicitors Freshfields. In the same year Kumagai bought a development site, now being completed, in Lower Thames Street, from Eagle Star; the new building, on the site of the old Vintry car park, has been dubbed Thames Exchange, a 185,000 square foot office. Also in the final stage of redevelopment is the old Hambros Bank headquarters in Bishopsgate, which will provide another 190,000 square foot investment. Kumagai's interest in this prime City position is enhanced by its purchase, for £145 million, of the new head office of Standard Chartered Bank, almost directly opposite the erstwhile Hambros building in Bishopsgate. Standard Chartered had become one of the worst casualties of poor lending both overseas and in the UK, and one way of restoring its reserve ratios was through the sale of some of its freehold offices. Among the

jewels in the portfolio were offices in the Far East which were the subject of much speculation when the bank put them up for sale. The spanking new headquarters in Bishopgate, with its indoor trees and fountains, were too spacious and valuable for a bank faced with retrenching its activities, so the sale to Kumagai was a welcome relief. The bank has now taken much more modest space in Aldermanbury Square. The Japanese company was also the redevelopers of the Moss Bros site in Covent Garden and the Distillers Group's old head office on the corner of Pall Mall and St James's Square. Kumagai did not restrict its activities to London: in a joint venture it is involved in a substantial project at Broomielaw, Glasgow.

Many other Japanese companies have been large buyers of selected British property; not all of them were household names for prudence in their own country. The top companies were involved: Mitsui Real Estate paid £135 million for 20, Old Bailey. Kowa Real Estate bought 50 per cent interests in Austral House and 55 Basinghall Street, to the south of London Wall, from Wates City offices, and paid £150 million for Gallus House. Sumitomo Real Estate bought a share of Wates City Offices' Vintners Place development, just yards west of the Kumagai development in Lower Thames Street. The Japanese trading houses have also participated: C. Itoh were partners with Guardian Royal Exchange in buying properties in Fleet Street and Austin Friars; Mitsui partnered Taylor Woodrow in modest refurbishments in Grays Inn Road; Marubeni bought 120 Moorgate from P&O for £45 million as late as the end of 1989; Sogo Sosha bought a 50 per cent interest in one of Mountleigh's few developments to reach completion, the new block on the Criterion site in Piccadilly Circus; Nissho Iwai was involved in two joint developments with Imry Merchant Developers, one on the Isle of Dogs in Docklands and the other off Fleet Street. Daiwa Securities bought a site for its future headquarters in Wood Street for £100 million only to suffer the same fate as Obayashi when the building was listed by the Department of the Environment. Kato Kogaku bought Bush House, the home of the BBC World Service, for £130 million in late 1989, and around the same time, EIE bought West Britannic House, a 446,000 square foot office investment, for £200 million. EIE is now being supported by the Japanese banks, and its venture into British real estate cannot have helped its overall position.

This bald list of investments made by the Japanese over a relatively short period is by no means exhaustive. Property owners are not forced, as are shareholders, to reveal their beneficial ownership, and can hide behind offshore vehicles or nominee companies. Such a list does, however, give some feel for the sheer size of the buying. The properties listed certainly cost more than £2.5 billion, almost matching the total investment made by UK institutions in the two years 1988/89. Also excluded are the purchases of the businesses, and property assets, of two prestige British clothing retailers: Aquascutum of Regent Street and Daks-Simpson of Piccadilly by Japanese investors.

Of the Europeans, perhaps the least likely potential candidates for substantial investment in British property might have been the Swedes. The Social Democratic government which has ruled the country for most of the last 40 years took a very restricted view of capital freedom for individuals, let alone the great investment institutions, and until the end of the 1980s, there were absolute rules against the export of portfolio capital. When Finance Minister Kjell-Olof Feldt removed some of these limitations, first in November 1987 for property companies, and in 1988 and 1989 for other investors, the rush for the exit was headlong. As in the UK after the removal of much less strict exchange controls in 1979, investors embraced with abandon this new freedom to invest abroad, and the results have so far been fairly appalling for the Swedes. The UK property market, then in the last phase of its bull market, seemed to be a low-risk choice for the investors, and the subsequent investment was very substantial.

The first major deal was the joint purchase by Wasa and Windborne of Proctor House in High Holborn for £50 million in September 1989; an anonymous Scandinavian consortium bought Stockley's Dorset Rise development for £65 million. Perhaps the most aggressive buyer of the period was the Skanska property group which developed, either alone or in partnership, Thomas More Square, east of the Tower of London, and a new office above Monument Tube station. Thomas More Square has six office blocks making up 550,000 square feet of space. This has proved one of the slower developments to let, and by the middle of 1991 only a fraction of the space had been taken. Skandia, the insurance group, bought an office development behind Canada House off Trafalgar Square and 146 Queen Victoria Street in the City for a reported £95 million. Another Swedish insurance company, Trygg Hansa, bought 77 Shaftesbury Avenue for £40 million. A Swedish-owned vehicle, Central London Securities, bought the *Times* building in the Grays Inn Road from Elliott Bernerd for £42 million and 1 Drummond Gate SW1 for a further £28.5 million; Pleiad, another Swedish investor, bought Rosehaugh's head office in Marylebone Lane, sold in May 1990 as part of Godfrey Bradman's search for liquidity, for £23.5 million; Arcona bought 14/15 Stanhope Gate W1 for £32 million, the £40 million International Press Centre just off Fleet Street and a development in South Audley Street, Mayfair which it sold in early 1992 for £37.5 million to clients of Citibank; it also jointly undertook the £18 million redevelopment of 14/17 Great Marlborough Street W1. The grand-sounding Scandinavian Investment Property Holdings company bought Wellington House in the Strand for £12 million and Facta Fastigeheter paid £14 million for the Cripplegate Institute, north of the Barbican, for redevelopment.

This partial list, which totals over £500 million, shows how important the Swedes were as buyers in the short period between 1988 and 1990 during which they were active. There were immediately unsuccessful Swedish forays too. A Swedish-controlled company exchanged contracts on the purchase of Dorset House, SE1 for £24 million, but failed to

complete, sacrificing its deposit, and Accura Real Estate took over the quoted City Gate Estates in March 1990 for £22 million; by mid-1991, City Gate was in liquidation. The largest Swedish purchase was that of London & Edinburgh Trust by the pension fund SPP, described in Chapter Eight, for £500 million, about the value of the underlying assets, in April 1990. That such a small nation, with a population of under eight and a half million, should have spent over £1 billion on British property in under three years is truly remarkable.

The Dutch, like the other major European maritime and colonial power, Britain, have always been large international portfolio investors. Their interest in British property is relatively long-standing. As mentioned above, the Rotterdam-based investment company, Rodamco, had taken over Haslemere Estates as early as 1986. In December 1988 the fund returned to the UK market with a contested bid for the much larger Hammerson Property company, run by the veteran Sydney Mason; Hammerson's assets were valued during the bid at almost £2.5 billion. The company still has a split share capital, with most of the votes being held by the relatively few ordinary shares. These have been issued very carefully by the company over the years, with the express intention of being able to maintain close control. The major holders of voting shares are Mrs Sue Hammerson, a patron of the arts and widow of the founder, and Standard Life Assurance, the huge Edinburgh mutual company. Standard has been a strong supporter and financing partner of Hammerson over the years, (notably on Brent Cross), and had no truck with the bid, which failed; during the bid, Standard Life increased its voting power to 28 per cent of the company through purchases in the market.

The other large Dutch property investor, Wereldhave, bid £281 million in October 1988 in a successful attempt to buy Peachey Property, a company finally restored in reputation after the Eric Miller scandal of the previous crash. Peachey's most noted properties were in the streets to the east of Regent Street, including the 1960s centre of swinging London, Carnaby Street. A more entrepreneurial view was taken by the Dutch company Noro, which bought effective control of New Cavendish Estates. The Dutch insurance and pension funds were also active: 1 Aldgate was sold to ABP for £50 million, and 120, Old Broad Street for £26.6 million to a subsidiary of the State employee's pension fund, which also bought an interest in Almack House, St James's, for an undisclosed sum from London & Edinburgh Trust. The multi-national insurer Nationale-Nederlanden bought Reed House off Curzon Street for £48.5 million; it is currently developing a £100 million investment in Henrietta Place behind Debenham's Oxford Street store, in a joint-venture with Lynton Holdings. After the market had fallen sharply, ABP returned in partnership with insurers Aegon to buy, in mid-1991, Aldwych House from AB Ports subsidiary, Grosvenor Square Properties, for £75.2 million.

The French, German and Swiss institutions were somewhat behind

their continental colleagues, but were also part of the invasion. Credit Foncier bought into developments in Birchin Court in the City for £40 million and in a project in Knightsbridge, again with London & Edinburgh as partners. Zurich Insurance purchased P&O's development at 90, Fenchurch Street for £50 million; Gertler Properties bought Kings Cross House in the Pentonville Road from Speyhawk for £50 million, as well as the Welbeck Street headquarters of Debenhams.

Two of the largest individual foreign transactions were among those where the purchasers were a closely guarded secret. The £250 million spent by an anonymous 'Far East' buyer, widely thought to be the Sultan of Brunei, on the acquisition of Lansdowne House, Berkeley Square, was perhaps the quintessential purchase of the late 1980s property boom. The price was a fabulous one, and the major tenants included Saatchi & Saatchi, a creature which both blossomed and faded with the decade, and Stuart Lipton's Stanhope. Almost matching that deal was the purchase by 'Middle Eastern' investors, of the Adelphi, overlooking the Thames from behind The Strand, for £200 million. A Middle-Eastern company, named Culverpalm, was also active, buying in Berwick Street in the West End and Mountleigh's 85, Gracechurch Street (for £40 million), as well as selling a property in Norton Folgate, on the northern edge of the City, to Wimpey for £15 million. This last property remains unlet and a burden to its owner.

Two large deals in the summer of 1991 proved that the foreign buyer had not suffered from terminal indigestion from earlier forays. The purchase of 50 per cent of Little Britain by Nippon Life for £110 million from Wimpey helped relieve that company's finances, stretched not only by the unlet Norton Folgate, but also by its refurbished but equally empty building by the elevated section of the M4 motorway to the west of London. Similar relief was given to the Rosehaugh Stanhope joint company by the sale, to a fund managed by the US Prudential Insurance, of Bishopsgate Exchange, part of the Broadgate development, for £180 million. To demonstrate that the continuing attraction of such trophy buildings was not the only magnet, in September 1991 the British investment and development company, MEPC, sold a partly let, 40,000 square feet, office in Chancery Lane, Holborn to Deutsche Gesellschaft Fur Immobilienfonds for £18.7 million.

The plethora of foreign deals demonstrates how international the British, and, particularly, the London, property market has become. These deals have been listed in this rather dry way simply because such a laundry list shows how pervasive foreign ownership of prime London offices is; and the list is by no means exhaustive. Many foreign investors were attracted to so-called 'trophy buildings', those that they could point to with pride as being theirs and which had some special cachet. Agents Debenham Tewson & Chinnocks calculated that foreign investment in British property between 1987 and 1990 totalled more than £8 billion, excluding the purchases of whole companies. When this is put in the

context of total UK institutions' net property investment in the same period of around £6 billion, it is clear that the foreigner played the unintended role of buyer of last resort for the British industry. Statistics are now published by the government of the number of transactions in property, derived from the forms delivered to the Inland Revenue for the payment of Stamp Duty. These show that the number of deals in individual, non-residential, properties for the whole UK in any year peaked at 117,000 in 1988. With so few transactions, it is no surprise that the foreign investor was the market in those years.

After the ignominious departure of sterling from the ERM on 16 September 1992, a new enthusiasm arose from foreign investors for British property investments. The German investors, notably co-mingled funds such as DGI, were active buyers of several large offices, let to solid tenants but at rents way above the then current market rent. LET and Norwich Union's Ropemaker Place, let to Merril Lynch, was sold for £75 million, MEPC's Finsbury Circus property went for £73 million and another Norwich Union investment, Plumtree Court below Hoborn Viaduct for a further £78 million. Further deals by international investors were said to be in the offing, attracted by the high running yields, long lease terms and lower short-term interest rates.

11

DOWN THE SNAKES AGAIN

THE END OF the 1980s property boom was foreshadowed on 19 October 1987. On that day the stock markets of the world fell by a quarter and the phrase 'Black Monday' was to enter the vocabulary of every financier. The boom had been sustained by a combination of extraordinary economic growth and institutional change together with gradual reductions in interest rates. The immediate consequences of Black Monday were two-fold: a reduction in demand for office space but, more important in the short term, a reduction in interest rates. After two years of economic growth at more than three per cent, the signs of incipient over-heating in the British economy were becoming apparent. While property developers sunned themselves on the beaches in August 1987, Nigel Lawson had signalled his concern by increasing interest rates by a full one per cent. A gradual tightening of monetary policy would have cooled the economy and the property market, with the probable avoidance of the excesses, both upward and downward, experienced in the following four years.

The stock market crash elicited predictions from many quarters of a repeat of the 1930s. The fall in share values was symptomatic of a deep economic malaise in the world economy and would also have an effect on consumers through the reduction in their wealth; they would become more cautious in their spending plans. As a consequence almost all the monetary authorities in the world, determined to avoid the mistakes of 1929, pumped funds into their economies by reducing interest rates. Britain was no exception. Interest rates, which had risen to ten per cent on 7 August, were cut to 9.5 per cent on 26 October, and further to 8.5 per cent by 4 December. At that stage the concern of the authorities to avoid a liquidity crunch was beginning to moderate, as there was little sign of consumer angst, except in the sales of BMWs in upstate New York. Unfortunately for the British economy there then emerged a dispute between Nos. 10 and 11 Downing Street about the proper level of the pound sterling against the German mark. As a result British interest rates

were lowered again, augmenting the already strong underlying trends in the economy. These reductions, which culminated in a bank base rate of seven and a half per cent for a few weeks in May 1988, were gradually reversed as the year progressed further. The damage had been done, however, and the economy was growing so fast that salutary action had to be taken to cool it down. This took ever higher interest rates, culminating in the imposition of a rate of 15 per cent on 5 October just before the 1989 Conservative Party Conference.

The property market brushed aside the stock market crash. Indeed 1987 was the first year since 1979 that property assets had outperformed British equity shares. Rents were accelerating as the inflation rate began to pick up and the new supply of space had not yet reached the market. In 1988 and early 1989 there followed the climactic of the boom. With institutional investors seeking to rebuild their long-neglected property portfolios, foreign investors searching for both trophy buildings and whole companies to buy and rents rising rapidly, returns on property assets outpaced anything seen over the previous seven years. The problem was that this final convulsion was built on very weak foundations. With higher interest rates, the completion of the more deregulated development market's products and the reduction in occupier demand, only the relatively low valuation of property against other investments was a potential support as 1989 progressed.

'Big Bang' in the City of London in November 1986 was a classic example of the effects of new capacity being introduced to a market with ultimately limited demand. For nearly 80 years the London Stock Exchange had protected itself from outside or, worse still, foreign ownership of the brokers. There was an historic compromise agreed between Trade and Industry Secretary Cecil Parkinson and the then-Chairman of the Stock Exchange, Sir Nicholas Goodison, ironically for this book one of the leading property company analysts in the late 1960s, and a man who taught this writer a lot as a young beginner. The government dropped its threat to refer Stock Exchange restrictive practices to the Office of Fair Trading. In return the Exchange promised to open up its membership to outsiders and a removal of the distinction between the brokers, who solicited orders, and the jobbers, who supplied the shares. The result was that, in the period around Big Bang, many new and wealthy institutions were drawn into ownership of securities firms. Almost every major British merchant and US bank, together with participants from France, Switzerland and Hong Kong, took over one of the leading British brokerage houses. The 1980s had seen an explosion in 'securitization': companies, instead of simply borrowing from their banks, had been offered sophisticated means of raising capital from the world's institutional savers, the insurance companies and pension funds, by-passing the banks altogether. It was widely accepted that, to be a major bank in the 1990s, each institution would need an international ability to create, distribute and trade both these new instruments and more old-

fashioned ones such as shares and long-term debt. London had long been a centre of innovation in these markets and dominated the European time-zone in financial markets. It was considered a centre in which, along with New York and Tokyo, every world player must have a representation in the securities market.

The new owners of these firms were often surprised to find that very profitable and prestigious businesses were operating from 1960s slab blocks with inadequate cabling for the new technology. Worse still, there was insufficient clear space for the giant trading floors which were to become a feature of the new integrated securities markets. As a result, the old brokers were showered with cash and told to upgrade their facilities. What had been ignored by the new owners was that there were very good reasons for the low overhead operations of the old partnerships. The partners had relied on bonuses for their rewards, attempting to keep their inevitable overheads of office and salaries to a minimum; they remembered the dark days of 1974 when, far from taking bonuses, most partners were called upon to make capital contributions. Now that they were merely salaried employees of banks which had apparently bottomless pockets, they were not going to stand in the way of this quantum improvement in their working conditions. Many of the glass and marble palaces built by the developers were let to those securities houses: Salomon took Greycoat's Victoria Plaza, Shearson Lehman one of the Broadgate buildings and UBS Philips & Drew another, and Citicorp the old Billingsgate fish market building. This last has yet to be occupied, and Citicorp are trying to sell their lease. James Capel, another of the leading houses, was on the brink of taking another Broadgate building when Black Monday came along. They settled instead for cramming themselves into their existing building.

The rash of new building which followed Big Bang was not complete by the time of the stock market crash in October 1987. At that time there was still deemed to be a shortage of space suitable for the financial supermarkets and their suppliers, the lawyers and accountants. Rents on new office property peaked at over £60 a square foot, with 62–64 Cornhill, developed by Greycoat and let to the Halifax Building Society in 1987, said to mark the absolute zenith in London City rents, and similar rents being achieved in the West End. The British economy was still growing at over four per cent in 1988, and rental growth in most sectors was sufficient to drive the value of property up.

According to analysts at Salomon Brothers, the amount of office space in the core of the City had remained at around 56 million square feet for twenty years before the relaxation of the City's planning constraints in 1986. As a result of that change, a further 20 million square feet was perhaps going to be built, with tens of millions more at Canary Wharf and, eventually, Kings Cross. The new supply really only began to reach the market-place towards the end of 1989. Agents Richard Ellis estimated that demand for new space, which had peaked at almost five million

square feet a year, was diminishing rapidly. In the last six months of 1989, 2.2 million square feet had been let, and another 1.6 million in the first quarter of 1990, but, by the second quarter, that had fallen to only 0.8 million square feet. At the same time, new space coming onto the market had risen from 3.4 million square feet in the second half of 1989 to 2.2 million in the first quarter of 1990 and 3 million in the second quarter. As a result, the vacancy rate, of unlet property to the total stock, was rising into double figures for the first time in years.

For well-financed companies with strong rental flows, this would have proved an embarrassment but not a disaster. They could wait until the rental market picked up again, either on the take-up of the surplus space, or as inflation drove economic rents to higher levels. However, as we have seen, much of the construction of the late 1980s was carried out by new companies, or those with a need to offer higher and higher profits, generated by trading or development. They did not have a continuing stream of income and their ventures were almost always financed by banks.

It was the rise in interest rates which caused mayhem and disarray amongst these participants. The gradual rise from the middle of 1988 initially had little effect, even though both the housing and car industries gave early warnings that the best was past. The killer blow was the rise in interest rates to 15 per cent in October 1989, one of the last acts of Nigel Lawson's Chancellorship before his resignation at the end of that month.

Although many merchant developers and traders had assumed that interest rates would not always be as low as the salad days of late 1987/ early 1988, none believed that short-term rates would regain the levels in the 'teens previously experienced in the 1980s recession. Because high short-term rates are normally a symptom of accelerating inflation, being the only effective way of controlling that phenomenon, there had been an assumption that such high rates would never again be needed, since inflation had been under four per cent throughout 1986 and 1987. A combination of the excess growth in the economy during 1987 and 1988, together with self-inflicted wounds such as the Community Charge, pushed inflation to seven per cent in 1989, and, after a pause, to almost eleven per cent in late summer 1990.

The recession which followed was of quite a different nature to that of the early 1980s. Only the English-speaking nations were affected initially, and financial services, which as an industry had grown throughout the 1980s, suddenly felt the cold winds for the first time. Although those in the north and Scotland were relatively sheltered from the effects of the 1990 recession, and they would claim that their areas had not fully recovered from the earlier set-back anyway, most of the property value was concentrated in the south and, particularly, London.

The great financial conglomerates created in the 1980s suddenly found all their certainties challenged. For instance the inexorable rise in residential property prices, which had attracted many companies into buying estate agents, reversed; the huge cash-flows of the pension funds

dried up as the funds took advantage of their accumulated surpluses to institute contribution holidays. The overheads and spanking new head offices remained, and action had to be taken to adjust the cost base to the new revenue levels. Ambitious plans for expansion were shelved, just as the newly developed space began to reach the market. The seeds of collapse may indeed have been sown, but in 1988 and 1989 a collective Masque of the Red Death was enacted: outside there might be the threat of an end to the good times, but, within the property market itself, things could hardly have looked better.

Rents in 1988 and 1989 grew at a faster rate than at any time since the agent's formal analyses of the market had begun in the late 1970s. There was continuing demand for modern office space, as the newly capitalized investment banks expanded in the expectation of a return to the high volume levels experienced up to the stock market crash in October 1987. The British consumer took spending to new record levels, as interest rates fell and increases in the value of houses were released through remortgages. In the industrial sector, an investment boom finally led to an increase in the demand for factory and warehouse space. Jones Lang Wootton's Property Index showed substantial rental growth in both 1988 and 1989. For offices, the rises were 23 per cent and 17 per cent; for shops, 32 per cent and 12 per cent; for industrial property 18 per cent and 28 per cent.

The rise in rental values also drove up capital values. As we have seen in previous chapters, these were the years of the most frantic turnover in the property market. The sole factor missing from the favourable environment was a fall in property yields. Only industrial property yields fell at all in these two years, and those only by one per cent between the ends of 1987 and 1989. As a result total capital values rose by about the same percentages as rents, and provided property investors with their best returns for a decade. According to the World Markets Company's analysis, the average return achieved by UK pension funds in their UK property portfolios in 1987, 1988 and 1989 were 19.4 per cent, 32.8 per cent and 18.2 per cent respectively. Nothing like those returns had been seen since the three year period 1977–1979; 1987 and 1988 were also the first years in which property had outperformed the UK equity market since 1979.

The enthusiasm for property infected companies which had only been involved via their occupation of buildings in the normal course of business. The first of these was Associated British Ports, the privatized dock company. As the method of transporting sea-going cargoes had changed, so the size and location of the docks changed, and AB Ports had found itself with acres of under-used land. In 1986 the company paid £15 million for the £7 million of published assets and the £100 million development programme of Grosvenor Square Properties, with the intention of using the management of that company to oversee all their property assets. In May 1988 BAA (the privatized British Airports

Authority) paid £165 million in cash for Lynton. Again the logic was that the airports had a large land endowment which needed active management. The largest and last of these incursions from outside was by British Aerospace, which paid £278 million in convertible preference shares for Arlington, the developers of Aztec West, the office park outside Bristol. All three companies have had to suffer the consequences of the poor timing of their purchases, although initially the AB Ports acquisition looked as though it would be very rewarding. By the end of the summer of 1991 British Aerospace was forced to raise over £400 million in new equity as cash continued to flow out of the company; Arlington was quoted as one of the culprits. It is ironic that these property company purchases were intended to be counter-cyclical, but, in the event, this property cycle was coincident with the downturn in the general economy.

The outsiders were not alone in making acquisitions which they learned to regret. The 1980s were the years of creative finance: the leveraged buy-out, whereby a predator was able to raise large amounts of bank borrowing to finance the purchase of a company, crossed from the United States at the end of the decade. In March 1988 a consortium used a vehicle named Giltvote to buy out Estates Property Investment Company for £73 million; the consortium was headed by Stephen Wingate, a survivor of the 1970s crash who had sold his family company to Wimpey, retaining some assets as a private investor. He was joined by institutions such as Eagle Star, Mercury Asset Management and Kleinwort Benson; his most prestigious partner was the London-educated Hungaro-American George Soros. Soros had built up the famous Quantum Fund by taking large positions, through both buying long and selling short, of shares, bonds and currencies. In late 1992 Soros was reported to be going into partnership with the Reichmanns to invest in property. He certainly had enough funds to be involved since it was said that he personally made $1 billion out of the collapse in sterling on 16 September 1992.

The purchase of Imry Merchant Developers, itself a merger between its two constituents in March 1988, was initiated by another company set up for the purpose, Marketchief, for £314 million in July 1989. The partners in this company again included Stephen Wingate, (although only to the extent of £1.25 million), partnered by Eagle Star (again), the US investment bank, Prudential Bache, and a Swiss-Canadian investor, Wolfgang Stolzenberg. Already by the summer of 1990, one of the two leaders of the old Imry Merchants, Martin Landau, had left; the company then had to be refinanced by the lead bank, Barclays, since the planned sales of assets had not been sufficient to enable Marketchief to service its reported £200 million debt; Barclays agreed to provide longer-term finance.

This initial refinancing proved insufficient; in June Barclays backed the take-over of Marketchief and Imry by Stolzenberg. The portfolio would continue to be managed by Imry's Martin Myers, and a new joint-venture was set up between Myers, Marketchief and Barclays, which put equity money into the project, a very unusual departure for a British bank. An

alternative might have been to put Marketchief into receivership; in this case the bank would be certain to make substantial losses, since the property would be put onto an unwilling market in which the buyers could name their own price. The Marketchief deal marked the zenith of the leveraged purchase, although the Pall Mall bid for Laing was larger and just as dependent on borrowing; the difference there was that there were existing companies onto which the bid was bolted. It was the stand-alone leveraged purchase which was vulnerable.

Between 1988 and 1990 there were over fifty bids for or by quoted property companies. Most of largest of them have been described in these pages, and many of them have ended in tears. Several of the participants have been under serious pressure and five have gone into receivership.

The banks were falling over themselves to lend secured on property assets in the late 1980s. A new generation of lending officers who had not experienced the 1970s, and an influx of foreign banks anxious to buy market share saw the total of bank lending on property rise to £40 billion by the February 1991. This represented about 12 per cent of all commercial lending, well below the 20 per cent level reached in 1974, but still enough to create unpleasant holes in any bank's balance sheet. The critical fact was that half the lending done between 1987 and 1990 was by foreign banks, with Japanese banks increasing their share of outstanding property loans from 2 per cent to 11 per cent over the period, and the other foreign (non-American) banks from 22 per cent to 26 per cent; in 1980 the share of these, mostly European banks had been only 11 per cent. The Americans might thank their recent experience in their home market for the fact that they actually reduced market share over the period from ten per cent to 6.5 per cent. With interest rates on a strong uptrend, both borrowers and lenders found that these easily arranged, secure loans soon turned into rapidly compounding debt millstones.

It was not long before the inevitable consequences of a recession, high interest rates and a flood of newly built space coming onto the market undermined the misplaced optimism. The critical question was whether a company had sufficient cash-flow to meet its interest payments and debt repayment schedules. Those particularly vulnerable also had new unlet developments. Sheraton Securities was a typical victim of the period, with no access to long-term finance and a development programme coming to fruition. Despite its well-respected management and an initial attempt at refinancing from the investment managers Mercury, part of the Warburg Group, in which Sheraton's broker Warburg Securities also operated, the rescue did not prove sufficient. By early 1991, several substantial companies, both quoted and unquoted, had gone broke: from the more residential development area Rush & Tompkins, Kentish Property (which specialised in the Docklands), and Declan Kelly; from the ranks of the commercial developers and traders, Sibec, Broadwell Land, Citygrove, Land & Property Trust and Rockfort were all in the hands of the corporate undertakers. As the reader will have learned from earlier

chapters, most of the substantial stars of the 1980s were struggling to make ends meet, with Rosehaugh, Mountleigh and the Reichmanns being the most prominent additions to the corporate cemetary.

Why did experienced property investors make mistakes which seem so obvious in retrospect? There is a substantial literature about popular delusions and the psychology of crowds. It applies to all markets from time to time, and suggests that there are times when rationality is thrown out of the window in the excitement of the moment. Whether it is the Dutch bulb market of the seventeenth century or the South Sea Bubble, the participants convince themselves that the current environment will continue indefinitely. Outsiders may point out that the interaction of supply and demand will eventually have an effect on rents or vacancy rates, but they are dismissed as ignorant amateurs. In fact the 1990/92 property recession was of a totally different type to earlier ones, and did not affect the mature companies nearly as much as in 1974/76. The rise in yields in the earlier period was much more dramatic, partly because they had not fallen in the bull phase of the late 1980s.

The area of greatest self-delusion of the 1980s property market was that the words 'non-recourse' or 'partial recourse' were a guarantee that the parent company would survive any mishap in a subsidiary. It seems to have come as a surprise to many participants that the banks took a dim view of any company which was prepared to walk away from these liabilities. The same banks would almost certainly have a relationship with some other part of the group, and could prove very awkward when those facilities came up for renewal. On the other hand, the move from relationship to transaction banking meant that some of the newer banks, particularly overseas ones, had less compunction about pulling the rug from a company where they had only one asset against which they had lent. The weakening of the old 'London Rules' of banking, whereby no individual bank would act without the tacit approval of the Bank of England, even if perfectly entitled to do so, probably brought more companies down than at an equivalent stage of the previous cycle. There was less systemic risk to the British banking system in 1990 and 1991 than there had been in 1974/75, so that the Bank of England's need to read the riot act to participants was much reduced.

Will the property market recover? The answer to that is a clear yes. But, as with any economic forecast, the timing of that recovery is much more difficult to predict. Yields have already begun to move down, so that fully let property which is not rented at above current market rates, will begin to increase in value. If inflation continues low and the yields against which property investments are measured, on bonds and shares, stay low too, then property yields will seem in retrospect to be astonishing value. If inflation takes off again then we should expect greater economic activity to be part of the cause and occupancy and rents will rise. Neither of these alternatives is likely to cause a marked improvement in the property market before 1994, and rents on London City offices may take much longer to recover.

Whenever the recovery starts, there will be new participants, who will be less constrained by the experience of this recession than those who lived through it. They will repeat many of the mistakes of the 1980s, as many of the companies repeated the mistakes of the 1970s. The market will then be driven to levels which will prove unsustainable. The market will discover again that no bricks can stand when assembled by mere mortals and built upon foundations of sand.

BIBLIOGRAPHY

Binney, M (1991) *Palace on the River* London: Wordsearch Publishing
Corporation of London, (1984) *Continuity and Change – Building in the City of London 1834–1984*
Duffy, F. and Henney, E. (1989) *The Changing City*, London: The Bulstrode Press
Duffy, F. and Chandor, M. (1983) *Orbit 1*, London: DEGW and EOSYS
Esher, L. (1981) *A Broken Wave: the Rebuilding of England 1940–1980*, London: Allen Lane
Glancey, J (1989) *New British Architecture*London: Thames & Hudson
Green, S. (1986) *Who Owns London?* London: Weidenfeld & Nicolson
Marriott, O. (1967) The Property Boom, Abingdon Publishing
Plender, J (n.d.) *That's the Way the Money Goes*
Reid, M. (1982) *The Secondary Banking Crisis*, London: Macmillan Press
Robinson, J. (1987) *Minus Millionaires*, London: Unwin Hyman
RIBA (1990) *Buildings and Health – The Rosehaugh Guide to the Design, Construction, Use and Management of Buildings*
Tutt, N. (1989) *The History of Tax Avoidance*, Wiseden
Wales, HRH the Prince of, (1989) *A Vision of Britain*, London: Doubleday
Whimster, S. and Budd, L., eds (1991) *Global Finance and Urban Living: the Case of London*, London: Routledge
Williams, S. (1990) *Docklands*, Architecture Design and Technology Press

INDEX

Luath Press Limited

committed to publishing well written books worth reading

LUATH PRESS takes its name from Robert Burns, whose little collie Luath (*Gael.*, swift or nimble) tripped up Jean Armour at a wedding and gave him the chance to speak to the woman who was to be his wife and the abiding love of his life. Burns called one of the 'Twa Dogs' Luath after Cuchullin's hunting dog in Ossian's *Fingal*. Luath Press was established in 1981 in the heart of Burns country, and is now based a few steps up the road from Burns' first lodgings on Edinburgh's Royal Mile. Luath offers you distinctive writing with a hint of unexpected pleasures.

Most bookshops in the UK, the US, Canada, Australia, New Zealand and parts of Europe, either carry our books in stock or can order them for you. To order direct from us, please send a £sterling cheque, postal order, international money order or your credit card details (number, address of cardholder and expiry date) to us at the address below. Please add post and packing as follows: UK – £1.00 per delivery address; overseas surface mail £2.50 per delivery address; overseas airmail £3.50 for the first book to each delivery address, plus £1.00 for each additional book by airmail to the same address. If your order is a gift, we will happily enclose your card or message at no extra charge.

Luath Press Limited
543/2 Castlehill
The Royal Mile
Edinburgh EH1 2ND
Scotland
Telephone: +44 (0)131 225 4326 (24 hours)
email: sales@luath. co.uk
Website: www. luath.co.uk

Image Credits

AM = Alan McCredie; SM = Stephen Millar

Cowboys and Cowgirls: 11, 14 AM; 16 SM
Gridiron Glasgow: SM
Barras Traders: SM
Bikers: AM
Muscle: AM
Jacobites SM
East Africans on the Bridge: SM
Buskers: SM
Circus: AM
Cosplay: 56 AM; 59, 60 SM
The Sabs: AM
Keep the Faith – Northern Soul: AM
Anarchists: images reproduced with the permission of the anarchist group
Opus Dei: AM
Karate: SM
Lolita: AM
Pagans; AM
The Dominatrix: AM
Graffiti: AM
The Gaels: SM
Traditional Musicians: AM
Roma: SM
Mixed Martial Artists: SM
Spiritualists: 119, 123 (lower picture) AM; 123 (upper picture) SM
Industrial Goth: SM
Scottish Martial Arts: SM
The Italians: SM
Gunslingers: 137 AM; 140, 141 AM
The Miners: AM
Drag Queens: AM
Mods: SM
The First Poles: SM
LGBT Boxers: SM
Flute Band: 165, 169 (top right, lower left, lower right) AM; 168, 169 (top left) SM
May the Force Be With You: SM
Tribute Act: AM
Wrestlers: SM
The Poets: 182 AM; 185 SM
Red-heads: 186 SM; 189 AM

One positive to emerge from this is that red-heads are starting to fight back and form a sort of community. Regular festivals and parades are being held by red-heads internationally, most notably the Red-head Days that originated in Breda, in the Netherlands. Every year similar events are held in the United States, Australia, Germany and Italy. Edinburgh hosted the first Ginger Pride march in 2015 and you can find out about events on websites such as www.gingerparrot.co.uk. There has also been a growth of dating websites aimed at the red-head world, including www.HotForGinger.com which has a fair number of Scots on its database. It may be that in years to come the red-heads of Glasgow will come together and hold their own regular city-based activities.

ARE GLASWEGIAN RED-HEADS a tribe? If they are, then apart from the East Africans featured elsewhere, the red-heads of Glasgow are the oldest of them all. Red hair arises as a result of a mutation in a gene located on chromosome 16 that determines hair colour and is known as the Melanocortin 1 receptor (or MC1R). It seems likely that modern humans began to migrate out of Africa between 60–10,000 years ago. At some point after they left, perhaps 40–50,000 years ago, the first mutation of MC1R took place, possibly due to reduced levels of sunlight. It is possible all red-heads are linked to one another, descended from a single person with whom the mutation began. Different forms of the mutation give rise to different shades of red – from strawberry blondes to auburn.

Only 1–2 per cent of the world's population have red hair. The highest concentrations are in Ireland (around ten per cent) and then Scotland (6 per cent). In Scotland around 35 per cent of the population carry the feature that causes red hair, although many do not realise it. MC1R is a recessive gene, meaning both parents must carry it to have a red-haired child.

The concentration of red-heads in the so-called Celtic nations suggests it was Stone Age settlers – perhaps arriving from the Russian Steppes or Middle East – who brought the red-headed gene with them. It is also possible many Scottish red-heads have connections to Irish settlers, particularly when during the Dark Ages the Irish kingdom of Dal Riata controlled much of Western Scotland and many Irish came to live here. If you see a Glaswegian red-head you are therefore seeing a living reminder of the very earliest settlers of Europe and Scotland in particular. A red-head with blue eyes is particularly exceptional, a member of the smallest minority group in the world, with less than one per cent of the global population having such an unusual combination.

In many societies throughout history the status of red-heads has been complicated: we know the Romans respected them, with red-headed slaves being highly valued. The Egyptians were not so positive and during the Medieval period being red-headed was often associated with witchcraft. In the last few decades in Western Society an anti 'ginger' tendency has emerged. In 2008 a teenager began a 'National Kick a Ginger Kid Day' Facebook campaign – said to have been inspired by an episode featuring red-heads of South Park that was first shown in 2005. It gained some traction and there have been subsequent press reports of kids being attacked as a result in schools from Canada to California, Yorkshire and Scotland.

What is it like to be a herring gull?

(After Thomas Nagel)

Circling the heavy church at the end of the street,
they see a cliff-stack above a grey Atlantic,

an inherited seascape sloshing inside their skulls,
salting their nerves, their desires' tidal pull.

Fat and imperious on rooftops, they laugh
down the chimneypots, my hearth

echoing with their uninvited call.
My father excuses himself. My tea cools

as I swallow his news.
The street heaves and yaws,

cherry blossom froths around the steps
and caught in the swell, a shopping bag pulses,

a jellyfish against the rail.
I throw my head back and call and call and call.

© Samuel Tongue

I asked Samuel if there is a cross over between the 'young' and more established poetry tribes: 'There is a perceived separation between the 'slams'/spoken word and the more 'traditional' events such as St Mungo's Mirrorball or the Scottish Writers Centre (SWC). However, individual poets do move between them and, increasingly, the definitions are becoming less useful. For example, our Clydebuilt Development Programme supports poets such as Katie Ailes and Juana Adcock, who might be defined as "spoken word". For all poets, good performance is key; poetry is, after, one of the most oral/aural of arts.'

As to how big the tribes are, Samuel suggests: 'In terms of "active" poets – meaning writing, performing, publishing and playing a part in the city's poetry networks – there are 30 plus solely within the Clydebuilt Programme. Bearing in mind the Strathclyde and Glasgow Universities MLitts, the spoken word events, St Mungo's Mirrorball, the SWC and so forth, I would have to hazard a guess of over 70.'

Do you get full time poets in Glasgow? Samuel thinks: 'It is extremely rare for somebody to be able to work full-time as a writer, let alone as somebody focussing solely on poetry. Full-time writing also involves myriad tasks and opportunities: workshops, school visits, collaborations, residencies, festival readings, and so on.'

Does Glasgow produce any particular type of poet? Samuel: 'I think that Glasgow's literary heritage is a major part of the inspiration for the city's poets. Edwin Morgan, Liz Lochhead, and Tom Leonard, to name but three, have had a huge influence over writers here. More widely, I think there is a keen respect for literature and poetry, echoed in the close links with the arts and music scene of which Glasgow is also justifiably proud. The patter does enter into quite a lot of poets' work too, whether they are Glasgow born and bred, or welcomed from further afield. There is also a sense that overly pretentious work won't be suffered, and that the cityscape, and the people in it, demand more earthy, post-industrial insights.'

BEFORE STARTING MY research into this tribe, I knew nothing about the poetry scene in Glasgow. Having read some articles about the decline of poetry reading in recent decades, I assumed there might not be much going on at all. Then I stumbled across a performance poet named Molly McLachlan, still in her early 20s. She recommended an event being put on by Inn Deep on the Great Western Road, hosted by another young poet named Sam Small.

When I turned up, there were over a hundred people enjoying a rare, sunny Glasgow evening. The crowd was lively, with an average age of 20. A string of poets stood up and performed, surrounded on all sides. Some, making their debuts, were nervous. Molly also performed, a relative veteran despite her age, on the performance poetry and spoken word circuit in Scotland. Some performers read out their lines from their mobile phones, others lost their thread, stumbling through to the end. The crowd was supportive and generous. Whatever this was, I had found my first tribe, many of whom attended similar events in cafes and bookshops around the city.

Another performer I met that night describes how, 'Inn Deep belongs to what some members of the performance poetry call the Young Team – the young students and 20-somethings who dominate a lot of stages with youthful exuberance and passion and the kind of work poetry purists would probably hate.'

A more traditional poetry scene is centred around St Mungo's Mirrorball. It describes itself as 'The Glasgow network of poets and poetry lovers' and members include Jim Carruth, poet laureate of Glasgow since 2014. Jim put me in touch with a young poet named Samuel Tongue, who told me about his experience as a young poet in the city: 'For me, poetry has the ability to condense images, stories and ideas into the tight and explosive space of words, like the gunpowder in fireworks. Once lit by a performer or reader, the show can be mesmerising. St Mungo's Mirrorball has been my poetry home since I arrived in the city in 2008 and Jim Carruth and the rest of the group have been incredibly supportive of my work.'

'The poetry scene is very diverse, but most poets are connected to a group, or, perhaps move between groups and have multiple affiliations. There is a lot of cross-fertilisation between the groups. The support networks are vital – a lone poet cannot survive without peer feedback, readings and a few senior voices guiding and highlighting opportunities for poets new to the scene.'

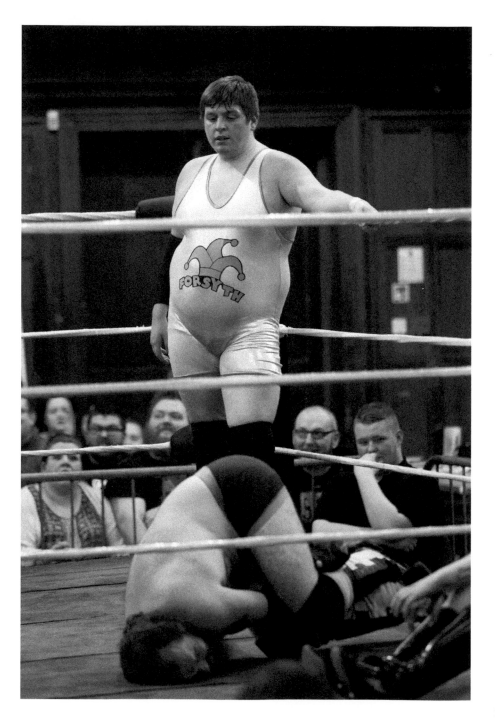

night. It was a testament to the dedication the wrestlers had to Source, particularly given that the financial rewards for less experienced wrestlers are modest.

The show itself is intimate, the crowd baying away. There are lots of overexcited kids, and adults wearing black, displaying multiple tattoos. Craig is transformed from the person I met at his flat in Maryhill into an 18 stone crowd-pleasing wrestler, children rushing forward to high-five him as he enters. He has real charisma – imagine Peter Kay mixed with a young Big Daddy. He tells me later that at school he was quiet, never wanting attention, so this side of his character has come as a surprise both to him and his family. Like many wrestlers on the local circuit, the rent is paid through a regular job, and Craig has to manage the sometimes difficult task of having a humdrum day job (in his case in a call centre) with being a larger-than-life wrestler beloved by young fans.

Wrestling tastes in Glasgow have changed hugely since the early 20th century when it was still a competitive sport in the same way as boxing. Wrestlers such as Frank Gotch and the 'Russian Lion', George Hackenschmidt, were world famous, filling stadiums wherever they fought. Glaswegians flocked to wrestling 'catch-as-can' bouts in venues such as the Govan Lyceum and in 1900 the previously invincible Alex Munro of Govan took on the legendary Hackenschmidt. The children of Govan would later taunt the defeated Munro with the shout 'Look out, Sandy, Hack's at your back!' The Govan show I attended was very different to the days of Alex Munro, but with schools such as Source attracting beginners brought up on ICW and other local home grown promotions, it seems likely the wrestling tribe in the city will only go from strength to strength in the future.

THE WRESTLING SCENE in Glasgow has changed considerably in the last decade, much of it due to the emergence of the Insane Championship Wrestling (ICW). Founded in 2006 by local boy Mark Dallas, ICW's originally modest shows were put on at Maryhill Community Centre. It soon connected with an adult audience who wanted a blood-spattered, more violent version of wrestling and ICW duly obliged. Television documentaries and clever social media marketing tactics brought ICW to national and then international attention. It now promotes sold out shows not just in Glasgow, but other cities such as Manchester and beyond. Media stars were made of unlikely wrestlers such as Grado, a tubby everyman comic character whose catchphrase 'IT'S YERSELF!' became famous. Other popular wrestlers who reflect the local ethos of ICW include the Bucky Boys – described as a 'gang of neds who fight in jogging bottoms and caps'.

Away from ICW, there is a small number of wrestling schools in Glasgow, one of which is Source Wrestling. Beginners to seasoned professionals train at Source under veteran wrestler Mickey Whiplash and there is a women only class that appeals to the growing number of female Glaswegians who have been bitten by the wrestling bug. The wrestlers at Source are like an extended family, regularly socialising outside of classes or events and helping each other with their character development and storylines. Some have dreams of making it to the top, the giant American WWF organisation, or wrestling in Japan. Others want to feature in ICW shows, or are content with just having the chance to perform at small-scale, family friendly shows at venues across the city.

One of the Source wrestlers is 23-year-old Craig Forsyth. He estimates there are about 80 wrestlers he is in contact with, giving some sense of the tribe's size. The physical demands mean the average age is fairly young – most wrestlers have stopped performing by their mid or late 30s, with some veterans moving into promoting shows or training. The wrestlers at Source do not just have to learn about the physical side of the business, but how to develop storylines and characters that will appeal to a wrestling audience. Many of the storylines run for months, wrestlers (in character) building up rivalries across social media so as to build anticipation amongst fans when the inevitable showdown takes place.

At a typical Source show I attended in Govan, the wrestlers had moved all the ring equipment from the training school to the venue. After the performance, they took down the ring and helped bring it back to the school and set it up again late that

One musician I meet uses the money he makes to collaborate on new music with his son, also a professional musician. Another tells me: 'I know people that do depend upon entertainment for a living and I think at a lower level it can be a bit of hard work. It depends upon the music you play and the reason that you are doing it. Some so-called wedding bands make a fortune, but I'd find doing that really tedious.'

For tribute bands that focus on a main star performer, the experience can be complicated. Much of the success of the band hangs on how they look, an actor's ability to create some intrigue and mystery that separates them from just being part of the better class of karaoke singers. It is a huge pressure and some can find it hard to switch back into 'civilian' life. 'Bowie' had this observation: 'I never had any bother with that until David died. Not because he was gone, but because people started going crazy about us. I think there was a time where I temporarily lost focus upon reality just a bit. I'm all right now though. I'm glad I'm me now.' Growing up a major fan of Bowie, the singer cherishes the memory of meeting the man himself: 'In the '90s when I was living in London. He was in a restaurant in Islington, close to where I lived. He was really approachable and very friendly.'

When I saw the band play a home gig in Glasgow, the atmosphere was electric and I noticed one woman dancing on the table near me sported a Bowie tattoo. She told me she had been a fan since 1974 and had seen this tribute act many times. It was more than just another good night out, but a crucial part of publicly celebrating her life-long fandom, something that stayed constant over decades whilst her personal life had suffered many ups and downs. The band is aware of their responsibility to fans like this to get it right and everyone leaves the venue happier than when they went in.

With the number of live music venues declining, does the new tribe of tribute artists squeeze out those trying to make their way with original material? 'Bowie' has a view on this: 'I think that the gap has narrowed and there are less spaces for new bands. I was a victim of this in the past when I was singing original songs in a young band and it used to wind me up when tribute bands took so much of the work and money! I do feel for young bands and I'd like to think that there is room for all of us. We've often given support slots to original young bands. Loads of them love Bowie!'

TRIBUTE ACTS ONLY emerged in Britain in the 1990s after the success of Bjorn Again, the Abba tribute act. Today they are everywhere. Killing time in a small town before attending a gig by Glasgow-based The Sensational David Bowie Tribute Band, I wandered the streets and noticed most of the posters advertising gigs were connected to tribute acts. Clearly in these troubled times people want nostalgia, but I wondered where the new breakthrough acts were coming from.

The gig was just weeks after Bowie's death and the atmosphere was charged. When the band took to the stage, it took a few minutes for the audience to warm up, but it was the women who led the way, usually in pairs, singing the lyrics, holding drinks and dancing. The men watched from the sidelines, finding it harder to let loose. But barriers came down and the interaction between 'Bowie' and members of the audience was touching; hands touch, almost like a big, boozy wake. The performance is excellent and later, when I listen to a live recording of a Bowie concert from the 1970s, I realise the standard of live musicianship on a Friday night in a small town bar is comparable.

You can find tribute acts playing in Glasgow every night of the week. Venues such as the Normandy Hotel near Glasgow airport specialise in genre, perfect for Hen nights and office parties. There is even an industry award for 'Scotland's Best Tribute Venue' (the hotel won in 2016 and favourites include tributes to Showaddywaddy, Abba, Dirty Dancing, Rod Stewart, Kenny Rogers and Take That).

There are probably between 30 and 50 tribute artists and bands active in Glasgow, suggesting a few hundred people earning some sort of living – mostly part time – from the public's love for nostalgia. 'Bowie' describes the experience of playing in the city compared to other places: 'Glasgow is really up there, as you can imagine. Sometimes the euphoria is staggering and the recent multiple sell-out gigs have been amazing. There's so many times when I can hear parts of the songs being sung along by the crowd. It's something amazing, almost like a football crowd.'

It isn't a perfect life. A jobbing musician might have to play in more than one tribute act to make enough money to avoid taking on a 9–5. For some it can be a chore, a disappointing end to a career that may have begun with ambitions to be a big star in their own right. On the other hand, the tribute artist industry allows many older musicians to indulge their love for playing long after they would otherwise have struggled to find a regular gig. At least there are no tensions about how to split the songwriting royalties.

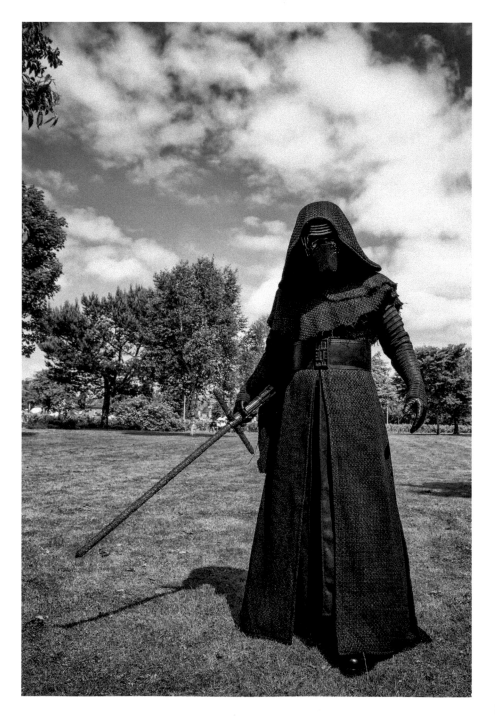

The more stormtroopers, the better it looks.' Joined by other enthusiasts, the 501st Legion was born.

The 501st Legion is a *Star Wars* fan volunteer organisation centred around dressing up and raising money for charity. Crucially, George Lucas supported the group, its stormtroopers being invited to attend *Star Wars* conventions organised by Lucasfilm. Today, the 501st has around 10,000 members in over 60 countries. Discipline is strict and a golden rule is that costumes must be 'screen accurate'. That means new costumes have to be vetted by senior members, often resulting in numerous rejections until the highest standards are achieved.

The Imperial Scottish Squad was recognised by the 501st UK group in 2010 after a six-month probation period. Ian McPherson, the Squad's leader, is in his late 40s and became a *Star Wars* fan at a young age. In 2005 he was browsing in an East Kilbride comic shop one day when he saw an advert to meet Darth Vader and the stormtroopers. He made contact with the 501st UK Garrison and went on to become its main organiser in Scotland.

The Squad takes part in around 40 events each year, with Glaswegians in the tribe coming from a variety of professions, including the police force. Part of the attraction for Squad members is exploring an alternative side to their personalities. Strutting up and down dressed up as a *Star Wars* baddy in front of an awestruck public provides an incredible, natural high.

There are parallels with the Cosplay scene, but the strict discipline imposed by the rules of the 501st Legion structure also distinguish it. Ian however does find time to dress up as other characters, mainly from the *Planet of the Apes* series and as Judge Dredd. The reboot to the *Star Wars* franchise in recent years after Disney acquired Lucasfilm means a film idea from 1977 could – amazingly – become an ever bigger deal in decades to come. It seems likely the quasi-religious, tribal nature of the hardcore *Star Wars* fan base will continue to attract more disciples. If this sounds far-fetched, bear in mind that the 2011 Census lists 177,000 people in Britain who described Jedi as their current religion. As Yoda said, 'Grow from an acorn a mighty oak will.'

LIKE MANY PEOPLE of a certain age, one of my strongest childhood memories was seeing the first *Star Wars* film in 1977. The hype around the film had been building for weeks and I took the bait like everyone else. Like most of my friends, I dutifully watched the next two films (culminating with *Return of the Jedi* in 1983), but my levels of interest were diminishing. The three later films between 1999 and 2005 left me cold.

For others the impact of the Force was more profound. Perhaps the most devoted tribe of *Star Wars* fans in Glasgow are those who are members of the Imperial Scottish Squad. Comprising around 35 members, the Squad regularly turns up wearing full *Star Wars* costumes to charity events, shows, weddings and even funerals.

When I went to meet the Squad at a military show, there were thousands of people milling around and I wondered how I would find them. But then I noticed heads turning in a single direction, as if some force was moving through the crowd. I moved closer to find the Squad in full *Star Wars* costume, completely surrounded by mesmerised onlookers. Soldiers who had previously attracted admiring looks for their best regimental outfits, were now ignored. Later the same soldiers would queue up alongside children to have their photos taken with the Squad. For a short while it seemed the dividing line between reality and fantasy had disappeared.

The Squad are fantastic with the public, jumping on and off military vehicles to pose for photographs, holding machine guns, doing anything that is asked of them. Only later, during a break, do I get a chance to see them out of their heavy costumes, sitting inside a tent having a short break. It is one of the hottest days of the year and they are all exhausted and sweaty. But then it is costumes back on, back into the fray – no complaints, more money for charity.

The origins of this tribe go back to the 1990s when two American *Star Wars* fans named Albin Johnson and Tom Crews realised they had a common interest in dressing up as stormtroopers. Johnson was born in 1969, so – like me – was the perfect age to be caught up in the *Star Wars* hype in 1977, seeing the film 20 times. Later he had a limb amputated after an accident, the result being he 'hid in [his] house and felt like a freak'. To console himself he made his own stormtrooper costume, and when he eventually left the house to attend a *Star Wars* screening in costume, people poked fun at him. When he and Crews turned up to another event together the reaction was completely different, Johnson recalling 'that's when the switch really flipped...

May the Force Be With You

the Hunger Strikes, some young Glaswegians decided to take action. The senior members of the Parkhead Republican RFB were part of this new movement and the date of the band's formation in 1978 was no coincidence. The band's original name – the Volunteer Billy Reid Republican Flute Band – reflected these turbulent times, Reid being an IRA volunteer who died in 1971 (according to the band's Facebook page 'brutally murdered by the crown forces of occupation while on active service for his country'). The band also became part of a wider Republican band movement – the West Coast Band Alliance.

While the band is ostensibly a close-knit, independent group of musicians, it cannot avoid the ups and downs of Irish Republican politics. The Good Friday Agreement in 1998 resulted in new divisions forming, as some hardcore Republicans decided Sinn Féin had conceded too much ground to the British. In Scotland the Republican flute bands had to choose sides. Parkhead, wishing to remain independent, stayed within the West Coast Band Alliance, whilst several bands left to link themselves to *Cairde na hÉireann* (Friends of Ireland), associated with Sinn Féin. There are therefore tensions not just between Republican bands and their Orange counterparts, but within the Republican band movement itself.

I walked with Parkhead RFB on a second, much bigger march involving a dozen bands and celebrating the centenary of the 1916 Uprising. Walking from Queen's Park to the Gallowgate, surrounded by hundreds of supporters, I could understand the impact of the parades. Traffic stops – indeed everything stops – and everyone turns to stare. I saw no violence or bad behaviour from anyone, including bystanders, and the stewards appeared to have everything under control. At the end, political speeches were given, speakers including controversial figures, such as Tommy Sheridan and Gary Donnelly, a prominent Irish Republican and councillor in Derry.

The future of bands such as Parkhead RFB is unclear. Many in the city dislike the marches regardless of which side of the sectarian divide they are on, believing they just perpetuate divisions that are bad for the city's image. I can see that, but on the other hand they remain a rare reminder of the working class immigrants from Ireland who would shape Glasgow.

THE PARKHEAD REPUBLICAN flute band (RFB) is the oldest continually operating group of its kind in Scotland. Founded in 1978 at the height of The Troubles, the band is dedicated to supporting the Irish Republican cause. Its members are working-class men, many from the Parkhead area and proud of their Irish ancestry. The band's activities revolve around weekly band practices and playing at a variety of events. This can range from playing to their core supporters in sympathetic pubs and social clubs in the city, often before Celtic games, to taking part in large-scale parades in Scotland, Ireland and England. The band members also regularly socialise together, meeting in local pubs and often attending Celtic games.

I joined the band on two marches. One was around Parkhead, their tribal stamping ground, in order to mark the 39th anniversary of their foundation. Joined by other independent Republican bands such as Garngad Republican Flute Band from Royston, Parkhead RFB led the parade from its starting point at the band's beloved Celtic Park, before following a route around the local district. For an outsider like me, the atmosphere felt tense at times – not helped by a significant police escort – particularly when passing by a Loyalist building (Union Jack, barbed wire, no windows on the street). At one point a car veered close to the marchers, the man in the car giving us the finger. Others sullenly looked down from their windows, having clearly seen this all before on many occasions.

The flute band movement grew up in the 19th century, as Irish immigrants – largely Catholic but also Protestant – flocked to Glasgow to escape economic hardships at home. The Irish immigrants brought sectarian conflicts with them. The flute bands of the Catholics were usually connected to the local church, or organisations such as the Ancient Order of Hibernians. The Protestants had their Orange Lodges and each side would take part in parades that marked significant dates for their respective communities.

The authorities tried and failed to ban the flute bands – terrified by the huge crowds that turned out in support and the frequent outbreaks of violence. The band members were (and remain) working-class and their aim was not just to remind people of their political and religious allegiances, but represent their local communities.

During the 20th century the size of the parades began to reduce, however The Troubles of the 1970s kick-started a new wave of flute bands being formed. Angry at how the British government were treating Irish Republicans and horrified by

Flute Band

Other LGBT friendly sports and leisure groups founded in recent years include Saltire Thistle FC, the Glasgow Gay Rambling Group, the Glasgow FrontRunners running club and the Glasgow Alphas, a gay-inclusive rugby club that was founded in 2015 – the same year as the first ever professional Rugby League player came out of the closet.

These new LGBT clubs in Glasgow also offer an alternative way for those in the LGBT community to socialise. Ewan's view is that: 'Less people from the LGBT Community are visiting the commercial gay scene now, mainly because there is more inclusivity. It's great that there are more ways now in which LGBT folk can meet face to face and engage in an activity other than the bars or the apps.'

The atmosphere at Knockout is open and friendly and Ewan encourages people from outside of the LGBT community to join. I suspect that many people, particularly women, and regardless of their sexuality, might feel intimidated joining a traditional boxing club in Glasgow, so Knockout offers an alternative. It is also perhaps offers a glimpse at how sports clubs may develop in the future, the ethos being more inclusive and welcoming to people from different backgrounds.

THE LGBT SCENE in Glasgow is well established. However, many people under 30 might be surprised to learn that homosexuality was only decriminalised in Scotland as recently as 1980 – 13 years after the equivalent change to the law in England.

Despite progress in recent years, many members of the LGBT community feel uncomfortable joining what are perceived as being male bastions of sport in the city, particularly combat sports and rugby. This led Ewan, in his early 40s, to found the LGBT friendly Knockout boxing club.

Boxing does not have a reputation for being LGBT friendly. Not a single professional Scottish boxer is openly gay, and the first ever professional boxer to come out was only in 2012. In recent years, high profile boxers such as Manny Pacquiao and Floyd Mayweather have been widely reported as making homophobic comments, hardly something to encourage members of the LGBT community to pop down to their local boxing club.

The Knockout club addresses this problem, with coaching provided by Boxing Scotland, the sport's official body in this country. To their credit they recognised more could be done to promote the sport within the LGBT community, and have worked closely with Ewan to set up the club. Some funding has also been provided by LEAP Sports – a Scottish charity based in the city that does a great deal of good work in trying to break down some of the barriers that prevent members of the LGBT community from taking part in the sporting world.

At a training session at Knockout, I meet the club's first 'tribe' of boxers – a mix of students, carers and working people, aged from late teens to mid-40s. The club is also suitable for older people, as it is largely based around fitness and coordination rather than full-on sparring. Whilst some members have boxed or taken part in martial arts before, many have not and one tells me that she would almost certainly not have considered going to a traditional boxing club for fears of prejudice. This concern is not unfounded – Ewan describes his experience at a martial arts gym in the city when he was on the sharp end of homophobic comments from one instructor: 'It didn't make me feel welcome or included, and I dreaded to think about the impact of these comments on any young people who perhaps were struggling with their sexual orientation or gender identity.' The positive side of the experience is that he set up Knockout, and now others who would not have taking up boxing have a chance to do so.

159

In 1954, Glasgow's most influential Polish institution was formed – the Sikorski Memorial House, dedicated to the memory of General Władyslaw Sikorski, Prime Minister of the Government in Exile and Commander-in-Chief of the Polish Forces during WWII. Commonly referred to as the Sikorski Polish Club, it soon became the main meeting place for Polish community in Glasgow. Young Poles who have arrived in recent years are starting to make their mark on the club, with new ideas about how to do things. It will probably take a little longer for two tribes united by a common nationality to decide what the club should stand for in the next few decades.

The artefacts inside the club reflect the concerns of that post-war generation, with graphic illustrations depicting Russian atrocities. Much of the message is probably lost on those who grew up in Poland after the collapse of the Soviet Union in the early '90s. Based in Parkgrove Terrace (opposite Kelvingrove Park), the club has around 400 members and includes a restaurant, bar and accommodation for a Catholic priest. The club also hosts a wide range of events ranging from Polish language classes, book fairs, film nights and dances.

Several younger Poles I met do not feel the need to be part of the Polish community in the city. This is in contrast to the post-war Poles who founded the Polish club. Perhaps young Poles find it easier to integrate into Glasgow life than their predecessors. Many marry Scots and get good jobs, so have less need for the support networks other groups feel they need to thrive.

Poles have entered all aspects of life in Glasgow in recent years and whilst writing this book I met bodyguards, shop owners, doctors, architects, photographers, nurses and baristas. One young Pole, a photographer, told me: 'We, as a nation, are generally distrustful of people, but it's especially true when it comes to other Polish people abroad. Personally, I've never been to the Polish club – I never saw the point. I left Poland because I didn't want to live there, so I didn't feel the need to try and find pockets of 'Polishness' here. I do have a couple of Polish friends here, but they tend to be people who I knew back home and who happened to move here as well. I don't think in my 13 years in Glasgow I've made lasting friendships with other Poles.' With Brexit, it may be that many of the new members of the Polish tribe return to Poland and we will witness yet another stage in the historic connections between the people of Glasgow and Poland.

THERE ARE ARGUABLY two Polish tribes in Glasgow. The first comprises those who trace their journey to Scotland back to those Poles who were stranded here after WWII. The second group – far larger – has arrived since 2004 when Poland became a full member of the EU. The original tribe numbered only about 1,000 people in 2004, whilst today there are over 10,000 Poles in the city.

Many Scots assume our links with Poland are fairly recent, however the truth could not be more different. Scots once migrated to Poland – around 30,000 Scottish families are thought to have lived there at the start of the 17th century. The 19th century wars in Eastern Europe saw many Poles come here as exiles, whilst in the early 20th century a new wave arrived to work in our coal mines.

However, it was WWII that changed everything. Thousands of Polish servicemen and their families were stationed in Scotland, and in 1942 their President in exile opened a school for Polish children in Glasgow. St Simon's Catholic church was adopted by Polish soldiers and became known as the Polish Church – an association it retains to this day. When the war ended, everyone expected the brave Poles to go home, but they refused. Stalin's brutal takeover of their homeland meant that they risked political persecution or even worse. The Russians had form, executing 20,000 Polish prisoners in the infamous Katyn massacre of 1940.

Unable to go home, Poles faced outright hostility from many parts of society here, despite having risked their lives to save Britain from Nazi occupation. One example from 1946 involved employees of Mechans Ltd., an engineering and boatbuilding company based in Scotstoun, who wrote to the *Sunday Post* announcing their decision to 'draft a protest' against Polish settlement, seeking help from other organisations in Scotland so 'a national protest can be made'. Beside their letter is another from a Glaswegian proudly recalling his time serving in the 302 Polish Squadron: 'I am proud to call any Pole my friend'. This has echoes today as many Poles feel unwelcome in Glasgow after the Brexit Referendum.

The Poles left here after the war proved a remarkably resilient tribe, creating their own self-help networks, including hundreds of ex-serviceman clubs. One legacy of this era is Antony A.C. Kozłowski (pictured on page 159), a second generation Pole, born in Scotland after his father was unable to return home. Sadly, all members of the first generation of Poles who came to Scotland during WWII have now passed on, but Antony is keen to keep their memory alive.

of banter between both groups, the scooter rallies have become a popular part of the calendar all over the UK.'

The scooter scene brings together many elements that were originally separate subcultures – mods, skinheads, Northern Soul, or just scooter enthusiast – often united by a love of American soul music. In and around Glasgow there are several scooter clubs such as the Glasgow Globetrotters Scooter Club (founded in 1980) and Paisley's Animals fae Naboombu Scooter Club (1987) – just some of the 70 clubs in Scotland.

DJ Mickey Collins, who organises Taylor Made mod club, estimates there are about 350–400 people who regard themselves as mods in Glasgow. Mickey sees about 50–100 mods turn up for weekly events, ranging from teenagers to original mods in their late 50s and 60s. The night also attracts skinheads, scooterists and soul music fans. He also helps organise some of the main mod get-togethers in Troon (May bank holiday) and the Glasgow Mod Weekender (June). Apart from attending scooter rallies, and dance nights, many members of the city's mod tribe frequent McChuills on the High Street, run by original mod Nick. For a subculture that began in Soho nearly 60 years ago, the mod scene in Glasgow appears to be remarkably resilient.

from that era still enjoy everything "mod" – the music, the styles and scooters. I was too young to appreciate it when The Jam first appeared on the music scene in early 1977, but two years later I caught up because I hung around with a group of boys in their early teens. The Jam released their third studio album *All Mod Cons*. They managed to shake off any punk influences on their first albums, and it was not just the fresh sound of the albums tracks and the "sharp" style of hair and clothing on the front cover that appealed to me, but the song's lyrics were politically current, having a dig at the upper classes and Tory government. This gave the band a direction that allowed their fans to associate the struggles of everyday life with the lyrics of their songs.

'By either good timing or pure coincidence, The Who's long-awaited film and soundtrack album *Quadrophenia* was released in 1979. It contained a catalogue of classic mod tunes that I had not heard before. I was instantly hooked. The style of the clothing was sharp and unique from the button-down shirts to the tonic suits and the iconic fishtail parkas. Any money I earned from my paper round would go towards clothes and music. I remember buying a pair of dogtooth trousers, Prince of Wales trousers, a two tone three button suit and a pair of 'Jam' shoes at 12 years of age, all of which I still own.

'As for the scooters... the attention to detail, the chrome, the mirrors, the sound – I would not have the privilege of owning my own scooter until I was 14, a "wreck" of a Vespa 50 Special that became my pride and joy with at least a dozen mirrors, more lights than I can remember and a six foot aerial that could take an innocent pedestrian's eye out. In two whole years of driving almost every day underage with no tax, insurance or licence I was only caught once and received a slap on the wrist for my "minor" offence.

'When it was announced The Jam were splitting up in 1982 I was totally devastated. I was lucky enough to attend their final Scottish gig in the Glasgow Apollo (after waiting in a queue overnight). I witnessed grown men crying.

'In the early days the skinheads and the mods did not get on together (I got a few bruises to confirm this). A common fascination with scooters meant that as mods and skinheads reached an age when they could own and ride a scooter of their own, they reduced their aggression towards each other and concentrated on arranging scooter rallies. "The more scooters the better" was the attitude and, apart from a bit

THE MOD SUBCULTURE emerged in Soho in the late '50s, its original members being working-class and part of a countercultural movement that was obsessed with modern jazz (hence mods), and Italian and French fashions (explaining the sharp suits and Vespas). In the early '60s, American soul and R'N'B replaced jazz as the preferred music of choice for younger mods and this youth subculture began to spread out from London to become a national phenomenon.

Nick Stewart, proprietor of McChuills bar on the High Street, was part of that early scene. He learnt about mod culture and music from Radio Caroline and the music papers and in his early teens became an apprentice mechanic. This funded trips down to London to attend nights at Mod HQ, the Flamingo club. For a young working class Glaswegian kid it was an incredible experience to be hanging out in London at this time (he also went to the Twisted Wheel in Manchester, later the birthplace of Northern Soul).

Nick remembers the '60s mod scene in Glasgow as working-class and cultured – Nick enjoyed European New Wave films, aping the dress styles of Jean-Paul Belmondo. He recalls nights spent at the Maryland on Scott Street and buying soul records at Gloria's Record Bar on Battlefield Road. One of his biggest regrets was missing a Tamla Motown All-Star Revue because he was worried about being seen going to a mainstream show. Nick estimates the original Glaswegian mod tribe had around 400 members.

Like many other working class mods, Nick left the scene in around 1966–67. He disliked the influence American Flower Power was having on mod fashions and preferred the sharper, more conservative styles of the early mod period. Others from that era became 'hard mods', morphing into skinheads and suedeheads, whilst some soul fans formed the beginning of the Northern Soul movement. By the mid-'70s it seemed the mod subculture was as good as over, as irrelevant as the Teddy Boys.

However, the mods returned, perhaps the greatest rebirth in British subcultural history. At a scooter rally in Glasgow I met Mark – a sharply dressed mod sitting astride a gleaming scooter. In his late 40s, he told me about his experience of the mod revival.

'In 1979, at the age of ten, I experienced the "mod revival". Musically it only lasted for three to four years but it planted a seed so that to this day huge numbers of mods

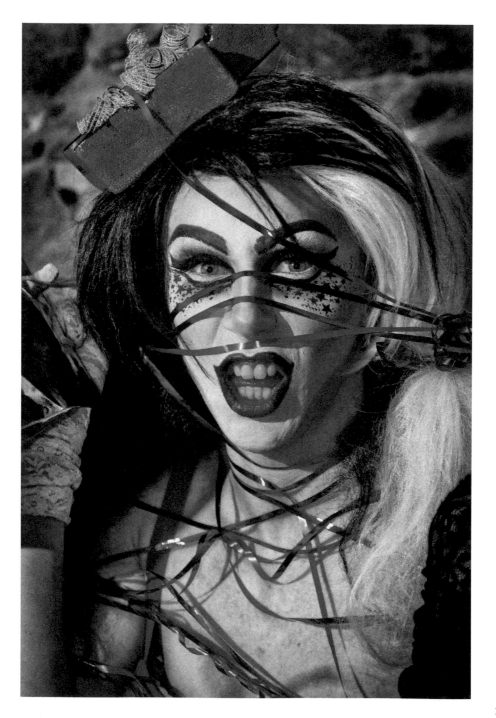

– 'Drag Mothers' – to help initiate them. This means getting advice on everything, from what make-up can cover up stubble, where to buy clothes, and how to create a dramatic stage persona (including a memorable name, and back story). However good a queen looks dressed up, the real test is whether they can hold the attention of a live audience.

Since 2009, the American superstar drag queen RuPaul's television series *Drag Race* has had a profound influence, many crediting him with bringing drag queens out from the underground and into the cultural mainstream. This is evidenced by the fact the show's live tours sell out large venues around the world (including Glasgow's SEC Armadillo). Suddenly young gay men in Scotland had a whole new reference point and many moved to Glasgow to pursue their ambitions to join a revitalised drag scene.

Whilst previous performers might have looked to Danny Le Rue, or Lily Savage, the variety of styles, races, and sizes on *Drag Race* has opened everything up. Rujazzle told me: 'Performers are absolutely influenced by American drag, but more so just modern drag and aesthetics and music in general. Old school British drag queens looked up to Liza Minnelli or Shirley Bassey. Modern queens look up to Lady Gaga, Ariana Grande, etc.'

Edging towards the mainstream may suggest the future of this tribe seems assured, its position in the evolving LGBT community may change. Controversies can erupt when the unwritten rules are enforced, causing offence to new groups that had no visibility when the drag scene first evolved. Even RuPaul, the closest thing to a Pope in the drag world, was involved in a media frenzy when he suggested trans women should not be allowed on *Drag Race* (he later clarified his position). Some feminists have objected to how queens portray women, and in 2015 queens were (briefly) banned from a gay pride march in Glasgow because organisers thought they might upset transgender individuals. As it continues to emerge from the underground, this Glasgow tribe will need to continue to change and adapt.

GLASGOW HAS A thriving LGBT community, most noticeable in and around the Merchant City. Drag queens are a small but highly visible part of this community, and prominent performers include Rujazzle, October Fist, Gwen Hart, Bee Fiarse Beaujambes and the Perry Cyazine (aka 'Bitter Bearded Bitch').

Most are in their early to late 20s and Rujazzle told me: 'There are over 100 drag queens in Glasgow, although the vast majority don't do drag full time. I do drag full time, and so do around ten or so others. The main places are the Gay scene: Polo, Delmonicas, AMX, Katie's Bar, etc. Then there's a handful of straight venues that hire queens for less regular events – such as the Hillhead Bookclub for the monthly Lady Balls Bingo.

'We generally all know each other, but there are certainly groups of friends who work together closely, and regularly, for example the Mothertucker Queen (Polo and Dels) or the Trigger Queens (AMX)'.

Many are students or ex-students (Rujazzle studied art at St Andrew's University). In terms of occupations, Rujazzle observed: 'We have a vast array of different jobs, as every queen is quite different from the other. I have friends who work in banks, restaurants, fabric shops, graphic design, and call centres.'

The drag scene is underpinned by a complex set of unwritten rules that is a legacy of the days when the scene was almost totally underground, operating in the shadow of anti-homosexuality laws. Queens developed their own mannerisms and language (for example some are 'fishy' – meaning deliberately feminine – others are 'fluid' or 'camp' or goth').

Men have dressed up as women to perform for thousands of years, but it was only from the 1930s that the drag scene – associated with the gay community – developed in its current form. In America, queens became the shock troops of the gay rights movement, standing in the front line during protests against oppression and police harassment. Charlie Hides, a British drag queen, summed up the importance of the scene recently when he said: 'Drag queens are defiant. We are the counter culture, the opposition party. We are everything that the moral majority and small-minded bigots fear.'

Joining this scene for the first time can be intimidating, and many seek out mentors

into paid slaves – unable to work elsewhere without the permission of their current employer. On the other hand, the owners could dismiss workers with no notice or compensation, usually resulting in the immediate eviction of a miner's family from a tied cottage. the Habeas Corpus Act of Scotland of 1701 even had a special exclusion clause in the case of miners.

Whilst reforms would take place over the years, relations between miners and management remained poor throughout the 20th century. The retired miners I met in the club stopped working in the '80s when the Thatcher government effectively killed the industry off. The result was that 250,000 jobs were eventually lost and today around 90 per cent of the coal used by Britain's power stations is imported. The old men seemed bitter about all that good coal left lying in the ground.

When talking about the miners' strike of 1984–85, their eyes lit up as if the events had happened only yesterday. Some of them had been paid off and retired with good financial packages, but clearly missed being part of the industry. Many of their friends had not lived long enough to enjoy the redundancy packages, dying from lung diseases and other illnesses. It was poignant talking to them here – the last survivors of a community that would have once filled this club to bursting.

I asked one of the men if he ever regretted going into the mines, following in the footsteps of his father and grandfather. He shakes his head, telling me he has had a good life, although he misses the camaraderie of the old days, particularly the humour.

I ARRIVED AT the Tannochside Miners' Welfare Club in Uddingston on a grey, miserable day. The club looked like it had seen better days and the interior is empty, except for the barman. He assured me the retired miners would be arriving soon for their fortnightly meeting so I sat and waited. Eventually four elderly men in their 70s and 80s filed into the large, empty club room and sat down. I bought them a round – diet Irn-Bru and vodka being the most popular tipple.

I sat and listened for a while, the old men clearly not used to strangers showing much interest in their get-togethers. Slowly the jokes began to come and then the reminiscences; there was a great deal of chat about insurance claims for various diseases they or their friends had suffered from the years spent working down the mines. I discovered they were all second or third generation miners, some having first entered the pits as teenagers just after the collieries had been nationalised in the '40s.

Like this small band of elderly men, the club house itself was a relic of a lost age. It began as a welfare club in 1924 when local collieries were still active. It served as an important focal point for the mining community, providing facilities for sport, entertainment and further education. The bitter miners' strike of 1926–27 saw many local mining families become destitute and in those dark days the welfare club would have been particularly important. By 1929 a local paper was reporting on the success of the domino and cards tournaments at the club, and the events that took place here were regarded as being newsworthy for the local community.

The retirees had originally worked in the same local collieries where their fathers and grandfathers had worked. From the 1950s, these began to close down and the miners were forced to travel further afield to get work. As the concentration of local miners began to dwindle, the Welfare Club instead became a social club for the local community as a whole. I found several accounts of events held here in the '50s, the venue 'packed to capacity' for performers such as the Kirkintilloch Junior Highland Concert Party with George Gilligan – the 'Voice of Scotland'. A harmonica band practised every Tuesday and Thursday on the premises. In this rather threadbare club, it is hard to imagine these glory days.

The history of mining in Scotland can appear unremittingly grim. For hundreds of years mine owners were able to work the system to keep their workers on a short leash. In the 17th century, legislation was passed that effectively turned miners

The Miners

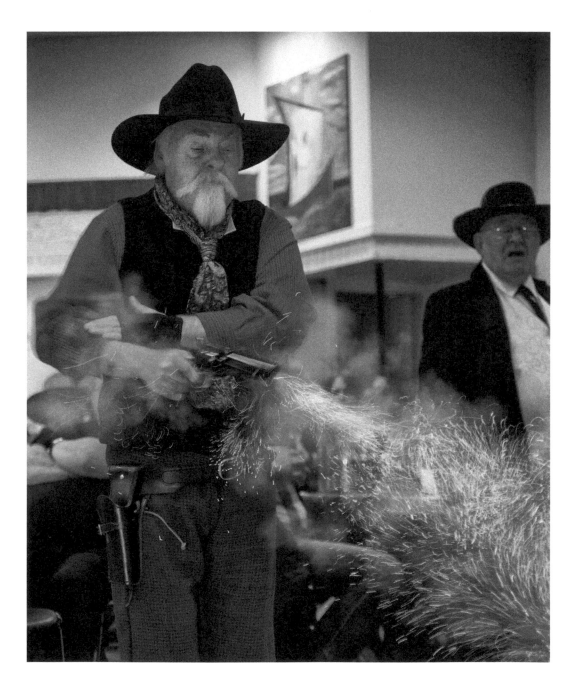

reaction speeds and by 1960 there were around 100,000 participants taking part in events. The Scottish Fast Draw Association was founded in 1975 and an enthusiast named Peter Hill (aka Ned Christian) – a regular at the Glasgow Grand Ole Opry in the late '70s – was the main driver behind the founding of the Glasgow Gunslingers club in 1981.

Many of the Gunslingers were drawn to fast-draw after being brought up on a fare of Western films, comics and television shows in the decades following wwii. Long before that many Scots, particularly drovers from the Highlands, became cowboys in American during the 19th century. Others emigrated there or travelled back and forth on merchant ships, perhaps explaining why so many Glaswegians are so fascinated by American culture. There were enough Scots living in New York during the American Civil War to form their own fighting regiment – the 79th New York Cameron Highlanders.

The Gunslingers of today are closely connected still to the city's c&w scene, often holding fast-draw demonstrations during club nights and taking part in the American Trilogy flag-folding ceremony that celebrates those who died during the Civil War and other tumultuous events in us history. At its peak, the Gunslingers had around 100 members, mainly drawn from members of the Glasgow Ole Opry. Today it has far fewer than that, but they remain a tight knit, friendly tribe, united by a love of dressing up as cowboys and cowgirls, socialising with c&w fans and testing their skills against the clock. If you ever want to experience this tribe yourself, you can join a practice session – just remember your earplugs.

THE GLASGOW GUNSLINGERS grew out of the city's Country and Western scene in the early '70s. I first meet the group assembling for their practice session in the basement of a tough looking pub near Glasgow's Grand Ole Opry. Craig – aka BJ Colt – introduces me to the other club members, who then bring out a strange array of equipment: a timer that could have come from an episode of *Dr Who* made in the '70s; a horizontal stand to which a balloon is attached.

Everything takes place under a garden gazebo-style structure, except the roof is attached to a huge, anaconda-type air extractor. The Gunslingers then unpack smart cases which reveal beautiful Colt Peacemakers and other replica weapons from the golden age of the American Wild West.

Holsters are put around waists, positions are taken. Whilst tonight the Gunslingers are not in costume, they start to look the part. I am particularly drawn to one man in his 70s whose alias is The Silver Fox. With grey hair and sideburns, he has the poise of Clint Eastwood c.1967. He stands silently, hips low, hand steady above the handle of his revolver. In a fraction of a second the light by the balloon goes off, starting the electronic timer. The Silver Fox whips out the revolver, a single-action piece that requires him to hit the trigger with the other hand. The revolver emits enough powder from the blank round to burst the balloon, stopping the timer and nearly rupturing my eardrums. I try to imagine what unusual activities might be taking place in other pub basements across the city on a wet Tuesday night.

Months later I visit the Gunslingers at the Phoenix Country and Western club in Yoker. Everyone is dressed in Western outfits and the Gunslingers are the centre of attention. They fire their guns during a break from the country band. It does not feel like we are in Glasgow but a small town in Mid-West America in the 1870s.

The Gunslingers all have aliases: The Traveller, Curly Bill, The Bounty Hunter, Country Joe, Daisy Duke, The Red-headed Stranger and Little Dakota. One lady – 'Rising Sun' – tells me she drives huge lorries for a living. When I ask if she ever changed her Western name she grimaces and explains that, once bestowed, your alias is kept for ever.

Fast-draw began in America in the '50s due to the efforts of Dee Woolem, a stuntman who organised Wild West shoot ups for tourists visiting Knott's Berry Farm in Anaheim, California. He created the first electronic timer that could measure

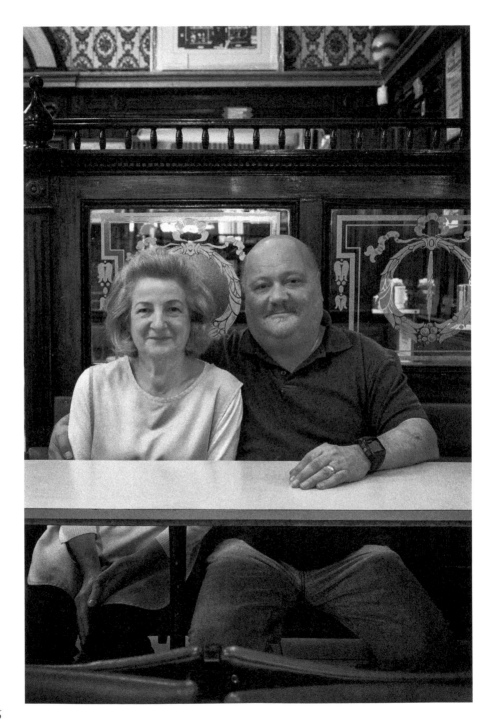

what today would be called a legal high. He also recalls darker days in the family's history – when his grandfather was interned during WWII on the Isle of Man, even though Gino's father served his country by serving in the Royal Navy. Gino met his wife Lydia at a dance at the Casa D'Italia, whilst his own daughter married a man from the family's old village. Whilst Gino speaks Italian, he is aware the phrases he learnt from his grandmother are antiquated and no longer used back in Italy.

The organisation and charity 'Italian Scotland' plays a key role in organising events for the community that remains, the largest being the traditional La Scampagnata ('day out in the country'), which includes a mass, football and bocce tournament and – of course – an ice-cream van. Today the spiritual home of the community is perhaps the Italian Cloister Garden in St Andrew's Cathedral which opened in 2011 and contains a memorial to hundreds of Scots-Italians who died on the Arandora Star that was sunk by the Germans during WWII. In recent years, many new, younger Italians have arrived to live and work in the city, driven by high unemployment rates at home. Living in the shadow of Brexit, these new arrivals are unlikely to revive the glory days of the original Italian community in Glasgow.

The connections between Italy and Glasgow go in both directions. If you happen to be in Barga in Italy in summer you can experience Barga Scottish Week and the Fish and Chips Festival, both testament to the immigrants from Barga who made their home in Glasgow so many decades ago.

the Italian community has been less focused, successive generations becoming more Scots than Italian and memories fading away. Few younger members speak Italian any more, although many still have loose ties with relatives back 'home'.

I visit Luigi's brother, Enrico, who runs the Tivoli on Stockwell Road, its walls covered with faded photographs showing the family over several generations. He wistfully remembers attending discos at the Casa d'Italia in the '70s with his young Scots-Italian friends, afterwards racing around Park Circus in their cars, like a Glaswegian version of Saturday Night Fever. He describes how the growth of coffee chains and other fast food outlets, coupled with rising rents, has forced many traditional Scots-Italian establishments to close. Some of the few that remain are The University Café (Byres Road), Guido's Coronation Restaurant (Gallowgate) and Café D'Jaconell – or Jaconellis – on Maryhill Road. It is possible that within a decade they will all have disappeared. If they do, with them will go the last public reminders of the original Italian tribe who made such a mark on Glasgow a hundred or more years ago.

The Italian community has long faced challenges. During wwii many were interned on suspicion of being fascists, whilst mobs smashed the shop windows of Italian businesses. The community survived, but in the post-war years younger members began to break away from the more rigid social conventions of their parents – marrying non-Italians and going into trades other than the family-run cafes and fish and chip shops.

The University Café on Byres Road was founded in 1918 by Alfredo Verrecchia – an economic migrant from the Province of Frosinone. Alfredo originally worked as a carpenter fitting out ships built in Glasgow's shipyards before opening the café (you can still see his carpentry inside). Today the café is run by later generations of the family – twin sons Carlo and Rico and their brother Gino. It is tough work running the café and fish and chip shop next door, although the homemade ice-cream remains some of the best in Scotland. For the sons, not working in the family business was never really a practical option, even though – like Luigi Corvi – they may have dreamt of other careers.

Gino recalls the busy days of the past when pubs shut at 10pm and every Friday and Saturday dozens of male drinkers would then flock here to fill their stomachs with soup and black coffee before heading home. He laughs at the memory of teenagers hanging around the café, putting aspirin in their bottles of coke cola to try and create

WHEN I FIRST entered the Val D'Oro restaurant on London Road, 'Home of the Great Glasgow Fish Tea', the owner, Scots-Italian Luigi Corvi, is talking to some German tourists. Without much warning, Luigi starts singing a German operatic piece, sitting beside the stacked up fried fish, still wearing his white apron. He tells anyone in earshot about his life story and how he almost became a professional opera singer before accepting the responsibilities of the family business. It is not something you experience in the local Starbucks. Owned by the Corvi family since 1938, the Val D'Oro is one of Glasgow's legendary chippies. However, despite the German tourists, it is pretty quiet. Luigi nostalgically recalls the old days when it was packed to the rafters, with queues stretching down the pavement.

The story of the Scots-Italian community began with a great influx of economic immigrants mainly from Picinisco in Lazio and Barga in Tuscany from the 1880s onwards. As Catholics and foreigners, settling in Glasgow was not easy. Many looked at the success enjoyed by another Italian, Carlo Gatti, who introduced ice-cream to Londoners and soon hundreds of Italians could be found walking the city's streets selling ice-cream from hand carts. Their cry of 'Gelati, ecco un poco!' led to them becoming known as the 'hokey pokey' men.

By 1903 there were 89 Italian-run ice-cream parlours in the city, and 336 just two years later. Their growth helped the new Italians assimilate into a city, providing something new and not undercutting the wages of those already living here. However, more conservative and religious people were resistant to the charms of ice-cream, believing Italian-run establishments encouraged youngsters to smoke and enter prostitution. A 1907 article in the *Glasgow Herald* reported on a debate on Italian ice-cream parlours held at a United Free Church conference, where they were described as 'perfect iniquities of hell itself and ten times worse than any of the evils of the public house'.

A distinct Italian community developed in the city, based around their cultural centre – the Casa d'Italia – that was founded in 1935. Located at 22 Park Circus, generations of Italians socialised there, meeting their life partners, attending language classes, dances, theatrical productions and maintaining contacts. The community also forged strong links with existing Catholic churches and there is still an Italian service held in St Andrew's Catholic Cathedral. The Casa d'Italia closed for various reasons in 1989 (I have heard several conspiracy theories), marking a watershed moment for the immediate descendants of the original Italian immigrants. Since then

The Italians

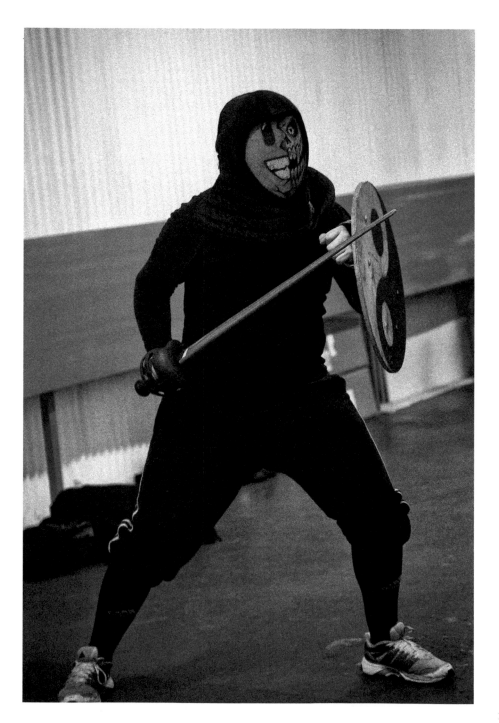

perfection in the use of this weapon as the Scots: and amongst them the Highlanders are most expert. From their youth they are train'd to it, and with the addition of the Roman target, they excel in the Roman method of fighting; having invented a great many throws, cuts and guards, unknown to the Roman gladiators.'

I ask Keith about the challenges in trying to interpret these historic manuals in the modern age: 'It is possible to reconstruct these fighting methods with a high degree of accuracy by reading the historical sources, as long as we take a scientific approach informed by good academic practices. Simply reading a book, grabbing a sword and jumping in to sparring in order to 'work it out yourself' is probably doomed to failure, but there are several instructors around who teach what I believe to be an excellent and believable interpretation of these fencing manuals.'

But what attracts people to this tribe, studying historical manuals and wielding heavy weapons? Keith tells me: 'People tend to get involved for different reasons. Some are interested in the history and the opportunity to interact with history in a hands-on fashion. Other people enjoy combat sports and relish the chance to learn how to fight with swords rather than just fists and feet. Other people think swords are cool and enjoy the opportunity to have them in their hand. Others are fans of fantasy, or role-playing, or some series of historical fiction, and find that learning historical fencing complements their other interests.'

Each year, the AHA has 200–300 people involved in activities nationwide and over the last few years has introduced historical fencing to around 600 people in Glasgow. From a small beginning, the teaching of traditional Scottish and other European fighting systems is starting to catch up with some of the better-known Oriental systems. It is going to be fascinating to see how the growing tribe of Scottish martial artists continue to make their distinctive mark in the city. If you would like to learn more about the AHA and their classes, visit their website at: www. academyofhistoricalarts.co.uk

THE ACADEMY OF historical arts (AHA) is based under the arches of a bridge on Commerce Street. When I arrive, Keith Farrell, one of the principal instructors, is working with a student. It is a formidable sight, both of them wielding huge German longswords and wearing protective jackets and fencing masks. Another group are training with Scottish broadswords – the double-edged weapon that was found throughout Europe, but became particularly associated with this country in the 17th century. In the far corner, a blacksmith is working away at a forge. I feel like I have travelled back in time and in many ways I have.

The AHA is part of a broad movement that has arisen in recent years and which is dedicated to the revival of traditional European martial arts. The AHA keeps these martial arts alive by providing regular lessons throughout the week in medieval German wrestling, archery, blacksmithing, the German longsword, the Scottish broadsword and the rapier. Most people associate martial arts with those developed in countries a long way from Scotland and Keith – himself a high-ranking karate expert – describes the challenge:

'People tend not to consider any of the European martial arts as "real" martial arts compared to Eastern arts such as karate. This is due to a lack of awareness – without having seen or read anything about the Scottish martial arts, there would of course be little opportunity to learn anything about them. Unfortunately, the stereotypes of European fencing being clumsy, awkward and all about strength over technical skill, have been perpetuated by media, Hollywood, books of both fact and fiction and also re-enactment groups who fail to make proper study of the fighting arts that they purport to re-enact.'

Because Scottish and other European martial arts fell out of general use, the instructors at AHA undertake detailed analysis of old techniques based on what written materials are available. The days when fencing masters would travel across Scotland from town to town passing on their techniques are long gone. However, some left manuals that set out how weapons should be used. The AHA's instructors therefore study obscure texts such as *The Art of Defence on Foot* (1798), *The Guards and Lessons of the Highland Broadsword* (1799), *The Use of the Broad Sword* (1746) and *The Expert Sword-man's Companion* (1728).

Thomas Page's *The Use of the Broad Sword* includes a section on that weapon's particular association with Scotland: 'No Modern Nation has arriv'd at such

'Separate scenes have intertwined to allow for something sustainable as far as gigs and nightlife go. I do think the stereotypical image of a cyber goth or a trad goth still applies, but probably only to those around the late teen and early 20s mark who still have quite a limited taste in music… festivals like Whitby wouldn't survive on goth bands alone, the fan base of these events are always very much 50/50 goth and industrial. There is somewhere in the region of 100 'active' goths kicking about in Glasgow, mostly in their 40s. You tend to find the younger folk are drawn in more by the dancier stuff.

'You see the same people at *every* gig and night out! These nights tend to revolve around a catch-up as much as seeing the bands. 70 per cent are working adults, with or without kids, and the rest are student types. I wouldn't particularly say there was a "core" element as much as the genre is diluted by a number of other scenes and subcultures. However, most if not all of these folk congregate at Asylum and any 'industrial' gig… even if they aren't particularly a fan of the performers.'

If you had to find a tribal headquarters for the industrial and goth world then Asylum would be the best bet. It describes itself as an 'industrial/goth/alternative' club and a 'place of refuge and expression for all alternative people in Glasgow and beyond to be free to dress and be what they want, without judgement or prejudice…' Can the industrial tribe that first emerged in the '80s continue for another 30 years? See Pat on stage with JLA and you cannot imagine it ending anytime soon.

I went to see JLA play at Audio, a small club on Midland Street. The first band on – Nightmare Frequency ('influences Skinny Puppy, Nine Inch Nails') – looked like unhinged extras from the *Mad Max* reboot. At one point the two male members rolled around on the floor having a mock fight. When JLA arrived, Pat stormed around the stage and then jumped into the crowd, thrusting his microphone into people's faces who screamed lyrics back at him. I felt very old.

The crowd comprised a mix of goth subgenres: some younger fans wore the short hair and military style clothing associated with the industrial scene, whilst others were more clearly middle-aged 'traditional' goths looking like younger versions of Nick Cave. There was a lot of black, from eye liner to the clothes.

Pat's own history helps explain the subtle connections between the different groups. He started off as a mainstream goth – into bands such as The Cure and Fields of the Nephilim. He later became attracted to the industrial scene, particularly Front 242 and Skinny Puppy. One of JLA's first big gigs was at the Whitby Goth Festival in 2002, confirming the cross over between the more traditional goth scene and the electronic/industrial movement, both of which emerged from different places within British subculture.

Gordon, drummer with JLA, describes the industrial tribe in Glasgow as he perceives it, breaking it down into three distinct, yet connected, scenes:

'The techno-industrial scene focuses more on DJs and various forms of hardcore techno, far removed from the shouty, aggressive driven metal sound that the other two scenes make use of (examples include Glasgow's Fracture 4). The power of the electronic/noise scene is the industrial purist's go-to corner of darkness! Aggressive vocals, as loud as possible and lots of home-made instrumentation, encapsulated in a ring of performance art (examples include Kylie Minoise). Lastly, we have the goth/industrial scene formed when bands like Skinny Puppy and Front Line Assembly started to appear whilst goth bands were making use of drum machines and synths. I don't see any of these subgenres being strong enough to create their own individual scene outside of London, or perhaps Berlin.'

It seems the 'sub-tribes' band together to survive, just as 'scooter umbrella culture' helps mods, skinheads and other previously separate youth subcultures to gather enough followers to make events worthwhile putting on. Gordon explained:

I WAS INTERESTED in whether there was still an identifiable 'goth' tribe in Glasgow, aware this subculture had splintered since I witnessed it emerge as a youth subculture in the early 1980s. The first goth I knew used to be picked on mercilessly by local mods, although at the time I was just thankful that diverted their attention away from me. Initial research left me baffled (one source suggested 23 different types of goth). Then I chanced upon a video of a Glasgow band named Je$us Loves Amerika (JLA) who were described as industrial goth. I decided just to look at their tribe (which, confusingly, may not be part of goth at all).

The video caught the manic energy of the band. A furious, thickset, cropped-blond singer stormed around like a crazed Viking king. He screamed into his microphone and confronted the crowd. JLA clearly had something to say and were not taking any prisoners.

I made contact, nervous about what the band would be like face to face. However, JLA could not have been more pleasant, the conversation ranging from music to politics, the difference between industrial and goth, the occult, biker gangs and the industrial (or rivethead) scene generally. The band are part of a counter-culture scene in the city, Pat in particular expressing strong views through his lyrics on the state of the nation.

'Industrial' is not easy to define. It has been described as 'the most abrasive and aggressive fusion of rock and electronic music... a blend of avant-garde electronics experiments and punk provocation'. Another described it as 'goth's meaner sibling, a style of dark, heavy music with some similar themes... a bewildering number of ever evolving subgenres and sub-subgenres from avant-garde to metal.'

One strand of JLA's DNA comes from the goth subculture that originated in Britain in the early '80s, whilst the rest is connected to the electronic, avant-garde experimental music that was pioneered by the Hull based musical collective Throbbing Gristle in the late '70s. Throbbing Gristle set up Industrial Records, their label's slogan 'Industrial Music for Industrial People' becoming used to identify the genre itself. Throbbing Gristle remains an obscure, cult band but it laid the blueprint of the movement. Their stage show mixed avant-garde performance art with aggressive, challenging lyrics and music – all elements incorporated by later pioneering bands described as 'industrial', such as Front 242 from Belgium (founded 1981), Skinny Puppy from Canada (founded 1982) and Front Line Assembly (also from Canada).

Industrial Goths

see spiritualism as a religion in its own right, or just as a way of life with no religious foundation.

Can anyone become a medium? The SNU offer training courses for healers and mediums, but 'Can you really teach anyone to communicate with the dead?' I ask. Elaine's own feeling is that: 'Everyone is intuitive and has certain intuitive or psychic ability. Speaking to the spirit world is different though, as you have to be able to lift your vibration to a higher frequency.' Whatever your views on spiritualism, the tribe has been firmly established in Glasgow for over 150 years now and shows no sign of fading away.

Elaine first realised she had special abilities when she was a teenager, receiving a vivid premonition of the Chernobyl disaster. Whilst she had always dabbled with tarot cards, for most of her adult life she concentrated on building up a successful career. It was only after suffering post-natal depression that she decided to make a career out of her calling. Elaine describes herself as a clairvoyant, clairaudient and clairsentient – meaning she can see, feel and hear 'spirit'. She uses various tools to help her communicate with the spirit world – including tarot and angel cards, runestones and dominoes. She also performs automatic writing – literally writing down messages from the spirits that are relayed to her.

In past centuries those claiming spiritual powers like Elaine risked being accused of witchcraft (Leviticus 20:27 – 'a man or a woman who is a medium or a necromancer shall surely be put to death'). The rise of the modern spiritualist movement is usually traced back to 1848 with the widely reported case of the Fox sisters in America, who claimed they could communicate with the spirit world. Spiritualist churches began to be founded in America and then Britain. Many followed the template of a Christian church, but had important differences, one being that women were often given a prominent role in running church affairs.

The first spiritualist church in Glasgow was founded in 1866 and continues today as the Glasgow Association of Spiritualists on Somerset Place. The explosion in spiritualism in Glasgow was no doubt linked to the city's low life expectancy rates. In the 1860s the average Glaswegian lived to just over 30, so the city was full of heartbroken people wanted to connected with loved ones who had died. This only increased after the carnage of WWI.

The Glasgow Association appears to be run along traditional Christian church lines – it even has its own hymn book. However, it is different – its website stating: 'Spiritualism is not, as is commonly believed, a sinister cult, meeting in darkened rooms to "call up the dead", but an officially recognised religious movement with its own churches and ministers, who possess the same rights and privileges as other religions'. It is also part of the Spiritualists' National Union (SNU), founded in 1901, which acts as a hub for many spiritualist groups in Britain.

Although spiritualism became less popular during the second half of the 20th century, there are probably still around 40 spiritualist churches in operation and countless more less formal groups. Some have a strong Christian connection, others

THERE ARE MANY hundreds of Glaswegians who regularly attend one of city's spiritualist churches, or turn up to demonstrations by mediums in pubs, community centres and other modest venues. Having never experienced spiritualism personally before, I got in contact with a prominent spiritualist named Elaine Claire O'Neil and booked a private appointment.

When I arrived at her suburban home everything seemed so normal: neighbours washing their car outside, Elaine's kids running around upstairs. There was some small talk, then the session began. Elaine asked me to choose from a pack of tarot cards and we began. I was worried that I might burst out laughing but as the session developed, that was the least of my concerns. I found the experience both unsettling yet therapeutic. At one point Elaine – communicating 'with Spirit' – informed me my dead father was sitting beside me. She knew things about me that I could not logically explain and I certainly did a lot of thinking afterwards.

Months later I watched Elaine give a demonstration to a large crowd at Cranhill Community Centre – typical of the sort of event many Glaswegians attend. The entrance fee was £3 and we sat on fold-up chairs. I spy the only other man in the audience, whilst Elaine loosens everyone up with a few jokes. And then she moves seamlessly into communicating messages from the afterlife. Connections are made, tears are shed and a box of tissues is passed around from row to row.

Afterwards, Elaine and another medium – both brought up as Catholics – tell me that many are drawn to this world after having lost faith in the church. In the past the local priest provided comfort to people in the community, but now many who have faced considerable adversity in their lives seek comfort in spiritualism. After Elaine heads home, some in the group stay behind to practise their own fledgling skills as mediums or apply hands as healers. For not much more than the price of a city centre cup of coffee, I begin to see why so many Glaswegians are drawn to spiritualism and wish to communicate with the afterlife themselves.

Elaine is one of maybe a hundred mediums active in Glasgow, many alternating between established spiritualist churches and other venues in places like Cranhill, East Kilbride, Maryhill, Coatbridge and Bridgeton. Elaine is typical of the younger generation of mediums who earn money in the internet age by finding clients online, conducting sessions by Skype, email, or promoting their services on Facebook and Twitter. This helps attract those who may be too self-conscious to attend a group session.

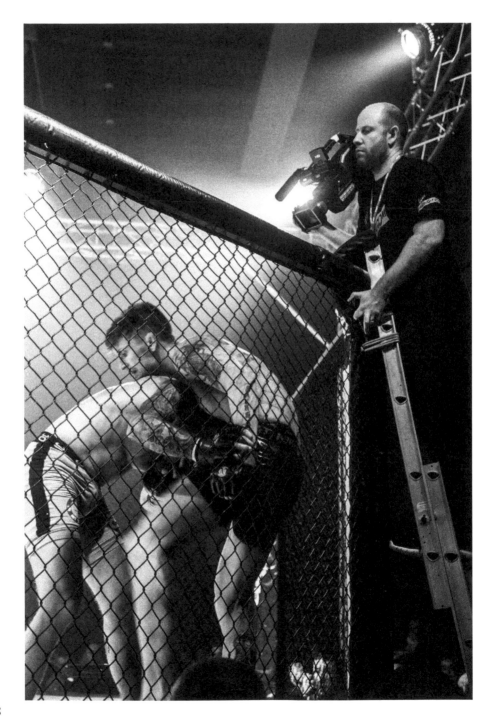

experiences I've had and the great people I've met through martial arts for the rest of my life. My successes have by far outweighed any setbacks and I still think my best is yet to come.'

The MMA tribe Glasgow, centred around a small number of elite clubs like the Griphouse and the Scottish Hit Squad, probably contains no more than 30–50 fighters taking part in paid events. Many more are training in the clubs for other goals – self-defence, confidence, fitness and the camaraderie. Over time it is likely more young people will join MMA clubs than traditional martial arts clubs and one young Glaswegian may even go on to become as famous as another Celtic superstar, Dubliner Conor McGregor.

The commercial power of MMA is considerable, however distasteful that is for those who regard it as a brutal blood sport. At another UFC event in Glasgow in 2017, ordinary Glaswegians were paying around £100 per ticket. The BBC – which has long ignored MMA – reported on the event, noting 'for decades football was the Scottish male's staple sport. Yet there were 15 competitive senior Scottish football matches played on Saturday and none of them came close to selling 10,589 tickets.'

I attended a smaller-scale event put on in a public sports hall by Valour Promotions. At the entrance I paid a tenner to someone at a flip-up table and asked a man nearby, dressed in black, where the toilet was. Only later did I realise it was the fight referee named Marc Goddard, regularly seen officiating bouts in the UFC's biggest globally televised events. It was like having a top international football referee officiate at a Sunday league game, illustrative of how the MMA scene in Scotland is still evolving.

Inside the hall the atmosphere was buzzing, full of mainly young men who looked like they could have come from the football terraces. There are cameras, sharp-suited commentators and blinged-up Glaswegians occupying the ringside tables. When the bouts begin only one fighter is knocked out. The level of skill and fitness on display are impressive – unsurprisingly, since many MMA fighters begin as youngsters in traditional martial arts.

I later talked to one young fighter (who had just lost) about what being part of the MMA tribe meant to him:

'It has had a massive impact on my life. When I started I was just looking to get into fighting with as few rules as possible. I had always considered myself pretty tough and had never lost a street fight regardless if the person had a weapon or "chib" – and I had been in many. I was an angry 21-year-old guy and at this point had stopped drinking for around a year because of the trouble I had been getting in. I started out at a club where I live. My very first day I got a chance to roll with a nice old guy with grey hair, half my size, who threw me about like nothing. I was blown away with the realisation of how little I knew about fighting and fell in love with MMA that day. I started off as a blank canvas and built myself through putting in hard hours in the gym.

'I've proven everything I ever wanted to prove to myself personally. I've learned lessons that have helped improve every part of my life. I will be thankful for the

MIXED MARTIAL ARTS – or MMA – is a combat sport combining techniques from individual martial arts. The Ultimate Fighting Championship – or UFC – was founded in the United States in 1993 and after a difficult start (it was banned in 50 states) it has gone on to spearhead the growth of the fastest growing sport in the world.

On a Friday night at the Griphouse MMA gym on Possil Road, the glamour of the UFC seems a world away. This is where many of Glasgow's best MMA fighters train and I am invited along by Guy Ramsay who co-founded The Griphouse in 2005. Like many others on the scene, he began in a traditional martial art – in his case, Muay Thai. When he came across MMA, he realised there was a whole range of skills still to master and became hooked.

During the regular Friday night sparring session at the Griphouse around 20 men and women (mostly in their early 20s) strike, wrestle and generally set about each other. It is intense watching it, but also fascinating to see women spar on equal terms with men. The experience levels range from beginners to an ex-professional. This MMA tribe did not exist in Glasgow just ten years ago, so I am witnessing a revolution in the world of martial arts. Until recently, a Glaswegian wanting to make a living out of combat sports would probably be forced to try their hand at boxing. But now MMA offers an alternative route. Many youngsters now have MMA role models, such as the multi-millionaire UFC star Conor McGregor or Scot Joanne Calderwood.

Youngsters now train in MMA techniques from the very start of their careers, including different disciplines such as Brazilian Ju Jitsu and wrestling (for fights that go down to the canvas) and boxing and Muay Thai (for strikes when standing up). The key goal of any MMA fighter is to practise these different techniques until switching between them becomes seamless.

Joanne 'Jo Jo' Calderwood exemplifies the MMA revolution in Glasgow. With links to the Griphouse, she was a champion Muay Thai fighter before switching to MMA. She went on to become a top ten ranked fighter in the UFC and in July 2015 won a landmark fight in a globally televised sell-out UFC event at the SSE Hydro in Glasgow. In front of 10,000 screaming fans, she received a $50,000 bonus for 'fight of the night'. Such level of recognition for a Scottish martial artist – let alone a female one – would have been unthinkable even five years ago. The young women sparring at the Griphouse on a Friday night have no doubt been inspired by Calderwood's rise.

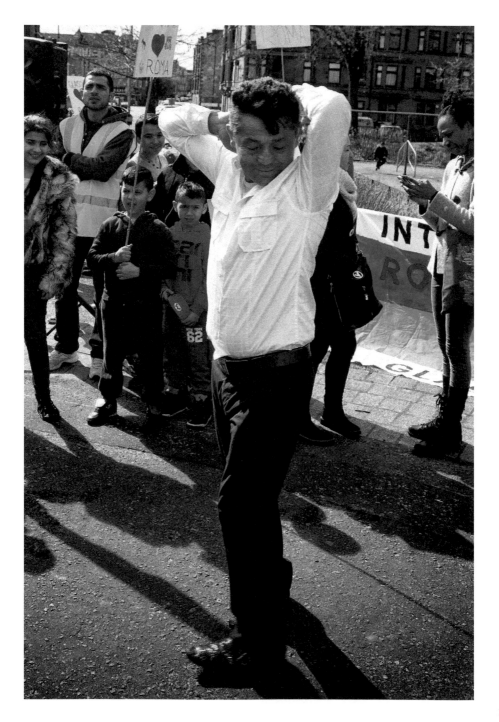

work together to create great things.

On another occasion I came to Govanhill on International Roma Day, the centrepiece of which involves a parade around the area. When I arrived at the starting point the atmosphere was tense; two people – neither of them Roma – started screaming at each other, one alleging the other (a local resident) had made racist comments about the Roma. Some young Roma children stood nearby. Previously laughing and playing, they stood bewildered as the argument continued. It seemed to symbolise the fortunes of the Roma in the area, caught between those who want to help them and those who wish they were gone.

A heavy police presence accompanied the Roma parade and as I walked beside it, I caught some critical remarks from locals standing outside pubs as we pass by. I wondered how many might be descendants of the Gaels and Irish who arrived here in the past and probably faced similar difficulties to the Roma living here today.

But there is a silver lining. While writing this book, I attended an excellent exhibition of photographs at Tramway, taken by some young Roma people of Govanhill. It suggested there is a growing awareness in the city of what the Roma community can contribute to its future.

ONE OF THE most memorable events I experienced writing the book was attending a Burns Night celebration held by the Roma community in a church hall in Govanhill. Many Glaswegians have strong preconceptions about the Roma community, but I wish the most cynical had been with me that night. Children danced, a Roma band played and everyone had huge amounts of fun. Having spent my entire life up to this point avoiding any Burns Night celebration, I was grateful it was the Roma who had introduced me to such a famously Scottish event.

Around 4,000 Roma live in Govanhill, most arriving from Slovakia, Romania and Poland after those countries became full members of the EU. Their presence has generated considerable debate and tensions within the district. Many locals blame the Roma for rising crime levels, whilst local landlords seem to get away with providing the Roma with terrible housing stock. Most people know very little about Roma history and culture and the Roma themselves are understandably cautious about strangers and the authorities.

No one really knows how many Roma live in Europe, but the figure of 14 million has been suggested, which would make them the continent's single largest ethnic minority. A recent report on the Roma in Glasgow, commissioned by Oxfam and written by academics from the University of the West of Scotland, included the following sobering passage:

'The history of the Roma in Europe is a tragic one. Migrating from northern India to Europe in the 11th century, most Roma live today in Eastern and Central Europe, with many large communities in other European countries. In the parts of the Ottoman Empire today located in modern-day Romania, they have endured persecution and enslavement at the hands of landowners and clergy since the middle ages, being emancipated from slavery only in the mid-19th century. During WWII, the Roma were collectively targeted for racial persecution. An estimated 1.5 million were murdered in Nazi concentration camps.'

There are a number of groups trying to help the Roma in Govanhill, most notably Romano Lav and Community Renewal. Members of Romano Lav are also in the band E Karika Djal – Romani for 'The Moving Wheel'. Formed as a result of a community project, the band contains several Roma singers and guitarists, as well as musicians from Scotland, New Zealand and other places. It was this band that played furiously at the Burns Night and it shows that Roma and non-Roma can

Roma

Jenn Butterworth and Laura-Beth Salter are two other leading musicians in what they describe as 'the close-knit and progressive Glasgow folk community'. They also collaborate on records (as Jean and Laura-Beth) and teach at the RCS and Glasgow Fiddle Workshop. Jenn describes the scene in Glasgow:

'There are different groups, but we all know each other well. There's a contemporary scene, a more traditional scene and a Glasgow Irish scene – and probably a lot more I'm not aware of. The sessions tend to have their own identity. There's a huge Gaelic community too.' She describes the varied life she has: 'In the last week, I've taught three classes, performed two gigs, lectured at the Conservatoire, rehearsed, prepared for gigs next week and met with a group that looks into issues involving gender and traditional music. Next week I've got a trip to Islay for an album launch. I have a friend's album launch and then I'm heading to Halsway for a guitar teaching weekend. Each day is different. Often I split the day into morning, afternoon and evening so I can manage different projects.'

Jenn describes the typical financial challenges: 'You have to have a number of different sources of income – gigs, ceilidhs, composing, teaching. I know a lot of people who have jobs with more regular hours and they organise their gigs around other work. Flexible work is helpful when you're a musician; often we have teaching commitments that we can ask other colleagues to cover.'

Jenn sees 'Glasgow as a progressive centre for traditional music – it's the New York of the jazz scene. There's a large concentration [of musicians] possibly due to the size of the city and the number of different courses. The RCS, Fiddle Workshop and Piping Centre are the core centres for the traditional music scene in the sense many musicians' CVs I read show they have studied there and/or teach there and others include Fèisean nan Gàidheal [a Gaelic art tuition charity], Hands Up for Trad and Celtic Connections to name a few more. I absolutely love being in Glasgow – the music scene is special and vibrant.'

THE URBAN JUNGLE that is Glasgow might seem an odd place to be described as the epicentre of traditional Scottish music, given that this musical form mostly developed in the countryside. Much of the success of the traditional scene is down to the community of musicians, teachers and students based in the city. Glasgow is home to important institutions such as the Royal Conservatoire of Scotland (RCS), the National Piping Centre and the Glasgow Fiddle Workshop. The RCS runs the UK's only Bachelor of Music degree course dedicated to traditional and folk music and many of the most celebrated artists to emerge in recent years have taken this course, some returning to teach new students. The city is also home to several pubs and folk clubs and hosts the annual Celtic Connections festival and World Pipe Band Championships.

One prominent member of Glasgow's traditional music tribe is Fiona Hunter, who belongs to the band Malinky as well as being a successful solo artist. A Glasgow resident, she studied traditional music at the RCS and between gigs teaches students on her old course there. Fiona described how she became involved in traditional music.

'It was because of my mum. I grew up in a very musical house, mum was always singing or music was always on somewhere in the house whether it was on the radio or cassettes. When I was old enough (around seven years old) I joined The Glasgow Islay Junior Gaelic Choir. My mum sang in the senior choir. Both choirs would compete at the local and National Mòd where you could meet other Gaelic singers from far and wide. It was a great occasion and I guess that is where I really began to fall in love with traditional music.'

There are many different styles of traditional music in Glasgow, for example those who focus on Gaelic songs, Ceilidh music, pipe bands and Irish traditional music. Within the Scots tradition, the relationship between those singing in Scots and Gaelic has become more defined in recent years – the Scottish Trad Music Awards awarding different prizes for Scots and Gaelic Singer of the Year. Fiona described some of the connections: 'I was involved in a Scots and Gaelic collaboration with Gaelic singer Kathleen MacInnes which was called Crossing Points. We look at songs which shared themes and melodies within the traditions, for example work songs, mouth music and lullabies. Some songs can't be directly translated from Scots into Gaelic as it sometimes doesn't work melodically or rhythmically and there are some which are only suited to their own traditions.'

on the island of Lewis and began singing in the Park Bar in 1965. He is credited with starting its association with traditional music. Those needing spiritual comfort can attend a Gaelic language services held at St Columba on St Vincent Street, known as the 'Highland Cathedral'.

Glasgow's Gaelic community undoubtedly faces challenges as the 21st century progresses. However the cultural scene in the city is very vibrant. The huge success of the Gaelic School bodes well, as does the fact Google have recently added Scots Gaelic to its Google Translate service.

The Highlanders' Institute, founded in the 1920s, served as a focus point for many Gaels. It hosted ceilidhs, acted as an informal employment exchange and provided a base for the territorial associations. But as the 20th century progressed, the institute's fortunes declined and it closed in 1979. The original territorial associations also began to struggle to replace members who died and today are much reduced in importance. In the 21st century a young Gael coming down to Glasgow from the North does not face blatant prejudice any longer, or need the help of the associations to make their way in the city.

Today the territorial associations still exist, but newer institutions have become central to the Gaelic community. The most visible is Sgoil Ghàidhlig Ghlaschu – the Glasgow Gaelic School. Like the old institute, it is based in Berkeley Street, and has around 650 pupils. Since being founded in 2006, demand for places has seen a primary school being founded. Around 80 per cent of the parents are not Gaels, suggesting the survival of the Gaelic as a living language may largely be down to those who have no links to the traditional Gaelic communities.

Other organisations that promote Gaelic culture include An Lòchran (The Lantern) which is situated on Mansfield Street, in Partick. According to the 2011 census, Partick has the highest concentration of Gaelic speakers in the city. Ceòl's Craic and An Gealbhan also organise social and cultural activities, ranging from language classes to Gaelic quizzes, musical evenings and ceilidhs. There is even a Gaelic theatre (Theatre Gu Leòr) and Gaelic choirs, such as the Glasgow Gaelic Musical Association (founded 1893), the Govan Gaelic Choir and The Glasgow Islay Gaelic Choir. These Glaswegian choirs regularly compete in The Royal National Mòd – the largest Gaelic cultural event in Scotland, which includes events such as Highland Dancing and Gaelic singing. There is an annual Glasgow Local Mòd held in the city, with many of the children educated at the Glasgow Gaelic School taking part.

Gaels also socialise at places such as the Park Bar on Argyle Street. For over 50 years it has hosted ceilidh bands representative of the Gaelic way of life in the North. It is run by Nina Steele and her sister Winnie, both from South Uist where the majority of the people are fluent Gaelic speakers. Many of the bands and regulars at the Park Bar have connections with the Western Isles and the Gaelic way of life. A random sample of bands at the Park Bar include Trail West (members from the island of Tiree and South Uist), Martin Pottinger (from Shetland) and the Beinn Lee Ceilidh Band (Uist). The legendary Gaelic singer Donald MacRae (b.1941) was brought up

THE HEARTLANDS OF the Gaelic world are found at the geographic edges of Scotland. The highest concentration of Gaelic speakers is in the Outer Hebrides, where around half the population are fluent. Over the last few hundred years there has been a marked decline in the number of Gaelic speakers, down to around 60,000 today. Around one sixth live in Glasgow, making the city, surprisingly, an important centre for the Gaelic community and increasingly important for its future.

The term 'Gael' was first used in the early 19th century and understanding what it really means to be a Gael is not easy for an outsider. Speaking the language is important, but the Gaelic way of life is broader than that, intimately connected to the geography of the Highlands and Islands, the sense of community, and shared cultural activities such as the ceilidh, storytelling and dancing. It raises tricky questions such as, can you be a Gael if you live in the Outer Hebrides but do not speak the language? Are you a Gael if you learn the language in a Glasgow evening class but have never lived in the Highlands and Islands?

Glasgow has long attracted Gaels. Significant numbers of economic migrants from the Highlands and Islands started settling in the city in the late 1700s. In the 19th century the Clearances forced many more to leave their homes and by the 1830s, around 40,000 Gaelic speakers lived here. Most lived in the traditional working class districts such as Partick and the Gorbals, getting jobs in factories, domestic service, on ships and in the police force. With echoes of the resentment shown by some today towards the Roma or arrivals from Eastern Europe, the Gaels were not generally welcomed, many residents of the city sharing the prejudice reported in *The Scotsman* in 1846 that 'morally and intellectually, the Highlanders are an inferior race to the Lowland Saxons'.

The Gaels looked after themselves, founding their own churches and schools. The Glasgow Highland Society ran schools for several hundred Gaelic speaking children and owned the Gaelic dominated Black Bull Inn on Argyle Street. Groups also founded self-help 'territorial' associations. The first of these was the Glasgow Sutherland Association, formed in 1857. It continues to this day, alongside The Mull and Iona Association (1866), the Glasgow Islay Association (1862), The Glasgow Skye Association (1865), The Tiree Association (1900), the Helensburgh & District Highland Association (1907), the Glasgow Lewis and Harris Association (1887) and the Glasgow Uist and Barra Association (1888). Gaels often congregated at the bottom of Jamaica Street by the Clyde before moving, by the 1930s, to a spot under Central Station bridge that became known as 'Hielanman's Umbrella'.

The Gaels

'This early scene lasted until around 1990 when Glasgow became European City of Culture and underwent a clean-up campaign that saw most of the graffiti buffed. Many of the original writers, jaded after the clean-up, retired from graffiti writing and instead turned to the emerging techno and house movements along with such vices as LSD and Ecstasy.

'I started writing graffiti in the mid-'90s when I got bored with skateboarding and BMX. As a kid, I remember seeing colourful 'burners' in the mid-'80s and was blown away. I remember standing touching a wall and trying to decipher what it meant. Fast-forward about 30 years later and here I am, fully submerged in the game and I still don't truly understand it – but I don't think anybody does.

'Graffiti has played a huge part in my life. It's bagged the majority of my attention, put me in numerous jail cells and had my life in tatters, but on the other hand it's given me a real sense of achievement, an abundance of freedom and ultimately saved my life. I'm thankful that I got involved when I did, not long before the internet made the game easily accessible to every Tom, Dick and Harry. It used to be much more exclusive. Something you had to be introduced to by other practitioners.

'Many think graffiti is an unthoughtful act of antisocial behaviour. I wouldn't knock anybody for expressing their opinion, but at least try to consider mine too. Graffiti is art. Fact of the matter is, it's one of the purest, most sincere art forms going. What other art form that exists today has its practitioners risking everything to create a piece of art purely for their own fulfilment with no monetary gain? Graffiti is communication. In a society where we're spoon-fed our views and beliefs and shunned for expressing ourselves freely, graffiti gives us that voice and the ability to stand up and be accounted for, to take control and pave our own paths.

'Thanks to my participation in the global graffiti movement, the chances are I have a wider social network than you do. Graffiti has given me an urge to travel the globe, spreading my name and sharing my work with likeminded individuals from Glasgow to Melbourne, Tokyo to Cape Town and everywhere in between. Graffiti is my vocation. It makes me who I am and gives me a purpose in day-to-day life.'

THE ORIGINS OF modern graffiti subculture began in America in the '60s and was only later consumed into the wider hip hop movement that exploded out of New York in the '70s. The early battles between New York graffiti writers and the city's transport authorities over the tagging of subway trains set the tone of how this subculture has been seen by those in authority ever since: unloved, criminalised, except if carried out in a controlled manner.

Hip hop culture began to spread around the rest of the world in the early '80s, including working class districts of Glasgow. Early graffiti pioneers included Gaz Mac (in around 1983) and 'crews' of writers such as the Easyriderz. While many would later leave the scene, Mac would go on to train as a graphic designer, and in recent years has helped organise the city's recent Yardworks Street Art and Graffiti Festival – the first in which many of the best local graffiti artists were featured. The city has also produced its own peculiar brand of aerosol produced 'art' – sectarian graffiti, murals and gang tags.

Glasgow's authorities have long waged campaigns against graffiti writers, although in recent years there has been a grudging acceptance of the art. Parts of the city centre are now adorned by huge pieces by prominent writers such as Rogue-One and Smug, sponsored by the City Centre Regeneration team. The team talks of 'embracing the concept of street art' and has even created the City Centre Mural Trail ('all contained in one easy walking route'). You can also buy the works of graffiti artists in the city's galleries, the Art Pistol Gallery selling work by Rogue-One.

I asked one graffiti veteran – who wished to remain anonymous – to describe his life as a writer in Glasgow: 'By the time hip hop landed in Glasgow around 1983, the city was already no stranger to graffiti writing known as "menchies". When the hip hop movement arrived the two were embraced by Glasgow's youths and the city, particularly the south side, became a real hotspot for graffiti "burners".

'Young people of different backgrounds battled it out to stand out and have their names noticed before it was packaged and promoted through art galleries as part of the hip hop movement with help from films like *Beat Street* and *Wildstyle* and the documentary *Style Wars*. Many feel graffiti and hip hop are totally separate – after all, graffiti was a flourishing movement long before hip hop. I love hip hop but I also listen to punk, metal, reggae, whatever I feel like.

Graffiti

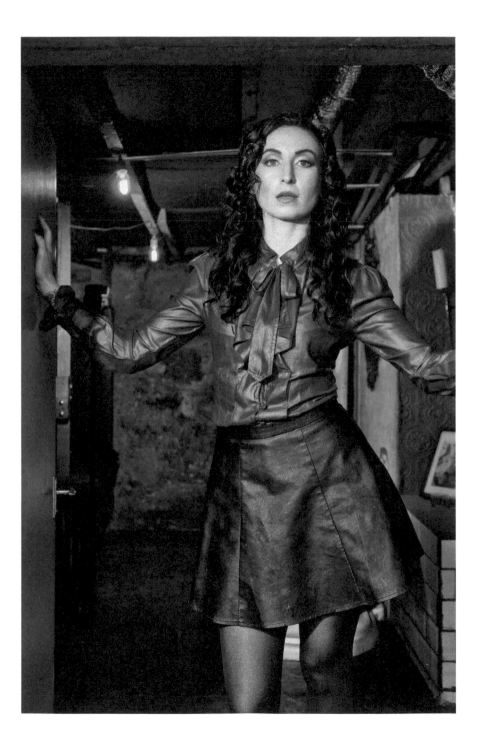

are the only animal in the jungle who deny themselves what they really want. Lions don't pass up an antelope, they take, hunt, devour, indulge, enjoy and feel no shame in doing so.' Her commitment to what she does and lack of embarrassment about the profession's reputation mean she is one of the few publicly visible members of a small, dedicated Glasgow tribe servicing the kinky demands of the city's population.

Many dommes in Glasgow have a close relationship with each other. Newcomers often serve an apprenticeship with an experienced woman, sharing their premises. Some may set up on their own, but often retain a relationship with their mentor. This serves a practical purpose, particularly if a client wants more than one person to conduct a session.

I asked Megara to explain why her clients want to be subjected to such humiliations: 'Imagine a young boy being hauled up in front of the class by a teacher for misbehaving and being humiliated in front of friends. This can produce a neurochemical link in their developing brain chemistry which joins adrenaline and dopamine with feelings of humiliation. As we now know, dopamine is the chemical responsible for addiction in our brains. Couple this with a boy who tends to look down when scolded (ie, at his teacher's feet) and there is a high chance a foot, heel or nylon fetish developing.

'Similarly, if as a boy one were to be told "no" to a chocolate biscuit. If they were brave enough to retrieve one when their mother leaves the room for a second we have adrenaline and serotonin (happiness at the taste of chocolate in their mouth) building. When the mother returns, catches them in the act and spanks them the chemicals are joined with an endorphin response to pain, which often is the reason for spanking fetishes.'

Many of Megara's clients seek to replicate these experiences as adults, particularly when their lives are boring or stressful. Many have partners with whom they dare not talk about such feelings. One client just wants Megara to tickle him. Another elderly client suffered depression for years because of his desire to cross-dress, helped by his wife, who encouraged him to experiment. When his wife died, he was devastated, but Megara helped by taking her elderly client on shopping trips for women's clothes and accompanying him to parties.

Her world is an international one and Megara has travelled the globe, working in other people's dungeons. Foreign clients also come to Glasgow, staying overnight in her dungeon. It is not an easy life and she tells me 'burn out is usually three to four years... Some last only a few months... Anyone worth their salt will be in this business for far longer than this, like any expert in their field – geology, business consultancy, writers – if they are good, they stick at it.'

Megara has a refreshingly honest approach to discussing desires, telling me 'humans

BEING A DOMINATRIX carries considerable social stigma, so finding one who was willing to speak with me was difficult. Mistress Megara Furie was the exception, welcoming me to her new dungeon in Glasgow. When I arrived, Megara was busy pulling down walls and ceilings, relishing the chance to have her own place at last. Petite and wiry, Megara is one of around a dozen established 'dommes' operating in Glasgow. They provide fantasy wish-fulfilment services for clients (known as 'submissives' or 'subs') and the techniques they specialise in are drawn from the world of BDSM ('bondage, discipline, sadomasochism'). Aspects of the BDSM services (or 'kinks') have gone mainstream in recent years, evidenced by the popularity of the *Fifty Shades of Grey* series. There remain misconceptions about the profession, for example that dommes are prostitutes. The reality is Megara does not have intercourse with clients. However, these misconceptions force most dommes to keep their profession a secret from friends and family.

The list of 'kinks' offered is broad – Mistress Megara lists around 40 on her website. The lighter end of the spectrum involves verbal humiliation, putting subs in nappies or publicly embarrassing them. They may be ordered to dress up as a woman or follow the domme around on a chain. The more extreme side can involve spitting, fisting, administering electric shocks, wrestling, anal sex (performed on the client using a strap on or machine), whipping and CBT ('cock and ball torture'). Mistress Megara is known for her expertise in CBT, proud of her ability to bring down the strongest man with a well-aimed kick. I decided to take her word for it.

In the years since she entered the profession, Megara has worked hard to learn the skills needed to satisfy client requests and to avoid physical damage. She has an impressive understanding of hygiene and human anatomy – essential to avoid spreading infections and internal injuries. The greatest skill is understanding human psychology – knowing how to fulfil a client's fantasies but also ensure boundaries are not crossed.

Megara is an entrepreneur, spending much of her time outside of the dungeon maintaining an active presence on social media, ordering her tax affairs and seeking planning permission for dungeon extensions. The use of social media and the internet can be a blessing and a curse. Whilst Megara can now sell video clips of her sessions to those who only want to experience BDSM remotely, she also has to distinguish herself from new competitors who can have a few photos taken and easily set up their own online presence.

The Dominatrix

about witches and pagans. It is much more like a Christian harvest festival and I find it very calming and peaceful.

Paganism – or neo-paganism – is a term used to describe a wide number of different faiths; the common connection is a belief in a higher deity or spirit that is closely connected to nature and the afterworld. Much of Druidcraft incorporates elements of the two main modern movements – Wicca, essentially modern witchcraft, and Druidry. The latter movement is largely based upon a recasting of Celtic traditions as recorded in historical texts, normally written by the Romans, whose legions wiped out many Celtic faiths in Europe.

Siusaidh and her husband Piet founded Tuatha de Bridget after having previously served the High Priest and High Priestess in Wiccan coven, 'Wicca' derived from the old English word for witch or wizard. Siussaidh, who trained as an astrologer, spends a great deal of time writing and publishing ceremonial rituals that can be followed by pagans of various beliefs. She is probably the most prominent pagan in Glasgow and describes the group's main moral code as 'do as you will, as long as you harm none'. Siusaidh was also a registered Legal Celebrant meaning she used to conduct events such as handfastings (pagan marriages) and other activities, including baby-naming ceremonies and funerals. She describes herself as a 'Druitch' as she is both Wiccan and Druid.

What impressed me about the ceremony and the get-together afterwards is how relaxed everyone is with no apparent tensions between those following different faiths within the group. Some are understandably cautious about how they are perceived – imagine how you might react if a colleague at work told you they were a witch or a druid. One woman – a witch – told me she was 'out of the broom closet', meaning she had only just told friends, family and people at work about her beliefs. It seemed to have been a great relief for her and clearly required a significant amount of courage to do. If you want to experience a ceremony with Tuatha de Bridget for yourself, you can visit their Facebook page or website [tuathadebridget.blogspot. com] for details of future ceremonies – everyone is welcome.

WHEN I ARRIVE late at the Pagan ceremony in a barn within Pollok Country Park, a dozen people are standing facing each other in a circle, most wearing cloaks and some with flowers in their hair. Worried I am intruding, I stay on the edge, trying to be invisible. But I am spotted by Siusaidh, High Priestess and the main organiser of the ceremony. She beckons me to join them and I take a deep breath before walking over, becoming part of the circle.

The group is called Tuatha de Bridget, which means 'the people (tribe) of the Goddess Bridget'. It describes itself as an open Pagan Druidcraft Group that holds ceremonies relating to the pagan 'wheel of the year'. The wheel consists of eight festivals – Imbolc, Spring Equinox (Ostara), Beltane, Summer Solstice, Lammas, Autumn Equinox, Samhain, Midwinter Solstice and Yule. Members of the group represent different faiths – or tribes – and those attending could include a Druid, a Wiccan, a Hedgewitch, a Heathen or a Shaman.

It is difficult to say how many active pagans there are in Glasgow – although Siusaidh estimates a few hundred. There are no pagan equivalent of churches and participants tend to perform ceremonies alone or in small groups such as Tuatha de Bridget. Most have been brought up as Christians before moving to paganism. A few have previously studied with either a Coven or a Druid Grove.

At each of the points on the wheel of the year, the group meets to celebrate the different festivals. Teaching is given at each ceremony and everyone is encouraged to write a poem or some prose, or bring a chosen piece from a book. Some sing and bring a seasonal carol or song, play different musical instruments and contribute in this way. For each person there is an opportunity to take part and parents bring their children. Siusaidh has written a book to help provide some structure to the meetings – *A Ceremony for Every Occasion*. It also covers Druidcraft and Wiccan baby naming ceremonies, Celtic Handfasting and a Yule incense recipe.

When I am part of the circle, I am made to feel welcome straight away. Cider is passed around in a wooden cup and by turn each participant gives thanks to the spirits of animals or Mother Nature for providing the apples of Autumn. A few read poems or ask for the others to pray for someone they know who is experiencing difficulties. Others talk about Mother Earth, the guardian spirit of the place, the fox spirit, brother eagle and sister seal. It is a gentle, friendly group – no devil worshipping or other unsavoury activities that some might associate from reading media stories

Another Lolita told me what attracted her to this world: 'The process for getting into the fashion is personal for each person. I would say the majority of those who wear Lolita get into it because of their interest in Japan. Some see Lolita in anime, some are interested in other Japanese fashions (gyaru, decora, visual-kei) and a few get into it because of cosplay. As a teenager I came across a copy of 'Gosu Rori' (a Lolita magazine that contained sewing patterns, advertisements and photoshoots from Lolita brands, all in Japanese) and became absolutely enamoured. I spent the next few years researching the fashion online and trying to immerse myself in the online communities. I didn't actually properly get into the fashion until I was 16 and was able to buy Lolita pieces and meet up with other Lolitas in Scotland.'

Glasgow is a long way from Japan, so local Lolitas seek inspiration from the internet, seeing what is being worn by Japanese and international Lolitas, through posts on Facebook, Tumblr and Instagram. They also look to non-Lolita sources for inspiration, one describing her personal style as 'incorporating religious and angelic imagery with gold crucifixes, halo, veil and wings based on the book and musical production of *The Phantom of the Opera*.

There are links between Lolita and cosplay, with some followers switching between the tribes, although I am told by one Lolita 'there is a very big stigma about cosplay and Lolita mixing or Lolita looking too costume-y.' For her, cosplay is more grounded in the Western tradition of dressing up at Halloween, whilst 'Lolita, doesn't really have that going for it. It's extravagant, expensive and has some pretty stringent rules that can be hard to wrap your mind around when you first get into the fashion.'

The Lolitas in Glasgow are young – most are in their 20s. It will be interesting to see if many will leave the tribe as they get older, or if the comm will continue to attract new blood, probably drawn from the city's student population. It remains a tiny, yet unique tribe, once seen never forgotten.

THE LOLITA FASHION movement originated amongst Japanese teenagers in the early 1980s and is a street style based around elaborate Victorian or Edwardian clothes. It is deliberately 'cute' and non-sexual, despite the term 'Lolita' being a provocative one given its association with Nabakov's controversial novel. From around 2000, the Lolita subculture spread out from Japan to the rest of the world and has been visible in Glasgow for less than a decade.

Lolitas in Glasgow abide by strict, unwritten rules. The main influences are from the Victorian, Edwardian or Rococo eras. Flesh is not exposed and long skirts, elaborate laces, bows and umbrellas are key components. To an outsider the tribe has a bewildering number of styles, although the main ones are Gothic Lolita, Sweet Lolita and Classic Lolita, each one distinguishable by the colour of the clothes worn, how make up is worn and accessories used. Men that dress in Lolita are known as Brolitas.

The quality of the clothes is astonishing and large sums are spent on specialist brands such as Angelic Pretty, Baby the Stars Shine Bright, Innocent World and Moi-même-Moitié. Some young women in Japan are said to stay at home with their parents, choosing not to 'settle down' in order to have enough money to keep up with Lolita fashion.

Like any 'dressing up' subculture, Glasgow's Lolitas are attracted by the opportunity for escapism, the sense of fantasy and rejection of society's conformist values. In Glasgow the most prominent 'comm' (or community) of Lolitas includes around 40 women, mostly in their early to mid-20s. They often congregate at tea parties or go on group outings. Their look attracts a great deal of attention and many bemused looks, some observers unable to process what they are seeing.

One Lolita tells me: 'The nicest comments we tend to get are from older people – I had an older lady who was waiting behind me in a queue give me some tips on keeping my petticoats big and starched. The reactions from young children are heart-warming – I've met a few little fellow princesses on my travels in Lolita and they always come up with the wonderful childlike mixture of excitement and shyness.' There is a darker side: 'Insecure teenagers who feel like they've got something to prove by calling out poorly thought-out insults, as well as drunk and sometimes somewhat intimidating middle-aged men and women who get in your personal space and grab at your clothes. It can take pretty thick skin to go out and about in such an eye-catching and over the top fashion.'

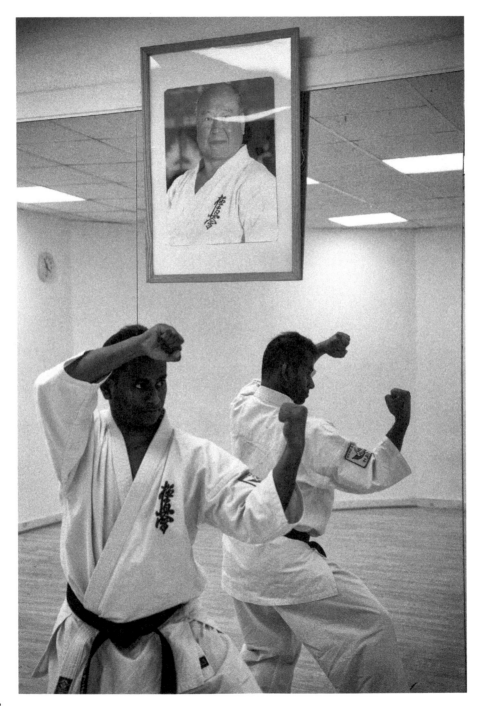

In the '50s he visited America, causing a sensation with his demonstrations of karate and fighting dozens of challengers. In the years before Bruce Lee, he became famous and upon his return to Japan he founded his own karate dojo – passing down the techniques he had developed over previous years. His 'hard' style was not popular with many traditional karate experts in Japan, but ever the outsider he founded his own karate organisation in 1964 – known as 'Kyokushin' – or 'the ultimate truth'. He attracted celebrity followers such as Sean Connery and videos of him conducting training sessions show massed ranks of students in white suits (or Gis) kneeling before him in silence. He had created a tribe, perhaps even a cult.

By the time of his death in 1994, Oyama's International Karate Organisation had branches in around 120 countries, with around ten million students and instructors. After Oyama's death the Kyokushin world splintered, his disciples founding their own rival organisations. Today, a number of Kyokushin 'tribes' each claim to represent the true legacy of Mas Oyma.

Back in Prasanna's dojo, his Glaswegian students are working hard, sparring against each other. This is not the acrobatic, delicate fighting style of Bruce Lee, but unrelentingly tough, with sledge-hammer-like kicks and punches designed to break your opponent down. It is hard and exhausting, the students' Gis heavy with sweat. This is a ritualised, controlled form of violence and it creates a strong bond and respect between students. Each of them knows how hard it is simply to follow in the footsteps of the great Mas Oyama.

ONE DEFINITION OF 'tribe' is of a group of people forming a community and claiming descent from a common ancestor. Practitioners of the Kyokushin School of Karate display many tribal qualities when they follow the strict teachings of a single, semi-mythical person – Masutatsu (or Mas) Oyama (1923–94).

I meet Prasanna, an expert in Mas Oyama's style of karate, as he gathers students for that evening's session. A Sri Lankan, he is in his late 40s but looks much younger. His gentle demeanour disguises the fact he is incredibly tough, with shins so hard that he can break wooden baseball bats (tied together) with them. He began his karate training in Colombo at a very young age and later travelled to Tokyo to train at the invitation of the great Mas Oyama himself before competing in two world championship tournaments.

As a fifth Dan Shihan (master of karate), Prasanna became one of the most prominent karate experts in Sri Lanka, founding 14 dojos there that have nearly 11,000 students. It was therefore a major decision for him to move to Glasgow and start all over again. Kyokushin is regarded as the hardest style of karate in terms of the physical demands and this can be difficult for new students to deal with. They are generally under 40 and include students, Poles who have come to Glasgow for work and Prasanna's daughter – a black belt in her teens.

Like Prasanna, the venerated Oyama was himself an immigrant. Born in Korea, he later moved to Japan where he suffered racial prejudice. During WWII he served in the Japanese air force; however, the defeat of Japan left him distraught. A bitter Oyama would later recall how he roamed bars picking fights with American servicemen stationed in his country.

Oyama decided to transform himself into the best karate practitioner he could be and the legend revolves around him retreating to the mountains of Japan where he trained alone, smashing stones with his bare hands. During this period he only descended from his mountain retreat to win Japan's national karate tournament in 1947, displaying the 'hard' style of karate that would later make Oyama world-famous. Oyama was a natural showman, with ambitions to travel the world. He put on demonstrations fighting bulls – killing them with single punches and breaking off horns. This earned him the nickname the 'God hand' – although the sole remaining film of him fighting a bull looks rather unconvincing.

Karate

a young student from Spain who was educated at an Opus Dei school back home. Afterwards there was a relaxed discussion group led by Dermot about a theme from the bible and it all felt very... ordinary. Dan Brown would have been disappointed.

I asked Dermot why he chose this path rather than another Catholic organisation. He explains 'it is really up to God to decide what vocation someone should follow. The fact that there is a wide variety of options is a sign of the richness of the Catholic Church, that it can include such a diversity of spiritualities united under the Pope.'

Whilst writing the book, Opus Dei had to elect a new leader and Glasgow-based priest Father Stephen Reynolds was one of 150 electors who travelled to Rome to cast his vote. Whatever happens in the future, the close-knit members of Opus Dei in Glasgow will continue to be influenced by events that take place in Rome and elsewhere.

MY INTRODUCTION TO the world of Opus Dei in Glasgow was through Dermot, an actuary, who runs Opus Dei's residential centre for men in the city. There is a separate centre for female members of Opus Dei and the organisation has had a presence in Scotland since the 1980s. Opus Dei was founded in 1928 by a Spanish priest named Josemaría Escrivá (1902–75).

An undoubtedly conservative and discreet organisation, Opus Dei first grew in Spain for several years. As is usual with new Catholic organisations, it took some decades for it to be approved by the Vatican. It slowly extended into other countries and today has around 90,000 members in 90 countries. Such was the impact made by Josemaría Escrivá that he was canonised in 2002 by Saint Pope John Paul II. Dermot told me that he was one of 300,000 people who crowded into St Peter's Square for the ceremony and it remains one of the most memorable events of his life.

Opus Dei means 'Work of God' and over 95 per cent of its members are – like Dermot – lay persons. Most have ordinary lives in the sense they live with partners and families, whilst some such as Dermot live in single-sex Opus Dei centres. Members of Opus Dei are inspired by the idea that they should aspire to holiness in their work and ordinary activities, Dermot tells that 'trying to bring the Christian message to one's workplace is not about imposing anything, but primarily about giving a good example of competence in one's work and having a positive attitude to others – loving one's colleagues for who they are, if you like. From time to time one of them may want to know what makes you tick and that is an opportunity to talk in a bit more depth.'

Dermot is not a priest, but there are some parallels – for example, he has decided to remain single. Spiritual activities take up a significant part of his time but are compatible with having a full time job. Opus Dei does not court publicity – a negative portrayal in Dan Brown's *Da Vinci Code* has not been helpful – but my experience of talking to Dermot was that he was open to discussion about the organisation and not afraid of challenge. Dermot explained that life in the centre of Opus Dei is modelled on life in a typical family, with daily family routines and tasks and spending time with each other. The routines include daily Mass and prayer as well as family meals and get-togethers.

He invited me to an Evening of Recollection preached by a priest of Opus Dei at a Catholic church and there I met some younger members of the group. One was

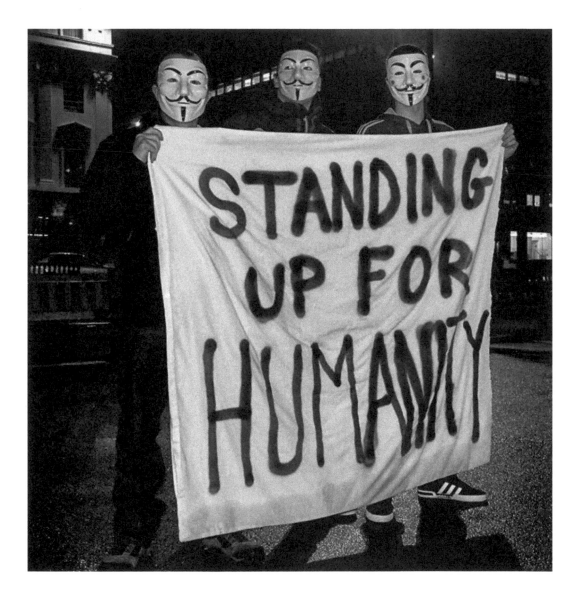

used terrorist tactics to change the world. The most famous victim was US President William McKinley, who was assassinated in 1901. However, the members of the Collective I met were friendly and clearly cared about the welfare of vulnerable groups in Glasgow, focussing on practical concerns such as the 'normalisation' of food banks.

When I ask how Glasgow would work if the Collective had their way, there is talk of worker communes and collectives but, as Chomsky identified, it is hard to pin them down. One tells me it would be up to people at the time how they chose to run their own affairs – that's the point of anarchism. But how do you persuade your average Glaswegian to ditch their dreams of their own house and a holiday abroad when the alternative is a bit hazy? One brief, golden period for the movement was in Spain during the Civil War in the 1930s when anarchist groups wielded real power in Barcelona. This was a city where Ethel MacDonald, member of a Glaswegian anarchist group, would become famous for her broadcasts from an anarchist radio station.

In recent years anarchists have linked up with new radical groups and in 2016 the Collective joined forces with Glasgow Anonymous, part of the global hacking movement, during the Glasgow leg of the Million March Mask protests. The internet has given anarchism a new lease of life, allowing innovative ways for members to interact and plan activities. Virtual currencies also offer an alternative to state-run economic controls. Despite these changes, members of the Collective have a sense of connection to their ideological ancestors who stood on Glasgow Green in the 1890s.

The Collective has no physical base, members of the tribe communicating by encrypted email and other anonymous means. It is not easy running such a group as it attracts people with strong views who do not like to be directed by people in authority. It also involves personal sacrifices and one member I met had been suspended from her job when a video of a speech she gave was seen by a work-colleague. The tribe of anarchists is also a fluid one: groups form, arguments break them apart, new factions are formed. This was confirmed when I visited the Collective's Facebook page to see a final, poignant post: 'The members of the Collective have decided to disband the Collective… [members] will be moving on and taking part in other aspects of the Anarchist Movement here in Glasgow and Internationally. NO GOD NO MASTERS… SMASH THE STATE'.

IN 1893 THE *Glasgow Herald* reported on the annual 'Labour Day' demonstration on Glasgow Green. The 'Glasgow Anarchist Communists' held a banner that read 'Anarchy is order', their speaker holding forth in 'rigorous language' about the 'ghouls who fattened on the results of honest toil and live in villas in the West End'. I wondered if the descendants of this anarchist tribe could still be found today in the city. Initially making contact with anarchists was not easy – most are suspicious of outside interest being shown, wary they are being monitored by the security services. When one group – the Collective – did reply, I thought perhaps I was being set up when their leader (as far as an anarchist group can have a leader...) suggested we meet in Buchanan Street one Saturday afternoon.

I arrived to find a dozen anarchists under a garden gazebo, passing out anarchist literature. I had to admire their dedication, attempting to convince rushing Glaswegian shoppers that they should unplug from the capitalist matrix. The anarchists, at least on that day, did not hide behind their masks. Most were students in their early to mid-'20s. They told me they sometimes attracted attention from Far Right groups and one – a bit older than average, admitted it would be good if the Collective could attract more working class people like him. They were part of a small number of anarchist groups in the city, often at odds with one another over ideological differences and collectively numbering no more than a hundred or so people. From my research on the anarchist cause in Glasgow since the late 19th century, this number was probably not far off the historical average.

Anarchism emerged during the 19th century and in the early days its supporters shared common ground with Marx's communists in terms of hostility to capitalism and private property. The early anarchists fell out with Marx over the role of the state in achieving their goals. Anarchists want a society without rulers, not (as is commonly believed) a society without rules. Theirs is an inherently optimistic view that ordinary people are better at organising their lives than any government. Beyond this, understanding how – practically – an anarchist society would operate is complex. Noam Chomsky has written 'Anarchism has a very broad back... so the question of what an anarchist society can be is almost meaningless. Different people who associate themselves with rough anarchist tendencies have very different conceptions'.

Mention anarchism to most people and it triggers thoughts of chaos and riots. Much of this is a legacy of the early years of the movement when some anarchists

caused huge divisions. The authorities also wanted to clamp down on drug taking amongst young club-goers and the closure of the Wigan Casino in 1981 marked the end of the golden period.

Northern Soul survived, retreating underground where it really belonged. Paul, in his 50s, is a key figure in Scotland's soul scene and at www.soulscotland.co.uk he lists the best events, such Southside Soul and Blacktrackin' In Glasgow. The days, when huge clubs were bursting with teenage Northern Soulers are long gone, so it is in this second tier of often smaller clubs and halls that the scene thrives.

Paul explains the appeal: 'You have to feel it. If I have to explain it, you probably wouldn't understand. I grew up with Motown and that led me to Northern Soul and once you're in – you're in… it is truly the cult that refuses to die.' In the Glasgow area there are probably no more than 100 people who are part of the tribe. They are mostly middle aged, but Paul sees some change: 'Younger mods have come into it, and films like *Soulboy* and the more recent *Northern Soul* have attracted some new faces, curious to see what the fuss is all about. As for the drugs… I think pretty much every dance / music scene has its devotees who will choose to "enhance" the experience. But on the soul scene in Scotland it is not anything like the part of it that it used to be.'

I ask Paul what it is like being part of this tribe. 'It is like being part of a family. People care about you and if you accept the music and the etiquette that surrounds the dancing then they will accept you. Some folk don't like 'tourists', but if you play by the rules you are part of the family. Being able to dance spectacularly is not a condition of entry. Some struggle to understand why you might want to drive miles on a Sunday afternoon, dance all evening, stay sober, then get home at 1.30am. But in time most come to accept it and if you can persuade them to visit a club they understand why it becomes addictive. It has been, and remains, a wonderful scene – unconditional and full of friendship. And of course great music.'

I FIRST MET Paul Massey and his friends at a Northern Soul 'all dayer', my first chance to experience Northern Soul after reading so much about this peculiarly British subculture. Seeing middle-aged Scottish men dancing expertly to rare soul records on a Sunday night without being drunk is a rare experience on its own. Perhaps the most striking aspect was that the men were completely comfortable dancing alone or with male friends. Stranger still were the women who sprinkled talcum powder onto the dancefloor to aid their moves. In dark corners rare Soul records were bought and sold and one younger dancer performed the back-flips and spins that Northern Soul is famous for. It was like being an observer at a secret club – exactly what Northern Soul has always been about.

Northern Soul is one of the most enduring subcultures to emerge in Britain over the last 50 years. Its origins lie with the mods of the '60s who loved soul music, frequently taking stimulants to help them dance all night. As the mod movement began to fade away in the late '60s, a core group of soul fans at Manchester nightclub The Twisted Wheel kept the scene going. The pursuit of ever more obscure American soul records became an obsession for these fans and the DJs who sought to win their loyalty. Slowly the mod dance moves and clothes morphed into something different and created a separate, much more exclusive youth subculture.

The term 'Northern Soul' was coined in 1970 after a London-based record shop owner and journalist noticed kids from the North visiting his shop were asking for soul records that were different to those preferred by his local clientele. The iconic Twisted Wheel was forced to close in 1971, but the scene spread across the North of England and Midlands. Every weekend hundreds of Scots travelled down to clubs such as the Golden Torch in Stoke, the Wigan Casino and Blackpool Mecca.

The popularity of Northern Soul in the '70s began to attract media attention and thousand would flock to the big club nights. Glaswegians adopted the Northern Soul look, including Adidas t-shirts, Northern Soul badges, baggy trousers and sports bags (used by kids to carry their dancing clothes). The Wigan Casino – which became famous after a 1977 television documentary on the Northern Soul phenomenon – even had an area where Celtic members of the tribe would congregate and which became known as Scotch Corner.

Every youth subculture inevitably fades. Tensions between DJs over whether they should stay true to '60s American soul or introduce some contemporary sounds,

Keep the Faith – Northern Soul

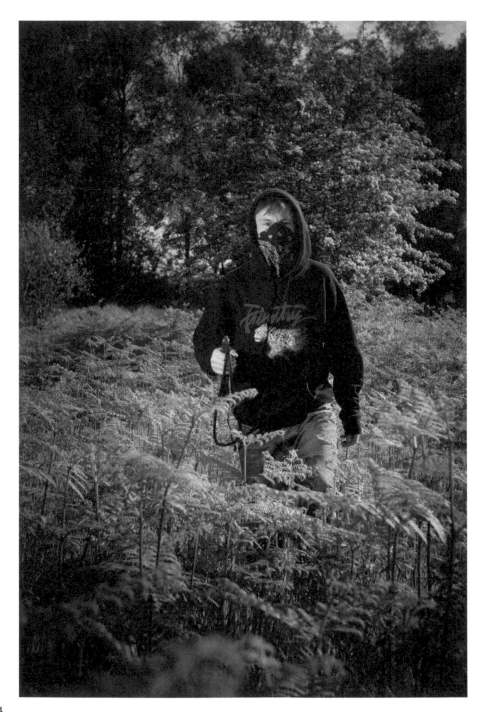

animals would be saved persuading people to go vegan. But, pretty much all vegan Sabs do that alongside sabbing anyway. With sabbing you are able to directly save lives, in that moment, which would otherwise have been lost. Also, I think raising the profile of fox hunting could have a positive knock-on effect – most folk disagree with fox hunting. Single issue causes – hunting, fur, sea-world, whaling… often get the support of otherwise non-animal rights people. I hope they become passionate, do research and see how it is a contradiction to support the exploitation and death of animals only in the ways we've become accustomed and desensitised to. Not to mention sabbing is fun (when it's not traumatic), worthwhile, effective and you meet and form friendships with some of the most compassionate, decent people.'

Emily seems fairly typical of the Sab community in Glasgow: a student, a vegan, with some connections to the anarchist/left-wing political world. Emily also described how she and other members of the group have suffered regular police harassment. This appeared to be confirmed when in early 2016 the *Sunday Herald* reported that it had 'uncovered the systematic harassment of animal rights activists by Police Scotland and an apparent bias towards fox hunts allegedly involved in illegal activity…'

In 2016 the Scottish judge Lord Bonomy published his review of the Protection of Wild Mammals (Scotland) Act 2002, which was supposed to have ended the hunting of wild animals such as foxes. His conclusions were, broadly, that the law was too complicated, making the detection and prospection of offenders difficult. Whatever reforms come, it seems unlikely that either side will be satisfied and that the polarised nature of the debate will continue.

I asked Emily if she gets scared: 'The welfare of animals is a priority and we're not scared to stand up for that. I'm a bit afraid of getting arrested, but that's mainly because I'd be worried about my animals at home. I guess I'm scared for the fox, the hounds going into cry is an unsettling sound.' For Emily keeping a Sab group going can be challenging – organising activities and attracting new members when people leave. Some are attracted by the excitement, but do not last long when it gets a bit hairy or there is a risk of a criminal conviction. Now well established, it seems likely this urban tribe will continue as long as fox hunting (in whatever form) continues in the Scottish countryside.

THE LIFE OF a Glasgow hunt Sab is not an easy one. Members of this small, intimate tribe, are regularly involved in confrontations with the pro-hunt community and the police. There is no love lost between the two sides, each accusing the other of all manner of wrongdoings. The Sabs I meet are concerned about their personal safety and this makes organising an initial meeting with them very difficult. All tell me they worry that members of the pro-hunting lobby will try and track them down, or harass them. Sabs also worry their communications are being intercepted or monitored.

A visit to the Glasgow Sab's Facebook page contains videos and photographs that are grim to watch. It features aggressive, face to face confrontations with hunt supporters; people screaming at each other, filming every move. Over the last few decades, people have lost their lives on both sides of the divide and many others have been injured. Regardless of your views on hunting, being a member of this tribe is a serious commitment.

For the Glasgow Hunt Sab's a typical weekend's activity may be: 'Glasgow Sabs arrived at [—] for 5.30am, there was only three of us, so we had to abandon the usual tactic of splitting up to keep watch from the roads and instead opted to get close to the kennel so there was no way they could sneak past us. Our first encounter was with a delightful chap who was doing his best to be scary, aggressively and continuously shouting at us to f*** off and inaccurately reciting the trespass laws (oh how we never tire of that!). When that failed to rattle us, he resorted to screaming that he would "set his Rottweiler on us". Lovely. This was the first time any of us had sabbed a cub hunt or been to [—] and stood there in the dark and cold, severely outnumbered and being threatened with violence, we wondered if this was to be the tone for the day... We are Glasgow Hunt Sabs, dedicated to saving wild animals from hunters.'

Glasgow Hunt Sabs was formed in 2014 and is affiliated to the Hunt Saboteurs Association founded in 1963. Whilst activities in respect of fox hunting tend to grab the headlines, Sabs in Scotland are involved in a much wider range of other activities. They use what they describe as non-violent direct action tactics to disrupt everything from pheasant shoots on grouse moors to badger culls and the killing of seals by fishery companies.

I met one of the group's leaders, a student named 'Emily'. Why did she become a Sab? 'It was a quandary deciding to tackle a single issue as it could be argued that more

The Sabs

Laura symbolises a cultural shift as nerd or geek culture has become big business. In America events with names such as 'Nerd Con' attract thousands and recently a 'Geek Out' event was held at Hamilton Racecourse featuring cosplay competitions, a gaming area, introductions to cosplay photography and costume workshops. Can you imagine a kid in the Glasgow of the '70s or '80s being openly proud of being called a nerd?

New cosplay careers have emerged – from models, photographers, event organisers, to bloggers. Models such as Adrianne Curry, who describes herself as 'Queen of the Nerds', have developed global media profiles, impossible before the internet. There is a darker side to this new world, with occasional reports of harassment of cosplay models at conventions showing some fans cannot draw a line between fantasy and reality. However, the world of cosplay appears to be a generally positive one.

Laura tells me: 'In ten years Glasgow has gone from having one major convention every two years to at least one a month. And between events cosplayers can be found having small meetups regularly in the city centre, where more casual costumes are worn. What makes cosplayers a tribe is the strong community that they form. They learn new crafts and skills from each other. They also protect each other.'

Laura had a fairly typical route into cosplay, growing up reading fantasy and sci-fi, then getting into comics and manga. 'I've always been quite a shy person and suffer from anxiety. Cosplaying has made me a lot more confident, in my own body and mind. A lot of people use it as escapism, to get away from their normal everyday life for just a few hours.' American clinical psychologist Dr Robin S Rosenberg's studies confirm this, suggesting many cosplayers are introverts drawn to the world of dressing up as it helps them become part of a community and explore their own creativity. It seems like the cosplay community in Glasgow will continue to grow, but will cosplayers give up as they get older? I ask Laura. 'I don't think I'll stop cosplaying as the years go on, maybe slow down a lot! There are a lot of badass older female characters that I can't wait to make in the future.'

COSPLAY, DERIVED FROM 'costume play', involves followers dressing up as fantasy characters drawn from superhero comics, Japanese anime and manga culture, video games, films and graphic novels. It has become a phenomenon and is arguably the only new global youth subculture to have emerged in the last decade.

The origins of cosplay go back to American science fiction conventions in the 1940s when fans began dressing as their favourite characters. It gained momentum after the first Comicon convention in San Diego in 1970 and then in the '80s and '90s when Japanese kids put their own spin on things and the term 'cosplay' was first coined. In the last decade, cosplay has blossomed in Glasgow, with several clubs in the city. Participants are generally educated and culturally sophisticated. The average cosplayer is in their late teens to early 20s, although as the subculture matures, a minority are considerably older.

I arrange to meet a well-known cosplayer named Laura (cosplay name 'Aranel') at a Comic Con event at the SECC in Glasgow. Even arriving at the arena on a grey, rainy Glasgow day is an experience. In the car park I am surrounded by superheroes and mythical figures, already in character before heading to the arena. When I find Laura – who has a PhD in biochemistry – she is dressed in a spectacular self-made costume, unrecognisable from the person I had first met a few months before wearing normal clothes.

She is a keen gamer and a self-confessed nerd. On short notice she can transform herself into any one of 40-odd characters, sourcing fabrics and accessories from all around the world. Her Facebook page contains the self-penned profile: 'My main love is fantasy! Swords, sorcery, horses and dragons! I play and love D&D [Dungeons and Dragons] as well as many other table top games such as Warmachine and Warhammer. Also all my money goes to Magic the Gathering. I read mainly from the DC Universe but also adore Top Cow and random titles from all over.'

Laura is regularly invited as a guest to conventions and judges costume competitions. She is also in demand by photographers, many of whom include cosplay themed photographs in their portfolios. Like many cosplayers, she has developed a significant presence online – posting photographs of herself in a variety of costumes on Facebook, Tumblr, DeviantArt and similar sites. This allows her to connect with people across the world, making cosplay a global subculture.

Cosplay

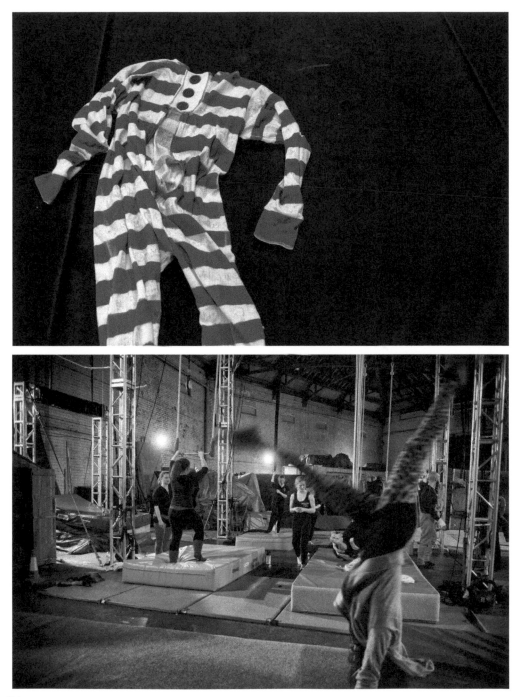

nies. One instructor discovered the circus when studying for a PhD in pharmaceutical science at the University of Strathclyde. Others also have parallel careers in parkour, massage therapy and the cabaret industry. Aerial Edge is also involved in the annual Edinburgh Aerial and Acro Convention (EAAC) which brings together circus people from around the world. The school offers a Foundation Course in Circus Arts (see aerialedge.co.uk).

Amy started classes as a beginner and ended up working for Aerial Edge on the marketing side. She is a modern-day example of someone running away to join the circus, and it has taken her to places such as Brazil. I asked her why she was drawn to this new circus tribe in Glasgow:

'Training has become an essential part of my life and you never get bored. It is addictive because of the friendships you make and the adrenaline you experience. It is empowering to experience your physical skills expanding, and links back to the playfulness of childhood where kids spend their time at gymnastics classes and climbing trees. Adults have this missing from their lives. There is something about learning circus that you cannot find in a CrossFit gym or trudging along in a marathon.

'There is a supportive ethos about the school and the circus feels like my spiritual home. You step off the trapeze platform and swing through the air and the day's concerns just melt away. There have been times when I've cried out of frustration but due to the support of my colleagues and fellow students I have never wanted to quit. Those are the moments when your resolve strengthens to achieve more – it's a great metaphor for life.'

THE GLORY YEARS of the circus in Glasgow were from the mid-19th century to the early 20th century when a number of permanent circuses were built in the city. These included Cooke's Circus near Glasgow Green, Frederick's Hengler's circus, and Bostock's Scottish Zoo and Variety Circus. When the world famous Barnum and Bailey Show – 'The Greatest Show on Earth' – came to the city for three weeks in 1898, it attracted 20,000 Glaswegians each day.

Many permanent-site circuses went out of business in the early 20th century due to competition from the cinema and other newer attractions, although traditional travelling circuses remained popular. In recent decades tastes have changed, particularly with the growth of the 'nouveau cirque' movement that provided an animal-free, new spin on the circus experience. For many people, companies such as Cirque du Soleil or Archaos are the new circus 'norm'. What remained a constant was that a Glaswegian wishing to join a circus would have to travel a long way to learn their trade.

This changed in 2007 with the foundation of the Aerial Edge circus school, based in the Briggait. It combines the permanent aspect of those early circuses, with more contemporary circus skills. Aerial Edge's opening created a groundswell of interest amongst locals and now it has over 300 students taking classes in around 25 different disciplines. These range from traditional skills such as the flying trapeze to parkour.

Classes are designed for complete beginners and the age range is from four to 75. Many want to keep fit, finding it a unique way to develop natural strength and agility that cannot be replicated in a normal gym. One female student named Cath only began training at the age of 50, but within a few years was able to take part in professional performances, including *Kylie The Musical* at the Kings Theatre in Glasgow.

Many students attend classes almost every day, developing a strong sense of camaraderie and trust within the circus tribe. One posted on Facebook: 'My second family & home! There isn't enough stars to even begin to give Aerial Edge what it deserves. I found Aerial Edge during a very dark time in my life and I can honestly say that if they hadn't been the amazing people that they are I wouldn't have had the platform to become the person I am today'.

The instructors are an eclectic bunch, several having experience in circus schools in Australia, Canada and Spain, and having toured the world with well-known compa-

wanted to have a career in music, but can be difficult to get your foot in the door of the music industry. I still see myself making it big someday. I reckon I'll be busking for a good few more years because for me it isn't about making money, it's more about enjoying myself and making new friends, which I have done with a few other buskers. Knowing what kind of crowd you can expect to have is dependent on different things such as the weather, the busker 100ft away from you, an Orange Walk going past, or in my case – not having an amplifier or a microphone. I do have the occasional drunk or arrogant member of the public who will try to say things when I play such as: "Nobody can hear you", "Get a job!", "You need a mic and an amp", "You're S***".'

Many of the younger buskers maintain online presences, their videos being seen my thousands more people on YouTube than they could ever hope to play for on the streets of Glasgow. It creates some division, one veteran telling me 'Once it was a way of life and you lived that life daily. Now it is about image, social media, playing chart music etc. When was the last time you seen a busker with a beard and old coat? The buskers of the '80s, '90s and early 2000s were all acoustic and you played with what you had and made it last. If it broke you repaired it. I doubt whether many of these new buskers can manually tune a guitar.'

Glen (who can tune a guitar) describes a typical day, making around £20–£40. He tells me, if the weather is good: 'Around 20–30 buskers will turn up all over the place – you can have buskers ranging from ten years old to 60. I usually stay in town for around six to seven hours which requires a lot of material to play to prevent myself from looking stupid.' I ask Glen about his favourite memory: 'One group of women summoned me from across Buchanan Street to a bar they were in. This resulted in me busking right beside them whilst they sang along and clapped, a whole new experience for me. When I finished the whole bar stood up and cheered. It makes you feel like what you're doing is worthwhile.'

IT IS HARD to avoid buskers in central Glasgow. In recent times my favourites have been rock guitarist Borja, the 'Spanish Slash', and the topless man who tries hard, yet cannot sing. On one typical day, walking from the St Enoch Centre to Sauchiehall Street, I encountered 17-year-old guitarist Glen, the Techno Binmen, a woman playing the ukulele, the Celtic-warriors of Clanadonia, and a young girl, no more than 13, singing away to a backing track. Many student buskers are looking for a bit of extra money. Some have serious ambitions of breaking into the music industry, but few make it.

Despite the transient nature of the busking community, relationships between buskers are generally good. In the past, buskers often met in certain pubs for a drink after finishing up, but this social side seems to have declined in recent years. The younger, ambitious buskers might instead play during the day and then frequent open mic nights in the city hoping to get noticed.

The council produces a 'Good Practice' guide which asks buskers to be considerate of local residents and to move on to another pitch at least 50 metres away after an hour. Ignoring the guidelines can lead to difficulties, although no one appears to have suffered the indignity dished out recently to one busker in Falkirk who was put in a choke hold and dragged away by several policemen after they received complaints about his singing.

Buskers regularly face threats of violence, particularly at night. In recent years an African performer was assaulted by racist thugs on Sauchiehall Street and another nearly blinded after a man threw ammonia in his face. However, for some the risks are worth it. Emma Gillespie went from busking in Glasgow to winning £100,000 on the TV talent show *Must Be the Music*.

One veteran busker told me why he started: 'It was about making some money and doing what I loved most – playing acoustic guitar. Meeting friends that did the same, counting the money over a pint and taking each day as it came. It somehow defined me, allowed me to have my own identity and take a step away from what everyone else was doing like buying cars and working 9–5. It allowed me to travel and broaden my mind, experience other cities and cultures and taught me to value each day.'

At the other end of the scale is Greg Henderson, just 17 when I meet him: 'It started off as my way to get myself recognised. From when I was around ten I've always

Buskers

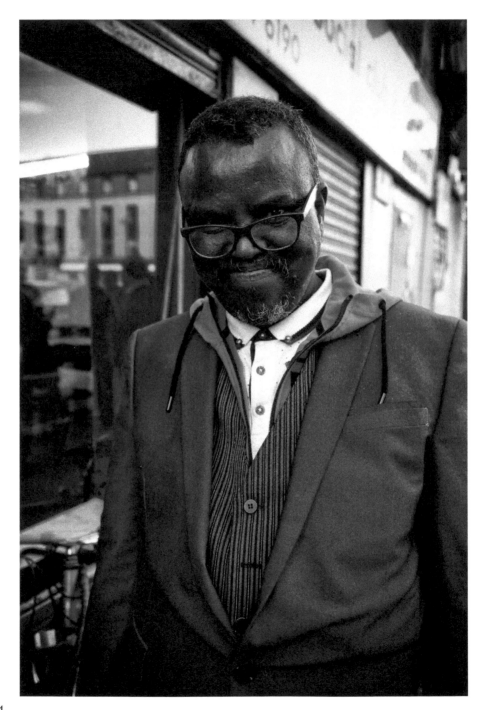

For an outsider understanding how the Somali community organises itself is not easy. In recent years it has become more self-confident, choosing community leaders to represent them, some of whom recently met Nicola Sturgeon. Within the community there are differences that only would be apparent to Somalis. For example, Mo can tell from someone's accent if they come from Mogadishu or from the north of Somalia. Tensions between rival clans back home can be apparent in Glasgow, but are far less pronounced. As time goes on, the Somalian children born here will assimilate further into Scottish life and these differences will no doubt diminish.

Cultural tensions can arise, notably when the government banned khat, the plant that Somalis traditionally chew to relax when socialising. Imagine the outcry if the government banned Tennent's lager in Glasgow's pubs, however it is a sign the Somalis have the disadvantages of new arrivals.

Any visit to the Club is memorable, not least because the members always look like they are having fun. I get a glimpse of life back home: superb coffee with ginger sprinkled on top, Italian Billiard (which involves rolling a ball with your hand), Somalian food. Tall Glasgow-born young Somalis arrive to join their dads and uncles after playing football. One tells me his size and colour sometimes mark him out for unwanted attention from local kids, but he feels as much a Scot as he does a Somali. Despite some negative press headlines, many positive things are happening within the community, one sign being the opening of Somali run businesses. If you want to experience Glasgow's East African community, pop down to Mama Africa and watch a game of football or play Billiard. The Somali community may be relatively new in the city but given the modern human race emerged from East Africa, remember – you're from where they're from.

THE MAMA AFRICA social club is an outpost of East Africa in the Gorbals. It is frequented largely by members of the Somali community, although other nationalities also congregate here. My host was Mo, one of many Somalis to settle in Glasgow in the last 15 years. Around 200–300 families form the core Somali community, most based in the same working-class districts that have welcomed immigrants to Glasgow for generations.

Like many others, Mo's family fled Mogadishu and the long-running civil war in Somalia to find a better life. A chance remark saw Mo arrive in Glasgow alone (his 12 siblings went to America). Today he has six children of his own, all born in Glasgow, and tells me it took several years to feel that the city was his real home.

The club was formed to provide a social hub, just as in the past Gaels flocked to the Highlander's Institute and Italian immigrants founded the Casa d'Italia. Members come to relax, exchange news and play pool, Italian billiard (a legacy of colonial rule by Italy) and cards. Watching football is an obsession, although most have skipped the joys of Scottish football and support clubs such as Chelsea and Manchester United. This is a male dominated club, not surprising given the Muslim heritage, and most I meet have the sort of jobs associated with new arrivals: taxi drivers, security guards, working in warehouses. The younger generation of Somalis have other aspirations – some I meet want to be engineers, sportsmen, businessmen.

The highlights for the community are the celebrations of the Muslim Eid holidays. Most Somalis are Muslim and speak Somali – the mother tongue – although many also speak Arabic. The Club is also near to the Glasgow Central Mosque in the Gorbals. Somalis also celebrate the Independence Day of Somalia (1 July 1960). Up until then at various times the British, Italians and French had tried to rule the territories that today comprise Somalia, although their often misguided efforts have led directly to much of the instability that blights the region to this day.

 They are noticeably international in their outlook, nearly all maintaining close ties with relatives and friends who have begun new lives all around the world. Posts on the club's website range from reports from the *Nigerian Daily News* and other African newspapers, adverts for Eid parties hosted by Mama Africa at Pollokshaws Burgh Hall Trust, to the football results of Man United versus Leicester City. Many members have lived, worked and travelled in more countries than most of us could ever dream of experiencing.

East Africans on the Bridge

Chris sees himself as a link between the past and the present. Most of the group are involved in the SNP and nationalist politics, and over a pint the conversation shifts seamlessly between topics such as the spread of food banks in Scotland to some obscure fact about Bonnie Prince Charlie's health. Whilst researching this book, I met members of a motorcycle club, and noticed similarities between them and the Jacobites. Members of both are mostly middle-aged men, and often include former soldiers like Chris who seek something to replace the sense of camaraderie they experienced whilst serving. Bikers and Jacobites follow formal rules of conduct and – in their different ways – dress up and attract attention.

On my second day with Chris the Jacobites attended a second commemoration, this one organised by a man named Henderson who wanted to remember the many Hendersons who died beside the MacDonalds during the Massacre. It was a strange moment, half a dozen of us trudging out across a boggy field in driving rain to the Henderson memorial stone. Chris played his pipes and a speech was read out. No other Scots were present, although curious faces looked out of passing car windows. However, in America, members of the Henderson Society were watching this rain-soaked commemoration as it was being live streamed on one Jacobite's smartphone. I suggested the descendants of Scotland's diaspora are more interested in aspects of our history than those who live here, something the Jacobites are keen to rectify. And then it was over. Chris headed south, back to his normal life – family, his lorry – already planning for the next Jacobite get-together.

THERE ARE HALF A DOZEN modern-day Jacobite groups in Scotland, and many have members based in or around Glasgow. One of these is Chris, an HGV Driver Trainer by day and, in his leisure time, a piper and member of the Jacobite Royal Oak Society. I first meet Chris in Glencoe where he and fellow members of the Royal Oak have travelled to commemorate the Massacre of 1692. Like the others, Chris is spending the whole weekend dressed as an 18th century Highlander, and the group – with their broadswords, replica pistols and dirks – draw attention wherever they go. During a poignant commemoration service at the memorial to the Massacre, Chris played his bagpipes, speeches were made and a prayer was recited. By chance a solitary woman turned up, a MacDonald here to pay a personal homage to her ancestors who were murdered in Glencoe. She is genuinely touched that Chris and the others had made such an effort to be there, the only other people who seem to care.

Chris and his fellow modern-day Jacobites often get a hard time, ridiculed for living in the past and supporting a cause that died on the field of Culloden in 1746 when Bonnie Prince Charlie and his army were defeated. Whilst it is true that some Jacobites can obsess about whether various obscure European aristocrats with distant links to the Stuart dynasty have a stronger claim to the British throne than Elizabeth II, Chris and the others I meet are mainly concerned about finding out more about the history of the Jacobite era, and educating others about this period of Scottish history. For years Chris has attended anniversaries at places such as Culloden (16 April) and Glenfinnan (19 August) and without people like him some of these dates might just be confined to dry history books.

After the ceremony at the memorial Chris and the others return to the pub where the fun begins. Broadswords are waved in the air. Chris, sporting a vast grey beard, plays Jacobite songs on his bagpipes. The fun is contagious and Chris talks to everyone – tourists from South Africa and America, walkers weary after a day on the West Highland Way and locals. Some must think they have wandered into an Outlander wrap party and the Jacobites carry on until three in the morning.

The Royal Oak Society is new, although Chris and other founding members have been involved in other similar groups for years. The society has adopted the name of a Jacobite secret society founded in the 18th century and which is believed to have counted Robert Burns as a member. Like some other Jacobite groups, joining is by invitation only and members must abide by strict rules on behaviour and dress code.

Jacobites

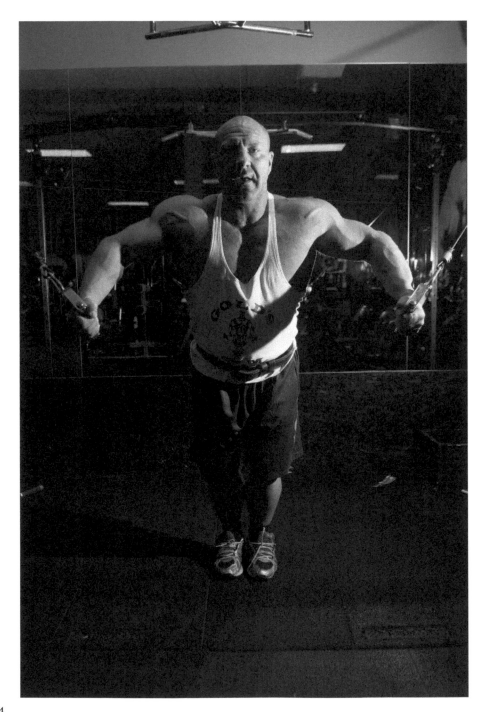

He has to eat six carefully prepared meals a day and train ferociously hard in the gym – even though his sciatica causes considerable levels of pain whilst doing so. He also has to train despite working late hours on the doors of Glasgow's clubs and bars, however for Ruddi this is just an extension of the challenges he overcame as a poor kid in Poland travelling for hours to learn martial arts.

The bodybuilding tribe Ruddi has dedicated so much of his life to has changed in recent years, and particularly since the glory days when Arnold Schwarzenegger was the sport's biggest star. The sport is having to find a new audience after ever more extreme body shapes, particularly amongst women, began to attract negative press attention. New competition categories were created such as 'Men's Physique', 'Bikini Fitness' and 'Body Fitness'. These promote more natural, less bulky bodies. Ruddi is old school, going for the traditional look.

Extreme Gym – describing itself as the 'House of Muscle' and 'the bodybuilders' factory' – is tribal headquarters for Ruddi, and where he and his friends can exchange tips, encourage each other through gruelling weight sessions, and just be part of the scene. The exterior of the red brick gym in East End is anonymous and serious looking – there are no windows or people visible in lycra on running machines. Everything happens on the inside, and Extreme's website declares 'Be prepared to see tears, sweat and blood... We have dedicated it fully to people who love bodybuilding, powerlifting and fitness, people like yourself. Remember... champions are not born... we build them!'

I ARRANGED TO meet Ruddi for the first time in an upmarket bar in Saltmarket. A member of the city's small tribe of competitive bodybuilders, when he entered several heads involuntarily turned towards him. He was hard to miss – a shaved head, and muscles that seemed to be straining to escape from the confines of his frame.

Ruddi only took up the sport in his early 30s, however he's since made up for lost time and regularly takes part in national competitions. His journey to this point has not been an easy one, growing up in difficult family circumstances in rural Poland. Small for his age and picked on in the playground, Ruddi had to toughen up quickly, so – like many working class Poles – he got into martial arts in the same way most British kids gravitate towards football.

He would travel for hours just to train at a particular gym, building up his strength in order to help him fight, not to show off his muscles. With limited career options he became involved in security,ecu working the doors of nightclubs – and beginning a career as a mixed martial artist. He moved to Moscow, again working as a doorman. Ilis stories of that time are hair-raising, not least the occasion when he was stabbed. It was during this time Ruddi began to suffer from severe sciatic nerve pain in his back, something that cruelly ended his hopes of a full-time career as a mixed martial arts fighter.

Having left the fight game, Ruddi ended up in Glasgow. He got work on the doors of the city's many nightclubs, something he still does today, normally with a crew of fellow Polish doormen. Glasgow can be a violent, hard city, but I sense for Ruddi it is fairly tame compared to what he has experienced in Russia and elsewhere. Ruddi has also qualified as a professional bodyguard, providing close protection services to those who have good reason to fear for their safety. If I ever needed a bodyguard, Ruddi would certainly be the sort of person I'd choose.

Ruddi began working out in Glasgow's Extreme Gym to keep fit, with no intention of becoming a competitive bodybuilder. However Extreme's management spotted his potential, and offered him sponsorship and free supplements if he would enter a competition. He agreed, winning the title and kick-starting an obsession with the sport. It has had a major impact on his personal life, with Ruddi having to learn graduate-level amounts of information about nutrition and muscle groupings in order to stand a chance of competing successfully.

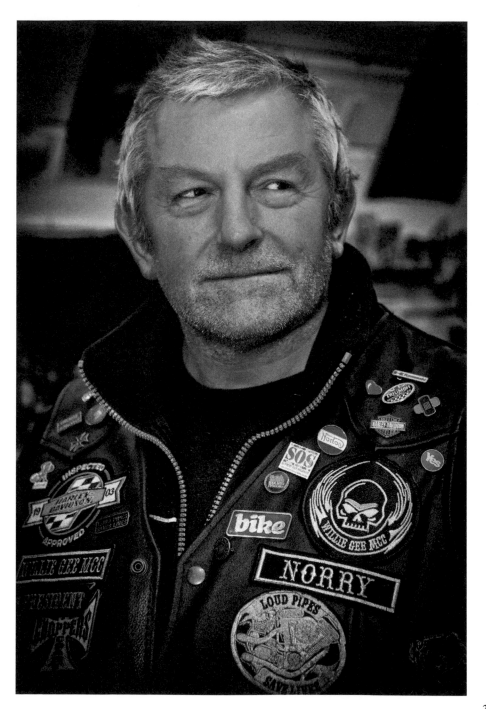

overshadows clubs that are part of the '99 per cent', including Willie Gee MCC, the Road Spartans MCC, Hillbillies MCC, Fool On MCC, Trusted Few MCC, Mutineers MCC and Freedom MCC. The tribe comprises of no more than 200–300 members – mostly male and usually old enough to afford top-end motorbikes. The club members are typically working-class and generally untouched by any sectarian divide.

At Willie Gee MCC senior club members set the tone and others follow. New members cannot wear the club's colours – the famous 'side rocker patch' – until the President and officers are happy they have shown sufficient commitment by turning up for club rides out and helping in social activities. There are no female members and this is very much a man's world.

One veteran member told me: 'We are inundated with people who see our guys on ride outs and they want to be part of what we are. You can tell pretty quickly if somebody is committed but also if they have the chemistry to get on with a pretty diverse bunch of guys. The average waiting time is around two to three months by which time I know if they are ready. It's one of the pleasures of the job being able to hand somebody their side rocker and seeing the look of genuine happiness on their face. 'We have suffered a wee bit from the Sons of Anarchy effect... wannabe hard men try to join us so that they can get the patch and pretend they are something they are not. They are easy to spot and don't get in.'

The mainstream clubs must show deference to the Blue Angels. To do otherwise risks being construed as disrespectful and could have consequences. Only the Blue Angels can use the initials 'MC' (for motorcycle club) after their name – all the others use 'MCC'. Some bikers show deference by selling 'Support 21' merchandise, 21 being a metonym of the name BA, just as supporters of the Hells Angels call themselves 81. MCC members are often seen wearing support patches, t-shirts and other evidence of their support for the 'Blues'.

The scene in Glasgow seems to be booming, one biker telling me: 'I have never seen so many bikers wanting to be part of something bigger than I see now. That feeling of 100 guys riding their bikes together as part of one big noisy family through a town or down the motorway is addictive. It's a new sense of belonging. True brotherhood.'

CURIOUS ABOUT THE culture of motorcycle clubs in Glasgow, I was invited by a member of the Willie Gee MCC to visit their club house in a quiet spot near Tollcross in the city's East End. After parking my battered, ancient Zafira beside a dozen gleaming, ship-sized motorbikes, I sat in the car for a moment, wondering if I was man enough to get out.

I entered the clubhouse known as 'The Bunker'. There is a bar, pool table, dart board and club memorabilia on every wall. Everyone is wearing leather and most have beards. There are no women in sight. Despite the carefree image, Willie Gee MCC is as organised and structured as any Freemason's Lodge. There is a President and several officers, all with clear roles and an irrefutable pecking order. The template for most motorcycle clubs was developed in the early 20th century by the American Motorbike Association (AMA). It was only after WWII that returning veterans began to set up their own clubs outside of the AMA's jurisdiction, the most infamous of which is, and remains, the Hell's Angels. The antisocial tendencies displayed by some of these newcomers attracted sensationalist press attention, particularly after a riot took place at a bike rally in Hollister, California in 1947. The AMA disowned them, stating that 99 per cent of its own members were law-abiding. The bad boys leapt on this, glorying in the title of being 'one per center' or 'outlaw' clubs.

In Scotland after WWII motorbikes changed from being the preserve of the better off to an increasingly popular mode of transport with working class men. In the 1950s the explosion of rock'n'roll, the influence of Brando in his leathers (in *The Wild One*, 1954), all contributed to a new young subculture. These early bikers would congregate in coffee bars and go on ride outs, and as 'ton-up boys', 'rockers' and 'greasers' became infamous in the '60s, the British press made the most of clashes with another emerging young tribe – the mods.

Glasgow's first American style motorcycle club – the Blue Angels MC – was founded in 1963 in Maryhill. 'Blue' stands for Bastards, Lunatics, Undesirables and Eccentrics, and also represents the Scottish flag. The Blue Angels developed a reputation in Glasgow and beyond for being 'one per centers', and were later influenced by the changing styles in the emerging American outlaw biker film genre, particularly *The Wild Angels* (1966) starring Peter Fonda (three years before *Easy Rider*).

The Blue Angels remain the undisputed leaders of the motorbike tribe in the city and no other outlaw club has dared set up a chapter in Scotland. Their reputation

Bikers

The future of the Barras is hard to predict. The old stalls and shops may decline to the point where the market ceases to operate in the way it was originally supposed to, and goes the way of Paddy's Market that closed in 2009. It could become a Glasgow equivalent of Camden Market, but that is largely for tourists not locals. No outcome is likely to please everyone. In 2016 the city's council announced funds to undertake a range of improvement works and make the Barras a 'must go' arts and events quarter. Everywhere you walk you can see new tribes – start-up companies, artists and innovative restaurants cheek by jowl with the knock-off merchandise traders.

The Glasgow Collective is a good example of the new Barras, offering co-working spaces on and around East Campbell Street, attracting businesses such as Dear Green Coffee Roasters, MacGregor MacDuff ('the King of Kilts') and a teenage photographer starting out on his career. Many Studios on Ross Street also provide spaces for creative businesses, including photographers, filmmakers and the Telfer Gallery. Many Studios also launched Ross Street market, its products a world away from the traditional traders selling cheap goods to the working classes. Barras Art and Design (BAAD) offers restaurants, pop-up shops, street food markets and craft fairs. It can only be hoped this new breed of locals can increase the overall prosperity of what has long been one of the most deprived parts of the city.

Time will tell how the old and new tribes of the Barras work together. For now, I suspect the lady I met in her 80s who helps sell second hand bikes will never experience the lobster and charred octopus on the menu of the A'Challtainn restaurant just a stone's throw away. Whatever happens, it can only be hoped the fortunes of the Barras are on the rise.

THE BARRAS MARKET stands in the shadow of the legendary Barrowland Ballroom, surrounded by a string of staunchly Celtic-supporting pubs. It is located in Calton, a working class district that has the lowest rate of male life expectancy in Scotland. The market's origins go back to the early 1920s and the efforts of Maggie McIver and her husband James. In the early days it was a place where hawkers sold goods from handcarts (or barras). Permanent sheds to house traders were then built, as well as the Ballroom. The McIver family, some of whom are today based in Canada, continue to own large sections of the market and constitute the upper echelon of the Barras tribe.

During the 20th century the Barras became the most popular weekend market in a predominately working class city. Those with limited funds could buy not only cheap goods, but be entertained by the fast-paced patter of the traders. Visit the manager's office at the Barras and you will see walls covered with photographs of the glory days of the market, one showing Cockney Jock, a famous trader, entertaining a crowd of hundreds of people in the '50s.

When I first visited in the '80s this was still a bustling market. The subsequent growth of discount shops, online retailing and relaxation of Sunday trading restrictions began a downward spiral. Reports of traders selling counterfeit goods have not helped. Most locals I talk to are pessimistic about the future, reminiscing about the old days when there was still a strong sense of community that is almost impossible to imagine today.

Reading a press article about the market's decline I noticed a reader's comment recalling the glory years: 'A Sunday wander around the stalls, listening to the barkers flogging knock-off goods at mad prices, buy some secondhand 45s, a plate of mussels – 5p in today's money – at the Loch Fyne Shellfish Bar – still there! – and a slow walk home to Bridgeton for a bowl of mum's flank mutton soup. Happy days!'

Whilst those days may be memories, the Barras still retains a huge charm, whether it be the stalls selling an eccentric range of goods or the many curiosities in Randall's Antiques. Many of the traders have been here for decades and come from families that have had stalls in the Barras since long before that. Some businesses in the area also go back a long way, including Bill's Tool Store (here since 1958) and Loch Fyne shellfish café (opened in 1960). I even discovered my great-grandmother had a stall here in the '40s.

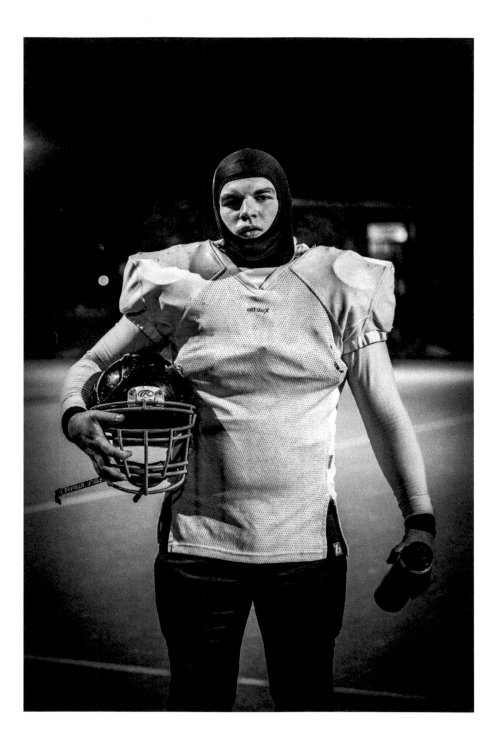

work for the owners of the League and the Claymores closed. It marked a watershed moment after the enormous growth of the game since the mid-'80s.

Despite this, the amateur game remains healthy with several local teams such as the East Kilbride Pirates (founded 1985), Clyde Valley Blackhawks (based in Wishaw), the West Coast Trojans (based in Paisley), Inverclyde Phoenix (Greenock) and a team based at Glasgow University. Those who do not want to risk the undoubted physical challenges of the game can also play 'Flag Football' – an increasingly popular variant that has mixed sex teams.

In 1896 the *Glasgow Herald* reported on how 'the American footballer is somewhat more careful of his skin than is his British cousins... [the latter] have not yet thought it necessary to don any such suits of armour. Leather helmets, mouthpieces, nose protectors are in a fair way to be soon as common [in the US] as jerseys are among ourselves.' Nothing much has changed, and acquiring the kit to play the game is expensive. Willie and other club officials spend a great deal of time trying to raise funds to help subsidise the cost of kit for new players.

The players are close to each other. The complexity of the tactics required to be successful means players have invest time in the club, and you cannot turn up and play one weekend as a 'ringer'. The small number of clubs in Glasgow also means players tend to stay put for longer. For new joiners the opportunities are impressive: the large number of players needed for a game (45) mean the chances to play are high. The variety of positions also means players of different skill sets, shapes and athletic abilities can normally find a niche and maximise their potential. Amongst the Tigers and other clubs in or near Glasgow, there are probably around 250 regular members of the American Football tribe at any one time.

Willie's tribe plays from April to September, with home games played at Lochinch. Their opponents have suitably American influenced names such as the Aberdeen Roughnecks, Dundee Hurricanes and Northumberland Lightning. Despite varying fortunes over the years, Willie remains optimistic about the future. Channel 4 has a lot to be thanked for.

I FIRST MET Willie Clark, chairman of Glasgow Tigers American Football team, on a freezing night in Govan. Over 50 players are training, mostly Glaswegians in their twenties, with a healthy sprinkling of players from Poland, Croatia, Switzerland and America. There are some big units and in body armour and helmets, they look ominous. When training starts everything speeds up, and it is much quicker than I expected, the players a blur under the bright stadium lights. This is an amateur team, but it feels fully professional. The coaches are intense, speaking to each other through radio mics. Players are filmed, their actions later analysed using a programme named Hudl. Those standing on the sidelines do not joke around, but watch intently. Players turn up on time. Everyone knows their place.

The origin of the team can arguably be traced back to 1982 when newly created Channel 4 launched a show about American Football hosted by Nicky Horne. Prior to this, Glaswegians were largely limited to a stodgy diet of television sports such as darts, wrestling, horse racing, football and rugby. The new programme sparked a groundswell of interest, and hundreds of new American Football clubs were founded around Britain in the mid-'80s. Willie Clark, then a policeman, was one of these pioneers. In 1985 he founded the Strathclyde Sheriffs with work colleagues, which was later renamed the Glasgow Tigers. Whilst the Tigers would expand beyond its police roots, a number of veterans from the early days remain integral to the coaching and management of the team.

In the early years Willie and others struggled to learn how the game should be played. There was no Amazon or Google, and everything was learnt from watching games on television (recorded on a VHS or Beta-Max), reading the few books available, and by simple trial and error. Willie told me: 'When I first started we trained real hard without the helmets and shoulder pads, probably for three or four months. Then we got the full equipment and enlisted the help of two American Navy officers who helped us learn how to block and to how to tackle. In 1988 we had an unbeaten season and won the Caledonia Bowl… great memories.'

The early scene in Glasgow benefited from the hype around the American National Football League's efforts to run a NFL Europe League. Scotland hosted the Scottish Claymores between 1995 and 2004, the team playing many games at Hampden Park. The Claymores briefly threatened to turn American Football into a mass spectator sport in Scotland, attracting an average attendance of over 10,000 fans, and recruiting rugby star Gavin Hastings as kicker. However, the economics did not

Gridiron Glasgow

15

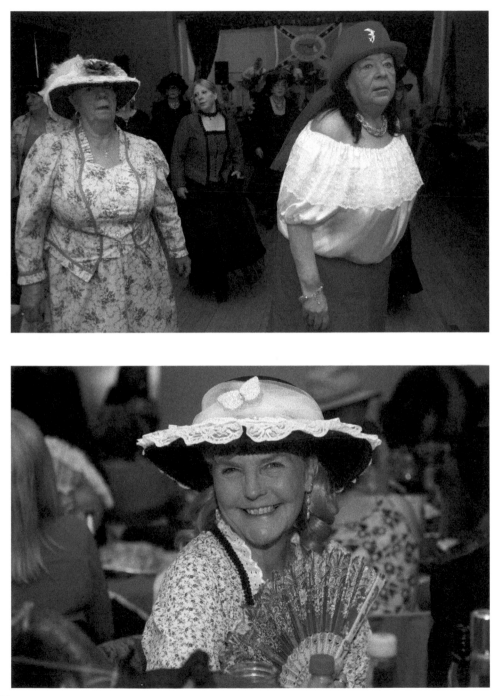

Arguably the parallel revival in the traditional folk music scene appealed more to middle-class audiences and Billy certainly saw C&W as 'working man's music' that was popular with those employed in heavy industry or in the shipyards: 'Many bands played at the American base on the Holy Loch and if there was a "Southern State" ship at the base then a Country band would be invited to play, whilst "Northern State" ships wanted soul bands.'

Billy remembers when Glasgow's Grand Ole Opry opened: 'The club was packed on a Friday, jam packed to capacity on a Saturday and a little quieter on Sundays. The management ensured that there was a "top" band performing at least once every month and the quality of the local bands was extremely good. Local clubs of smaller capacity were also well attended during that time and there was a club night somewhere in Glasgow at least five nights a week.' He saw a decline in the '80s onwards, for the bands at least. Tougher economic conditions meant promoters wanted to pay less, which put pressure on bands to replace musicians with backing tracks and drum machines. The growth of line dancing also meant more competition for the bands.

The C&W scene in Glasgow has declined generally over the last few decades for a variety of reasons and the average age of those who still form the core group of fans has crept up significantly. However, there is still a vibrant scene, often in the smaller clubs far away from the Glasgow Grand Ole Opry. These include the Phoenix Country and Western Club (CWC) in Yoker, the Tombstone and Kentucky CWC in Paisley and The Silver Spur in Linwood ('we cater for gunslingers, line/partner dancers and those that just love country music'). The photographs included were from a charity night at the Phoenix where hundreds of fans dressed up as Western characters, danced to a band and enjoyed a show put on by the Glasgow Gunslingers. As Alan and I left, the whole club broke out into a bout of communal song singing, ringing in our ears as we stood in a dark car park surrounded by grey, silent suburban streets. It was easy then to understand why C&W fans enjoyed living in a fantasy world of Americana, even if just for a few hours.

THE COUNTRY AND WESTERN scene has been popular in the city for a long time, its focal point being Glasgow's Grand Ole Opry on Govan Road. Founded in 1974, inspired by the legendary Grand Ole Opry in Nashville, in its early years it was the only C&W club in Scotland. In its heyday, it had 2,000 paid-up members and people would queue around the block to get in. Those days are long gone, but it is probably still the largest C&W club in Europe.

Why American C&W took hold so strongly in Glasgow in the '60s, '70s and '80s is complex. No doubt many who grew up in the difficult years after WWII sought escapism in American Western films and television shows and were attracted to emotionally charged Nashville songs of tragedy, love and redemption. Much has also been made of connections between C&W and the music of Irish and Scots immigrants to America in the 19th century and even gospel music has been likened to Gaelic psalm singing.

For many cowboy-loving Glaswegians of the '50s, '60s and '70s, stars such as Johnny Cash also epitomised the tough, independent rebel many (particularly males) aspired to be. The reality of life for most working-class people was very different and C&W was, and remains, a form of escapism. Tellingly, Cash was obsessed by his own Scottish roots, his musician daughter describing how 'our Celtic past made him realise that this was where he derived his tone of voice, the mournful quality to his music... and it was that sense of place and time that was passed on to him and then on to me.'

The C&W tribe in Glasgow contains several smaller groups, including those in C&W bands, line dancers and gunslingers. I met one veteran C&W musician named Billy, a pedal steel guitar player in the band Nickles & Dimes. In his 70s, he dresses in black and wears a Stetson. The gig I meet him at takes place at a small C&W club on a Monday night, but it is packed, most attendees in their 60s and 70s. Billy tells me he would play every night if he could but there just are not as many gigs as there used to be.

His love of C&W began in the '40s: 'I don't think I was alone in discovering this music. In the late '40s and early '50s America seemed to become a little bit closer to our shores. The US troops brought loads of things with them and we were so ready to greet the "technicolor' life".' His youth was spent soaking up American culture; his local cinema became known as 'The Ranch' due to showing a Western film every day of the week. These influences, he thinks, were 'possibly the reason Glasgow folk were such fans of the Cowboys and country music'.

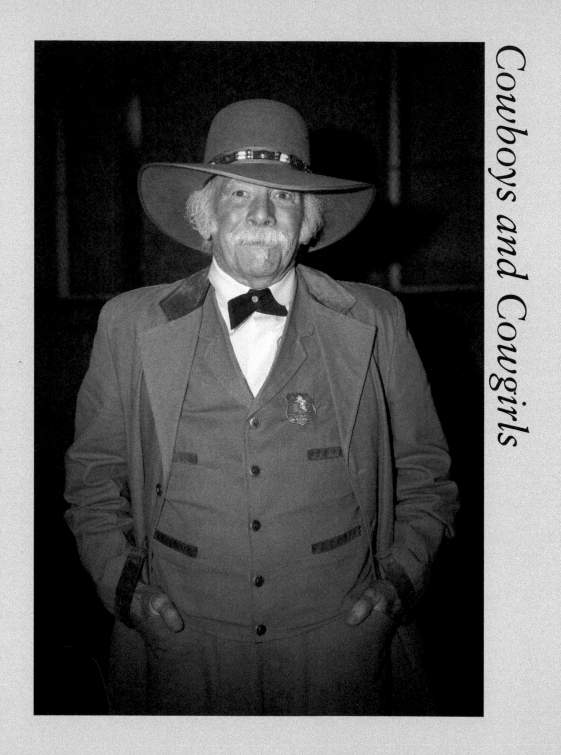

Beyond this aim, the actual manner of selection of individual tribes was often random and haphazard. Many groups turned me down flat, or expressed interest in helping but disappeared from view as I got closer to them. I will admit to giving up a number of times, particularly on one occasion after I left work, drove to a tough pub and ended up in an empty back room with half a dozen large men who wanted to know if I was really a member of Special Branch.

But the more connections I made, the more new tribes were revealed to me, and slowly I made progress. The final selection is very subjective and I don't claim this is a representative sample of the city's tribes – you could write ten volumes and still only scratch the surface of what a city as big as Glasgow has to offer. However each tribe has – to varying degrees – its own rule of behaviour (written or not), sometimes a charismatic leader (alive or otherwise), and a particular purpose or shared heritage.

This book is my tribute to John 'Hoppy' Hopkins, a leading countercultural figure of the '60s and one of the best British photographers of any era. He once told me about a book project of his own, focusing on groups at the fringes of society. For some reason it was never completed, but ever since the idea has intrigued me and it is the inspiration for *Tribes of Glasgow*.

Stephen Millar, February 2019

Introduction

I RECENTLY RETURNED to Scotland after leaving as a child, and wanted to reconnect with Glasgow, my home city. But it wasn't easy. Then I began to seek out tribes in the city that might make me understand what Glasgow was really like, away from the headlines and buildings. The tribes of Glasgow you will meet in this book are as diverse as you can imagine and probably not the ones you might immediately think of. My encounters with them revealed a side of the city I had never seen before.

I met gunslingers with Stetsons and pistols, hunt saboteurs and industrial goths. I experienced the thrill of MMA fighters in combat inches from my face and enjoyed my first Roma-style Burns Night in Govanhill. In frank conversations, people revealed to me the inner workings of their subcultures and I thank them all for letting me into their lives.

I came across Alan McCredie on Twitter, loved his photography and got in touch. So began an unusual partnership. Our first meeting was over coffee, our second in a dominatrix's basement, our third at a pagan gathering... and so on.

What did I learn along the way? As someone who has spent their entire life actively trying to avoid becoming part of any tribe, I recognised nevertheless that being part of one had many benefits, particularly in the modern age when increasing numbers of people feel lonely or disconnected from others. As Donne said, no man is an island.

How did I select these particular tribes? I asked several people for suggestions and the majority (usually taxi drivers..) always went for gangs or supporters of the Old Firm. However, I decided to try and avoid stereotypes. Instead, I wanted the book to be positive and feature groups who never seem to make it onto the shelves of mainstream bookshops. I am willing to bet that, whatever its faults, this book is the only one in the history of the world that features Opus Dei alongside anarchists, wrestlers and red-heads.

Contents

This book is dedicated to my children – Patrick, Anna, Blythe and Arran – and all the Tribes who helped me along the way.

First published 2019

ISBN: 978-1-912147-85-4

The paper used in this book is recyclable. It is made
from low chlorine pulps produced in a low energy,
low emission manner from renewable forests.

Printed and bound by CPI Antony Rowe, Chippenham

Typeset in 11 point Sabon by Main Point Books, Edinburgh

Tribes of Glasgow

STEPHEN MILLAR

and

ALAN McCREDIE

Luath Press Limited

EDINBURGH

www.luath.co.uk